RACHAEL ZIADY DELUE is assistant professor
of art history at the University of Illinois,
Urbana-Champaign.

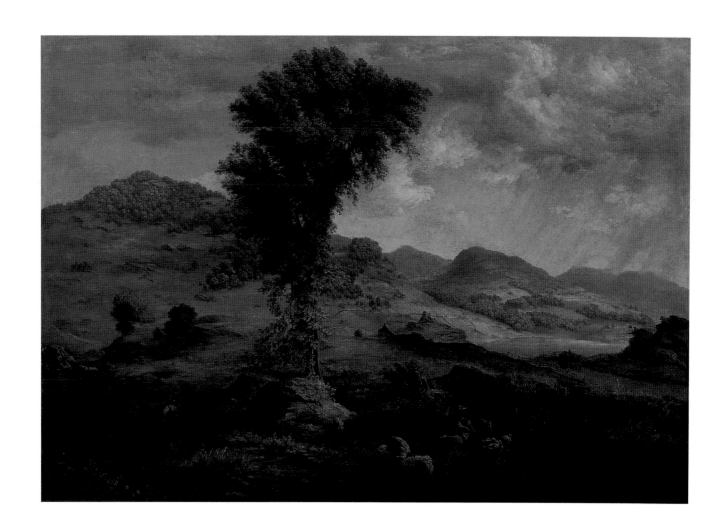

GEORGE INNESS

AND THE SCIENCE OF LANDSCAPE

RACHAEL ZIADY DELUE

The University of Chicago Press · Chicago and London

Rachael Ziady DeLue is assistant professor of art history at the University of Illinois,
Urbana-Champaign.

The University of Chicago Press, Chicago 60637
The University of Chicago Press, Ltd., London
© 2004 by The University of Chicago
All rights reserved. Published 2004
Printed in China

13 12 11 10 09 08 07 06 05 04 1 2 3 4 5

ISBN: 0–226-14229-9 (cloth)

Library of Congress Cataloging-in-Publication Data

DeLue, Rachael Ziady.
 George Inness and the science of landscape / Rachael Ziady DeLue.—1st ed.
 p. cm.
 Includes bibliographical references and index.
 ISBN 0-226-14229-9 (cloth : alk. paper)
 1. Inness, George, 1825–1894—Criticism and interpretation. 2. Landscape painting,
 American—19th century. 3. Spirituality in art. I. Inness, George, 1825–1894. II. Title.

ND237 .15D45 2004
759.13—dc22

 2004004953

The paper used in this publication meets the minimum requirements of the American
National Standard for Information Sciences—Permanence of Paper for Printed Library
Materials, ANSI Z39.48–1992.

For Erik

CONTENTS

ix List of Illustrations

xiii Acknowledgments

George Inness, Metaphysician INTRODUCTION *1*

The Struggle of Vision CHAPTER 1 *7*

Painting from Memory CHAPTER 2 *31*

Painting Unity CHAPTER 3 *59*

Painting the Past CHAPTER 4 *91*

The Plight of Allegory CHAPTER 5 *145*

The Mathematics of Psychology CHAPTER 6 *171*

"We must work our way to Paradise" EPILOGUE *235*

239 Notes

291 Selected Bibliography

307 Index

ILLUSTRATIONS

PLATES (following page 96)

1. George Inness, *Kearsarge Village* (1875)
2. George Inness, *Old Homestead* (ca. 1877)
3. George Inness, *Autumn Oaks* (ca. 1878)
4. George Inness, *Saco Ford, Conway Meadows* (1876)
5. George Inness, *The Coming Storm* (ca. 1879)
6. George Inness, *Sunset at Etretat* (ca. 1875)
7. George Inness, *A Gray, Lowery Day* (ca. 1877)
8. George Inness, *The Sun Shower* (1847)
9. George Inness, *Lake Nemi* (1872)
10. George Inness, *The Valley of the Shadow of Death* (1867)
11. George Inness, *The Home of the Heron* (1893)
12. George Inness, *Niagara* (1889)
13. George Inness, *Summer Evening, Montclair, New Jersey* (1892)
14. George Inness, *October Noon* (1891)
15. George Inness, *Summer Montclair (New Jersey Landscape)* (1891)
16. George Inness, *Morning, Catskill Valley* (1894)
17. George Inness, *The Passing Storm* (1892)
18. George Inness, *Sunny Autumn Day* (1892)
19. George Inness, *Landscape with Trees* (1886)
20. George Inness, *The Mill Pond* (1889)
21. George Inness, *Home at Montclair* (1892)

FIGURES

1. Washington Allston, *Belshazzar's Feast* (1817/1843) *9*

2. George Inness, *Winter Morning, Montclair* (1882) *14*

3. Albert Bierstadt, *Moat Mountain, Intervale, New Hampshire* (ca. 1862) *16*

4. Jean-Baptiste-Camille Corot, *Ville d'Avray* (1870) *24*

5. Jean-Louis Ernest Meissonier, *The Chess Players* (1853) *24*

6. Alexandre-Gabriel Decamps, *The Suicide* (ca. 1836) *42*

7. George Inness, *Sunshine and Clouds* (1883) *64*

8. George Inness, *Sunset* (1878) *65*

9. George Inness, *The Coming Storm* (1878) *66*

10. George Inness, *Medfield* (1877) *66*

11. Joseph Mallord William Turner, *Slave Ship (Slavers Throwing Overboard the Dead and Dying, Typhoon Coming On)* (1840) *67*

12. George Inness, *Homeward* (1881) *70*

13. George Inness, *Two Sisters in the Garden* (1882) *70*

14. George Inness, *The Rainbow* (ca. 1878–79) *77*

15. George Inness, *Passing Clouds* (1876) *77*

16. George Inness, *Early Recollections: A Landscape* (1849) *90*

17. George Inness, *Landscape* (1848) *92*

18. George Inness, *Evening at Medfield, Massachusetts* (1875) *97*

19. Asher B. Durand, *The Beeches* (1845) *101*

20. Jasper Francis Cropsey, *Autumn—on the Hudson River* (1860) *101*

21. George Inness, *Storm Clouds, Berkshires* (1847) *107*

22. George Inness, *Hackensack Meadows, Sunset* (1859) *108*

23. George Inness, *Landscape with Cattle and Herdsman* (1868) *109*

24. George Inness, *The Lackawanna Valley* (ca. 1855) *110*

25. George Inness, *A Passing Shower* (1868) *110*

26. George Inness, *Landscape with Cattle* (1869) *111*

27. George Inness, *The Alban Hills* (1873) *111*

28. George Inness, *Hillside at Etretat* (1876) *111*

29. George Inness, *Landscape with Fishermen* (1847) *112*

30. George Inness, *The Wood Chopper* (1849) *112*

31. George Inness, *Evening Landscape* (1862) *114*

32. George Inness, *The Road to the Farm* (1862) *114*

33. George Inness, *Winter Moonlight (Christmas Eve)* (1866) *115*

34. George Inness, *Landscape, Hudson Valley* (1870) *115*

35. George Inness, *Lake Albano* (1869) *120*

36. George Inness, *Road through the Woods* (ca. 1856) *129*

37. George Inness, *Going out of the Woods* (1866) *129*

38. George Inness, *Peace and Plenty* (1865) *130*

39. George Inness, *Landscape with Farmhouse* (1869) *132*

40. George Inness, *Landscape near Perugia* (ca. 1873) *138*

41. George Inness, *Visionary Landscape* (1867) *144*

42. George Inness, *Valley of the Olives* (1867) *146*

43. George Inness, *Evening Landscape* (1867) *146*

44. W. H. Gibson, after George Inness, *The Light Triumphant* (1862) *148*

45. Eugène Delacroix, *Apollo Vanquishing Python* (1850–51) *152*

46. Frederic E. Church, *Christian on the Border of the Valley of the Shadow of Death* (1847) *154*

47. Attributed to Joseph Kyle and Edward Harrison May, *"The Shepherds Pointing out the Gates of the Celestial City from Hill Clear," Panorama of Bunyan's "Pilgrim's Progress"* (ca. 1850–51), scene 40 *158*

48. Attributed to Jasper Francis Cropsey, *"Land of Beulah," Panorama of Bunyan's "Pilgrim's Progress"* (ca. 1850–51), scene 43 *160*

49. George F. Nesbitt & Co., New York, Broadside: Bunyan's *Pilgrim's Progress* (ca. 1851–54) *162*

50. Broadside: Exhibition of John Banvard's *Panorama of the Mississippi, Missouri, and Ohio Rivers* in North Shields, Tyne and Wear, England, 1852 *162*

51. "Banvard's Panorama—Figure 1." Schematic drawing of the machinery for John Banvard's *Panorama of the Mississippi, Missouri, and Ohio Rivers* (1846–48) *163*

52. Attributed to Frederic E. Church, *"Dawn of Day over the Valley of the Shadow of Death," Panorama of Bunyan's "Pilgrim's Progress"* (ca. 1850–51), scene 20 *163*

53. George Inness, *Pine Grove of the Barberini Villa* (ca. 1875–76) *177*

54. George Inness, *Early Autumn, Montclair* (1891) *178*

55. George Inness, *Near the Village, October* (1892) *179*

56. George Inness, *Woodland Scene* (1891) *179*

57. George Inness, *The Brush Burners* (1884) *180*

58. George Inness, *Sundown* (1894) *180*

59. George Inness, *Moonlight, Tarpon Springs, Florida* (1892) *181*

60. George Inness, *Indian Summer* (1891) *181*

61. George Inness, *Early Morning, Tarpon Springs* (1892) *182*

62. George Inness, *Georgia Pines* (1890) *183*

63. George Inness, *Autumn Gold* (1888) *183*

64. George Inness, *The Old Farm, Montclair* (1893) *184*

65. George Inness, *Apple Orchard* (1892) *184*

66. George Inness, *October* (1882 or 1886) *185*

67. George Inness, *Harvest Moon* (1891) *186*

68. George Inness, *Sunset Glow* (1883) *192*

69. George Inness, *Autumn, Montclair, New Jersey* (n.d., ca. 1890) *192*

70. George Inness, *Apple Blossom Time* (1883) *194*

71. George Inness, *September Afternoon* (1887) *195*

72. George Inness, *Spring Blossoms, Montclair, New Jersey* (1889) *196*

73. George Inness, *The Clouded Sun* (1891) *196*

74. George Inness, *Off the Coast of Cornwall, England* (1887) *217*

75. Detail: George Inness, *Summer Montclair (New Jersey Landscape)* (1891) *222*

76. Detail: George Inness, *October Noon* (1891) *222*

77. Detail: George Inness, *Early Autumn, Montclair* (1891) *223*

78. George Inness, *After a Summer Shower* (1894) *224*

79. George Inness, *Early Autumn, Montclair* (1888) *224*

80. Detail: George Inness, *Woodland Scene* (1891) *225*

ACKNOWLEDGMENTS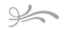

It would have been impossible to complete this study without the assistance and insight of numerous individuals. To Michael Fried I owe perhaps the greatest debt, for his continuing investment in my work and for the example of intellectual rigor and innovation his teaching and his writing hold forth. I am also deeply grateful for Brigid Doherty's involvement in this project; the present study would have taken a much different, and far inferior, shape had she not given it her assiduous attention. I first entertained the idea of undertaking a study of George Inness in a graduate seminar taught by Franklin Kelly at the University of Maryland; I thank him, and his then-colleague at the National Gallery of Art, Nicolai Cikovsky, Jr., for their wisdom and generosity. Michael Quick and Mary Quick of the George Inness Catalogue Raisonné Project, who assisted my efforts to locate paintings and secure reproductions, and who provided me with information at various, and crucial, stages of my research, also deserve my gratitude. William Gerdts kindly read and commented on this material in its dissertation stage. Sally Promey also provided a close and careful reading of the dissertation; she deserves my thanks not just for her continuing support but also for the example of collegiality she has given me to follow. I am also deeply grateful for the insight afforded me by conversations and collaborations with Leo G. Mazow, at the Palmer Museum of Art, whose work on Inness has shaped the direction and content of my own.

Conversations with colleagues at the University of Chicago, where I was a visitor during the 2000–2001 academic year, and at the University of Illinois at Urbana-Champaign (UIUC) have advanced my thinking about this project in

important and productive ways. In particular, Joel Snyder at the University of Chicago offered incisive and transformative readings of this material at various stages of development. Members of the UIUC faculty reading group, "Rethinking Descartes," also pushed me to think in fresh ways about the subjects of my study, as did student and faculty participants in the UIUC "Modern Art Colloquium." I was privileged to have Michael Gaudio, now at the University of Minnesota, as a colleague (and office mate) during my first year at UIUC, and his advice and insight have proven invaluable. John Davis, at Smith College, provided me with the opportunity to present material from the present study at the 2001 College Art Association Annual Conference (in a session organized by the Association of Historians of Nineteenth-Century Art), and I am indebted to him for that. My students at the University of Chicago and at UIUC, for persistently but graciously challenging or expanding my view of landscape in nineteenth-century America, should know that I appreciate their contribution to this book, as well.

The following individuals also offered inspiration, encouragement, and aid: at UIUC, Jonathan Fineberg, Cara Finnegan, Andrea Goulet, Dianne Harris, David Hays, Jordana Mendelson, and Kerry Morgan; at Swarthmore College, Michael Cothren and Constance Cain Hungerford; at Johns Hopkins University, Sharon Cameron, Virginia M. Hall, Neil Hertz, Ruth Leys, Ronald Paulson, Patricia Piraino, Carol McDaniel, Daniel Weiss, and Ann Woodward; at the University of Toronto, Marc Gotlieb; at the University of Chicago, Richard Neer, Linda Seidel, and Martha Ward; at Rutgers, the State University of New Jersey, Wendy Bellion; at Northwestern University, David Van Zanten; and at the School of the Art Institute of Chicago, James Elkins. Members of an informal works-in-progress group at Johns Hopkins also deserve mention, for they listened to and commented on this material in its nascent phase: Elena Calvillo, Esperança Camara, Frances Gage, Morton Steen Hansen, Peter Low, Griffith Mann, Charles Palermo, and Rosemary Trippe. Palermo is owed special thanks for reading and commenting on drafts of several chapters. I would also like to thank Lauren Gotlieb and Margaret MacNamidhe for their continuing friendship, spirit, and support.

Thanks also go to those individuals at museums, galleries, and other institutions around the United States who provided valuable assistance over the course of the past several years: Bill Bachhuber, Linda Best, Randolph Black, Jerry Bloomer, Chip Brennan, Thomas Colville, Janet Comey, Claire Conway, Shaula Coyl, James Crawford, Clark Evans, Ilene S. Fort, Heather Hole, Jennifer A. Jaskowiak, Sona Johnston, William R. Johnston, Kathleen Jones, Cindy Koebel, Jennifer C. Krieger, Kenneth W. Maddox, Allison Kemmerer, Miguel Martinez, Frank Martucci, Julia McCarthy, Marshall Price, Prudence Roberts, Peter Schweller, Mara Sultan, Margaret Tamulonis, Dominique Vasseur, Krishanti Wahla, Andrew Walker, Sylvia Yount, and the Chicago Theory Group. I also extend my gratitude to the staffs of the following: Ricker Library and the Krannert Art Museum at UIUC; the interlibrary loan offices at Johns Hopkins

and the National Gallery of Art; and the rights and reproductions departments at various institutions in the United States and abroad. I also want to offer my thanks to those individuals who provided information about and reproductions of works by Inness in their personal collections; their kindness and generosity is greatly appreciated.

Research for this study was conducted with the assistance of a Lucretia Mott Fellowship for Graduate Study, awarded by Swarthmore College, and a Walter Read Hovey Memorial Fund Award, granted by the Pittsburgh Foundation. I thank these institutions, as well as the Department of the History of Art and the Zanvyl Krieger School of Arts and Sciences at Johns Hopkins and the Campus Research Board at the University of Illinois at Urbana-Champaign for their financial support. A Wyeth Fellowship in American Art at the Center for Advanced Study in the Visual Arts, at the National Gallery of Art, provided for two years of travel, research, and writing. My time at the center was invaluable, as were the many conversations about my work I had with the other fellows in residence during the 1999–2000 academic year. Faya Causey, Therese O'Malley, and Henry Millon deserve special thanks, as do Melissa McCormick and Kathryn Tuma. The Wyeth Endowment for American Art made possible my participation in the symposium "American Art History in the New Century" at the Center for Advanced Study (October 2001), where I presented material from chapter 5, and I am grateful for its generosity and support in this regard. It was at this symposium that I met Eric Gordon, of the Walters Art Museum, who invited me to the Walters to examine three fragments of an important Inness painting that, prior to the identification of these fragments by Michael Quick, had been thought lost (chap. 5); I thank Eric for sharing his time and research with me.

Near last, but in no way least, Susan Bielstein of the University of Chicago Press deserves my gratitude for her support of my project as well as her continuing and generous advice, patience, and insight. Anthony Burton, an editorial associate at the press, is owed my thanks as well, as is Yvonne Zipter, for her meticulous review of my manuscript. I should add that I consider myself fortunate to have had at my disposal exceptionally thorough, carefully considered, and eminently constructive anonymous reader reports.

Finally, I dedicate this study to my husband, Erik N. DeLue; to his family, Steven, Karen, and Dan DeLue, and Anna Coopersmith; and to my own, Merrie, Jonathan, and Joshua Ziady, all of whom have lived with George Inness for many years now. Without their kindness, love, tolerance, inspiration, and encouragement, this study could not have taken concrete form.

INTRODUCTION ❧

George Inness, Metaphysician

"Passionate as is his fondness for painting," wrote the critic George W. Sheldon in reference to his friend the American landscape painter George Inness (1825–94), "he is most passionately a metaphysician."[1] What Inness "most enjoyed in his hours of ease," he said, "was talking and writing on metaphysical subjects like the Darwinian hypothesis of evolution, and the distinction between instinct and reason."[2] Sheldon was not alone in describing Inness in such a manner. Inness, recalled Charles De Kay, "used to lure in those who passed his open door to examine the work on his easel [and] would soon fall into metaphysics."[3] "If he had not possessed an intense love of form and a wondrous sense and power of expression of color," reported *Harper's Weekly* in 1867, "he would have been a preacher or a philosopher in another way, for he has a deep religious nature and an extraordinarily analytical philosophical mind."[4] The critic A. T. Van Laer concurred, saying that Inness was "both poet and philosopher . . . who spoke through the painter's medium."[5] "He was rarely idle," wrote Arthur Hoeber. "A deep reader, he had a fluency in conversation that made him a delightful companion and he had a power of application to a remarkable degree, while his concentration was enormous."[6] By all accounts, Inness "wrote voluminously" and left behind masses of manuscript.[7] As his friend the artist Elliot Daingerfield reported, much of this was of a "purely scientific nature."[8] In his biography of his father, George Inness, Jr., wrote that the elder Inness had throughout his career engaged in "metaphysical research" and had formulated "a spiritual science" based on the unity of the religious and the scientific mind.[9] "Years ago," Sheldon recalled Inness saying in reference to a manuscript the

artist had written entitled "The Mathematics of Psychology," "if I had only had money, and hadn't had to paint, I should have got into a lot of all this kind of thing."[10]

No other nineteenth-century American artist was spoken about in quite these terms, and Inness was the only one who declared that he would have preferred a career in philosophy to one in painting. In this study, I explore what it meant in nineteenth-century America to call a landscape painter a metaphysician and also what it meant for a landscape painter to consider himself to be one. Inness's paintings are well-known and celebrated today, and for good reason: in a manner distinct from other nineteenth-century American landscape artists, Inness combined careful attention to the features and phenomena of nature with an intense investment in the rendition of feeling or mood, all of this wrapped up in breathtaking color, extraordinary technique, and sensuously intricate facture. Our admiration of Inness has been accompanied by and is also the cause of his assimilation into conventional histories of American landscape, and a number of scholars have been content to characterize him as an affiliate member of the so-called Hudson River School, defining his practice by way of the conventional terms and categories we use to discuss this latter group of painters. In the chapters that follow, I attempt to restore what I would call and what critics at the time described as the idiosyncrasy and strangeness of Inness's art—for his landscapes are peculiar and his views about them weird—by drawing attention to those things that set him apart from his contemporaries and by exploring those aspects of his practice that have been insufficiently addressed in previous accounts of his art, starting with the persistent association of his practice with metaphysics, philosophy, and science.

Inness was born in 1825 near Newburgh, New York, and he grew up in and around New York City and Newark, New Jersey. He received little formal training as an artist, studying briefly with the itinerant painter John Jesse Barker in Newark in 1841 and with the Frenchman Régis-François Gignoux in 1843 in New York. Inness spent most of his career in the Boston and New York areas; he began exhibiting publicly in 1844. He made several trips to Europe, spending most of his time in Italy and France; his travels also took him south, to Virginia and to Florida, where he lived for a brief period in 1890, and west, to California and Mexico, in 1891. In 1878, he moved to Montclair, New Jersey, where he was to live until his death in 1894. Inness was made an associate member of the National Academy of Design, New York, in 1853, and a full member in 1868. As did most landscape painters during this period, Inness made summer trips to the White Mountains and other popular sketching spots, and he occupied a city studio during the winter months. He was active in artistic circles in both New York and Boston and was regularly discussed in writing about art.[11]

A great deal is known about Inness beyond these basic biographical facts—some of the books he read, the church to which he belonged and the faith he professed, his opinions about various schools of art, his manner of working, the paintings he exhibited, and the manuscripts he undertook to write. It helps that

he expended a fair amount of energy describing his activities and expressing his ideas in letters and interviews and that he seems to have been determined to make his opinions known. All the same, we lack a focused understanding of what this wealth of information can tell us, in specific terms, about the motivation and meaning of Inness's art, and there exists no study that thoroughly and systematically examines the significance of his various involvements within his artistic project as a whole. What, for instance, would compel a landscape painter to pen a manuscript entitled "The Mathematics of Psychology"? Why was Inness reading Darwin and, as Sheldon reported, Richard Whately and John Stuart Mill?[12] What motivated him, at a time when artists were admonished to paint directly from nature, to paint most of his pictures from memory? Why did he attach poetic captions to the frames of paintings he exhibited in 1878? For what reason did he invoke the work of the French psychiatrist Valentin Magnan (1835–1916) in an interview conducted by the *Art Journal* in 1879? What did he set out to accomplish when he explained his practice by way of a paraphrase of an exchange between the philosophers William Molyneux and John Locke, as he did in a letter he wrote to a critic in 1884? Why did he describe the science of geometry as the only "abstract truth"? And why did he call himself a metaphysician?

In recent years, scholars have offered new interpretations of certain aspects of Inness's practice, but there has been no study of his career in its entirety since Nicolai Cikovsky, Jr.'s, important dissertation, which appeared more than three decades ago.[13] A fresh look is long overdue and not just because newer methodologies have provided a number of useful interpretive tools. Fundamental questions regarding the nature of Inness's practice and the meaning of his art remain unanswered or have yet to be posed. One aspect of this practice that demands attention, and that I explore in detail in this study, is Inness's interest in the problems of nineteenth-century scientific inquiry and, more specifically, his interest in the nature and limits of human perceptual capacity. Inness's project was shaped by a preoccupation with questions concerning visual function; his landscapes make a series of fascinating claims about the nature of seeing and, collectively, represent an ongoing investigation of the larger problems of perception. The central claim of this study is that the aim of his art, what he called his "struggle," was the construction of a model of spiritual sight, the means by which to discern and then see with God. More broadly, I argue that Inness understood his art to be a cognitive practice—a means by which to explore the workings of the eye and mind. He developed a set of pictorial strategies that in his view constituted a scientific system utilized in exploring the processes by which knowledge of the world was acquired, reasoned about, and described.[14] Inness saw himself as a philosopher; his chosen tool of reasoning was paint. It is this self-perception that forces us to understand his quest as something more than just an expression of faith, more than an attempt to make manifest in paint the nineteenth-century's belief in a spiritual beyond (although it was, most emphatically, these things). For in looking to see with God,

in seeking to attain an acuity of vision far greater than the norm, Inness sought a vision that would enable him to discern a system or structure of knowledge (and to represent this system or structure in paint) whereby nothing less than the nature and meaning of existence—in spiritual but also physical and physiological terms—would be defined and articulated. No small beer, this quest, and what I shall describe as the complexity and intricacy of Inness's practice reflected the complexity, and immensity, of his mission.

I should say a few words about method. In accounting for Inness's preoccupations, I build on recent and innovative scholarship in the field of American art history that examines landscape painting through the lens of historical context.[15] However, I shift attention toward issues and problems of representation and, specifically, vision and viewing, following the example of scholars such as Bryan J. Wolf, Alexander Nemerov, Michael Fried, T. J. Clark, Carol Armstrong, and Martha Ward.[16] I present the landscape genre as something more than an intersection of nationalist discourse, identity politics, and ideology independent of particular experiences of intention and response, and I claim that Inness involved himself in a tradition of philosophic and scientific inquiry that scholarship on American landscape painting does not normally consider in relation to the production and reception of landscape art. My study takes its cue from Cikovsky's in that it treats as evidence the voices of Inness's contemporaries—his friends, colleagues, and critics—but I extend the reach of Cikovsky's analysis by combining a systematic examination of the material characteristics of Inness's landscapes with an exploration of his work alongside conceptualizations of perception within artistic and scientific circles, nineteenth-century and earlier—that is, in relation to a network of discourse that one might designate intellectual context. This set of concerns may not seem to fit into the category of social history; however, I would argue that the theoretical concerns we now associate with aesthetics and the pictorial arts, along with investigations of cognition and philosophies of perception, were, in nineteenth-century America, eminently social and should be treated as such.

My study, then, does not concern itself with the issue of national identity and does not perpetuate what I would characterize as a lingering need on the part of many scholars of American art history to define what is "American" about American art. In the past, scholarship on Inness, and on American landscape painting in general, has been isolationist in its relative inattention to the European context; herein, I dispense with questions of Americanness—historically important but limiting when used to define the parameters of a field—and, instead, examine the place of Inness's project within a larger modern landscape tradition and, in particular, in terms of its relation to the art of France.[17] Scholars of American art have successfully delineated the cultural and political meanings of landscape imagery, as well as the sociopolitical identities of artists and audiences; with this study, I mean to direct more attention than has been heretofore paid to the problems, strategies, and effects of picture making—not simply its subjects and objects. I hope to accomplish this is by examining the

place of Inness's landscapes within a geographically and conceptually broader network of pictorial, intellectual, and philosophical issues and concerns.

My account imputes intentions—I say something about how Inness might have conceived of his pictures—but I also attempt to demonstrate how these paintings were assigned meaning by audiences and individuals other than the artist.[18] Throughout his career, Inness's landscapes prompted a wide range of critical response, with exultation and horror at either extreme; an understanding of these works must proceed from a grasp of what it was possible for him and his viewers to see in his paintings at the time. By attending to a series of different yet interconnected voices—to what Inness said his pictures were about, to what the paintings seem to say about themselves, to what critics thought they represented and, finally, to the philosophical underpinnings of these various articulations—I construct a historically specific account of the material characteristics and motivation of his art. This means that what I have to say about the meaning of Inness's paintings will, in places, not jibe with what, to our eyes, the landscapes appear to do or say, but there is a difference between what we see in Inness's art and what Inness wanted—not necessarily achieved, but wanted—his art to accomplish. To put it slightly differently, there may be disparity between what Inness and his contemporaries thought he was doing (and what it was possible for them to think at the time) and what, in the end, the paintings actually do or seem to do (and what it is possible for us to see and think today). One of the reasons I find Inness's paintings so compelling is precisely this: the fact that the claims he and his contemporaries made for his landscapes can at times seem outrageously unrelated to what we, as twenty-first-century viewers, see in them.

This brings us to the problem of evidence. In this study, contextual analysis establishes the framework for what is a more speculative exploration of issues about which the historical record often has little to say. A great deal is known about Inness, and Inness said a great deal about himself. The difficulty that arises is one of making connections among what Inness and his critics thought his landscapes meant, the cultural and historical fabric of which these works were a part, and what *I* see in and want to say about them. My argument is at times conjectural; I offer an interpretation, one usually, but not always, grounded in historical fact. I am not convinced that the work of art history always requires the presence and proof of a smoking gun. In chapter 4, for instance, I claim that Inness believed that the experience of spiritual sight combined the effects of the body and those of the eye. He, however, never said as much, and neither did his critics, nor did any of his friends. I build my case by piecing together different types of evidence—what the pictures look like, what was said about them, the assumptions that lay behind those articulations, the ideas that lay behind those assumptions—and by making sure everything I claim about Inness's pictures would have been conceivable at the time they were made. In a sense, then, the present study does not simply proffer a new and deeper understanding of the complexity of Inness's art but fashions, as

well, an alternative to recent approaches in the American field to the problems associated with bringing together object and context in interpretation. Building on the example of Wolf's chapters, in *Romantic Re-Vision,* on Thomas Cole, this study also provides a model of historical analysis that treats American landscape paintings as something more than illustrations of ideas and events.[19]

It is also my hope that this study, in that it grounds many of its claims in analysis of nineteenth-century art criticism, will illuminate trends in thinking and writing about art at the time and, in so doing, go some way in arguing for the necessity of a more systematic analysis of art-critical discourse in the United States. Scholars have begun to pay more attention to what might be called "reception" in the American context. Rejecting the claim that art writing in nineteenth-century America was largely derivative and usually predictable, these scholars have begun to characterize the interest and specificity of American art-critical discourse, not so as to demonstrate the "Americanness" of it but in order to develop a focused understanding of the substance and development of art theory, amateur as well as academic/professional, in the United States during these years.[20] Looking at Inness through the lens of contemporaneous criticism, and situating his practice with regard to a variety of critical articulations about picture making, will aid us in learning more than we presently know about how art was understood by artists and critics in nineteenth-century America and will give us a better sense of the nature of the relationship between artistic practice and its various critical climates and contexts during this period in the United States.

Readers will notice that I commence my analysis with an examination of the middle years of Inness's career. I begin where I do for a number of reasons. It was in the 1870s that Inness's ideas began to crystallize, as evidenced by a compulsion to speak and write about his project that manifested itself at that time, as if he were desperate to give his theories specific, and textual, form. What Inness had to say about his career up to that point sheds important light on his earlier work, some aspects of which make the most sense when examined through a retrospective, but not ahistorical, lens. By beginning at the middle, rather than at the beginning, I also hope to unseat the notion that Inness's career, or that of any other artist, must be thought of in terms of a linear progression, from initial experiment to apotheosis, an assumption on which monographic studies of American artists are usually based. In the chapters that follow, I draw attention to a set of concerns that was sustained from beginning to end. In so doing, I attend to what I would term the deepest structures of Inness's art, those things that, from his earliest works in the 1840s to those landscapes he made the year of his death, provided the armature around which he fashioned an experimental landscape mode or, as I call it, a science of landscape.

The Struggle of Vision

TRUTH

In 1878, a critic for the *New York Times* registered what can only be described as bewilderment when faced with the landscapes of George Inness. "We are not sure," the critic wrote, "that Mr. Inness is quite right in his mind."[1] This critic was not the only writer to propose that Inness, or at least his work, was addled; others had leveled the same charge. What interests me about this statement, and others like it, is not its validity—whether Inness was in some way disturbed—but, rather, the fact that his paintings made his critics describe him as such. What was it about his landscapes that provoked worry over his mental state? How is it possible to square the Inness we know with the Inness who was not quite right?

Inness painted *Kearsarge Village* (plate 1) during a summer visit to North Conway in the White Mountains, New Hampshire, in 1875. The canvas depicts a mountain valley framed on the left by a distant ridge, in shadow, and on the right by a grass-covered and tree-studded hill, illuminated by the sun's whitish glow. Storm clouds darken the sky as cattle graze in a sun-streaked meadow. Two men accompany the herd; the one closest to us stands still, the other is engaged in some sort of work. Save for touches of orange in the middle ground, greens, browns, and grays predominate, making the scene, despite the coming storm, appear relatively quiet and subdued.

Many nineteenth-century critics praised Inness's paintings of the 1870s and early 1880s for their beautiful and truthful effects. Inness was called one of

America's most promising artists because, among other things, his landscapes appeared to be accurate and striking representations of the natural world. His pictures, reported a writer in the *Sun,* "if unlike those of most American artists, are quite as true to nature, and exhibit often an individuality which renders them particularly attractive."[2] *Appletons' Journal* expressed a similar view. On the one hand, *Appletons'* wrote, Inness's landscapes were "'Nature passed through the alembic of humanity,' as Emerson says"; on the other, without this "human feeling," the beholder "would suppose that he painted only for the pleasures of reproducing a daguerreotype likeness of natural objects."[3] Inness's color, wrote one critic, seemed "as if it had been placed there by nature herself"; his "masterly manipulation," declared another, made the landscapes of other artists look "mean and weak," altogether "puny" by comparison.[4]

Such praise reflected a more general conviction that pervaded writing about art in the United States at the time. Careful attention to the appearances of the natural world was of great importance within art-critical circles; observation was understood as the necessary first step in any attempt at landscape representation. Most artists and critics, following Asher B. Durand's pronouncements in the series "Letters on Landscape Painting" (1855) and Thomas Cole's in his "Essay on American Scenery" (1835), advocated the direct study of nature and adherence to its actual forms.[5] Although critics in the 1870s no longer insisted that pictures be minute and polished transcriptions of nature—given the direction taken by a good deal of landscape art at the time, such insistence would have been futile—they did still insist that landscape painters produce believable and real-seeming views based in the appearances of the natural world. In an 1879 article entitled "The Material of American Landscape," for instance, William Mackay Laffan recounted a conversation, probably fictional, between himself and a young artist recently returned from study abroad who had gone through "the usual Continental course that is essential to the manufacture of an American painter." Unlike other young artists who had traveled to Europe to study painting, this artist, wrote Laffan, "could see," and the "'material of the American landscape' was not a sealed book to him." The majority of the men who studied abroad, he continued, "refuse to see" the matter of the natural world, and "as a consequence we have them painting bric-à-brac landscapes in their studios, delving into archaeology, and struggling obstinately and helplessly in their own futility."[6] Other critics expressed a similar view. Worthington Whittredge's contribution to the exhibition of the National Academy of Design in 1875 received praise for its realistic effects of light—"it is so natural a lighting up of its amber hue that the spectator has to carefully study it before he can determine whether this pleasing effect is due to a real ray that has straggled in through the window of the gallery or to the painter's skill"—and Thomas Moran's entry was lauded for its photographic accuracy.[7] Our painters, wrote the art editor for *Appletons' Journal* in 1879, "have that spirit of simplicity and truth that is admired so much in literary artists. They detest exaggeration or

sensation. . . . They reveal the real qualities and true character of American landscape. . . . They go to Nature as humble and reverent students, and endeavor to be at one with her."[8] The idea that a "great painter does not paint nature as it is, but as he sees it," insisted the *Appletons'* critic, was absurd: "One who paints nature as he sees it paints it as it is, so far as he can realize it; if he does not see it as it is, his vision is abnormal, and assuredly this unfits him for the vocation. If he consciously paints it as it is not, painting it neither as it is nor as he sees it, what have we, then, but an artist substituting a fancy, a notion, a perverse and intentional fallacy for the verities of creation?"[9]

Simplicity, truth, verity, reality: these were the words and concepts used regularly in the 1870s to describe landscape paintings that properly shunned exaggeration, distortion, fantasy, and perversion in favor of close study and accuracy of effect. These terms are, of course, hard to pin down, in part because they were used at the time to describe a wide range of landscape practices and styles, including the work of artists who rejected the minute realism of the Hudson River painters in favor of looser, more spontaneous facture, and also because, as Margaret C. Conrads has pointed out, critical terminology was nothing if not unstable in the 1870s, a period of intensified interest in and debate about art matters in the United States.[10] Yet the frequency of the appearance of concepts such as truth and verity in writing about landscape gives some sense of the value that critics during this period believed lay in attending to external appearance and making pictures that approximated what the world looked like and how it behaved (or, in the words of the *Appletons'* writer, "nature as it is").

Inness also valued truth and accuracy in art. In an 1878 interview published in *Harper's New Monthly Magazine,* he praised Washington Allston's *Vision of the Bloody Hand* (1831) because its story, albeit fantastical, was "given with the simple earnestness of the 'I saw' of inspiration." Yet he criticized what he called the "literary rubbish" of Allston's ambitious but unfinished *Belshazzar's Feast* (1817/1843; fig. 1) precisely because it distorted the visible real: "Who cares for Belshazzar or his feast, unless we can meet him on 'Change, and he asks us to dinner? The story of *Mene, Mene, Tekel, Upharsin* is a story of today, and if Allston had freed his head from the clouds of literary fancy, and taken notice of the facts before his eyes, he would not have struggled (his picture bears most evident marks of a struggle) with the impossible. . . . Things that were can be properly represented only in things that are."[11] Allston, Inness suggests, would have been better off expressing his message by way of imagery from his own time and place,

Figure 1. Washington Allston, *Belshazzar's Feast* (1817/1843). Oil on canvas. 144⅛ × 192⅛ in. The Detroit Institute of Arts; gift of the Allston Trust. Photograph © 1979 The Detroit Institute of Arts.

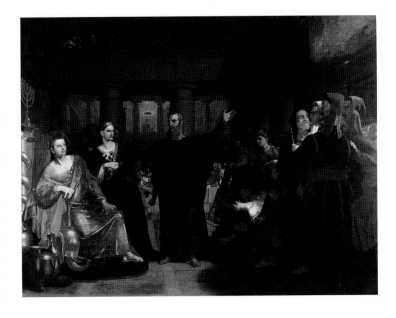

what he could have witnessed himself. By all accounts Inness was an avid student of nature, and he expended no small amount of energy in studying the appearance and character of "things that are."[12] A painting such as *Kearsarge Village,* with its effects of light and weather, its earthy palette, and its meticulously rendered tree trunks, branches, and leaves, reflects this preoccupation, as do many of his landscapes from the 1870s and 1880s. Critics called these pictures "true to nature" because they appeared to render, beautifully and masterfully, the facts before Inness's eyes.

Yet not everyone thought that Inness's pictures were properly true to life, including that critic who called him not right in his mind. Many critics took an opposing view, calling his landscapes incomprehensible, unconventional, and "odd."[13] Inness was a contemporary of the landscape painters Albert Bierstadt (1830–1902), Frederic Edwin Church (1826–1900), Jasper Francis Cropsey (1823–1900), Sanford Robinson Gifford (1823–80), John Frederick Kensett (1816–72), and Worthington Whittredge (1820–1910). His paintings, however, bear little resemblance to the minutely detailed, highly polished, and fastidious landscapes for which these artists were known, and they were consistently described as a departure from this norm. The author and art critic S. G. W. Benjamin wrote in 1879 that Inness, "although contemporary with many of our leading landscape painters, has from the outset worked in a style altogether distinct in aim and quality from that of what is called par excellence the American landscape school."[14] In 1875, the *Cincinnati Commercial* contrasted Inness's "vague, undefined treatment" and his simplification and unification of parts "into a harmonious whole" with Whittredge's "strength and literalness of tree delineation" and "exactitude of still life painting." "The importance of [Inness's] works," wrote the *Commercial*, "does not consist in their absolute resemblance to the botanical and geological facts of out-door existence."[15] "His motive," noted the critic Edgar Fawcett in 1881, "has always been strikingly different from that of his contemporary American landscapists."[16] Of course, Inness's landscapes of the 1870s did share some characteristics—loose facture, vigorous brushwork, flattened space, attention to the material qualities of paint over and against illusionistic effects—with those of certain of his contemporaries, including, among others, George Fuller, R. Swain Gifford, Homer Dodge Martin, Dwight W. Tryon, and Alexander Wyant, many of whom were heavily influenced, as was Inness, by the artists of the Barbizon school.[17] But what is striking, given these shared characteristics, is what amounted to a critical insistence on Inness's uniqueness or difference, as if something about his paintings precluded automatic comparison of his art to that of these painters and prevented his critics from understanding his landscapes in terms of any given set of conventions, whether these conventions were older and accepted (as exemplified by the Hudson River artists) or newer, known but not yet fully assimilated.

Not a few critics characterized Inness's landscapes of the 1870s and 1880s as "peculiar" and "strange."[18] "A man of remarkable originality in the study of nature," noted one commentator in 1879, "[Inness] throws a strangeness into its

more ordinary aspects."[19] "It is not often that Inness paints a picture which can be understood by ordinary people," wrote another.[20] A third called his foreground trees "uncouth and distasteful," his trees and clouds "strange and unreal," before pleading with the artist to leave off painting "nightmares."[21] "It is almost a matter of course," stated the *Chicago Tribune* in 1875, "that the highest appreciation for Inness should come from Boston, for it is in Boston that they understand strange and unaccountable things, and we know not how it happened that Inness was born down at Newburgh, N.Y."[22] "Sometimes Mr. Inness aspires to the plainly impossible," reported Fawcett, "he shows himself tormented with visions that are not realizable of expression through any naturalistic medium. . . . He succeeds notably in effects of surpassing weirdness."[23] Again: "We are not sure that Mr. Inness is quite right in his mind," wrote the *New York Times* in 1878; that paper's critic went on to say that "he may be considered one of the artists who do not paint for the public; it is doubtful whether he paints for any fellow craftsman; the inference is that he paints for himself."[24]

Others described Inness's landscapes as unpleasant and jarring, even violent, despite characteristically brilliant effects of color, lush expanses of brown and green, gleaming yellow light, and sensuously applied paint. His pictures, wrote the *Times,* "are violent instead of dignified, loud instead of deep in color. They would be improved by hanging in a smoky chimney."[25] "Mr. Inness's 'Mountain Stream,'" another critic stated, "is unpleasantly hard and uncertain in sentiment."[26] "His 'Summer Storm near Leeds,'" noted a third, is "violent, full of rough, crude contrasts and without expression."[27] The critic Clarence Cook wrote in 1879 that "Mr. George Inness explodes again in one of his landscapes where the force put forth is all out of proportion to the work to be done."[28] Cook characterized his experience of looking at Inness's *Autumn* as involving something like an assault: "Its air of simple, solid, sunlighted fact—with a suspicion of hardness in the trees on the right—is indeed very striking; the picture seems to detach itself from the wall and advance to meet those who enter the North Room."[29] Unlike Sanford Robinson Gifford's landscape, which "from the opposite side of the room . . . seems to pierce the wall and create its own horizon, far away," Inness's picture advanced, detaching itself from the exhibition wall, and gave "so much of [Nature's] poetry as reaches the optic nerve." The encounter with Inness's "striking" picture was an exhausting one. "The eye needs a little rest," Cook reported, before it moves on.[30] "Mr. George Inness is present, we were about to say, in force," he wrote a year later, "but his pictures are so noisy this year, that it takes a quiet hour to listen to them."[31]

A critic for the *Art Journal* was equally troubled by Inness's submissions, *Autumn* and *The Homestead* (now titled *Old Homestead*), to the 1877 exhibition of the National Academy of Design; they provoked, he said, "both admiration and criticism" (the passage is worth quoting at length):

> The first of these pictures is a low watered plain covered with grass, and studded
> with groups of trees. . . . One rarely sees upon canvas such a breadth of rich,

glowing sunlight as in this picture; in truth, genuine sunshine is somewhat rare in our landscapes. But upon this sun-lighted plain the autumn trees stand up in a sort of independent pictorial display. There is little composition, no autumn sentiment, nothing of the atmosphere of an October or November day, and no harmonious relation of parts. View the painting as we may, we find it perplexing. Its radiant sunlight commands attention, but we can discover no artistic purpose in the arrangement. . . . 'The Homestead' has in a less degree similar unaccountable characteristics. That is hardly a work of Art that sets down a house and scatters trees about it promiscuously, as if a section of a country had been framed in for a picture without the least selection, with all its scattered and unrelated effects. . . . One can but wonder at the isolated tree-studies and the lack of unity. Mr. Inness has even introduced in his open plain tall, branchless saplings, in face of the fact that trees in open places invariably send out spreading branches, while in compact forests they shoot up in long, straight lines toward the light.[32]

Perplexing and unaccountable, disunified and scattered: this writer was forced to attend to the parts of each landscape without seeing the whole and had trouble finding the words to characterize what he saw. He fixated on particulars—the growth of trees, radiant sunlight, a great deal of masterly painting, a randomly placed house, promiscuously scattered trees—because the pictures, conglomerations of "unrelated effects," precluded a more complete comprehension, defying, or at least deferring, apprehension, verbal as well as visual. He tried on a variety of points of view ("view the painting as we may") hoping to make what he saw more amenable to vision, and to his understanding of landscape convention, but, in the end, felt compelled to call each painting "hardly a work of Art."

Old Homestead (ca. 1877; plate 2), despite its rich browns and greens and its sunny glow, *is* odd, and it is not surprising that the *Art Journal* critic found it difficult to look at and describe. It was painted while Inness lived in Medfield, Massachusetts, but does not depict a specific site. Many of Inness's works do not, a fact that set him apart from many of his contemporaries, especially painters of the so-called Hudson River School, who were almost always exacting in their rendition of locale or place (and whose art continued to serve as exemplary within art-critical discourse, despite the advent and spread of other, often European-inspired styles).[33] Here, distant fields are a patchwork of tan, orange, and green; trees, shrubs, houses, farm buildings, and cattle punctuate the landscape, producing a somewhat haphazard effect, compelling the eye to stop and start as it roves about the scene. The viewer's gaze is fragmented; it settles only on encountering the dully painted white of the house at right whose one-eyed facade resists rather than invites exchange.[34] Flecks of white paint litter the foreground space, sitting at the surface of the canvas, detached from the forms to which they ought to adhere, further fragmenting what the critic-viewer would like to be a single and coherent inhabitable space. A touch of crimson atop the house designates a chimney but may also be read as a spot of

pure paint, attracting and isolating the gaze with its vivid gleam. A glimmer of red in the foreground at right produces a similar effect. A figure guides a boat at left; his body is slumped, barely held together by loose brushwork, and his features are smeared and lost to view. Eyeless, as if blind to his surroundings, his compromised vision in a sense emblematizes our, or at least the *Art Journal* critic's, experience of the work. This figure, and his counterparts in *Kearsarge Village, Autumn Oaks* (ca. 1878; plate 3), *Saco Ford, Conway Meadows* (1876; plate 4), and *The Coming Storm* (ca. 1879; plate 5), are typical of Inness's production at the time. They resemble the *staffage* figures that populate the landscapes of his predecessors and contemporaries, gesturing bodies meant to facilitate the eye's passage through a scene; yet faceless and barely sketched, at times barely distinguishable from their painted surround, Inness's bodies hardly seem up to such a task.[35]

Critics often had trouble accounting for their experience of Inness's paintings. One noted that he felt it necessary to put distance between himself and Inness's pictures in order to view them properly: "Clouds, figures, trees and architecture are mere blotches of paint just sufficiently shaped to convey an idea of relative positions. One involuntarily recedes from the picture in order to obtain a focal point at which this blotchy vision of things will disappear."[36] Inness's landscapes were consistently characterized as hard to see, unaccountable in configuration and effect; they were said to present their viewers with things that could have no referent, that could not have been seen in the natural world. A painting at the academy exhibition in 1879 elicited the following remarks: "The scene ['Old-Time Sketching Ground, North Conway'] is a spring day in North Conway, with the great range of Mount Washington standing off in a distance. . . . The mountains tower to an inconceivable height, and the foreground tree-forms are forced into impossible shapes."[37] Inness's *A Cloudy Day* prompted a similar response when it went on view at the Society of American Artists exhibition in 1879:

> It is . . . impossible not to believe that Mr. Inness was here under an illusion—that he persuaded himself that he saw the picture as he has painted it. Trees assuredly do not become transformed, under any conceivable glamour of light, or possible swiftness of vision, into round masses of wool-like substance, without contour of spreading branches, or articulation of limb, or broken lights and shadows. The painting in this particular is unthinkable. The sweeping mass of cloud is masterly, the burst of light that illuminates sundry objects is truth itself, but the groups of trees are incomprehensible. The picture here exemplifies a theory that can never permanently stand; for, even supposing it possible that artists have a gift of seeing nature under exceptional and strange aspects, an art that relates experience and reports impressions which the rest of the world have never known or seen, would be as meaningless to that world as color is to the blind. Under such a rule art would consist of a series of phantasies . . . instead of a trustworthy but supreme and exalted reflection of the life that we know and the things that we see.[38]

Unthinkable and unseeable under any circumstances, including "swiftness of vision," a quick and blurring glance, *A Cloudy Day* to this commentator's mind suggested, through fantastical forms, not just an inconceivable world but an unimaginable mode of perception as well.

I have not been able to identify *A Cloudy Day,* but I imagine it must have looked something like *Sunset at Etretat* (ca. 1875; plate 6), an exquisite but patently strange view of the terrain of the northern coast of France, in Normandy. We are invited to look with the red-vested figure seated at right, and what we see is stunningly beautiful, yes, but also stunningly weird. Foreground sinks into middle ground, which in turn sinks into distance. Buildings, to the left, situated miles away, are as sharply delineated as the sheep and shepherd who sit close to us, up front. Rich yet watery greens and browns muddle the forms they are meant to delineate, as roiling clouds—bands of gray, gray-black, and blue—push forward in space even as they reduce the sky to a series of thickly stacked strips. The crimson streak at the horizon sears but attracts the eye, pulling our gaze to the back of the canvas even as it is stalled by the shock of red that delineates the watcher's vest. Foreground and horizon are linked by this striking hue; distance disintegrates, as if the lines in a perspectival diagram

Figure 2. George Inness, *Winter Morning, Montclair* (1882). Oil on canvas. 30¼ × 45¼ in. Montclair Art Museum, Montclair, New Jersey; gift of Mrs. Arthur D. Whiteside, 1961.1.

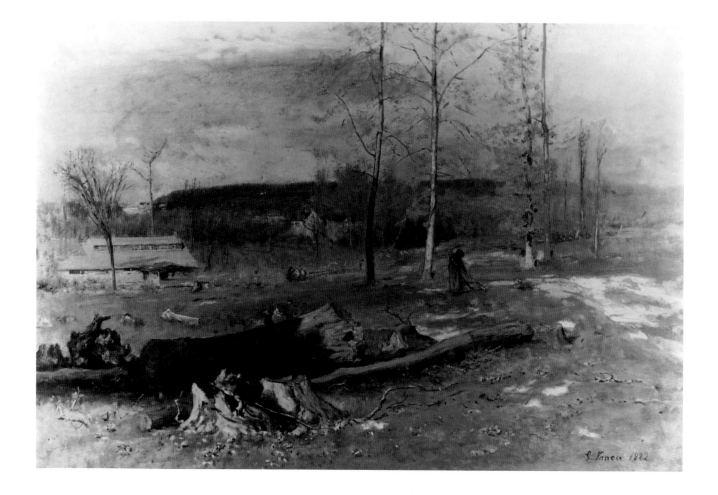

have folded in on themselves and collapsed. Inness was regularly chided for such deformation, what was characterized as his tendency to paint paintings that distorted nature and evoked the idea of distorted vision. His *Winter Morning, Montclair* (1882; fig. 2), wrote Cook in a review of the 1882 academy exhibition, called for and represented impossible perceptual acts. The painting, he said, "is interesting in many ways . . . but we cannot like its chalky tone, nor the want of atmospheric perspective that makes the nearest object as far off as those in the middle distance. In such an atmosphere as this it would be impossible to see the horizon, yet here it is plain as a foreground log."[39]

Look, once more, at *Kearsarge Village*. A breezy summer day in the White Mountains? Yes. A painting that critics would have described as impossible, incomprehensible, and weird, made by an artist not quite right in his mind? Absolutely. Speaking from the point of view and employing the criteria of nineteenth-century writers on art, Inness's *Kearsarge Village*, like *Old Homestead* and *Sunset at Etretat,* could easily be characterized as unconventional and odd. "That is a fine picture," wrote Durand in his "Letters on Landscape Painting," "which at once takes possession of you—draws you into it—you traverse it—breathe its atmosphere—feel its sunshine, and you repose in its shade without thinking of its design, execution, effect, or color."[40] *Kearsarge Village* draws us toward it and in but slows and stalls our perambulation. At the image's heart is an obstruction—a tree—and traversal is deferred or delayed. This evergreen attracts the eye, holding the gaze, not perpetually but for a moment or two, as it catches on the opaque green and brown brushstrokes that delineate each branch. Inness had been admonished earlier in his career to abandon such motifs, which were said to obstruct what should be the eye's free and easy passage through a scene. Yet these isolated trees stayed put, appearing and reappearing in his landscapes of the 1870s and 1880s, as if he understood them as productive of an important and necessary effect.[41] Clearly visible brushstrokes that scrape and strip the immediate foreground and the slope of the hill (beginning with the center tree and descending to the left), and loosely applied paint throughout, also demand attention and halt progress. We may easily take note of the painting's facture before succumbing to any illusionistic effect, a process Durand said should occur in reverse. This structure of beholding—paint first, fictional inhabitation after that—prompted by Inness's sketchy brushwork and his emphasis on paint as such, was nothing like that called for by the finical paintings of his contemporaries, works that took illusionism as a reason for being.[42] Albert Bierstadt's *Moat Mountain, Intervale, New Hampshire* (ca. 1862; fig. 3), for example, is a fastidious portrait of a specific scene. Attention is paid not only to the particulars of plant life and geology but also, through atmospheric perspective (what Inness, according to Cook, got wrong), to the facts and effects of visual function: a sharp foreground and a blurred distance approximate the experience of looking at an actual expanse of land. Inness's canvases were, in the words of one critic, "ragged" and "painty," not finished, polished, or, it would seem, illusionistic enough.[43]

But Inness had a different sense of truth than did his critics, even those sympathetic to newer trends in art and who considered Hudson River School landscapes hackneyed and stale. Distortion and obscurity were, for him, strategic and essential components of his practice and, as I am about to explain, provided the very foundation on which he constructed his version of the real. Sometime shortly before 1879, during an interview with George W. Sheldon, Inness characterized the process of coordinating the lights and darks of a painting in the following terms:

> If we consider for a moment that all things appear to us (so far as their light and dark, or *chiaro-scuro,* are concerned) by means of the shadow which their own objectivity produces, we shall see at once that, in reasoning concerning light and dark, we must start from the point of equilibrium, which is half-way between light and dark. *At that point all things cease to appear—all is light and flat as a fog of vapor that obscures everything.* Now, in Nature we find that the horizon is where all things cease to appear. . . . Hence, it is the horizon that the artist must consult in producing a representation in which all parts are in equilibrium; and there is no greater difficulty than in finding the relation which the sky bears to the objects in his landscape.[46]

We have here a pictorial prescription—instructions on how to organize the parts and tonalities of a composition so that everything coheres—as well as a meticulous, albeit abstruse, description of how we perceive the world and the importance of attending to certain rules of perception when rendering a landscape representation. Coupled with the remarks that follow this passage, wherein Inness discusses the relation of the properties of shadow and light to visual appearance and offers a detailed analysis of the manner in which we perceive objects at the horizon (including a demonstration regarding the sensory experience of a person standing on the deck of a ship and looking toward the sun), Inness's musings on equilibrium and the horizon line sound almost scientific, like propositions a nineteenth-century student of optics might have explored.[47]

But the claim, radical for its time and place, that pictures ought to originate in *obscurity,* that one must begin to paint at a point where "all things cease to appear" and "all is light and flat as a fog of vapor that obscures everything," should stop us short, for it sounds nothing like science, nor does it sound like something an artist interested in rendering accurately the appearances of the natural world would venture, even dare, to suggest. It strikes me as both interesting and significant that Inness could propose that picture making begin blindly, at a point (the horizon) where all forms become lost to view and, at the same time, argue for an art based on undeceived observation and clarity of sight, as he did when speaking of Washington Allston, who he scolded for not rendering things that were. Taken together, these concerns and claims reflect a complex, even paradoxical understanding of the pictorial process and the role

of perception in this process: if vision is to be clear, and landscapes truthful, how can painting, and the looking that precipitates it, begin in a fog?

We are faced with a paradox, yes, but only if we understand "accuracy" in the terms that most of Inness's critics did. Inness had a wholly different sense of it, and this different sense goes some way in explaining why he made his pictures look the way they do. In 1882, Charles De Kay, who knew Inness and was one of his most perceptive critics, characterized his pictures as unpleasant or strange at first glance. "But now and then," he said, "we come upon a picture that may not be certainly and at once pleasurable in its effect, but it arrests the attention with a shock." "We may be troubled before it," he continued, "but if we are not hampered by prejudices or schooled learning,—if we have resolved not to take opinions at second-hand, but to be brave enough to admire what gives us sensations of pleasure, or akin thereto—we may be sure that, to us at least, the work of art is a masterpiece." "Some such shock," concluded the critic, "has befallen the writer while looking at more than one—yes, more than ten—of the landscapes of George Inness."[48] Inness's pictures, De Kay implied, were masterpieces precisely because the beholder was troubled before them, as if lack of convention—the absence of prejudice and schooled learning—were a reason for being, not a fault. What De Kay seems to suggest here is that the form of aesthetic experience, the mode of enjoyment that Inness's works offered up, ultimately depended on a confrontation with the peculiar and strange. This, I believe, was a basic structure of Inness's art. The difficulty of his landscapes—what critics wound up describing as their origin in inconceivable acts of vision—was deliberate, designed to confront his beholders with the unknown and the new. By presenting viewers with features they would not have been able to understand or categorize according to landscape conventions of the time, Inness may well have been hoping that they would have to see things in a different, and radically new, light.

This, I believe, was precisely what Inness was up to when he set about making his "impossible" landscapes. In 1875, Inness returned to the United States after four years of travel in Europe. He settled in Medfield, Massachusetts, near Boston, where he had a studio. A year later, in 1876, he moved to New York City and then, in 1878, to Montclair, New Jersey, where he was to live for the rest of his life. It was in the second half of the 1870s that Inness began, in a systematic fashion, to give voice to his ideas about art. Interviews in art periodicals and letters-to-the-editor began appearing shortly after his return to the United States, and he began writing what was described as a "work on art" around 1875; articles published after his death in 1894 record his remarks and theories as well.[49]

What emerges from these various texts is a portrait of an artist intensely interested in perception and possessed by the belief that he was witness to a crisis of vision, at the level of not just art but society as well. This crisis was not a metaphorical one; Inesss was worried about our eyes. He spoke often of visual capacity—what the human eye could and could not discern—and he

lamented what he described as his contemporaries' inability to see accurately and penetratingly. "Through malformed eyes we see imperfectly and are subjects for the optician," Inness wrote in an 1884 letter, "Though the normally formed eye sees within degrees of distinctness and without blur we want for good art sound eyesight."[50] "When we know how imperfect the human eye is when compared with the eyes of some insects, although it is so wonderful," he asked Sheldon during an interview, published in 1882, "why should we undertake to say that states do not exist of which we have no physical perception, and can have none? Why could we not exist in a subtle condition imperceptible to sense?"[51] Inness's curiosity about untapped sensory capacity, or extraphysical vision, echoed the speculations of the Columbia University physicist Ogden Rood, who delivered a lecture entitled "Modern Optics and Painting" at the National Academy of Design in New York in 1873. An "unknown chasm's worth" of wavelengths, similar but not identical to those of sound and light, the scientist maintained, existed but remained undetected. These stimuli, he said, "excite no sensation. At this point there begins for us a great blank, in which . . . there is room for the play of not less than a dozen new senses, each as extensive of that of sight."[52] As will become clear, Rood was only one of a number of nineteenth-century scientists whose work overlapped with or informed Inness's own concerns. In this case, Inness intimated, as did Rood, the possible existence of a new sense that would allow for the apprehension of those things the artist believed were as yet out of vision's range. Inness implied, as did Rood, that work could be done to bring the invisible within vision's reach. For Rood, experimentation would reveal the unseen; for Inness, such was painting's task. "The mission of art," Inness told Sheldon, is to "teach the world to see reality in a new light."[53]

Inness described one aspect of this new mode of perception in an interview conducted shortly before his death in 1894. "In the beginning of my career," he said,

> I would sit down before nature and under the impulse of a sympathetic feeling
> put something on canvas more or less like what I was aiming at. It would not be
> a correct portrait of the scene, perhaps, but it would have a charm. Certain artists
> and certain Philistines would see that and would say, "Yes, there is a certain charm
> about it, but did you paint it outdoors? If so, you could not have seen this and
> that and the other." I could not deny it, because I then thought we saw physically
> and with the physical eye alone.[54]

Painting a picture of nature, Inness suggested, did not necessarily entail an attention to what one saw, for perception, which precipitated the activity of painting, encompassed more than the physical eye could achieve on its own. Picture making engaged a vision that originated not only in the body's optical apparatus but somewhere else as well. In fact, seeing, in order to be penetrating and pure, involved the derailment of physical perception, the making of oneself

blind to sensory data, or, as Inness put it, "to see, and not to think we see [so that] our eyes are lighted from within, and the face of nature is transformed."[55]

The end of this transmutation of vision, according to Inness, was spiritual sight, the ability to discern the divine, or "spiritual force," and to see with God.[56] "The true happiness of man," he insisted, "consists in his spiritual elevation, and in his communion with the Divine Personality."[57] As Inness saw it, this communion would come about by way of a reorientation of perspective and a redirection, or reeducation, of vision. "Our intelligence," he stated, "is occupied with the contemplation of effects," that is, the objective, physical world, but it "should be occupied with the contemplation of cause," in other words, with divine will and design.[58] Inness's understanding of spiritual sight was of course shaped by his study of the work of the Swedish philosopher and theologian Emanuel Swedenborg (1688–1772). In suggesting that things in the natural, or external, world corresponded to things in the spiritual, or internal, world, Swedenborg's doctrine of correspondence, which I discuss at greater length in the following chapter, offered Inness a means by which to conceptualize a keener and extrasensory form of sight. This acuity would enable penetration beyond the appearances of the natural world and the consequent apprehension of what Inness called "the reality of the unseen," the secrets, or truths, of both the earthly and heavenly realms.[59] The artistic mind, Inness wrote, must be "continually engaged in endeavouring to give men sensuous apprehension of . . . that which is unseen—of that which the Spirit of God working in it reveals."[60]

For Inness, spiritual truth was not to be found in what the eye could see and what the hand could render in exacting detail but, rather, in realms more obscure and unexplored. "Reality" was that which was hidden from view. The "real difficulty," he said, "is in bringing the intellect to submit to the fact of the indefinable—that which hides itself so that we may see it."[61] Truth was by nature unseeable, and it was unseeable so that, in the end, it could be seen—one just had to know how and where to look. Truth, Inness insisted time and time again, was available to an individual only if he looked at the world properly, or if a painting showed him how to see. Spiritual sight would bring the unseen before consciousness; landscape was to be its vehicle, but not in landscape painting's usual guise.

"Certain members of the National Academy of Design," Inness wrote in 1879, "have been stigmatized . . . as the Hudson River school. . . . It is true that scenic art can never assume to be a representative of the higher forms of mind."[62] The minute rendition of nature's forms and the unmediated transfer of visual experience, of sensations generated by the physical eye, to paint on canvas could not fulfill art's mission, could not reveal what had not yet been seen, could not show the artist or viewer God. "The intellect," Inness told Sheldon, "desires to define everything. It is a Pre-Raphaelite par excellence; its cravings are for what it can see, lay hold of, measure, weigh, examine. But God is always hidden, and beauty depends on the unseen, the visible upon the invisible."[63] Consciousness through eye and touch alone was insufficient; observation and

the study of nature, by themselves, would not reveal hidden beauty or cause, nor would they disclose the operations and outcomes of spiritual sight. Keeping the physical eye open, in fact, blocked apprehension of what was invisible yet had to be seen. "The memory is the daguerreotype shop of the soul," said Inness, "which treasures all God creates through eye and touch. What we painters have to learn is to keep this shop closed in the presence of nature: to see, and not to think we see. When we do this, our eyes are lighted from within."[64] Spiritual sight, in Inness's view, came about only when the conventional senses faltered, or were trained to remain oblivious to the stimuli of the natural world, and when all things in nature ceased to appear. Constitutive of spiritual seeing, then, was a relationship between vision and its occlusion, seeing and being blind, the very relation suggested by Inness's declaration that painting and vision begin in an obscure flat fog and by landscapes that offered up impossible, unaccountable, incomprehensible, unseeable visions of the world.

THE SCIENCE OF LANDSCAPE

We cannot see certain things; we need to see what we cannot; in order to see we need to be blind; the real or true is the invisible and indefinable; paintings should show us how to see; landscapes have to be made according to certain laws of perception in order to show what cannot be seen; one of these laws stipulates that we begin our quest for vision in the act of painting in a place most obscure. What should we make of this set of claims? Taken together, to what kind of process or project do they amount? To what sort of painting, and then vision, could they possibly lead? What I want to argue, here and throughout this study, is this: for Inness, these claims, in conjunction with his pictures, added up to a science, a science of landscape, to be exact. In 1884, Inness wrote a letter to the critic Ripley Hitchcock, who was preparing an essay on the artist's life and work. "Several years before I went to Europe," Inness told the critic,

> I had begun to see that elaborateness in detail, did not gain me meaning. A part carefully finished, my forces were exhausted. I could not sustain it everywhere and produce the sense of spaces and distances and with them the subjective mystery of nature with which wherever I went I was filled. I dwelt upon what I saw and dreamed, in disgust at my ability to interpret. I watched thought and fought Pre-Raphaelitism. I gave way to my impulses and produced sentiments the best I could always finding myself in a hobble as I tried to make them look finished. Gradually year after year I discovered one truth after another until I had formed *a scientific formula of the subjective of nature.* My whole aim for twelve or fifteen years has been to apply this.[65]

The idea that a scientific formula had to be devised in order to make the spiritual manifest, to express nature's subjective, what Inness understood as an

individual's experience of spiritual truth—the reality of the unseen, those things imperceptible to ordinary sense—is a provocative one and may shed some light on the seeming paradox of Inness's model of painting and vision, as well as on what many critics described as the difficulty and impossibility of his art. "Science now teaches us," Inness told an interviewer in 1879, "that it is the inexperienced eye that sees only surfaces."[66] What else had science taught him? What did he imagine the role of the scientific to be, what could it be, in the construction of a model of vision that took a form of blindness as one of its most instrumental aspects and that had as its end spiritual revelation?

According to Inness, paintings did not just reflect the world—"the greatness in Art is not in the display of knowledge, or in material accuracy"—but, rather, in the process of their making, they discovered or created knowledge: art "creates law, while in the process of expansion." Landscapes that failed to do so, in Inness's words, were "scientifically incorrect." To be fully effective, to create or discover law, works of art, he believed, should be subjected to the gaze of the painter and the gaze of the scientist as well: "A man of science will often discover, in a work of Art, principles of which the artist was wholly unconscious."[67] To be significant and instrumental, Inness stated in his 1878 *Harper's* interview, landscapes had to convey an impression of nature that revealed its subjective aspect, but they could do so only with the aid of the scientific, only if science was brought to bear on their artistic operations. The best paintings thus combined material accuracy and individual feeling, science *and* the subjective of nature:

> Meissonier always makes his thought clear; he is most painstaking with details, but he sometimes loses in sentiment. Corot, on the contrary, is, to some minds, lacking in objective force. . . . He tried for years to get more objective force, but he found that what he gained in that respect he lost in sentiment. If a painter could unite Meissonier's careful reproduction of details with Corot's inspirational power, he would be the very god of art. But Corot's art is higher than Meissonier's. Let Corot paint a rainbow, and his work reminds you of the poet's description, "The rainbow is the spirit of the flowers." Let Meissonier paint a rainbow, and his work reminds you of a definition in chemistry. The one is poetic truth, the other is scientific truth; the former is aesthetic, the latter is analytic.[68]

According to Inness, the expression of nature's subjective required the scientific, a union of Jean-Baptiste-Camille Corot's dreamy landscapes (fig. 4) and Jean-Louis Ernest Meissonier's exquisitely detailed and precisely rendered genre scenes (fig. 5). In suggesting that, to make godlike paintings, one must combine the practice of these two men, painters understood in nineteenth-century America as entirely opposed in terms of motivation and effect—Corot's paintings were always described as veiled, vague, mysterious, dreamlike, impenetrable, and hard to see, Meissonier's as photographic in their accuracy and attention to detail—Inness proposed an art almost impossible for its time and

place, one based on both obscurity and clarity of vision, poetry and the princi-
ples of science.[69] "Landscape is a continual repetition of the same thing, in a
different form and a different feeling," Inness stated. "When we go outside our
minds are overloaded: we don't know where to go to work. You can only achieve
something if you have an ambition so powerful as to forget yourself, or if you
are up in the science of your art. If a man can be an eternal God when he is out-

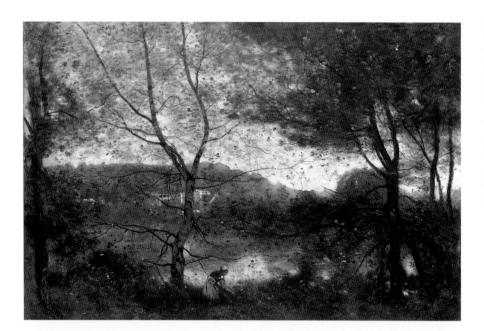

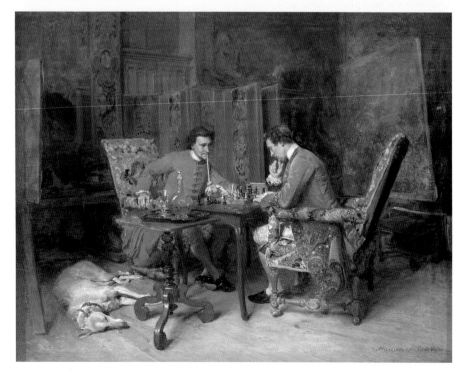

Figure 4. Jean-Baptiste-Camille Corot,
Ville d'Avray (1870). Oil on canvas. 21⅝ ×
31½ in. The Metropolitan Museum of Art,
New York, Catharine Lorillard Collection,
bequest of Catharine Lorillard Wolfe,
1887 (87.15.141). All rights reserved,
The Metropolitan Museum of Art.

Figure 5. Jean-Louis Ernest Meissonier,
The Chess Players (1853). Oil on panel.
24.1 × 31.7 cm. Courtesy of Edward
Wilson, The Fund for Fine Arts, Bethesda,
Maryland.

side, then he is all right; if not, he must fall back on science."[70] For Inness, making good pictures was akin to being up on the science of one's art. Yet the fact that Inness equated "science" with something other than physical vision, and with physical vision's occlusion, is, again, remarkable, for it suggests that his science meant to account for far more than what could be empirically observed.

What I am suggesting is this: unwilling to accept the models of perception offered up by either the Pre-Raphaelites—who he said wrongly insisted "that the material is the real" and whose work, in that it "carried the love of imitation into irrational conditions," was "false as a philosophy"—or by the scenic art of the Hudson River School, Inness submitted for scrutiny a new mode of pictorial realism that embraced what it ought to have shunned—the indefinable, impossible, and indirect—even as it utilized what he understood to be the methods of scientific inquiry.[71] He pursued a practice based not only on the assumption that art and science were related enterprises but also on the idea that they were coincident and corresponding fields of inquiry or, to borrow a phrase from Jonathan Crary, "part of a single interlocking field of knowledge and practice."[72] In 1878, an interviewer asked Inness whom he considered to be the best landscape painters, and he responded by saying that the landscapes of Rousseau, Daubigny, and Corot were "more or less nearly perfect." But, he continued, "in their day the science underlying impressions was not fully known. The advances already made in that science, united to the knowledge of the principles underlying the attempts made by those artists, will, we may hope, soon bring the art of landscape painting to perfection."[73] Without Meissonier's science, without what critics in nineteenth-century America referred to as his accuracy, precision, logic, reason, photographic vision, and "miraculous sureness of eye," art would never attain perfection and nature's subjective (God's true will and law) would remain hidden from sight.[74] By the same token, without Corot's poetry and inspirational power, painting would be nothing more than cold, lifeless fact. "An artist may study anatomy, geology, botany," Inness said, "any science that helps the accuracy of his representations of Nature; but the quantity and the force of his acquisitions must be subjected to the regulating power of the artistic sentiment that inspires him. Otherwise, his pictures will be anatomical platitudes, scientific diagrams, geographical maps, instead of living men and significant landscapes."[75] And an artist had to be cautious in his embrace of what Inness called "the scientific tendency of the new age," that is, "the epoch of the scientific mind," for science on its own, he said, "gives no true image of humanity. Its man is a machine, reasoned from sensation."[76] All the same, Inness compared his study of the spiritual, which he insisted was intrinsic to his art, to scientific pursuit: "[When I grow weary of painting] I take to theology. That is the only thing except art which interests me. In my theory, in fact, they are very closely connected. That is, you may say it is theology, but it has resolved itself gradually into a scientific form, and that is the development which has become so very interesting to me. I have written piles and piles of manuscripts on it."[77]

Inness did not formulate his science of landscape in a vacuum, nor did he do so wholly against the grain; what he came to conclude about his "scientific formula of the subjective of nature" was in part a function of, and was made possible by, contemporaneous conceptualizations of the relationships among various disciplines of thought. It must be emphasized that, during the period under discussion, art and science, and science and theology, were not always considered incompatible. In fact, a good deal of space in popular periodicals, art journals included, was given over to explorations of the nature and implications of the perceived network of relations among these areas of inquiry, and writers frequently argued for their mutual application. In a lecture published in *Popular Science Monthly* entitled "Man as the Interpreter of Nature," William Carpenter, the eminent English physiologist and physician whose works were widely read and discussed in nineteenth-century America, characterized science as the intellectual representation of nature.[78] He discussed the processes of perception that produced artistic as well as scientific knowledge and spoke of color blindness (or "Daltonism") in relation to engravings of J. M. W. Turner's landscapes.[79] The English sociologist Herbert Spencer, whose work was also extremely influential in the United States, applied the methods of scientific inquiry to an understanding of social and cultural history, including religious belief and practice.[80] In his two-part essay "The Idea of God," published in the *Atlantic Monthly* in 1885, John Fiske attempted to reconcile science and religion in an analogous fashion, by comparing historical conceptions of the nature of God and analyzing them not in terms of biblical exegesis but in light of scientific theory.[81] The critic James Jackson Jarves also drew on Spencer's work in *The Art-Idea* (1864) and *Art Thoughts* (1870), which presented a view of the history of art wherein racial and/or geographical characteristics determined the nature of artistic production and the evolution of style.[82]

The debate waged over the phenomena of spiritualism exemplified what was considered at the time to be a natural and necessary connection between science and religion (or, alternately, belief in the otherworldly), one assumed by and implicit in Inness's practice.[83] Inness was known to have visited spiritualist practitioners. Elliot Daingerfield reported that "spiritist mediums . . . were forever telling [him] that Titian stood at his elbow," and the critic Montgomery Schuyler wrote that he "easily united with his adherence to Swedenborg an unquestioning credence of the grosser 'manifestations' of the mediums."[84] Such spiritualists claimed that their belief in the continuation of life after death and in the possibility of communication through a medium with the deceased was based in fact and supported by science.[85] In an article entitled "Science and the Spirits," published in *Appletons' Journal* in 1872, for instance, R. R. Bowker discussed the possibility of verifying spiritualism's claims scientifically.[86] He described a number of scientific experiments conducted to test spiritualist phenomena and insisted that such trials offered proof of their verity. "This border-land of physico-mental investigation is the most difficult in which a man can labor," he wrote, but "science has its grandest work before it in the

investigations of the mysterious agencies which have frightened men too long."[87] Even Carpenter, who attacked spiritualism in a two-part essay titled "Mesmerism, Odylism, Table-Turning, and Spiritualism," resorted to science in doing so.[88] In a response to Carpenter's critique, published in *Popular Science Monthly* and entitled "The Psycho-Physiological Sciences," Joseph Buchanan, a physician, objected to Carpenter's materialist bias and argued against the exclusion of the study of the soul from the realm of science.[89] Science, he wrote, must recognize the "progress and present state of spiritualism," "mesmeric and spiritual facts," and the "invisible power which acts sometimes with force sufficient to break furniture, and to be heard at considerable distances."[90] "I have," Buchanan concluded, "preferred to cultivate physiology in a more philosophic way, recognizing the eternal man who inhabits the body, as well as the transient physical form, and discovering a new class of facts which render our chemical and anatomical physiology far more philosophic and intelligible."[91]

This period also saw a number of articles on optics and optical theory meant for popular as well as scholarly audiences; these, as did debates over spiritualism, constituted threads of the discursive fabric of which Inness's theory and practice were a part.[92] For Inness and his contemporaries, vision, in addition to being a privileged form of knowing, was an object of knowledge and observation, itself the subject of scientific inquiry.[93] In particular, Inness's interrogation of perceptual function shared with scientific writing in the United States a tendency to underscore the stranger aspects of sensory experience.[94] The author of "Our Eyes, and How to Take Care of Them," for instance, instructed his readers on the proper use of the visual organ, characterized a number of ocular imperfections, including "hyperopia, or over-sight" and "strabismus" (lazy eye), and proposed a variety of treatments for these and other ailments.[95] An article entitled "Curiosities of Vision" considered the retinal "blind spot"—an area of the eye if on which the image of an object should fall, we "could no more see it . . . than if we had no eyes or kept them shut"—and puzzled over the fact that the spot was located at the place where the optic nerve entered the eye, "the very place which we might suppose would have the keenest sight of all."[96]

Numerous writers, like these two, drew attention to discoveries that highlighted vision's oddities, blemishes, and defects, emphasizing vision's inconstancy by noting, among other things, its subjective aspect; this, of course, was what interested Inness. Many writers also discussed the relation of optical theory to the practice of picture making, reflecting an increasing interest in the relation of visual function to the creation and evaluation of art; this, too, was a subject in which Inness was deeply invested, owing in part, I would imagine, to his familiarity with just this body of work. A. Von Graefe, the author of "Sight and the Visual Organ," employed a pictorial metaphor in describing faulty vision: people possessive of only "direct vision," unable to discern the presence of objects to their side or out of the direct range of their sight, saw as if "holding a long tube of small calibre" to the eye and perceived "the image of the external

world that is imprinted on the retina, like a picture highly finished in the middle, and only roughly sketched out at the sides."[97] As did many science writers at this time, he characterized the difference between what he called subjective and objective vision and described how visual sensation could arise of its own accord, without stimulation from the outside world, "by the media of eye and light." The "gay visions that surround us in the intoxication caused by opium," he argued, "the comic phantasmagoria that hashish conjures up; the compact shapes that belladonna brings so near us; the airy forms seen in our dreams, or the scintillations produced by pressure [on the eye]" demonstrated that there existed no intrinsic relation between visual data and objects in the natural world.[98] Von Graefe also discussed the retinal blind spot and said that the blank it created was compensated for by subjective vision, perception with no actual referent: "The *idea* has learned to fill it up in the most natural manner . . . a conjunction of objective sensory action and subjective influence."[99] An essay entitled "Effects of Faulty Vision in Painting," published in *Popular Science Monthly* in 1872, explored the relation of optical function to the practice of painting and focused on vision's fallibility as well. The author ascribed what he characterized as the peculiarities of Turner's late landscapes to defects in the painter's vision and, specifically, to his astigmatism, a diagnosis arrived at by way of the examination of his paintings.[100] Vertical streakiness, indistinct boundaries between forms, and oddly diffused light were the result of an "ocular disturbance" and were matters of vision rather than style. Even the greatest artists, the author stated, if afflicted with faulty vision, may have no awareness of their plight, suggesting that an individual's perception of the world must always be the subject of doubt (and implying, of course, that science had a hand in the production and interpretation of art).[101]

It was against this backdrop of what we would now call interdisciplinary inquiry that Inness pursued his practice and defined his science. Beginning with a closer examination of Inness's output in the 1870s and 1880s (what Montgomery Schuyler called Inness's "season of experimentation"), the chapters that follow explore the manner in which Inness incorporated what he understood to be the procedures as well as the conclusions of scientific inquiry into his art and thereby formulated a set of pictorial strategies that in his view constituted a science of landscape, one designed to examine the properties of perceptual function as well as the processes by which knowledge of the world was acquired, reasoned about, and described.[102] Painting was for Inness a cognitive or scientific practice—a process by which to explore the limits of a static medium as well as the workings of the eye and mind, an enterprise akin to optics, biology, psychology, or chemistry (what Meissonier's works called to mind). In the act of painting, he attempted to devise what he understood to be a scientific formula of the subjective of nature that would be the foundation for a new kind of art and a new mode of vision as well. He spoke often of principles, formulas, and laws, was fascinated by mathematics and number theory,

and said that the "science of geometry" was the only means to abstract truth.[103] He was called a psychologist more than once, and his pictures were frequently characterized as governed by logic, order, and mathematical rule. Each of his landscapes was an experiment, his art was research, and his aim was the approximation or evocation of a (scientific) model of the principles and processes of spiritual sight.

Yet in intimating his desire to unite the truth of Meissonier with its own obliteration in the dream of Corot, and in calling for an art and a mode of vision that originated in a vaporous fog, Inness laid claim to a science not entirely attentive to empiricism's central tenet, that sensory experience constituted the single source of knowledge. This, I imagine, was why critics who knew Inness to be an avid student of nature were so troubled by the way he rendered his knowledge of the world. If his works had not actually intimated accuracy and fidelity, or if they were clearly fantasies, or appeared to be based on anything—the bible, literature, poetry—other than nature's facts, they probably would not have caused such a stir. However, because his landscapes were somewhat "scientific" and because they purported to present a clear vision of the natural world, their impossibilities and obscurities, the fact that they seemed to reflect an experience of looking at nature through a malformed or dysfunctional lens, really rankled. De Kay, who described Inness's pictures as carefully and scientifically wrought, characterized the aesthetic, one that married the spiritual to the laws of science, that I am claiming his landscapes offered up: "Back of the landscapes, in whose confection rules founded on logic that can be expressed in the mathematical terms have been strictly followed, lies the whole world of immaterial spirits, of whom Swedenborg was the latest prophet."[104] This I imagine, was why Inness's pictures could be described as both truthful and poetic—"Inness always has great poetical feeling in what he paints"; "Mr. Inness is perhaps more susceptible to 'moods' than any other, and the result of these moods have been some of the most poetical pictures that have ever been produced in this country"; "He is a grasper after poetic shadows, which he often has the magic dexterity to secure"—as if to suggest that his paintings attended to nature but also to something seemingly impossible to demonstrate, quantify, or define.[105]

In letters, interviews, and an unpublished manuscript titled "The Mathematics of Psychology," Inness alluded not just to his generalized interest in science but also directly and indirectly to specific traditions of philosophical and scientific inquiry that were manifest in, among other things, scientific writing in the United States, especially writing on psychophysiology, optics, and perceptual function. Indeed, Inness seems to have believed that he represented the continuation and transformation of these traditions. Looked at in this way, Inness's practice may be described as situated squarely within a specific nineteenth-century discursive milieu, one constituted by discussions of the observations, methodologies, and claims of empirical science in scholarly writing and

the popular press at the time. Yet, as I have been saying, his practice was also marked by a willingness to dispense with this milieu's positivist bent. In referring to Inness's science, then, and to the techniques and strategies employed therein, I am speaking of an affinity between his methods and those of nineteenth-century investigations of physical phenomena but also of his own idiosyncratic understanding of scientific inquiry, one developed alongside and as an alternative to or at least an expansion of the principles and assumptions that formed the basis of scientific writing and inquiry in the second half of the nineteenth century in the United States. The perceived difficulty of Inness's art arose from the doubt his pictures, and his strange science, with its embrace of the objective and subjective and its insistence on the intrinsic relation between seeing and being blind, cast on accepted or conventional forms of knowing, painting and perception included. This difficulty also evoked the ambition of Inness's self-appointed task and articulated his awareness of the lengths to which he would have to go in order to achieve his mission and goal. "No one can conceive the mental struggles and torments I went through before I could master the whole thing. I knew the principle was true, but it would not work right," he stated in an interview conducted late in life, as if to suggest that the complexity and confusion of his canvases constituted nothing less than an attempt to convey the inconceivable labor of teaching the world to see reality in a new light, what amounted to an arduous struggle of vision.[106]

TWO ❧

Painting from Memory

"The beautiful memory of things"

Inness did not usually paint landscape in the way it had been painted for years in the United States, by going out into nature to draw and then retreating to a studio to paint what had already been rendered in sketch form, hoping to produce as close a match as possible to what had been observed, nor did he follow the example of the impressionists by painting finished works *sur le motif*.[1] Sanford Robinson Gifford's working methods, as described in 1877, constituted what was considered the norm: first, "a little sketch," in pencil, of that which impressed him, so that "the idea of the future picture" is fixed; second, a "larger sketch, this time in oil," which fixes the motif in "enduring material"; finally, "the picture itself."[2] Inness, we know, was a student of nature. Yet his pictures, or at least most of them, were not the offspring of a linear series of spatially and temporally discrete moments of looking, sketching, and painting with the natural world as their referent, as were Gifford's. That is to say, they did not offer exacting views of what Inness saw with the physical eye, nor did they purport simply to be poetic interpretations of the actual visible world. Inness's summer's work in North Conway, noted a critic in 1875, "seems a creation, it is so different from the stereotyped views so common."[3] His pictures "may be better designated as 'days' here," wrote another, "than as this or that particular view."[4] Inness's son recalled his father's intense study of nature but indicated that it was his memory of nature's forms, rather than their precise record, that inspired his works. "Out of doors," the younger Inness wrote, "he was quiet,

[31]

rational, and absorbed. I have seen him sit in the same spot every day for a week or more studying carefully and minutely the contours of trees and the compositions of the clouds and grass, drawing very carefully with painstaking exactness." Yet, "he seldom painted direct from nature. He would study for days, then with a sudden inspiration would go at a canvas with the most dynamic energy, *creating the composition from his own brain* but with so thorough an underlying knowledge of nature that the key-note of his landscapes was always truth and sincerity and absolute fidelity to nature."[5] "Take the 'Autumn Oaks' [plate 3] in the Metropolitan Museum," he said, "Was it done from nature? No. It could not be. It is done from art, which molds nature to its will and shows her hidden glory."[6]

As a number of his critics reported, Inness painted most of his landscapes in his studio, from memory. "A picture by Inness," wrote the *Art Interchange,* "is never boisterous, but it is often like a full orchestra. He may be said to give the symphony of nature. It is not the imitation, but the beautiful memory of things."[7] "In a peculiar way," stated Frederick S. Lamb, "George Inness was a modern realistic painter, without knowing it—a memory student, without ever using the word."[8] "The greatest of his pictures," said Daingerfield,

> were painted out of what people fondly call his imagination, his memory—painted within the four walls of a room, away from and without reference to any particular nature; for he himself was nature. . . . His eyes burned like fire when in coal and red-hot; he looked through the blank canvas, through the besmeared paint, through the days and hours of work, to that vision which was within himself, and that alone was his goal, and no likeness of any place or thing tempted him aside. . . . It is per-haps interesting to note the difference in the artist who works in the way I have here tried to indicate and in that more exact copyist, who, strong only in his eyes, and depending always upon them, grows blind and weak at the last.[9]

In Daingerfield's view, Inness's pictures were products of an inward turn on the part of their maker; they were not painted by referring to observable nature but, rather, through attention to an inner vision, a brand of sight that did not depend on the physical eye. The activity of the exact copyist, "strong only in his eyes," whose methods Daingerfield opposed to Inness's own, led to blindness and weakness. Inness's practice, in contrast, brought about a vision that the critic went on to describe as "wide of horizon, perfect in all its parts."[10]

In the studio, Inness preferred to use old sketches and painted on old can-vases, thereby putting more distance between the seen, or remembered, and represented. "Even when he went so far as to make a sketch or a study of a spot," wrote Inness's biographer, Alfred Trumble, "this memorandum might lie by for years before he took it up to work upon, or it might never be touched again."[11] According to commentators, some of Inness's works consisted of ten, twenty, or more separate and superimposed pictures, layer after layer of paint, each one a development from, a reconfiguration of that which came before.

This habit, Daingerfield lamented, "cost the world many good pictures."[12] "It is said to be literally true," said Schuyler, "that one of the remaining canvases contains twenty-five separate and superimposed pictures. There is another that was begun as a 'Morning Hunting Scene,' and that in its final phase was a 'Summer Afternoon.' In most cases the later pictures were developments from the earlier. A new notion of the treatment of some particular 'passage' led to a reconstruction of the whole."[13] This is evident, for example, in *Landscape with Trees* (1886; plate 19), where the topmost composition is disturbed by the ghost of a thick-trunked tree emerging at left. Landscapes made after such a fashion originated in a pictorial recollection of something once perceived; the process of painting itself became an operation of memory, for it recalled yet transformed the visage of an already painted scene.

Inness often used the sketches of his friends or colleagues when beginning a painting rather than his own, doubly distancing painting from its usual origins. "Inness did not care to work from new sketches," reported his pupil, John A. S. Monks, who studied with the artist in North Conway and Boston in 1875. "He preferred to look over those he had somewhat forgotten, because they did not suggest too much of the impossible but merely some fact or phase in nature. He was also fond of looking over the portfolio of friends and working from their sketches."[14] Successful art, Inness appears to have believed, took shape in the space of the studio over an already-painted surface created by someone else. The French painter Alexandre-Gabriel Decamps, he told *Harper's*, "bought old pictures and painted over them; his canvas was a painting before he touched it; and I should say that if a man wished to paint as Delacroix painted, an old picture would suit him as well as a new canvas to put his scene on."[15] Inness, reported Monks, once asked him to sketch in on canvas a motif suggested by a drawing executed by one of the artist's friends: "He brought in a careful drawing of an oak tree he found in the studio of a friend, and said if I cared to *frotté* [sic] it in for him on a canvas I would better understand what he had been explaining for days previously. I worked on it several days, and then he said that I understood what he wished me to, thanked me for the drawing, and in less than three hours made one of the most truthful, breezy autumn pictures I ever saw, and had decided what he wanted to paint."[16] In such an instance, Inness took as his referent the memory of an individual distanced by virtue of several intervening pictorial acts. A friend's drawing rendered on canvas by a student in the artist's studio stood for the activity of Inness seeing and sketching in nature. The origin of painting, and of vision, was thus thrice deferred. According to Daingerfield, Inness considered such displacement integral to his practice: "He believed, most ardently," the critic wrote, "in a true scientific application of his principles, and at one time thought that if he might find a man who could, from the sketches, draw in his new canvases, that he could proceed to a perfect, scientific finish."[17] It is not a stretch to say that this "perfect, scientific finish," brought about by memory, deferral, and delay, was one aspect of that formula that Inness thought would fulfill the mission of art

and, thus, that memory and good vision, for Inness, were in some way inextricably linked.

"BY-AND-BYE I SHALL PAINT MY DREAM"

Painting from memory, from old sketches or pictures, on top of old canvases, and from the work of colleagues or friends: these practices were unusual, if not unique, at the time Inness incorporated them into the procedures of his art (I am speaking, of course, of the American context).[18] Yet they seem in keeping with what I have described as his conception of perception's blind or obscuring aspect, the lapse of seeing necessary to spiritual sight, and they became, in his hands, strategies of vision, strategies, he seems to have thought, of a scientific sort.

Painters were often praised in writing about art at the time for having what was considered to be a good visual memory and for creating works that reflected the retention of nature's facts.[19] Memorableness itself was a criterion for art, and critics frequently described good pictures as those that left a lasting impression. Susan N. Carter implied in her review of the 1878 academy exhibition that Inness's landscapes, or memories of them, compelled their viewers to return for a second look: "A little gem of a girl . . . by Mr. La Farge, catches the attention; then, when the spectator has been examining one of Inness's strange and poetical landscapes, and perhaps comes back to look at it again, he is astonished to find that a very fine Tiffany is hanging close by, which he did not observe before."[20] Church's panoramic and minutely detailed landscapes, despite their dexterity and general cleverness, failed in Jarves's view because they produced the opposite effect, leaving "no permanent satisfaction to the mind, as all things fail to do which delight more in astonishing than instructing."[21] In order for a picture to succeed, a writer for *Scribner's Monthly* stated in 1875, "it must be reflected in the beholder's memory through a hundred frames of its lesser companions."[22] Inness's paintings, he said, did just this, for they effaced the memory of other works on view at the academy exhibition that year. His Italian scene, for example, caused the viewer "buoyantly to reject nearly all the rest and erase them from his memory."[23]

Some artists and writers advocated the cultivation of the visual memory, saying that its improvement was an integral part of learning how to draw and paint. Inness, who was in Paris in the early 1850s and again in the 1870s, may have been familiar with Horace Lecoq de Boisbaudran's pamphlet, *L'Éducation de la mémoire pittoresque* (The training of the pictorial memory), published in 1847 and in expanded form in 1862. *L'Éducation* was the subject of some discussion in Parisian art circles during these years, as was Lecoq's role in an ongoing attempt to reform the curriculum of the École des beaux-arts.[24] The text outlined an alternative to academic instruction and suggested that students practice drawing from memory in order to improve their visual acuity and artistic skill; memory and intelligence, including visual intelligence, Lecoq

insisted, should be cultivated side by side. After mastering the memory of geo-
metric form, students following his system practiced drawing simple anatomical
details from memory, a nose, for instance, then entire heads, then engravings
after classical sculpture and old master drawings and paintings, then original
sculptures and paintings, and, finally, the actual human form. This course of
study, Lecoq said, sharpened and strengthened skills of observation, enabling
the student to develop his or her own artistic disposition and produce original
works of art.

Even if Inness was not familiar with Lecoq's proposals, he may have known
of similar methods available for study in the United States. Marie-Elisabeth
Cavé's *Drawing from Memory,* published in France in 1850 and in the United
States in 1868, provided a course of instruction similar to Lecoq's.[25] Cavé pro-
posed a step-by-step method wherein the student practiced drawing objects
from memory, beginning with simple forms and progressing to more complex
objects. Even more so than the author of the *Éducation,* Cavé stressed the role
she thought drawing from memory played in learning to see correctly: "The ed-
ucation of the painter is like that of the child; it begins in the cradle, since its
first principle is seeing correctly, comparing surrounding objects; and this
study is renewed and continued every day."[26]

Inness's understanding of the relations among vision, memory, and paint-
ing bore a superficial resemblance to Cavé's and Lecoq's, for all three linked
memory's function to good painting and good seeing; his habit of painting
from memory may well have been influenced by their recommendations. How-
ever, it was not these theorists' claims that ultimately shaped Inness's concep-
tion of the relation of perception to memory's operations and effects, nor was it
their suggestion that the process of painting consisted of a retrieval of images
from an archive of remembered forms that defined the contours of his experi-
mental art. Recall that Inness described the memory as "the daguerreotype
shop of the soul," a storehouse for visual and tactile sensations that had to be
closed when learning to see reality in a new light. "You can only achieve some-
thing," he wrote, "if you have an ambition so powerful to forget yourself," if you
close your eyes when you "go outdoors" and are blind to what you (physically)
see.[27] The critic Mariana Griswold Van Rensselaer expressed a similar view in
an article entitled "Some Aspects of Contemporary Art" published in *Lippin-
cott's Magazine* in 1878. The "new men," she stated, referring to that class of
young painters who had studied and refined their craft in Europe, are distin-
guished from the old masters by their self-consciousness. Such "inward con-
sciousness that they *are,*" however, did not provide them with the inspiration of
genius. Genius, she insisted, proceeded involuntarily, "by a sort of *possession*
rather than a voluntary intellectual effort."[28] "The noble physical endowment of
an artist," she wrote,

> . . . is twofold: power of eye and power of hand. By power of vision I mean simple
> vision exalted into a special gift, a special appreciation of line, an ultra delicate and

profound perception of color, and an exact, unconscious memory. This last is not imagination nor imaginative memory, but an automatic power, if I may so say, of the retina—as unconscious as is the pianist's memory of his notes, and as unerring. It is not the power to fix in the mind by conscious effort the objects before one, and to recall them deliberately, inch by inch, at any time, but the power, when the brush pauses trembling for the signal, to put down unerringly facts learned God knows where, or imagined God knows how. Automatic, I repeat, this power must be.[29]

According to Van Rensselaer, artists could achieve great work only if they allowed consciousness to lapse. The obscurity of forgetting, the loss of awareness of the conscious self, gave rise to untraceable sensations and facts and, ultimately, masterful art. Unconscious memory—not a storehouse of facts but an automatic operation of the mind—enabled godlike power of the hand and eye. We are reminded here of Inness's plea to dismantle the intellect so as to replace the sensory experience of "eye and touch" with another mode of perception, something like what Van Rensselaer called "simple vision exalted into a special gift."

What we know of Inness's understanding of painting, memory, and vision resonates not just with Van Rensselaer's but with that of the American artist William Morris Hunt as well. In *Talks on Art,* published in 1875, Hunt described what he understood as the necessary role of memory in the landscape painter's practice:

> I believe that the best paintings of landscape are made from memory. Of course you must study nature carefully for certain details, but for the *picture,* paint it in-doors, from memory. I never saw Millet out with an umbrella. When before nature you are so much occupied with representing what you see, that you can't study combination and composition. You can't make a *picture! . . .* See what makes the *picture!* not what makes the *thing! . . .* Do things from memory, because in that way you remember only the *picture.* No matter what you do, but make the thing look like a picture.[30]

In the *Talks,* a collection of Hunt's practical and theoretical musings compiled by his student Helen M. Knowlton, little time is dedicated to the discussion of landscape. When Hunt did speak of it, as he does here, he suggested that the landscape painter paint not from nature but from memory. The artist must study nature carefully, he insisted, but pictures of it ought to originate in recollection and only indirectly in actual observation: "That way you remember only the *picture.*" Paintings, Hunt seems to suggest, ought to be memories even before they are made tangible by the pictorial act—the painter must remember his painting before he paints it—especially if they were to be "pictures," that is, successful works of art and not mere sketches or studies.[31]

Although there is no record of direct contact between the two artists, and despite the fact that Inness does not mention Hunt in his correspondence or in

any published interview, it is likely that the two met in Paris in the 1850s or in Boston in 1875 or 1876, where Hunt was a prominent figure in artistic circles. On his second trip to Paris, in 1853, Inness may have seen Hunt's entries at the Salon.[32] Hunt's *Talks on Art* was published in Boston and was the subject of articles and reviews during the time Inness lived in Medfield and occupied a studio in the nearby city.[33] Both artists, only a year apart in age (Hunt was born in 1824), exhibited their work at the galleries of Doll and Richards and of Williams and Everett, and both were members of the Boston Art Club and participated in the club's exhibitions during these years. Inness, who had made a study of the painters of Barbizon on each of his European journeys, and Hunt, who had studied with Jean-François Millet when in France, were both greatly influenced by their encounters, abroad and at home, with the work of Millet, Jean-Baptiste-Camille Corot, Charles François Daubigny, Constant Troyon, and Théodore Rousseau.[34] Doll and Richards was one of the first galleries in the United States to exhibit the work of the Barbizon painters, and Inness's and Hunt's paintings hung among those of their French counterparts. Both artists were discussed in terms of the Barbizon school's influence and were understood as exemplars of an increasing interest in French art in the United States, and in Boston especially.[35] Inness's project was compared to Hunt's in a review published in *Atlantic Monthly* in 1875, and both were described as having "something of the French accent."[36] Inness's interview, "A Painter on Painting," was discussed in the *New York Evening Post* alongside Hunt's *Talks on Art*.[37]

I draw attention to Hunt's remarks on landscape and memory and to the possibility of an encounter (direct or indirect) between him and Inness not because I want to demonstrate that Inness followed his compatriot's advice and painted in the exact manner prescribed (although he came close to doing so) but because I want to highlight the fact that both artists imagined the act of seeing that led to representation as something other than unobstructed physical perception. Both Van Rensselaer's and Hunt's theorizations of the role of recollection and forgetting in picture making entailed such a claim. All three, Inness included, appear to have been convinced that any act of painting should be and inevitably was shaped by memory's intervention, premised on an originary obscuring of vision and a convolution of the temporality of the process of picture making itself. This conviction lay behind Inness's tactics and techniques of deferral and delay—the visual difficulties of his landscapes as well as his unconventional and idiosyncratic working methods—and this conviction is what motivated what I am calling his conscious effort to make his paintings challenging for viewers who, in the act of beholding, not only experienced the obscurity he seems to have thought vision's acquisition entailed but also relived the struggle of Inness's own search for a scientific formula of the subjective of nature, one that would both represent and produce the laws that governed sight (physical as well as spiritual).

Inness's habit of painting from memory was undoubtedly shaped by an attention to Corot, as well as by descriptions of Corot's art in nineteenth-century

America. As we know, Inness greatly admired the older artist: Corot's merger with Meissonier, he thought, would bring forth the very god of art. Corot, as is well known, also painted from memory. "Memory," he said, "has served me better at times than could nature herself."[38] The author of a review of an exhibition of Hunt's pictures in Boston in 1872 cited a similar remark: "'I will tell you my idea of a portrait,' said Corot: 'Let a person walk slowly through an open door, about ten feet away from you; let him pass and repass a few times; then, if, after he has gone, you can paint the image which he has left in your brain, you will paint a portrait. If you sit down before him, you begin to count his buttons.'"[39] Both Corot and Inness used old studies, souvenirs, memories of places once seen, when painting finished works, and Inness's landscapes were often compared to those of the Barbizon group, Corot's especially.[40] "That Mr. Inness is an absolute master of his art all persons who are well informed will concede," wrote one commentator in 1879, and he "believes, with Turner and Corot, in imagination in art—in painting dreams rather than realities."[41] Thinly painted and gauzy screens of trees, blurred and quivering layers of hue, delicately applied skeins of pigment, smeared bands of gray, brown, and green, and atmospheric haze are characteristic of Corot's landscapes of the 1850s–70s, including *Ville-d'Avray* (1870; fig. 4), many of which Inness would have seen while in Paris or at exhibitions in Boston, Philadelphia, and New York. These features, shared by works such as *Kearsarge Village* and *Sunset at Etretat,* give material form to the obscuring effects of memory that intervened when both artists came to render a view, or a recollection of it, in paint.

Corot's pictures were described in writing about art in the United States in precisely these terms and were characterized as expressive of both truth and obscurity, as were Inness's. Corot painted, stated Earl Shinn in a review of the Centennial Exhibition held in Philadelphia in 1876, "vapory, dreamy, invisible landscapes, that nobody perhaps can fully understand: by summoning up all your resolution, coming up to a Corot very fresh, keeping the catalog-title very distinct in your mind, and if possible turning the picture upside-down, you *think* you distinguish a tree, a fog, a boat, a pond, a bog, and a fisherman. . . . The Corot was to put [its owner] in a state of trance."[42] William Hoppin, writing in the *Atlantic Monthly,* reported that Corot "delights in pale greens and morning mists" and that his landscapes "are as unsubstantial as those we see in a dream."[43] Jarves expressed a similar view: "Corot is a poet. Nature is subjective to his mental vision. He is no seer, is not profound; but is sensitive and, as it were, clairvoyant, seeing the spirit more than the form of things. There is a bewitching mystery and suggestiveness in his apprehension of the landscape, united to a pensive joyousness and absorption of self in the scene, that is very uncommon in his race. . . . They are no transcripts of scenery, but pictures of the mind."[44]

In an 1880 essay about the artist Homer Dodge Martin, a critic for the *Art Journal* excerpted a letter, cited frequently in American periodicals, written by Corot to a friend. In the letter, Corot described his process of painting as

involving direct looking but also, and necessarily, remembering. He spoke of "his going out of doors at three o'clock in the morning, and sitting under a tree and waiting and watching":

> Nature, writes Corot, is like a white veil upon which some masses are sketched in profile. The sun gets clearer; he has not yet torn the gauzy veil behind which hide the meadow, the valley, the hills on the horizon. At his first rays the landscape lies entirely behind the transparent gauze of the ascending mist. At last you can see what at first you only imagined; the sun has risen, everything sparkles, shines, is in full light—light soft and caressing as yet. The backgrounds, with their simple contour and harmonious tone, are lost in the infinite sky through an atmosphere of azure and mist. The sun scorches the earth. Let us go back; everything is visible; there is no longer anything (*on voit tout; rien n'y est plus*). Let us go breakfast at the farm, a good slice of home-made bread, with butter newly churned, some eggs, cream, ham. Work away my friends; I rest myself. I enjoy my *siesta* and dream about my morning landscape. I dream my picture. By-and-bye [*sic*] I shall paint my dream.[45]

Corot exults in the haze of morning; when the sun reveals the outlines and forms of the earth, he retreats. When things become visible, when one can see everything, clearly and without the intervention of mist and infinite sky, there is, according to the artist, nothing left to see. Looking at a landscape, seeing it properly, in a way that led to good painting, required, for Corot, obscuring effects. Mist, haze, and sky, however, were by themselves inadequate; they did not obscure enough. Corot insisted on the necessity, in picture making, of memory and then dream and then memory (of the dream) again. While his friends painted under the scorching sun in front of the motif, he slept, painting only after this lapse (of time, of consciousness), only after memory and dreamscape had intervened. It was after the fact of looking, after recollection's intervention, Corot believed, that successful landscape paintings could be made. Only after the veils of haze, mist, sky, and atmosphere were rendered doubly and triply distancing by virtue of recollection's and dreaming's dislocation did he paint what he (dreamed he) saw. Pictures created in this manner originated at the point where Inness thought good painting ought to begin, in a haze of flatness and fog, and they transferred the act of recollection that guided their creation to the experience of the beholder who tracked the artist's reverie through veils of paint, screens of delicate branches and leaves, half-uttered forms, transparent gauzes, and hovering, hesitating hue.

In periodical literature around 1870 in the United States, discussions of memory were rather common, and numerous writers set out to debunk conventional conceptualizations of its capacity being similar to a storehouse, data bank, or photographic plate—Inness's "daguerreotype shop of the soul"—by addressing memory's fallibility, its distortions and delusions rather than its archival aspect. As with writing about optics at the time, these texts marshaled

scientific fact as well as anecdotal experience to make revisionary claims about
human perceptual capacity, and it was against the backdrop of these texts that
Inness undertook his memory work. "Our remembrance," Frances Power Cobbe
wrote in the New York–based *Galaxy* in 1866, "is habitually, not merely fallible,
but faulty. . . . Let any one endeavor to draw from memory a street, a mountain,
a park, which he has gazed at for years, and then let him compare his sketch
with the original, or with a photograph of the spot. We venture to affirm he will
not do so without a little start, at the sudden jerk of rectification, as the wheels
of memory run off the wrong rail upon the true one."[46] Memory, she continued,

> is forever likened by poets and rhetoricians to an engraved tablet, treasured in the
> recesses of mind, and liable only to obliteration by the slow abrasion of time, or
> the dissolving heat of madness. We venture to affirm that such a simile is not in
> the remotest degree applicable to the real phenomenon of the case, and that mem-
> ory is neither an impression made, once for all, like an engraving on a tablet, nor
> yet safe for an hour from obliteration or modification, after being formed. Rather
> is memory a finger mark traced on shifting sand, ever exposed to obliteration
> when left unrenewed, and if renewed, then modified, and made not the same,
> but a fresh and different mark.[47]

A writer identified only by the initials J. S. expressed a similar view, insisting
that philosophers erroneously distinguished "memory as mediate knowledge of
something absent, from perception as immediate knowledge of something
present." His analysis was typical for its time in that it assumed a network of
relations among memory, vision, and representation, one that I have been ar-
guing Inness set out to explore in his landscapes. It is possible, J. S. stated, "to
illustrate mnemonic illusion by visual illusion. It will be found, we believe, that
there is a close analogy between the forms of illusion in vision and recollection,
as well as between the modes of their production." "All recollection," he con-
tended, "takes place by means of a present mental image."[48] J. S. likened mem-
ory's fallibility to a certain class of optical illusions—"those . . . which depend
on the effects of haziness . . . of atmospheric action, and of any reflecting and
refracting media interposed between the eye and object"—effects that I am
suggesting were characteristic of the landscapes of both Inness and his precur-
sor Corot.[49] J. S. called these illusions of memory "atmospheric illusions": "We
do not recall the event as it happened, but see it in part only, and obscured, or
bent and distorted by the process of refraction [and] this transformation of the
past does closely correspond with the transformation of a visible object effected
[*sic*] by intervening media."[50]

 With Corot as a model, and against a backdrop of scientific doubt with re-
gard to the vitality of recall, Inness explored in paintings such as *Kearsarge Vil-
lage* and *Sunset at Etretat* the role memory could play in his scientific formula
of the subjective of nature—that thing, he told Hitchcock, he had spent his

whole career aiming to obtain and apply.[51] In combination with Meissonier's "science," Corot's practice provided Inness with a way to express his beliefs about painting and perception—both of which, according to him, were to originate in a blank, flat fog, J. S.'s "intervening media," one might say—and with the means by which to make of memory more than a storehouse, more than a record of surface appearance, to discover, in the act of painting, the means by which to see with God. By incorporating what this periodical literature and what Corot's landscapes characterized as memory's effects (veiling, dimming, fading, occluding, obscuring, distorting, flattening, reconfiguring) into the looking that led to his painting (by way of the strategies described above) and into the material characteristics of his landscapes (blurred and smeared screens of trees; swirling skeins of paint; atmospheric haze and dimmed light; thickened and pulled streaks of soft, pressed gray; distorted perspective; dissolved and flattened space), Inness reproduced what he understood to be the originary occlusion of vision, the blindness necessary to spiritual sight. Corot, and his model of memory, mystery, and the dream, must have suggested to Inness that in any quest for clear and accurate vision, memory had to intervene. Corot's practice, which substituted the operations of memory for the sensations of physical perception, and Corot's pictures, which rendered the effects of such a substitution in painted form, gave Inness an idea as to how the obscurity he thought keen vision entailed could be represented and communicated in art. The act of painting from memory expressed what was for Inness a fundamental law: seeing came by way of being temporarily blind to the external visible world, at that point where the senses faltered, vanquished by a fog of vapor that obscured the visible real. Of the work of Decamps, that artist who began new paintings on top of old, Inness wrote,

> Take one of his pictures, "The Suicide"—a representation of a dead man lying on
> a bed in a garret, partly in the sunlight. All is given up to the expression of the
> idea of *desolation*. The scene is painted as though the artist had seen it in a dream.
> Nothing is done to gratify curiosity, or to withdraw the mind from the great central
> point—the dead man; yet all is felt to be complete and truly finished. The spectator
> carries away from it a strong impression, but his memory is not taxed with a multi-
> tude of facts. The simple story is impressed upon his mind, and remains there for-
> ever. . . . Deschamps's [*sic*] mind is more perfectly governed by an original impulse,
> and it obeys more perfectly the laws of vision.[52]

Unified and strong, singular and above all, memorable, in Inness's view, *The Suicide* (ca. 1836; fig. 6) did not tax the beholder's memory with a multitude of facts, making of recollection an archive or photographic plate. Rather, it transformed the process of memory's intervention ("as though the artist had seen it in a dream"), one represented by the paintings and practice of Corot, into a law of vision.[53] It was this law that Inness's landscapes worked to determine and express.

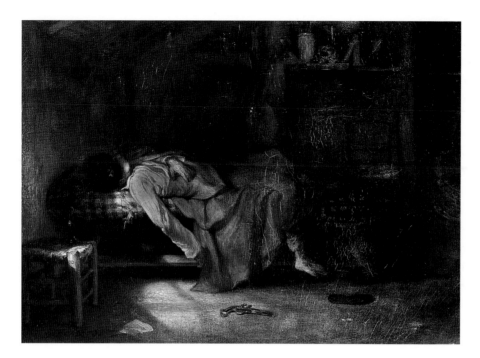

Figure 6. Alexandre-Gabriel Decamps, *The Suicide* (ca. 1836). Oil on canvas. 15¾ × 22 in. The Walters Art Museum, Baltimore, Maryland.

"THICK DARKNESS"

Inness's interest in memory was also shaped by his intense engagement with the work of the Swedish philosopher, scientist, and theologian Emanuel Swedenborg. Inness was a member of the Swedenborgian Church, or the Church of the New Jerusalem, and had made a thorough study of the theologian's many scientific and religious texts.[54] As Sally Promey has described in a recent and important article that examines the spiritual significance of Inness's color in terms of his involvement with the Swedenborgian church in the United States, Inness wrote an essay entitled "Colors and Their Correspondences" for the *New Jerusalem Messenger,* a Swedenborgian journal, which appeared in 1867.[55]

Inness became familiar with the writings of Swedenborg during his residence at Eagleswood, an estate near Perth Amboy in New Jersey. The site of a utopian and abolitionist community called the Raritan Bay Union, Eagleswood was home to Marcus and Rebecca Spring, the union's founders.[56] By the time Inness arrived, in 1863, the union had for the most part dissolved and Eagleswood had become, under Marcus Spring's guidance, a military academy and artists' colony. Eagleswood offered instruction in art and design, and a number of artists and other intellectuals, including Inness, lived and worked on site.[57] By all accounts, Inness undertook an intense study of Swedenborg after the artist William Page, another Eagleswood resident and an ardent disciple of Swedenborgian thought, introduced him to the theologian's work.[58] As Inness's son reported, "This philosophy came at a time in his life when he most needed something to lift him out of himself and the limited doctrines of orthodox

creeds." Inness, said his son, "threw himself into its teachings with all the fire and enthusiasm of his nature, and although he did not adhere strictly to its tenets, it led to other metaphysical research, and he at last truly found that form of expression for which he had searched throughout his life—the conscious-ness of God in his soul manifested in every experience of his life."[59]

Inness's writing and conversation were filled with references to Swedenbor-gian concepts and, as Nicolai Cikovsky, Jr., has argued, his practice cannot be understood apart from an examination of the theologian's work. However, as the remarks of his son suggest, Inness did not adopt Swedenborgian doctrine uncritically and, as a number of the artist's contemporaries noted, he did not in-vest himself wholeheartedly in the beliefs of the church. Sheldon reported that "Swedenborgianism interested him as a metaphysical system, especially in its science of correspondences; but he never formulated for himself a theological creed, because, as he said, a man's creed changes with his states of mind, and the formulation made to-day becomes useless to-morrow."[60] "In the mind of In-ness," De Kay wrote,

> religion, landscape, and human nature mingle so thoroughly that there is no sepa-
> rating the several ideas. . . . Inness is a modern to the last degree, and, thrown in
> upon himself by a scoffing world, tries to express his religious opinions under the
> veil of landscape. Perhaps even that is saying too much. Do his landscapes hint of
> religion? Does he try to express religion? We should say no. It is rather *the methods
> by which he does them* that are governed in his own mind by religious ideas. . . . Let
> us, then, rather say of his religion that he does not express, but hides it, in his art.[61]

In essence, Inness transformed Swedenborg's conception of the spiritual into an aesthetic system, reshaping Swedenborgian doctrine so that it approxi-mated what he imagined to be scientific (and pictorial) method. Swedenborg provided Inness not only with a particular understanding of spiritual sight but also with a model and a methodology, a way of seeing and representing, rather than a creed, that aided him in proposing for vision an origin and function as yet unthought (just as Swedenborg's theology, remarkable in its originality and bold in its claims, radically reimagined biblical history, revelation, and the rela-tion of exegesis to the apprehension of the divine).[62]

Swedenborg's work would have appealed to someone interested in develop-ing a scientific formula for use in exploring spiritual truths. He was a scientist by profession and served for years as an assessor on the Swedish Board of Mines. Before turning to biblical exegesis, he studied and published treatises on mechanics, engineering, geology, mathematics, astronomy, chemistry, metal-lurgy, psychology, and physiology. For the philosopher-mystic, scientific inquiry and theology represented corresponding and interrelated fields of inquiry; his theological tracts continued and were informed by his researches in the scien-tific realm. His masterwork, the *Arcana coelestia* (Secrets from heaven), pub-lished in eight volumes in Latin between the years 1749 and 1756, included,

amid chapters of biblical exegesis, meditations on the nature of existence and the physical and mental capacities of humankind.[63]

In the *Arcana,* Swedenborg described the cosmos as constituted by two distinct but interconnected realms: the external (the natural world) and the internal (the spiritual world). He claimed that things in the external/natural world corresponded to things in the internal/spiritual world: "It has been given to me to know from much experience that in the natural world and its three kingdoms there is nothing whatever that does not represent something in the spiritual world, or that has not something there to which it corresponds" (*AC* 4:2992).[64] According to Swedenborg, the correspondential relation between the natural and the spiritual realms was not a matter of symbol or allegory but of cause and effect. The two worlds were contiguous and in constant communication, one a response to or an end of the other. Nothing, Swedenborg wrote, could subsist on its own:

> For it is a universal rule that nothing can subsist from itself, but from and through something else, consequently that nothing can be kept in form except from and through something else, which may also be seen from everything in nature. . . . In respect to his external, man cannot subsist except from and through his internal. Neither can the internal man subsist except from and through heaven. And neither can heaven subsist from itself, but only from the Lord, who alone subsists from Himself. . . . For all things occur by means of influx. (*AC* 8:6056)

Things in the natural world were visible manifestations of things in the spiritual world, wrote Swedenborg, in much the same way that a smile responded to and manifested a feeling of happiness or joy (*AC* 4:2987–88).

The idea that different realms were interconnected, sustained by the influx of that which was conceptually and actually behind or prior to them, formed the basis of Swedenborg's mode of exegesis. The relationship of the biblical books of Genesis and Exodus, and the word of the Old Testament in general, to spiritual truth, Swedenborg claimed, was analogous to the relationship between the external and internal worlds: "All things in the Word both in general and in particular, nay, the very smallest particulars down to the most minute iota, signify and enfold within them spiritual and heavenly things" (*AC* 1:2). By explicating correspondences between text—individual words, sentences, and entire narratives—and true meaning, a task to which the *Arcana* was devoted, Swedenborg stated, the "internal sense" of the word could be perceived and heaven's deepest secrets revealed.[65] As such, the theologian's exegetical method, what Sheldon had called his "science of correspondences," functioned as a model of spiritual sight, for it described humankind's perceptual relation to both the natural and the heavenly realms and outlined, in meticulous detail, the scientific means by which individuals could be made to see, first, by discerning the true word of God, coextensive with but hidden by the Bible's "surface" text

and, second, by comprehending and deciphering the relationship between external and internal existence, by seeing the latter by way of the former, which obscured yet harbored truth.

Inness's convictions regarding a crisis of vision, his understanding of spiritual sight as a revelatory visual mode, and his insistence that painting should serve as a medium of revelation—teaching the world to "see reality in a new light"—derived in part from Swedenborg's exegetical and perceptual model, as did the distinction he drew between spiritual seeing and physical vision. In the *Arcana* and elsewhere, Swedenborg described the nature and limits of normal perception as well as vision's higher forms, saying the latter were attainable only by men, like himself, who had undergone a process of spiritual regeneration.[66] Most people, he claimed, saw with the physical eye alone and were blind to everything but the surfaces of the natural world. The thoughts of natural men, he wrote, "terminated in the natural [external] things which are connected with his senses. Whatever is not said from and according to these natural things is not comprehended, but perishes, like sight that has no bound in some ocean or universe" (*AC* 3:2553). Seeing like a spirit was to enjoy "much more excellent sensitive faculties . . . than when living in the body, so that the two states scarcely admit of comparison" (*AC* 1:321). So long as he lives in the body, Swedenborg wrote, "man can feel and perceive but little of this [spiritual truth]; for the celestial and spiritual things with him fall into the natural things in his internal man, and he there loses the sensation and perception of them" (*AC* 4:2994). Only a form of regeneration, which would involve the attainment of spiritual sight, would allow an individual to see past the surface of things and toward the divine: "If the internal sense of the Word . . . were to appear before a man who is not regenerated," contended the theologian, "it would be like thick darkness, in which he would see nothing at all, and by which he would also be blinded" (*AC* 10:8106).

Inness also followed Swedenborg in his belief that true vision (the internal, seeing reality in a new light) found its origin in and was constituted by an obscuring or blinding agent (the external, a fog of vapor that obscures everything). Vision, the theologian said, came about only by way of its eclipse, after death or regeneration, when an individual entered darkness so as to be reborn into light:

> As regards spirits and angels in general, who all are human souls living after the death of the body, I may say here that they have much more exquisite senses than men. . . . Spirits however are not able, and angels are still less able, to see anything that is in the world by their own sight, that is by the sight of the spirit; for the light of the world or of the sun is to them as thick darkness; just in the same way as man by his sight, that is, by the sight of his body, cannot see anything that is in the other life; for the light of heaven, or the Lord's heavenly light, is to man as thick darkness. (*AC* 2:1880)

Vision, he suggested, originated in "thick darkness," in a serial instance of non-sight; no one really saw, no one excepting the Lord himself: "All perception flows in through the internal into the external or natural. For of itself the natural perceives nothing whatever, but its perceiving is from what is prior to itself; nay, neither the does the prior perceive from itself, but from what is still prior to itself, thus finally from the Lord, who Is of Himself. Such is the nature of influx, and therefore such is the nature of perception" (*AC* 8:6040). Perception occurred by way of influx; the visual organ perceived nothing on its own and relied on something outside of or, rather, prior to it, its operations encompassing moments of blindness and lapse:

> The eye . . . could not possibly apprehend and discern any object; for it is the interior sight which, through the eye, apprehends the things which the eyes sees; and by no means is it the eye, although it so appears. . . . The . . . interior sight, or that of the spirit . . . does not see from itself, but from a still more interior sight. . . . Nay, neither does this see of itself, but does so from a still more internal sight. . . . And even this does not see of itself, for it is the Lord who sees through the internal man, and He is the Only One who sees because He is the only one who lives, and He it is who gives man the ability to see, and this in such a manner that it appears to him as if he saw of himself. (*AC* 2:1954)

Vision, at each step in its process toward light, was a great blank, a blind spot, one might say, and only the Lord actually saw anything at all; at each instance of their serial and subsisting operation, the eyes perceived no more than if they had been kept shut.

Swedenborg had a specific sense of how an individual should go about learning to see spiritually, without recourse to the external. In the *Arcana,* he spoke of an originary people, present at the beginning of time; these were members of what he called the Most Ancient Church of "Adam" or "Man" (*AC* 2:1114), who possessed a form of spiritual vision that eliminated the need for exegesis, but had since been forgotten, replaced with a debased and indirect mode of sight:

> As the men of the Most Ancient Church in every thing of nature saw something spiritual and celestial, insomuch that natural things served them merely as objects for thought about spiritual and celestial things, they were for this reason able to speak with angels, and to be with them in the Lord's kingdom in the heavens at the same time that they were in His kingdom on earth, that is, in the church. Thus with them natural things were conjoined with spiritual things, and wholly corresponded. But it was otherwise after those times, when evil and falsity began to reign; that is, when after the golden age there commenced the iron age; for then, as there was no longer any correspondence, heaven was closed; insomuch that men were scarcely willing to know that there was anything spiritual (*AC* 4:2995).

Able to discern the spiritual in the natural, the men of the Most Ancient Church possessed the capacity to see automatically and instantaneously the reality behind and within their earthly realm. "In the most ancient times," Swedenborg wrote, "men were informed about heavenly things . . . by immediate intercourse with the angels of heaven; for heaven then acted as a one with the men of the church, for it flowed in through their internal man into their external, and from this they had not only enlightenment and perception, but also speech with angels" (AC 12:10355).

The Most Ancient Church did not rely on "representatives" (representations in the natural world or in texts) to see. Not until the time of its successor, the Ancient Church, did perception come to depend on the discernment of relationship (AC 4:3419), on writing and its signification (AC 2:1756). The members of the Ancient Church knew of but did not directly perceive spiritual truths; their eyes dwelled on external objects, or representations, and interpretation replaced automatic apprehension and immediate intercourse: "I have been taught from heaven," Swedenborg reported in *Heaven and Hell* (1758), "that the earliest people had a direct revelation. . . . Later, however, this kind of direct revelation no longer occurred, but rather an indirect revelation by means of correspondences."[67] When "internal respiration [the respiration of the Most Ancient which enabled them to speak without words and with the Lord] ceased," according to Swedenborg, "external respiration gradually succeeded, almost like that of the present day; and with external respiration a language of words, or of articulate sound." As a result, Swedenborg wrote, "the state of man was entirely changed" (AC 1:608). Seeing in the Most Ancient Church was akin to breathing; it was unconscious, unmediated, immediate, involuntary, and instantaneous. "Thus," stated Swedenborg,

> they spoke not so much by words, as afterwards and as at this day, but by ideas, as angels do; and these they could express by innumerable changes of the looks and face, especially of the lips. In the lips there are countless series of muscular fibres which at this day are not set free, but being free with the men of that time, they could so present . . . ideas by them as to express in a minute's time what at this day it would require an hour to say by articulate sounds and words. . . . As these most ancient people had a respiration such as the angels have, who breathe in a similar manner, they . . . were able to have such perceptions as cannot be described. . . . But in their posterity, this internal respiration little by little came to an end. (AC 1:607)

Members of the Most Ancient Church communicated by way of the motion of muscles that responded immediately to thought and conveyed ideas in a minute's time. With the Ancient Church, respiratory seeing was replaced by representational seeing: mediated and delayed, available only by way of the scrutiny and interpretation of correspondences and representations, and reliant on the articulation of sounds and words in time. Subsequent churches (the Jewish church

and the Christian church of Swedenborg's day) forgot their knowledge of corre-
spondences and representatives and resorted to magic and ritual. The vision of
his world, lamented Swedenborg, was neither immediate nor direct; rather, it
was malformed and mediated, its operations serial, constituted by deferral and
delay (first the external sense, then the material idea, then the idea or thought).

As did Inness, who characterized his contemporaries' vision as imperfect
and said that his or any artist's practice should involve the reclamation of pen-
etrating sight, Swedenborg felt that the world needed to learn or, more accu-
rately, relearn, how to see, to regain a state of vision that did not depend on rep-
resentation (on words, sounds, or appearances) and that assumed the capacity
of breath. In order to regain this state, he contended, in order to see as had the
men of the Most Ancient Church, instantaneously and directly, without media-
tion, intervening layers of representation had to be cast off and the origin of
true vision exhumed. "Without this knowledge," Swedenborg wrote, "scarcely
anything of cause [God] can be known, for without it, the objects and subjects
of both worlds seem to have but a single meaning, as if there were nothing in
them beyond that which meets the eye."[68]

At the heart of Swedenborg's exegetical project, then, lay the suggestion
that, in order to regain an originary state of unmediated and unencumbered vi-
sion, one had to remember it. Swedenborg understood his exegetical endeavor
as productive of a second coming coincident not with apocalyptic destruction
or the reappearance of Christ but with a remembering of and return to the way
things were at the origin of being and time.[69] Central to Swedenborg's thought
was the remarkable and bold claim that, by recalling the ways of the Most An-
cient Church, by exhuming their truths, as an archaeologist would the remnants
of a lost civilization, the vision of its people could be reclaimed (and a New
Church, to cultivate and disseminate this vision, established). Exegesis, writing,
as it were, was for the theologian an act of remembering and a means to spiri-
tual sight.

Inness, I want to suggest, believed that his painting constituted a similar en-
terprise. At the very least, he thought something could be gained by exploring
landscape's instrumental, and recuperative, potential. He certainly appears to
have made extensive use of the ideas represented by Swedenborg's archaeology
in his search for a science of spiritual sight. His landscapes make manifest the
dimness and blur of recall so as to highlight vision's strange, foggy, and distant
origin; made from memory, on top of old canvases, or from the memories and
canvases of Inness's friends, they explore and instantiate the procedures of rec-
ollection Swedenborg suggested were necessary to an exhumation of spiritual
sight. It is as if obscuring layers of paint—"twenty-five separate and superim-
posed pictures," in Schuyler's words—stood for the layers of text, symbol, and
surface appearance that had to be penetrated and stripped away before compre-
hensive and unmediated vision was regained, as if, to Inness's mind, to paint
was to remember was to see. These layers, each one responding to the profile
of the layer beneath it, also embody the process of influx, what Swedenborg

described as an intimacy and contiguity between cause and effect, between an emotion of joy and its physical manifestation as a smile, the one subsisting in the other, giving it contour and form. In this way, overpainting, overlap, and encroachment articulate the relationship between external and internal, between the surface of the world and those spiritual truths immanent in it. "I can conceive of creation," Inness wrote, "only as something produced from its first cause, God, of whose act I am conscious. As I am a point conscious of this movement of the Infinite Being, I can not cease to exist; for my consciousness forms a point of that infinite movement. Therefore my consciousness must be infinitely continuous, as the movement of the Infinite is infinitely continuous."[70] Beyond infinite layers of pigment, overlapping and confused zones of paint, all embodiments of this influxing continuum of which Inness understood himself a part, and through which viewers had to find their difficult way, lay the origin, or first cause, of vision and the world. "Our intelligence is occupied with the contemplation of effects," Inness had said. "It should be occupied with the contemplation of cause," that is to say, with the memory of an originary vision akin to God's.[71]

Inness's memory work, and especially the part of it that involved using the memories, sketches, or paintings of other people, including those of his friends, also suggested a model of perception wherein the act of seeing was necessarily intersubjective, much as it was in the Most Ancient Church, proceeding as it did by way of respiratory influx from one body/mind to the next (as Swedenborg put it, "such is the nature of influx, and therefore such is the nature of perception"). Recall that, for Swedenborg, "immediate intercourse" with other humans and with angels provided the means by which "men [of the Most Ancient Church] were informed about heavenly things." Communication between beings was, thus, the selfsame thing as spiritual sight; seeing divinely was, by nature, something that originated from within a network of breaths and eyes, something that was a communal affair. It may well have been this sort of network that Inness attempted to approximate by way of incorporating other people's sketches and paintings into his own productions. Think of it this way: the sketches or paintings of Inness's friends influxed into his art, as if breaths from another being; these breaths mingled (or spoke) with Inness's own, much as the members of the Most Ancient Church breathed/spoke with one another and with angels so as to attain heavenly insight, what Inness would come to call spiritual "benefit," "elevation," or "force."[72] Borrowing, thus, was for Inness a model for communicating, which in turn was a model for spiritual sight; Inness's intersubjective pictures suggest a community of intersubjective seers, collectively bent on speaking and seeing with God. In a very specific sense, then, Inness's landscapes embodied the nature and capacities of the Most Ancient Church. As will become even clearer in subsequent chapters, Inness's interest in cognition encompassed curiosity not just about the manner in which knowledge is acquired but about the manner in which it is communicated from one intellect to another as well. The model of spiritual vision postulated by

Inness's memory work, in that it dwelled on intercourse, the passing of information between minds (or paintings between artists), manifested this interest and foreshadowed other, later pictorial investigations of the same set of concerns.

In the *Arcana,* Swedenborg stated that man had two memories, "one exterior and the other interior," the former "being proper to his body," the latter "to his spirit" (*AC* 3:2469): "These two memories are entirely distinct from each other. To the exterior memory, which is proper to man while he is living in the world, pertain all the words of languages, also the objects of the outer senses, and also the knowledges that belong to the world. To the interior memory pertain the ideas of the speech of spirits, which are of the inner sight" (*AC* 3:2471). It should be clear which kind of memory I believe Inness's landscapes offered up—"that vision," as Daingerfield put it, "which was within himself"—and also why: Inness believed that a capacity that enabled an individual to see with God came about only after vision was subjected, in some fashion, to the operations and effects of recollection so that respiratory perception was exhumed, thereby allowing for a new mode of realism—a hybrid of science and spirit, exegesis and dream—and for a new (albeit ancient) form of sight as well.

BLIND MEN MADE TO SEE

Both Corot and Swedenborg offered Inness a model for his own exploratory work. But it was Inness's engagement with a particular and long-standing problem of philosophy and science that provided the exact framework for his adaptation of Corot's memory practice and Swedenborg's method of exegesis. It was Inness's attention to this problem—which comprised a debate concerning the acquisition of knowledge and the role of sensory perception and memory in this acquisition—that supplied the precise contours of his understanding of the place of memory in his practice, and it was this problem that he undertook to explore in the procedures, or science, of his art.

In a letter, written in 1693 to John Locke, the philosopher and scientist William Molyneux asked the following question: Could a man blind from birth, suddenly made to see, tell the difference between two objects, a sphere and a cube, he had known previously through touch only, without handling them, or would he see surface, flatness without depth, only?[73] Molyneux believed he would not be able to discern the difference on sight, and Locke agreed. It was the experience of how each object felt to the touch that enabled the man, when blind, to make the distinction; immediately on coming into sight, Molyneux explained, he would not have had the experience of coordinating his sensations of touch with those of his vision and thus would not be able to tell "that what affects my Touch so or so, must affect my Sight so or so."[74]

In his letter to Ripley Hitchcock, written in 1884, Inness offered his own version of Molyneux's query: "Whoever has been without sight and has sight given sees only surfaces. Shall we therefore ignore these experiences of vision

which induce thought and try to paint as though we had never seen?"[75] "Science now teaches," Inness said in 1879, "that it is *the inexperienced eye* that sees only surfaces."[76] "It is well known," he stated, "that we through the eye realize the objective only through the experiences of life." Before then, "all is flat, and the mind is in no realization of space except its powers are exercised through the sense of feeling."[77]

Molyneux's question preoccupied not just Inness but several centuries' worth of artists, critics, philosophers, and scientists. An understanding of the relationship of touch to vision and the role of this relation in perceptual experience was considered central to an understanding of the nature of cognition.[78] Locke, Voltaire, Bishop George Berkeley, Étienne Bonnot, the abbé de Condillac, Denis Diderot, Edmund Burke, Hermann von Helmholtz, John Ruskin, William Carpenter, and William James all discussed the problem.[79] In the United States, Molyneux's query was pondered regularly in the pages of scientific as well as popular periodicals; it is to this network of discourse, of which Inness's articulation was a part, that I now turn.

Considerations of Molyneux's problem in the 1870s in America were based on the assumption, itself underlain by nineteenth-century positivist philosophy, that sense perceptions were the only admissible basis of human knowledge and thought. Conversation centered around explorations of the psychophysiological mechanisms by which vision proceeded from sensations of flatness (what the blind man saw when given sight) to apprehension of extension and solidity in depth (what he became cognizant of after the passage of time) or, to phrase it as Inness might have, from a place where all is flat and things cease to appear to good painting and surface-penetrating godlike sight.

William Carpenter was one of the most important interlocutors in discussions of physiology and perception at the time in the United States. His work, and discussions of it, appeared with frequency in the pages of *Popular Science Monthly,* an American journal, and *Mind,* a London publication that was widely read in the states. Carpenter's analysis of Molyneux's query centered on a celebrated medical case, one that had provided the basis for an empiricist approach to the problem, placing it squarely within the arena of scientific inquiry. In 1728, the English surgeon William Cheselden successfully restored sight to a boy of fourteen who had been blind from birth resulting from cataract. The physician had operated on one of the boy's eyes a year earlier, attending to the second eye in 1728. In an article published in the *Philosophical Transactions* of the Royal Society, Cheselden described how his patient responded to and utilized his new visual capability.[80] On gaining sight, he said, the youth "was so far from making any Judgment about Distances, that he thought all Objects whatever touch'd his eyes (as he express'd it) as what he felt, did his Skin; and thought no Objects so agreeable as those which were smooth and regular, tho' he could form no Judgement of their Shape, or guess what it was in any Object that was pleasing to him: He knew not the Shape of any Thing, nor any one Thing from another, however different in Shape or Magnitude."[81] As Carpenter

described it in his *Principles of Mental Physiology,* published in 1879 and widely read in the United States, the boy "for some time after tolerably distinct vision had been obtained, saw everything *flat* as in a picture, simply receiving the consciousness of the impression made upon his retina; and it was some time before he acquired the power of judging, by his sight, of the real forms and distances of the objects around him."[82]

According to Carpenter, an individual, such as this boy, learned to see, to perceive, and then to understand the world by experiencing both visual and tactile sensations and subsequently coordinating the two. Perceptual capacity, what he called "perceptional cognitions," came by way of "experiential acquirement":

> It may now be affirmed with certainty, that Sight originally informs us only of
> what can be represented in a Picture—that is, light and shade, and colour; and it
> may be affirmed, with equal certainty, that the notions of form which we obtain
> through the sense of Touch . . . are originally unrelated to those derived from
> Sight; so that when a blind adult first acquires vision, objects with which he (or
> she) possesses the greatest tactile familiarity, are not recognized by its [vision's]
> means, until the two sets of Sense-impressions have been co-ordinated by repeated
> experience.[83]

Perceptual capacity, thus, was not innate but derived from the acquired memory of this process. In an earlier article, "The Unconscious Action of the Brain," Carpenter had discussed this scenario, and the case of a young girl who, when brought to sight after a lifetime of blindness, was unable to recognize a pair of scissors she had often used. He attributed her inability to make a judgment about an object known previously by touch alone to a lack of coordination of visual and tactile impressions, a process that happened over time but eventually became automatic, perception being the "resultant."[84] As he explained in his 1879 text:

> Now, although it may be inferred from the actions of many of the lower Animals,
> that the perception of the relative distances of near objects or parts of an object . . .
> is in their case intuitive, it may be affirmed, as a conclusion beyond reasonable doubt,
> that this also is *acquired* by the Human infant during the earliest months of its life,
> by a co-ordination of its muscular and visual sensations. . . . The self-education of
> this Perceptive faculty which goes on during the first few months of infantile life,
> is the basis of our subsequent Visual knowledge of the External World, as it seems
> to be for the most part also of the primary belief in its objective reality.[85]

Carpenter compared this sequence to the coordination of two dissimilar perspectives in the operation of a stereoscope, a device that reproduced the effect of binocular vision, wherein two dissimilar retinal images were coordinated to form a single image or three-dimensional view.[86]

The English sociologist Herbert Spencer, whose work was also central to scientific discourse and the subject of much debate in the United States during the period under discussion, characterized the process of vision's acquisition and, in particular, the process by which our ideas of visual extension are developed in similar terms. In his *Principles of Psychology,* first published in 1855 and in expanded form in New York in 1873, he provided a lengthy description and demonstration of the mechanisms involved. He asked his reader to consider "a visual impression as it is received at the periphery of the nervous system" (the eye) and then described the process of perception instigated by this first sensory impact. The retina, he said, "examined microscopically," consists of a "tessellated pavement made up of minute rods and cones packed side by side, so that their ends form a surface on which the optical images are received." Each one of these rods and cones is connected to a separate nerve fiber and, thus, is capable of independent stimulation. A model, devised by Spencer, offered clarification: "Imagine," he wrote, "that an immense number of fingers could be packed side by side so that their ends made a flat surface," extending from point A to point Z, "and that each of them had a separate nervous connection with the same sensorium." Should an object be laid on the flat surface formed by these finger ends, an impression of touch would be given to a certain number of them; if two different objects were laid on these finger ends, one after the other, there would be a difference not only in the number of finger ends stimulated but in the combination as well. How, then, asked Spencer, would the sensorium interpret each separate impression, "while as yet no experiences had been accumulated?" And, if a straight stick were to be laid on these finger ends, "by what process can the length of the stick become known?" Spencer's answer: only after "the accumulation of certain experiences," or successive and intermediate touches, what he called "a series of states of consciousness," will the series of fingers between A and Z—first finger B, then C, and so on—become known to the perceiver. Eventually, said Spencer, the "*simultaneous excitation* of the entire row of fingers will come to stand for its *serial excitation,*" so that when our retina receives an impression (akin to a sensation of touch) we see not the successive parts of an object but the whole. Only after "numberless repetitions" did simultaneous excitation come to stand for the series A to Z. The independent and serial stimulation of many fingers (or the independent pictorial displays and scattered, delayed, and fragmenting effects of Inness's pictures) constituted, after time, excitation all at once. It is "by habit," said Spencer, that these simultaneous excitations, known first as serial ones, are perceived, and the serial ones forgotten.[87] In other words, the memory of a series of touches produced the possibility of a unified excitation of vision (seeing an object as a whole all at once), but this same memory in turn was, and had to be, obliterated by the very unity it engendered so as to ensure that an individual could see extensively and into depth, beyond the surface of things, thereby masking perception's flat and blind, serial and delayed origin.

It was precisely this concealed but constitutive origin that I would propose Inness's landscapes, with their troubled, overlapping, and confused zones of paint, brought to light, and it was precisely this model of vision—first flatness, then depth—that his works set out to explore. Layers of the prior, instances of vision pressed together, remembered as one, palimpsests of the already painted, the scraped off, the recollected, the forgotten, the obscure, the redone, works such as *Kearsarge Village* and *Sunset at Etretat* confronted their viewers with a vision constituted by stops and starts—a series of states of consciousness and "numberless repetitions"—one premised on and made up of the occluding yet generative effects of memory. Taking his cue from contemporary discussions of visual function, and incorporating these discussions into his understanding of the nature and origins of spiritual sight, all the while dispensing with empiricism's attachment to a vision both immediate and direct, Inness offered up a science or, as he put it, a scientific formula, that described the processes of perception and the possibility of subjective and spiritual vision by virtue of the visible's perceptual dislocation. Carpenter and Spencer described how vision, according to them, really worked; Inness appropriated their claims and made pictures that did more than illustrate optical and physiological processes as laid out by scientific tracts. Rather, his landscapes, set in motion and validated by experimental data, created new law, strange and difficult though it was.

Inness's paintings do not just record in pictorial form what I am proposing Inness imagined to be the serial commingling of sensations that eventually, with the aid of habit or recollection, produced keen and spiritual sight. Rather, they put the viewer in the midst of this process. Figures, diminutive and slurred, heads bent and backs turned, repel the direct regard of the eye but act as viewer surrogates all the same, asking us to live (or relive and, thus, remember) Inness's pictorial and perceptual experience, the processes of seeing, touching, collecting, contemplating, remembering, and forgetting that constitute cognition, so that we too, in a sense, grasp the nature of perception and learn how to see. *Autumn Oaks* (plate 3) is exemplary. It is hard to recapture the difficulty and complexity of a picture such as this, given that more than a century of art making has intervened, but we must trust the eyes of those who saw it first, in 1878, and by all accounts what those eyes saw in Inness's pictures of around this time was beautiful but also difficult and troubling, as if indeed confronted with a restaging of the struggle to see.

In *Autumn Oaks,* zones of paint mingle and mesh. Black streaks that denote a log at left detach themselves and press into and under streaks of the more distant meadow's green. Parallel strips of gray and yellow in the distance at left overlap the brownish-red pigment of the middle-ground trees, while two patches of straw-colored paint break free from the plain and sit on top of the blackened shape of the leftmost oak. Flamelike streaks of red, gold, and green swirl away from the tree in the right foreground and mingle with the rich reds of a tree behind it. A cow that turns its back to us, and a figure in the distance,

summarily rendered and subsumed in part by the yellow of the field in which he stands, slurred over and stooped, tell us that we must endure first obscurity and then the haltingly difficult procedures of coordination—the gathering up of scattered forms, perplexing and promiscuous paint, independent pictorial displays—before coming suddenly into sight. The horizon is an amalgam of overlapping color and form: orange trees; brown-black brush; the red roof of a house; distant fields and even more distant structures, white and rust colored; a body of water, perhaps, designated by strips of midnight blue that sink into and overlap the yellows of the field and oranges of the trees; and arbitrary dots of color, a green dab above the nearest roof, three red ones above the strip of blue. It is to this area that the viewer is led, by the back-turned cow's gaze and by the streaked-yellow path that runs through the center of the canvas, between herd and oaks, directing the eye to the obscuring effects beyond. It is here, where things flatten and cease to appear and a fog envelops and deforms shapes and colors, as memory does recollected images, that we begin to see. "It is the horizon that the artist must consult in producing a representation in which all parts are in equilibrium," Inness said, "and there is no greater difficulty than in finding the relation which the sky bears to the objects in his landscape." In *Autumn Oaks*, Inness constructs not one but three or four, or five or six, horizons, stacked one on top of the other at far left: a strip of blue, then orange-red, then blue again, then sky, then a thick, dully painted swath of gray that hovers over the ground yet is not a part of the sky, and then a strip of darker gray, interrupted by a cloud and subsumed by an even blacker swath of paint. In this inability to render just one horizon—that place where equilibrium, and also vision (understood as an equilibration of sight and touch), were supposed to emerge—we are witness to the difficulty of such an exercise, the difficulty of locating vision in just one instance, rather than in a series of independent points between *A* and *Z*.

As in *Autumn Oaks,* touches of pigment in Inness's *Winter Morning, Montclair* (fig. 2)—red-orange, tan, violet, gray, yellow, and white—cling to the surface and compromise the painting's depth. Throughout, effects of overlap and encroachment (layers of appearance awaiting excavation) check the viewer's traversal and delay comprehension of the whole as do the massive foreground log and stump, independent pictorial displays that overpower what should be the picture's subject, the woman, her back turned to us, gathering wood.[88] A patch of snow at right, left over after a midwinter thaw, does the same, transforming that portion of the canvas into a great white blank. The painting's "chalky tone," as described by Clarence Cook, and the dry and dully rendered sky, horizon, and roof flatten space and resist the beholder's gaze even as Inness's delightful and brilliant golds and oranges attract the eye. Splotches of liquid red-orange and scratches of brown paint at the far edge of the meadow at right animate what would otherwise be an opaque and blurred square of intermeshed red, yellow-white, and violet-tan contained by a vigilant albeit spindly tree to its left. The horizon zone, a slab of dark blue-gray visible above the barn

at left and behind the shabby screen of trees at right, presses to the surface and pulls into itself trees, shrubs, houses, and fields. This zone's gray overtakes the thin, blackish branches and trunks of the trees to the immediate right of the barn as does the orange of the leaves of the trees behind them. Cook, we know, responded to this painting by ascribing to it an impossible feat of vision.[89] It should be impossible to see the horizon so clearly, he declared, to sense its palpable and mutating presence, but Inness pulls it forward, makes it as plain as the foreground log, thereby compelling the viewer to acknowledge, even dwell on, its effects, thus attaching to this zone the idea of impossibility and obscurity by way of radical visibility, so that one comprehends its double role.

After seeing *Winter Morning, Montclair* at the academy, a critic for the *Art Journal* described it as "thin and vapory, wanting in agreeable color, and lacking in that poetical charm which usually belongs to [Inness's] brush."[90] A reviewer for the *Boston Advertiser* drew attention to a "bluish haze which pervades it throughout," saying that although it was "hardly more than a ghost of a landscape . . . it exercises a fascination which it is difficult to escape."[91] Perhaps these critics were responding to the painting's unwillingness to make of itself a coherent and graspable whole, to its insistence on an experience of viewing constituted by comprehension's infinite delay. (It should come as no surprise that Inness painted this scene over another, distinct composition, one he had already laid down on canvas, as if he meant to reproduce what he understood as the multiple stages of vision, its fragmentation and seriality, as well as the process of influx—from one layer to the next—described by Swedenborg.) Trees at far left and at far right consist almost entirely of blackish underpaint, as if their maker wanted to infer, by way of their unfinished quality, the painting's status as always on the verge (as if he wanted the viewer to wait for him to finish painting them or, at least, imagine the time this would take; as if he wanted this viewer to subsist in serial excitation for a good long while). Ghostlike indeed, these trees, in their incomplete and fragile delicacy, in their resistance to being seen, exemplify the principles of Inness's evocative yet confounding science, the laws of his idiosyncratic model of spiritual sight.

CONCLUSION: INNESS'S MEMORY WORK

This chapter has covered a fair amount of ground, ranging from a description of Inness's working habits to an analysis of the theories of William Hunt, from Camille Corot to Emanuel Swedenborg, from John Locke to nineteenth-century psychophysiology. What constitutes the adhesive link between these various discussions is, of course, memory: Inness's habit of painting from it, and his reliance on it (and on various theorizations of it, seventeenth century and onward) as a strategy within the context of his landscape practice. We know now that memory was a key aspect of Inness's science of landscape, of that scientific formula of the subjective of nature that he said it was his aim to discern and produce, for use in describing and achieving a vision with which to see the

most intimate secrets and truths of the world. We also know that this was a science most intricate and complex, owing in no small part to its unwillingness to behave or look as a science should, a recalcitrance that may, in turn, be attributed to the constitutive role Inness cast for memory in his "scientific" art. A student of optics, and a painter of dreams who believed that the keenest of sight originated in flatness and fog (the obscurity that memory was meant to manifest)—should it come as a surprise that Inness's landscapes were praised even as they were called difficult, impossible, unthinkable, and strange? That for the majority of Inness's critics in the 1870s, even those who were sympathetic to his work, his art gave rise to, in De Kay's words, "some such shock"? In cobbling together a strategy of memory from a variety of sources, including philosophy and science but also his own metaphysical musings and those discoveries he made while at work with paint, and in incorporating memory's operations and effects into his practice and his pictures, which in turn became demonstrations of the claims he was attempting to make, Inness fashioned one branch of a grand and ambitious—and idiosyncratic—investigation, an inquiry that, over his fifty-year career, would wander in a number of directions but that always came back to a single dogged (if at times unsystematic) course. For what Inness was after was not just his own "spiritual development," as he called it, but the "regeneration" of "general civilization," starting, of course, with the eyes.[92] Memory, as he understood it, got him some way toward this goal, and, as we are about to see, other, equally complicated strategies were meant to do so as well.

THREE ✒ *Painting Unity*

"Cut a hole in a piece of paper"

In the fifth discourse of his "Optics," published in 1637, René Descartes undertook to explain how it is that the objects we look at imprint "very perfect images" on the backs of our eyes. He first compared this process to the operation of a camera obscura: light enters a chamber (the eye) through a single hole (the pupil), passes through a lens, and casts an image on a cloth stretched at the back of the chamber (the retina). Descartes then invited his reader to recreate this process for himself by constructing a similar model or apparatus. I quote at length from this well known passage:

> But you will be even more certain of this if, taking the eye of a newly deceased man, or, for want of that, of an ox or some other large animal, you carefully cut through to the back of the three membranes which enclose it, in such a manner that a large part of the humor . . . remains exposed without any of it spilling out because of this. Then, having covered it over with some white body thin enough to let the daylight pass through it . . . place this eye in the hole of a specially made window . . . in such a manner so that it has its front . . . turned toward some location where there are various objects illuminated by the sun. . . . You will see there, not perhaps without admiration or pleasure, a picture which will represent in natural perspective all the objects which will be outside of it.[1]

Almost 250 years later, Inness offered his own account of image formation and,

[59]

like Descartes, invited his audience to reproduce this process by way of an experiment of sorts. As described by the artist's son:

> Cut a hole in a piece of paper, say two by three inches, then measure diagonally
> across it from corner to corner, the distance being three and a half inches. Multiply
> this by three, and the result is ten and a half inches. Now hold the paper ten and
> a half inches from the eye, and whatever can be seen through the opening can be
> grasped in one vision. Hold it closer to the eye, and it will be necessary to shift
> the eye to see all that is contained within the opening. My father held invariably
> to this mathematical exactness that gives a perfect harmony of vision.[2]

Inness, of course, was not attempting, as was Descartes, to characterize the production of a retinal image, nor did he undertake to describe here, as had Descartes, how vision actually, physically, physiologically worked (although we know that this is part of what he was after in his pictures). Here, Inness's concern is, on the surface, quite different: this cut-a-hole-in-a-piece-of-paper technique was meant to assist landscape painters in constructing a properly unified and harmonious composition. Looked at through a mathematically derived and exact paper portal, the landscape would fall into proper perspectival place. Descartes's experiment described how an image in "natural perspective" is formed on the retinal membrane; Inness's apparatus demonstrated what the eye can and cannot see or, rather, should and should not see under specific circumstances, and what pictures, accordingly, should include and exclude so as to create, as he put it, "a perfect harmony of vision."

It may come as a surprise, given everything that I have said about Inness's practice and pictures thus far, to learn that Inness was, in fact, intensely interested in, even obsessed with, making his landscape compositions geometrically coherent, harmoniously organized, and perfectly unified. He worked hard to articulate the deferral and delay, the blindness he understood necessary to spiritual sight, but he also endeavored to represent the outcome of serial and successive coordination, the plentitude and coherence of unified vision—Spencer's "simultaneous excitation," a fully manifest whole instead of serial parts—which for the artist described a mode of sight that pushed beyond surface flatness and into the depths of the divine. Inness's landscapes tracked and mapped Corot's memory work, Swedenborg's recollective archaeology, and Carpenter and Spencer's serial diffusion and delay, but they also strove for the unity of vision, the result of recollection's delay and dislocation, that Swedenborg called instantaneous perception and that both scientists described as coordination's end. Unity, for Inness, was also a strategy of vision, a way to explore and articulate the exquisite and perfect harmony of spiritual sight, a mode of perception so coherent and unified that it was akin to breathing: the suffuse and automatic, uninterrupted and total saturation of inhalation and exhalation, the surge in and out of body, the back and forth merger of breath between lungs and surrounding atmosphere.

Inness had a lot to say about unity; his interviews and letters are peppered with references to the concept and its importance to his practice. "The first great principle in art," he wrote in 1884, "is unity representing directness of intent, the second is order representing cause, and the third is realization representing effect."[3] The production of inspired and spontaneous art "is governed by the law of homogeneity or unity," and an artist's genius is directly proportional to "the unity of his picture."[4] According to Inness, unity played a role in learning to see well: "We tend eventually to ideas of harmonies in which parts are related by the mind to an idea of unity of thought. From that unity of thought the mind controls the eye to its own intent within the units of that idea; consequently *we learn to see* in accord with ideas developed by the power of life."[5] Unity had a spiritual aspect, as well: "The great spiritual principle of unity . . . is the fundamental principle of all Art."[6] Unity, as a principle, combined Corot and Messionier, a formula Inness thought necessary to good art and good sight and to his subjective science as well: "Whatever is painted truly according to any idea of unity will as it is perfectly done possess both the subjective sentiment—the poetry of nature—and the objective fact sufficiently to . . . elevate [the mind] to an idea higher—that is more certain than its own."[7] The work of painting, Inness said, had as its goal the expression of the principle of unity, which governed both art and life, and vision as well: "What's it all about," he asked. "What does it mean—this striving—this everlasting painting, painting, painting away one's life? What is art? That's the question I've been asking myself, and I've answered it this way: Art is the endeavor on the part of the mind (mind being the creative faculty) to express, through the senses, ideas of the great principles of unity."[8] We know that for Inness, the acts of painting and beholding involved the discernment and creation of formulas and laws, including, it appears, the identification and articulation of the principles that governed unity. "Every artist," Inness said, "must depend on his feeling, and what I have devoted myself to is to try and find out the *law of the unit*."[9]

Inness criticized two of Turner's paintings because they did not appear to him to represent an experience of vision in which looking was quick, keen, and confined to a moment in time or, at least, within the perimeter of an outlining circle. "Parts of Turner's pictures are splendid specimens of realization," he said, "but their effect is destroyed by other parts which are full of falsity and claptrap. Very rarely, if ever, does Turner give the impression of the real that nature gives." "For example," he continued, "in that well-known work in the London National Gallery which presents a group of fishing boats between the spectator and the sun . . . we find that half of the picture, if cut out by itself, would be most admirable. Into the other half, however, he has introduced a dock, some fishermen, some fishes: an accumulation of small things impossible under the circumstances to unity of vision." "His 'Wreck,'" Inness lamented, also contains "little figures in boats, and other details which are incompatible with the distance, and which prevent that impression which comes to the spectator from a vision of nature."[10]

In suggesting that Turner's paintings evoked and called for impossible acts of viewing and vision, Inness registered a complaint similar to those so often leveled against his own work. He also indicated that it was the compositional clutter of Turner's pictures that precluded the creation of a model of properly unified perception, or "unity of vision." Similarly, Inness found fault with Meissonier's historical compositions because they presented a view of things for which normal vision could not account: "Here the tendency seems to me to be toward the gratification of lower desires, and you see long-winded processions and reviews . . . horses painted with nails in their shoes, and men upon them with buttons in their coats—nails and buttons at distances from the spectator where they could not be seen by any eye, however sharp or disciplined."[11] However, he praised the artist's smaller works, and his *Chess Players* (1853; fig. 5) in particular, for their attention to the laws of unity and vision, as if to suggest that the "science" represented by the best examples of Meissonier's art provided the principles necessary to unification and, thus, subjective and penetrating sight (or at least its evocation): "Meissonier's *forte* lies in his power of representing one, two, or three figures under circumstances where they can be controlled by a single vision."[12] According to Inness, unity bore the burden of not just properly functioning vision but of society's health as well; discerning the law of the unit, then, was no inconsequential task. Without the elements of mind, thought, and feeling, "more or less in unity," Inness wrote in 1884, "we as human beings have no existence, and the use of art, which in its whole meaning is the first great factor in social being is as man arises from degree to degree to hold them in equilibrium."[13]

Clearly, a lot was at stake in unity (this despite Inness's apparent cultivation of the utterly disunified), and Inness developed a number of strategies, "cut-a-hole" included, for use in ensuring that his landscapes offered up a "perfect harmony of vision." Described by Inness himself, or by his friends and contemporaries, these strategies invoke the vocabulary of optics and geometry in the Cartesian tradition, concerned as they are with things like the horizon, height, length, proportion, and distance. Here, first, is Daingerfield, characterizing Inness at work on one of his landscape compositions:

> One of those problems which obsessed his mind in his search for principles—scientific laws by which he might construct and complete his work, attacked him—the picture fell a victim to the problem. The trees were too near the front of the canvas—they were cut off—at once the cliff was out of proportion; a drove of red and white cows drinking was added . . . then the cliff was changed into a mass of trees. Nothing was right, and change after change followed. . . . This was the law he laid forward afterward, and followed relentlessly:—From the horizon (not the sky line) to the nearest point—the bottom of the canvas—there shall be three great planes; the first two shall be foreground, the third, or last shall contain all the distance. The subject matter must not be within the first plane, but behind it,

and whatever reaches above the horizon line, by its size and proportion becomes subject matter—herefore trees that find their plane within the first great section are too near, and perforce must be cut off at the base to force them away. So too, a figure, wherever placed, must not reach above the horizon, else it becomes subject matter and therefore a figure picture.[14]

It is, of course, impossible to know how accurate Daingerfield's description of Inness's method was. Still, one gathers from the critic's remarks that the artist's quest for the principles and laws of unification was a sedulous one and that it entailed an interest in the representational or pictorial capacities of geometry. Inness himself reported that "the science of geometry" was the only means to "abstract truth."[15] This interest manifested itself in a fastidious attention to relation, proportion, and division and was expressed as a desire for equilibrium that involved putting everything, including the horizon, in its proper place. Here, now, is the *New York Evening Post:* Inness's "vision was broad, and all his life he was striving for the ensemble of earth, air, and sky. He knew they were a unit and could figure it out cleverly with geometrical figures, and it was his great aim to demonstrate it in his art."[16] And, here, Charles De Kay: Inness prided himself "on the logic displayed in the management of his landscapes," wherein "particulars are reasoned out with a rigidity of logic that sounds dry." One can learn from Inness, the critic said, "how the symbolization of the Divine Trinity is reflected in the mathematical relations of perspective and aerial distance."[17]

Inness's pictures in the 1870s and 1880s (and beyond) do bear the mark of scrupulous organization. His compositions are measured and the arrangement of his forms precise, the products of continual and careful coordination and consultation. Space in Inness's *Sunshine and Clouds* (1883; fig. 7), for instance, is divided horizontally into two nearly equal halves by an illuminated horizon strip of houses, trees, and steam engine (at far right) that is balanced and held in place by a decisive and dull swath of steel gray that sits on top of it, and by apple-green streaks of paint beneath. A dark brown foreground sets off a bright yellow-gray sky, while the diagonal thrust of foreground path and figure is checked by the diagonal formed by the gray storm cloud at left and the randomly streaked and swirled gray paint in the sky to its right. The exuberant orange-brown pigment at lower left, which sits on the surface of the canvas even as it is meant to denote the grass of the field, echoes the multidirectional and animated brushstrokes Inness has used to represent the clouds above. Balance and harmony, point and counterpoint, complement and contrast: these, along with Inness's cut-a-hole-in-a-piece-of-paper technique, are some of the scientific strategies employed in his search after unified sight. The tripled horizon (gray strip, house/tree/train strip, green strip) in *Sunshine and Clouds* typifies, or at least articulates, as did the horizon(s) in *Autumn Oaks,* the serial procedures of this quest. In that they manifest Spencer's seriality and, thus, act as scientific

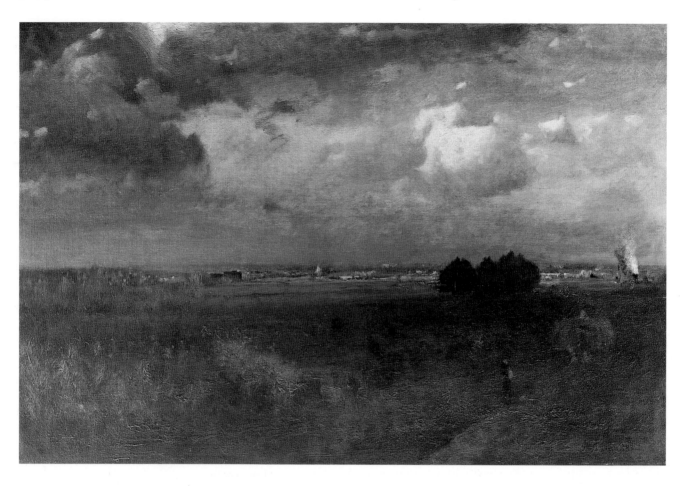

Figure 7. George Inness, *Sunshine and Clouds* (1883). Oil on canvas. 27½ × 41½ in. Kennedy Galleries, Inc., New York, New York.

diagrams or demonstrations of a sort at the same time that they stand for a moment prior to clarity of sight, these horizons are perfect emblems for what seems to be a paradoxical and irreconcilable investment on Inness's part in the order of geometry (the law of the unit) and the blur of disorderly, not-yet-fully constituted sight, and we see these two things battling it out in canvases that mean to, and have to be, both.

The compositions of *Autumn Oaks, Kearsarge Village, Old Homestead,* and *Sunset* (1878; fig. 8) are practically identical, as if constants in a continually mutating equation or unchanging evidence in an ongoing investigation. Space in each is divided into three distinct zones: a triangular foreground area bathed in shadow that appears level with or slightly above the viewer; a sunken middle ground made up of alternating strips of color and occupied by clusters of trees; and a flattened and vertically oriented area of horizon and sky, obstructed in places by houses, trees, or hills. *Winter Morning, Montclair, Saco Ford, Conway Meadows* (plate 4), *The Coming Storm* (1878; fig. 9), *The Coming Storm* (ca. 1879; plate 5), and *Medfield* (1877; fig. 10) boast a similar compositional structure. In all of these paintings, a horizon zone divides the canvas in half horizontally, while a stand of trees toward the center divides the canvas vertically, into

halves or thirds (in the latter case, as in the 1878 *The Coming Storm,* a second stand of trees echoes its counterpart slightly to the left or right). Inness composed the space of these paintings with care. Alternating strips of color and areas of light and dark divide and subdivide meadows and plains, and barrier elements—fences, hills, screens of trees—work to enclose and contain, bringing measure and coherence to each scene. In nearly all, a decisive diagonal element stands as a precise but diverting contrast to the otherwise strict horizontality and verticality of the composition; in *Kearsarge Village, Saco Ford, The Coming Storm* (1878), and *Autumn Oaks,* especially, the diagonal thrust of foreground hills or paths that recede into depth counteracts and balances, and holds firmly in place, the other elements of the scene. Humans, cattle, and vegetation seem as chess pieces, deliberately placed here and there, in meadow and plain, by stream and near house, so as to create orderly but pleasing rhythmic designs; characterized as piecemeal and fragmented, disruptive and disorienting by Inness's critics, these were meant as geometric order—and simultaneous, unified excitation or, in Inness's parlance, a perfect harmony of vision—nonetheless.

Figure 8. George Inness, *Sunset* (1878). Oil on canvas. 16 1/8 × 24 1/8 in. Portland Art Museum, Portland, Oregon; gift of Mrs. Frederic B. Pratt 15.1.

Figure 9. George Inness, *The Coming Storm* (1878). Oil on canvas. 26 × 39 in. Albright-Knox Art Gallery, Buffalo, New York. Albert H. Tracy Fund, 1900.

Figure 10. George Inness, *Medfield* (1877). Oil on canvas. 20 × 30 in. Private collection, Winter Park, Florida.

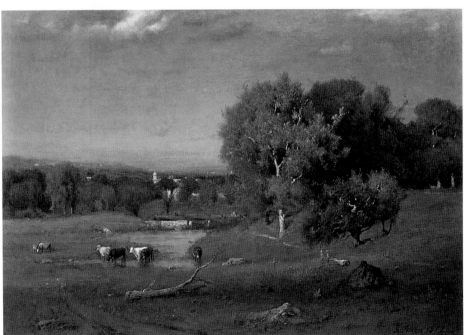

"A TABLET BEARING STRANGE WORDS"

In 1878, Inness contributed at least three paintings to the exhibition of the National Academy of Design: *The Afterglow, The Morning Sun,* and *The Rainbow.*[18] To two of these paintings, *The Afterglow* and *The Morning Sun,* and to a sculpture by his future son-in-law Jonathan Scott Hartley, he attached poetic fragments of

his own creation, engraved on the frame or pedestal of each.[19] As Susan N. Carter noted, "on the frame beneath each picture is engraved a sentence that suggests Jean Paul Richter in style and in poetical feeling."[20]

Carter did not attempt to explain Inness's poetical addenda, nor did any of the critics who drew attention to them in their reviews. I suspect that these captions were yet another strategy of unity and, thus, related to Inness's quest for spiritual sight. For the most part, Inness stayed away from literary or overtly narrative content in his landscapes. Although he experimented with literary and allegorical themes in the 1860s, as I shall discuss at greater length in chapter 5, by the late 1870s, and after his second trip to Europe, Inness had come to shun explicit literary and symbolic content and faulted a number of paintings by Delacroix, an artist he greatly admired, for failing to do the same: "Many of Delacroix's pictures are bad—broken, confused, and presenting the appearance of efforts to describe what he never saw, and could not have seen, but what he only heard. Hence arises the confusion, though the realization in parts is wonderful."[21] Narrativity, Inness implied, precluded unity. Delacroix's works, and Turner's as well, because they were premised on the desire to tell a story, appeared fragmented and disunified, even if pleasant in their parts. "Turner's 'Slave-Ship'" (1840; fig. 11), stated Inness, "is the most infernal piece of claptrap ever painted. There is nothing in it. It is as much to do with human affections and thought as a ghost." The color, he continued, "is harsh, disagreeable, and discordant." As Inness saw it, this was because in Turner "the dramatic predominated—the desire to tell a story." "A mere make-up of fancies" replaced the

Figure 11. Joseph Mallord William Turner, *Slave Ship (Slavers Throwing Overboard the Dead and Dying, Typhoon Coming On)* (1840). Oil on canvas. 90.8 × 122.6 cm (35¾ × 48¼ in.). Museum of Fine Arts, Boston. Henry Lillie Pierce Fund (99.22). © 2003 Museum of Fine Arts, Boston.

truth of "air and light." As a result, a painting by Claude Lorrain, "which hangs next to one of the Turners in the National Gallery," said Inness, "knocks the Turner all to pieces." In the Turner, literary and narrative detail got in the way of both truth and coherence, and prevented simultaneous vision, what Inness called an "impression" of nature.[22]

On at least two occasions, Inness wrote a poem in response to a patron's request that he explain the meaning of his work; perhaps his captions were meant to function in a similar manner.[23] It could be that Inness attached poetry to his pictures because he wished to bequeath meaning, to tell a story, without disrupting them materially, without injecting into them overtly symbolic or narrative content, thus preserving their unity and preventing them from breaking apart and becoming confused. "That fit of symbolic landscape," wrote the *Atlantic Monthly* in reference to the allegorical works of the 1860s, a few years prior to Inness's adoption of his captioning technique, "no doubt taught him that he would do best to follow Nature, without crowding upon her own peculiar and profound significance any additional meaning."[24]

Inness's poetic gesture in 1878 was the first and last of its kind. Carter called the works on view in 1878 peculiar, "poetical and strange" to be exact, even as she praised their color, skill, and fidelity to the forms of nature (she attributed their technical completeness to the latter, and not to the added textual explanations).[25] Other critics were not so kind. Clarence Cook lambasted Inness's attempt to body together painting and poetry:

> The visitor will easily think it [Hartley's *Whirlwind*] worse than it is, if, while looking at it, he reads Mr. George Inness's "poetry" appended to the title in the catalogue. This is a most comical production—a kind of cross between Mr. Tupper's thought and Mr. Whitman's versification, and there is more of the same sort inscribed on the frames of Mr. Inness's own pictures in this exhibition, so that Mr. Hartley cannot complain that he is an exclusive victim. But as Mr. Hartley is victimized in such a way that he who runs may read, while the "poetry" on Mr. Inness's frame is so faintly printed that we need not read it unless we will, Mr. Hartley is, after all, a little the worse off.[26]

Inness responded to Cook's attack with one of his own, and Cook struck back, calling the artist's poems "sorry stuff," devoid of "rhythm, rhyme [and] reason." "As for Mr. George Inness," Cook declared, "till he can rail the seal of lunacy from off the verses he insists on thrusting before the public, he offends his lungs to talk so loud."[27] The *Nation*'s critic described Inness's pictures as equally confounding, inferior to his previous work, saying that the artist's appended texts "remind one of Turner's 'Fallacies of Hope'" and that the landscapes exhibit "strain without attainment," failing to impress the viewer with "truly poetic elevation of style."[28] The critic for the *New York Times* (whose words we have previously encountered) also found Inness's entries puzzling and his poetry odd:

We are not sure that Mr. Inness is quite right in his mind, so startling are the developments of his studio for the year. . . . Under his green and yellow landscapes he now affixes a tablet bearing strange words, more or less rhythmical, more or less reasonable. These are the lucubrations of Mr. Inness's own brain; he disdains the trumpery poets of acknowledged literature and supplies his own legends from his own muse. As to his landscapes, they are not being better painted, but rather the contrary. . . . They have a new touch of what looks like bumptiousness. They are violent instead of dignified, loud instead of deep in color. They would be improved in tone by hanging in a smoky chimney.[29]

As did his colleague at the *Nation,* this commentator described Inness's pictures as worse than his earlier, and successful, attempts. As did Cook, he characterized them as loud, calling them violent and in need of a muting and unifying layer of smoke.

Inness's poetic appendages, rather than contributing to that unity of vision in which he had placed great store, appear to have played a part in what was perceived to be their fragmentation and strain. His verse, which called for prolonged looking—first seeing, then reading, or vice versa—wound up disrupting the desired coherence of these paintings, producing, as his critics put it, a peculiar and clamorous effect. It is as if these critics, preoccupied with Inness's captions, were too distracted to really look at his paintings, let alone bestow on them praise. The critic for the *Nation* focused on a mere "passage" of one of Inness's canvases; as with the commentator who characterized *Autumn* and *Old Homestead* as constituted by numerous independent pictorial displays, unrelated effects, promiscuously scattered houses and trees, and above all, a lack of unity throughout, he seems to have been unable to see these paintings as unified and coherent wholes. Supplemental and mediating, Inness's captions provoked the opposite response in their readers/viewers than that intended, for they thwarted what could well have been a unified and instantaneous effect, one designed to evoke unified and instantaneous, or perfected and penetrating, scientific and subjective sight.

"A LAW OF TRUE REALISM"

In the early 1880s, Inness experimented again. As his son reported, in 1881 he "became very enthusiastic about figure-painting, and decided to go into that almost to the exclusion of the broader subject."[30] In July of that year, Inness, who was spending the summer in Milton, New York, wrote a letter to his wife Elizabeth and described a figure painting of a man and a boy on which he was at work: "You have no idea how stunningly I am painting it. Every part speaks of reality. I begin to feel now that I have got at what will always be in demand at good prices, and I feel my interest in this thing sort of gradually taking the place of landscape."[31] In his letter, Inness implied that his decision to turn to figure painting was in part provoked by financial concerns. This may have been

the case, for by 1880 figure painting was becoming increasingly prominent at exhibitions, and more and more dealers and collectors began to patronize it over and above landscape art.[32] Inness noted this shift in taste and demand in a second letter to his wife. "I begin to feel the increasing interest in them," he wrote, "and I find that the landscape which I introduce has a charm greater than when painted alone. . . . In fact, I begin to see how the interest of figure and landscape are to be combined better and better every day, and how the charm of the latter can be vastly increased thereby."[33] Inness may well have been responding to a heightened interest in figure painting, but the fact that he thought landscape's charm might be increased by the addition of figures suggests that his experiment was motivated by more than market pressure and that his abandonment of the project a few years later was not provoked by lack of demand.

In the majority of Inness's landscapes, early and late, figures are represented on a small scale, often rendered with a few strokes of the brush, and do not dominate the scene.[34] This is not the case with works from around 1881, in which the figure is the ostensible subject. In *Homeward* (1881; fig. 12), an unfinished work, a farmer leads two cows while another figure at left looks on; in the unusual *Two Sisters in the Garden* (ca. 1882; fig. 13), the figures of two young women dominate the canvas, while the landscape surrounding them is barely indicated. It was to paintings such as these that Inness referred in his letter to his wife.

Figure 12. George Inness, *Homeward* (1881). Oil on canvas. 51.4 × 76.8 cm (20¼ × 30¼ in.). The Brooklyn Museum of Art; gift of the Executors of the Estate of Colonel Michael Friedsam (32.827).

Figure 13. George Inness, *Two Sisters in the Garden* (1882). Oil on millboard. 20 × 16 in. The Art Institute of Chicago, Edward B. Butler Collection (1926.132). Reproduction, The Art Institute of Chicago.

Whatever its motivation, Inness's engagement with straightforward figure painting was short-lived. Figural works, it seems, did not allow him to do what he wanted to do with painting, what he thought he could accomplish with landscapes in which figures, if present, played second, or third or fourth, fiddle to their surround. I discuss the role of the figure in Inness's landscapes in greater detail in subsequent chapters but, here, want to propose one possible explanation for his abandonment of figural art, which he initially called "more satisfactory" than landscape and worthy of taking its place.

According to Inness, for whom unity was paramount, in order for a picture to be a unified impression of nature, and in order for it to be perceived as such, it had to cultivate distance. "Angularity, rotundity involving solidity, air and light involving transparency; space and colour involving distances," he wrote, "these constitute the appearances which the creative mind produces to the individualized eye and which the organized mind endorses as reality. A representation which ignores any one of these elements is weak in its subjective and lacking in its objective force and so far fails as giving a true impression of nature."[35] Distance occupied an important place in Inness's scientific formula of the subjective of nature, which combined the subjective and objective, Corot and Meissonier. Thus, in addition to being a strategy of unification, it was also, and necessarily, a strategy of spiritual sight. Recall what Inness said to Ripley Hitchcock in 1884: "Several years before I went to Europe . . . I had begun to see that elaborateness in detail, did not gain me meaning. A part carefully finished, my forces were exhausted. I could not sustain it everywhere and produce *the sense of spaces and distances and with them that subjective mystery of nature with which wherever I went I was filled.*"[36]

When it came to the rendition of figures, Inness developed elaborate techniques of distancing so as to ensure the integrity of the impression and to secure unity of vision:

> Here is a pencil sketch of my own—a young girl about to slip into a brook from the overhanging trunk of a tree. . . . I paint the girl at a distance of thirty or forty feet, which gives at once a subdued effect. The reason for doing so is that the mind does not receive the full impression of any object looked at, unless the object is at a distance three times its own length or height. For example, a man six feet high should be painted as if he were eighteen feet off from the spectator. If he is in the midst of accessories, a proportionate distance should be allowed in addition; else you get a linear impression only, and produce a work more or less literary or descriptive. You can't receive the full impression of a large object that is just under your nose. It must be distant from you at least three times its own length. This is a law of true realism.[37]

This formulation, similar in motivation to Inness's cut-a-hole-in-a-piece-of-paper technique, and akin to what Daingerfield described as his strategic testing and retesting of the relation among and coordination of parts, was, as the

artist suggested, a necessary component of realism, or at least his version of it, wherein a calculus of sorts determined the configuration of perception as well as space. "My theory," Inness said, "is that there should be no figure below the line of consciousness."[38] It is not entirely clear what Inness meant by this "line of consciousness," but the term was without doubt related to his study of geometry, for when he referred to the "science of geometry," for him the only abstract truth, he also called it "the diversion of the arc of consciousness and so on."[39] "A figure," Daingerfield wrote, "wherever placed, must not reach above the horizon, else it becomes subject matter and therefore a figure picture."[40] Without such distancing, works of art ran the risk of becoming "more or less literary or descriptive," as did the broken paintings of Delacroix and Turner, along with those pictures to which Inness attached verbal supplements, that, in their attempt to tell a story, wound up, in the words of his critics, "violent," "comical," and "strange."

In 1884, around the time Inness abandoned his designs on figure painting, a critic by the name of Richard W. West discussed the differences between landscape and figural art in the pages of the *Art Journal,* asserting that the former was in no way inferior to the latter. West's commentary is fascinating, and pertinent to the present discussion, for it characterizes the role of the figure in landscape in terms of visual capacity and takes distance as a criterion of good landscape art and of good seeing as well. West began his essay, entitled "The Apprehension of Pictures," with the claim that pictures were better seen without the intervention of words; he said that the best kind of beholding consisted of a coincident feeling, or "close mental correspondence," "between minds that have been bred alike, which have had like experiences, reflections, reveries; and which, mutually unknown otherwise, discern through some common language their friendly approach to one another."[41]

The idea that optimal looking occurred by way of shared memory is an interesting one (especially when considered in relation to Inness's model of intersubjective seeing, discussed in chap. 2), as is the author's discussion of what he called landscape's perceived lack of an "interest which is peculiarly and distinctively human." This lack, West wrote, although it had contributed to an understanding of the genre as inferior to figural art, was a necessary one. Figures in landscapes, he warned, unless depicted appropriately, that is, unless distanced, served to distract: to "put a human figure or two" in a landscape "would be to reduce the whole range of the picture by calling the mind away from a potentiality for any thought, to limit it to the *particular* thought created by an obtrusive figure. By the addition of the figure the picture . . . has lost something of its power, if it no longer seems to accompany the wanderings of the mind like music, but fixes it instead to a single contemplation which grows stale directly."[42] Figures, as did text, fragmented, and they drew attention to the parts of a picture; they compelled the beholder to focus on independent pictorial displays and scattered, unrelated effects, and they precluded the sort of automatistic or unconscious viewing Van Rensselaer might have prescribed. Demand

for "human interest" in paintings, West wrote, discouraged painters from paint-
ing "representations of things which people walk by without noticing," as most
men were interested only in "curious or outlandish or episodical sights in pic-
tures as in the realities around them, and do not care to see things represented
except that they would stop to look at and have to tell about afterwards."[43]

Figural paintings, the author implied, generated description; they were by
nature narrativistic and compelled verbal supplementation (viewers "have to
tell about afterwards"). Artists who diminished and distorted their figures, as
did Inness in the second half of the 1870s and after 1883 or 1884, did so for a
reason: "The scribbled and blotted look which is often noticeable in the figures
introduced into landscape [is] a more or less intentional device of the painter to
repel the direct regard of the eye."[44] Artists did so, Inness did so, in order to de-
flect the verbal, in order to preclude a piecemeal and fragmenting gaze, so as to
prevent narrative augmentation during and after the fact of looking that would
disrupt the unity of their scenes as well as the unity of the experience of view-
ing them. Figures in landscapes, which limited the mind to a single and partic-
ular thought, prevented the effects of distancing proper and necessary to suc-
cessful beholding and resulted in what West called "faulty sight," a "kind of
depravity of the eye."[45] Figures compelled a narrow focus and did not allow
broad and unified comprehension and, by extension, unity of vision. He "who
captures a picture fully," on the other hand, stated West,

> feels as if he were looking not at a canvas three or four feet or yards off, but through
> a window or four-sided boundary of some sort, right off into a space with objects
> in it farther or nearer. He finds that when he removes his eye from the foreground
> or nearer objects in the picture, he re-arranges the focal length of his sight uncon-
> sciously in obedience to the delusion of his imagination that the counterfeits are
> real. . . . He is guided by instinct to stand at the right distance from the picture. . . .
> His consciousness takes in the whole simultaneously, and for awhile he examines
> nothing; forgets that he sees a picture, and feels the quickening within of the
> thoughts which such a scene might stir up.[46]

He who captured a picture fully looked at it as if through a window, or a hole
cut in a piece of paper, and forgot he was in the presence of representation. Vi-
sion was (unconsciously) reordered so as to make it more unified and pleasura-
bly keen. Pictures that presented this kind of unity of vision, that could be
taken in as wholes all at once, and that stimulated unconscious excitation did
not have figures in them or, if they did, made sure to distance and distort these
figures so that they repelled the direct, conscious, isolating, and disunifying
regard of the eye.

Inness's landscapes of the 1870s were often praised for their effects of
breadth and distance; adulatory remarks regarding his grasp of atmosphere, ex-
panse, and aerial space seem almost compulsory in writing about his art.[47] His
paintings of the early 1880s also met with praise, as long as figural elements

were subordinated to the landscape surround, so as not to interfere with distancing or broadening effects. The *Art Journal* compared two of his pictures at the 1881 academy exhibition and lauded his treatment of the figure precisely because it was summary: "The two were very different, the latter being a light landscape with blue distance and sky and considerable variety of detail in the foreground, and that in the main room being a forest interior, without outlook, and grave and almost solemn in tone. This, to our mind, was the finer picture, both in sentiment and in technical expression. It was very broadly treated, the two figures in the foreground modeled but very slightly, and detail nowhere carried so far as to contradict in any degree the massive largeness of effect."[48] As early as 1879, Inness had been admonished to abandon emphasis on the figure. In his "wide stretch of country from North Conway in Spring," on view at the academy exhibition that year, wrote the *Atlantic Monthly*, "a commonplace figure of the artist in a sketching attitude shows much too conspicuously in the otherwise rather vacant foreground."[49] Critics chastised Inness when his figures became too prominent or noticeable or if they seemed to detract from the overall effect of a work: "We would . . . have the badly-drawn figure omitted," wrote the *Independent* in 1878, "but we feel its value as color and as expression."[50]

Inness abandoned his experiment with figure painting by around 1883. Perhaps he did so because it had become clear to him that, even in conjunction with elaborate techniques of distancing, the figure, disunifying and literary, particular and mediating, could not be the subject of his art if he wanted the latter to achieve a perfect harmony of vision. Figures, Inness seems to have realized, contributed to the production of disunified and faulty, not clear and total, sight. Indeed, neither figure nor appended text seemed able to convey or sustain, by ensuring harmony, "the great spiritual principle of unity," what Inness called the fundamental principle of all art and, by extension, the formula for a vision of unmediated and all-encompassing grasp.

"THE HALF-WAY POINT BETWEEN LIGHT AND DARK"

When Inness suggested that good landscape painting and good vision originated at the horizon, that place where "all is light and flat as a fog of vapor that obscures everything" and "all things cease to appear," he described this zone as a "half-way point between light and dark." He also called it a point of equilibrium, saying it was the place to which an artist must refer in organizing and harmonizing all of his parts. Inness often used the word "equilibrium" to designate balance, harmony, coherence, or unity, and he had a very specific idea what equilibrium comprised.[51] Equilibrium, he said, was determined by a "middle tone," the "half-dark or half-light of the picture," located at the horizon, that, as a reference point for the entire composition, enabled organization and harmonization. It was the painter's task to determine and then deploy this tone in his art. Judging by his pictures, the middle-tone horizon zone seems to have

been the strategy of unification Inness most often pursued; it was also the most complicated means by which he sorted out his science.

According to Inness's son, the middle tone was William Page's idea. The tale of the two artists' deliberations about what became a much-debated hue is worth quoting at length:

> [Page] claimed that the horizon should be a middle tone: that is, it should be half-way between the lightest light and the greatest dark in the picture. Father agreed with him on that point, but what they could not agree on was just what a middle tone really was. So Page, to explain more fully, took a strip of tin and painted it white at one end and black at the other, and then graded in stripes from both ends until it reached a gray tone in the middle. This he showed my father and said triumphantly, "There's the true middle tone!" The next day father went to Page's studio with a similar strip of tin and declared that he had the true middle tone. When they compared the two hues, there was no resemblance between them. Then the fight was on, and these two gentlemen, after yelling themselves hoarse and saying some very uncomplimentary things to each other, would break away, and not speak to each other for days. . . . These hostilities were kept up, off and on for two years, when Page built himself a house on Staten Island and painted it white, then glazed it down to a middle tone. In a few months the sun had faded out the middle tone; at which my father declared that there was no such thing as a middle tone, anyhow, and that Page was a fool.[52]

Inness did not, however, abandon the idea. "His love of the 'middle tone,' and search for the law controlling it," wrote Daingerfield, were all-consuming and entailed an elaborate and, to our eyes, mystifying inquiry into its nature and effects:

> He arrived at this middle tone law in this way: If a set of eight upright lines be drawn to represent an octave, sound will proceed from top to bottom in spiral or vortexical movement connecting them, the initial or potential energy generating the sound will be greatest through the center of the spiral—hence the middle tone will ever be finest, strongest, purest. He pursued this thought, proving (to his own satisfaction at least) that in this movement one-tenth of the initial sound in each octave was lost—returned to the infinite—"the tithe of the ancients," he said.[53]

According to Daingerfield, Inness believed that the middle tone could be generated by a representation of the vortexical movement of sound, the potential energy at its center representing the finest, strongest, and purest note. The critic had stipulated elsewhere that Inness "always held that visualization was vortexical."[54] Considered together, these statements suggest that the artist understood the middle tone, a strategy of unification, and vision, in its purest (vortexical) form, as inextricably linked, an idea that makes sense given the evidence I have

presented thus far. The critic's comments also give some indication as to how we might understand the seeming contradiction inherent in the idea that a horizon zone of vaporous and flat gray fog could serve as vision's source.[55]

In 1873, a writer in *Appletons'* made the following observation concerning Inness's most recent work: "Since he went to Rome . . . he has at times varied [his] brown under-tint with a neutral gray, an entirely negative basis, from which he can equally work in colder or warmer, darker or lighter hues."[56] By 1875, this gray tint had taken on an entirely new aspect in Inness's works, though I would argue it retained its "negative basis." Indeed, in a number of paintings from 1875 and onward, including, as we know, *Autumn Oaks* and *Winter Morning, Montclair,* and also *The Coming Storm* (plate 5), *Medfield* (fig. 10), *Sunshine and Clouds* (fig. 7), *The Rainbow* (ca. 1878–79; fig. 14), and *Passing Clouds* (1876; fig. 15), the horizon, or a part of it, has been transformed into a middle tone, a flat and muddled grayish strip of paint that effaces the edges of plain, hillside, sea, lake, and sky where they converge.[57] This type of horizon zone is in fact one of the most conspicuously frequent features of Inness's landscapes of the 1870s, 1880s, and beyond; it appears and reappears with such regularity that one begins to sense an obsession or, at least, a dogged interest in a particular formula or technique. In *Sunshine and Clouds,* the obdurate wall of gray paint that occupies the space between field and cloudy sky does indeed appear to be a place "where all things cease to appear," for it represents nothing and impedes the eye's passage through the scene, echoing as it does the faceless and flat gaze of the figure who stands motionless on the path at lower right. As we have seen, in *Autumn Oaks,* the middle-tone strip has migrated skyward, multiplying and dividing all the while, and hovers between two passages of swirling blue-gray cloud at left, flattening what should be an illusion of depth. Halfway between light and dark, the sought-after middle tone is more like a void or a limbo, a vortex perhaps, than it is a designated or locatable hue or space. In *Passing Clouds,* a breathtaking view of sunlight streaming onto meadow and tree as clouds retreat (this effect made all the more dramatic by what resembles a volcanic spewing forth of cloud and sun above the hills and by the mesmerized watcher at lower left, who has turned her head to see the spectacular show), something similar occurs. A mass of gray saturates the hillside at right and snakes behind the sunbeams at center to reemerge along the leftmost ridge and in the sky, transforming what it touches into streaked shadows rather than distinct, palpable forms. Clarity, represented by the piercing, light-bringing sun, and obscurity, as manifest in this creeping, advancing yet retreating hue, make this scene, at one and the same time, radiant and difficult to read. Here, as in all of these works, the horizon zone attracts the eye even as it blurs forms and compromises space, piquing our interest before withdrawing into a haze.

What the middle tone does not seem to do is unify, not in these pictures, anyway, and not in numerous other landscapes in which this supposedly equilibrating half-dark, half-light zone, or a variation of it, appears. Perhaps Page *was*

Figure 14. George Inness, *The Rainbow* (ca. 1878–79). Oil on canvas. 30 × 45 in. Indianapolis Museum of Art; gift of George E. Hume.

Figure 15. George Inness, *Passing Clouds* (1876). Oil on canvas. 20 × 30 in. Collection of Mary Ann Apicella and Jack Hollihan.

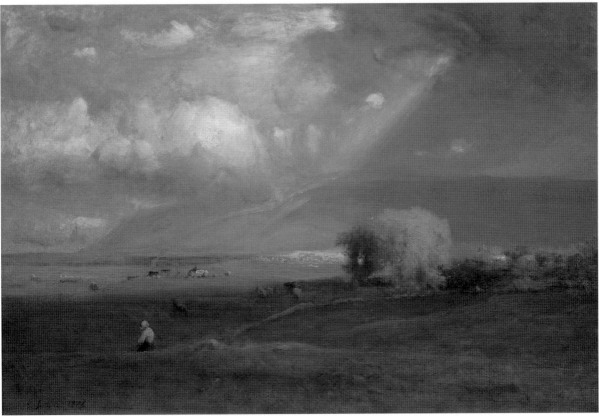

a fool, and perhaps Inness was, too, for sticking with a strategy that appears to have failed. In *Sunset* (fig. 8), as in *Kearsarge Village,* perception of distance is made difficult by foreground pigment, yellow and apple green at center and right, that sinks into and is overtaken by its darker complements to the rear. A stand of three trees, silhouetted against a lowering sky of gold, red, and blue-gray, occupies the near center of the canvas; pieces of this stand, a mix of gray, brown, and black strokes that mingle but never congeal, seem to break off as paint is flung from the rightmost tree and toward the picture's surface. Brownish-red underpaint encroaches on the lighter blue-gray that sits over it in the immediate right foreground, and flecks of white, black, and yellow dot the foremost portion of the canvas, calling attention to the surface plane rather than to what should be an illusion of atmospheric depth. A path divides the picture vertically in two; it seems to begin in the viewer's space, inviting entrance, but its head is overcome by arbitrary strokes of black and green, and its course is interrupted by blurred passages of green, gold, and brown. A house sits at the horizon, brownish-gray, obscured in part by a single and decisive brushstroke that originates at the base of a tree at center and careens to the edge of the canvas, unchecked by other pictorial gestures. As with *Old Homestead*'s one-eyed visage and the faceless figures in *Kearsarge Village,* this horizon house, windowless and overlain by thickly streaked middle-tone paint, makes explicit the picture's, and Inness's, investment in a model of perception and a mode of representation the structure of which cultivated and depended in part on vision's lapse. Seeing, in Inness's pictures, begins where it did for Swedenborg's spirits, at a point where "the light of the world or of the sun is to them as thick darkness." *Sunset*'s horizon is structurally and stylistically similar to the middle-tone zones in other of Inness's works, composed as it is of stacked and streaked strips of color and form; prominent but blurred, overlapping, indistinct, and ever in flux, it both stands for and signals not unity or equilibrium but the origination, and the necessary and originary fragmentation and then obliteration of vision, and it defines the contours of an experience of viewing meant to convey as much.[58]

Although it boasts no distinct horizon, *A Gray, Lowery Day* (ca. 1877; plate 7) produces a similar effect. As if a discrete nod to the middle tone, a patch of gray paint, a house perhaps, sits at the horizon to the right of center, even as it, along with stacked zones of varying shades of green, pulls this horizon, which should be distant, toward the canvas's face. This double structure, which evokes expansive space even as it precludes its effects, is overlain by the saturated and heavy air of a humid summer's day, a suffusing veil of soft yet dull gray, a middle tone writ large and out of control. We are confronted with a scene that alludes to depth through contrasts of light and dark—sea green trees and darker, blacker ones—but that presses color toward the front, flattening space and blurring the edges of what should be distinct forms, as if compelled to do so by the weight of hazy damp. Only the four ducks, delicately painted and brightly

silhouetted against the muddy sheen of the stream, escape this seep; everything else in the picture begins to cease to appear.

Saco Ford, Conway Meadows (plate 4), which depicts a scene in the White Mountains, is a painting "full of . . . peculiar excellences," wrote the *Boston Evening Transcript*.[59] Brilliant and languid yellow and scratched and muddy gray combine to form a thick stream and a solid bank, at once lush and stripped bare, that reiterate the streak of yellow path to the left and split the canvas into two slanting and skewed halves. Alternating bands of lighter and darker yellow-green imply recession in space and time but also, stacked one on top of another as in *Kearsarge Village,* compress. A broad expanse of gray-brown in the foreground, meant to connote the shadow of clouds (as opposed to the illuminated central plain), seems, instead, tacked on, a precarious and sinking space inhabited by a few cows and sheep, two figures, and a scraped and scraggly weed or shrub that is much too big in relation to everything else. A flat, gray strip at the apex of the stream echoes the gray of Moat Mountain above, a piece of middle tone, perhaps, relocated to a more conspicuous spot. The artists of the so-called Hudson River School blurred distances and made the up-close utterly distinct so as to approximate normal, physical perceptual experience. Here, Inness does no such thing. Atmospheric perspective overtakes even the foremost objects in the picture and blurs the row of brush situated behind the stream at right, yet leaves legible and sharp the outlines of a house in the far distance at left. Middle tones proliferate and overtake all parts of the picture's space: the horizon at left, the top of the mountain at center, the mountain slope, at right, and, again, the head of the dully colored stream, even the stream itself. It is as if Inness, in struggling to bring equilibrium to his canvas, tried one and then another middle tone, and then a third, and so forth, laboring to get his science just right. One can almost hear him saying "just one more . . . no not yet . . . maybe another . . . not quite." Rather than equilibrium, however, Turner's astigmatism, or something like it, has become the formula or norm; blur and streak combine with carefully wrought forms in a view of nature that makes the difficulty and doubt of vision a matter of course.

"I'M AFRAID THE CANVASES NEVER WILL BE DONE"

We are faced, then, with what appears to be another paradox. How do we explain the magnificent clash between obscurity and unity, muddled sight and perfect harmony of vision, manifest in Inness's landscapes? And how was it that Inness thought that a formula that embraced two mutually contraindicating strategies—one that blinded, the other that attempted to make things perfectly clear—could lead to spiritual, truth-getting sight? Could it really have been unity that Inness was after, or was it something else?

Earlier, we negotiated the paradox of Inness's "truth" by acknowledging the idiosyncrasy of his understanding of the real, and a similar negotiation, or

reorientation of expectation, is required here. What Inness gives us in his land-
scapes is no paradox, and his understanding of his project makes perfect sense,
at least if we listen, again, to those voices of nineteenth-century science that un-
derlay his practice. We know that, for Carpenter and Spencer, total vision came
only after moments of confusion and blindness ("all is flat"), after the delay of
memory, and after diffusion, prolongation, and then coordination in time and
space (such was the case with Swedenborg and Corot as well). We also know
that science, in the nineteenth century, at least to our minds, was capable of
making no more sense than did Inness's strange strategies. Case in point: In-
ness's cut-a-hole-in-a-piece-of-paper technique may be compared to optical
devices described and employed by his contemporaries—the phenakistiscope,
the zoetrope, the stereoscope—that were intended to approximate and operate
according to the normal functioning of vision.[60] Meant to unify the act of per-
ception—looking at an actual landscape—that led to painting, and thus provide
for good art and penetrating sight, Inness's device may also have been designed,
as was his middle tone, to represent that flat fog of vapor that he at one and the
same time called the origin of sight and employed to preclude it and that was
obsessively articulated in "unthinkable" or "impossible" works such as those I
have described thus far. In his *Principles of Mental Physiology,* Carpenter dis-
cussed at length the phenomenon of binocular vision, wherein the combination
of two dissimilar perspectives enabled perception of the solidity of forms in
three dimensions, as in the operation of a stereoscope.[61] Carpenter also ana-
lyzed the experience of looking at a representation of an object on a plane sur-
face—a "single flat picture"—and suggested that, in such a case, perception of
solidity derived from monocular sight:

> It has long been known that if we gaze steadily at a picture, whose perspective
> projection, lights and shadows, and general arrangement of details, are such as
> accurately correspond with the reality of which it represents, the impression it
> produces will be much more vivid when we look with *one* eye only, than when
> we use both; and that the effect will be further heightened, when we carefully
> shut out the surroundings of the picture, by looking through a tube of appropriate
> size and shape. . . . The fact is, that when we look with *both* eyes at a picture
> within a moderate distance, we are *forced* to recognize it as a flat surface; whilst,
> when we look with only *one,* our Minds are at liberty to be acted-on by the sugges-
> tions furnished by the perspective, chiaroscuro, &c.; so that, after we have gazed
> for a little time, the picture may begin to start into relief, and may even come to
> possess the solidity of a model.[62]

I do not mean to suggest here that Inness read Carpenter's text and painted a
picture of it, cutting a hole in a piece of paper in order to mime the gesture of
looking through a tube. Rather, I am proposing that the artist's device, by repro-
ducing the aspect and effects of monocular vision, may have been designed to
transform nature into a flat surface, a picture before the fact of painting even,

thereby reproducing the flatness of perception's and painting's origin and inti-
mating, through a process of adjustment and coordination, the duration—
"after we have gazed for a little time"—of coming into penetrating and unified
sight. The idea that vision may be keener with one eye closed is a startling one,
as was Carpenter's challenge to the conventional notion that only binocular
vision produced an awareness of extension, solidity, and depth. Inness's propo-
sitions regarding vision and his scientific techniques seem slightly less far-
fetched, and his landscapes slightly less "unaccountable," when understood in
the context of the scientist's remarks (part of what I have called a broader con-
text of experimentation and radical doubt), which claimed for obscured and
cyclopic seeing clarity and truth and described the act of looking at a picture
over time as a hallucinatory process ("the picture may begin to start into re-
lief"), as something akin to Allston's *Vision of the Bloody Hand,* which Inness
described as obedient to the laws of realism but fantastical nonetheless.[63]

What Inness seems to be calling for in his landscapes, what he seems to
consider necessary for the instantiation (pictorial and actual) of spiritual see-
ing, is not just blindness but also a reversal of vision or, more precisely, a rever-
sal of the structure of Cartesian optics (one analogous to Carpenter's reversal of
the idea that binocularity makes for the keenest sight). According to Descartes,
pictures are formed on the retina when light (described by the philosopher as a
"subtle material") enters the eye. According to Inness, in order to paint well and
to see properly and purely, a blank, flat fog must substitute itself for a "picture
in natural perspective" (the words are Descartes's), for an image at the vanishing
point, the horizon, really, where those lines of sight so meticulously calibrated
and described in the "Optics" converge. If we think of Inness's landscapes, im-
ages formed by way of a paper portal, as analogs to the retinal image formed as
light enters the lens and traverses the medium of Descartes's dead man's eye,
the nature of this reversal of Cartesian optics becomes even clearer. The hori-
zons of Inness's landscapes, the place where, in Descartes, light is supposed to
coalesce, retinal images to form, natural perspective to emerge, these horizons
are spaces where just the opposite occurs: all is light and flat as a fog of vapor
that obscures everything, paint is smeared, forms are dim and dispersed, pig-
ment shudders and coalesces and then trembles yet more, matter flattens out
and smears, red streaks burn the eye. If we think of an Inness painting as a
Cartesian eye—canvas/horizon as retina, paper portal as lens—what we realize
is that, according to the painter, vision begins with its own disfiguration, and
seeing is instantiated in a misaligned and distorted space. Spiritual sight origi-
nates by way of perspectival collapse or, put another way, before perspective, or
extension into depth, has had a chance to congeal. It had to be this way, Inness
suggested with his science of landscape, if the world was to see reality in a new
light. His paintings had to do more than replicate visual function, more than il-
lustrate the laws of optics, Cartesian or not. His landscapes had to invoke yet
transform, rethink and rewrite these laws so as to, as he put it in 1882, "see, and
not to think we see" so that the "face of nature is transformed."[64]

Looked at in this way, Inness's unity, we come to realize, was more a matter of intimation than it was of realization; that is to say, it was an approximation in paint of the time of experience, what he elsewhere called the "alchemy of life," necessary to the *eventual* acquisition of penetrating sight ("consequently," he said, "we learn to see in accord with ideas developed by the power of life").[65] Unity was also something that, by law, had to be deformed, it had, in a sense, to fail in order to succeed. In *Kearsarge Village* and other canvases, unity of vision—what amounted to the visual reach of God, what did and did not respect the perimeter of the gazed-through, cut-a-hole-in-a-piece-of-paper circle, what was ever at the limit or on the verge—was rendered by way of blurred outlines, the push and pull of mutually obliterating pigment, obscure and hazy middle tones, effects of encroachment and overlap, deferral and delay. Inness, his friends and colleagues reported, never knew when a picture was finished; he tended to paint and repaint his pictures, even after they had been purchased or hung in a patron's home.[66] He was in fact reluctant to finish his works, citing the great art of the past as justification for his recalcitrance: "Who ever thinks about Michael Angelo's work being finished? No great artist ever finished a picture or statue."[67] His friend and travel companion Samuel C. G. Watkins (a dentist in Montclair) noted that he had the habit of painting many pictures on one canvas, as many as fifteen layers on a single surface, as did the artist's son (who upped the ante to twenty-six; Schuyler, as noted in the previous chapter, called it twenty-five). Inness's pupil Monks observed that if a painting of Mount Washington executed by the artist while in the White Mountains "could be taken to pieces in layers [it] would reveal twenty different phases and conditions of [a] mountain. It was snow-capped, bare, sunrise-tinted, cloud-capped, gray, bathed in full noonday light, rose-crowned with sunset and all the lesser changes."[68] The portraitist Frank Fowler wrote of seeing a painting by Inness entitled "Dawn" that was transformed a few days later into a "subtle and beautiful representation of Sunset."[69] *Winter Morning, Montclair,* Schuyler took as an example, was painted on a canvas on which a "striking and promising composition was already 'laid in.'"[70] Inness believed, Henry Atkins stated, "that a canvas before it can be considered complete must necessarily go through a definite and prolonged number of stages and treatments."[71] These steps and stages, what amounted to Inness's reluctance to stop painting, his uncertainty regarding completion, produced landscapes that were not "units" at all or, rather, were "units" of a special and idiosyncratic sort, instruments that waited for perspective to harden even as they worked to melt its bones.

Inness's landscapes are ever in process, are ever engaged in working out a proper way to conceive of the relation between self and world, eye and truth, and they articulate, on a procedural as well as a stylistic level, the serial and successive origin of sight. "I have changed from the time I commenced because I had never completed my art," Inness wrote in 1884, ten years before his death.[72] He was frustrated by his inability to bring his paintings to completion but seemed to sense that his struggle resulted from the fact that he sought some-

thing almost impossible to express. He told his dealer, patron, and friend Thomas B. Clarke that he often "got in quite a muddle" over his attempts to fix the parts of his pictures:

> Sometimes, Clarke, it is hard to find just where the thing is wrong; it doesn't seem to hitch. It may be in the sky or in the patch of light across the foreground; and then you will find that it isn't that at all, but the fault lies in the composition, and those trees in the right are out of place and mar the breadth and grandeur of the picture. But then the misery of the thing is that you can never get back the thing you had before you touched it. Clarke, if I could only learn to leave a thing alone after I feel that I have what I want! It has been the curse of my life, this changing and trying to carry a thing nearer to perfection. After all, we are limited to paint. Maybe, after we get to heaven, we shall find some other medium with which to express our thoughts on canvas.[73]

In the meantime, he lamented, "I'm afraid the canvases never will be done."[74] De Kay responded to the labor of this search—"Sometimes it is plain to see that he has labored hard at his sketches; hours and days pass while struggling at one scene. In such cases the work is minute, painstaking, almost painful"—as did those commentators who described Inness's canvases as violent or difficult, even impossible, to comprehend.[75] Critics responded in such a fashion, I would argue, because Inness's pictures, as did Corot's, transferred the acts of recall that initiated and shaped their creation to the experience of the beholder, asking the latter to recollect the artist's perceptual experience, to remember, even enact, his struggle in the act of viewing (in much the same way that Inness recalled the perceptual experience of other artists when he began work on his paintings). Inness's pictures were "almost painful" because they brought their viewers to the verge of simultaneous excitation, promising them a perfect harmony of vision; but then they regressed, splitting apart and slipping through the fingers as if to disavow, or at least discredit, the law of the unit after which they seem to have so assiduously sought. But what results, again, is not the rejection of unity but, rather, the formulation of a law that constitutes unity as something perpetually caught between seriality and simultaneity of vision, between steps or stages and perfect harmony.

The Coming Storm (plate 5) depicts a meadow, grazing cattle, a cluster of trees, a house, and what might be a distant town, all under a threatening yellow-gray sky. Inness organizes and orders the whole by juxtaposing vertical, horizontal, and diagonal elements, by locking into place sections of landscape that, if not pinned in just this fashion, would threaten to shift in ways their maker did not intend. A series of diagonals—formed by the foreground hill, by an abrupt shift from a lighter to a darker gray in the sky above, and by the movement of the foreground path and its occupant toward the left—intersect the stand of trees at the canvas's heart, holding it secure. The slant of chimney smoke at left and of the rainbowlike and curving white stroke of paint in the

sky at right, along with the thrust of the staff borne by the shepherd, counter the slant created by hill, cloud, and path, while the triangular area created by the meeting of cloud shift and rainbow is reiterated in the shape of the house's roof. Horizontal strips of brown, green, yellow, and gray at right and of black and brown at far left are balanced by the emphatic vertical of a yellow tree and smoking chimney to the left.

Yet this order, Inness's insistence on balance and harmony, barely holds its own in the face of shifting, overlapping, and swirling paint. Even atmospheric breadth, which should unify, instead obscures, as if approximating those processes, lost to view, of Swedenborg's respiratory sight, wherein perception took the form of inhalation and exhalation and people saw as they breathed, through the inspiration of ethers and airs (or Descartes's "subtle material"), here represented by the heavy-lidded press of hazy damp. Thickly applied white and whitish-gray pigment denotes a turbulent sky in which spiraling brushwork and sketchy splotches of paint combine, creating a sense of flux appropriate to the picture's subject yet anathema to its grasp at order and stability. The foremost central tree flings toward the viewer three strokes of bright brick-red pigment, as if spinning in place and dislodging unnecessary parts. Bands of paint that constitute the right foreground and middle ground mingle and merge, depriving the scene of a solid base, putting into doubt the surface plane. Flecks of whitish-yellow in the foreground at left, meant as flowers or sticks or shrubs, sit at the surface of the canvas and aid the soaked-through and overlapping space opposite them in rendering groundless and unstable, ever-shifting, this landscape view. The horizon zone at left, visible between the leftmost shrub or tree and the house, is a wall of striped white, green, and brown that obstructs an expansive view; it is met at its top by a band of gray that stretches across the picture's surface, interrupted only by the central trees, terminating at its right edge. Propped up by an orange-red plain dotted with houses, more cattle, and strips of brush and trees, gray, gray-green, gray-black, and tan, this zone both secures and destabilizes the picture's space; its double impulse iterates the double injunction of Inness's conception of vision, that it be both clear and obscured, penetrating and ever deferred.

In front of the house, itself composed of enmeshed layers of brown, tan, yellow, and green, hover strips and scratches of the same color as a screen of erratically gesturing yellow-green trees: these suspended strokes seem as ghosts, shadows, traces, afterimages even, of their like-colored brethren. These traces, and those that break free from and hover over the tree at far left, iterate Inness's insistence on the seriality of vision, on the individual stops between the A and Z of perception's simultaneous excitation. Such doubling and tripling of form puts unity and singularity into doubt; bodies seem as apparitions, palpable memories of things already seen, neither composite nor fully present wholes—retinal images dislodged from their perspectival grid and split into pieces and parts. This is Inness's painting and repainting writ large; this is the inevitable delay and disunity, and the originary elusiveness, of a most ancient

and godlike sight. Insubstantial and obscure, these traces propose a model of
perception that is at once available to the gaze of science but that troubles and
displaces its usual strategies. This is science's subjective side, hallucinatory (as
with Carpenter's monocular vision) and dreamlike (as with Decamps's scene of
suicide and Corot's hazy landscape views). The fact that Inness painted this
landscape scene over the top of another, finished picture, one not his own (it
was his son's), only underscores his desire to make of perception its own dislo-
cation, to transform memory into a strategy of vision, and to transform vision
into a function of memory's, and obscurity's, intervention.[76] Only death, only a
plunge into darkness and a subsequent journey into light, Inness suggested in
his conversation with Clarke, would enable painting's, and vision's, restoration.
Perhaps it is to this plunge that the painting's subject—a coming storm—
refers.[77]

In an article entitled "The Pleasure of Visual Form," published in *Popular
Science Monthly* in 1880, James Sully characterized the aesthetic experience
and appreciation of form as a "refined sort of intellectual activity." His descrip-
tion, which drew on contemporary theories of perception as well as the claims
of eighteenth-century British theorists of aesthetics, Edmund Burke and
William Gilpin in particular, included an analysis of "the activity of the visual
organs" and a characterization of what he called "the subjective aspects of ocu-
lar movement," that is, the response of the eye to different sorts of form and the
comfort or discomfort that ensued.[78] As were both Burke and Inness, Sully was
interested in describing how vision operated and felt, and he characterized per-
ception as a serial process. "What we call a simultaneous perception of form,"
he wrote, "is often a sequence of simultaneous perceptions."[79] However, Sully
also insisted that an experience of vision that led to a sensation of pleasure con-
sisted in a unified act of attention, a simultaneous impression, constituted by
but that masked succession. He compared this mode of vision to the act of look-
ing at a painting:

> The substitution of simultaneous retinal perception of form for successive percep-
> tion has the effect of bringing together the terms of the relations of variety and
> contrast, unity and similarity, under what is approximately one act of attention.
> If we watch the movements of a painter's hand as he draws the outline of a human
> figure on a canvas, our eye may attain a rough perception of the successive direc-
> tions and distances; but how vague will this perception be as compared with that
> which we instantaneously obtain when the artist moves away from his canvas,
> and shows us these as parts of a permanent coexistent whole! In the former
> case we had to bring together by the aid of memory a number of impressions
> occupying some appreciable time: in the latter these were presented to us in one
> and the same instant.[80]

By now it should be clear what kind of vision, of the two sorts proposed by
Sully, I believe Inness's science of landscape called for and produced. Rather

than simply substitute "simultaneous retinal perception" for disunified vision, Inness took his cake and ate it too; he bodied together with the aid of memory a number of impressions that allowed for only a vague, and ever delayed, perception of the whole. The reality of the unseen, Inness imagined, came only in the dim space of recollection, and only after a prolonged and ever-interrupted search—from flatness to depth—in the act of painting and then, again, in the act of viewing: this is the formula on which his landscapes insisted. The figure in *The Coming Storm* whose face is obscured by blotchy paint and who turns his back on, walks away from, makes himself blind to, the painting's horizon, the place where vision was supposed to commence, embodies the obscure origin of perception, and vision's originary obliteration, that the difficulty and impossibility of Inness's pictures and his science of landscape hold forth. This figure exemplifies the operations and intended effects of Inness's "law of true realism," formulated by an artist bent on obtaining a vision, in Daingerfield's' words, "wide of horizon, perfect in all its parts."

In taking up Molyneux's query, or a version of it, Inness introduced one of the most famous problems of philosophy and science into the procedures of his art. In concluding that, in order to see beyond a flat surface, beyond, in Carpenter's words, "what can be represented in a Picture" and toward God, one must endure the time of experience, coordination, deferral, and delay, Inness made of painting a spiritual science, an exercise in realism that depended on the instantiation of both the objective and the subjective, both the actual and the imperceptible, the obscure. Molyneux and Carpenter, of course, made no mention of spiritual sight, but Inness, determined to understand his quest as a scientific one, governed by principles and laws, transformed and recombined the elements of their inquiry so as to accommodate his own. Cheselden's flatness was Inness's horizon, or vision's obscure origin, and Carpenter's coordination was the consultation and coordination in time and in paint that formulated a way to see beyond it, deeply and penetratingly—extensively, one might say—and toward the divine. Art, Inness said, "is not a thing of surfaces, but a moving spirit."[81]

CONCLUSION: THE QUEST FOR UNITY

To memory, then, Inness added a set of strategies that he believed would bring him closer to mapping out a science of spiritual sight; all of these strategies—from holes cut in paper to the elusive middle tone—took as their starting point a desire for unity, which Inness understood as a fundamental aspect of his art and of his quest. If it was simultaneity of vision that he was after (in terms of physiology but also in terms of Swedenborg's vision as shared breath, or "immediate intercourse" among corresponding bodies, minds, and ideas), it makes sense that he would want the canvases that were to speak of such a thing to embody it in their very form, and, thus, it should come as no surprise that Inness

worked hard to articulate the "law of the unit" in his landscape views, whether that meant applying "the science of geometry" to pictorial space, or making sure that words did not interfere with the coherence of his works.

Yet all of these strategies also operate in the space of paintings that can seem to give unity no real mind, that often appear to scoff at the notion that good landscapes and great vision originate in carefully regulated, equilibrated, and containable space. It is as if Inness purposefully staged the failure, or at least struggle, of his stratagems; if this is indeed the case, we must ask: Why? As I have been suggesting, Inness's unity was repeatedly and deliberately undercut because Inness was determined to articulate the process of coming into vision, not just the end of this acquisition, and this meant that he had to press together the before (obscurity, seriality) and after (clarity, unity) of perception and, by extension, of spiritual sight. Unity was undercut so that Inness could make sure that the full story of perception, including the constitutiveness of obscurity and blindness, would be told. And yet it seems to me that there must be something else—and something of great significance—at work here. In lamenting to his patron Clarke that he was "limited to paint" and, thus, unable to finish a painting, Inness expressed regret that the tools necessary to "carry a thing . . . to perfection," to transform a landscape into a perfect harmony of vision, were as yet unavailable to him. Those tools that Inness did utilize in reaching for unity—perforated paper, poetic captions, distance, the middle tone, geometry—may have gone some way in achieving their desired end, but Inness himself said his aim was impossible to satisfy during his time on earth. What I want to suggest, then, is that by releasing these tools or stratagems— this science of landscape—into paintings that resisted their very presence, Inness intimated not just better sight but, also, another sort of release, that is, a liberation from those very things—rules, formulas, laws—after which he so assiduously sought but that may not have been entirely up to their declared task. What can look to us like the failure of his strategies of unification may well have been, in the end, an attempt to describe a space or realm of existence about which we have no knowledge and over which we cannot possibly exert control, where our laws do not apply or, perhaps, where the idea of a law or a formula or a science does not even obtain.

At the beginning of this study, I said that Inness was convinced that only something radical would transform the visual capacity and thus the knowledge and consciousness of humankind; in intimating a space of liberation and release, where rules fall apart, where what we know or have devised to help us know deliver no returns, where science does not work, Inness painted for his viewers something so radical it was as yet unknown, a state, as he himself had put it, "of which we have no physical perception, and can have none."[82] What Inness's painted was Ogden Rood's "room for the play of not less than a dozen new senses," a space beyond science and, perhaps, beyond sight (for what else does Swedenborg's respiratory communication evoke?).[83] What we have, then,

Figure 16. George Inness, *Early Recollections: A Landscape* (1849). Oil on canvas. 40 × 50 in.
Private collection. © Christie's Images Incorporated 2005.

FOUR ❧

Painting the Past

"MANNERISM OF THE VERY WORST KIND"

In 1849, Inness exhibited a painting at the National Academy of Design entitled *Early Recollections: A Landscape* (fig. 16). In it, two men, one on horseback and the other in a horse-drawn wagon, converse beside a forest stream near a ruinous bridge and watermill. The picture did not please the *Knickerbocker Magazine*: "Mr. Innes [*sic*] is rapidly rising into excessive mannerism, and mannerism of the very worst kind. His fore-ground trees are the same color with his middle-distance hills, and over the whole picture a sad and heavy tone pervades, and wounds the eye. This young artist should study the *colors* of nature, and not so much the mere *form*. Color is fixed in nature; form is arbitrary. If he will take our advice, he will pay more attention to the various lights and shades of his picture."[1] I will have something to say about this critic's suggestion that Inness's canvases wound the eye later in this chapter; for the moment, I want to address the other major complaint registered here. During the early years of his career, Inness was chastised repeatedly for what was described as his mannerism, a term that, at the time, indicated a tendency to imitate the paintings of the old masters rather than nature itself. In the early part of his career, from 1845 onward and prior to 1875, Inness's landscapes were often described by critics as derivative, artificial, and uninteresting, and he was admonished to stop repeating the past, especially the work of the seventeenth-century landscape painters Claude Lorrain and Gaspard Dughet (also called Gaspar Poussin).[2] In 1848, for instance, the *Literary World* reported that "several landscapes by

Mr. Inness show an advance from last year." "But we fear," the review contin-
ued, "that he is beginning to lose sight of Nature, in the 'Old Masters.' His
Evening . . . is an imitation of the sunsets of Claude Lorrain, and his *Diana Sur-
prised by Acteon* . . . is, if our memory serves right, a literal copy, so far as form
and composition are concerned, of a picture by that master, in the National
Gallery at London."[3] The trees in a painting by Inness on view in 1863 were de-
scribed as "merely traditional," and the figures as "handed down from Claude
through ten generations of people who never painted out of doors or read nat-
ural history. It is not necessary that we should be pre-Raphaelites to say that
men who make pictures must use their eyes in this age."[4]

These critics could easily have been speaking of Inness's *Landscape* (1848;
fig. 17). As in Claude's landscapes, a dark foreground, an illuminated middle
ground, a horizontal and shaded row of trees, and a hazy, light-filled distance
combine so as to create the illusion of deep space through which the eye is led
in an orderly fashion; passage is abetted by an opening at center, the stream
that passes through this opening, and the bright purplish haze of the hills visi-
ble in the distance. A gnarled and ancient tree at the canvas's left edge and an-
other at right frame the scene, enclosing the depicted space and, along with the
gazing sheep at left, guiding the eye as it makes its way down the stream, under
the bridge, past a properly picturesque house and ruins, and toward the distant
bank and hills. As with *Early Recollections: A Landscape,* with its time worn
horse and cart, rustic characters, sun-dappled and pebble-strewn path, pictur-
esque mill, inward-inclining, craggy trees, and receding planes (a church steeple
in the distance serves as an off-center vanishing point), this painting evokes the
masters of Europe's grand landscape tradition.

Figure 17. George Inness, *Landscape* (1848).
Oil on canvas. 29½ × 44½ in. Fine Arts
Museums of San Francisco, Mildred Anna
Williams Collection (1942.21).

In 1852, the *Literary World* again declared its distaste for Inness's affectation, writing that his recent trip to Europe had had a negative effect on his practice: "And this is what nineteen out of twenty of our artists get by going to Italy. Mr. Innes [*sic*] was once an artist of great power and promise, and even in his short absence he has acquired weakness and degradation." It was his attention to art, rather than nature, that was to blame: Inness has been ruined by "false and affected methods," and his pictures had become "affectations of that which is at best superficial to Art—the accomplishment, not the substance. . . . The artist's mission is to interpret nature; what, then, is he who contents himself with studio concoctions as blank and wanting in the truths of nature as the canvas they are painted on?"[5] A critic for the *Knickerbocker,* writing about the 1853 academy exhibition, praised one of Inness's paintings for successfully combining nature and art, something other "traveled artists" had failed to do, but he qualified his remarks and admonished Inness to depend less on the example of the old masters: "In the other pictures from Mr. Innes's [*sic*] hand, he seems to have sacrificed effect to his great love of mere *tone*. In this respect he will find that TIME, a greater toner than he, will entirely obliterate them. They are too much like the 'old masters' for a 'young master.' Kept up a little higher, they would 'go down' much better."[6]

Most writers, like this one, enjoined Inness to refrain from painting what were characterized as imitative works. The *New York Daily Tribune*'s critic devoted several long paragraphs to Inness in his review of the 1852 academy exhibition and stated that his too-avid interest in the landscapes of old compromised what he called his "undoubted talent":

> Mr. INNES [*sic*] . . . exhibits several large-sized landscapes, which betray a much
> profounder regard for "old masters" than for Nature. They are not sincere pictures.
> He is consumed by the old landscapes. . . . Is an artist to-day to be satisfied with
> doing pictures which might be taken for Gasper [*sic*] Poussin's? . . . An artist who
> erects Gasper Poussin, or Raphael, or Phidias, or Milton, as his model, and does
> not study from their models, will never paint a picture nor write a poem worthy
> of attention. . . . Let Mr. INNES look at the landscape, and if it inspires him, paint it.
> If he paint it sincerely—and without sincerity his work is worthless—it will not
> be like Gasper Poussin, or Claude, or Salvator Rosa, or Turner, or Mulready, or
> anybody else, because the artist is not any one, or all, of those gentlemen, but is
> Mr. INNES. If he has looked at Berkshire scenery, and beheld what he has painted
> in No. 424, he has seen what no other man ever saw in Berkshire or in any other
> region of the world.[7]

According to the *Tribune* critic, Inness's reliance on the example of the old masters led him to paint the impossible and the unaccountable ("what no other man ever saw"): things that had not existed and would never exist. "That woolly, scumbly, dirty effect," he continued,

those trees, all of the same kind, and that kind unknown to Dendrology, that earth
of the same mysterious substance as the trees and skys [*sic*] and rocks, are not
Berkshire, or Summer fields and woods, or anything to our eye, but a reminiscence
of a series of pictures by Gasper Poussin in a damp old church in Rome. . . . The
difficulty with Mr. INNES is, that he has gone all wrong, but there is no proof that
he cannot go right if he will. We see by the Catalogue that he is in Italy. But let
him not be mastered by the masters. The end of the artist in studying Raphael,
Claude or Titian is not to know them, but Nature. It is the eternal old story, we
know, but if artists will paint the eternal "old pictures" what can we do?[8]

In this critic's opinion, Inness's paintings failed because they were as memo-
ries, "reminiscences" or ghosts of the landscapes of Claude and Gaspar.

During the period under discussion, Inness was often the focus of debates
about originality and imitation. Whether they were praised or criticized, his
pictures were clearly understood to bear some sort of relation to the art of the
past. In 1862 he was the subject of a lengthy and multipart exchange between
two critics in the *Boston Evening Transcript* that compared the advantages and
disadvantages of influence. The first writer, "H.," attributed Inness's genius to
his encounters with the art of other painters, and to what he called the "right
character" of influence, and asserted that the idea "that an artist should not
study superior works of art, and be guided by such study, is, to our mind, sim-
ply absurd."[9] The second, "B.," spoke of Inness's "own peculiar individuality"
and insisted that it was "pernicious for young artists to run after and imitate
the manner of every new celebrity, thinking they have at last found the true
recipe for compounding a good picture."[10]

In drawing attention to Inness's "peculiar individuality," this second critic
echoed the sentiments of many of his colleagues, who described the artist's
landscapes as refreshing and original departures from the hackneyed or imita-
tive landscapes perpetually on view at the National Academy of Design.[11] Such
approbation, however, was usually accompanied by anxious claims as to the
pictures' freedom from influence, and critics made sure to insist that Inness's
accomplishments were his own, as if desperate to overlook or expunge traces of
the past from his art. In 1860, he was called "a man of unquestionable genius;
he is one of the finest and most poetical interpreters of Nature in her quiet
moods among our landscape painters. He follows no master, but adopts his
own methods of expressing his ideas."[12] "If Mr. Inness perseveres in the course
he has laid out," stated the *Transcript* in 1875, "he will do a grand work in the
next few years in creating and developing a new and original school in Ameri-
can art, where American landscape will be seen with American eyes, and repro-
duced as American subjects rather than weak imitations of either French or
German methods."[13]

Inness's landscapes were, in fact, frequently singled out as "an exception to
the general rule of our landscapes," "totally different in handling and treat-
ment" than those of his predecessors and contemporaries, sometimes by the

very same critics who accused him of imitating Claude and Gaspar (the *Knickerbocker* critic who called Inness mannered, yet so incapable of organizing his composition properly and conventionally that he wounded the viewer's eye, is a perfect example of this).[14] It is as if his landscapes, labeled "freaks" by a writer in 1855, were considered unsuccessful not because he painted poorly but because he did not paint like anybody else, including those seventeenth-century artists he was repeatedly accused of imitating.[15]

One of the questions I seek to address in this chapter is this: How was it that Inness's pictures, and in particular those of the period 1845–75, could be at one and the same time criticized for not looking like the art that preceded them and criticized for looking *too much* like this work? During the early years of Inness's career, critics often spoke of his propensity to experiment with style, handling, composition, and subject matter. Jarves called him "recklessly experimentive," and the *New York Evening Post* wrote that he "never seems sure of himself, and his work may undergo a dozen changes, and yet not be the thing he aimed to do."[16] Perhaps it was what Schuyler called Inness's "insatiable curiosity" and "willingness to experiment," his tendency to formulate and reformulate his practice, drawing on one source and then another, substituting this style or influence for that one, that wound up producing some landscapes that looked like the past and some that did not (and some that did both).[17] Perhaps these contradictions can be explained away by the not fully developed proficiency of an artist in the early years of his career, one not yet the master of his means, who periodically turned to the work of others for inspiration, with varying and unequal results.

Perhaps, but there is more to it than this. First of all, Inness was "recklessly experimentive" throughout his entire career (according to his critics, his experiments ruined many a good canvas). Second, the mannered "mistakes" that he made in the 1840s–60s and early 1870s—those that have compelled scholars of American art to adopt a narrative of progression where Inness's art is concerned, one that has him fumbling about for a while before producing what have been called his most "modern" and successful paintings, his "signature" works of 1884–94—these mistakes persisted throughout his fifty-year career.[18] Inness continued to make these mistakes and continued to both depart from and adhere to tradition, even after critics begged him to leave off such improprieties, to stop imitating the past or to pay more attention to it in his work.

Another question I explore in this chapter is a short but by no means simple one: Why? Why make landscapes that, at one and the same time, attended to tradition and transformed, even disfigured it? By and large, scholarly accounts of Inness's relation to tradition, especially those that want to see him as "American" to the core, assume a simplistic model of influence—encounter, appropriation, rejection—and do not entertain the possibility, as I want to here, that he may have used tradition purposefully and strategically. Inness openly admired the landscapes of his European predecessors and once compared his paintings to theirs. "He noticed," reported Sheldon, "in some prints after the old masters

the presence of a spirit that did not animate his own productions. He took the prints with him out to Nature, and tried to find what it was that produced the sentiment he so admired and missed."[19] And as Cikovsky has noted, despite critical admonition, Inness persisted in alluding to old master landscapes, producing picture after picture that made explicit its relation to the art that preceded it.[20] He did so not simply because he was fishing around for ways to paint or because he wanted to iterate his debt to the past or enhance the stature of his own production. Rather, in his hands, allusion took on a new form and purpose, becoming less about the relation of an artist to his precursors and more about the interaction between a painting and its beholder. That is to say, Inness's allusions had a hand in shaping the experience of viewing his landscapes compelled, as well as the model of vision this experience evoked. A consideration of the place of tradition in Inness's practice, then, will go some way in explaining the diversity—and what one critic called the freakishness—of his early work but will also draw attention to a set of concerns that were sustained throughout his career, what I have termed the deepest structures of his art, those things out of which he fashioned an experimental, and scientific, landscape mode.

WOUNDING THE EYE

Let us begin by returning to the fascinating claim that Inness's painting, *Early Recollections: A Landscape,* "wounds the eye." The *Knickerbocker* critic said that the picture's tone was generally displeasing, and he faulted its failure to make the foreground trees distinct from those in other parts of the painting. However, in stating that the work wounded his eye he did more than label it, in simple terms, a bad picture. Rather, he implied that landscape paintings ought to treat the eye, and vision, in a certain manner, as if to suggest that pictures that did not do so could be detrimental to vision or, at least, to the viewing eye. During the period under discussion, critics often spoke of landscapes in these terms, praising those pictures that offered up what was understood to be a pleasing visual experience. Clearly, Inness's *Early Recollections* produced the opposite effect, and a brief look at writing about landscape in the 1840s–60s and early 1870s will tell us why.

The phrase "the eye" functioned as more than a figure of speech in writing about art at this time. It served as a virtual beholder and stood for that beholder's visual experience. It was "the eye" that was addressed by pictures and it was "the eye" that was moved, invited in, shocked, relieved, annoyed, wearied, pleased, overpowered, or soothed by paintings. "There are many works that amuse the eye by a pleasing combination of tints, or curious display of imitative skill," wrote a critic reviewing the 1850 academy exhibition for the *Bulletin of the American Art Union.*[21] At exhibitions of diverse works from a variety of hands, stated the *Boston Daily Advertiser* in 1875, "the eye wanders from one to another, often bewildered by startling contrasts."[22]

Plate 1. George Inness, *Kearsarge Village* (1875). Oil on canvas. 40.96 × 60.96 cm (16⅛ × 24 in.). Museum of Fine Arts, Boston; gift of Miss Mary Thacher in memory of Mr. and Mrs. Henry C. Thacher and Miss Martha Thacher (30.102). © 2003 Museum of Fine Arts, Boston.

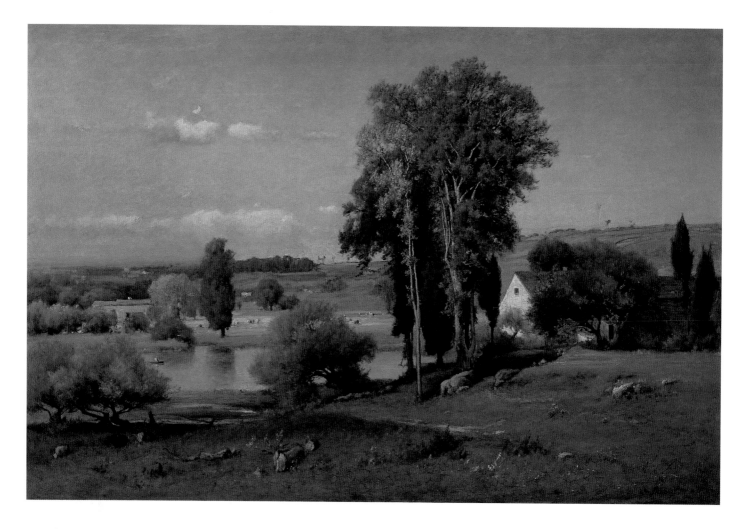

Plate 2. George Inness, *Old Homestead* (ca. 1877). Oil on canvas. 36¼ × 54⅛ in.
Haggin Collection, The Haggin Museum, Stockton, California.

Plate 3 (*following page, top*). George Inness, *Autumn Oaks* (ca. 1878). Oil on canvas. 20⅜ × 30⅛ in. The Metropolitan Museum of Art, New York; gift of George I. Seney, 1887 (1887.8.8). Photograph © 1992 The Metropolitan Museum of Art.

Plate 4 (*following page, bottom*). George Inness, *Saco Ford, Conway Meadows* (1876). Oil on canvas. 38 × 63¼ in. Mount Holyoke College Art Museum, South Hadley, Massachusetts; gift of Ellen W. Ayer.

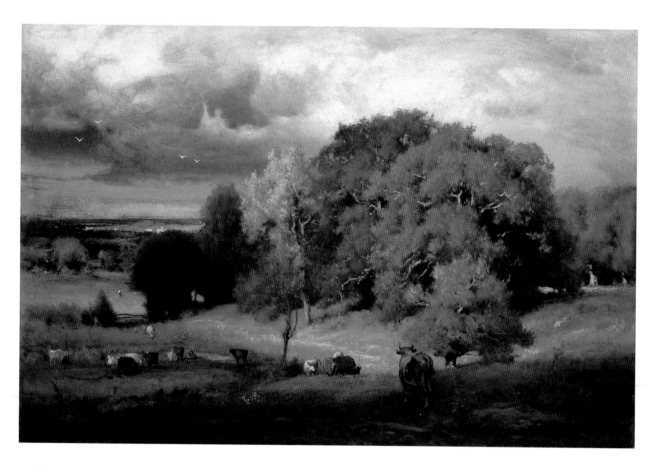

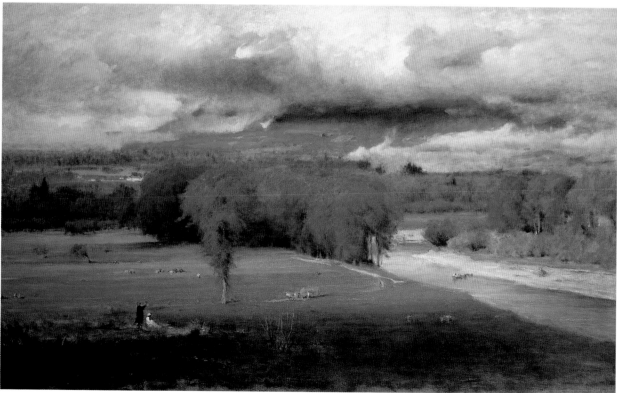

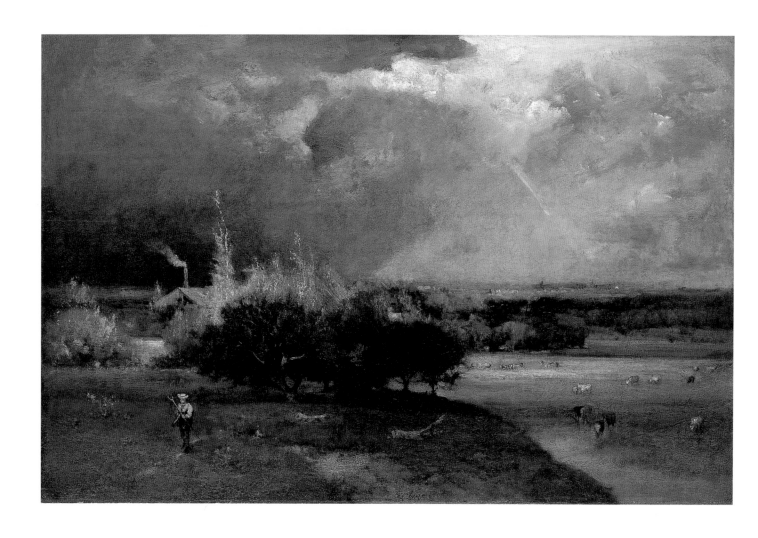

Plate 5. George Inness, *The Coming Storm* (ca. 1879). Oil on canvas. 27¼ × 41¾ in. Addison Gallery of American Art; gift of anonymous donor (1928.25). © Addison Gallery of American Art, Phillips Academy, Andover, Massachusetts.

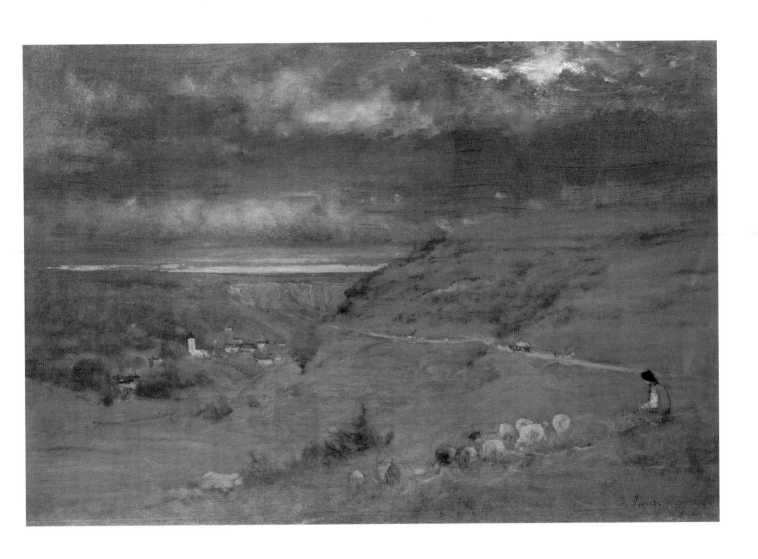

Plate 6. George Inness, *Sunset at Etretat* (ca. 1875). Oil on canvas. 20¼ × 30¼ in.
Collection of Mr. Fayez Sarofim.

Plate 7 (*preceding page, top*). George Inness, *A Gray, Lowery Day* (ca. 1877). Oil on canvas. 16 × 24 in. Davis Museum and Cultural Center, Wellesley College, Wellesley, Massachusetts; gift of Mr. and Mrs. James B. Munn (Ruth C. Hanford, Class of 1909) in the name of the Class of 1909.

Plate 8 (*preceding page, bottom*). George Inness, *The Sun Shower* (1847). Oil on canvas. 29¾ × 41¾ in. Santa Barbara Museum of Art; gift of Mrs. Sterling Morton to the Preston Morton Collection.

Plate 9. George Inness, *Lake Nemi* (1872). Oil on canvas. 75.56 × 113.98 cm (29¾ × 44⅞ in.). Museum of Fine Arts, Boston; gift of the Misses Hersey (49.412). © 2003 Museum of Fine Arts, Boston.

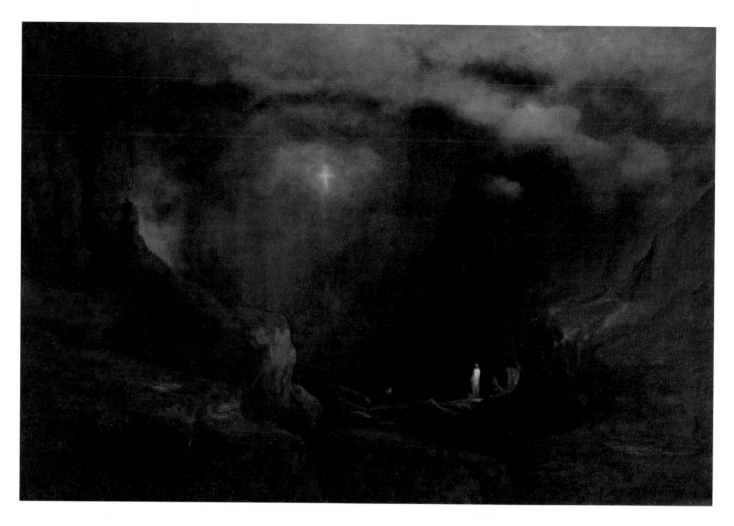

Plate 10. George Inness, *The Valley of the Shadow of Death* (1867). Oil on canvas. 48 ⅝ × 72 ⅞ in. The Frances Lehman Loeb Art Center, Vassar College, Poughkeepsie, New York; gift of Charles M. Pratt (1917.1.6).

Plate 11 (*following page, top*). George Inness, *The Home of the Heron* (1893). Oil on canvas. 30 × 45 in. The Art Institute of Chicago, Edward B. Butler Collection (1911.31). Photograph by Greg Williams, reproduction, The Art Institute of Chicago.

Plate 12 (*following page, bottom*). George Inness, *Niagara* (1889). Oil on canvas. 30 × 45 in. Smithsonian American Art Museum, Washington, D.C.; gift of William T. Evans (1909.7.31).

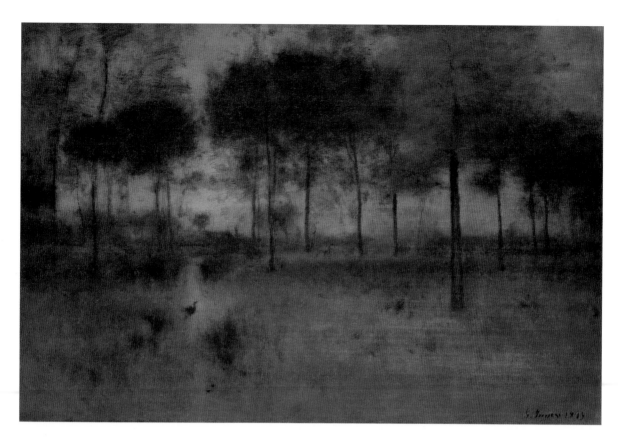

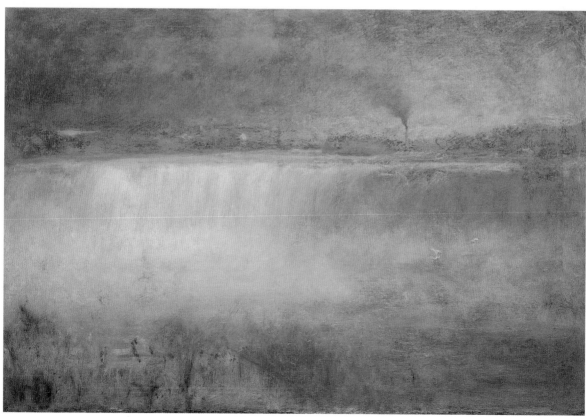

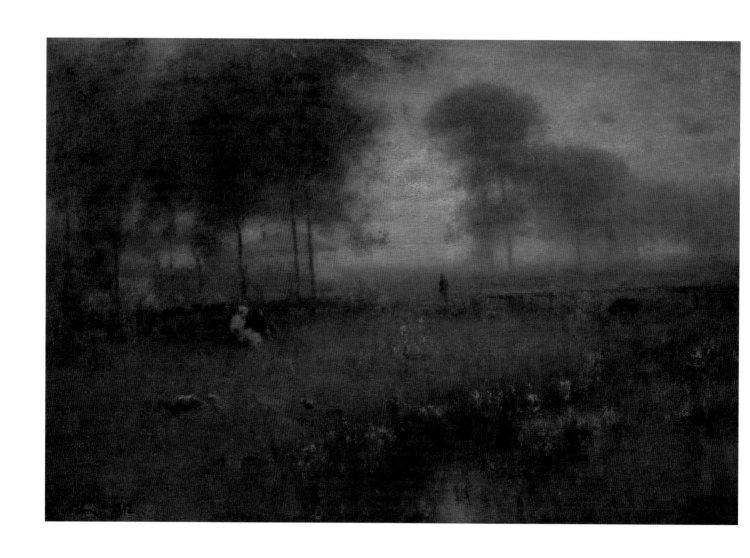

Plate 13. George Inness, *Summer Evening, Montclair, New Jersey* (1892). Oil on canvas. 30 × 45 in. Private Collection, New England, Courtesy Thomas Colville Fine Art.

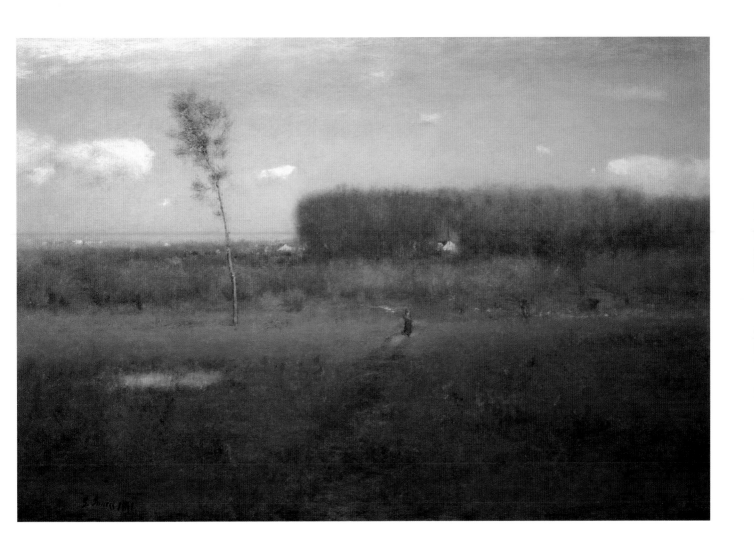

Plate 14. George Inness, *October Noon* (1891). Oil on canvas. 30 × 45 in. Courtesy of the Fogg Art Museum, Harvard University Art Museums, Cambridge, Massachusetts, bequest of Grenville L. Winthrop. Photograph Katya Kallsen. © 2003 President and Fellows of Harvard College.

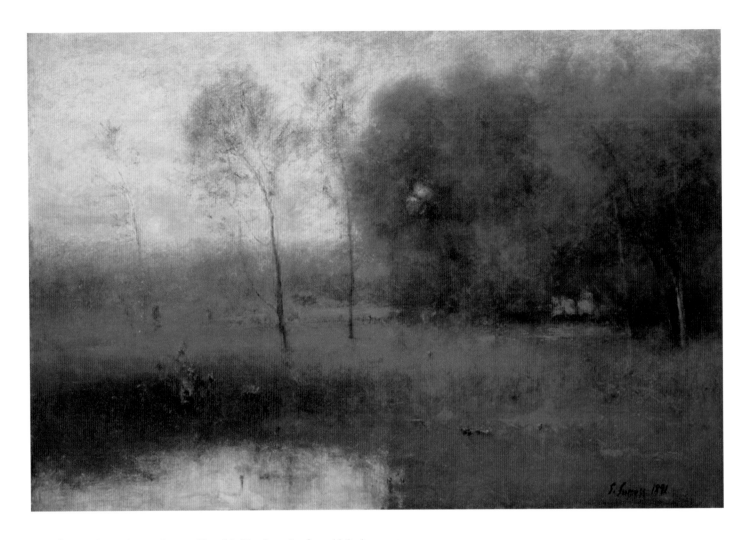

Plate 15. George Inness, *Summer Montclair (New Jersey Landscape)* (1891).
Oil on canvas. 30¼ × 45 in. Collection of Frank and Katherine Martucci.

Plate 16 (*following page, top*). George Inness, *Morning, Catskill Valley* (1894). Oil on canvas. 45 × 63 in. Santa Barbara Museum of Art; gift of Mrs. Sterling Morton to the Preston Morton Collection.

Plate 17 (*following page, bottom*). George Inness, *The Passing Storm* (1892). Oil on canvas. 30⅛ × 45¹⁄₁₆ in. High Museum of Art, Atlanta, Georgia; gift of Mrs. Howard R. Peevy (75.53).

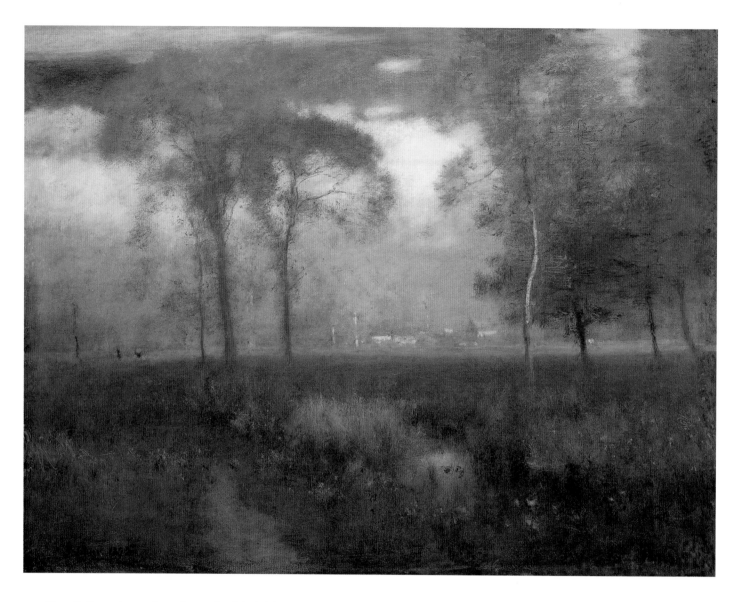

Plate 18. George Inness, *Sunny Autumn Day* (1892). Oil on canvas. 81 × 106 cm.
© The Cleveland Museum of Art, 2003. Anonymous gift (1956.578).

Plate 19. George Inness, *Landscape with Trees* (1886).
Oil on canvas. 39½ × 29½ in. Santa Barbara Museum
of Art; gift of the A. E. Clegg Family.

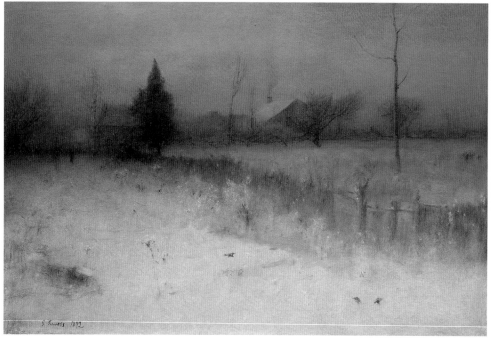

Plate 20. George Inness, *The Mill Pond* (1889). Oil on canvas. 37¾ × 29¾ in. The Art Institute of Chicago, Edward B. Butler Collection (1911.30). Reproduction, The Art Institute of Chicago.

Plate 21. George Inness, *Home at Montclair* (1892). Oil on canvas. 30⅛ × 45 in. Sterling and Francine Clark Art Institute, Williamstown, Massachusetts.

"The eye," then, served as the point of convergence for a network of criteria concerning the relation of a picture to its beholder. It was also a key figure in theorizations about the relation of perceptual function to landscape representation. When it came to landscape painting, the proper treatment of the eye was an important criterion. Inness's *Evening at Medfield, Massachusetts* (1875; fig. 18) pleased the *Advertiser:* its "tender gray shadows . . . refresh the eye and preserve the balance of color."[23] Cropsey's *Mount Washington,* on view at the academy in 1855, was praised for "carrying the eye with it a willing captive," but its foreground was described as "raw, harsh, and unpleasant. It cuts the eye like a hundred-bladed knife."[24]

In a remarkable essay about the landscapes on view at the American Art Union exhibition in 1849, a critic identified only by the initials GWP undertook to explain the difference between what he called "copies of nature" and "compositions," or landscapes that ventured beyond mere imitation and were products of an artist's imagination. GWP also described in great detail what he and many of his colleagues understood to be the role of landscape painting in shaping the experience of the eye. As even a cursory examination of contemporaneous criticism makes clear, the claims that GWP made in 1849 persisted in writing and thinking about art for a good long while, at least through the 1860s, despite the dramatic transformations American art witnessed during these years. For these reasons, his essay provides crucial insight into the period's understanding of the relation of landscape representation to vision. It also gives some indication as to why Inness's paintings, especially those of the 1840s and 1850s, were considered so unusual, and why one of them was described as injurious to the eye.

For GWP, a landscape's success was tied to a particular spatial configuration that structured the experience of the eye in a precise fashion. "In the Landscape,"

GWP wrote, "it is too common to see all the interest of the picture thrown into the distance, and the foreground left neglected, and in some instances rendered uninviting." The eye, he continued, "will not consent to overlook the foreground and rest in a vague horizon, howsoever beautiful it may be; it seeks at first a point of repose in that which is near and definite—a base line, as it were, from which to extend its surveys." To facilitate this, the critic said, "there ought to be in the middle foreground an open space on which the vision may *rest*—a patch of lawn or broad surface of rock, whatever the scene may admit, only it must be something on which we may look with a feeling of pleasure in being there; for *there is the place where we must be,* or else the picture is so much dead wall." This place "must not be a rough, unsightly field, or confused heaps of rock or other substance; but an open place, where at least we may stand. Whatever be the character of the picture, this rule is of the first consequence."[25]

A painting, GWP insisted, must provide in its foreground a space for the eye's rest and repose as well as a vantage point from which the viewer may extend his or her surveys—or else "the picture is so much dead wall." In nineteenth-century America, when used in reference to property or land, the word "survey" often connoted ownership, real or desired; foregrounds, GWP implied, could provide for entrance but also imagined or actual possession. From a point on high, the gaze measured and mapped space, making a prospect its own.[26]

In GWP's conception, three zones—the foreground, the middle ground, and the distance (or background; distance was the term most often used in writing about art in the nineteenth century in the United States)—were responsible for bringing this sensation about, and these three zones bore the burden of ensuring that the beholder's vision was evoked and entertained properly. Because it was the beholder's point of entrance as well as the place where viewing commenced, it was essential that the painter configure the foreground properly, making it amenable to imagined visual inhabitation ("*there is the place where we must be*"). The foreground, GWP wrote, "ought always to be conceived and executed so as to afford repose for the eye. There never should aught unsightly, however exact it may be as a copy of nature, come between the eye and the centre of light and interest [the middle ground]. Even where the object of the painting is to fill our minds with some dark or terrible aspect of nature, the artist has no right to ask the beholder to place himself in physically unpleasant circumstances while studying the scene."[27]

The foreground was the subject of much attention and theorization during this period, and Inness's contemporaries, GWP included, were preoccupied with its configuration and role.[28] As we know, the *Knickerbocker* critic found fault with Inness's *Early Recollections: A Landscape* because of what he considered to be the zone's impropriety. Similarly, Church's *Mountain Stream,* wrote the *Literary World* in 1847, was "injured by the careless profusion of black and white touches thrown into the foreground. They are necessary perhaps, but not necessarily obtrusive; it looks too much as if they had been sprinkled from a pepper box or a mad cat had sneezed over the canvas."[29] Critics worried over the

effect the foreground would have on the experience of viewing and whether the foreground zone attended to or defied what were understood to be the laws of vision. Brownlee Brown, for instance, described how artists manipulated their foreground zones so as to accommodate these laws and "affect the sight." "So if the eye is directed toward a distant point," he wrote, "the objects nearer will be seen indistinctly as dark spots, having more or less intelligible form as they are nearer or farther removed from the focus of attention. The artist often chooses to direct our sight and thought to the far or middle distance, and for that purpose he sinks his foreground in shadow, or treats it not in accurate detail, but suggestively, showing only the general character of objects."[30] *Twilight on the Shawagunk Mountain* by Worthington Whittredge, wrote a visitor to the 1865 academy exhibition, "is filled with good intention," "but the eye is painfully afflicted with the superfluous amount of rock-work in the foreground. . . . The sharp edges and points of this picture may possibly possess interest for the geologist, but they occupy so much room that they are somewhat in the way of a more general spectator."[31] "The trees in the foreground" of one of D. W. C. Boutelle's landscapes at the Art Union in 1847, a critic noted, "give one an impression of double sight."[32]

The experience of the eye, GWP stated, depended on the establishment of proper relations among foreground, middle ground, and distance; this was essential if a landscape painting was to evoke an appropriate visual response, and for this reason the middle of a picture was considered almost as important as its foreground space. "If the eye requires to be simply pleased in the foreground," GWP wrote in his essay, "how much more it must be *enchained* in the middle ground, or that part of the picture which is the actual centre and life of the scene—the portion where all its effects are collected and sublimed into an expression of the artist's design." In the middle ground, "nothing should come in to conflict with, or even to obstruct the complete union of the elements. Everything should tend one way, and all should be so broadly and openly expressed as to leave the intention not only out of all doubt, but unmistakably clear and earnest." GWP illustrated this idea by referring to the landscapes on view at the Art Union, and the proliferation of examples he offered his readers reflects the conviction, even obsession, behind his claims. "Imagine in Durand's landscape, No. 203," he wrote, "instead of the group at the fountain, a company of the City Guards shooting at a target! Or scarcely worse, suppose a group of trees to interpose and either half hide the prospect, or so distract us with some peculiar defect or excellence of their own, that we are half indifferent to what is beyond. Our attention will of course be diffused, and we shall be unable to perceive what the artist would have of us—whether he designed to show us a fine picture, or only a fine collection of groups, or an incongruous heap of discordancies." One of the surest ways to avoid this, GWP said, "is to be careful of crowding the centre of the picture. Let there be a wide open passage for the vision, and the surrounding elements and groups which enter into the scene will be much more disposed to combine effectively and harmoniously. What fine

studies, in this respect, must be the landscapes of G. POUSSIN?" Another example: "In COLE's '*Dream of Arcadia*,' No. 909 . . . it seems to us that a greater unity of effect would have been produced by throwing open the trees in some manner from the middle ground, so as to have given more light to that which is the centre of the painting, and permitted the eye an unobstructed range to the distance."[33] And another: the composition of *A Study—Basking Ridge* "draws the eye to the left of the distant ridge. But between the eye and the point of sight comes a belt of green trees which hide the horizon. . . . The eye requires a free scope through the middle of the scene to the end."[34] And yet one more: in *Willow Brook,* what could have been a "pleasing view" turned out to be only a "bad portrait of a tree" because the scene was obstructed. "Here," GWP said, "directly in the centre, between the observer and the sun, a large tree interposes itself, so as to shut out all behind it. One's first impulse is to endeavor to walk aside to get a better view, but the consciousness that it is only a picture, and that the scene cannot be changed gives in a moment a sense of suffocation. The tree plagues the eye; it seems placed there only to be an annoyance; something beautiful is behind it which we are never to see; it is like a horrible false relation coming in the midst of agreeable music."[35] Obstructed middle grounds suffocated and plagued vision and did not allow the viewer to forget he was looking at a picture, imagining himself as occupying and owning its space. That pictures should invite such imagined participation, or visual inhabitation, was a criterion of paramount importance within writing about art in these decades. What allowed for and produced such participation, based, ultimately, on the correct treatment of the eye, was the proper arrangement of compositional zones and the mode of perception that was believed to ensue.

As important as the foreground and middle ground within this construction of composition and sight was the distance. The background zone, GWP insisted, "must be in harmony with the scene, and even in the most rugged views must *attract the eye.* . . . We want warmth, life, beauty."[36] In all landscapes, he said, "there must be a direct road or air line of attraction, where the eye shall naturally fall, and where it can expatiate with a sense of freedom." The poetic power, beauty, and grandeur of a scene "must surround and depend upon this central track of observation. . . . All should combine, in the first instance, to this one central story—the foreground, the middle, and last, though not least, the distance. . . . It mars the effect of a landscape when there is anything interposed which breaks and subdivides the distance in such a manner that we are obliged to take separate *looks* in several directions in order to see the whole. . . . The eye [must have] but one way to look, and that is right through the picture."[37]

In his remarks, GWP said that the landscapes of "G. Poussin" were exemplary in that they allowed for the free and easy passage of vision. During the period, the landscapes of Claude and Gaspar were held up as a pictorial standard within American artistic circles, although, as we have seen, outright imitation was discouraged. Artists studied engravings of their works and, along with a more general audience, read accounts of their lives in illustrated volumes on

art. As the *New York Evening Post* reported, Inness's family owned one such
tome, "an old volume on landscape painting" that "talked of the glories of
Claude" and that Inness "used to read, re-read and dream about."[38]

Landscapes such as Durand's *The Beeches* (1845; fig. 19) and Cropsey's *Au-
tumn—on the Hudson River* (1860; fig. 20), as with Inness's *Landscape,* are or-
ganized according to the example of these seventeenth-century masters. In each,
a darkened foreground area provides ample space for occupation; a smooth rock

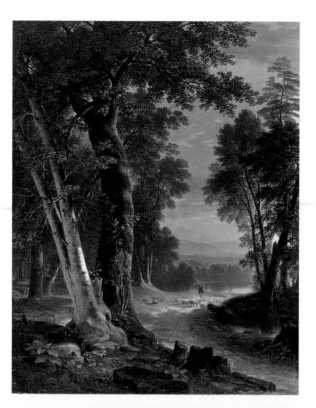

Figure 19. Asher B. Durand, *The Beeches*
(1845). Oil on canvas. 60⅜ × 48⅛ in. The
Metropolitan Museum of Art, New York,
bequest of Maria DeWitt Jesup, from the
collection of her husband, Morris K. Jesup,
1915 (15.30.59). All rights reserved, The
Metropolitan Museum of Art.

Figure 20. Jasper Francis Cropsey, *Au-
tumn—On the Hudson River* (1860). Oil
on canvas. 59¾ × 108¼ in. National
Gallery of Art, Washington, D.C.; gift of
the Avalon Foundation. Photograph ©
2003 Board of Trustees, National Gallery
of Art, Washington.

in the Cropsey provides a place for the viewer to stand. The foreground zone is distinct from the middle ground by virtue of the latter's illumination; in each, the distance is composed of mountains properly dissolved in atmospheric haze. In both the Cropsey and the Durand, the distant sky is a bright but warm yellow; its glow pervades and unifies the whole. Nothing obstructs the passage of the eye from zone to zone; indeed, its traversal is made easy by alternating strips of light and dark, Claudean in origin, that ferry it from foreground to depth in an orderly fashion.[39] Framing elements, or *repoussoirs* (also from Claude and Gaspar)—here, inward-inclining trees—further emphasize the eye's intended route, as does the bright sun or sunlight at the vanishing point of each that, in proper fashion, attracts the eye. Without doubt, GWP would have approved.

Critics throughout the period insisted on the propriety of the Claudean or Gaspardian compositional type and paid close attention to how American artists configured their landscape zones. "It seems to have been [Farrer's] attempt to get general truth of effect," wrote a critic in the American pre-Raphaelite journal the *New Path* in 1865, "that has injured [his painting of Mount Holyoke], and made the foreground so very faulty as it is. The distance is distant and yet brilliant, and the middle distance is made to glow with color;—but at a heavy cost." Exaggerated and gloomy shadows "at a distance of many hundreds of yards from the spectator" appeared too black; spongy and isolated middle-ground trees were "the worst of the separate evils which make up the unsuccessful, unbeautiful, untruthful foreground."[40]

Nineteenth-century drawing manuals and instructional articles on landscape also offered guidelines based on the principles of composition provided by the trizonal paintings of Claude and Gaspar.[41] Even travel guidebooks encouraged readers to perceive nature in terms of the organizing principles of their art. In *The Home Book of the Picturesque,* an illustrated gift book collection of essays on American scenery, published in 1852 and in expanded form in 1868, N. Parker Willis described the landscape around West Point in the following terms: "From every little rise of the road, it must be remembered, the broad bosom of the Hudson is visible, with foreground variously combined and broken; and the lofty mountains, (encircling just about as much scenery as the eye can compass for enjoyment), form an *ascending background and a near horizon* which are hardly surpassed in the world for boldness and beauty."[42] Although by the 1870s, the grip of GWP's formula had loosened considerably (and, because of this, Inness's landscapes would not have appeared nearly as disorderly to their viewers), we need only recall Inness's own formulation of a trizonal rule (as reported by Daingerfield, who became acquainted with Inness in 1884), what amounted to a revised version of GWP's, to know that the notions set forth in the critic's 1849 article still held some sway a number of years hence, at least as a vocabulary or conceptual frame for thinking about organizing a work of landscape art: "From the horizon . . . to the nearest point—the bottom of the canvas—there shall be three great planes; the first two shall be foreground, the

third, or last, shall contain all the distance. The subject matter must not be within the first plane, but behind it . . . herefore trees that find their plane within the first great section are too near, and perforce must be cut off at the base to force them away."[43]

EDUCATING THE EYE

Clearly, what I have been describing thus far amounted to more than concern for nicely and prettily composed paintings. Critics were preoccupied with GWP's zones, for which Gaspar and Claude served as exemplars, not only because they wanted to look at good art but because they believed that looking at good art, especially the kind that treated the eye in a particular manner, was a means by which to learn how to see, to acquire not just good viewing habits but an improved visual faculty. During this period, critics frequently described paintings as instruments of perception and artists as individuals who could and should, through their pictures, reveal things to their viewers. Debates about the zonal configuration and landscape painting, and the forms of looking that both of these things were understood to cultivate, ensure, or derail, were part of a more widespread and ongoing conversation about human perceptual capacity and, in particular, good vision, seeing correctly, and, not surprisingly, seeing spiritually or beyond the surface of things and toward the divine.

Both Henry Ward Beecher, the popular and influential Congregationalist minister and nature writer, who was a friend of Inness's, and Ralph Waldo Emerson, theorist of the transcendental, believed as did Inness that they were witness to a contemporary crisis of vision; each spoke often and passionately of learning to see in a more penetrating and pure fashion, and both thought that art could play a role in this process. "The true artist," Beecher wrote, "is he who perceives in common things a meaning of beauty or sentiment which coarser natures fail to detect. The artist is not an imitator who makes common things on canvas look *just like* common things anywhere else. Artist is Interpreter. He teaches men by opening through imitation the message of deeds, events, or objects so that they rise from the senses . . . and speak to the higher feelings."[44] "It has been the office of art to educate the perception of beauty," Emerson wrote. "We are immersed in beauty, but our eyes have no clear vision."[45] "As the eyes of Lyncaeus were said to see through the earth," he said, "so the poet turns the world to glass, and shows us all things in their right series and procession."[46] Others shared this view. "The Painter," stipulated John Durand and William Stillman in the *Crayon*, which they coedited, "shall be regarded as the Seer of the Beautiful, and shall be looked to as the instructor of that perception, who shall teach us what to see and how to see it . . . [thus providing] the very guides by which their blind brethren might be made to see."[47] The Reverend W. S. Kennedy and Russell Sturgis concurred. The artist's insight, said the former in an 1859 essay on the development of American art, reveals whole new worlds to the viewer, so that he "feels like the man whose eyes the Redeemer

his sketch, as groups of foreground objects with glimpses of the middle ground and distance."[56] "In landscape," the *Crayon* reported, "we generally begin with foregrounds, and the poet, as the painter, should paint them well before he goes further."[57] In order to become a true landscape artist, Durand insisted in his partly instructional and partly theoretical "Letters on Landscape Painting," published in serial form in the *Crayon* in 1855, in order to paint something other than "unmeaning scrawls," one had to begin at GWP's suggested place of repose and survey: "Proceed then," he wrote, "choosing the more simple foreground objects—a fragment of rock, or trunk of a tree. . . . This purpose, that is, the study of foreground objects, is worthy of whole years of labor; the process will improve your judgment, and develop your skill—and perception, thought, and ingenuity will be in constant exercise."[58] After mastering the foreground, he instructed, move on to larger expanses, to the middle ground, and finally, to mastery of the distance and effects of atmosphere. Seeing nature, representing landscape, and looking at pictures, stipulated Durand and the other writers cited, began in the foreground; the path to truer sight, they implied, began there as well. The foreground, then, not only bore the burden of the eye's initial entrance and repose but was described, as well, as the place where perceptual and phenomenological relations between painting and beholder were constructed. As such, it was taken to be the all-important jumping-off point for the cultivation, through drawing, painting, and, ultimately, viewing, of penetrating sight.

ROUGH UNSIGHTLY FIELDS AND CONFUSED HEAPS OF ROCK

Inness knew the art of Claude and Gaspar well and often paid homage to it in his own work. It is hard to imagine, then, that he was unaware of the connections his contemporaries had drawn between the zonal configuration derived from their landscapes and the education of the eye or the consequent cultivation of penetrating sight. Inness was probably also familiar with the connections that drawing manuals made between structures of drawing and structures of vision, learning to draw and learning to see. Largely self-taught, he appears to have made use of these texts at the outset of his career, for in his earliest paintings he employed techniques recommended therein. In *Storm Clouds, Berkshires* (1847; fig. 21), for instance, he adopted the schematic and generalized tree and leaf types recommended by books on landscape drawing. The middle-ground maples or elms closely resemble those illustrated in Otis's *Easy Lessons in Landscape,* and the bright green plants that line the foreground path at right match the sketches of foliage types recommended for foreground decoration in numerous volumes.[59]

Yet, and this will come as no surprise, Inness did not follow the rules. Despite accusations of mannerism, he had little interest in reproducing the compositional type touted by GWP and exemplified by the landscapes of his seventeenth-century predecessors. His paintings organize space and coordinate forms in a manner that seems deliberately opposed to the dictates of this convention.

Figure 21. George Inness, *Storm Clouds, Berkshires* (1847). Oil on canvas. 40⅛ × 54¼ in. Fisher Gallery, University of Southern California, Los Angeles. The Elizabeth Holmes Fisher Collection. Photograph courtesy of USC Fisher Gallery.

In the 1840s and 1850s, his pictures were indeed, for their time and place, freaks.

The Sun Shower, executed in 1847, just a few years after Inness's professional debut, is a strange painting (plate 8). Inness seems to have had trouble deciding whether to render the terrain of the Roman *campagna* or that of the Berkshires, an autumn scene or one from early spring, a lush meadow or a patchy pock-marked lawn. What he created is a haphazardly organized and garishly colored landscape, littered with scraggly shrubs, an erratic boulder or two, and several lackadaisical sheep. Atmospheric perspective starts entirely too soon, and objects diminish in size far too quickly, so that the sheep in the foreground, the one that looks up at us sleepily, appears much too large in relation to his keeper, the shepherdess seated on the grass to the right, even more so in relation to the sheep grazing under the tree. This tree, of course, is the strangest feature of all: too large for its surroundings, it appears plunked down, unmotivated, out of its element, and generally in the way. A path and a narrow strip of lake, at right; crisscrossing fences in the middle distance; ridges dotted with trees at far right and left; scattered rocks and boulders; an abrupt division between the green and gold central meadow and the grayish-green hills in the distance; a random smattering of rock, shrub, and grass in the foreground; and, finally, the unusual central tree: these elements transform this scene into something that resembles a crazy quilt, an expansive field irregularly divided and then divided again. As GWP would have put it, "A fine collection of groups, or an incongruous heap of discordancies" replaces any "direct road or air line of attraction" or "central track of observation," giving the eye far too many places to go.

In *Hackensack Meadows, Sunset* (1859; fig. 22), one of Inness's most beautiful early works, space consists of an accumulation of zones created by at least three paths that recede into the center distance (two that originate at left, one that begins toward the foreground at right); by a stream that traverses the foreground space and establishes the canvas's primary dividing line; by alternating strips of light and dark green paint at left; by a row of shrubs that separates the right middle-ground meadow from the more distant, and yellow-gold, background; by the screen of trees, a house, and two haystacks that designate the horizon, partially obscured by a central clump of trees; and finally, by the dark shadow cast by these trees that lies perpendicular to the rightmost path. Paths invite in, but the canvas's manifold and confused spatial zones and its centrifugal structure compromise any fantasy of entrance and traversal, as does the stream, the outward flow of which contradicts the viewer's impulse to penetrate the scene visually or imaginatively.

Even into the late 1860s, by which time landscape practice in the United States had changed enough so that his paintings may not have qualified as outright "freaks," Inness persisted in employing those strategies he developed in

Figure 22. George Inness, *Hackensack Meadows, Sunset* (1859). Oil on canvas. 18¼ × 26 in. Collection of the New-York Historical Society (S-22).

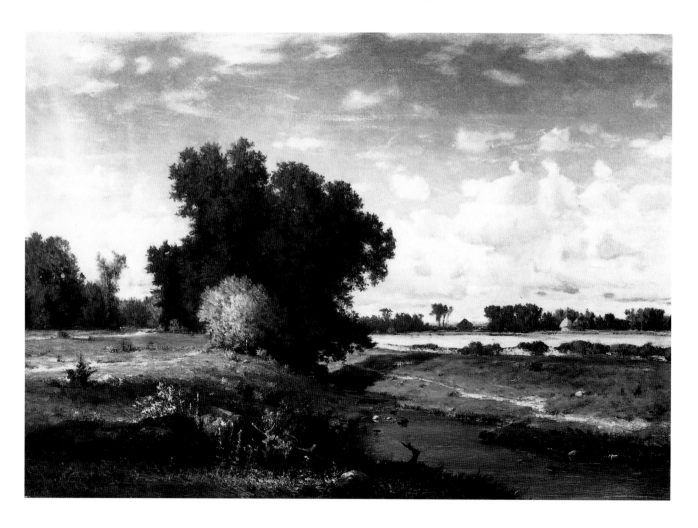

reaction to the principles elucidated by GWP, as if he understood these principles to be a necessary presence in his art, even if by virtue of their rejection or absence. In *Landscape with Cattle and Herdsman* (1868; fig. 23), a farmer leads his herd down a dirt road and across a green meadow; a few animals stop to drink from a muddy stream that runs alongside and slightly below the road while others graze in the open field. Two houses sit behind a row of shrubs at right; mountains, cloaked in a purple-gray haze, are visible in the far distance. The foreground, bounded on either side by diagonal elements (the stream and the fence) that originate in the middle distance slightly to the left of center, seems to expand into the viewer's space, as if the dirt road were coextensive with the beholder's realm. As in numerous of Inness's landscapes of the time, including *The Lackawanna Valley* (ca. 1855; fig. 24), *A Passing Shower* (1868; fig. 25), *Landscape with Cattle* (1869; fig. 26), *Lake Nemi* (1872; plate 9), *The Alban Hills* (1873; fig. 27), and *Hillside at Etretat* (1876; fig. 28), a foreground path provides an entrance point for the eye or, as GWP put it, a "point of repose," an "open space on which the vision may rest [and] we may stand."

Figure 23. George Inness, *Landscape with Cattle and Herdsman* (1868). Oil on canvas. 24¼ × 34¼ in. Montclair Art Museum, Montclair, New Jersey. Museum purchase; Lang Acquisition fund, 1946.11.

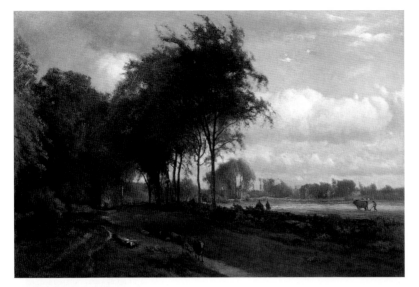

Figure 24 (*opposite, top*). George Inness, *The Lackawanna Valley* (ca. 1855). Oil on canvas. 33⅞ × 50³⁄₁₆ in. National Gallery of Art, Washington, D.C.; gift of Mrs. Huttleston Rogers, 1945. Photograph © 2003 Board of Trustees, National Gallery of Art, Washington.

Figure 25 (*opposite, bottom*). George Inness, *A Passing Shower* (1868). Oil on canvas. 26 × 40 in. Canajoharie Library and Art Gallery, Canajoharie, New York. Courtesy of the Canajoharie Library and Art Gallery.

Figure 26 (*top*). George Inness, *Landscape with Cattle* (1869). Oil on canvas. 20 × 30 in. Los Angeles County Museum of Art; gift of Dr. and Mrs. Christian Title (M.91.309.2). Photograph © 2004 Museum Associates/ LACMA.

Figure 27 (*center*). George Inness, *The Alban Hills* (1873). Oil on canvas. 30 × 45 in. Worcester Art Museum, Worcester, Massachusetts. Museum purchase with a gift from the Lucius J. Knowles Art Fund.

Figure 28 (*bottom*). George Inness, *Hillside at Etretat* (1876). Oil on canvas. 25¾ × 38⅛ in. In the Collection of the Corcoran Gallery of Art, Washington, D.C.. Purchase, William A. Clark Fund.

In *Landscape with Cattle and Herdsman,* however, the effect of opening up, the sensation that the bottom quarter of the canvas stretches itself so as to embrace its beholder, exists in sharp contrast to the painting's larger effect. Although its right distance alludes to the panoramic, the scene is composed of numerous spatial compartments set off from one another by boundary elements that serve to divide and subdivide space, requiring "separate looks in several

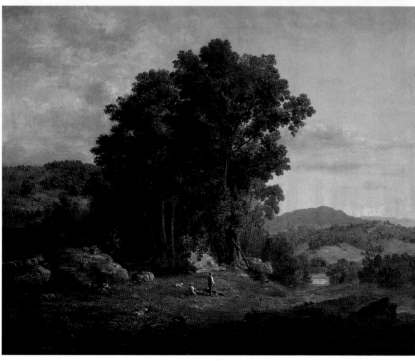

Figure 29. George Inness, *Landscape with Fishermen* (1847). Oil on canvas. 25 × 36 in. Santa Barbara Museum of Art; gift of Mrs. Tracy W. Buckingham.

Figure 30. George Inness, *The Wood Chopper* (1849). Oil on canvas. 50.5 × 60.6 cm. © The Cleveland Museum of Art, 2003. Mr. and Mrs. William H. Marlatt Fund (1963.501).

directions in order to see the whole." The road invites the viewer, or at least his "eye," to step into and wander about the scene, but imagined entrance and traversal is complicated by the painting's disjointed configuration and by the forward, stalling motion of the blank-faced herdsman and his equally featureless charges. Nothing, insisted GWP, should intervene in the space between "the eye and the point of sight," least of all "a belt of . . . trees which hide the horizon." In *Landscape with Cattle and Herdsman,* however, a screen of bright green trees and shrubs halts the eye's passage and divides the canvas into two slightly unequal halves. "Be careful of crowding the centre of the picture," GWP warned. A dilapidated fence further fragments the painting's space; it intersects a somewhat isolated stand of trees at the canvas's heart that, "indifferent to what is beyond," prevents the eye's free range. We saw such a stand in *The Sun Shower;* similar groupings that "interpose and either half hide the prospect or, so distract us," appear in a number of Inness's works, including *Hackensack Meadows, Sunset* (fig. 22), *Landscape with Fishermen* (1847; fig. 29), *The Wood Chopper* (1849; fig. 30), *A View Near Medfield* (1861), and *Landscape, Sunset* (1870), as if he was intent on interrupting what GWP stipulated should be vision's easy and unimpeded course. The centered trees in *Early Recollections: A Landscape* (fig. 16) seem to mock the critic's charge; they part only slightly, creating a small aperture at the canvas's heart, thus giving the eye a place to go but forcing it to squeeze through a mere tunnel of space.

In *Evening Landscape* (1862; fig. 31), *The Road to the Farm* (1862; fig. 32), and *Winter Moonlight (Christmas Eve)* (1866; fig. 33), Inness divides his canvas horizontally in two. As in *Landscape with Cattle and Herdsman,* a screen of trees and houses sits at the horizon, and in each, a road fills the canvas's bottom half and opens into the viewer's space. A series of diagonals—dirt paths, a log, a row of shrubs, a line of trees, wagons, wagon-wheel tracks, approaching or retreating figures and animals—reiterates and reinforces the outward and expanding thrust of the triangular foreground space as well as its inward and inviting pull. In *Winter Moonlight (Christmas Eve),* an isolated and bare-limbed tree stands to the right of center, its uppermost branches silhouetted against the white light of the winter moon. As in *Landscape with Cattle and Herdsman,* the middle-zone screen of trees is of greater height toward the left; further extension in depth is implied at right, and one can imagine looking past the shorter wall of blackened-green into deeper space. The triangular and snow-encrusted foreground, bordered on the right by a stone wall that passes through the single slightly off-center tree and on the left by a dark shadow cast by a ridge in the frosty ground, seems to expand into or encircle the viewer's space. Inness, however, complicates and counteracts this gesture. Subdividing elements—the stone wall and numerous and repeating ridges and furrows in the frozen field—compromise breadth and, along with white, gray, and orange paint that hovers at the canvas's surface, serve to flatten and verticalize what looks like it ought to be receding into horizontal depth. As in *Winter Moonlight (Christmas Eve),* in *The Road to the Farm,* a figure, his back turned to the viewer,

solicits imagined inhabitation, his pose reproducing ours as we stand in front of the canvas and look, even as his lack of address signals the painting's recalcitrance. Similar back-turned or gazing farmers, herdsmen, picnickers, tourists, peasants, woodchoppers, fishermen, and children are scattered throughout Inness's canvases. In *The Lackawanna Valley,* a young man reclines in the left foreground, his back to the viewer, his feet intersecting a path that originates in the beholder's space. His gaze reproduces ours as we look at the landscape scene. Two figures in *The Wood Chopper* adopt a similar pose and look past the trees at center toward the distant hills to the right; so too their counterparts in *A Passing Shower, Lake Nemi, Sunset at Etretat* (plate 6), *Landscape, Hudson*

Figure 31 (*top*). George Inness, *Evening Landscape* (1862). Oil on canvas. 48 ½ × 66 ¼ in. Permanent Collection, Museum of Art, Washington State University, Pullman, Washington; gift of Dr. and Mrs. William E. Boeing.

Figure 32 (*bottom*). George Inness, *The Road to the Farm* (1862). Oil on canvas. 66.04 × 91.44 (26 × 36 in.) Museum of Fine Arts, Boston; gift of Robert Jordan from the collection of Eben D. Jordan (24.221). © 2003, Museum of Fine Arts, Boston.

Figure 33 (*opposite, top*). George Inness, *Winter Moonlight (Christmas Eve)* (1866). Oil on canvas. 22 × 30 in. The Montclair Art Museum, Montclair, New Jersey. Museum purchase; Lang Acquisition Fund, 1946.29.

Figure 34 (*opposite, bottom*). George Inness, *Landscape, Hudson Valley* (1870). Oil on canvas. 30 × 45 in. Cincinnati Art Museum; bequest of Frieda Hauck.

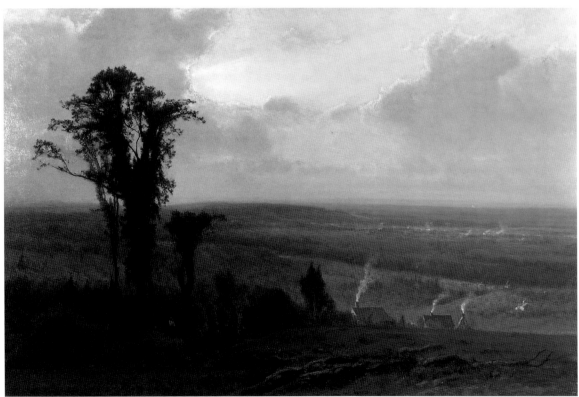

Valley (1870; fig. 34), *Midsummer Greens* (1856), and *The Juniata River* (1856). These figures encourage what GWP referred to as looking "with a feeling of pleasure in being there," yet do so in the midst of obstructing and dislocating structures and motifs.

GWP insisted that "the artist has no right to ask the beholder to place himself in physically unpleasant circumstances while studying the scene," yet Inness's landscapes are often precisely what the critic said they should not be, that is, rough unsightly fields or confused heaps of rock. The near zone of *The Sun Shower,* for instance, is nothing but an expanse of weed-filled and pebble-strewn dirt, and *Winter Moonlight (Christmas Eve)* welcomes its viewer with ungainly ridges of frozen and barren soil. In *Landscape with Fishermen,* Inness provides no place for the eye to repose, for he fills the foreground area with wind-whipped water; the viewer must hover, as it were, above the scene. Inness often used a body of water or a stream to deflect or complicate imagined entrance, assigning to the front spaces of his landscapes a double, and seemingly contradictory, function. In treating his foregrounds in this manner, he confounded expectation, as if deliberately challenging the zone's eminent status and role, thus transforming the relation between painting and beholder that was supposed to be established therein. Even if the eye were to make it to the middle ground of *Landscape with Fishermen,* its traversal would be halted by the central stand of trees, and its journey into the distance complicated by unconventionally configured space. It is difficult to discern what lies beyond the middle-ground boulders and trees. Flattened strips of land combine with rocky ridges and rolling hills to create an ambiguous and eclectic terrain, nothing like the smooth and uniform distances in landscapes by Claude or Gaspar or by Inness's contemporaries, Cropsey and Durand. Space is not organized in terms of serially progressing zones; the eye roves about these landscapes with no direction, its erratic perambulation guided by meandering figures, cattle, fences, streams, and paths.

Traversing, back-turned, or gazing figures; foreground roads that lead into, or from, the viewer's realm; compartmentalized, and often confusing, space; central, and patently strange, stands of trees; barrier-like middle zones composed of screens and inhabited by houses and barns; expanding, and recalcitrant, foreground spaces: these structures and motifs appear and reappear in Inness's pictures prior to 1875 (and in his paintings of Italian scenery from around 1875 and 1876, which I group with this earlier set of works) and are typical of his production at the time (and of subsequent work, as well). Inness was not, of course, the only artist during this period to incorporate such features into his landscape paintings.[60] He, however, included them with unmatched frequency, as he did his middle-tone horizon zones in the 1870s on, and he did so consistently, almost obsessively, throughout the first three decades of his career.[61] He was exceptional, also, for painting pictures that seemed to attend so scrupulously to some of GWP's recommendations while turning the rest of the critic's formulation on its head. What motivated this

compulsion? What explains the recurrence of the features I have just described? And why would an artist try so assiduously, as Inness appears to have done, to confound the very formula that was supposed to guarantee good viewing and good sight?

CIVILIZED LANDSCAPES

Recall that Inness was chastised for depending too much on the example of the past, even as his output was described as original and unique. This was the case, we now know, because he did and did not pay attention to convention and to GWP and, I want to claim, because his allusions to past art were at once familiar and strange. As his manipulation of the highly theorized foreground zone suggests, his project depended on an attention to tradition, but it also depended on tradition's strategic reconfiguration. Inness borrowed compositional devices and motifs from old master landscapes but transfigured their function as well as their appearance. In his landscapes the past did indeed persist but in a radically altered form.

In his 1878 interview "A Painter on Painting," Inness declared that "some persons suppose that the landscape has no power of communicating human sentiment. But this is a great mistake."[62] "The civilized landscape," he continued, "peculiarly can, and therefore I love it more and think it more worthy of reproduction than that which is savage and untamed. It is more significant. Every act of man, everything of labor, effort, suffering, want, anxiety, necessity, love, marks itself wherever it has been. In Italy I remember frequently noticing the peculiar ideas that came to me from seeing odd-looking trees that had been used, or tortured, or twisted—all telling something about humanity. American landscape, perhaps, is not so significant; but still every thing in nature has something to say to us."[63] Inness preferred "civilized" landscapes, both real and painted, because they bore the mark of history and brought to mind—recalled—the activities and emotions of their inhabitants, because they were recognizable, or made familiar, by virtue of their use and evoked a chain of recollections on the part of their beholders.

During this period, landscapes and the natural features in them were often spoken of in such terms. The capacity of recollection was assumed to bear an important relation to the making and viewing of landscape art. Critics praised landscape artists who exhibited acute and accurate visual memory; memory and memorization skills were understood to play a vital role in drawing instruction; writers on art demanded that paintings, especially landscapes, insinuate themselves into their beholders memories (what amounted to what might be termed a "memory criterion"); and paintings were frequently described as catalysts to recall, the experience of looking at them as evocative of memories, personal as well as cultural or historical.[64] In his *Book of the Artists* (1867), for instance, Henry Tuckerman said that, when looking at a landscape, the viewer becomes lost "in a retrospective dream of country life."[65] In a how-to essay on

private picture galleries, the Reverend J. Leonard Corning wrote that a "prisoner bound with golden chains for the greater part of the year within the walls of his Wall Street office or his freestone jail on Fifth Avenue has a right to relish painted trees and brooks and cattle on his parlor walls."[66] One of the "chief things which make landscape paintings sources of joy," he continued, "is their association with our own experience. Think for a minute how we prize that bit of canvas, daubed over by a rustic artist, which roughly reproduces the home of our childhood."[67] "Every man who has lived in the country and made his fortune in the city," observed Samuel Osgood in *Harper's New Monthly Magazine* in 1864,

> must be haunted by charming scenes about the old homestead that he would gladly keep before him in his more artificial life. What would you or I give, dear reader, to get hold of Kensett, Hart, Colman, Inness, Haseltine, Cropsey, Casilear, Gignoux, Bierstadt, or Church for a month or two, so as to have them take suitable sketches of the charmed spots about the old country home, and in due season enshrine them in gems of choice art that would make great Nature our household friend, and carry into the shady side of life all the sunshine and witchery of our early days.[68]

Inness's remarks on the civilized landscape have been taken by scholars as explanation for his preference for painting pastoral scenes in which nature and civilization peacefully coexist, instead of images of the untamed wilderness.[69] However, his belief that the American landscape was relatively insignificant compared to that of Europe constituted more than a pronouncement on subject matter. In fact, his statement was a version of an oft-expressed lament over the new world's lack of historical, or human, association, that is, its lack of memory, and it echoed and incorporated the idea expressed by critics at the time that landscape and memory were inextricably linked. Numerous writers during the period under discussion expressed anxiety about, or celebrated, American scenery's dearth of associative value. Nathaniel Hawthorne, for example, in the preface to his novel *The Marble Faun* (1860), a story of American sculptors in Rome, stated that America did not offer a proper setting for a romance for it did not boast the trappings necessary to such a narrative: "No author, without a trial, can conceive of the difficulty of writing a romance about a country where there is no shadow, no antiquity, no mystery, no picturesque and gloomy wrong, nor anything but a commonplace prosperity, in broad and simple daylight, as is happily the case with my dear native land. . . . Romance and poetry, ivy, lichens, and wall-flowers, need ruin to make them grow."[70] In an essay on the scenery of the Franconia Mountains, William M'Leod expressed regret that what he called a "scene of primeval nature and solitude," Franconia Notch, was not associated with any storied event: "Would that its stupendous scenery were linked with mighty incident, and that its rare loveliness were clothed with the sacred vestment of traditionary lore! But alas! its magnificent grandeur and

picturesque beauty, so fitted to figure in Indian romance or the settler's legend is sadly deficient in the hallowing charm of historic or poetic association!"[71] An "important influence upon the development of art in America," wrote a critic in 1851, "is that occasioned by the want of a picturesque past history."[72]

Inness's admiration of the tortured and twisted trees of Italy and his preference for landscapes that recollected past events and emotions were part of this ongoing debate about landscape's evocative and recollective force. We might say, then, that the centered and isolated, craggy and time-worn trees in works like *The Sun Shower* and *Landscape with Cattle and Herdsman* were intended to evoke ideas of past human activity and emotion, attempts at instilling memory in the American landscape. Yes, but Inness's civilized landscapes are much more complicated, and much more interesting, than this. At a time when landscape paintings were understood in terms of memory's function, Inness, who said that the better picture was the one that did not want for associations, developed what I would term a strategy of recollection, one that amounted to a structure or strategy of perception and that made deliberate and strategic use of the art of the past. Viewers recognized this past but not without reservation or discomfort, for the familiar (GWP, the old masters) was reconfigured in his works so that the experience of memory was rendered uncertain, even disorienting—not a pleasurable swoon into sweet recollection, as Tuckerman, Corning, or Osgood would have it, but a troubling, even uncanny, encounter with the strange but known. It was this model of viewing and vision, not GWP's, that Inness undertook in his landscapes to construct and convey. And it was those motifs that recur throughout his earlier work, as described in the preceding sections, that he employed in his effort to make his paintings at once familiar and strange.

Let me explain what I mean by way of example: The isolated trees in landscapes such as *The Sun Shower* and *Landscape with Cattle and Herdsman* refer to a conventional framing device, the *coulisse* or *repoussoir*, in a new and unfamiliar context and capacity.[73] In the landscapes of Claude and Gaspar, strategically placed trees, mountainsides, cliffs, or picturesque ruins frame the scene and prevent one's eye from wandering, directing it toward and through the canvas's heart. Pushed from the wings to center stage, Inness's trees, rather than helping guide the eye, only obstruct its passage. Alternating zones of light and dark in *Hackensack Meadows, Sunset* (fig. 22) and other of Inness's canvases of this time also refer to their seventeenth-century origins but bear little resemblance to and serve a different function than similar strips in the landscapes of Claude. As John Barrell has described, such a structure led the viewer, who compared one area to the next and so forth, into and through a scene.[74] Light and dark contrasts in Inness's landscapes, however, flatten and confuse space. Similarly, Inness's back-turned figures refer to the *staffage* figures of old master landscapes but eliminate or compromise the gestures (uplifted and pointing arms) and the directionality of gaze that were meant to aid and ensure

the eye's easy-going passage through a scene. The figures in *The Sun Shower* do not interact with the viewer or with one another; indifferent to us and to their surround, they provide little clue as to where we are to train our look. The red-vested and reclining figure in *A Passing Shower* (fig. 25), who looks away from us and across the landscape yet turns his body so that it faces or addresses the viewer, points up the manifold and complex nature of identification Inness's canvases hold forth, as do the many and varied back-turned surrogates in *Lake Albano* (1869; fig. 35) and the barely sketched figure in *Landscape, Hudson Valley* (fig. 34) whose slight and slurred body seems unable to bear the burden of our identificatory gaze. It is as if this figure is embarrassed by his duplicitous function, convincing us that we know him from somewhere but then denying full recognition, refusing to own up to the fact that we have seen him before. For we have, and we have not—such is the nature of Inness's recollective strategy, wherein timeworn formulas are evoked but then transmuted so that they hover just beyond memory's conscious grasp. Inness did not reject the past of painting, nor did he give it his full embrace; rather, he acknowledged it by way of barely graspable allusions that made his viewers have to think twice (and

Figure 35. George Inness, *Lake Albano* (1869). Oil on canvas. 30 3/8 × 45 3/8 in. The Phillips Collection, Washington, D.C.

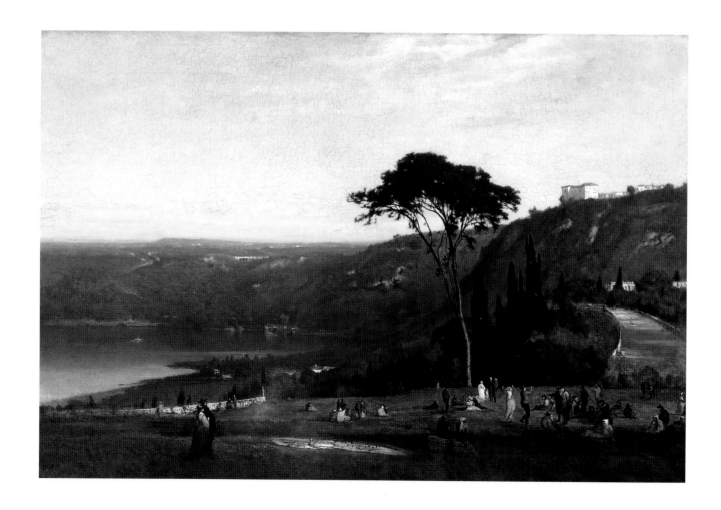

that compelled his critics to accuse him of mannerism even as they praised and/or derided him for bucking convention).

It was the commentator who called Inness's paintings "reminiscences," mere ghosts of the art of past masters, who came closest to understanding what I want to argue Inness meant to produce by way of the unconventional and peculiar motifs and configurations we find in these early works. For this critic described the relation of Inness's landscapes to those of Gaspar not as a relation of imitation or emulation, but of remembrance. Inness's landscapes, he suggested, evoked, but did not imitate, did not make fully present, the art of this seventeenth-century master. It is precisely this effect—one of allusion, wherein the art of the past is called to mind but not fully instantiated, wherein the familiar is invoked yet rendered unfamiliar and strange (I have seen that before but I am not sure where or as what)—it is this effect that I would argue Inness was after in pictures like *The Sun Shower* and *Landscape with Cattle and Herdsman,* paintings that misappropriated and recontexualized, reconfigured and *dis*figured tradition and convention, the old masters and GWP. In these landscapes, motifs that the nineteenth-century gallery-goer, steeped in engraved and gift book images of old master art and perhaps familiar with art criticism as well, frequently encountered elsewhere, would have activated an operation of recall—yet transformed, dislocated, and deformed, these motifs complicated such a process, making both recollection of the past and misrecognition, a not quite right déjà vu, vital aspects of the experience of Inness's art. Reminiscences, not copies: it is as if in distorting, displacing, and reconfiguring the art of his predecessors, Inness hoped to provoke in his viewer the memory of a past experience but wanted this viewer to struggle to make this vague and misshapen memory more clear. A writer in the *Crayon* described such a process when he wrote that "a landscape, unknown to us, assumes under [the artist's] pencil known characteristics—we have seen the like before."[75]

"The thousand remembrances which rise over the soul"

To return to the question that opened this chapter: Why? If all that I have been describing amounted to a structure or strategy of memory and viewing, what did Inness understand to be its end? What motivated Inness's strategic reconfigurations and misrecollections? What did he hope to gain by provoking but stymieing recall, and why make this troubled provocation such a conspicuous aspect of his art?

As it turns out, the structure of perception (allusion, recollection, disorientation) evoked by Inness's landscapes, what he seems to be proposing should happen when viewing his paintings, is strikingly similar to a mode of vision characterized by his friend the Reverend Beecher in his many essays on nature, spirituality, and art. This mode of vision, described by Beecher by way of accounts of and encounters with landscape scenery, penetrated beyond the surface of things and toward the divine. This was a spiritual vision that would

allow its possessor to see, but also to see with God. Beecher described it like this: "What a man sees in Nature . . . will therefore depend on what he has to see with. . . . If he have all his physical senses, and nothing more, he will see the rind and the husk of Nature. . . . If he add imagination, he will find yet deeper insight; if feeling, deeper yet; if religious feeling, more profoundly; and if he hold all these up against the background of the Infinite, then indeed, to his unspeakable satisfaction, the heavens declare the *glory of God,* and the firmament showeth his handiwork."[76]

The fact that Inness was acquainted with Beecher has been noted in almost every study of the artist's career, yet no real attempt has been made to determine exactly how Beecher's thought might have influenced or shaped Inness's practice. Without taking into account the precise relationship between Inness's early landscapes and Beecher's work, our understanding of Inness's project in the 1840s–60s and, more broadly, our grasp of religion's place in American visual culture, and within the development of American aesthetics, must remain incomplete.[77] For it was a version of Beecher's model of good viewing and vision, not GWP's, that Inness most closely approximated by way of his landscapes, and it was Beecher's understanding of expanded visual capacity that provided a template for Inness's manipulation of the past and his transformation of GWP's configuration in these works. Paying attention to what Beecher had to say about perception, then, will tell us a great deal about the "why" of Inness's recollective strategies, about his wish to generate vision by way of misremembering in his art.

In many of Beecher's essays, written in the 1840s and 1850s for various newspapers and then gathered together in two books, *Star Papers* (1855) and *Eyes and Ears* (1862), a series of descriptions of perceptual experience form the armature for a characterization of the operations of this spiritual, truth-getting, world-penetrating sight. In these cases, Beecher does not say what he sees, but *how,* and in each case, memory plays a role. In the essay "Niagara Falls, but Not Described," from *Eyes and Ears,* he wrote:

> I was conscious, that I did not so much see simply the Falls, as, seeing them, feel *thousands of associations* which they touched and vivified. And it seems that, besides their wondrous quality of beauty and force and grandeur, they have a yet more wonderful power of *suggestion.* Thus, while I was steadily gazing at these perpendicular waves, and thought that I was really *seeing* them, the mind had glanced back, and was experiencing a strange sense of the length of years, and unending, unintermitted work. For ages before an eye saw them, long before even an Indian wandered toward their mysterious thunder,—while Columbus was steering westward, while battles were destroying Rome, while Romans were sacking Jerusalem, while Israel wandered in captive lands, while David was penning in his psalm, "The voice of the Lord is upon the waters . . . ,"—these mighty falls were making their solemn chorus. . . . Then one wonders what the sensations

must have been of the millions of diverse minds that have thronged these banks, in all degrees of capacity and sensibility, in all moods of sobriety and sorrow, in all experiences of gayety and joy.[78]

Here, looking at nature involves a process of recollection, and remembering replaces physical vision. While gazing at the falls, Beecher's mind "glanced back" and, rather than seeing the view before him, he apprehended a series of images from the past: Indians, Columbus, Rome, the Israelites, David and the Psalms, the millions of people who had visited the site before him. Beecher filled his *Star Paper* essays with descriptions of this kind, wherein the external world is not a thing seen but an instrument of evocation, memory, and, ultimately, insight. "Certain places," he wrote in "A Ride to Fort Hamilton," in *Star Papers,* "[such as] nooks in a mountain side, clefts in rocks, sequestered dells— have their imputed life. Whenever we come back to these places it is as when one reads old letters, or a journal of old experiences, or meets old friends, that bring thronging back with them innumerable memories and renewed sensations of pleasure or sadness."[79]

Beecher takes his cue here from Archibald Alison's theory of association as expounded in the latter's influential and widely read *Essays on the Nature and Principles of Taste* (1790), wherein Alison undertook to explain the mental processes by which the beautiful and the sublime in nature and art were perceived and enjoyed.[80] The imagination, and the series of ideas that qualities in objects provoked, rather than the qualities themselves, he argued, generated the emotions of taste:

> Thus, when we feel either the beauty or sublimity of natural scenery . . . we are conscious of a variety of images in our mind, very different from those the objects themselves can present to the eye. Trains of pleasing or of solemn thought arise spontaneously within our minds; our hearts swell with emotions, of which the objects before us seem to afford no adequate cause; and we are never so much satiated with delight, as when, in recalling our attention, we are unable to trace either the progress or the connection of those thoughts, which have passed with so much rapidity through our imagination.[81]

These associations, "seem often," he said, "to have but a very distant relation to the object that at first excited them; and the object itself appears only to serve as a hint, to awaken the imagination, and to lead it through every analogous idea that has place in the memory."[82] Aesthetic pleasure, thus, consisted of the evocation of trains of thought, associated memories of past experience and emotion stimulated by the perception of nature and art. This kind of aesthetic pleasure, in Beecher and, I want to argue, in Inness, was a precondition for and an approximation of spiritual sight, the ability to see beyond husk, rind, and surface (Niagara) and toward a series of more profound truths.

Inness, who expressed his preference for tortured and twisted trees and civilized landscapes, was one of many artists and writers in nineteenth-century America, Beecher included, whose understanding of nature's significance was shaped by Alison's theory and who proposed that looking at the natural world, or pictures of it, involved recollection, wherein the very act of perception initiated an operation of memory, the end result of which was pleasure, intelligence, and sight. A writer by the name of James Henry spoke in the *Crayon* of what he called that "peculiar mnemonic tendency of the mind, to write its whole history on . . . a favorite tree or a bench beneath its shadows [which is] so strong a necessity of our nature, that our material surroundings become identified with our whole being."[83] "It is a remarkable truth," he said, "that in our communings with the choicest localities of nature, every spot becomes a teeming record of past recollections":

> A portion of the individual is thus infused into Nature, while, at the same time, she herself becomes absorbed by him, and this mutual interchange constitutes what Humboldt terms the *magic* of her operations. . . . Thus, the sombre woodland receives an impress from the mind, which recalls, whenever addressed by it, a thousand associations of feeling and intellect. The silent group of trees addresses the well known visitor by the force of those accumulations of past thought recorded amongst them. They exist no longer, the sensuous objects of symmetry and color, but speak by an intelligence which man himself has given them.[84]

Associationism was a nineteenth-century habit of mind (or vision); Inness's viewers would have come to his pictures, which made the operation of the memory a critical part of their viewing, with an implicit understanding of the role of recollection in the experience of perception. This was certainly the case for a *Post* critic who spoke of Inness's pictures at the 1865 academy exhibition in terms of the associations they evoked: "That sumptuous afternoon and evening glow, which transfigures our most familiar country fields at times in the full-hearted summer, when the rapt silence and balmy repose of the fragrant meadows fills us with unutterable dreams and associations—that 'Abendroth' or evening red of the German poets, burning behind the large, leafy elms—with a cottage here and there . . . or a little pool reflecting the sky, or a farmer with his sheep or his sows, 'plodding homeward his weary way.'"[85] For Inness's beholder, looking at nature and at pictures was almost always a matter of memory; he seems to have counted on this fact in devising what I am calling his strategies of imitation and association. In keeping with Beecher's model of penetrating sight, wherein recollection replaces physical vision, Inness's allusions in *The Sun Shower, Landscape with Cattle and Herdsman,* and other paintings from this period—allusions that I am saying were meant to provoke a chain of associations (of old master pictures, of the experience of other people's art)—were to facilitate aesthetic pleasure and, eventually, spiritual sight.

It was Beecher's texts, then, along with numerous other nineteenth-century voices, that I would say gave Inness an idea as to what landscape was supposed to do and how. Beecher and others gave Inness a charge: make landscape a vehicle or instrument of good sight; show us God with your paint and make us see like he does. It was Beecher alone, however, that gave Inness an exact idea as to how he should get at (evoke, represent, instantiate, suggest) the operation of spiritual sight through his art, and it was Beecher who laid the groundwork for what I have been calling Inness's strategy of misrecognition. For pleasure comes by way of disorientation in Inness's landscapes; his allusions are not straightforward, and they do not provide for an experience wherein the past is reconstructed in its original form (this is what sets Inness's associationism apart from its more conventional nineteenth-century incarnations, even though it was his viewers' conversance with these conventions on which Inness relied). The various instances of associative thought and vision that punctuated Beecher's texts also failed to provide for such an experience, and it was Beecher's insistence on the necessity of reconfiguration and reorientation within the operation of spiritual sight that provided a template for Inness's own articulation of good seeing, for the model of viewing and vision he constructed by way of memory's simultaneous invocation and denial. For Beecher, and for Inness, it was not just the act of memory that created the possibility of godlike vision; it was memory's transformative capacity, its ability to reconfigure time and space—a capacity figured in Inness's disfigured trees—that laid the ground for the expansion of vision's power and reach.

The reverend described his visit to Warwick Castle, in England, as productive of a "strange effect," wherein seeing amounted to memory, and things strange were familiar all the while:

> Primeval forests, the ocean, Niagara, I had seen and felt. But never had I seen any pile around which were historic associations, blended not only with heroic men and deeds, but savoring of my own childhood. And now, too, am I to see, and understand by inspection, the things which Scott has made so familiar to all as mere words— moats, portcullises, battlements, keeps or mounds, arrow-slit windows, watch towers. They had a strange effect on me; they were perfectly new, and yet familiar old friends. I had never seen them, yet the moment I did behold, all was instantly plain; I knew name and use, and seemed in a moment to have known them always.[86]

Caesar's Tower, at Warwick, transported Beecher back in time, to the dawn of English civilization; once there, he glanced, or remembered, into futurity and contemplated what was to be (what he already knew had been):

> It may touch your imagination to say that Cesar's Tower has stood for 800 years, being coeval with the Norman Conquest! I stood upon its mute stones and imagined the ring of the hammer upon them when the mason was laying them to their

bed of ages. . . . I was wafted backward, and backward, until I stood on the founda-
tions upon which old England herself was builded. . . . There, far back of all litera-
ture, before the English tongue itself was formed, earlier . . . than all modern
civilization, I stood . . . and, reversing my vision, looked down into a far future
to search for the men and deeds which had been, as if they were yet to be; thus
making a prophesy of history; and changing memory into a dreamy foresight.[87]

Here, "dreamy foresight," the ability to see the world afresh, is a function of
memory's convolution and reorganization, of a radical reenvisioning of the di-
rectionality and outcome of recollection (history is prophesy, and memory is
knowledge of the future). Inness's strategy of allusion, and the reorganization
of memory's operations that resulted from convention's disfiguration in his pic-
tures, were, of course, not identical to what Beecher characterized as memory's
transmutation (I do not mean to imply that Inness's pictures illustrated the
writer's words), but they constructed a similar experience and had a similar
aim. Looking, for both author and painter, entailed remembering—for Beecher,
memory and the reversal of vision were one and the same—and recall, in the
work of each, was construed as an experience of recognition wherein the never
before seen (things in Inness's pictures, Warwick Castle) was rendered disori-
entingly familiar.

If you want to see, Beecher wrote in *Star Papers,* "let your eye alone" and
wait for those "thousand remembrances which rise over the soul"; wait until
memory has resurrected and then reconfigured knowledge of the world: only
then will you see beyond surface and toward the divine.[88] Wait until the almost
familiar motifs in Inness's pictures make you remember what you do not think
you have seen, until convention's and memory's disfiguration makes you per-
ceive in unexpected, uncomfortable, and altogether new ways. Strange freaks,
wounding to the eye but also strategies of vision: all of those things that alluded
to tradition by making it misshapen and unclear—Inness's trees, his unsightly
fields, his haphazardly organized space, his transformed memories of Claude
and Gaspar—all serve as flip switches that trigger a process of perceptual
reconfiguration; Inness's "civilized landscapes," which move the eye in ways
that would have left GWP profoundly disturbed (even as this movement de-
pended on Inness's and his viewers' reminiscence of his edicts years after they
were first declared), serve, we now know, as templates for the operation and
acquisition of spiritual sight, for the apprehension, as Beecher put it, of "the
Glory of God."

"WE ARE IN IT, A PART OF IT, AND AS A PICTURE WE HARDLY THINK OF IT"

But it was not only the eye that Inness provoked by way of his uncanny allu-
sions, and it was more than a detached encounter with the surface of a painting
that was required to facilitate the substantiation of spiritual sight. When GWP

described the desired action of the foreground and middle ground on the viewer of a landscape, he indicated that these zones should provide a pleasurable feeling of being in the scene: "There is the place that we must be." *Willow Brook,* he said, was not a pleasing view but a bad portrait of a tree precisely because it did not elicit such imagined participation; a large tree interposed itself "between the observer and the sun, so as to shut out all behind it." The critic would have liked to feel as if he were in the picture and, thus, walk around this obstruction—"One's first impulse is to endeavor to walk aside to get a better view"—but the painting did not allow for this fiction, and its configuration did not encourage him to forget that what he was looking at was, in the end, only paint on canvas: "But the consciousness that it is only a picture," he said, "and that the scene cannot be changed gives in a moment a sense of suffocation."

In writing about art at the time, it was often suggested that looking at pictures involved physical penetration or participation: imagined entrance, inhabitation, and traversal. Narratives of fictional participation and accounts of paintings that made their viewers forget they were looking at pictures abounded, and critics frequently described themselves as entering and inhabiting, or desiring to, the landscapes they encountered in galleries, exhibitions, and collectors' homes. Landscapes that were labeled masterly and forceful, enchanting and poetic, were often described as such precisely because they appeared to invite the beholder into their fictional spaces or, at the very least, to produce the conditions under which viewers forgot that a mere picture was before their eyes and felt as if they were actually experiencing the things depicted. This kind of critical response was, of course, metaphorical, and commentators did not suppose that they, or the viewer in general, actually and physically entered a painting of landscape or that a painting could trick its beholders into thinking a real landscape was before the eyes. However, as a criterion, the fiction provides an important glimpse into what were perceived to be the nature and aims of landscape painting during the first three decades of Inness's career, and it goes some way in explaining why, when he chose to, Inness did follow criticism's conventions and rules. For if memory's evocation and disfiguration produced the conditions under which viewers began to see reality in a new light, it was viewers' participation in this process that was supposed to ensure such a transformation.

The participatory response may have derived from the example of the French philosopher and critic Denis Diderot, who discussed the landscape genre in terms of the production of a fiction of physical entrance; for Diderot, the success of specific types of landscape representation could depend on the encouragement of this fiction.[89] This criterion may also have taken its cue from picturesque theory, for the notion of the "picturesque" originated in descriptions of the experience of walking through landscape gardens, as well as in narratives of the tour and thus involved, at its origin, being in and traveling through a landscape. The "picturesque" of the English theorists William Gilpin and Uvedale Price had a hand in shaping the demands associated with land-

scape representation in America throughout the first half of the nineteenth century; it may have been the resultant merger of criteria for actual and pictorial landscapes that helped generate the discursive strategy that I am describing, which involved being in a fictional landscape space.[90]

Whatever its origin, the link that was made between a picture's success and its amenability to a fiction of participation was an important element in theorizations of landscape representation at the time. "That is a fine picture," wrote Durand, "which at once takes possession of you—draws you into it—you traverse it—breathe its atmosphere—feel its sunshine, and you repose in its shade without thinking of its design or execution, effect or color."[91] Suppose a man, he continued,

> on his return home, after the completion of his daily task of drudgery—his dinner partaken, and himself disposed of in his favorite arm-chair, with one or more faithful landscapes before him, and making no greater effort than to look into the picture instead of on it, so as to perceive what it represents; in proportion as it is true and faithful, many a fair vision of forgotten days will animate the canvas, and lead him through the scene: pleasant reminiscences and grateful emotions will spring up at every step, and care and anxiety will retire far behind him. . . . He becomes absorbed in the picture—a gentle breeze fans his forehead, and he hears a distant rumbling; they come not from the canvas, but through the open window casement. No matter, they fall purified on his sensorium, and *that* is far away in the haunts of his boyhood.[92]

Durand makes a connection here between the efficacy of a landscape and its ability to absorb a viewer into its space; the work of landscape, he suggests, ought to be the evocation of such a pleasurable state.

Critics often spoke of landscape paintings in such terms. In his review of the 1849 academy exhibition, the critic for the *Knickerbocker* extolled the virtues of one of Durand's own landscapes and located its success in the participation it compelled: "See over the waving woods the vapory effect of light; catch the sparkling brook, tumbling among rocks; hide yourself, lest you disturb that listening stag; tread lightly over the stones, for fear that you may ruffle the limpid surface of the mountain-stream; lie prostrate on one of those rocks, and gaze through the interlacing branches of those forest-kings; and, lulled by the rippling flow of water, sleep, and dream of a sylvan paradise, *for you are in one now.*"[93] Church's landscapes were equally transporting, reported the *Bulletin of the American Art Union:* they take us "to the scene at once. . . . *Twilight* . . . is an instance of this. We seem to breathe the air of this landscape while we look at it, and to feel the cool breeze, which wreathes the smoke in eddying volumes about the chimney, blowing also upon us."[94] George H. Boughton's view of Breton at the academy in 1867 should be considered "a very charming picture," said a critic who called himself "Outsider," and succeeded as

a landscape precisely because it invited its viewer to enter its space. "The artist," he wrote, "has invested the whole scene with so much tenderness and sweetness that we forget his art—or work, as the cant slang of criticism will have it— the more we look at it and become part of the scene. When an artist can do this, whether he work with pencil or pen, he has done all that he can do. Some artists labor to make their forms stand out of the canvas; but the greatest triumph of the artist is to absorb the spectator into his canvas and make him a part of his composition." "A landscape," he concluded, "which does not compel the spectator to walk up to it fails of its purpose."[95]

The participation criterion is important to our understanding of Inness because his landscapes were described as inhabitable and as inviting their viewers to project themselves into their spaces and because his foregrounds,

Figure 36. George Inness, *Road through the Woods* (ca. 1856). Oil on canvas. 15⅛ × 26¼ in. The Newington Cropsey Foundation, Hastings on Hudson, New York.

Figure 37. George Inness, *Going out of the Woods* (1866). Oil on canvas. 48 × 72 in. The R. W. Norton Art Gallery, Shreveport, Louisiana.

despite their difficulty and recalcitrance, appear designed to encourage imagined participation, a gesture that would have made GWP proud and one that, as we will see, was intimately related to Inness's strategy of misrecognition. A painting by Inness on view at Snedecor's Gallery in New York in 1865 realized what one critic called "the most perfect attainment of landscape art" for, as he stated, it "carries us away from the hot, dull city into the grand and solemn woods."[96] Paths invite in, and back-turned surrogates encourage identification; as we have seen, these elements recur in Inness's landscapes throughout this period, suggesting that he was invested in producing a participatory response. *Road through the Woods* (ca. 1856; fig. 36) and *Going out of the Woods* (1866; fig. 37), both sun-dappled forest interiors, invite viewers to enter by way of paths that originate in the foreground or near-foreground space, leading them through a canopy of trees toward the distance. In the first painting, the gaze of the nearest of two back-turned figures follows, and reproduces, that of the viewer and reinforces the path's gesture of

invitation. "Who does not like Innis [*sic*]?" wrote a critic in 1858 when a similar painting was on view at the academy: "That 'Twilight'—or rather that gorgeous, glowing sunset—cannot be mistaken for his; nor can that 'Road Through the Wood'—a charming grove of trees, with marvelous perspective, whose foliage and shadows invite one to step across the frame for a walk among them."[97]

In his 1867 *Book of the Artists,* Tuckerman described some of Inness's landscapes as "among the most remarkable works of the kind produced among us"; he appears to have thought they were so because they prompted participation.[98] When describing Inness's now-lost allegorical landscape *The Sign of Promise* (1863), he cited a passage from a review of the painting that had appeared in the *New York Evening Post.* Its author began by delineating the eye's traversal of the scene and ended with an account of bodily inhabitation: "From a road upon the rising hill, in the immediate foreground, the eye passes over a broad harvest-field with reapers, down across an ample lawn with cattle, to a farm-house and barn among the trees, and beyond, to a winding river. We do not cross the river, but pass directly around the bend, by green fields, to the foot of the mountain on the right, or we cross directly, and are lost among the clustered trees, till they, too are lost in the far-off storm-mist."[99] Tuckerman responded to Inness's painting *Peace and Plenty* (1865; fig. 38) in a similar fashion, and implied that it caused him to forget that it was only a picture. "Passing an art-store in Broadway on a warm and breezy spring day," he wrote,

> a glance in at the open door deluded us with the idea that we caught a glimpse of
> a meadow on the Connecticut. There was the long sweep of green plain, the lofty

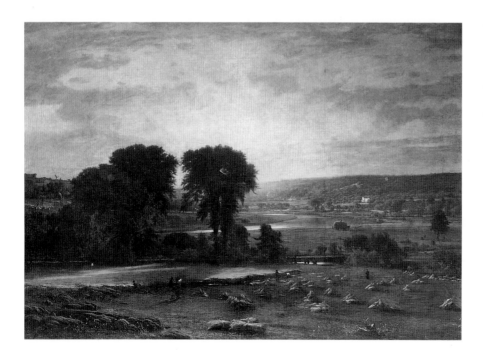

Figure 38. George Inness, *Peace and Plenty* (1865). Oil on canvas. 77 5/8 × 112 3/8 in. The Metropolitan Museum of Art, New York; gift of George A. Hearn, 1894 (94.27). All rights reserved, The Metropolitan Museum of Art.

and graceful cluster of elms in the foreground, the thick-set field of ripe grain, the reapers here and there, the distant hills—all glowing in the sunshine, so real, fresh, palpable, and alive to the eye, that it required a second thought to bring home the fact that we were looking on a picture entitled "Peace and Plenty" by George Innes [*sic*]; truly a marvelous and magnificent American landscape.[100]

It is as if Tuckerman meant the words "warm and breezy spring" to characterize both his day as well as that of the canvas, despite its autumnal subject, and their feel to envelop, metaphorically at least, his as well as the painting's space, making its world coextensive with his own (at least until that "second thought").

Tuckerman was not the only writer to project himself into Inness's landscape scenes; numerous critics responded to his paintings by doing the same. *Evening at Medfield, Massachusetts* (fig. 18) is a work showing Inness's "perfect mastery," wrote a critic in response to a group of the artist's landscapes on view at Doll and Richards; as did Tuckerman, he linked the painting's success to its provocation of participation: "It is his last work, and thus far his greatest, showing his perfect mastery of the materials and thorough knowledge of color. The sun has set, but the after-glow pervades the whole scene with golden splendor; *we are in it, a part of it, and as a picture we hardly think of it. . . .* Hardly a detail is drawn as such, but everything is *felt,* and the unity and harmony of tone so well preserved that their absence is unnoticed."[101] A foreground path invites in and encircles a ragged tree that stands, isolated, just to the right of center. A figure whose back is turned toward the viewer stands next to a stone fence in the middle distance. His posture reproduces ours as we look into and imagine wandering about the scene; the facelike visage of a house, behind the trees at left, meets our gaze with its own. As with the building that peers over the horizon, windows like eyes, in *Landscape with Farmhouse* (1869; fig. 39), this house addresses us, its look coincident with or at least a figure for ours as we gaze at and into the scene.

In 1864, Jarves praised Inness's aerial distances and perspective: "We can breathe in his atmosphere, and travel far and wide in his landscape."[102] He compared Inness's paintings to those of both Church and Bierstadt, and attributed the power of his pictures to the fact that they took their viewers into them. "Let us . . . turn to [Inness's] semi-ideal composition of Rome," he wrote, "and put it beside Church's Heart of the Andes or Bierstadt's Rocky Mountains, all three composed on the principle of rendering the general truths of landscape . . . so that a true impression of the spirit and appearance of the whole is given." The radical difference between the "antagonistic styles of these masters," Jarves stated, "will be felt at once. However much our admiration is captivated for a season by the dramatic spectacular touch of Church and his gemlike, flaming brilliancy of color, or the broader, less artificial, colder tinting of Bierstadt, the rich harmony of Inness and the attendant depth of feeling, with his perfect

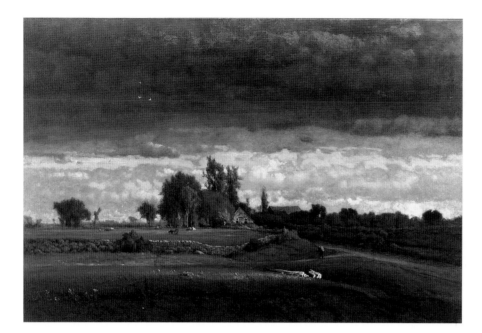

Figure 39. George Inness, *Landscape with Farmhouse* (1869). Oil on canvas. 30¼ × 45⅛ in. Mead Art Museum, Amherst College, Amherst, Massachusetts (AC 1948.49).

rendering of the local idea of the City of the Caesars, seize fast hold of the imagination, and put the spectator on his feet in the very heart of the scene." The viewer, Jarves concluded, "becomes an integral part of the landscape. In the other paintings he is a mere looker-on, who, after the surprise or novelty is gone, coolly or impatiently criticizes the view."[103] As did Durand, who insisted that the viewer must "look *into*" a picture instead of merely "*on* it" in order to be absorbed into its space and, thus, to see it properly, Jarves suggested that landscapes succeeded only if they put the spectator in the scene, and only if the spectator was made more than a "looker-on."

Both Beecher and Emerson had spoken of true sight as enabling penetration beyond the surface of things; Jarves conceived of good viewing, and the experience of vision that ensued, in similar terms. He blamed the panoramic construction of Bierstadt's and Church's paintings (the very construction that Inness alludes to but stymies in works such as *Landscape with Cattle and Herdsman*) for their failure to incorporate or absorb the beholder. "The countryman who mistook the Rocky Mountains for a panorama," he said, "and after waiting awhile asked when *the thing was going to move,* was a more sagacious critic than he knew himself to be." According to Jarves, such a picture, "more or less panoramic," always keeps its spectator "at a distance." The viewer "never can forget his point of view, and that he is looking at a painting." Nor is the presence of the painter ever fully vanquished: "The evidences of scenic dexterity and signs of his labor-trail are too obvious for that." We want art, Jarves said, "to sink the artist and spectator alike into the scene. It becomes the real, and, in that sense, true realistic art. . . . The spectator is no longer a looker-on, as in the other style, but an inhabitant of the landscape. He enjoys it with the right of ownership . . . not as a stranger who for a fee is permitted to look at what he is

by its very nature debarred from entering and possessing. . . . The idea should
be so treated, in accordance with the requirements of beauty, as to absorb the
spectator primarily into the subject."[104] Viewers who were mere lookers-on
when in front of pictures by Church or Bierstadt, Jarves suggested, were made
inhabitants, possessors even, of Inness's landscape paintings. Looking, or sur-
veying, to use GWP's term, was not enough to ensure identification and posses-
sion; viewers had to penetrate and inhabit a landscape's space in order to enjoy
and see it properly and to feel that it was their own.

At Warwick Castle, perception, as Beecher figured it, involved not just recol-
lection but also incorporation, a coalescence of self and world: "My mind was
so highly excited as to be perfectly calm, and apparently it perceived by an
intuition. I seemed to spread myself over all that was around or before me,
while in the court and on the walls, or rather to draw every thing within me."[105]
He described his experience at Stratford-on-Avon in similar terms: "I seemed
not to have a body [and could] hardly feel my feet striking against the ground;
it was [as] if I were numb."[106] In "Snow Power," an essay in *Eyes and Ears*,
Beecher described the associations engendered by the apprehension of falling
snow; the texture of his narrative reproduces the processes of recollection and
absorption that he imagined such an act of looking entailed:

> Is there anything in the world so devoid of all power as a snow-flake? . . . It forms
> in silence and in the obscurity of the radiant ether, far up above eyesight or hand-
> reach. . . . We have sat and watched the fall of snow until our head grew dizzy, for it
> is a bewitching sight to persons speculatively inclined. There is a [*sic*] aimless way
> of riding down, a simple, careless, thoughtless motion, that leads you to think that
> nothing can be more nonchalant than snow. . . . If you reach out your hand to help
> it, your very touch destroys it. It dies in your palm, and departs as a tear. Thus, the
> ancients feigned that—let me see, what was it they feigned? Lot's spouse went into
> salt. That was not it. Niobe to stone, several into vegetables, some into deer; but
> was nobody changed into a fountain? A yes, it was Arethusa. But now that we have
> hit the thing that dimly floated in our memory, it is not a case to the point, so we
> will let Arethusa flow (slide), and return to our snow.[107]

Beecher's rhetoric shifts from description ("We have watched. . . . it is a bewitch-
ing sight. . . . and departs as a tear") to a series of questions, ideas, and
associated thoughts (biblical scripture, Lot, ancient mythology, Niobe, vegeta-
bles, Actaeon, a fountain, Arethusa) that interrupt the narrative ("—let me see")
and are set apart from its general flow. As readers, we are witness to the process
of association that Alison described in the *Essays* at, it seems, the very moment
Beecher experienced it as he looked/thought/wrote. "Arethusa" is the final link
in the author's chain of recollections; at its termination, she returns to Beecher's
memory or, rather, "our snow." Association (Arethusa), its cause (snow), and its
abode (Beecher's memory) are figured as coeval, and Arethusa eventually flows,
slides, lapses back into this amalgam of snow/memory/mind. Vision, thought,

memory, and matter are here imagined as one, and looking/remembering as consisting in the commingling, or transubstantiation, of self and world. Niobe, Actaeon, Arethusa—turned to stone, a stag, and a stream and fountain, respectively—are appropriate figures for such a metamorphosis; the wood nymph Arethusa was turned to water by Diana so that she could escape the advances of the river god Alpheus and, here, by Beecher who characterized her dissolution, or "flow," into his mind as a similar transformation. As at Warwick, looking, remembering, and coalescing combine in a single act of perception.

According to Beecher, the radical fusion of the beholding subject and the object or view beheld, which he appears to have thought was a primal condition of the experience of penetrating vision, happened only if the perceiver lost sight of his or her surroundings and lapsed into a semiconscious state, much like that described by the *Knickerbocker* critic who imagined himself as an inhabitant of the landscape painting onto which he looked: "Sleep and dream of a sylvan paradise, for you are in one now."[108] Durand's world-weary beholder became "absorbed into the picture" before him precisely because, off in the "haunts of his boyhood," he had forgotten where he was and that he was looking at a painting; he felt the landscape's gentle breeze and mistook rumblings from outside his window for noises generated from within the depicted scene.

The notion of lapse, and consequent incorporation and/or participation, was central to both Beecher's and Alison's conceptions of the relation, established through acts of looking, between an individual and things seen, and I believe it was their work that provided the theoretical impetus for Inness's own. As did Jarves, who contrasted the participatory viewer in front of, or in, a picture by Inness with one who, after the surprise or novelty of a landscape view fades, "coolly or impatiently criticizes" it, Alison insisted that in order to see a work of art properly one had to abandon the vantage point of a critical, detached, and conscious eye. "The landscapes of Claude Lorrain, the Music of Handel, the poetry of Milton," he wrote in the *Essays,* "excite feeble emotions in our minds, when our attention is confined to the qualities they present to our senses, or when it is to such qualities of their composition that we turn our regard." We feel the beauty and sublimity of their productions, he continued, only "when we lose ourselves amid the number of images [associations] that pass before our minds, and when we waken at last from this play of fancy, as from the charm of a romantic dream."[109] Alison opposed the activity of criticism to such a state and said that when we "sit down to appreciate the value of a poem, or of a painting, and attend minutely to the language or the composition of the one, or to the colouring or design of the other, we feel no longer the delight which they at first produce."[110] Pleasure in looking, he implied, came only after one yielded to an object's suggestions.[111] Remembering (apprehending a chain of recollected associations) when looking, he suggested, led to correct seeing only if forgetting occurred as well: "In such trains of imagery," he wrote, "no labour of thought, or habits of attention are required; they rise spontaneously in the

mind . . . and they lead it almost insensibly along, in a kind of bewitching reverie, through all its store of pleasing or interesting conceptions."[112] Beecher's most profound perceptual experiences corresponded to just such a "bewitching reverie," a passive, almost automatistic state, what he called a "tranquil, dreaming, gazing life" wherein the eye is let alone so that it goes "as clouds go, floating hither and thither." "The art of seeing," he said, "is not to think about seeing. . . . One looks at a great many things, but sees only a few; and those things which come back to him, spontaneously, which rise up as pictures, afterwards, are the things which he really saw."[113]

It should be clear by now that I believe it was such a state that Inness's landscapes brought about, by compelling, through allusion, the recovery of the past, and, through participation, the lapse of the present. It was just this kind of forgetting that played an important part in the experience of perception that Inness's landscapes offered up. His participatory gestures (foreground paths, encircling space, surrogate viewers, and engulfing atmosphere), produced a similar effect—"We are in it, a part of it, and as a picture we hardly think of it"—as two aspects of memory's capacity conjoined: recollection, triggered by transformed allusions to the works of Claude and Gaspar, and forgetting, instigated by convention's disfiguration but also by the invitation to enter, inhabit, and traverse.

In the galleries of the Louvre the "walls beam upon you," Beecher wrote, "as if each was a summer; and, like strolling at summer's eve, you can not tell whether it be the clouds, the sky, the light, the shadows, the scenery, or the thousand remembrances which rise over the soul in such an hour, that give the pleasure. I saw all that the painter painted; I imagined in each scene . . . what had gone before, and what had followed. I talked with the beautiful or fearful creatures, and they spake to me."[114] Here, looking (being in a gallery), passivity ("the walls beam upon you"), association ("like strolling at summer's eve"), recollection ("the thousand remembrances"), and incorporation ("I talked with the . . . creatures, and they spake to me") combine to form what the author described as a visual experience of "complex pleasure" and what I am claiming was the effect of Inness's allusive art. Beecher characterized his walk through the picture galleries at Oxford in similar terms:

> I find that the keen, and fine excitement, which inevitably steals upon one in the walks and galleries of these venerable Colleges, is precisely of the kind favorable for the appreciation of pictures. They cease to be pictures. They are realities. The canvas is glass, and you look through it upon the scene represented as if you stood at a window. Nay, you enter into the action. For, once possessed with the spirit of the actors or of the scene, all that the artist thought lives in you. And if you are left, as I was once or twice, for an hour quite alone, in the halls, the illusion becomes memorable. You know the personages. You mingle in the action as an actor. . . . At last you are with them![115]

The pictures at Oxford, Beecher suggested, were memorable because a sense of excitement stole unexpectedly on him and he forgot that he was looking at paintings. He felt as if he were in the scenes they depicted, fraternizing with their inhabitants, whose memories and experience he made his own. He, in Jarves's words, took possession of what he saw, was more than a looker-on. Forgetting and remembering combined in Beecher's experience of viewing; as a result the paintings he looked at/was in took a lasting hold. The poet, Emerson wrote, turns the world to glass; here, Beecher describes such an operation, the same one I am suggesting Inness's landscapes engendered through participation's compulsion, thus allowing for penetration, figured as a piercing of the canvas's surface and, consequently, sight.

Inness's early works, and the modes of viewing and vision they produced, claimed for memory a central role. They proposed a structure of perception, much like that presumed by associationism, that relied on memory as well as its lapse and that suggested that penetrating sight involved both recognition and recall as prompted by allusion and the forgetting that participatory and absorptive reverie entailed. In this sense, Inness's allusions to old master landscapes *had* to be disfigured and transposed, lest they draw even more attention to the painted-ness of his views. His displaced *repoussoirs,* his unusual yet usually inviting foreground spaces, his back-turned figures, and his elaborate and disorienting spatial configurations, all of which referred to yet transformed the example of Claude and Gaspar and the formulas of GWP, haunted the beholder's memory yet, rendered unfamiliar by virtue of convention's distortion, did not inspire the diligence and attention that would preclude the forgetting and fictive inhabitation that Alison and Beecher considered instrumental to correct, and sublimely pleasurable, experiences of vision. Moments of perceptual dislocation in Inness's landscape views stopped just short of preventing the incorporation that he imagined constituted a model of penetrating and spiritual sight. Because of the opacity of Inness's allusions, the viewer entered that confused yet blissful state of reverie that associative recall required and provoked, invited in by that place, the foreground, where good painting and penetrating perception were thought to commence.

REATTACHING THE BODY TO THE EYE

Yet this delightful and participatory reverie was not all that Inness's landscapes worked to provoke, or, to put it slightly differently, this state, as promulgated by his pictures, did not want to limit itself to happy, imagined memories of "being there." That is to say, in his efforts to involve his viewers in his pictures, Inness pushed GWP's participatory model beyond its stated bounds and rendered Beecher's pictorial mingling as literal as it could possibly be within the space of works into which, of course, no one really walked and that, probably, no one ever touched. For Inness's pictures, which invited people to look beyond the "rind and husk" of the natural world by undergoing an analogous procedure

when viewing (entering and traversing the depicted scene), explored not just the behavior and treatment of the eye but that of the body as well. Inness's landscapes were, as Beecher and others suggested they should be, spaces wherein seeing was examined and enhanced, laboratories that hosted manifold (even reckless) experiments in sight. They were also instruments that encouraged exploration of other sensory modes, including that of touch and the role that touch played in the perceptual act. Inness's landscapes enjoined the beholder to simultaneously forget and feel his pictures, to be in them, dreamily, but to constantly bump up against their strange and disfigured motifs, those roadblocks that Inness erected everywhere—fences, walls, paths, streams, isolated trees, scattered and unsightly rocks—so as to disrupt the eye's easy and, I would add, disembodied passage through a scene. GWP had the eye floating, detached and unhindered, through meadow, lake, and distant hill. Inness wanted his viewers to walk, to feel the ground under their feet, to sense the material qualities of his scenes or, as one of his critics put it in 1874, "to *smell* the woods, *touch* the soft mould, and be warmed or chilled by their sunshine and shadow."[116]

In order to make the viewer forget that he was looking at a painting, Jarves had said in 1864, the artist had to efface his "labor-trail." Inness did nothing of the sort. He refused to let his viewers forget his means or to lose sight of the fact that they were looking at paintings, pigment on canvas rather than slickly rendered illusions of the real. Inness's "great sprawling marks of the brush every which way all over the canvas" and his "great coils and lumps of paint," one commentator wrote in 1862, took audiences by surprise, for the "transition from smooth, glossy, scraped and polished surfaces, was too great." Viewers wished, this critic added, to see these pictures "rubbed and pumiced up with a thousand and one fine touches."[117] In 1864, the *Knickerbocker* critic described Inness's *The Sign of Promise* in similar terms; its design, he said, was "much better than the execution, but at a considerable distance from the canvas the general effect is very fine. . . . The manner in which Mr. Inness dabs his paint on the canvas throws even Turner into the shade, and he was very partial to laying it on thick with a knife."[118] Inness's *Evening,* on view in 1865, was criticized by a critic for the *New York Evening Post* for its "rawness of color" and its "ragged and painty touch." Inness, he reported, is a man who "delights in the use of his brush, and who never forgets his means of expression nor lets us forget." His pictures would be better if he "triumphed over his means."[119] A year later, this same critic stated that it "has been a common weakness of Inness to think too much about his means of expression, for which reason some of his finest subjects have been rendered in a powerful but coarse manner—a manner obvious though not vulgar, yet not subtle, and forcing us to think more of his method than of this theme."[120]

The painty-ness of Inness's landscapes ran the risk of counteracting their invitation to forget and participate, but they also made the traversing eye aware of the body to which it was attached. Viewers imagined themselves bumping

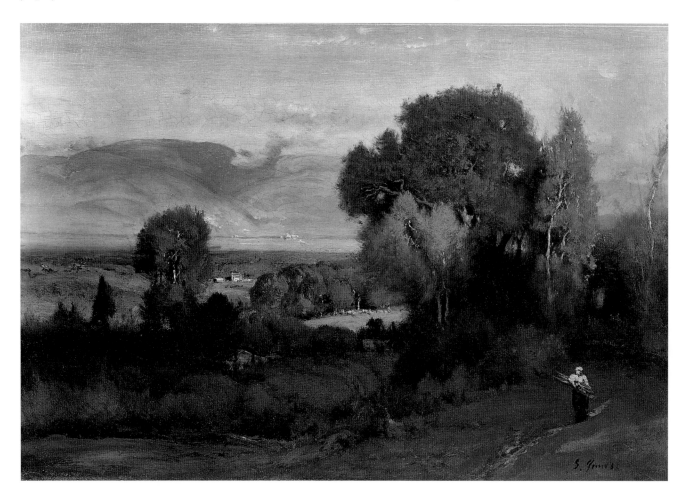

Figure 40. George Inness, *Landscape near Perugia* (ca. 1873). Oil on paper on board. 12½ × 18 in. Grant and Patricia Shoemaker.

up against obstacles, and they also imagined running their fingers, or feet or legs or arms, through thickly applied, lustrous, scraped, enmeshed, and pooling paint. Who wouldn't be prompted to think of the feel of pigment on skin when in front of works like *Landscape with Cattle* or *Hackensack Meadows, Sunset,* where layers of palpable paint entangle the gaze and blotches of yellow, white, red, and tan ("great coils and lumps") combine and collide? What else but the body could the slurred and sketched figures of *Landscape near Perugia* (ca. 1873; fig. 40) and *Landscape, Hudson Valley* (fig. 34), their limbs pressed against and between planes of paint, call to mind?

The back-turned figures that appear and reappear in Inness's landscapes during this period, and throughout his career, help ensure that these works are something seen, that is, constructed according to the assumption of and in order to accommodate a look and, I would add, something felt as well, thereby transforming and expanding the surrogate figure's usual function.[121] Unlike, say, Caspar David Friedrich's *Rückenfiguren,* who almost always have their backs turned fully toward the viewer, faces hidden, as in *Wanderer above the Sea of Fog* (ca. 1818), Inness's adopt a variety of postures and angles of vision.

From one picture to the next, his surrogates change—they turn away, they face us, they sit, they stand, they are clearly delineated, they are blank-faced and barely sketched—as does the nature of our identification with them, each permutation drawing attention to what I want to argue Inness's pictures imagine to be the complicated, and corporeal, nature of perception.[122] Inness preferred to exhibit his landscapes in groups, rather than one at a time; perhaps he hoped to keep his pictures together so that the viewer, in looking at one and then another and then another still, could try on a variety of surrogate bodies, feeling his way through each work by virtue of many different sets of eyes and limbs.[123] In the space of a single painting, even, Inness offered several bodies for his viewers to make their own. In *Lake Albano* (fig. 35), for instance, the meadow surrounding an isolated tree is occupied by a number of back-turned and gazing figures, variously posed and arrayed, including the man and woman who stand in the left foreground and the two or three figures who lean against the stone wall at left, gazing out over the tranquil and shimmering lake before them.

Bodies assume diverse guises in Inness's landscapes. The lone and slightly off-center tree in *The Lackawanna Valley* (fig. 24) mirrors, with its inward-inclining rightmost branches, the pose of the reclining and back-turned figure beneath it. The tree turns its back to us as does this figure: its bare trunk faces us, while its leafy limbs extend out between it and the canvas's distance, reproducing the directionality of the seated figure's limbs and gaze as well as our own.[124] Boy and tree look down on the traces, or labor trail, of civilization's tramp—stacked logs and tree stumps that litter the meadow below—and both encourage the beholder not just to enter and wander about but also to imagine himself touching his painted surround.

Other strategies in these early landscapes appear designed to evoke bodily participation, as well, as if to suggest that their maker put a great deal of store in the sense of touch. At the heart of *A Passing Shower* (fig. 25), Inness placed an emblem of vision: a rainbow. Ruskin, it was reported, was fooled by the rainbow in Church's *Niagara* (1857) when the work was on view in London, thinking it was real; this story was recounted often in American art criticism, and the rainbow became a trope for correct and accurate sight.[125] In fact, in 1860, the *Crayon* published an essay entitled "A Chapter on Rainbows in Landscapes," which provided scientific calculations concerning the optical theory behind the phenomenon, its appearance to the eye of the beholder, and its accurate representation in landscape art.[126] In the painting, our red-vested surrogate, seated on a slight rise beneath a tree, gazes at this emblem/spectacle, touching one hand to his face and another to the grass on which he sits; looking and touching come together in the very figure with whom we identify and that encourages our participation. Seated to the side of a road that originates in the right foreground and invites in, he guides our traversal of a pictorial field that, as in *Hackensack Meadows, Sunset* or *Landscape with Cattle and Herdsman*, is littered with obstructions and diversions: fences, strips of meadow, stacks of hay,

screens of trees, alternating and somewhat confused bands of sun and shadow, a column of sheep, three stooped and barely sketched men toiling in the field, a herdsman brandishing a staff, and merging and mingling paint in the middle zone and at the horizon. As we make our way through this picture, we reproduce the experience of our surrogate; as we look, we touch (we bump into things, make our way around obstacles, feel the cool shade turn into the sun's warm glow).

Inness's back-turned figures often wear red vests, kerchiefs, or shirts—concentrated bursts of color that attract the eye—as in *Early Recollections: A Landscape, Landscape with Fishermen, The Alban Hills, Sunset at Etretat, Hillside at Etretat,* and *Etretat* (1875).[127] In his 1867 essay, "Colors and Their Correspondences," Inness described red as one of three primitive colors, blue and yellow being the other two, and said that it corresponded to love.[128] He utilized the color sparingly—a roof here, a flower, vest, or kerchief there—but strategically. Red may indeed express love; in these canvases, however, it also aids in guiding vision, drawing attention to the viewer's surrogate by virtue of its vivid blaze. As we have seen, in *Sunset at Etretat,* a strip of brilliant crimson streaks across the horizon as the hills at right reflect the setting sun's auburn glow. Here, red occupies and defines the very zone, the horizon, which Inness would come to believe bore the burden, along with the foreground, of penetrating sight; the resplendent band of color meets the gaze and reflects the hue of the red-vested and back-turned figure who contemplates the evening's radiance as he tends to his flock. He, and the other red-garbed figures that populate Inness's landscapes, are at once emblems of vision and vision's guides. The color red, along with the rainbows that appear in many of his works, by calling attention to the processes of spectral reflection, refraction, and dispersion, calls attention to the processes and phenomena of perception; because it defines the contours of the surrogate body, this optics-evoking red also makes a case for what I believe Inness held to be vision's tactile dimension.

In *Lake Nemi* (plate 9), painted in the summer of 1872 while Inness was in Albano, Italy, a back-turned figure pauses on a path that originates in our space; he looks across the descending hillside toward the lake at its base and the fields and hills beyond. This figure, in the space of the distancing panoramic, ensures our inhabitation, for his gaze and posture reproduce ours as we stand in front of the picture. The path, and the outward-expanding foreground, draw us in and toward him; we must pass through his body before we reach the splendid and glowing haze of the middle ground and distance. His presence assures that we can make it past both the edge of the hill and the diagonal line between darker foreground and illuminated distance that splits the canvas into two triangular, and seemingly disconnected, halves.

"I trust that you will find the picture of Lake Nemi one of my best, as I intended it should be, and I am happy to say it was so looked upon by all who saw it in my studio," Inness wrote in a letter, dated August 13, 1872, to Mr. A. D. Williams of Roxbury, Massachusetts, the painting's purchaser.[129] The picture

"was a great favorite with Mr. Inness," stated Susi F. Williams in a letter to a Mr. and Mrs. Hersey, who had since acquired it. "He told me himself most exultantly, that at last he had got an atmosphere he had been trying for all his life."[130] This atmosphere, a combination of bright sunlight and haze, dissolves everything it touches—the distant fields, the tops of the trees at right, the Villa Sforza-Cesarini situated on a distant hill above the town of Genzano—making the scene appear somewhat impenetrable, hard to imagine looking or walking through. Yet it can also be said to function in conjunction with the beholder's surrogate to ensure participation. Inness confines the glowing mist to the upper half of the canvas, but its creep blurs the hillside line of divide and silhouettes the back-turned figure, his black robe and hat turning red at the edges as its glow lights on him. Only a network of erratic and wild scrapes and scratches in the right foreground zone that look as if they have been made with the wooden end of a paintbrush prevent this mist from engulfing our space; no matter, for it has already overtaken us as we pause with, or as, our surrogate to gaze at the scene.

Perhaps Inness considered the atmosphere of this painting to be perfect because, in conjunction with the back-turned figure and the foreground path, it made of his viewers inhabitants who saw *and* felt the damp warmth of the spreading and engulfing haze. Perhaps Inness imagined that these viewers, having climbed through the entangling skein of scratches that met them as they entered, lapsed with relief into the air that surrounded them and into the body of another. Here, the panoramic does not exclude its beholder but, rather, orchestrates incorporation; the viewer becomes more than a looker-on, more than a mere "eye," for the painting engages the physical frame as well as the organ of sight.

And this, again, is precisely the point; here, an argument for the embodied nature of vision is emphatically made, and an argument for the expanded potential of the embodied eye is put forth as well. Durand, theorizer of the participatory, called atmosphere "that which above all other agencies carries us into the picture, instead of allowing us to be detained in front of it." "Not the doorkeeper, but the grand usher and master of ceremonies," he said, atmosphere conducts us through the "mansion" of nature, through all its "vestibules, chambers and secret recesses," explaining, as it does, "the *meaning and purposes of all that is visible.*"[131] Atmosphere not only compels entrance, Durand suggests, but, in allowing for penetration beyond the surface of the canvas, it also provides for a view of the deeper meaning of the visible world. Durand characterized atmosphere as "an important personage," saying that "no pains should be spared to make his acquaintance," as if to suggest that effects of atmosphere were to be thought of as bodies of sorts, as corporeal guides that, when grasped by the hand, pulled one toward an embodied plunge into heavenly realms.[132]

What Inness gives to us in *Lake Nemi* is not far from this. Emblems of vision, juxtapositions of light and shade—concentrated instantiations of chiaroscuro, what Inness elsewhere linked to the middle tone, that thing responsible for good

painting and spiritual sight—punctuate the canvas space: two illuminated birds at center against a dark ground; a bird in shadow against a white ground at lower left; alternating and stacked zones of light and shade at right (illuminated field, shaded field, white wall, darkened trees, a bright sky); the tree, in shadow, at lower left and the bright haze behind it; the front-facing and illuminated wall of the Villa Sforza-Cesarini and the one in shadow adjacent to it; the dark-cloaked figure and the brilliance before him.[133] These emblems occupy a pictorial field in which light, in the form of warmly damp atmospheric haze, is both seen and felt; they are made visible, revealed, only through this medium, or "personage," and, as such, are figurations of the sort of vision Inness's canvases appear to engender, microcosms of the painting's larger structure and intent. That is to say, they are revealed by way of both vision and touch, declaring—in the space of a painting we already know to be a demonstration of the conditions under which keener vision comes about (memory, allusion, participation)—that both capacities are necessary to the invocation of spiritual sight.

What we have here, then, is something like a diagram or tract: this is what you need, Inness says, in order to see reality in a new light, and this is how it feels. In asking his viewers to negotiate their way through palpable paint and to identify with a body or bodies in the act of looking at, or being in, his landscapes, he took steps to ensure that they did more than just glance at his works, and he insisted that penetrating sight depended on effects of the body as well as the eye. In Inness's landscapes, penetrating perception entailed a fantasy of incorporation, the radical fusion of seeing, body, and world (what would manifest itself later in the idea of breathing as sight), wherein vision pushed past the skin or surface of things and touched and conspired with what it found.[134] And atmosphere—that thick and hazy damp that weighs down so many of Inness's landscape views, and his rendition of which garnered consistent critical praise—made the components of this merger manifestly clear. Tactile (water molecules suspended in air) but revealed to the eye by way of a visual effect (refracted light), atmosphere is indeed that thing that physically grabs us (we feel it on our skin and may even notice its damp warmth pass into our throat when we inhale) but then transforms what we see. Inness himself said as much when interviewed by the *Art Journal* in 1879. "That which inspires" and that which makes appeals between men, he said, "is a subtle essence which exists in all things of the material world." This subtle essence addresses "through the senses, the human consciousness," creating, as it does, "an intellectual perception of niceties of relation [what Inness so eloquently describes by way of his Lake Nemi chiaroscuro vignettes], of peculiarities of condition, and *consisting of an atmosphere around the bald detail of facts.*" Much as did Durand's misty messenger, then, Inness's subtle essence explained "the meaning and purpose of all that is visible," or, as Inness put it, it spoke to men "of that which is unseen," of what is revealed to the mind by the "Spirit of God."[135]

By 1865, the critic who chastised Whittredge's foreground for painfully af-
flicting the eye could say the following about Inness's *Sunset,* on view at the
academy that year: "The true art vision penetrates the wholeness of a scene,
and balances its parts *in atmosphere that is all-pervading,* even if it be some-
times exceptional. The ken of the other perception extends only to physical
things; the sky, the air, are like a bad actor's hands, generally in the way."[136] In-
ness's picture, with its permeating atmosphere, the critic suggested, succeeded
because it encouraged viewers to forget it was a painting and to experience it as
a substance touching eyes and skin and soul as well. A bad actor's hands, "gen-
erally in the way," reminded the theatergoer that what he was seeing was arti-
fice; his relation remained spectatorial, he was never more than a mere looker-
on fronting rind and husk. Inness's audience got a taste of a better perception,
what another critic would describe as the perception of "spiritual meanings"
underlying nature's "external forms" and what Inness suggested came about
when the eye and the hand joined forces or, one might say, when seeing be-
came something like a touch, a subtle essence that revealed truth in its caress.[137]

CONCLUSION: INNESS'S USE AND MISUSE OF TRADITION

Tortured and twisted trees in Inness's landscapes—in, for example, *Landscape,
Landscape with Fishermen, Winter Moonlight (Christmas Eve),* and *Evening at
Medfield, Massachusetts*—evoke associations of, in the artist's words, humanity,
civilization, "labor, effort, suffering, want, anxiety, necessity, love." They also
point up and stand for the transformative nature of Inness's art. By referring to
the scenery, history, and art of the European past, these tortured and twisted
giants install memory, making recollection a crucial aspect of the beholder's ex-
perience; yet, in their disfigured aspect, they also envisage the world as seen
with new eyes. What Inness called the "civilized landscape" was, in the end, as
much about the mode of apprehension it conjured as it was about the things
depicted in it; in his paintings, recollection, forgetting, allusion, association,
sensations of touch, convention's inversion, and imitation's new and strategic
guise combined to form and evoke a structure of vision in which memory and
bodily participation played leading parts. Inness's use and misuse of tradition
was a strategy of vision, and his landscapes made of memory, and memory's
lapse—into reverie but also into atmospheric haze—a means to radical fusion
and then to sight.

Figure 41. George Inness, *Visionary Landscape* (1867). Oil on canvas. 15½ × 26 in.
Collection of Mr. and Mrs. James M. Myers.

FIVE ❧

The Plight of Allegory

INNESS AND ALLEGORY

In 1867, Inness exhibited a three-part landscape series at Snedecor's Gallery in New York. He based the series, which he called *The Triumph of the Cross,* on John Bunyan's *The Pilgrim's Progress* (1678), written while Bunyan was imprisoned for preaching sectarian religious views. The text recounts a dream Bunyan had in his jail cell and, at its most basic level, is an allegory of faith. The first part of the book, from which Inness took his subjects, relates the story of Christian who, after a spiritual awakening, flees his homeland, the City of Destruction, and undertakes a pilgrimage to the Celestial City, or Heaven. (The second part is devoted to Christian's wife, Christiana, who, after a similar awakening, sets out after her husband.) The journey is dangerous. On his way to the holy city, Christian encounters an assortment of villains, including the monster Apollyon, who nearly kills him. He must triumph over dangerous terrain as well as his own mistakes, misgivings, and self-doubt. At the outset of his trek, Christian's guide Evangelist tells him that, in order to reach his destination, he should follow a specific and difficult "way." His efforts to adhere to this way, however, are challenged at every turn.

The first painting in Inness's series, *The Valley of the Shadow of Death* (plate 10), is now in the collection of the Frances Lehman Loeb Art Center at Vassar College. The location of the second painting, *The Vision of Faith,* is currently unknown. As Michael Quick has discovered, at least three fragments of the third

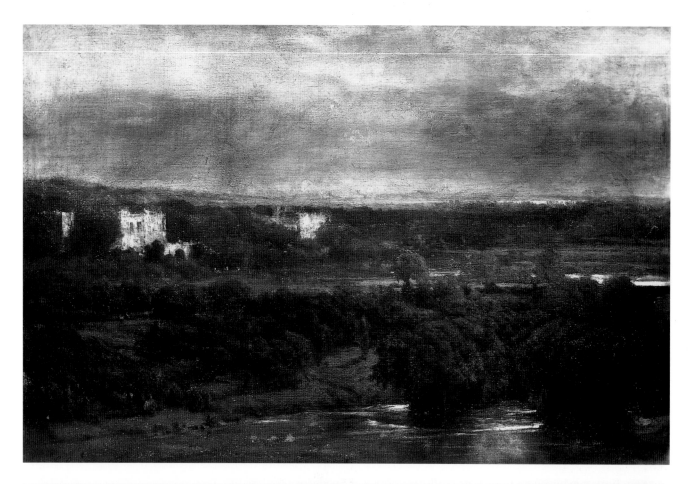

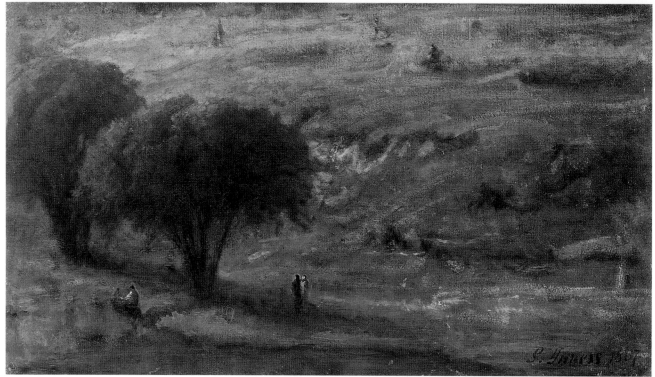

painting, *The New Jerusalem,* survive. One was sold at auction by Sotheby's in 1992; a second, and the largest of the three, is in the collection of the Walters Art Museum, Baltimore; and a third is in the collection of the Krannert Art Museum, at the University of Illinois, Urbana-Champaign (figs. 41–43).[1] According to Inness's son, the series was commissioned by "a syndicate of gentlemen, Fletcher Harper, Chauncey Depew, Clarke Bell, and others." Inness, he stated, chose the subjects himself.[2] James William Pattison, editor of the *Fine Arts Journal,* who knew Inness, wrote that "an effort was made to give him an opportunity to fully express his many-times announced theories. A party of his friends, impressed by the artist's earnestness, pledged a sum of money amounting to $10,000, which he was to freely use, during one year, for the production of any sort of pictures to illustrate Swedenborgian theories."[3]

The Triumph of the Cross was something of a departure for Inness. Prior to the 1860s, he had painted few canvases based directly on textual sources, and after 1867, to my knowledge, he did so only once.[4] He did not tend to paint allegorical landscapes, but for a brief period in the 1860s, he produced a number of pictures that were described by critics at the time as allegories, attempts to convey abstract ideas through the representation of American scenery. *The Light Triumphant* (1862; fig. 44), known today only through an engraving, *The Sign of Promise* (1863), now lost, and *Peace and Plenty* (fig. 38) are three such works.[5] Critics described the illumination of *The Light Triumphant* as symbolic of the divine and said that the picture as a whole expressed a higher or deeper meaning. Inness, wrote the *New York World,* "had an Idea (a good thing for a painter or poet to have), and he has stricken it into current shape with a bold, free hand."[6] The Reverend Beecher certainly thought the work, with its brilliant rays of light, cast by a setting sun, was an allegory, for it was he that gave it its title.[7] *The Sign of Promise,* on view in 1863 at Williams and Everett in Boston and then at Snedecor's in New York, was characterized as an allegorical landscape by the *New York Evening Post,* and a pamphlet, most likely written by Inness, which accompanied the exhibition, described the painting as "the visible expression of a strongly felt emotion of Hope and Promise." If the picture, it read, "presents not to the observer more than he sees, the picture is clearly a failure—at least to him."[8] In such a work as this, Jarves reported, Inness uses "nature's forms simply as language to express thought." *The Sign of Promise,* he said, "reveals the aspirations and sentiments of the artist. It is a visible confession of his theory, faith and aims. Outwardly, a beautiful composition of mingled stream, meadow, field, hillside and forest, with its rich associations of harvest and human labor, overcast by storm, through which gleams the rainbow of hope; inwardly an eloquent symbol of a struggling soul. This double sense ranks it as inventive art, to be judged from that high aspect than from a merely material point of view."[9] As with *The Light Triumphant* and *The Sign of Promise,* Inness's large-scale landscape *Peace and Plenty* seems to have been intended, by way of its brilliant light, harvest motif, and title (resonant at the close of the Civil War), to convey a deeper message or meaning and should be considered a

Figure 42. George Inness, *Valley of the Olives* (1867). Oil on canvas. 30 × 45 in. The Walters Art Museum, Baltimore, Maryland.

Figure 43. George Inness, *Evening Landscape* (1867). Oil on canvas. 15 × 26 in. Krannert Art Museum, University of Illinois, Urbana-Champaign.

Figure 44. W. H. Gibson, after George Inness, *The Light Triumphant* (1862). Wood engraving. From George W. Sheldon, *American Painters* (New York: D. Appleton & Co., 1879), facing p. 31. Photograph Bill Bachhuber.

part of Inness's experiment with allegorical landscape, of which *The Triumph of the Cross* was both climax and end.[10]

Scholars of American art who have written about Inness tend to describe *The Triumph of the Cross* as a straightforward expression of Inness's religious conviction. As we know, in the *Arcana coelestia,* Swedenborg described what he understood to be a process of spiritual regeneration that entailed a journey from ignorance to awareness of the true nature of the divine. In her groundbreaking article on Inness's Swedenborgianism, Sally Promey argues that Inness's allegorical canvases embodied his religious beliefs, evoking a hidden, but spiritually discernible, ideal world and illustrating a Swedenborgian journey of spiritual regeneration.[11] The fact that Inness began the series while at Eagleswood, and shortly after his first serious encounter with the writings of the Swedish philosopher and theologian, lends weight to the argument that he meant his series to be an expression of religious conviction. Cikovsky has also argued that *The Triumph of the Cross* reflected Inness's interest in Swedenborg, stating that it celebrated the change and solidification of Inness's religious faith.[12] Both Promey and Cikovsky note his adaptation of *The Pilgrim's Progress;* the former addresses the narrative's widespread popularity in nineteenth-century America and indicates that Inness's endeavor was one of many spiritually, socially, or politically motivated appropriations of the text, while the latter argues that Bunyan offered Inness only a frame for his own, and Swedenborgian, meaning. Both authors regard *The Triumph of the Cross* as a function of Inness's ongoing attempt to render what he called the "reality of the unseen," what

Promey terms "an ultimate reality beyond the purely scientific."[13] Cikovsky, however, labels the series an anomaly, a "side issue in Inness's art, a diversion of some interest but no lasting significance."[14]

Yet *The Triumph of the Cross* was anything but an anomaly, and Bunyan's text offered Inness much more than a form around which to construct a Swedenborgian-inspired narrative of spiritual growth. Just as Swedenborg's exegetical method, exemplified by the theologian's ambitious rereading of Genesis and Exodus in the *Arcana coelestia,* gave Inness an idea of how the role of memory in spiritual seeing might be conceived and articulated, the subject and structure of *The Pilgrim's Progress* and allegory in general seem to have suggested a means by which to transform landscape into a medium of sight. *The Pilgrim's Progress* explores questions concerning the function of vision and the role of memory in perception, the same questions that motivated Inness's project throughout the first four decades of his career and beyond. Bunyan's book manipulates landscape and his characters' perceptions of it in order to make claims about different aspects of cognition. The narrative is punctuated with episodes about looking and remembering that, cumulatively, represent a sustained and systematic inquiry into the various cognitive processes that constituted, as Bunyan would have it, the path to enlightenment and spiritual sight, the ability to discern the divine and see with God. It was the possibility of comprehending and representing the processes of spiritual sight that interested Inness when he set about making *The Triumph of the Cross.* It was Bunyan's book, wherein vision and memory motivate and drive the progress of the tale's protagonists through the landscape as well as the narrative itself, that gave him an idea as to how this might be done.[15]

WORD AND IMAGE IN THE 1860S

Although a critic for the *Independent* referred in 1863 to "the present prevailing phase of allegorical painting" and voiced his "objections against its use," allegorical works, and especially allegorical landscapes, were somewhat exceptional in the United States during the period under discussion. Aside from Thomas Cole's series *The Course of Empire* (1836), *The Voyage of Life* (1840), and the unfinished *The Cross and the World* (ca. 1848), as well as a few noteworthy canvases by Cropsey, Durand, and others, there is little pictorial or critical evidence for such a "phase," especially in the 1860s.[16]

When critics in nineteenth-century America discussed allegory, they spoke of its difficulty and, in many instances, asserted that it should have no place in the domain of painting. When describing Inness's *The Triumph of the Cross* in his *Book of the Artists,* Tuckerman called allegorical landscape "a branch of art at once difficult and delicate, for it presupposes some poetical sympathy in the spectator, whereby he can recognize the latent and sublime affinities and suggestions of scenery."[17] A writer in the periodical the *Round Table* agreed, saying

that Inness, "like Corot in France, enjoys the reputation of being spiritual in his landscape painting" and that his series took up "the difficult task of conveying an allegorical idea through the medium of . . . tracts of arable and pasture lands."[18] The *New York Evening Post* praised Inness's three pictures for overcoming such difficulty: "Allegorical painting is justly regarded as belonging to the highest range of art, and in this difficult field Mr. Inness has developed an originality of invention and power of execution which must add to his reputation and that of American art."[19]

The *Bulletin of the American Art Union*'s characterization of a painting by Thomas Prichard Rossiter, on view at the academy in 1851, that depicted the three ideals or types of human beauty—moral, intellectual, and physical—represented a more typical midcentury response to allegory in art: "[In] painting, as in poetry, the allegorical can never afford any lasting interest. The mythological is bad enough, but even that is far better than this—an attempt to incarnate abstract ideas. . . . The beings in whose images we take pleasure, are those who have loved and hated, and through whose veins warm blood has run; and not these cold, shadowy abstractions, these creations of the rhetorician and the moralist. . . . The heart and the mind must be satiated as well as the eye, and with more solid food than painted metaphors and similes."[20] The author of an article entitled "Allegory in Art," published in the *Crayon* in 1856, expressed a similar sentiment, describing the four paintings in Cole's series *The Voyage of Life—Childhood, Youth, Manhood,* and *Old Age*—on view in 1848 as "the weakest in conception, and least artistic of all Cole's works."[21] He objected to these pictures and to "allegoric art" in general because, as he wrote, the "effectiveness and permanent value of any work of Art must depend mainly on its adherence to the particular function of the class of art to which it belongs."[22] "The office of painting," he continued, "is with the visible world" and any attempt to "point a moral or adorn a tale" by painting constituted an unfortunate departure "from the position in which Art is strongest, because at home" rather than in a sphere, namely poetry, "where words can act far more economically and effectively." There is a "double danger," he concluded, "in the mingling of the two elements of thought."[23] In addressing another artist's attempt to illustrate *The Pilgrim's Progress,* a critic for the *Independent* was equally insistent that painting not stray beyond its usual bounds: "No. 112, by Samuel L. Gerry, is called 'Beulah,' and is an attempt to illustrate 'Bunyan's allegory: 10th stage.' The entrance of the pilgrims upon the borders of Heaven, in the country of Beulah, where the sun shineth night and day, is a subject beyond the reach of any artist whose productions have yet been exhibited to mortal eyes; but Mr. Gerry . . . has attempted it without any misgivings; and the result is, of course, frivolous and feeble."[24]

When critics found fault with allegorical paintings, it was often because they considered them unintelligible, hard to read or understand. On those occasions when Cole's series were praised, it was because they were perceived as easy to comprehend. In *The Course of Empire,* wrote *Harper's New Monthly*

Magazine in 1856, "The sentiment and moral were obvious, and *everybody could read as he ran.* The works told their own story, and the story was very simple."[25]

Allegorical and literary works, many critics insisted, should explain themselves to their viewers without the aid of a text, and images that depended on words failed as paintings.[26] Recall that when Inness attached poetic fragments, or captions, of his own creation to two of the landscapes he exhibited at the academy in 1878 and to a sculpture by his son-in-law, the attempt was called "peculiar" by one critic and lambasted by another. Inness was not the only artist who was chided for bodying together painting and text. When Durand exhibited a landscape that illustrated an episode from William Cullen Bryant's poem "Thanatopsis" (1817), a writer in the *Literary World* called the painting "a mistake." "The picture," he said, "apart from the poem" has "little individuality. It does not explain itself, and without the key afforded by the lines quoted in the catalogue, could hardly be understood."[27] Landscapes, wrote another critic in 1852, should tell their stories "without any lettering."[28]

All the same, Inness was more than a little interested in getting "lettering," writing, or at least something of language's expressive potential into his pictures. As I see it, Inness's interest in allegory and in the possible collusion of painting and the written word was motivated by his preoccupation with the possibility of expanding vision's power and reach. His experiment with allegorical landscape in the 1860s constituted a first attempt to create a place for writing in the realm of painting, one that anticipated his poetic captions at the academy in 1878. Inness wrote poetry, penned "mountains of writings," was engaged in writing a "work on art," characterized the creative act as a matter of inscription, was interested in Egyptian hieroglyphics, and equated his study of geometry and the principles of *disegno,* or design, with writing's ability to express philosophical and spiritual thought.[29] He wrote a pamphlet to accompany the exhibition of *The Triumph of the Cross;* this, in conjunction with his interest in the written word and the fact that he based his series on a text, amounted to a declaration that writing and looking, rather than acting as mutual usurpers, were, or should be, coincident and combinatory experiences.

Inness rarely discussed American painters, preferring to comment on the art and artists of Europe. In the interview "A Painter on Painting," he spoke of Decamps, Couture, Gérôme, Troyon, Meissonier, Corot, Delacroix, Rousseau, Daubigny, Turner, Constable, and Michelangelo; Allston was the only American painter that warranted more than one or two lines.[30] When he did speak of American art, he singled out Cole for praise, comparing the latter to the old masters and saying that "there was a lofty striving" in his art "though he did not technically realize that for which he reached."[31] If combined with what he characterized as Durand's "intimate feeling of nature," Inness suggested, Cole's project would be complete.[32] Cole had throughout his career sought to develop a higher and more noble landscape style, and Inness surely looked to his example, and in particular, to his unfinished *The Cross and the World,* which was

inspired by Bunyan's allegory, when he began to think about painting a series of allegorical landscapes that, as with *The Sign of Promise*, were meant to present the observer with "more than he sees."[33] His allegorical works were chided by some for their impropriety, as were Cole's, yet they were described by many as representing a noble effort in a difficult field, as if Inness had succeeded where others, including Cole, had failed.

In "A Painter on Painting," Inness professed his admiration for Eugène Delacroix and described the latter's allegory "The Triumph of Apollo" at the Louvre (1850–51; fig. 45) as one of the "best works of art." It "really signifies," said Inness, "the regeneration of the human soul": "An enormous serpent represents the sensual principle; the smoke from its mouth, forming the whole base of the picture, represents all ideas of darkness and gloom, and, as it spreads and rises, assumes monstrous forms, which are the evil consequences of natural lusts. Above is Apollo, the sun-god, standing in the brilliant light, his chariot drawn by horses which are intelligences, and surrounded by various divinities which drive down the monstrous forms that are rising. It is a splendid allegory, painted with immense power."[34] Perhaps Inness's allegorical landscapes consisted of an attempt to combine what he called Delacroix's "sublime story" (an instance, to his mind, wherein the literary did not wind up "broken" and "confused") with Cole's lofty landscapes and Durand's intimate feeling of nature, thus creating landscapes with a higher purpose as well as producing a representational mode that went beyond or, rather, expanded the limits of painting so as to allow a place in art, and in landscape representation, for what had been disparaged as "cold, shadowy abstractions," "creations of the rhetorician and the moralist," and "painted metaphors and similes." Inness had faulted Delacroix for not attempting to "realize nature, to represent what we see," and he could easily have lodged the same complaint against Cole's fantastical landscape views.[35] Collectively, Cole's higher purpose, Delacroix's allegory of the forces of dark and light (what Inness may have understood as a struggle between obscure and enlightened vision), and Durand's quiet but powerful renderings of American scenery, which mitigated the fantasy represented by the other two, may well have suggested to Inness a way of making allegory a proper and instrumental pictorial and visual mode.

In the pamphlet that accompanied *The Sign of Promise* when it was on view in New York, Inness wrote the following (a portion of which I have already cited): "He [the painter] does not offer this picture as a perfect illustration of the epic in landscape, but only as the visible expression of a strongly felt emotion of Hope and Promise. How well

Figure 45. Eugène Delacroix, *Apollo Vanquishing Python* (1850–51). Oil on remounted canvas. 800 × 750 cm. Musée du Louvre, Galerie d'Apollon, Paris. Réunion des Musées Nationaux/Art Resource, New York.

that emotion is expressed, the public must judge for themselves. The feeling sought to be conveyed, the true meaning of the picture will not be found in any hieroglyphics, for which those who seek them will seek in vain. If the picture presents not to the observer more than he sees, the picture is clearly a failure—at least to him."[36] Allegory did not announce itself—there were no obvious hieroglyphics—in *The Sign of Promise,* yet there was a hidden meaning—"more than he sees." Allegory and landscape, Inness seems to imply, were meant to be so tightly fused in this painting that viewers could read, and see, as they ran. It may have been this type of viewing experience, wherein text structured looking but did not distract and painting's limits expanded to include reading (and reading into, so as to discern higher purpose), that Inness set out to investigate in *The Triumph of the Cross,* and it may be that he considered allegory, in an expanded and revised form, a potential model for a new and spiritual mode of sight, one based on the collusion of two different representational systems (writing and painting) and on the radical transformation of viewing and vision that, taking into account contemporary assumptions about image and text, would have had to result.

"THIS BOOK WILL MAKE A TRAVELER OF THEE. . . . THE BLIND ALSO DELIGHTFUL THINGS TO SEE"

By the time Inness came to paint it, Bunyan's *The Pilgrim's Progress,* one of the earliest illustrated books in America, was incredibly popular in the United States and had appeared in numerous editions; many of the nation's leading landscapists had illustrated episodes from it.[37] Shortly before Cole painted *The Cross and the World,* Frederic Church painted a landscape entitled *Christian on the Border of the Valley of the Shadow of Death* (1847; fig. 46). In 1850, a moving panorama of *The Pilgrim's Progress* that included among its fifty-three scenes designs by Church and Cropsey began a multicity tour and was seen by more than 200,000 people during the first six months it was on view in New York.[38] A notice in the *Independent* sang the panorama's praises, encouraged the attendance of children, and exclaimed that the "chequered life of the Christian" was "now an object of study to artists, and as portrayed by the pencil, of admiration to the multitude! The dream of John Bunyan instructing thousands, who, had they lived in Bunyan's day, would have sneered at the preaching tinker!"[39] In 1867, the year Inness exhibited his series in New York, a second version of this panorama, which had been touring continuously for more than fifteen years, attracted a great deal of attention in that same city; the exhibition closed only weeks before Inness's paintings went on view.[40] "While this attractive panorama is on exhibition in New York," wrote one commentator, "it is a good time to give a new reading to the PILGRIM'S PROGRESS. Next to the King James's version of the Bible, it is the purest well of old English undefiled. . . . The frequent reading of the *Pilgrim* is not only a literary entertainment of the highest order, but a rich and precious spiritual profit to the soul."[41] Bunyan's

Figure 46. Frederic E. Church, *Christian on the Border of the Valley of the Shadow of Death* (1847). Oil on canvas. 40 × 60 in. Olana Historic Site, Hudson, New York, New York State Office of Parks, Recreation, and Historic Preservation.

tale was popular enough to inspire parody. Nathaniel Hawthorne's delightful short story, "The Celestial Railroad" (1843), recounts the narrator's aborted journey on rail from the City of Destruction to the Celestial City.[42] Accompanied by a "Mr. Smooth-it-away," the protagonist traveled unharmed through the landscape that offered the pilgrim Christian only hardship and woe; the Valley of the Shadow of Death had been brightened with gas lamps and the Giant Despair's house was inhabited by a harmless and incoherent Transcendentalist. Hawthorne's moral, however, was the same as Bunyan's, for taking the "easy way" resulted in disaster, as the train travelers were refused entry when they reached their exalted destination.

The *Pilgrim's Progress* may well have appealed to Inness because of its popularity; it would have been recognized by the majority of visitors to the exhibition of *The Triumph of the Cross,* who, if they had not seen one of the panoramas, probably knew of them and, if nothing else, had read the book (or looked at an illustrated version of it). This may have been a crucial factor in the perceived success of the series. Yet a close reading of Bunyan's text suggests that it offered Inness more than an easily recognizable narrative that aided in enhancing the intelligibility of his canvases and served a purpose beyond that of supplying a jumping-off point for his claims concerning the divine.

This is because *The Pilgrim's Progress,* an allegory of faith, may also be understood as an allegory of perception. Bunyan, like Inness, believed that it was the task of the artist and the poet to teach people how to see: "This book will make a traveler of thee / If by its counsel thou wilt ruled be / It will direct you to the Holy Land / If though wilt its direction understand / Yea, it will make the slothful active be / The blind also delightful things to see."[43] Also like Inness,

Bunyan differentiated true vision from its more debased forms, drawing a distinction between a vision of the "bodily eyes" and a kind with which one was able to see Christ.[44] The tale, a description of dream images, hinges on visual experience; throughout, action is precipitated by phrases such as "Now I *beheld* in my dream," "So I *saw* that," and "I *looked* then."[45] Comprising a series of perceptual acts and images seen, the text's structure resembles that of a tour through a picture gallery in which description, interpretation, and instruction combine. After trudging through the Slough of Despond on his way to the Wicket Gate, Christian comes on the house of the Interpreter who shows him a series of emblematic tableaux—a person with a stack of books and a crown, a parlor full of dust and a man sweeping, two seated children, one happy, the other upset— and explains the meaning of each as the confused pilgrim looks on.[46] Interpreter leads him from emblem to emblem as if the two were in rooms filled with paintings and statuary; at the end of his tour, Christian recounts an emblematic vision of his own.[47]

In the poem that introduces *The Pilgrim's Progress,* Bunyan defended his use of metaphor by asking, "Were not God's laws / His gospel laws, in olden time held forth / By shadows, types, and metaphors?"—implying that truth abided in obscurity and darkness.[48] In the act of reading, he suggested, one pierced, by way of interpretation, the shadows of the text's imagery and, as did Christian, acquired a new vision, thus apprehending both truth and light. The reader, as he progressed through the text, experienced what Bunyan implied the quest for enlightenment actually entailed. The looking that occurs at Interpreter's house is exemplary of the experience of vision in Bunyan's narrative (and of Bunyan's reader); the perception of truth and seeing in general are continually delayed or blocked—by emblem and metaphor and, also, fog, darkness, illusion, memory, and fear. A view of the Celestial City and the "reflections of the sunbeams upon it" cause Christian and Hopeful to fall into a debilitating fit of sickness as they gaze and their perception of the glorious scene is obscured.[49] As the pilgrims approach the abode of God, they are blinded by its glory: "But, as I said, the reflection of the sun upon the city (for the city was pure gold) was so extremely glorious, that they could not as yet with open face behold it, but through an instrument made for that purpose."[50] Even at the doorstep of the heavenly city, vision is mediated; seeing cannot happen without the aid of an optical device.

The first image in Inness's series, *The Valley of the Shadow of Death* (plate 10) is about looking but not just in the sense that all paintings, especially those that show people using their eyes, are in some way about perception. The painting depicts the pilgrim Christian, clothed in a white robe and carrying a walking staff or perhaps a sword, pausing on his journey through the desolate landscape described in Bunyan's text.[51] His back is turned to the viewer, and he looks through the darkness toward an image of the cross that illuminates the distant blue sky. At the border of the Valley, Bunyan wrote, Christian met several men who warned him of "hobgoblins, satyrs, and dragons of the pit; . . . a

continual howling and yelling, as of people under unutterable misery, who sat bound in affliction and irons; . . . [and] discouraging clouds of confusion."[52] The dark and fantastically configured terrain in Inness's picture, unlike that in any of his other works, certainly conveys the horror of the place; as one reviewer reported, he had made the painting frightful by "painting the rocks to resemble hideous forms, reptiles, and goblins."[53]

In Bunyan's text, Christian encounters an emblematic vision immediately on entrance into the dreaded land: "I saw then in my dream, so far as this valley reached, there was, on the right hand, a very deep ditch; that ditch it is, into which the blind have led the blind in all ages, and have both there miserably perished."[54] A marginal note in an edition of *The Pilgrim's Progress* published in New York in 1855 explains: "The ditch on the right-hand is error in principle, into which the blind, as to spiritual truths, lead the blind, who were never spiritually enlightened."[55] In the circular that accompanied the exhibition, Inness characterized his painting as just such an allegory of enlightenment:

> In this picture I have endeavored to convey to the mind of the beholder an impression of the state into which the soul comes when it begins to advance toward a spiritual life, or toward any more perfected state in its journey, until it arrives to its sabbath or rest. Here the pilgrim is leaving the natural light, whose warm rays still faintly illumine the foreground of the scene. Before him all is uncertainty. His light hereafter must be that of faith alone. This I have represented by the cross, giving it the place of the moon, which is the natural emblem of faith, reflecting light on the sun, its source, assuring us, that although the origin of life is no longer visible, it still exists; but here, clouds may at any moment obscure even the light of faith, and the soul, left in ignorance of what may be its ultimate condition, can only lift its eyes in despair to Him who alone can save, and lead it out of disorder and confusion.[56]

The pilgrim in Inness's picture has just left the world of natural light and enters a realm where the physical eye has no real power; obscurity and darkness reign and vision is, in effect, a form of blindness, consisting of the light of faith alone.[57] The painting is about what can and cannot be seen, and it suggests that the process of spiritual regeneration, and the acquisition of spiritual sight, had to involve physical perception's temporary suspension or lapse. At the end of his arduous passage through the Valley, Bunyan wrote, "by-and-by day broke" and Christian, "now morning being come . . . looked back" and "now saw more perfectly." He, the preacher said, "discovereth deep things out of darkness, and bringeth to light the shadow of death."[58] With Christian, we look through darkness (vapors, mists, and metaphors) toward this promise of light; his gaze reproduces ours, and as we countenance the view, we begin to understand that, in order to see, we must first be blind.[59] The light of the moon, which represents the light of consciousness and understanding, directs our gaze back to the sun,

the light of which makes available to our eyes the visible, material world. In Inness's formulation, the path out of disorder and confusion lies in the combination of these two kinds of seeing, in the marriage of the understanding and the visual sense and the subsequent expansion of physical perception, what involves first blindness then a redirection, not a wholesale abandonment, of physical sight.

As with the first image, the second canvas in Inness's series, *The Vision of Faith,* depicted a moment from Bunyan's text where an act of looking is presented as a lesson in spiritual seeing. "Here," Inness wrote,

> the soul, lifted from out of the Dark Valley, is ministered to by angels. To represent this idea I have taken the story from Bunyan's beautiful allegory, where Christian has arrived at the Delectable Mountains. Shepherds are pointing the way, and he, lifting the glass which they have given him, is striving to catch a glimpse of the Holy City, where his journey ends. I leave each beholder to look for it with his own perspective glass, giving my own feeling of what it is, so far as I am able to convey it, in the last picture of this series.[60]

In *The Pilgrim's Progress,* Christian and his companion Hopeful arrive at the Delectable mountains after they have escaped from the Giant Despair; they refresh themselves in the gardens, orchards, fountains, and vineyards of the mountainous lands, and at the summit of one of the peaks, they encounter a group of shepherds tending to their flock.[61] After a good night's sleep, the shepherds take the pilgrims on a stroll about the hills.[62] The narrative takes on the aspect of a picturesque tour at this point, as Christian and Hopeful's guides lead them through the land, pointing out, as Interpreter had, a series of emblematic sights.[63] Eventually, the shepherds lead the pilgrims to a valley and show them a by-way to Hell.[64] Frightened, Christian and Hopeful express their desire to move on, and their guides show them one last view; it is this episode that Inness rendered in *The Vision of Faith:*

> So they walked together towards the end of the mountains. Then said the Shepherds . . . Let us here show the pilgrims the gates of the Celestial City, if they have skill to look through our perspective glass. The pilgrims then lovingly accepted the motion; so they had them to the top of a hill, called CLEAR, and gave them the glass to look. Then they tried to look, but the remembrance of that last thing that the Shepherds had showed them [the by-way to Hell], made their hands shake; by means of which impediment, they could not look, steadily, through the glass; yet they thought they saw something like the gate, and also some of the glory of the place.[65]

Here, the pilgrims' attempt to see the Celestial City is foiled by the obscuring effects of memory ("remembrance of that last thing"); vision on the Mountain

Figure 47. Attributed to Joseph Kyle and Edward Harrison May, *"The Shepherds Pointing out the Gates of the Celestial City from Hill Clear," Panorama of Bunyan's "Pilgrim's Progress"* (ca. 1850–51), scene 40. Distemper on cotton muslin. 8 × 900 ft. Collection of the Saco Museum of the Dyer Library Association; Saco, Maine; gift of the heirs of Luther Bryant, 1896.

Clear is anything but, and, despite the aid of a "perspective glass," perception of the spiritual realm remains clouded. The panorama on view in New York in 1850 included an illustration of this scene (fig. 47). Christian, standing on a mountain summit and clothed in the garb of a knight, with Hopeful by his side, looks through a tube-shaped instrument toward a distant and brilliantly illuminated prospect and sky. Inness wanted his pictures to show his viewers what they could not but should learn how to see; it is especially interesting, then, that he chose to illustrate a scene from Bunyan where a figure looking at a landscape uses an instrument that was employed by painters as an aid to representation. A perspective glass's double-concave and ruled lens reduces the visual field so that through it one sees a broad expanse of land in a very small space and can imagine that what is seen is a picture already painted. What both Bunyan and Inness suggest here is that one cannot perceive and know Heaven with the physical eye on its own, that the Celestial realm can be seen only as representation, shaped by a mediating device, as if to suggest that pictures can do the work of spiritual sight, that paintings reveal things that the eye does not perceive, that an artist (Inness) had to show his viewers how to really see.

According to Inness's pamphlet, the final picture in the series, *The New Jerusalem*, depicted what the pilgrims would have seen through the perspective glass had the effects of distance and memory not interfered:

> The picture represents a state of peace and rest, after the states of depression
> and elevation to which the soul has been subjected since leaving the natural light.
> I have endeavored to convey this thought by a landscape, where no part is left
> uncultivated, but all is made subservient to the pleasure and happiness of its
> residents. Here the cross is no longer a burden to be borne, nor is faith any longer
> its emblematic character; but it has become the love of the purified heart, and

the perfected understanding, now always acting from its true source of life, acknowledges nothing as the effect of human intelligence, but that all things come from God.[66]

As *Frank Leslie's Illustrated Newspaper* characterized it, the scene "shadowed out" the Holy City and depicted "a great expanse of varied, pastoral landscape, over the distant trees of which the architecture [of the city] is dimly visible. This architecture is repeated mystically in the sky; and the whole scene is intended to convey the sentiment of tranquility and rest."[67] The critic for the *New York Evening Post* noted Inness's "use of exquisite tones of green"; the wealth of vivid color in *The New Jerusalem,* he said, stood in marked contrast to the palette of the other two pictures in the series. "The composition and treatment of the subject," he wrote,

> is on a grand scale. The Cross is here again seen in the heavens, but it is more than
> a hope and a promise—it is a glorious realization. Its light illumines and vivifies
> every object in the broad extended scene. It reveals to our sight the city descending
> into the clouds; it floods with golden glory the towers and domes, which almost
> melt into the sky on the horizon's edge[;] meadow, and forest, and trees, and river
> are bathed in this radiance. In depicting the earthly symbol of the New Jerusalem,
> the artist has given us a beautiful landscape garden, where every object makes glad
> the eye and soul. The River of the Water of Life flows out of the picture at your
> feet. Into its tranquil depths are being carried the sick and the lame to be healed
> of their wounds and fitted for eternal happiness and rest. The picture of the "New
> Jerusalem" is a revelation of exquisite design and beauty of color. If, with its com-
> panions, it leads the mind to higher conceptions of the good and beautiful, they
> will have fulfilled the mission of the artist and his art.[68]

Not everyone was enamored of this work. Two years after *The Triumph of the Cross* was first exhibited, a critic called this third painting an "awkward endeavor to precipitate an iron-blue New Jerusalem, of Hottentotish architecture, upon an unprepared and unsuspecting New England farming land."[69]

It is impossible to reconstruct perfectly Inness's fantastic scene, but, when pieced together, the three existing fragments, in conjunction with critical descriptions and the corresponding panorama view (fig. 48), give us a good idea of what the whole entailed. When placed alongside one another, the canvas at the Walters Art Museum and the one sold by Sotheby's, on the left and right, respectively, are approximately two inches shorter in length than *The Valley of the Shadow of Death.* The two are contiguous, connected by an aqueduct, painted dark brown, that horizontally bisects the Walters scene and runs along the base of the Sotheby's view. The Krannert canvas constitutes a portion of the painting's lower-right quadrant and may be contiguous with the Walters piece, to its left, although it almost certainly is not a direct extension of the Sotheby's fragment above it. In combination, the three fragments delineate a brilliantly

colored and lavishly painted panoramic landscape view with a river originating in the foreground, cultivated fields throughout, a heavenly city of glorious architecture in the distance, and hints of a second identical city in the clouds above. In both the Walters and the Sotheby's fragments, a series of loosely sketched but grandly elaborate buildings—palazzos, towers, and domes—stretches across the horizon; in the Walters work, two additional castlelike complexes appear slightly below the horizon zone, at center and left. The shimmering whites, grays, tans, and yellows that Inness used to delineate these architectural forms and the atmospheric haze in which he envelops them make them seem to melt into and merge with the surrounding sky and ground. In the Sotheby's canvas, the horizon strip does indeed appear to be echoed in the clouds above, for thickly applied whitish-yellow paint, in-mixed with bright blue here and there, takes on the form of what lies beneath; traces of this effect can be identified in the Walters fragment, as well. No cross is visible in the sky, but it may have appeared in the uppermost portion of the painting, at right, now missing. The space beneath the horizon is occupied by a series of plains, most cultivated (we should think of Inness's "civilized landscape" here) but some not, as well as numerous lushly painted gleaming dark and light green trees. In the Sotheby's work, two groups of figures can be seen toward the bottom of the canvas, one at far left and one toward the center, walking along the aqueduct. Other figures appear throughout, perhaps part of the throng being carried to Heaven by the River of the Water of Life. Indeed, a river element seems to connect the three pieces; it appears at the bottom of the Krannert and Walters canvases, and at lower right, underneath and on top of the aqueduct, in

Figure 48. Attributed to Jasper Francis Cropsey, *"Land of Beulah," Panorama of Bunyan's "Pilgrim's Progress"* (ca. 1850–51), scene 43. Distemper on cotton muslin. 8 × 900 ft. Collection of the Saco Museum of the Dyer Library Association, Saco, Maine; gift of the heirs of Luther Bryant, 1896.

the Sotheby's piece. In the Walters work, the river or stream flows out beyond the right edge and reappears in the middle ground (where it connects with the water element in the Sotheby's fragment), as if it has circled around on its journey toward the fabulous Celestial City. Numerous figures, wearing what appear to be cloaks or shrouds, can be seen throughout the Krannert canvas (some may even be in boats); two adopt the posture of Christian in *The Valley of the Shadow of Death* (and what we imagine to be the pose of the pilgrims as they gaze through the perspective glass in *The Vision of Faith*), backs turned to the viewer, gazing at the prospect before them. This third canvas, then, as with the other two, highlights an act of perception, an instance of vision that takes place on the road to heavenly wisdom and sight. What might be similarly cloaked figures appear in the foreground of the Walters work as well.[70]

As with *The Pilgrim's Progress,* Inness's series is about faith, but it is also about seeing, as understood in the way I have been describing it. In all three pictures, Inness chose to depict episodes from Bunyan's book where the protagonists engage in acts of looking; in the first two canvases, seeing is compromised: by darkness in *The Valley of the Shadow of Death* and by distance, memory, and an intervening optical instrument in *The Vision of Faith*. In *The New Jerusalem,* the double image of the Holy City—one dimly visible, the other mystically resplendent in the sky—represents the stages, first blindness, then heavenly vision, that Inness appears to have imagined the search after a more revelatory mode of perception entailed.[71] In the space of a landscape that is anything but coherent—as James Turner has noted, Bunyan's terrain is marked by varieties in scale, multiple and misleading paths, and discontinuous and contradictory spaces—and that fails to approximate the functions of normal, or carnal, perception, Bunyan staged a narrative of the struggle of a search after spiritual vision.[72] It is not difficult to imagine that, in choosing *The Pilgrim's Progress* as the subject of his own allegory, Inness had in mind not just the illustration of this serial struggle and, with the third painting in the series, the glory of its end but also the proposition that, through allegory's recuperation, a painting could be made to produce the conditions under which the experience of the beholder, who was faced with allegory's veiling and obscuring effects, reproduced or, rather, enacted such a striving toward spiritual sight.

"I LEAVE EACH BEHOLDER TO LOOK FOR IT WITH HIS OWN PERSPECTIVE GLASS"

I say enacted because I think Inness wanted his viewers to do more than look at his allegorical canvases; he wanted them to imagine themselves as in them, taking part in the action they depicted (something those critics of "allegoric Art" implied was impossible to achieve). Recall that, in writing about art in the United States in the 1840s–60s, landscapes that were described as masterful and compelling, enchanting and poetic, were those that appeared to invite the

beholder into their fictional spaces. Inness, we know, worked hard during these years to meet this demand for inhabitability, to get his viewers imaginatively, fictionally into his landscape views.

The Triumph of the Cross was the only multipart series that Inness painted during the whole of his fifty-year career. I am sure that he was thinking of Cole's various allegorical series when he began to formulate an idea for one of his own, but I would also guess that he was thinking about the fifty-three-scene moving panorama of Bunyan's *The Pilgrim's Progress* that was touring New

York as he began to work on his own three-scene version of the tale. And I am convinced that what Inness took from the example of the moving panorama was an idea as to how to get his viewers to forget their actual surroundings (Snedecor's gallery) and imaginatively inhabit and participate in his scenes.

Painted in distemper on thin cotton cloth, "The Grand Moving Panorama of Bunyan's Pilgrim's Progress" (fig. 49), as it was called when it toured during the period between 1850 and 1867, consisted of a length of fabric, 8 feet high and 900 feet long, wound on two spools and reeled across a stage, exposing 15–30

Figure 49 (*opposite, left*). George F. Nesbitt & Co., New York, Broadside: *Bunyan's "Pilgrim's Progress"* (ca. 1851–54). Printed on wove paper. 21¾ × 7⅞ in. Olana Historic Site, Hudson, New York, New York State Office of Parks, Recreation, and Historic Preservation.

Figure 50 (*opposite, right*). Broadside: Exhibition of John Banvard's *Panorama of the Mississippi, Missouri, and Ohio Rivers* in North Shields, Tyne and Wear, England, 1852. Missouri Historical Society, St. Louis.

Figure 51 (*top*). "Banvard's Panorama—Figure 1." Schematic drawing of the machinery for John Banvard's *Panorama of the Mississippi, Missouri, and Ohio Rivers* (1846–48). From *Scientific American* 4 (December 16, 1848): 100.

Figure 52 (*bottom*). Attributed to Frederic E. Church, *"Dawn of Day over the Valley of the Shadow of Death,"* *Panorama of Bunyan's "Pilgrim's Progress"* (ca. 1850–51), scene 20. Distemper on cotton muslin. 8 × 900 ft. Collection of the Saco Museum of the Dyer Library Association, Saco, Maine; gift of the heirs of Luther Bryant, 1896.

feet of the painting at a time. An advertisement for John Banvard's moving panorama of the Mississippi, Missouri, and Ohio Rivers, from 1852, and a schematic illustration of Banvard's panorama apparatus, taken from the December 16, 1848, issue of *Scientific American,* provide some sense of what this would have entailed (figs. 50, 51).[73] Each panel illustrated an episode from Bunyan's book, Christian's fight with Apollyon, for instance or, as with Inness's first canvas, the Valley of the Shadow of Death (fig. 52).

The sequence of scenes, designed and/or painted by Joseph Kyle and Edward Harrison May and academicians such as Cropsey and Church, as well as lesser-known artists or craftsmen, approximated the movement of a tour, reproducing Christian's walk through the landscape on his way from the City of Destruction to the Gates of Heaven. Each scene was separated from the next by a blank space, or sometimes clouds, bits of foliage, and a rock or two, as if the viewer, imagining himself or herself walking alongside the pilgrim, was himself on a tour, starting and stopping and taking in a select number of self-contained sites (or sights). Stagehands manipulated light fixtures so as to create effects of changing weather and times of day; as one viewer reported, "the low soft melody of an instrument" accompanied the display of the succession of scenes, or stops on the tour, while a narrator, or guide, described each view as it passed.[74] This episodic mode of seeing—a site, or stop, and then a blank, and so on and so forth—produced by the moving panorama resembled the mode of vision and viewing constructed by travel literature of the day, which took its cue from the picturesque tour, wherein the reader was instructed to follow a specific itinerary that took him from one striking spot to the next, while more or less ignoring what came in between. Moments of looking remained isolated from one another because of their textually produced frames, and each site was successively lost to view (but not forgotten) as traversal progressed.

Inness took his cue from this example of panorama technology and produced a series of views that were meant to be experienced as stops along a landscape tour. The pamphlet he created to accompany the exhibition functioned as a kind of guidebook, which viewers consulted as they strolled around the gallery and looked, imagining themselves as inside of and walking through the scenes they saw, the spaces between his pictures, empty gallery walls, reproducing the voids between one and then the next striking sight. Inness, of course, took a risk when he incorporated into what he wanted to be a participatory experience the elements of a popular entertainment that required the audience to sit still, look at, and passively listen. Jarves, remember, criticized Bierstadt's painting of the Rocky Mountains precisely because its viewer could easily mistake it for a panorama; he waited for it to move and never lost sight of the fact that he was looking at a picture, rather than imagining himself in the landscape depicted. Inness, however, made sure to populate his three pictures with back-turned figures looking at things, and he provided viewers with a text to read on their own as they physically walked around and looked, moving between image and void, from one sight to another, with blanks in between, so that they

"forgot" their surroundings and their experience of looking in some way approximated the feel of a landscape traverse.

Bunyan's narrative is motivated and driven not just by acts of looking but by instances of remembering and forgetting as well. As Stanley Fish has suggested, the text is a matter of looking forward but also of looking back, recollecting a previous terrain or event, while holding a present scene in one's eyes. Along with vision, recollection, or its failings, motivates the progress of the narrative and determines the outcome of the crises the pilgrim encounters on the way.[75] Acts of remembering provide Christian and Hopeful with the means to enlightened perception. At Interpreter's house, for instance, Christian's host enjoins the pilgrim to take what he sees to heart and shape his actions according to each emblem's lesson; as Interpreter points to a tableau of a despairing man trapped in an iron cage, he says, "Let this man's misery be remembered by thee, and be an everlasting caution to thee." As Christian prepares to depart, his host instructs him to keep what he has witnessed in his memory: "Well, keep all these things so in thy mind, that they may be as GOADS in thy side, to prick thee forward in the way thou must go."[76] Well into their journey, Christian and Hopeful encounter the pillar of salt into which Lot's wife was transformed; on it is written the word "Remember."[77] They escape from the Giant Despair's dungeon only because Christian remembers he has a key "called PROMISE, that will, I am persuaded, open any lock in DOUBTING CASTLE."[78] Hopeful had encouraged this recollection by asking his companion to call to mind his triumphs against the monster Apollyon as well as the various horrors of the Valley of the Shadow of Death.[79] Time and time again, forgetting results in disaster and diversion. The shepherds at the Delectable Mountains tell Christian and Hopeful to "beware of the flatterer" and then give them a "note of the way," but the pilgrims forget to heed the warning and pay no attention to the directions provided; as a result, they follow a strange path and wind up ensnared in Flatterer's net.[80] Later on, Christian begins to succumb to the soporific fumes of the Enchanted Ground before Hopeful admonishes him: "Do you not remember, that one of the Shepherds bid us beware?"[81] Throughout, remembering allows the pilgrims to undermine the reality of a given situation (we are trapped in Doubting Castle) and to see beyond appearances (I have a key); recollection, and the accumulation of a series of things remembered, propel their journey and enable them to inch ever closer to their goal.

At the beginning of *The Pilgrim's Progress*, Evangelist asks Christian, who had just escaped from the City of Destruction, "Do you see yonder WICKET-GATE?" Christian answers "No"; "Then said the other, Do you see yonder shining light? He said, I think I do. Then, said EVANGELIST, Keep that light in your eye, and go up directly thereto, so shalt thou see the gate; at which, when thou knockest, it shall be told thee what thou shalt do. So I saw in my dream, that the man began to run."[82] Here, obscured or dimmed sight ("No . . . I think I do") combines with an injunction to remember ("Keep that light in your eye") at the very portal through which the traveler had to pass in order to begin a quest to

meet and see with God. Any search for enlightenment and vision, it is implied, must involve a blinding of the physical eye (what Inness called "leaving the natural light") and an operation of memory as well, one that, in essence, has become a mode of perception, since remembering is figured as keeping a light in one's eye. It was the memory of fear that prevented the pilgrims from attaining a view of the Delectable City through the perspective glass, and it was the recovery, through recollection, of the all-important "note of the way" that gave the pilgrims both physical and visual access to Heaven.

The picturesque tour was supposed to amount to a similar experience of accumulation, wherein a series of sights, a succession of seen and subsequently absent but remembered views, added up, in the end, to a feeling of intense pleasure, akin to what Gilpin called a "deliquium of the soul, an enthusiastic sensation of pleasure," and what Burke characterized as an exquisite "circle of fire."[83] In looking from text to image, letting the memory of words inflect the experience of paintings, and the recollection of images inflect the experience of words, Inness's viewers were doubly implicated in a system of cognition that counted veiling and dimming, deferral and delay, moving forward and going back, seeing anew but remembering what came before, as crucial to its operations and effects. Time, as was then understood, was the sphere of the poet, and space that of the painter; pictures were to confine their action to a single moment whereas poems could depict time's passage.[84] Inness's allegorical landscapes, however, did not heed this distinction, one drawn by Lessing in the *Laocoön* (1766) and held up in writing about art during this period in the United States. Inness's incorporation of textual duration (the pause between the apprehension of allegorical sign and the acknowledgment of meaning) into his works figured not just physical vision's temporary and necessary lapse but also the time and feel of travel, creating a structure of perception, akin to that proposed by Bunyan and books of picturesque travel widely popular at the time, that made looking, reading, remembering, and being in a landscape corresponding and coincident experiences.

Inness enjoined the viewer to utilize "his own perspective glass" when viewing his second scene, *The Vision of Faith,* thus encouraging his active participation in the prospect before him and asking him to identify with, become, as it were, the back-turned pilgrim who did the same, training a telescope toward the gates of heaven. Visitors to midcentury exhibitions of single pictures or landscape series were often advised to bring opera glasses to aid them in viewing the works on display; such was the case in a notice for the exhibition of Inness's *The Sign of Promise* at the galleries of Williams and Everett.[85] Had Inness's viewers brought along their opera glasses to the exhibition of *The Triumph of the Cross* and trained them on the second canvas in the series, they would have been triply implicated in the action of the scene, through just looking at someone else looking through a lens and through looking with the aid of an optical device at this person looking through this lens.

When it went on view in 1867, *The Triumph of the Cross* solicited just such a participatory response from its viewers, at least according to several critics who wrote about it. "You gaze," wrote the critic for the *New York Evening Post* about *The Vision of Faith,* "across this broad expanse of pasture-land to the lake which lies placid at the base of the hills, and then up the declivity and be-yond, to where the peaks of the snow mountains tremble in a heaven of blue and pearl. . . . A mountain torrent falls into a deep ravine cut in these hills, and which comes forward nearly to the feet of the spectator."[86] This same critic had described the River of the Water of Life in *The New Jerusalem* as flowing "out of the picture at your feet," as if he were imagining himself as part of the scene, identifying with the bodies carried toward eternal happiness and rest by the inward and inviting flow of the stream and with the cloaked figures standing on the shore, backs turned, gazing at the gates of Heaven. When describing *The Valley of the Shadow of Death,* he called it "a grand composition" and char-acterized its optical and phenomenological effects in some detail: "This chiaroscuro, or what expresses it better, this stereoscopic effect, is marvelously rendered where the figure of the Pilgrim and the projecting rock stand out in absolute relief from the blue of the dark valley, while the clouds above form a vaulted roof *which each instant threatens to embrace you in its folds.*"[87] Accord-ing to this writer, the painting achieved an effect of three-dimensionality so vivid it seemed as if created by a stereoscopic device, thereby imitating the operation of binocular, and actual, vision, as if to say that the viewer's own vision, functioning from within the confines of the landscape scene, was re-sponsible for the stereoscopic effect described, as if the phenomenal worlds of the viewer and the picture were one and the same. Indeed, the painting shares its stage-set quality—discrete layers of alternating light and dark rock receding into depth, as in a diorama—with stereographic views, wherein the effect of three-dimensionality is created by abrupt moves between advancing and reced-ing objects or scenery. Our viewer-surrogate stands in relief against his painted, stereoscopic surround; his posture within this popping-out space in-vites us to imagine being in the canvas, standing on a projecting rock looking toward the light, about to be embraced by the folds of yellow cloud that ob-scure the sun. Anthropomorphized rocks, characterized as such by at least two commentators at the time, do the same, for they invite identification and figure the possibility of a body being physically in and a part of a landscape that mimics and echoes bodily contours and forms.[88] Although the foreground space is precarious, composed of three squarish rock fragments that are discon-tinuous with the viewer's realm, thus offering only a sheer drop on entrance, the cliff formations at left and right (proper *repoussoirs* at last) frame a vortex-like central space that pulls the beholder into the canvas's heart. "In the first composition, 'The Valley of the Shadow of Death,'" the critic for *Frank Leslie's Illustrated Newspaper* wrote, "everything is wrapped in a mystic gloom, save one spot of sky, in which there appears a luminous cross, toward which the

eyes of a pilgrim just plunging into a yawning abyss beneath are directed."[89] The viewer's eyes, and his body, bound by surrogacy to Christian's, reproduce this plunge.

Given Inness's interest in writing and his investigation of the possible collusion of writing and the pictorial arts, it is not difficult to imagine that he created the conditions for participation (surrogate viewers, inflowing rivers, embracing clouds, projecting rocks, vortexlike space), borrowing from the moving panorama and literature of the tour, so as to test out a means by which to circumvent allegory's distancing and abstracting effects. He may well have thought that by putting his beholders into his allegorical landscapes, by making them more than mere lookers-on, they would be less likely to discern what he had called "hieroglyphs" or, in other words, the doubly dangerous and debilitating distance between word and image that plagued the landscapes of his predecessors and contemporaries. Involved in the action and the message of his pictures, Inness's viewers would become participant-interpreters, perhaps even possessors, of the truths about vision and vision's acquisition that I am suggesting his paintings offered up. They would be party to, as were Bunyan's readers, the experience of enlightenment that the apprehension of allegory, in the space of landscape, construed and entailed.

It was in order to avoid the pitfalls of allegorical landscape that Inness expanded the frame of his pictures so as to incorporate allegory's function, hoping to bring the latter, and language, within the limits of pictorial art. The back-turned figure in *The Valley of the Shadow of Death* is to Inness's pictures what Christian is to Bunyan's narrative, for he scrutinizes and deciphers as he wanders through the landscape and looks; as such, he is a surrogate for Inness's viewer, accompanying text in hand, who is supposed to do the same. The goings-on at Interpreter's house are exemplary of the relation between painting and beholder encouraged by *The Triumph of the Cross;* Christian looks at a series of emblematic tableaux but also speaks with the figures represented, thereby taking part in the action of each scene. As with Beecher, who "talked with the beautiful creatures, and they spake with me" in front of each painting he saw at the Louvre, the pilgrim is part of the scene even as he unravels its meaning, reading as he runs.

Allegory, in Inness's landscape series, was to provide for incorporation, not cold abstraction, and lettering, looking, and partaking were to coalesce, becoming complementary components of a single perceptual experience. As in Bunyan's text, where perusal of "notes of the way" and "rolls" enabled progress, reading was as integral to this experience as were memory and vision, facilitating movement through the landscape and, eventually, enabling the apprehension of truth. In front of *The Vision of Faith,* the beholder, Bunyan's text in mind and Inness's in hand, looks with Christian through a perspective glass across an expanse of land and toward a not yet visible Heavenly City. The coming together of gaze and text in such a manner announces Inness's intent: to conjoin looking and reading, word and image so as to create a transformative

and vision-altering landscape art, one that provided a template for a radically new pictorial and, perhaps, cognitive mode. Seeing is reading is looking at landscape. This seeing-reading-looking, as far as Inness was concerned, constituted much more than a pictorial stratagem. It was to be a new way of seeing/reading and knowing the world; it was to amount to spiritual sight.

"THAT FIT OF SYMBOLIC LANDSCAPE": ALLEGORY ABANDONED

Although *The Triumph of the Cross* met with high praise in certain quarters, Inness never repeated his experiment with allegorical landscape. It is difficult to say exactly why he abandoned the project; he may well have considered it deficient or flawed, as did a number of his contemporaries. Inness's *The Sign of Promise,* stated one commentator in 1873, several years after the allegorical series first went on view, was a "fitting solution to the vague problem which his brush is . . . ever striving to express." However, "that fit of symbolic landscape . . . no doubt taught him that he would do best to follow Nature, without crowding upon her own peculiar and profound significance any additional meaning."[90] This critic's remarks recall those of the writer who characterized Inness's *The New Jerusalem* as an awkward endeavor to graft a heavenly city onto the unsuspecting New England landscape; both point to the impracticability of adding allegorical or symbolic meaning to paintings of nature and imply that landscape is better off without any suggestion of text. "As landscapes," *Frank Leslie's* reviewer reported, "these pictures possess a good deal of merit, chiefly in the rich mellowness of their color; but we do not think that they convey very forcibly the allegorical idea aimed at by the artist."[91] Inness's friend James Pattison concurred: "For these great allegories he could find no actual motive. His pathos became bathos. . . . It was a case of a man mistaking the nature of his genius."[92]

When discussing Inness's turn to allegory, Tuckerman called allegorical landscape "a branch of art at once delicate and difficult." "It is not surprising, therefore," he went on to say, "that many who thoroughly appreciate one of Cole's genuine transcripts from nature, fail to enjoy thoroughly his 'Voyage of Life,' 'Course of Empire,' and 'Cross and World'; that is, the picturesque truth is felt, but the meaning of the artist but faintly interpreted." The "subjects of George Innes [*sic*]," he continued, "are still more vague and ideal; 'Peace and Plenty' is a simple and appropriate designation; but the 'Sign of Promise' and 'A Vision of Faith' require a poet to sympathize with the painter, although any true lover of nature can appreciate them as landscapes."[93] Perhaps Inness realized that he could make his paintings into poetry but could not make poets, or more properly, *readers,* of his beholders. Another critic said as much: *The Valley of the Shadow of Death,* he wrote, "is a cheerful place, and looks like the Grotto of Antiparos. We suppose there is some very profound meaning in painting the valley this pretty blue, and making the rock in the front look like a man, and in putting a person in a white sheet in a conspicuous place; but as the

printed description does not tell us what these things mean, and as we are not very good at understanding allegories, we give up."[94]

In 1911, Elliot Daingerfield wrote that Inness's "strange allegorical canvases" were "merely an excursion aside, a momentary putting away of the real intention, and in the total of his art will not be taken with too great seriousness." All the same, he acknowledged the relevance of *The Triumph of the Cross* to Inness's subsequent production: "The ideas then formed continued a real influence throughout his life."[95] Although Inness's experiment with allegory was short-lived, Daingerfield was right to suggest that the work and thought involved in the undertaking were of great consequence for Inness. Daingerfield and some of his contemporaries may not have taken the allegorical work too seriously, but Inness did, and he continued to explore the problems represented by writing and painting into the 1880s and beyond. By the second half of the 1880s, he had begun to explore alternate ways of bringing language's expressive potential within the limits of his landscapes so as to convey "additional meaning" without resorting to painted metaphors or similes. Both poetic captioning and allegory had proved unsatisfactory, so he devised an altogether different formula, at once scientific and subjective, for perceiving, understanding, and, above all, communicating, through the medium of painting, the order and truth of the natural and heavenly realms. With *The Triumph of the Cross,* Inness tried to make writing, painting, and looking correspond; in his landscapes of the 1880s and 1890s he attempted to make these acts indistinguishable and created a pictorial language that abandoned almost all reference to the written word and that, to his mind, succeeded in conveying his "many-times announced theories" about being and seeing with God.

SIX ❧

The Mathematics of Psychology

SIGNATURE WORKS

Often, when I visit the American galleries at the Art Institute of Chicago, I see a person or persons standing motionless in front of Inness's *The Home of the Heron* (1893; plate 11), as if mesmerized. These individuals, I imagine, are responding to the same qualities—brilliant color, dazzling technique, breathtaking scenery, an ethereal glow—that first enticed me to give Inness a second look and, more to the point, that have compelled scholars to call Inness's production after 1884 his "signature work," landscapes that gathered together all the impulses behind what had come before and marshaled these impulses toward transcendent triumph. These are the works after which Inness strove his entire career, and these are the works that embody perfectly not just his practice but his artistic and personal needs and desires as well, or so the story goes.

This story is not incorrect; it is simply incomplete, and not because *The Home of the Heron* and other landscapes from the period 1884–94 are not the stunning culmination of a complicated but brilliant career. They are this, and they do embody Inness's motivations as a painter, but they do so in ways that have not been fully explored or even discussed at all. Inness's art changed considerably around and after 1884, the year of an important monographic exhibition of his work at the American Art Galleries in New York. The exhibition, sponsored by the American Art Association, included almost sixty paintings. As Ripley Hitchcock wrote in the catalog, the story of the collection was "a simple one." When Inness exhibited his painting of Niagara in his studio, Hitchcock

said, "the surprise and admiration of the visitors were divided between his new departure and a group of recent landscapes. That such achievements deserved a larger audience seemed obvious." To everyone but Inness, that is: "Perhaps," Hitchcock added, "the artist failed to see how much he had accomplished. Others were less uncertain. And so he has been persuaded to gather the ripest fruits of his life works, with such other pictures as may be held to illustrate the successive phases of his art, and to exhibit these examples of American landscape painting in a gallery always hospitably open to American art."[1] Included in the exhibition were a number of recent paintings, among them *Niagara Falls*, now in the Museum of Fine Arts, Boston, which had received praise when it went on view in Inness's studio in 1884, as well as paintings from the previous thirty years of the artist's career.[2] Visitors to the gallery could compare *The Valley of the Shadow of Death* and several landscapes from the 1850s, for instance, to examples of Inness's more recent production, including the celebrated view of the falls.

Although it is impossible to say exactly whose agenda the exhibition reflected, we can reasonably assume that the undertaking had a profound impact on Inness and was instrumental in shaping his subsequent practice.[3] As Cikovsky has suggested, the occasion enabled Inness to assess his artistic past, allowing him to evaluate his output with an eye to improving his art.[4] The 1884 event, which provided him with an opportunity to scrutinize a variety of works from, as Hitchcock said, almost every "phase" of his career, appears to have aided him in clarifying and solidifying but also in diversifying the terms of his artistic project. Confronted with a large group of his landscapes—a summary of sorts—he would have been able to discern where his art had been and where he wanted it to go (he no longer "failed to see how much he had accomplished" and would have had an idea of what remained to be done).

Indeed, Inness's later landscapes, those made around the time of or after the monographic exhibition, although not exactly departures from his earlier work, do seem as if galvanized by a momentous event. They represent what may be described as a singular outpouring of ideas, a rather breathtaking accumulation of manifold representational techniques in the space of single canvases, as if Inness kept discovering more and more things to try out and add, as if his struggle for vision had become a matter of testing and communicating every imaginable strategy and outcome. This diversification of pictorial means encompassed, among other things, an intensification of color—as evidenced by *The Home of the Heron*, with its striking, seeping orange hue—and, as Cikovsky has noted, an increased interest in compositional rhythm, cadence, and harmony, what, to use Inness's own term, we might call geometry.[5] Scholars of American art have drawn attention to these features—Inness's color and his ordering impulse (the second more so than the first)—but have not considered them in any detail or depth or spent time examining what, exactly, color and geometry meant to Inness and what he understood their role in his late land-

scapes to be. Other striking features of these landscapes—including Inness's habit of scratching the surface of many of his later paintings with the wooden handle of a brush as well as what amounts, in these pictures, to a persistent confusion between the painted and the drawn—have gone unnoticed or, at least, have not been attended to in any study of his work.

In the preceding chapters, I suggested that Inness's paintings were, simply put, about perception. This chapter, in accounting for the characteristic features of his later landscapes, presents a similar interpretation, for I maintain that these paintings continued, in slightly altered form, what I have characterized as his attempt to formulate a model of penetrating sight. These paintings present a highly controlled yet extraordinarily complex, diverse, and mutable visual system—one constituted by audacious color and ordered form but also by strategies and techniques that scholars have not noticed or chosen to discuss— a visual system that approaches philosophy in its aims. These landscapes explore the means by which we reflect on and reason about whatever exists in the natural world, and they make claims about the visual, linguistic, and conceptual systems by which we come to see, know, and understand. Yet inclined somewhat less toward physiology and the particularities of cognition than his earlier work and more toward language and communication, the later landscapes explore how knowledge, once arrived at, passes from one mind to the next and how paintings might describe, but also amplify, this process (something Inness investigated in the 1870s when attempting to approximate the breathing/seeing of the Most Ancient Church). It is as if once he had got his optics and his allusions and his middle tones and his scientific formulas how and where he wanted them, or knew what they had yet to be or where they had yet to go, and could see all of this on view at the American Art Galleries in New York in 1884, Inness turned to searching for more deliberate and more diverse ways to record and then express his ideas and conclusions to the world and to determining how he could best communicate his truths.

The final chapter of this book, then, is about the continuation and coalescence, but also amplification and transformation, of Inness's science of landscape, his pictorial philosophy and language of vision and thought. But this chapter is also about the unraveling of Inness's science, what I would call Inness's purposeful and deliberate challenge to his own embrace of principle and rule, a challenge to the very ideas of purpose and deliberateness, to the notion that something as complex as human perception or thought (let alone the vision of God) could, or should, be diagrammed and mapped, subjected to constraining formula and law. This is tricky, of course, because until the end, Inness conceived of his work as science and evoked in his pictures and proclamations ideas and concepts at home in and borrowed from the realm of scientific inquiry, and I want to take him at his word. But the proliferating diversity and exuberance of his later works suggest that his science of landscape was not just idiosyncratic and strange but as yet unthought (recall Inness's lament to Clarke,

"maybe, after we get to Heaven . . ."), a network of strategies that, in their invocation of the irrational and in their reliance on chance, were meant to intimate an indefinable mode of being, beyond the grasp of rule, what amounted, in the end, to unpredictable and glorious play.

THE SCIENCE OF GEOMETRY

As Inness himself tells us, he put a great deal of store in geometry, the mathematics of the relationships of points, lines, angles, surfaces, and solids in space. "The worst of it," he said, "is that all thinkers are apt to become dogmatic, and every dogma fails because it does not give you the other side. The same is true of all things—art, religion, and everything else. You must find a third as your standpoint of reason. *That is how I came to work in the science of geometry, which is the only abstract truth.*"[6] Inness expressed a geometer's interest in relation when speaking of two of his favorite painters, Corot and Daubigny. He lauded their mastery of "the relation of things in nature one to the other" and spoke of the difficulty and necessity of determining the proper relations of colors and forms in his own landscapes: "Look at those two trees, one of them ten feet in front of the other; it is so hard to get their exact relation to themselves and to their surroundings."[7]

Inness was also intensely interested in numbers and their properties. In 1882, Sheldon reported that Inness was at work on "pounds of manuscript . . . which one of these days may be known to book-buyers as 'The Mathematics of Psychology.'" He described the text as a "contribution to the philosophy of numbers, which, as Inness treats it, is a veritable *scientia scientiarum* [knowledge of the sciences]."[8] While it is impossible to know exactly what this manuscript contained and of what this "philosophy of numbers" consisted, Sheldon did provide a few clues.[9] "Before my first trip to Europe," he recalled Inness saying, "I became impressed with an idea of the significance of numbers, and worked at it for two years, till I reached number six. Then I got blocked. In Rome I picked it up again."[10] In "The Mathematics of Psychology," the critic wrote, Inness continued to develop an idiosyncratic numerology, wherein particular numbers symbolized specific concepts or states: "[Inness] demonstrates that number one stands for or represents the infinite; that number two represents conjunction; that number three represents potency; that number four represents substance; that number five represents germination; that number six represents material condition, etc. The treatise is necessarily fragmentary. Its principles could be carried into the hundred thousands were human life long enough. Each successive step involves a distinct and laborious demonstration. . . . If the *Mathematics of Psychology* ever see the light, the folios of the schoolmen will seem more trivial than ever."[11] Sheldon excerpted two passages, which he called "comparatively unimportant side issues," the first expressing Inness's doubts about the concept of evolution ("no argument can prove a sheep to be a

goat, nor can any science show that point where one species becomes another"), the second comparing John Stuart Mill's theory of logic to that formulated by Richard Whately.[12] These excerpts were hardly "side issues," however, for they tell us that Inness had conducted researches into the areas of logic and rhetoric, and they cast his statement regarding the philosophical potential of a "science of geometry" in a broader contextual light. As a notice published in the *Boston Evening Transcript* in 1875 suggests, Inness believed that, when it came to the practice of landscape painting, the study of the principles of argumentation and reasoning most certainly obtained: "George Inness will read a paper on Saturday night before the [Boston] Art Club, entitled 'The Logic of the Real, Aesthetically Considered,' which will not only be instructive to those engaged in art studies, but, treated in Mr. Inness's able and energetic manner, will be interesting as well. There has been some talk of a succeeding 'talk' by the same artist, he painting a sketch in the meantime as an illustration. This will indeed be a rare treat."[13] Inness, the advertisement implied, used his paintings as rhetorical tools, perhaps because he believed that landscape, governed by some sort of numerical or mathematical rule, could configure reason's instrumental aspect and, thus, philosophize.

Throughout his career, and especially toward the 1880s and 1890s, Inness's critics and colleagues drew attention to his interest in numbers, mathematics, and geometry and to the harmony he thought a pictorial practice based on mathematical principles would produce. According to De Kay, Inness followed "rules founded on logic that can be expressed in . . . mathematical terms."[14] He prided himself "on the logic displayed in the management of his landscapes" and once instructed the critic on "how the symbolization of the Divine Trinity is reflected in the mathematical relations of perspective and aerial distance."[15] As J. Walter McSpadden, author of *Famous Painters of America*, reported, Inness "believed that not only the stars in their courses, but also every event in the human life and every character and temperament of the individual were under the influence of numbers."[16] Inness's art was religion, wrote the *Independent*, "his pastime the truths of geometry," and his theology "might not pass current in the schools; it is rather the system of inner rules by which his methods of painting are governed."[17]

All of this is hard to swallow when faced with paintings like *The Home of the Heron* and *Niagara* (1889; plate 12), two of Inness's most "impressionistic" and spontaneous-seeming "signature" works. At first glance, *Niagara*, one of several paintings Inness made of the falls, offers up a chromatic blur of pinkish haze, tumbling water, and swirling mist. But look carefully, a second time (with Inness's and his critics' words in your head). On closer inspection, a sense of order, or at least deliberate organization, emerges: three similarly sized horizontal zones; two equal horizontal halves, created by virtue of a dark shadow in the center of the foreground, a shift from light to dark in the zone designating the falls, and a darkened split in the rose-colored smog that spews forth from a

well as an interest in how different elements relate to one another, individually or in numbered pairings or groups (this investment was manifest in what Daingerfield described as Inness's obsessive coordination of parts). In both *Early Autumn, Montclair* (1891; fig. 54) and *Near the Village, October* (1892; fig. 55), Inness pairs two trees—in the first, a large, sunlit tree and a smaller, shadowed one, and in the second, two similarly shaped trees, one illuminated, one in shadow—as if to underscore this interest in the relation of parts. He does the same in many other canvases, including *Woodland Scene* (1891; fig. 56), *The Brush Burners* (1884; fig. 57), *Sundown* (1894; fig. 58), and *Moonlight, Tarpon Springs, Florida* (1892; fig. 59). In *Sundown,* the pairing of trees is doubled—two trees in the foreground and two in the distance at the horizon—and, in a sense, tripled, for two cows, situated directly behind the foremost pair, repeat the rhythm of the trees. The standing female figure is striking in her singularity when considered in relation to all these sets of two. Similarly, in *Indian Summer* (1891; fig. 60), what appears to be a random scattering of figures and cattle in the canvas's right two-thirds is counteracted by a row of three precisely placed and unyielding trees at left, a foil for the blurred and sketchy stand opposite it.

Figure 54 (*below*). George Inness, *Early Autumn, Montclair* (1891). Oil on canvas. 30 × 45 in. Delaware Art Museum, Wilmington, Special Purchase Fund, Friends of Art, 1965 (1965–1).

Figure 55 (*opposite, top*). George Inness, *Near the Village, October* (1892). Oil on canvas. 30 × 45 in. Cincinnati Art Museum; gift of Emilie L. Heine in memory of Mr. and Mrs. John Hauck.

Figure 56 (*opposite, bottom*). George Inness, *Woodland Scene* (1891). Oil on canvas. 30 × 45 in. Courtesy of the Pennsylvania Academy of the Fine Arts, Philadelphia; gift of John Frederick Lewis, Jr.

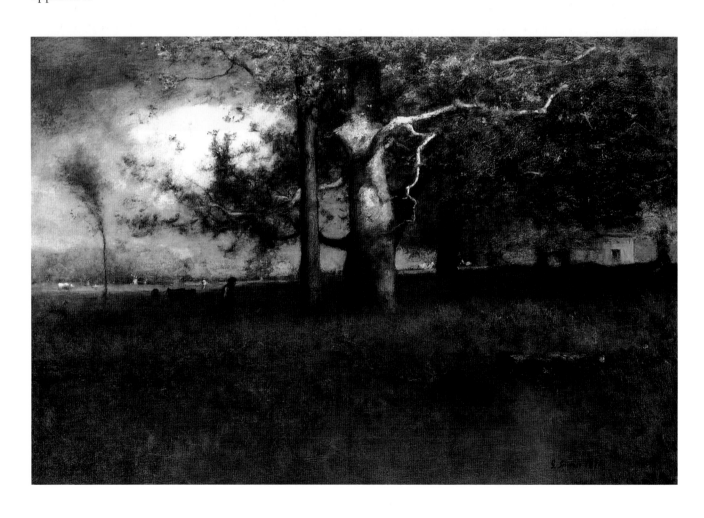

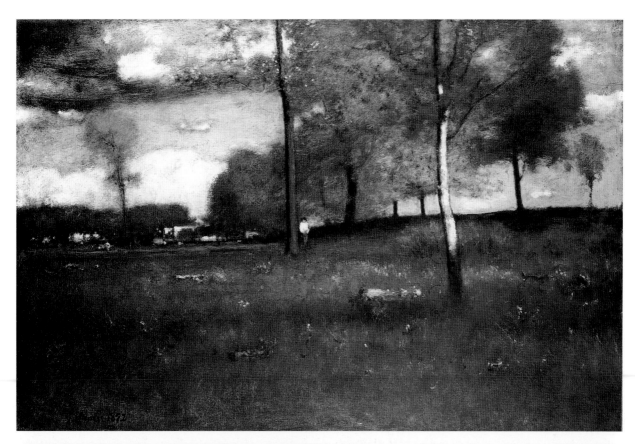

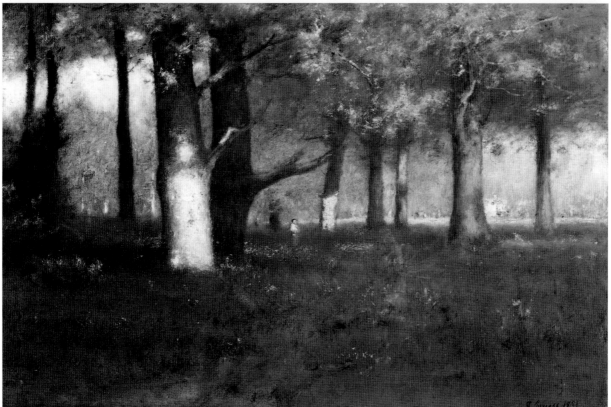

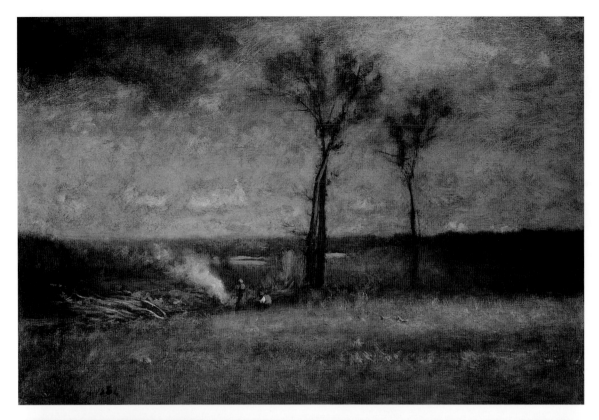

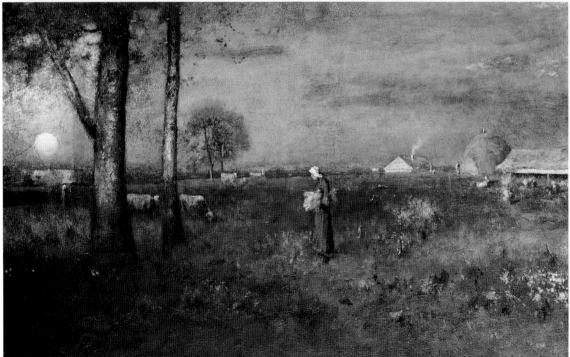

Figure 57. George Inness, *The Brush Burners* (1884). Oil on canvas. 30½ × 20¼ in. The Nelson-Atkins Museum of Art, Kansas City, Missouri; gift of Albert R. Jones (42–47).

Figure 58. George Inness, *Sundown* (1894). Oil on canvas. 43¼ × 68½ in. Smithsonian American Art Museum, Washington, D.C.; gift of William T. Evans (1909.7.32).

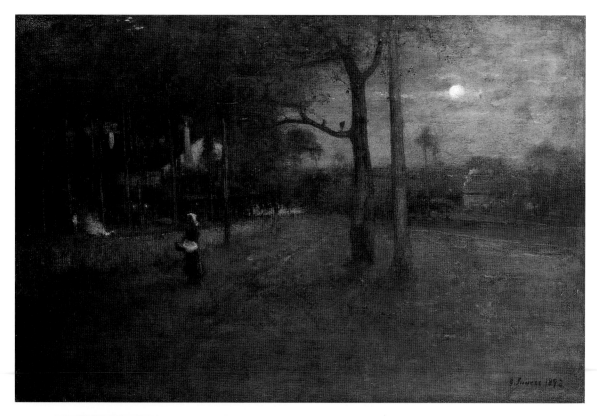

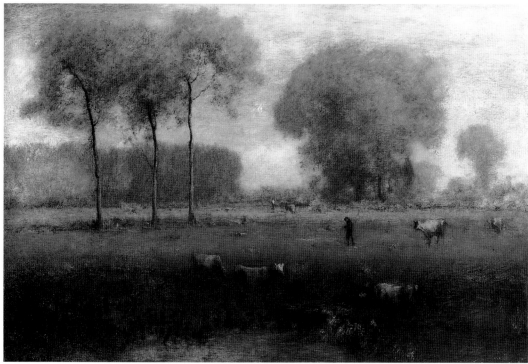

Figure 59. George Inness, *Moonlight, Tarpon Springs, Florida* (1892). Oil on canvas. 30 × 45½ in. The Phillips Collection, Washington, D.C.

Figure 60. George Inness, *Indian Summer* (1891). Oil on canvas. 30 × 45 in. Private collection.

Inness's figures are as still and stoic as their hardwood counterparts, emblematic of the stability and order of the spaces they occupy. They seem carefully placed, suggesting that their relation to the things that surround them was of paramount importance, and the subject of careful and prolonged deliberation. In *Early Morning, Tarpon Springs* (1892; fig. 61), for instance, a red-vested figure stands to the side of a tree, the shape of which echoes the slight curve of his back; in *Near the Village, October* a figure leans against the central dividing tree, establishing his relation to it and, by virtue of his bright white shirt, his relation to the sunlit tree in the foreground. The figure in *Georgia Pines* (1890; fig. 62) produces an analogous effect; she pauses quietly on the path that runs

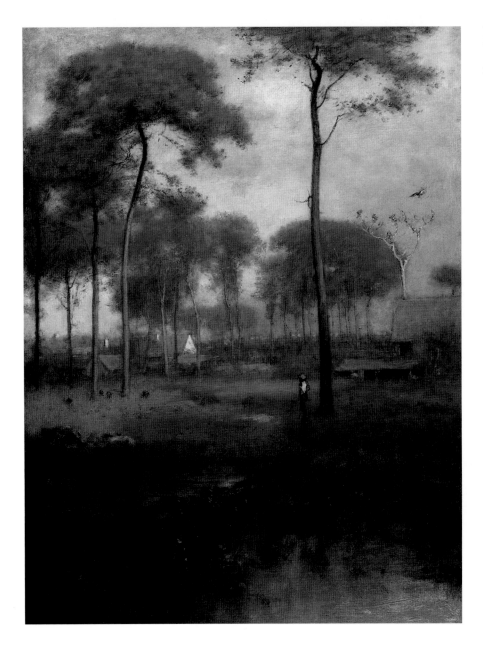

Figure 61. George Inness, *Early Morning, Tarpon Springs* (1892). Oil on canvas. 42³/₁₆ × 32³/₈ in. The Art Institute of Chicago, Edward B. Butler Collection (1911.32). Reproduction, The Art Institute of Chicago.

Figure 62. George Inness, *Georgia Pines* (1890). Oil on wood. 17⅛ × 24 in. Smithsonian American Art Museum, Washington, D.C.; gift of William T. Evans (1909.7.33).

from front to back, echoing the upright trees that surround her, touched, as are they, by the sun's warm glow. One has the feeling that, if any of these figures were to move even slightly to the left or right, forward or toward the back, the order and harmony of the spaces they inhabit would be profoundly disturbed.

After spending some time with Inness's late landscapes, it can seem as if, for Inness, working in the science of geometry meant the production of countless variations on single structural themes: meticulous and serial organizations of shapes, spaces, and forms. *The Home of the Heron*, for instance, is just one of a number of works wherein space is divided—and emphatically so—in half horizontally, the lower portion containing meadows and trees, the upper portion, clouds, sky, and perhaps a house or two. *Autumn Gold* (1888; fig. 63), *Summer Evening, Montclair, New Jersey* (1892; plate 13), *The Old Farm, Montclair* (1893; fig. 64), *Apple Orchard* (1892; fig. 65), and *October* (1882 or 1886; fig. 66) are organized in much the same manner.

Inness seems to have been particularly interested in the relation of horizontal elements to vertical ones, and he repeatedly juxtaposed emphatic horizon lines and insistently upright trees. *Early*

Figure 63. George Inness, *Autumn Gold* (1888). Oil on canvas. 29¹⁵⁄₁₆ × 44¹⁵⁄₁₆ in. Wadsworth Atheneum, Hartford, Connecticut. Purchased through the gift of Henry and Walter Keney.

Figure 64. George Inness, *The Old Farm, Montclair* (1893). Oil on canvas. 30 × 50 in. The Nelson-Atkins Museum of Art, Kansas City, Missouri. Purchase: Nelson Trust (39–21).

Figure 65. George Inness, *Apple Orchard* (1892). Oil on canvas. 30 × 45⅛ in. The Detroit Institute of Arts; gift of Baroness Von Ketteler, Henry Ledyard, and Hugh Ledyard, in memory of Henry Brockholst Ledyard. Photograph © 1981 The Detroit Institute of Arts.

Autumn, Montclair, and *Near the Village, October,* are typical. A horizon line divides each canvas in half. A tree that finds its roots just below the horizon divides the canvas vertically. Other trees, to the side and in the distance, arrange themselves around this central line so as to create a series of spatial intervals that approximates the cadence of a numerical series (not a geometric progression in the strictest sense, where each term is a constant multiple of its precedent, but a mathematical-seeming series nonetheless). This is especially evident in *Near the Village, October,* where emphatically darkened trees form a bold pattern against a gray-blue sky at right, and in other works from around the

Figure 66. George Inness, *October* (1882 or 1886). Oil on panel. 19 15/16 × 29 7/8 in. Los Angeles County Museum of Art, Paul Rodman Mabury Collection (39.12.12). Photograph © 2004 Museum Associates/LACMA.

same time, including *Summer Evening, Montclair, New Jersey,* where rows of silhouetted trees at right and left undulate softly as they proceed along the canvas's horizontal divide. The same sort of effect turns the space of *Woodland Scene* into a study of the relationship between light and dark, concave and convex; eleven trees form a complex rhythm within the middle ground space, as if to suggest a specific and measured perambulatory course. The figure standing between the two most central trees is part of the cadence established by the blackened trunks. As in *Pine Grove of the Barberini Villa,* in *Early Autumn, Montclair,* the rectangular shape of a house at right and the rectangle of its door echo the shape of the canvas and draw attention to the geometric relations constructed within the work. Like numerous other paintings from this period, the edges of the canvas slice off the tops and sides of trees, making explicit the rectangle's organizational force, its apparent unwillingness to accommodate forms that push beyond its bounds. The scene does indeed appear as if seen through a hole cut in a piece of paper or, in this case, a rectangular frame, one that makes the beholder blind to anything outside of its perimeter.

Inness adopted the same emphatic horizontal format in a remarkable group of landscapes he painted in 1891 that includes *Moonrise, Alexandria Bay, Harvest Moon* (fig. 67), and *October Noon* (plate 14).[23] In these paintings, strikingly similar in composition and palette, he arranges and rearranges meadow, tree, sun, and figure, testing and retesting the relations of one thing in space to another. In *Moonrise, Alexandria Bay,* the sun is placed at the horizon, close to the exact center of the canvas; in *Harvest Moon,* it rises slightly to the left of center, throwing the whole slightly off balance. In each, space is divided vertically into thirds and, again, cropping iterates the rectangle's organizational logic and force. The lower half of *October Noon* is composed of three rectangular strips—

the foreground meadow, the middle-ground row of shrubs, and the screen of trees just beyond it; the latter stops abruptly slightly to the left of center, as if inevitably, as if Inness knew or had calculated exactly how far across the canvas to take it. The shape of the sky repeats and inverts that of the meadow/trees, two interlocking puzzle pieces perfectly paired. A single and slight tree inclines toward the left; the rightward and diagonal trajectory of a path that originates in the foreground and the figure on it provide an exquisite foil for this tree's gentle sway. In the breathtaking *Summer, Montclair (New Jersey Landscape)* (1891; plate 15), which, with its marshy foreground, zonal divisions, and delicate trees, seems to belong in this group, the vertical divide is even more insistent than the horizontal one; one-half of the canvas is filled with rich green, the other with gray-white sky. This juxtaposition is further emphasized by the contrast between the trees that occupy the two halves: lush, leafy trees on the right, bare-limbed and slight trees on the left. The glistening pool of water that fills the immediate foreground at left stops just short of the vertical halfway point, as if the logic of the canvas, and of Inness's "system of inner rules," could not permit its extension.

MATHESIS

Taken together, Inness's interest in the properties of numbers, his claim that the "science of geometry" was the only abstract truth, and his visual exploration of the terms and attributes of this science—numbers and numerical groupings,

Figure 67. George Inness, *Harvest Moon* (1891). Oil on canvas. 30 × 45 in. In the collection of the Corcoran Gallery of Art, Washington, D.C., bequest of Mabel Stevens Smithers, the Francis Sydney Smithers Memorial.

relationships, organization in planar space—tell us not just that we must take the "geometry" of his landscapes of the 1880s and 1890s seriously (for his critics certainly did), this despite its lack of precision and rigor and despite previous scholarly fixations on the dreaminess of these works, but also that this "geometry" had a purpose and an end. Emerson had suggested in his essay "Circles" (1841) that the structure and processes of the natural world could be discerned and represented by way of geometric figures. He considered the circle to be the most exemplary shape and implied that any act of vision consisted of a deciphering of nature's structure by way of its ideal forms: "The eye is the first circle; the horizon which it forms is the second, and throughout nature this primary figure is repeated without end. It is the highest emblem in the cipher of the world."[24] I would argue that behind Inness's "science of geometry" lay a similar idea: that cosmic understanding—the deciphering of the codes of existence—could come by way of the manipulation of figure, number, and form, that particular configurations of relations in space would resolve into diagrams of truth, for all to see and read.

Guillaume Oegger, a propounder of Swedenborgian doctrine in France, also believed that mathematics, and geometry in particular, could describe the structure and processes of the natural world. His treatise *The True Messiah; or, The Old and New Testaments Examined according to the Principles of the Language of Nature* (1829) was translated into English in 1842 by the American Elizabeth Peabody and was read by Emerson and other members of the transcendentalist circle. In this treatise, he insisted that knowledge of the physical and moral universe was necessarily subject to geometric organization, and he conceived of the hierarchy of species in terms of angles, perpendicular and parallel lines, quadrants, and degrees.[25] Oegger's belief that the forms of nature and our understanding of them could be subjected to geometric demonstration came straight from Swedenborg. As we know, according to Swedenborg, the most exalted sight was both a mode of vision and a means of communication. It was also a "science." In fact, as he stipulated in *The True Christian Religion* (1771), it was "the science of sciences" by which all "tracts and books were written" and all knowledge was revealed, a system that produced the conditions that made possible communication of truth, wherein seeing, reading, knowing, and telling (or representing) were coincident, and simultaneous, acts.[26] Swedenborg's understanding of this science of sciences, what, for him, was both a means of perception and a universal philosophy, bears close resemblance to what Inness characterized as his own science of geometry and to what Sheldon called the artist's "veritable *scientia scientiarum*." It was the theologian's account of the science of psychology, in particular, that appears to have shaped the contours of Inness's interest in the potentiality of numbers and math.

Swedenborg's most systematic articulation of his proposal for a universal philosophy took shape in *The Soul or Rational Psychology* (1742), published in English translation in New York in 1887. In this text, he brought together his interests in psychophysiology and theology and attempted to describe not just

the physiological structures and mental processes of cognition (what we understand psychology to be) but the physiology of spiritual seeing as well. His "psychology" was, thus, a metaphysical, even mystical, one.

It was also mathematical. *The Soul or Rational Psychology* and the philosophy it described represented an important expansion of Swedenborg's doctrine of correspondences, for it attempted to describe the actual structure of those relations (between internal and external) that the theologian believed led to spiritual seeing and the discernment of universal truths. That is to say, it described not only what correspondence revealed but how and outlined a mathematically based system of logic for use in discerning this mechanism. By perceiving and describing the mathematical relationships among different, but corresponding, aspects, entities, and states, Swedenborg said, citing a passage from John Locke's *Essay concerning Human Understanding* (1690), knowledge would be gained: "As soon as we discover these relations, we shall to that point be in possession of so many real, certain, and general truths."[27] Because cognition, Swedenborg continued, happened by way of exchanges between different, and hierarchically organized, states of mind, these states of mind, and the relations among them, when expressed as geometric figures, "especially the circular and the spiral," or as "algebraic calculation," could be subjected to calculation and manipulation so that "ideas of the mind" gradually resolved into a formulation of truth, which in turn manifested cosmic understanding: "We should be able to know truths purely . . . as something harmonious from a sacred shrine."[28] Swedenborg's text, then, defined psychology as a science of spiritual sight, one founded in the discernment and articulation of mathematical relationships, what constituted a demonstration of the mechanisms of cognition; the theologian called this psychology a "mathematical formula of universals," or "the universal mathesis."[29]

The German philosopher and scientist Gottfried Wilhelm Leibniz (1646–1716) was the first to provide a systematic theorization of "universal mathesis" (he called it a general or universal characteristic), and it is his work that appears to have prompted Swedenborg's and then Inness's interest in the idea.[30] Leibniz imagined a philosophy of great explanatory power that would replace disputation with calculation and provide an abstract formula, what he called an alphabet of thought, based on the analysis of the compatibility or incompatibility of numerically expressed concepts or categories, for use in any kind of philosophical or scientific inquiry. Both an ideal and artificial language and a system of logic, it would utilize arbitrary characters or symbols in order to express the analytic relations among all metaphysical concepts so as to establish truths mechanically.[31]

In his "Preface to the General Science," Leibniz wrote, "this language will be the greatest instrument of reason." Its characters, "which express all our thoughts," may be written or spoken, and easily learned, he said, and "will serve wonderfully in communication among various peoples."[32] "The only way to rectify our reasonings," Leibniz insisted, "is to make them as tangible as those of

the Mathematicians, so that we can find our error at a glance, and when there are disputes among persons, we can simply say: Let us calculate, without further ado, in order to see who is right."[33] Under Leibniz's formulation, geometry would serve as the medium for these calculations. The analysis of concepts using geometric figures, various configurations of line, angle, figure, and space, the scientist stipulated, would provide an instrument of perception and reasoning "even more useful to the mind than telescopes and microscopes are to the eyes. . . . This will become the great method of discovering truths, establishing them, and teaching them irresistibly when they are established," making possible the perfection of philosophy and the sciences.[34]

Leibniz declared that the universal characteristic "will lead us into the secrets of things" and into the "secrets of thinking"; Swedenborg meant for his mathesis to do the same, for he characterized it as at once an instrument of revelation and a model of cognition, a system of seeing and knowing both the earthly and heavenly realms.[35] Leibniz stated that his characteristic embodied "both the art of discovery and the art of judgment."[36] Swedenborg specified that his philosophy of universals, what he called "the science of souls," which reconciled the "inmost and secret laws of mechanics, physics, chemistry, and many other phenomena" with the communication of angels, was both of these things as well.[37]

Although Inness's paintings do not actually illustrate Swedenborgian or Leibnizian mathesis (their "geometry" is too haphazard for this), it was these thinkers' idea that cosmic design could be discerned and represented by way of numbers as well as by way of the organization and manipulation of space, form, angle, and line that helped inspire Inness's interest in numbers and mathematics, and I believe that it was this idea that his landscapes explored and expressed. What critics called Inness's investment in logic and systems of rule, we now know was based in a broader network of thinking about the instrumental potential of numbers, geometry, and math, and we now have a better sense of what was meant when these critics, and Inness himself, associated his practice with the processes and products of geometry. What Inness described as his "work in the science of geometry" may well have been an attempt to, as Swedenborg put it, "submit the ideas of the mind to calculation" and, in the artist's case, to do so in the space of pictorial representation.[38] And by undertaking to determine in "The Mathematics of Psychology," by way of "laborious demonstration," what ideas particular numbers represented (one stood for the infinite, two conjunction, three potency, and so forth), Inness was quite possibly fashioning his own "universal characteristic," a Leibnizian language of numbers or figures, each representing a philosophical concept or term, that could be used to reason without failure, confusion, or doubt ("let us calculate," the mathematician had said).

One could argue, then, that Inness's "The Mathematics of Psychology" was concerned with the discovery of a formula (this would be the "mathematics" part) for seeing nature (the "psychology" element) so as to read her truths, an

ambition that motivated Inness's practice throughout his career.[39] Swedenborg understood psychology as at once a description of cognitive processes and a mathematically based and scientific model for the cultivation of godlike vision, and I think Inness did as well. It makes sense, then, to suggest that Inness's "mathematics of psychology" consisted of a set of rules, calculating tools, or formulas for the construction of a mode of perception or, more broadly, a way of knowing, organized according to mathematical principles of relation, by way of which nature's mysteries (*arcana*) would be revealed. We might think, then, of his pictures as explorations of formulations developed and tested in the now-lost text and his hypotheses in this text as explorations of postulates developed in his pictures. The idea that Inness's late landscapes explored the possibility of mathesis suggests not only that he understood the reach of his practice as extending toward the realm of philosophy but also that he wanted to add one more term to the mathetical mix or, rather, a dimension, that of the pictorial or visual (as opposed to the symbolic or linguistic), thereby expanding the domains of philosophy to include the practice of picture making, not just the production of words. In order to find a "scientific formula of the subjective of nature," Inness, I am proposing, devised an idiosyncratic geometry, one appropriate to pictorial representation (and one that took great license with the science), testing and retesting in his paintings of the 1880s and 1890s those relationships on which Swedenborg and others thought the perception of truth and knowledge itself were based. One could say, then, that the late landscapes utilize even as they expand, through the addition of visuality, the scope of mathesis, the science by which all the disciplines were said to produce and communicate meaning, making of it a pictorial psychology that attempted to describe the relations necessary for the construction of a perceptual capacity akin to God's and that attempted to formulate a language for use in communicating what this divine vision saw and learned.

Not every artist undertakes to write a book such as "The Mathematics of Psychology." One could argue that almost all nineteenth-century American landscape painters were interested in perception and in the relation of self to world and heaven that they may have thought acts of painting and vision could define and construe. Yet if my hypothesis concerning Inness's practice is correct, he was unusual for undertaking to make the methods and means of mathematical science, or his version of them, an integral part of his art. To be sure, Inness's late landscapes are about the objects they depict; sublimely wrought compositions, glorious color, and lavish yet delicate facture speak of the beauty of nature and present the beholder with an idea of God's immanent presence. Yet these works are also about landscape's instrumentality. In them, things in nature become as abstract terms in a logical calculation, and landscape representation itself becomes a science of reason, a model of seeing and knowing all the secrets and truths of the world. As I have said, Inness's was an ambitious project.

DISLOCATIONS

Yet what is so extraordinary about Inness's science of geometry, as I have been describing it, following Inness's own articulations as well as those of his critics, is that it failed. To put it slightly differently, what is fascinating about Inness's paintings of this period is that they take steps to unhinge what I have been describing as their investigation of pictorial system and rule. It is as if Inness—having spent years (the entirety of his career) struggling to divine principles and formulas and having experimented with one strategy and then the next so as to hit on a calculus of vision and truth—finally accepted or fully comprehended what he had intimated years before, in pictures that refused coherence and unity, that made looking at them difficult, that took steps to obscure; in his lament to Clarke regarding the impossibility of his task; and in statements that questioned the validity of science: "Science gives no true image of humanity," science is "unable to conceive of spirit."[40] That is, Inness acknowledged that science, at least in the forms it was available to him, was not enough. "No one can conceive the mental struggles and torments I went through before I could master the whole thing," Inness told an interviewer toward the end of his life, "I knew the principle was true, but it would not work right. I had to constantly violate my principle in order to get in my feeling. . . . I found I was right, and I went on in perfect confidence."[41] And this is what we get in these late landscapes, where geometry is not exactly what it should be: violation of principle, the unraveling of attempts at order unfolding before our very eyes. As I said earlier, it is hard to swallow the late landscapes as geometry, at least in its strictest sense (gridded paper, lines drawn with a rule), and this, as I see it, is precisely the idea. These landscapes are geometry only to a point: they evoke the science but never reproduce it, they hint at calculation but never make good on their promise to render equations and proofs. To be sure, Inness remained invested in principles and formulas to the end and spoke of the science of his art the year of his death, but the landscapes he created after 1884 articulate what might be described as a kind of self-release, a form of pictorial letting-go that involved not a disavowal of his project but an emphatic shifting of its terms and strategies so that instead of reason, rule, and system you had their collapse, so that instead of science, even, you had something quite different, something, as I said earlier, akin to unfettered play. For how else can you explain not just idiosyncratic and imperfect geometry but a career's worth of puzzling paintings and reckless experimentation (Jarves's words), what, when looking back, can seem like a haphazard running from one strange strategy to the next, even if the goal remained ever the same?

Emerson, who described nature as a series of circles originating with the eye, also wrote that "the natural world may be conceived of as a system of concentric circles, and we now and then detect in nature slight dislocations which apprize us that this surface on which we now stand is not fixed but sliding."[42] I

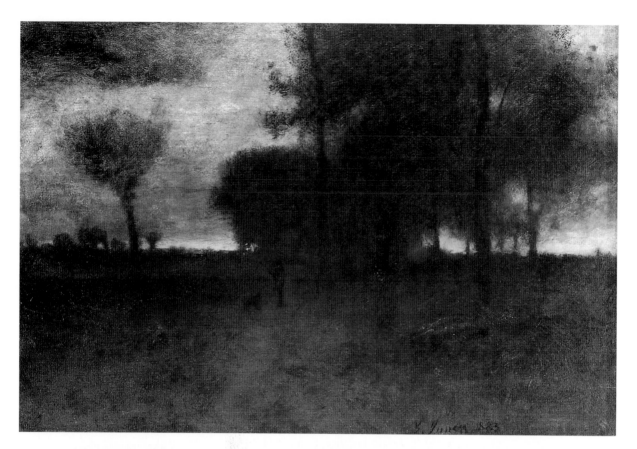

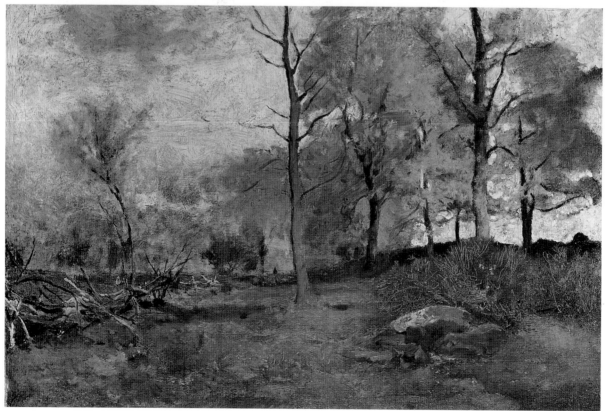

cite this remark so as to draw attention to what I call the dislocations of In-ness's landscapes: pictorial incidents that seem to dislodge what purports to be the measure, balance, and logic of his works. The slightly off-center sun in *Harvest Moon* is one such dislocation; the barely sketched figure who stands just to the right of center in *Summer Evening, Montclair, New Jersey,* is another. In *Sunset Glow* (1883; fig. 68), a single, delicately rendered tree stands isolated at left, its placement defying the compartmentalizing logic of the whole. Similar trees appear in a number of Inness's canvases of this period—*Near the Village, October* (fig. 55), *Early Autumn, Montclair* (fig. 54), *Autumn Gold* (fig. 63), *Autumn, Montclair, New Jersey* (ca. 1890; fig. 69), and *Spirit of Autumn* (1891)—and can seem aberrant in their refusal to relate logically to their surround, small signals that, in the land of geometry, all is not well.

In many canvases from this period, sliding foregrounds disrupt the stability and balance of otherwise stable compositions, putting the latter's organizational logic into doubt. The balance of *Summer Evening, Montclair, New Jersey* (plate 13), is complicated by the fact that toward the left edge, at the point where a brownish-black stone wall is overtaken by a blur of greenish-brown, the canvas seems to dip down and toward the left, while the foreground space as a whole appears to slide toward the viewer, its downward plunge echoed and accentuated by the stream that flows out of the canvas toward the viewer at right. In *Moonlight, Tarpon Springs, Florida* (fig. 59), a series of decisive diagonal lines—the border between meadow and trees at right and left, the shadow cast by two trees, a strip of white-yellow representing the moon's soft glow, the trajectory of a figure's stroll—cannot hold the foreground in place, and it sags at center, pulling all parts of the canvas toward us as we watch. Geometry cannot fully contain and fix the forms and spaces that these works suggest it was supposed to, and parts slip and flow despite its putative force. In *October* (fig. 66), a water-soaked foreground presses toward the canvas's lower edge, as if the painting's bottom half cannot bear its marshy weight. Vertical streaks of black paint at the lower left, dragged across bright green and yellow-brown and dotted with orange-red, reproduce this sense of downward motion, dislodging the symmetry of the whole. The water-soaked foreground was a favorite with Inness—it appears, for example, in *Summer, Montclair* (*New Jersey Landscape*) (plate 15), *October Noon* (plate 14), *Early Morning, Tarpon Springs* (fig. 61), *Apple Blossom Time* (1883; fig. 70), *Morning, Catskill Valley* (1894; plate 16), *September Afternoon* (1887; fig. 71), and *Spirit of Autumn* (1891)—and its pulling and vacating effects complicate our experience of these otherwise carefully organized paintings; in Emerson's words, "the surface upon which we now stand is not fixed but sliding." Paths that originate in the foreground, or in the viewer's space (a motif that recurs in works from all stages of Inness's career), as in *Spring Blossoms, Montclair, New Jersey* (1889; fig. 72) and *The Clouded Sun* (1891; fig. 73), create a similar effect, for they slice into what should be impenetrable systems of space, inviting another network of relations—that represented by the beholder's point of view—to order, or reorganize, each scene.

Figure 68. George Inness, *Sunset Glow* (1883). Oil on paper mounted on canvas. 16 × 24½ in. Montclair Art Museum, Montclair, New Jersey; gift of Mrs. Francis M. Weld, 1946.1.

Figure 69. George Inness, *Autumn, Montclair, New Jersey* (n.d., ca. 1890). Oil on canvas. 12 × 18 in. Santa Barbara Museum of Art; gift of Dr. and Mrs. Ronald M. Lawrence.

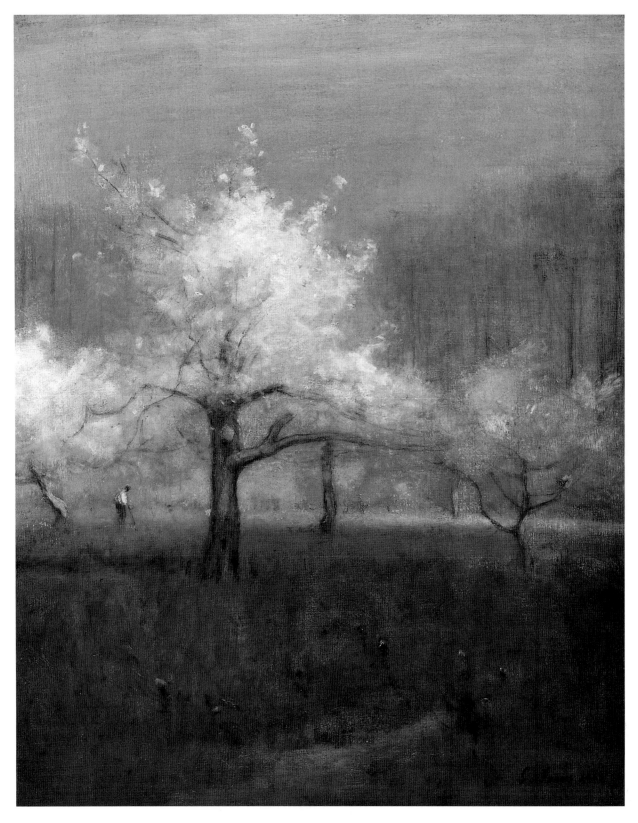

Figure 70. George Inness, *Apple Blossom Time* (1883). Oil on canvas. 27⅛ × 22⅛ in.
Courtesy of the Pennsylvania Academy of the Fine Arts, Philadelphia, bequest of J. Mitchell Elliot.

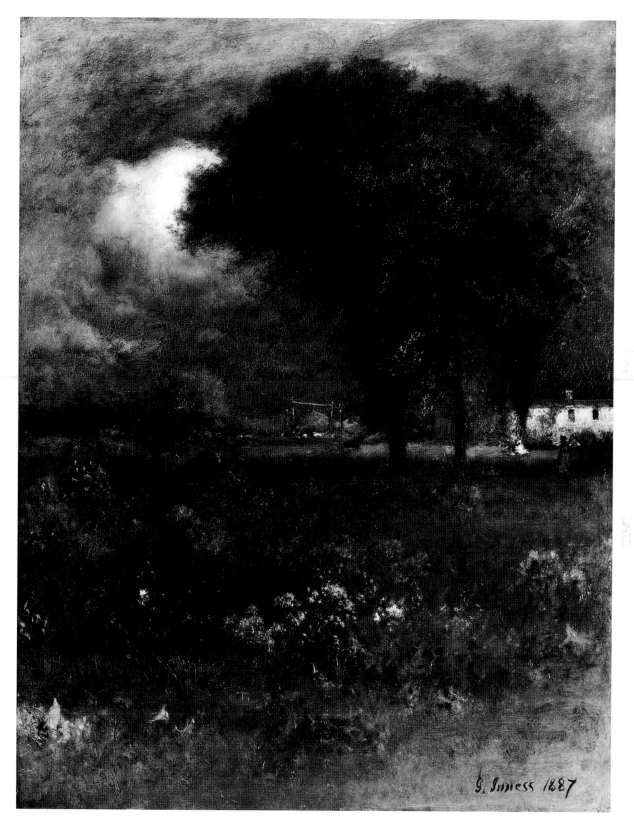

Figure 71. George Inness, *September Afternoon* (1887). Oil on canvas. 37½ × 29 in.
Smithsonian American Art Museum, Washington, D.C.; gift of William T. Evans (1909.7.34).

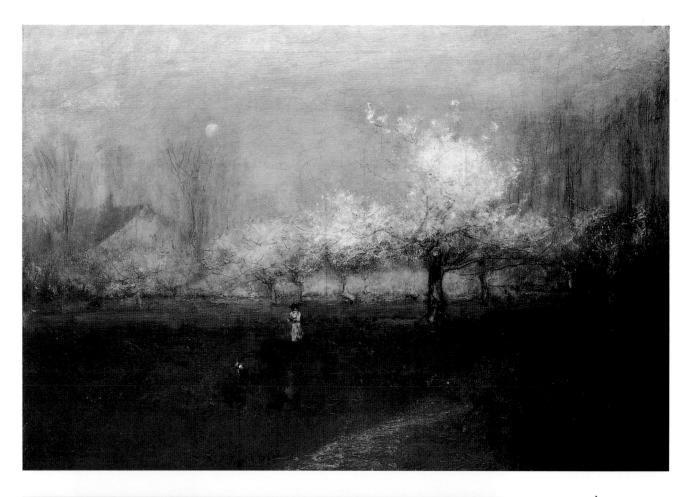

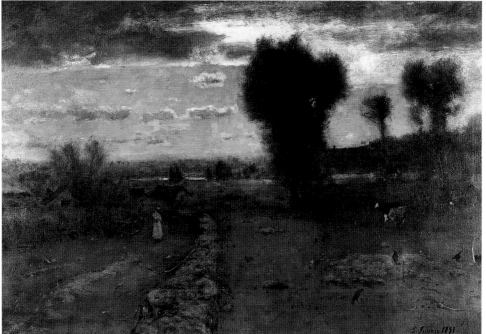

Figure 72. George Inness, *Spring Blossoms, Montclair, New Jersey* (1889). Oil on canvas. 30¼ × 45¾ in. The Metropolitan Museum of Art, New York; gift of George A. Hearn in memory of Arthur Hoppock Hearn, 1911 (11.116.4).

Figure 73. George Inness, *The Clouded Sun* (1891). Oil on canvas. 30⅛ × 45¼ in. Carnegie Museum of Art, Pittsburgh, Pennsylvania, Museum Purchase, 99.9.

Our experience of Inness's landscapes is shaped by structures and motifs that, in the space of what were supposed to be logic-bound works, seem out of sorts, that draw attention away from the idea of system or rule. It is as if the idiosyncratic science of geometry these works endeavored to create and represent was struggling to account for ideas and forms that demanded expansion beyond geometry's, and science's, scope, as if, in fact, idiosyncrasy, and not geometry, had become the dominant term. Inness wanted to find a scientific formula for the subjective of nature, including those secrets and truths he may have thought could never be adequately described, quantified, or fixed. "The true end of Art," he said, "is not to imitate a fixed material condition, but to represent a living motion."[43] His inclusion of elements that refused to be reduced to rule, that defied the geometries that his canvases appear to propose, suggests that his project entailed an embrace but also a revision of Swedenborg's philosophy of universals, what amounted to an unfixing of matter, space, and time. It was through dislocation and, as I am about to argue, color that Inness formulated and drew attention to a dimension of mathesis that he may well have thought Swedenborg and others had overlooked, one that refused to respect science's conventional operations and bounds. Indeed, it was through the purposeful but reckless embrace of all that science was not that Inness intimated what he knew he could not, ultimately, paint. "What man could paint these things," asked the critic Alfred Trumble, "were he not both a psychologist *and a poet:* able to penetrate the soul of nature, and to render the results of his analysis with the sympathetic hand of the bard?"[44] Inness was indeed one part psychologist and one part poet, but unlike Trumble, he surrendered to the fact that, when it came to penetrating nature's soul, his analytical methods, even if made poetic and pleasing, were not yet enough.

COLOR, THE SOUL OF PAINTING

Throughout his career, Inness was described as a colorist.[45] As early as the mid-1850s, color began to emerge as a major force in his work. During the 1880s and 1890s, however, Inness's use of color became increasingly imaginative and bold. His critics responded to this shift by becoming more attuned to the peculiarities of his palette; some praised his color harmonies, some described his color as violent, even dangerous, in its intensity. All, however, seemed convinced that color had taken on a newly important role.

In an 1878 letter to the editor of the *New York Evening Post,* Inness argued for the supremacy of painting over the graphic arts, saying it was the painter's use of color that tipped the scale. "The painter must be a colorist—the most difficult thing in the world," he wrote. "Where are our colorists? Every painter tries to be one, but how many of us succeed? No artist feels that he perfectly succeeds with his color—*with that which is the soul of his painting.*"[46] Years earlier, Inness had expressed his interest in color's potential in his essay "Colors and Their Correspondences."[47] He indicated that he had "given the study of

color great attention during the larger portion of [his] life" and described the symbolic valence of what he called the three "primitive colors," red, yellow, and blue. Red corresponded to love, he stated, blue to faith, and yellow to the external or natural (a formulation that calls to mind the symbolic numbers of "The Mathematics of Psychology").[48] Inness was as interested in the relations among colors as he was in the relations among forms: "In a work of art red in excess produces fineness, or what is artistically called hardness. Blue in excess produces coldness. Yellow in excess produces vulgarity, but the perfect combination of these three colors in their relative properties produces harmony."[49] A work such as *September Afternoon* (fig. 71), with its brilliant blues, reds, red-oranges, yellows, whites, and greens, may represent an attempt to explore color's correspondent, or relational, force.[50] Through bold yet subtle color combinations—blue against red, red against green, green against blue—in the space of a carefully organized canvas (it is divided horizontally in half, with a hayrick at center drawing attention to the rectangle's preeminence), Inness appears to test his notion that the "great spiritual principle of harmony" must be sought after by every artist in his work.[51]

Most of the canvases discussed in the previous section reflect Inness's interest in color relation and harmony. Vivid green and fiery orange compete for attention in *Summer Evening, Montclair, New Jersey* (plate 13), yet somehow seem perfectly matched. Green trees against a golden-orange sky transform the upper half of the canvas into an abstract pattern of solid and void, and touches of orange throughout (in the foreground at right, in the faces of the seated figures at left, and along the upper edge of the stone wall that divides the meadow at right from the screen of trees behind it) unify the disparate parts, making of the painting a single, resplendent whole. In *The Passing Storm* (1892; plate 17), areas of light and dark green combine to create a single field of softly undulating hue. Passages of red and red-orange in the foreground set off the soft green of their surround, and the whole is suffused in a dark, damp yet warm glow. Many of Inness's late landscapes experiment, as does this one, with the tonal variants of a single color, and sometimes its complement, and express what Hitchcock characterized as the artist's zealous determination to "keep the parts of his picture[s] in tone" so as to maintain the harmony of his works.[52]

A number of Inness's landscapes from the 1880s and 1890s, however, display a lack of interest in this sort of chromatic decorum. Intense and bold color combinations, though radiant in their beauty, appear resistant to any organizing impulse, suggesting that they were meant to test the limits of order itself. In comparison to the landscapes of his contemporaries, including those of American painters working in an impressionist vein, the colors of Inness's late works are truly audacious, and were described as such by his critics.

In *Morning, Catskill Valley* (plate 16), color appears to organize itself in a pattern coincident with that of the composition, dividing into four horizontal sections: water, meadow/bank, trees, and sky. Strips of green-brown meadow and vivid red- and yellow-orange trees are wedged between zones of blue-gray

sky and brown-gray stream; the latter consists of a complex layering of transparent paint: luminous blues, browns, yellows, reds, and greens combine to create a prismatic and watery sheen. The top and bottom sections (sky and stream) act as foils for the bright color of the middle zones, yet cannot contain the vivid red gleam of the trees at center. The water in the immediate foreground glows orange in response to the blaze of color above, and a mix of light blue-gray and pinkish-white pigment that designates several partially submerged boulders reflects both the blue sky and the red-orange leaves. The reddish haze that suffuses the canvas almost serves to unify it, as with the orange glow in *Summer Evening, Montclair, New Jersey,* but the area of eye-blistering red at center refuses to succumb to its hazy effects. The zone of red and yellow trees is itself a complex interweave of various colors, anything but an orderly presentation of calculated relationships among pigmented parts; green, gray, white, red, orange, yellow, mauve, tan, peach, brown, and gold mingle and mix, forming a band that reads as both "trees, houses, hills" and pure, unadulterated color. The serenity of the scene—a cow gracefully lowers its head to drink from the stream, a figure stands motionless in a field illuminated by the soft rays of the morning sun—stands in marked contrast to the vehemence of the pigment used to render it.

Other canvases are similar in their coloristic exuberance: *Early Autumn, Montclair* (fig. 54), a study of complementary colors, here red and green; *Niagara* (plate 12), where aquamarine and mauve define the contours of the falls and the distant shore before coalescing in the cataract's watery plunge; and *Sunny Autumn Day* (1892; plate 18), in which passages of yellow, orange, green, and blue form a patchwork of effulgent hue. In this last canvas, Inness appears bent on fashioning the most striking color combinations possible and creates a rather stunning pattern of contrasting hues. A bright orange tree against a deep blue-gray sky; a cluster of red-orange blossoms in the foreground against a field of bright green; a screen of yellow trees, at left, wedged between areas of blue, green, and orange; a single yellow tree in the distance, silhouetted against a field of light blue; flecks of red, at right, that hover over a passage of leafy green: these juxtapositions are typical of Inness's late works, exemplary, on the one hand, of his interest in relation and, on the other, of his tendency to deploy color at its boldest and most intense. One has the feeling that, in pictures such as this, he was more concerned with how far he could push the limits of any given hue or juxtaposition of hues than he was with rendering the specifics of nature or place.

In *Landscape with Trees* (1886; plate 19) color is equally bold. A pair of trees, one bright yellow, the other fiery orange—striking against a blue-gray sky—emerge from a field of dark green. Strokes of yellow and orange pigment that seem to have been flung from the leaves above sit atop green paint at center foreground, and a tangle of yellow-green, pink, peach, and gray delineates a horizon-like strip of houses and shrubs behind the two tallest trees. A strip of bright yellow-green paint sits just beneath this screen, designating the sun's

lurid glow. The area is dotted with delicate strokes of pinkish hue that create a subtle yet stunning foil for the blue-gray sky above. Space is rent by great slicing brushstrokes, audacious zigs and zags of yellow and blue that form abstract patterns against patches of sky between the trees. These marks reiterate the exuberance and excess of Inness's color, which, here and in other paintings, takes on a life of its own apart from any explicit denotative function. Color, in fact, threatens the structural order of the work, for it blurs the outlines of forms and makes of an otherwise precise composition a stunning chromatic stew. Boundaries between carefully organized spatial zones are rendered unstable or indistinct as paint seeps beyond forms it is meant to delimit and contours collapse under the weight of vivid hue; this is especially apparent in the upper half, where a bluish-red smear obscures the line between trees and sky, and also toward the horizon, where house, tree, and shrub succumb to a streaked and painty haze.

My characterization of the boldness of Inness's color reflects nineteenth-century descriptions of his paintings that drew attention to his strong and vigorous color sense and characterized his palette as singular in both its richness and its intensity. Viewers responded to Inness's color by ascribing to both his paintings and his person qualities of wildness, passion, and vigor, as if they were trying to characterize what he meant when he designated color as painting's soul. Whether they described his color as harmonious and subtle or brilliant, powerful, and reckless, these commentators seemed convinced that it was a crucial and instrumental component of his art.

"He was a man of most impressive originality, a draughtsman of force and a colorist of great richness and brilliancy," the *Boston Evening Transcript* wrote upon Inness's death, "and there is in his work vigor and fiery manner of handling the pigment that is singularly fascinating."[53] The same periodical noted the contrast between "the wild war of color raging in the sky" of one of Inness's landscapes at Doll and Richards in 1881 and a more "reposeful" landscape by Cropsey also on view.[54] De Kay stated that Inness was "strongly responsive to color impressions," and, in his 1884 catalog essay, Hitchcock described him as frenzied and "reckless in his use of pigments, daring in his brushwork, eccentric in results," saying that he "takes an impassioned delight in color."[55] "We know," Hitchcock wrote, "how tenderly he cares for the harmony of his subtle coloring, and we know that to keep the parts of his picture in tone is a matter of high importance to him."[56] The *Nation*'s critic called *September Afternoon*, which was exhibited at the National Academy of Design in 1888, "a handsome canvas, powerful and subdued in color, and of the finest decorative quality with its rich tones of browns and pinks, and its puissant notes of deep blue in the sky."[57] *Art Interchange* said the painting's orange flowers burned in the foreground "just as they would in a dream."[58] *Short Cut, Watchung Station, New Jersey* (1883), on view at the Society of American Artists exhibition, was also praised for its harmonious color combinations and tone: "This absolute justness of color relation in lights and shades is rarely so admirably reached. There is no instance in this

picture of that forcing of shades which we sometimes find in works by Mr. Inness. The whole subject here is rendered in pure and delicate middle-tint, which is set off by just enough emphatic light and dark."[59] For these critics, Inness's color, in all its intensity and vigor, was a successful and compelling, even breathtaking, aspect of his art; the beauty and harmony of his paintings, they suggested, owed much to his manipulation of hue.

Others, however, found Inness's works anything but harmonious, and his palette almost too much to bear. Chromatic intensity and crude color, for these commentators, were understood as shortcomings, not virtues. Even the writer who drew attention to the "absolute justness of color relation" in Inness's *Watchung Station* alluded to his tendency to "force" shades and criticized "the too strong color in the distant figures, which slightly disturbs the general harmony and quiet."[60] The *Post* critic went so far as to advise Inness, who he said was "not educated up to the point of knowing really great color when he sees it," to stick to his more tonal works so as to avoid the "absolute discords" of the colorist: "Mr. Inness, classed in respect to his color powers, must be considered as a tonalist, and whenever he attempts to leave this quality and venture into the higher power of colors he fails."[61]

For some critics, Inness's palette was simply perverse. The color combinations of a picture on view at the academy in 1885 were described by the *Nation* critic as inadmissible and "impossible as fact and inartistic as treatment," and the painting's intense and fantastical colors as startling to the eye. The green of its foreground was akin to poison: "arsenical," the critic complained.[62] A writer for *Studio* responded with similar ire to Inness's contributions to the academy exhibition in 1885, and seemed more than a little disturbed by the fervor of his palette. "'A Day in June,'" he wrote, "is neither a day in June, nor any time of the day in particular. It is a canvas without light, without color, without composition, and so far as we can see, after much hard looking, without truth of any kind." A sunset view embodied only trickery, not skill: "Even supposing that the violent coloring of this picture is, now and then, justified, say, once in a summer, in our northern regions, the effect is so short-lived, and so far from pleasing—suggesting as it does some *cosmic disturbance*—that no one would wish to see it fixed on canvas." "This intense green," complained the critic, "bordered with this intense yellow; the native intensity of the yellow intensified still further by bringing it up with a bang against the edge of a dark wood—all this violence becomes wearisome to the mind, as any concentrated food does to the body." Tonal blending and harmonizing would have helped:

> Nature never put her material together so crudely as Mr. Inness makes her in this
> picture, and in many another. She would filter this gold through the leafage of
> the wood, carry it sparkling along the grass, and break up the monotony of this
> meadow with dimpling hollows, or an occasional tufted weed or flower. Heaven
> and earth, at such a season, seem to blend; the heavens, in soft splendor, permeate
> the gross mass of earth, and the earth, etherialized [*sic*], becomes lucent as the

sky. There is none of this glamour in Mr. Inness's landscape; his western sky is a stage-curtain let down before the green-baize carpet that does duty for a pasture.[63]

CROOKED VISION AND STRABISMIC OBSERVATION

Inness's color, so these critics said, posed a threat to the well being of art and to the cosmos as well. Two things, I believe, motivated such critical concern and prompted such vehement critique. One was the advent and spread of the impressionist style in the United States, a phenomenon that, in the opinion of many critics at the time, represented the degradation of art. The other was what can only be described as increasing anxiety on the part of nineteenth-century audiences over the status of design (what was understood as color's converse), instigated in part by contemporary conceptions of impressionism. This anxiety provoked widespread critical debate about the status of drawing and its relation to color as well as the capacity of each with regard to good painting (and, ultimately, societal health). This debate continued a centuries-long discussion of the status and role of color and design in the pictorial arts but took on a dimension peculiar to its late-nineteenth-century American context and was expressed as concern for the proper functioning of vision.[64] Impressionism, of course, had always been discussed in terms of visual capacity; since its inception in France in the late 1860s, the style was continually implicated in art-critical debates about perception.[65] In the United States, however, impressionist "vision," and the important role pictorial representation was understood to play in constructing models of perception, were linked to what was described as impressionism's subordination of drawing to color effects.

Evaluations of Inness's late landscapes were situated squarely within this network of concerns. During his lifetime, his works were often characterized as advancing the aims of impressionism, and writers employed a common vocabulary of concepts and terms when discussing his art and that of the impressionist school.[66] Inness himself had a particular view of impressionism, and the model of painting presented by the style most certainly shaped the way he conceived of his own practice and, importantly, gave him an idea of what landscape could and should never do.

Although artists and critics in America kept abreast of and were involved in artistic developments overseas and would have known of or perhaps seen the first impressionist exhibition in Paris in 1874, it was not until the mid-1880s that impressionism truly caught hold in the United States.[67] The exhibition of French impressionist paintings mounted by Durand-Ruel at the American Art Galleries in New York in 1886 instigated a flurry of debate about the style and its implications for the pictorial arts in the United States.[68] One of the most frequent observations made about impressionism was that it dispensed with construction, that in its attention to effects of color and color impressions, it neglected matters of design. The color/design debate was not a usual topic of conversation in writing about art in America before the 1880s; by around 1885,

it seems that everyone had to have his or her say on the subject, and most critics weighed in by noting that impressionism, in its pursuit of truth of color and color harmony, abandoned line (or form, construction, design, drawing—the terms were interchangeable at the time).[69]

The impressionist painters, wrote Theodore Child in 1886, followed in the footsteps of Giorgione and Correggio in rendering impressions from nature that could not be delineated "simply by analytic drawing." Rather, "they endeavored to express poetically the harmony that emanates at first sight from an ensemble of form and color."[70] De Kay referred to this impulse as "a species of Impressionism in which the old anxiety for definiteness, for drawing, was given up."[71] A "great truth" supports the art of the impressionists, wrote a critic in the *Collector:* "So far so good. On the other side may be urged against the extremists their sacrifice of qualities that have, throughout the past, been regarded as necessary to great art. One sacrifice is beauty of line, or, in simpler terms, fine composition."[72] "After a glance at this solitary example of *le style* [a painting by Henry O. Walker in the academy exhibition]," wrote the *Critic,* "we can more easily understand why naturalistic painting has resulted in impressionism and almost complete avoidance of line. . . . In fact, if we wish to give a vivid impression of actuality, any great refinement of line is more apt to be a hindrance than an aid. Even when it exists in nature, it cannot be perceived without some special effort of attention."[73]

A lot was at stake in impressionism's abandonment of line, at least according to those writing about the new style; at issue was the very capacity and health of perception. The critic who, in discussing Henry O. Walker's academy entry, suggested that impressionism avoided line because the eye did not see line in nature was just one of many writers who understood the impressionist aesthetic to be, most crucially, about the capacity of vision and who saw the subordination of design to color as a crucial component of impressionist sight. According to the critics Hamlin Garland, Cecilia Waern, and Mariana Van Rensselaer, for instance, impressionism presented an accurate model of visual function. The impressionist painter, Garland wrote in a review of the 1893 Columbian Exposition, teaches "that the retina perceives only plane surfaces." The eye "takes note, in its primary impressions, of masses rather than lines" and sees sharply toward the center of its field of vision, and less so at it periphery; the artist, thus, responds accordingly.[74] Impressionism, stated Waern, because it obeys the "law of focus" (the eye sees either distance or foreground; it cannot see both at once), "is more likely to . . . produce the illusion of looking at a real scene, than would a landscape painted by an artist who has allowed his eye to travel painfully from object to object."[75] "If we really use our eyes," wrote Van Rensselaer, "and not merely our memories of other pictures, we shall soon confess that much truth is told in these singular seeming canvases."[76] They show us how to see as would the "primitive eye . . . opened upon the outer world for the first time," that is, in masses of color rather than lines.[77]

As with the impressionists, Inness was said to have abandoned drawing in

favor of color masses and effects of light in his late landscapes so as to capture the experience of sight. He prefers, wrote Rensselaer, to "portray the general effect of a natural scene rather than all its minor factors [and] to portray forms in the totality of the impression they make upon the eye, color in its masses, tone in its harmony, and the effects of light, rather than the details of . . . form."[78] Inness's aim, concurred *Art Amateur,* "appears to have been that of the Impressionists—to attain as close a rendering as possible of some fleeting effect in nature [and] he felt himself called upon to vie with nature in intensity of light and color."[79]

For some critics, this amounted to a misstep. "Where he more especially falls short," reported a critic for the *Nation,* "is in his lack of feeling for form and style. His composition is often ragged and without dignity of mass or line, and his foregrounds . . . are apt to be vague and unsubstantial . . . but these faults are largely compensated for by a depth of poetic temperament and a passionate color sense."[80] For others, it was treason, as is evidenced by a particularly troubled response to one of Inness's landscapes at the American Art Association Prize Fund Exhibition in 1885: "Happy go-lucky drawing, and everything in the picture going off on its own hook! In No. 61, the ground and the sky do not go together. . . . The expression of the place is malarious and feverish. No. 64 is like cold fireworks. The moon, the trees, the clouds, everything here, is popping-off in a soft, explosive Roman-candle fashion. And our eyes are obliged to look all ways at once."[81] Poor drawing and feverish and firecrackery hues—lack of design and inadequate color—according to this critic, made for an unpleasant and unnatural experience of vision (here, looking all ways at once). As a writer in the *Nation* wrote: "Mr. Inness never gives us a decisive form, never a well-defined contour. Everything with him is softened, and is, as it were, melting away."[82] Inness, complained the *Boston Evening Transcript,* purveyed a "perverted" and "diseased" impressionism, not a "rational" and "healthy" sort.[83]

The fact that critics associated him with the impressionist school did not please Inness, as evidenced by a letter-to-the-editor he wrote in 1884: "A copy of your letter has been handed to me in which I find your art editor has classified my work among the 'Impressionists.' The article is certainly all that I could ask in the way of compliment. I am sorry, however, that either of my works should have been so lacking in the necessary detail that from a legitimate-landscape painter I have come to be classed as a follower of the new fad 'Impressionism.'"[84] "That my father was an impressionist in the highest sense of the word cannot be denied," stated Inness's son, "but he abhorred the name and what it stood for in its generally accepted terms."[85]

Inness was interested in the idea of the "impression" (which, for him, was linked to unity and "harmony of vision") and he spoke eagerly in 1878 of the imminent perfection of the "science underlying impressions."[86] Yet in his 1884 letter he made clear that the impressionism of Monet and his compatriots was not to be mistaken for his own: "And Impressionists, who from a desire to give

a little objective interest to their pancake of color, seek aid from the weakness of Preraphaelism, as with Monet. Monet made by the power of life through another kind of humbug. For when people tell me that the painter sees nature in the way the Impressionists paint it, I say, 'Humbug'! from the lie of intent to the lie of ignorance. Monet induces the humbug of the first form and the stupidity of the second."[87] Inness's remarks about a crisis of vision—"Through malformed eyes we see imperfectly and are subjects for the optician. Though the normally formed eye sees within degrees of distinctness and without blur we want for good art sound eyesight"—came immediately after this rant. "Impressionism," he had stated a few years earlier, in 1879, "has now become a watchword, and represents the opposite extreme to Pre-Raphaelitism. It arises from the same skeptical scientific tendency to ignore the reality of the unseen. The mistake in each case is the same, namely, that the material is the real."[88] Inness's first complaint, that impressionism presented the world as a blur of indistinguishable and impossible forms, was identical to that registered in those critical assessments of his own art. In each case, it was the model of vision that paintings appeared to construct that was cause for concern. Inness was desperate to distance himself from the impressionist aesthetic because of its emphasis on materiality (rather than soul) and because of what he thought it said about perception and what he thought it did to the eyes; his impressionism was, in fact, meant as an antidote to that of Monet and his followers in the United States, and he was deeply troubled by the fact that his paintings could be characterized as furthering the aims and the vision of the impressionist school.

Inness was not the only artist or critic to describe impressionism's model of perception as malformed, and its abandonment of line (or "pancake of color") as misguided and wrong. George P. Lathrop worried over enthusiasm for the "new artistic cult" and characterized impressionism as "violent spottiness."[89] Like the writer who expressed dismay over the color effects of Inness's paintings at the academy in 1885, Lathrop used the word violent to describe what he must have understood as color in excess or at the limit (the impressionists, he also said, "overshoot the mark"). Theodore Child cautioned that "chemistry and optics are dangerous studies for a painter of nature," while a writer in *Art Amateur* called on his readers to consult a "learned oculist" so as to ensure that members of the impressionist school did not suffer from any ocular malady.[90] Charles Henry Hart, a critic for the *Independent* who described Inness as an artist who was an impressionist long before the word was coined, also chided the impressionists for painting according to a faulty model of perception, although his language was not as strong. He responded to a work he labeled impressionist on view at the Pennsylvania Academy of Fine Arts in 1890 by alluding to visual dysfunction. "There is a mysticism here," he wrote, "an airiness, an imagery, that undoubtedly is attractive; but is it Nature? Is it anything more than the vague *impression* that half opened eyes take of Nature, and afterward try to note down by way of memoranda to recall the scene?"[91]

The color scheme of another painting in the same exhibition, he wrote, "can only be accounted for by the conclusion that the painter is a sufferer from color blindness."[92]

One of the most acrimonious and anxious responses to impressionism came from Alfred Trumble, editor of the *Collector,* who spoke often and highly of Inness in the pages of his serial and who was adamant about drawing a distinction between Inness's landscapes and the impressionists' works. He called impressionist canvases "despicable daubs," "scrawls," and "phantasms of dynamitic dexterity," and the movement itself a foolish cult whose members were no better than bunco steerers and confidence men.[93] His vitriol was typical of those who considered the new painting a humbug or sham; as did Inness, he expressed anxiety over impressionism's view of things as well as its effect on vision:

> Only imagine having to reside in one of Monet's farm-houses, the very look of which would make a tramp dog glue his tail between his legs and seek refuge in the wilderness; having to shiver under those noisome groves, more poisonous in their rank crudity of eye-blistering paint, and gloomier than the fabled upas; to sail one of those slimy pools, fouler than the accursed waters of the Dead Sea; to look up at those dirty or slobbery skies—to live, in short, in a world without tenderness or feeling, a world which might be produced by machinery, like the scenes on a stage.[94]

"You go into my old friend Fagin's gallery," Trumble continued, "and find yourself in a species of artistic chamber of horrors. You are surrounded by explosions of paint—wild bombardments of the primary colors, hurled at your eye by brushes as brutal as the blows of slung-shots."[95] The impressionists, he stated, not only did damage to the viewing eye but they also saw nature through a malformed lens: they suffered from "a crooked vision," and their paintings were the result of "superficial and strabismic observation."[96]

Trumble's language is, of course, sensational, but the vocabulary he employed in describing impressionist paintings—"eye-blistering" works resulting from "crooked vision" and "strabismic observation"—reveals a great deal about what he understood to be the movement's greatest treason. "Strabismus," a term that appeared often in nineteenth-century discussions of perception and its failings, including those described in chapter 1, refers to a visual defect, often called "lazy eye" or "walleye," that affects coordination and alignment, thus derailing binocular vision and making it impossible for both eyes to focus on a single object at once (each eye points in a different direction, one straight ahead, the other inward, outward, or down). Double vision and/or loss of depth perception result.

It was precisely the issue of focus—the ability to distinguish the outlines of objects and to tell the difference between one form in nature and another—that had prompted discussion of and concern over impressionism's abandon-

ment of line for an aesthetic based on vivid color effects. Impressionism rendered actual perceptual experience ("precisely as in life"), Garland, Waern, and Van Rensselaer argued, because it depicted an in-focus/out-of-focus visual field (what Inness failed to approximate in the landscapes that hung at the 1885 academy exhibition). Trumble himself linked what he imagined was the style's visual impropriety to matters of focus and the delineation of form. "I do not think that any sane man with eyes in his head," he wrote, "could see Nature, under a rainy sky, with the tender atmosphere which always accompanies such a period, as a mass of coarse, opaque tints, with scarcely any form, and no delicacy of color."[97] According to Trumble, vision did not operate as impressionist canvases suggested it did; the haze brought on by a formless mass of tints was nothing less than the blur of dysfunctional sight.

Both Inness's and Trumble's critiques of the impressionist style were motivated by concern for the physical and psychological health of society. "The true use of art," said Inness, was "to enter as a factor in general civilization." The impression, and its basis in individual feeling, lay at the heart of this endeavor: "Every artist who . . . aims truly to represent the ideas and emotions which come to him when he is in the presence of nature, is in [the] process of his own spiritual development, and is a benefactor of his race."[98] If painting presented a distorted view of nature, and if the impression offered up a model of dysfunctional perception, art would contribute to the degradation and decline of civilization, a conclusion that most certainly underpinned Inness's condemnation of the style. Inness's 1879 statement, discussed at length in chapter 2, that "science now teaches that it is the inexperienced eye that sees only surfaces," followed a description of the "folly" of the impressionists' pursuit of flatness and the "error" of their conviction that representing "only flat surfaces" would express an idea of truth. The statement preceded another, more abstruse claim about impressionism: "The efforts of Magnan and others to reduce their aesthetic culture to zero was wonderfully attained."[99] Valentin Magnan (1835–1916) was a French psychiatrist whose work was at the center of fin-de-siècle debates about systems of psychiatric classification; he proposed a model of disease classification wherein mental illnesses fell into two broad and distinct categories: hereditary degeneracy (potentially curable conditions that often manifested in childhood) and "délire chronique," or chronic delusional insanity (nonhereditary, incurable, adult-onset dementia). Diseases in the former category resulted from a combination of physical factors (hereditary weakness of the nervous system, for instance) and psychological factors, which were often the result of sociopolitical circumstance (working and living conditions, especially where the urban and rural poor were concerned, that contributed to degeneracy; for Magnan, this included alcohol consumption).[100] It is hard to know to what Inness referred when he linked Magnan's work to the idea of reducing an "aesthetic culture to zero," but in invoking Magnan's theories of classification and degeneracy, which implicated the social and the political in the etiology of

undoubtedly, of all the qualities of painting, that which most readily and imme-
diately appeals to the untrained sense."[117]

Behind worry over impressionist color and Inness's chromatic exuberance,
then, lay a whole network of concerns about perception, representation, and
signification, one that informed and shaped Inness's practice in the final
decades of his career. Critiques of impressionist practice and impressionist vi-
sion were motivated by anxiety over color's fantastical and irrational force, as
well as by concern about the threat color posed to design and to the intellect
and reason. With this background in mind, it is easier to understand why a
critic might have likened Inness's color to arsenic or to "cosmic disturbance,"
characterizations echoed in Trumble's description of the blistering, dynamitic,
diseased, and distempered effect of Monet's paintings on the eye. Perhaps it
was the model of vision that Inness's late landscapes were thought to construct
that incited such a reaction. Such intensity and vigor of hue may have been
considered unacceptable or, at the very least, troubling because brazen and
blurred color and the consequent evaporation of line were the very things that,
for many writers, signaled or stood for bad vision (this despite the fact that
many commentators described impressionism as successful in its attempt to
render an experience of vision and despite the fact that several critics consid-
ered impressionism's lack of outline and unblended vivid color to be the very
thing that allowed it to fashion such an accurate model of sight. Inness, remem-
ber, was chided for not blurring the colors in one of his landscapes enough).
The writer who, in 1885, described a landscape by Inness as "cold fireworks"
and "feverish," blamed inadequate drawing for the unpleasant visual experi-
ence he said the work produced: "And our eyes are obliged to look all ways at
once." The critic William Coffin was actually relieved to find that Inness, at
least in one of his paintings, had not abandoned attention to form (his work, he
said, is "quite free from a certain softness and indecision in form that may be
noted in some of the other pictures").[118] Perhaps it was Inness's "diseased" or
"strabismic" view of things—the walleye effect of his pictures, eyes looking dif-
ferent ways—that made a certain number of his viewers nervous, as if his
paintings posed a threat to usual ways of looking at and acquiring knowledge
about the world. Perhaps it was Inness's own nervousness about the ferocity of
his palette and the wildness of his color, along with the perceived closeness of
his "impressionism" to the imbecilic visual pancake of Monet's, that fueled his
compulsion toward geometry and rule. The science of geometry, for Inness, was
in this sense an absolutely necessary means to abstract truth.

GARDENS OF THE DEAD

Wherefore, then, paintings like *Landscape with Trees* and *Sunny Autumn Day?*
Despite his distaste for impressionist color and its associations, Inness, as we
should know by now, was not at all interested in purging color's irrational as-
pect from his art. "With most of his contemporaries the art of painting became

the art of colored engravings," reported Montgomery Schuyler. "With Mr. Inness, even from the first, this was not so. Color was not an addition to design, but an integral element of the picture."[119] Inness's paintings luxuriated in those qualities of color that he and others had described as false or dangerous and that were held responsible for the degradation of vision and painting. The color of his late landscapes poses a distinct threat to what I have been calling his version of mathematical rule and his careful coordination of parts, the structure around which he built his impressions, a threat that he appears to have acknowledged. Perhaps this explains why his critics could describe his compositions as subtended by formula and design even as they called his pictures feverish, violent, perverted, arsenical, and disturbed.

How, for instance, would one bring the relationships and principles explored and established in his works to bear in describing the dashing and exploding color of *The Mill Pond* (1889; plate 20), a picture characterized by one critic as "too 'rich' in color to be true"?[120] Convoluted and twisting strokes of vibrant red-orange paint designate the leaves of trees at both left and right; pigment breaks off from the forms it is meant to represent and swirls through the surrounding air, as if the trees are shaking off excess weight, as if they cannot fully bear their chromatic load. This red-orange matter scatters throughout the foreground space, vivid against the bright green of the water-soaked meadow and, above, as it inclines toward the sky's bright blue. Color is the soul of painting, Inness said, that element that distinguishes it from the graphic arts. Color, as soul, seems also to be what establishes an aspect beyond the systematizable by destabilizing the very structures that I have been arguing represent and actualize geometry's role. As we know, Inness had his doubts when it came to science: "Science is unable to conceive of spirit," he said. "It ignores the reality of the unseen."[121] A figure seated in a boat at center is the single note of calm amid the riot of *The Mill Pond;* it is only his contemplative presence that reminds the viewer that reason and logic do still obtain.

In this and other late landscapes, Inness released color from its traditionally subordinate position with regard to design and exploited what were understood to be its most worrisome qualities, letting it unhook the science of his works. It is as if he counted on the associations explicitly exultant and ungoverned color would, in the late nineteenth century, call forth, and could do so precisely because he had not entirely abandoned line. His color must have seemed doubly fierce, juxtaposed as it was with carefully organized and mathematically based compositions, making it all the more intense and all the more troubling.

In an essay on Swedenborg in *Representative Men* (1850), Emerson criticized the theologian's "system of the world" for its lack of spontaneity and vitality. It is bereft of "power to generate life," he wrote. "There is no individual in it. The universe is a gigantic crystal, all whose atoms and laminae lie in uninterrupted order, and with unbroken unity, but cold and still. . . . The universe, in his poem, suffers under a magnetic sleep, and only reflects the mind of the magnetizer. . . .

All his types mean the same few things. All his figures speak one speech. All his interlocutors Swedenborgise."[122] "It is remarkable," Emerson continued, "that this man, who, by his perception of symbols, saw the poetic construction of things, and the primary relation of mind to matter, remained entirely devoid of the whole apparatus of poetic expression, which that perception creates. He knew the grammar and rudiments of the Mother-Tongue,—how could he not read off one strain into music?" "Be it as it may," he concluded, "his books have no melody, no emotion, no humor, no relief to the dead prosaic level. In his profuse and accurate imagery is no pleasure, for there is no beauty. We wander forlorn in a lack-lustre landscape. No bird ever sang in these gardens of the dead. The entire want of poetry in so transcendent a mind betokens the disease, and, like a hoarse voice in a beautiful person, is a kind of warning."[123]

According to Emerson, the language that Swedenborg used to describe and define the world failed because it was too regimented, because it was devoid of music, poetry, and play. Inness's color suggests that he may have felt the same and that he hoped to succeed with a grammar of painting where, as Emerson implied, Swedenborg's grammar had failed. His own statements were sympathetic to Emerson's estimation of the deindividualizing effects of Swedenborg's system, its turning of men into magnetized and slavish automatons: "The Creator," he said in an interview in 1894, "never makes any two things alike, or any two men alike. Every man has a different impression of what he sees, and that impression constitutes feeling, and every man has a different feeling."[124] Although a person's "state of mind" can be assigned a "scientific formula," he stated twelve years earlier, in another interview, this state is always changing and "such scientific formulas change as our states change."[125] Inness's audacious hues, in their defiance of system and rule, their refusal to "speak one speech," manifest the impermanent and ever-changing mind, its thoughts individual and unaccounted for by a one-size-fits-all scientific formula. In so doing, these bold colors refer to secrets and truths for which a system or philosophy such as Swedenborg's, lifeless and cold, could not possibly account. In the late works, Inness's wild color established itself as geometry's converse, as an alternative "Mother-Tongue" to Swedenborg's, one not constrained by the ideal logic of mathematics or by the limits of a single formula or set of rules. Because of its associations, because of those properties that made Inness and others nervous about it, color offered a ready-made mode of intimating and expressing truths that inhabited a realm beyond conventional signification's, reason's, and science's grasp, and viewers responded to Inness's palette as if rules, principles, systems, and laws had indeed been violated or breached, and new and disturbing paradigms of perception entertained.[126]

Color, I believe, was for Inness the thing that could transform grammar into soul, into what several commentators had likened to music. Color offered release: it interrupted Swedenborgian "order," "unbroken unity," and mathematically induced "magnetic sleep." Inness did want to subject his world to system but not at the expense of poetic expression; he did want to figure out a way to

represent relation but not if his science of all sciences, not if his psychology of spiritual sight, refused to allow for an indefinable, wilder side of being, not if his landscapes, and the world they represented, would turn out to be nothing more than, in Emerson's words, "gardens of the dead." Inness's paintings made a plea for a psychology that described the structure of relations underlying nature and the cosmos, yet repudiated any descriptive system that claimed it could account for all aspects of the physical universe and the spiritual realm. He recuperated impressionist color by hanging it on an armature of design and recuperated mathesis by lacing it with arsenical hues; in so doing, he radically expanded and transformed rational psychology's formula and reach.

Put somewhat differently, Inness's color may have been designed to prompt the realization that a psychology meant to describe penetrating sight had to push past or expand the limits of empiricism (and what some critics described as normally functioning vision) thus making science more like the researches of Swedenborg—which combined mysticism, physics, mathematics, biology, psychology, biblical exegesis, and faith (though perhaps, as Emerson said, not poetry)—and less beholden to what we think of as science's usual configurations, rules, and laws. Perhaps Inness's color was designed to shock, to do violence to the eye, because motivating it was the conviction that beyond conventional appearances and habits of viewing lay a radically better form of sight, one so new and strange that from this side of things it appeared malarious and diseased. It is not entirely clear what, according to Inness, the "play" of vision, its wild aspect, might have been; what does seem almost certain is his reluctance, expressed by way of color, to turn the experience of perception and the work of pictorial philosophy entirely over to science. This must be why the late landscapes propose and were described as proposing divergent models of perception; this must also be why critics could call some of these works harmonious and some of them violent, some unified and some profoundly disturbed. The landscapes spoke of both order and disorder, reason and its lack and, in asking their viewers to experience color as it extricated itself from the pull of design, and design as it repelled the advances of color—in orchestrating this tug-of-war so it unfolded as viewers looked—they made a plea for various and new modes of painting and, of course, perception. These works attended to relation but also to elements of consciousness beyond the reach of such a logic, suggesting that through the unbinding of color—through the transformation of its usual appearance in painting and the world—the mathetical model, and philosophy itself, could be greatly revised and improved, suggesting that, perhaps, the irrational was the logical and that ferocious and fiery music was, after all, thought.

BEYOND TIME AND SPACE

What Inness discovered in these late landscapes, as color exploded the science of geometry, had been intimated in works such as *The Coming Storm* (plate 5),

which suggested a world beyond the purview of the conscious mind and a mode of cognition beyond even the most exalted visual sense. With these late paintings, then, what you have is Inness realizing that, in a sense, he had grasped the formula all along: that there was none or, to put it slightly differently, that his notion of formula, and of "science" as well, had to be radically revised, so much so that "formula," in the end, would be everything it was not (playful, unsystematic, spontaneous, irrational, ruled by chance). The principles and rules and strategies that he had devised and applied in his previous work—holes in paper, middle tones, allusions, arcs of consciousness, appended poetry—by his own estimation, had not been enough, could not fully account for the shape of thought, the truths of the world, and the vision of God (for how could they?), so he bound his science to things far less systematic and secure and, in so doing, he intimated a realm where he might find the tools to accomplish his ambitious pictorial task. Staging the unhinging of geometry at the hands of color—building up precarious structures so that his viewers could see them torn down—was one of the ways he hinted at a space and a mode of seeing and being beyond what he or his paint could imagine and depict. In the remaining sections of this chapter, I describe other striking features of these late landscapes, which appear to have been created with the same goal in mind.

Inness, who was interested in the grammar of painting, was also interested in its time, as his description of the desired operations of art, cited previously, suggests. "The true end of art," he said, "is not to imitate a fixed material condition, but to represent a living motion. . . . It creates law, while in the process of expansion. . . . It is not a thing of surfaces, but a moving spirit."[127] With the advent of impressionism and its embrace of fugitive effects, the temporality of painting became newly important in art-critical circles in the United States. Time was understood as a descriptive category, and pictures, especially those viewed as impressionist, were often classified according to their perceived temporal mode.[128] Inness's landscapes engaged these concerns, and complicated them as well.

The idea of immediacy or instantaneity was of particular interest to critics and artists, especially when it was understood as related to the rendition of the experience of the eye. Impressionists, wrote *Lippincott's Magazine,* reproduce the object "so far as it can be seen at a glance. . . . It is like painting a landscape from the window of an express train."[129] "The great secret of all impressionism," wrote Cecilia Waern, "lies in aiming to reproduce, as nearly as possible, the same kind of physical impression on the spectator's eye that was produced on the eye of the artist by the object seen in nature; to make one immediate impression on our retina."[130] Such attempts to capture the fleeting moment were likened to the effects of instantaneous photography, and several commentators, including Van Rensselaer, found this troubling. She criticized a painting at the 1886 Prize Fund exhibition because, as she said, "there has been too much expression of those facts of equine motion which are perceptible not to the eye—

THE MATHEMATICS OF PSYCHOLOGY [215]

which should be the artist's teacher—but only to instantaneous photography."[131]

As I have said, critics often associated Inness with the impressionist school, and they must have done so in part because his paintings appear interested in rendering instantaneous impressions. Effects of motion and weather—passing storms, glowing sunsets, breaking light, gusting wind, soaring birds, drifting smoke—along with quick-seeming brushwork, insinuate a sense of fleetingness in many of Inness's late landscapes, as if he were bent on producing a present tense of painting, on capturing a single and compressed moment in time. "Inness," wrote Benjamin Constant in 1889, "contrives to seize the fleeting aspects of Nature and to fix them on canvas in a most wonderful way."[132] Toward the end of his career, reported the *Illustrated American,* "he seemed to have lost some of his sympathy with Nature in repose and saw only phenomena. The eye and brain were tortured by suspended action—suns about to rise, storms about to burst."[133]

Yet no one "time" can be ascribed to Inness's late landscapes, for they offer up several paradigms of temporality and equivocate when it comes to designations of before and after, now and then. Instantaneous effects combine with motifs that suggest time's prolongation, as if Inness, by complicating our engagement with these works, was struggling to expand and transform the limits presented by a static medium. Still and silent figures, water-soaked meadows, expanding foregrounds, thickly damp atmosphere, and pulled and viscous paint temper the experience of immediacy suggested by fugitive motifs, slowing each painting down, creating an effect of gradual unfolding and continual flux. The atmospheric haze that pervaded the artist's *Nantucket Moor,* exhibited at the academy in 1885, said one critic, "seems to live and vibrate before our eyes and to stretch palpable, breathable depths between us and the gray walls of the distant buildings," as if its exhalations called to mind both the spatial and temporal distance between the foreground and distance portrayed.[134] Back-turned figures populate Inness's later canvases, as they do his earlier work, but do not appear to train their gaze on anything in particular; the idea of a "single glance," or coup d'oeil, and its association with a moment in time has no sure place in these works. In *Sundown* (fig. 58), *Georgia Pines* (fig. 62), *The Old Farm, Montclair* (fig. 64), and *The Clouded Sun* (fig. 73), figures stand motionless, not merely pausing but softly frozen, bodies slumped and heads bent, absorbed in thought. Although atmosphere envelops them in a glowing and sumptuous haze, these figures never succumb entirely to the ensemble's hold; rather, they strain, tensely quiet, heads bent in concentration, against the pull of pure paint. We identify with their stoic and contemplative presence, and that of their forward-facing and slowly stilled counterparts in works such as *Moonlight, Tarpon Springs, Florida* (fig. 59), and we live the duration of their thoughts. The impressionist painter William Merritt Chase had been called a "wonderful human camera—a seeing machine" in 1889.[135] Inness's pictures and the bodies in them

were meant as machines for seeing, but their operations lasted far longer than a shutter's glance, as if to invoke the inhalations and exhalations of Swedenborg's most ancient and spiritual sight. The silence of these scenes, the soft hush of their atmospheric weight, marks this aspiration as indeed most ancient, of a time prior to the advent of communication by sound, as the voiceless seeing/breathing/speaking about which Swedenborg wrote.

Vignettes of minutely rendered detail scattered throughout these landscapes—foreground flower blossoms, brush-handle scrapings, smoke from a chimney, a hayrick, a cord of wood—lead the eye from one spot to another, as if it were on a picturesque tour, proceeding from one site to the next in serial and meticulous fashion, yet broad and sweeping effects of color, atmosphere, and light unify these singular instances and encourage us to take them in with just one look. Detail brings us close to the canvas surface, prolonging yet fragmenting our gaze, and effects of breadth push us away, leaving us with an instantaneously intelligible whole. Daingerfield recommended viewing Inness's canvases from both near and far, as if responding to this effect:

> Here, there, all over the canvas, rub, rub, dig, scratch, until the very brushes seemed
> to rebel. . . . But stand here, fifteen feet away. What a marvelous change is there!
> A great rolling billowy cloud sweeping across the blue expanse, graded with such
> subtle skill over the undertone. Vast trees with sunlight flecking their trunks,
> meadows, ponds—mere suggestions, but beautiful; foregrounds filled with detail,
> where there had been no apparent effort to produce it, delicate flowers scratched
> in with the thumb-nail or handle of the brush. One's imagination was so quickened
> that it supplied all the finish needed.[136]

Inness's paintings, and those of the impressionists, were said to necessitate this sort of retreat in order to be properly seen; they hung together only if several feet of viewing distance intervened. "The contrast between the greens of the sward and the foliage and the yellow-red sky" in Inness's *A Sunset,* on view in 1885, "is very marked—abrupt even," wrote the *Boston Evening Transcript.* "The effect is rather startling, particularly as the perspective is poor—almost lacking, in fact. If one looks at the picture from the north gallery, through the corridor, that is, the effect is better."[137] In this commonly acknowledged necessity of stepping back in order for an image to fall into place, in the construction of a first and second delayed moment of looking, there was an implication of duration, of time conjoined with seeing, a prolongation of the viewing that Inness's canvases produced (what one critic described years earlier as the impulse to recoil).

One of Inness's "storm effects," *Off the Coast of Cornwall, England* (1887; fig. 74), was described by *Art Amateur* as capturing a "fleeting effect" and a "momentary aspect" of nature, yet was also ascribed a less-than-straightforward rendering of time: "Every one of these incidents was doubtless observed in nature," the critic wrote, "but it is unlikely that they all occurred just so at the same moment. Seized on as they happened, in succession, they yet give one the

impression of a momentary glance."[138] Crashing waves, billowing sails, strug-
gling sailors, and birds caught midflight produce the effect of instantaneity, but
do in fact seem like isolated incidents gathered together as one, pressed into a
too-small pictorial space; the slow and faceless gaze of the woman standing mo-
tionless alongside a boat at left further divides, or rather, expands, the time of
the scene.[139] As with those back-turned and thinking figures in the works de-
scribed above, she checks the speed of our glance, arresting it at the canvas's
face and detaining it for a few moments or more. A similar effect is produced
in *Early Morning, Tarpon Springs* (fig. 61), where the absorptive reverie of a red-
vested and capped figure, as well as the slow pull of the marsh in which he
stands—his feet disappearing under the heavy weight of muddy brown, the
surrounding air laden with softening, expanding damp—contrasts sharply

Figure 74. George Inness, *Off the Coast
of Cornwall, England* (1887). 25¼ × 30 in.
The Paine Art Center and Arboretum,
Oshkosh, Wisconsin; gift of Nathan and
Jessie Kimberly Paine.

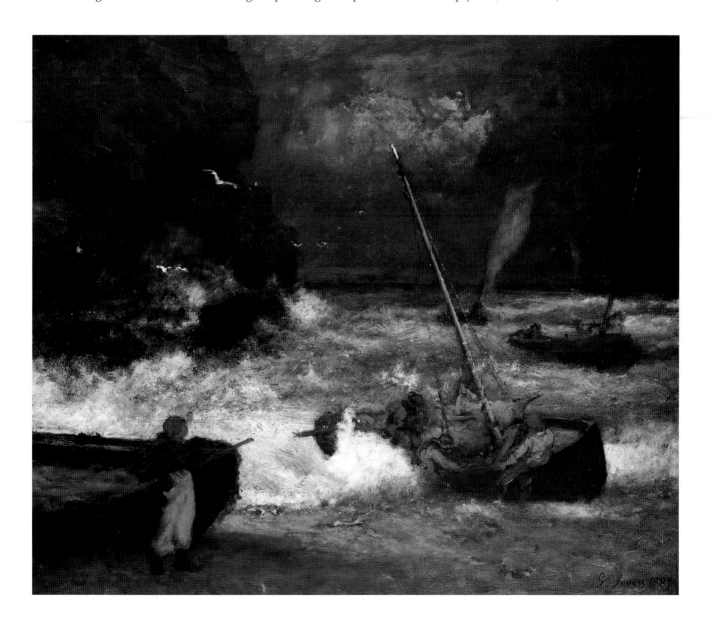

with the snapshot arrest of a bird, at upper right, in midflight. Our eyes, "tortured by suspended action—suns about to rise, storms about to burst," wait anxiously for the bird's release. Daingerfield, who described Inness as working at his canvases "in that rapt condition of mind during which the *lapse of time* is not felt, in which the mind seems to extend itself through the fingers to the tip of the brush" in order to create nature "counterfeited *at the instant,*" seemed to grasp the multiple and contradictory temporal effects of works such as these.

Inness's late landscapes not only refuse to be either simply fast or simply slow, they appear resistant to usual conceptions of time's serial and progressing structure. They rearrange time, suggesting that their maker did not want his beholders to confuse the quickness of penetrating sight with impressionism's naive and imbecilic instantaneity and, also, that he hoped to distance his works from the paradigms of temporality other sorts of landscape painting (that of the Hudson River School or the Pre-Raphaelites) offered up. I have described how Inness's landscape practice during the first four decades of his career diverged from that of his contemporaries. Although he did go out into nature to study its forms, he neither drew on a regular basis nor did he usually paint pictures after drawings or oil sketches he executed in the open air (a process understood in terms of both spatial and temporal progression: you attend to the foreground before attacking the distance; you begin with the outdoors and finish in the studio; you go sketching in the summer and then paint in the fall and winter). Yet it appears that drawing, or a version of it, found its way into his late works after all and, I would suggest, played an integral role in shaping their operations and effects, especially with regard to the representation and reorganization of time.

In many of his late landscapes, Inness allowed what should be black underpaint to penetrate or sit on top of layers of colored pigment; these black marks appear drawn, rather than applied with a brush, as if an attempt to blur the boundaries between those divergent representational modes. What results is the confusion of before and after, as sketch (for this is what his underpainting reminds us of) and painting are made to occupy the same pictorial register.

The trunk of the tree at left in the 1891 *Early Autumn, Montclair* (fig. 54) is composed of a single unadorned black line, as are some of the tree branches above it, and in *Early Morning, Tarpon Springs* (fig. 61), black marks dance about and on top of the green leaves that hover around the tallest tree at right while black lines snake in and out of the leaves and branches of the cluster of trees at left, faltering and stuttering here and there, as if to evoke the catching of charcoal on paper or canvas grain. Sketchlike trees assemble at the horizon in *Home at Montclair* (1892; plate 21), a picture that resembles a charcoal sketch as much as it does a painted landscape, despite thickly applied white pigment in the bottom half. Black underpaint presses forward through the brownish red that designates a fence and seeps through an area of grayish white in the foreground at left, as if the bones of the work were slowly and quietly breaking apart its flesh. The scene shifts and stirs under our gaze as we encounter layer

on layer of mutating pigment and line. A line of scraped-off paint that appears to have been made by the wooden handle of a brush sits atop a patch of white in front of the fence, slightly to the left of center and a few inches beneath the trunk of the tree that obscures the distant house, echoing with its calligraphic twist what look like pencil marks throughout; yet, as a kind of absence (the removal of paint from canvas surface), this scratch further complicates the relation of drawing and painting by taking away that—the drawn—which ought to be irrevocably under or before paint, making the former a version of the latter.

In *Apple Blossom Time* (fig. 70), sketch consumes paint as the former twists from under the whitish green pigment that attempts to stay its progress. Ever in motion, the charcoal-colored branches and trunk of the apple tree, and the blackish limbs that constitute a screen of elms in the distance, push forward through overpaint and are pulled back again as the whole moves both toward and away from us as we look. Smothered by the smeared brown paint that binds them to the surface, blackish and sketchy flowers, the blooms of which seem to occupy an altogether separate pictorial plane, remain suspended in a realm between, neither past nor present, prior or seen right now. Similarly, the whitish-blue haze that designates a screen of trees running across the upper half of *Spring Blossoms, Montclair, New Jersey* (fig. 72), lies over, auralike, but also under a network of black lines; these marks create an armature of sorts that supports the forms it underpins but also hovers, unmoored, as if in need of the embrace offered by the thinly streaked white paint, which itself detaches from solid form in places, floating away. Black lines snake in and out, above and below the thick yellow-white of the apple tree, and drawing and painting compete as one presses into and encroaches on the other's space. It is important to keep in mind the fact that these are not necessarily unfinished works, their underpaint bared because Inness never had the chance to cover it up or make it recede; often, such canvases were exhibited, sold as finished, and considered complete by their maker and his critics.[140]

These paintings press together moments—looking, sketching, painting—and representational realms—near, far, above, beneath—understood at the time as temporally distinct. Traces of the formerly prior—figurations of the drawn—make of sequentially progressing time its own dislocation. Drawing, the "past" of painting, usually hidden beneath layers of pigment or at a distant reach in a sketchbook or portfolio, trespasses on painting's "present," putting the latter in serious doubt. Encroachment and overlap (drawing that takes the place of painting, painting that bleeds into drawing's realm) signify the crossing over of one temporal modality into another, destabilizing and reconfiguring our experience of time and its records in representation. Inness was known to photograph his paintings at different stages of completion, as if attempting to capture and then collect a series of instances—photographic (or impressionist) glances—and then render their instantaneity obsolete in the space of pictures that were the products of accumulated and reorganized paint and time.[141]

All of this provides for an experience of viewing marked by deferral and delay, by topsy-turvy and upside down, and, consequently, by the transfiguration and undoing of time and space: going forward and then stepping back, underdrawing on top of painting, far in front of near, fast and slow, and then fast again, last before first, and first in front of last. Color puts us face to face with the irrational and wild; these effects declare once and for all that time and space as we knew them are no longer, their governing principles and laws rendered illegitimate and moot. What we have here is a release from constraint: from what we know and from what science tells us about the temporal and spatial workings of the world. These paintings imagine a space beyond what we can fathom; as Inness would have put it, they imagine "a subtle condition imperceptible to sense," of which "we have no physical perception," wherein new forms of perception might arise.[142] What we have here is the staging of a dimension beyond explanation, beyond formula, principle, and law, the construction of a realm wherein, in the words of the physicist Ogden Rood, "there is room for the play of not less than a dozen new senses, each as extensive as that of sight."[143] Recall that when speaking of this unfathomable space and of the possibility of an as-yet-unknown sense, Inness spoke of the "eyes of insects," saying that the powers of the human eye were imperfect by comparison. It is as if, by way of the spatial and temporal transformations and dislocations of these paintings, Inness meant to evoke just such an insect vision, or what might have been his understanding of it, wherein compound eyes see an object from multiple, possibly hundreds, points of view (rather than the mere two of binocular vision).[144] In so doing, in giving his viewers time and space from multiple and mutually contraindicating vantage points (front and back, before and after, all at once), Inness suggested a space as yet outside the scope of human knowledge, and by way of the example of insects and their alien vision, he suggested a form of sight far beyond the purview of human inquiry and experience, a mode of perception approachable only after the collapse of order into random and unbridled play.

RUB, RUB, DIG, SCRATCH

One of the most striking features of Inness's late landscapes, and one that I believe is intimately related to his temporal and spatial experimentation and to his intimation of a dimension beyond our own, seems to have gone unnoticed or, at least, has not been attended to in any study of his work. In chapter 4, I mentioned that Inness filled the foreground of *Lake Nemi* (plate 9) with what appear to be scratches made by the wooden handle of a paintbrush. The scrapes are continuous, rather than broken, and the contours of their impress are curved, rather than angular, as if made with a brush handle's rounded tip or, perhaps, a fingernail. These broad, horizontally sloping strokes that, trenchlike, strip away the brownish-red and green paint that designates the hillside as it slopes up and then down toward the lake, create an animated zigzag pattern

that does not appear to perform any real denotative function. This elaborate network at once seems to hover at the canvas's surface and to press into its flesh.

To my knowledge, *Lake Nemi* is the only pre-1880 Inness landscape that features this type of mark. After 1884, such scraping proliferates, recurring in numerous canvases of the late period. In an essay on Inness published in 1913, Daingerfield recalled that the artist's fingernails were "not overclean, because of his habit of using them in his work" and, when speaking of the close-up/far away effects of his art, he described his painting process as "all over the canvas, rub, rub, dig, scratch."[145] The critic's 1911 study of Inness provided more detail:

> In working on a new canvas the subject was drawn in with a few bold strokes, the structure, and principle underlying the theme being fully grasped, this was then stained with due regard for breadth and light and shade.... As this stain grew tacky, it was rubbed and scrubbed into the canvas, lights were scratched out with thumb nail or brush handle, or wiped out with a rag—always modeling, drawing, developing in the most surprising manner.... As this color tightened in the drying, the forms were sharpened.... The picture now being fully set, and the whole theme fairly pulsating with the vibrant, unctious [*sic*] flow of it all, for as there as yet was no touch of opaque color, he would sharpen a few lights by scratching— perhaps with a knife, more often with the fingernail—add a note here and there of stronger color and stop for the time.[146]

It is impossible to say with certainty what it was that Daingerfield was describing when he referred to this process of sharpening and scratching, rubbing and digging, but his remarks imply that it was an important and conspicuous component of Inness's practice, one that more recent commentary has overlooked. Inness's late landscapes consist of layer after layer of commingling and, in places, liberally applied paint; these scraped lines, made by taking pigment away, are singular, for they seem to reverse or undo his efforts to build his canvases up, and they stand out in paintings that, in their embrace of color effects, often seem uninterested in line.

The scraping technique described by Daingerfield does not appear to have been applied at random. Indeed, the lines etched into the surfaces of Inness's canvases can seem scripted or choreographed, as if the product of careful deliberation; their often elaborate and always playful trajectories interact with and respond to their painted surrounds, shadowing the sway of a tree, or accentuating a touch of color or the contours of a form. A scrape in *Summer Montclair (New Jersey Landscape)* (plate 15), for instance, originates at the base of the tree left of center and traces the line of its trunk, cutting through gray-white pigment to reveal a duller green underneath (fig. 75). It doubles back and folds over itself when it nears the bottommost leaves and then forms a dangling, lyrical loop as it inclines toward the top and then drops down again. Similar scratches mirror the bend of the leftmost tree, a more substantial version of

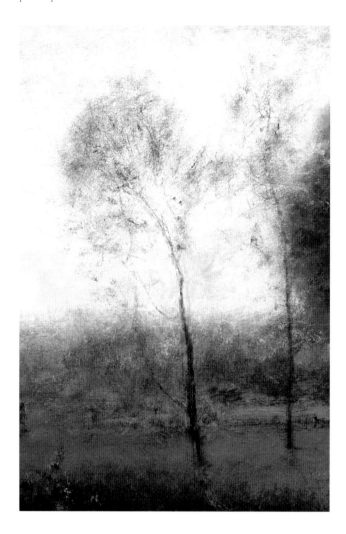

this ghostlike and fading form. In *October Noon* (plate 14; fig. 76), a twisting and spiraling scrape loops itself around the red-orange leaves of the gently swaying tree, eloquently echoing the slope of its trunk and the gesturing of its branches, tousled by the wind; here, color and line perform a delicate pas de deux, one responding to and transforming the look and feel of the other.

Only rarely do Inness's scrapings actually represent things in nature, standing in for the paint, scratched off, that originally denoted tree, flower, cow, or shrub. In *September Afternoon* (fig. 71), for instance, vertical scrapes in the lower-left quadrant delineate marsh grasses and the stems that support a row of orange-red blossoms, vibrant against the meadow's dark green. In *Early Autumn, Montclair* (figs. 54, 77), the figure to the left of the central trees wields what looks like a grain cradle, here represented with four or five decisive strokes of the brush handle or fingernail.

More often, Inness scatters his scratches throughout, limning paint or form but not exactly representing, as if rendering a language that has abandoned its conventional referential capacity. The tightly wound squiggle directly beneath

Figure 75. Detail. George Inness, *Summer Montclair* (New Jersey Landscape) (1891). Oil on canvas. 30¼ × 45 in. Collection of Frank and Katherine Martucci.

Figure 76. Detail. George Inness, *October Noon* (1891). Oil on canvas. 30 × 45 in. Courtesy of the Fogg Art Museum, Harvard University Art Museums, Cambridge, Massachusetts, bequest of Grenville L. Winthrop. Photograph Katya Kallsen. © 2003 President and Fellows of Harvard College.

Figure 77. Detail. George Inness, *Early Autumn, Montclair* (1891). Oil on canvas. 30 × 45 in. Delaware Art Museum, Wilmington, Special Purchase Fund, Friends of Art, 1965 (1965–1).

the second largest tree in *September Afternoon,* along with scrapings in the lower-left corner and below and to the side of the hayrick, are typical, as is the twisting line that, in *After a Summer Shower* (1894; fig. 78), forms a loop within the rust-red and barely delineated shape of a cow to the right of the foreground path. In *Autumn, Montclair, New Jersey,* a small-scale sketch from around 1890 (fig. 69), a reddish-brown clump of brush is pinned to the canvas support by a network of scratches that in places attends to the contour of the form it presses into and in others seems uninterested in anything but formal play. A scrape wraps itself around the appendages of a shrub in the foreground, just to the left of center, in *Early Autumn, Montclair* (1888; fig. 79), and encircles the flower-tipped branch toward the top, yet transforms rather than mirrors its profile, as if it were a memory or afterimage, echoing yet distorting its form as it maps out a second system of bends and curves. Scratches reiterate the weight of the branches that pull a clump of red leaves toward the ground on the central tree's lower-right half, but they extend beyond this form, snaking through the green and peach paint below and to the right; scrapings create a similar effect in the

Figure 78. George Inness, *After a Summer Shower* (1894). Oil on canvas. 32 1/8 × 42 5/16 in. The Art Institute of Chicago, Edward B. Butler Collection (1911.29). Reproduction, The Art Institute of Chicago.

Figure 79. George Inness, *Early Autumn, Montclair* (1888). Oil on canvas. 30 × 45 in. The Montclair Art Museum, Montclair, New Jersey. The Valley Foundation, and Acquisition Fund, 1960.28.

dark green tree that frames the scene at left, denoting the network of branches beneath the leaves even as their horizontal swing contradicts the upward tilt of gesturing limbs.

In *Woodland Scene* (fig. 56), scraped lines squeeze themselves into touches of light—in the yellow strips at the horizon between the two rightmost trees and in an orange smear toward the center of the canvas, just below the half-lit tree—and engage in an energetic exchange with paint itself; exuberant and swirling scratches and scrapes mingle and mix with equally exuberant strokes of yellow, white, and green in the brightly lit intervals third and fourth from left (fig. 80). Above the buildings at right, spiraling scratches extend up toward the branches of the trees, and an additional line curves, twice doubling back, through the topmost leaves. Scrapes meander through the area beneath the bright orange and red trees in *Morning, Catskill Valley* (plate 16), peeling off pigment to reveal the canvas's grain and reiterating the horizontal pull of brownish-gray paint along the strip that divides the canvas into halves; zigzagging scratches at once follow and counteract the trajectories of both branch and orange paint in the leftmost tree. Other canvases, including *Early Morning, Tarpon Springs* (fig. 61), *Near the Village, October* (fig. 55), *Off the Coast of Cornwall, England* (fig. 74), *Sunset at Montclair* (1892), *Landscape, Sunset* (1889), *In the Valley* (1893), *Summer, Montclair* (1887), *Approaching Storm* (1893), and *Sunrise* (1887), boast scraped passages such as these, some easier to discern than others, but all of which I am suggesting represent the rubbing, digging, and scratching to which Daingerfield twice referred.

The question, of course, is this: What do we make of Inness's habit of scratching and scraping the surfaces of his canvases in such a fashion? Daingerfield indicated that Inness scraped his canvases so as to sharpen areas of light. Yet many of these scratched passages produce the opposite effect, removing transparent and glistening hue and leaving in its place dull underpaint and canvas grain. I have the feeling that Inness's rubbing and digging had another end, in addition to that suggested by the critic. When looking at these canvases, the viewer is faced with a peculiar system of notation that calls to mind a form of expression that was thought, in the earlier part of the nineteenth century, to be inimical to painting. I mean, of course, writing, an activity that the idea of holding a paintbrush upside down, using it to fashion a scraped and calligraphic line, conjures up.

To be sure, these scrapings could be anything (except, of course, accidental), and it may be a stretch to say that they represent or even allude to writing, in any of its various forms. They do not form letters or words, and they do not arrange themselves in patterns that resemble the configuration of text

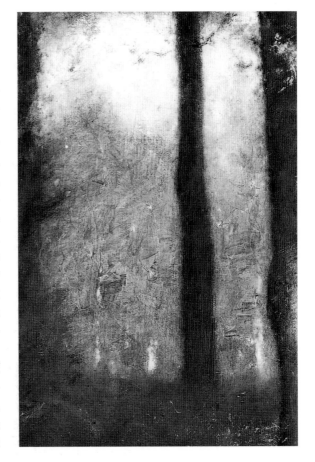

Figure 80. Detail. George Inness, *Woodland Scene* (1891). Oil on canvas. 30 × 45 in. Courtesy of the Pennsylvania Academy of the Fine Arts, Philadelphia; gift of John Frederick Lewis, Jr.

on a page. Inness never referred to his scratches as writing, nor did any of his nineteenth-century viewers. Yet given what I have characterized as an insistence on the collusion of discursiveness and line (or design) on the part of writers in late-nineteenth-century America and Inness's dedication to written expression (exemplified by his poetry, his poetic captions, his allegorical canvases, and his "Mathematics of Psychology," among other things), I believe these scrapings may be understood in terms of the fact that they call writing to mind, or, to be more exact, because they evoke the act of writing—hand and pencil moving across planar surface—if not writing itself. And, I should emphasize, evoke is all they do, for evocation, not imitation, was the point.

As we know from our examination of *The Triumph of the Cross,* Inness was interested in getting writing, or a version of language's expressive potential, into his pictures and in creating the conditions under which text inflected the beholder's experience of his art. What Sheldon called Inness's endeavor to produce pounds of manuscript (or, as Daingerfield said, "mountains of writings") was not unrelated to his landscape practice.[147] As Inness himself indicated, his researches into philosophy and metaphysics, his writing, and his picture making were aspects of a single and dogged pursuit:

> And when you grow weary of painting, Mr. Inness?
>
> Then I take to theology. That is the only thing except art which interests me. In my theory, in fact, they are very closely connected. That is, you may say it is theology, but it has resolved itself gradually into a scientific form, and that is the development which has become so very interesting to me. I have written piles upon piles of manuscript upon it, and my method is to take these piles and rewrite them in a very condensed form. Gradually this grows and is "boiled down," and all the first essays destroyed.[148]

This process of stripping away should remind us of what Inness's colleagues and friends characterized as his habit of continually painting and repainting, his tendency to go back, do over, and start again. Painting, for Inness, was a matter of accumulation, and writing just the opposite, but each act involved doing away with what had come before: the effacement of layers of paint, or whole compositions, and the destruction of written words, a process analogous to the subtraction of matter that Inness's scraping entailed.[149]

Many of Inness's contemporaries noted his propensity to write (the newspapers reported in 1875 that he was at work on a book about art) and they often implied that the activity was an integral part of his practice as a painter.[150] Sheldon said that Inness once wrote a poem to explain a painting to the person who bought it and noted that other examples of the artist's verse were inspired by his own works.[151] Inness's poem "Despair," which the critic included in his 1882 essay on the artist, "was written in connection with a picture of a figure in a cell, expressive of hopeless grief. On one side of a sheet of paper is Inness's sketch for the picture; on the other, the poem, hastily and rudely recorded."[152]

"He would scribble hurriedly on any scrap of paper he could lay his hands upon," wrote McSpadden, "and his long, cumbrous sentences were not easy to understand. The writing was chiefly for his own reference, and without regard for style."[153] And, as Trumble noted:

> When he was not endeavoring to paint [his theology] he was writing it, not with any special idea of giving it to the public, but for the purpose of more closely examining and expounding it for himself. After a long day's labor in his studio, he would refresh himself with a long night at his desk. After a day of disappointment at his easel, through failure to secure upon the canvas that subtle spirituality which he saw, or rather felt, in his subject as its soul, he would turn for fresh enlightenment and inspiration to his manuscripts, and seek in them the clue which he had lost.[154]

It is not difficult to imagine Inness, paintbrush and pencil in hand, moving from easel to writing desk and back again, perhaps in the course of a single day, as he struggled to make his thoughts clear and his art look and function as he wished it to. According to Daingerfield, "Inness used to say that his forms were at the tips of his fingers, just as the alphabet was at the end of the tongue."[155] Indeed, Inness believed that writing and painting had similar and analogous ends: "There is the art of writing, for instance. In that art the great endeavour is so to personalise things as to make the appeal as nearly as possible analogous to that which is addressed to the senses," meaning the natural world or its representations, painting, to be exact.[156]

Inness painted *The Triumph of the Cross* at a moment characterized by serious misgivings about the relationship between painting and poetry, or image and text. His scraped canvases, however, were created in a context, the late nineteenth century, in which affinities between the activities of painting and writing were often assumed, as indicated by significant shifts in the vocabulary critics employed in speaking about the pictorial arts. During the 1880s and 1890s, interest in painters who wrote, and writers who painted, increased, as did attempts to devise stylistic categories into which both sorts of practitioners could be put.[157] "Painting is, indeed," wrote De Kay, "a development, a powerful shoot from the same taproot as literature; for pictures antedate writing and at the origin of every letter of every alphabet in the world in all probability lies a picture."[158] The alphabet itself was understood as interchangeable with images or pictorial signs. The letters of the alphabet, wrote the author of an essay on the use of memory in sketching from nature, "may often be used as signs by which to remember some remarkable form in nature. . . . A sea coast scene, with a tree in the foreground . . . may be held in mind by comparing it to an italic capital F."[159] Pictorial compositions were spoken of in terms of letters and also in terms of grammar; Inness, we know, used such a term when discussing design. Paintings with flawed compositions were labeled "ungrammatical," while pictures with what was perceived to be a good sense of design were, accordingly, "grammatical" in nature. The *Nation,* for example, compared a work

that included elements "harmful" to its design to "an example of good, quiet, grammatical painting" and described Albert Pinkham Ryder's contributions to the academy exhibition as "maimed and incomplete" because of their inattention to grammar, to an alphabet and vocabulary provided by nature.[160]

The notion of a "grammar" of pictorial representation, especially where landscape was concerned, followed from a common nineteenth-century conception regarding the significance and expressive character of the natural world that described any experience of nature as involving reading as well as seeing. It is a matter of course that, during the span of Inness's career, American artists, writers, and audiences spoke of nature as a kind of book that, when looked at or read properly, revealed truths about the world and the divine force or forces responsible for its creation. As James Collins Moore has noted, references to the "book of Nature" were legion in the nineteenth century; things in nature—trees, rivers, rainbows, mountains—were considered types or signs of deeper truths and were thought to constitute an emblematic language.[161] This understanding was practically a nineteenth-century habit of mind, and it was assumed that any perception of the natural world, or any representation of it, took into account what was understood as nature's referential, or textual, dimension. In his 1884 essay on Inness, Hitchcock spoke of the artist's works in just these terms, finding in them "a translated page from the book of nature, and not a mere color scheme or a studio study of chromatic effects."[162] McSpadden, too, stated that Inness "might be called the painter-preacher, finding 'Tongues in trees, books in the running brooks / Sermons in stones, and good in everything.'"[163]

Inness's practice, then, encompassed an explicit dedication to written expression, this at a time when landscape and representations of it were commonly discussed in terms of language and nature's supposed linguistic aspect. Given this, it seems quite possible that his scrapings and scratches were meant to call to mind the act of putting words on a page and, I would add, the operations and properties of language itself. And again, let me emphasize the fact that this is all that these scrapings and scratches do: call to mind. For Inness, ever desirous of formulating a language for use in rendering and then communicating truth but also resigned to or perhaps delighting in the fact that conventional representational systems, pictorial and written both, were not up to the task, thus evoked but transfigured the writing/language-making process (as he did his allusions to old master art in the 1840s–60s) so as to make this very point: so as to intimate a language beyond the conventional, fathomable, and known. These markings, for a split second, can look or feel like writing, if only because they make us imagine Inness holding his brush as he would a pencil (or because they do what writing does: they employ combinations of lines to represent and convey an idea or concept, as in "grain cradle," "tree," or "flower")—but the point of this split second consists in emphasizing that writing, in its usual forms, is precisely what these markings are not.

So, what are they? If the late paintings engender a realm beyond time and space wherein a new perceptual capacity might arise, the scrapings and scratches in them may be understood as an intimation of that realm, wherein normal representational systems do not obtain, and also as an attempt to articulate the properties and operations of just such a new sense. Recall Swedenborg's description of exalted vision (that of the Most Ancient Church), wherein seeing, knowing, and breathing were one and the same, where the eyes, the mind, and the bodily breath congealed into a single perceptual apparatus. This, I believe, is what we might have here: a diagram or cipher of a form of cognition that both Inness and Swedenborg believed could access cosmic truth. Let me explain what I mean. Inness turned to words when painting had him stumped, and he tried repeatedly to create a place for them—through poetry, book writing, allegory, and captioning—in his art. Inness's scrapings and scratches, I would argue, represent another grasp at the possible unification of painting and writing's expressive potential. For with these scrapings and scratches, Inness was not testing out the possibility of marrying text and image but, rather, experimenting with the creation of a model of perception that would be at once a way of looking at and a way of deciphering the world, that would meld the process of seeing a painting with the act of conveying knowledge through verbal expression. This vision, represented as careening and cavorting line, would see and read things, and thus know truth, in a single instance of cognition. Such a mutual exchange and fusion of faculties is figured in Inness's landscapes by the confusion of categories brought about by his scratches and scrapes: the confusion of painting and writing, color and design, music and discourse. Inness's brush-handle markings call writing to mind, but they do so in the context of painting and, as a result, are themselves picturelike. They snake about as if they were unhinged script, but they also limn forms and create patterns and shapes, staking claims in two different representational realms. Line, which, as we know, was associated with discursiveness at the time, is stripped of such a function, for it cannot be read, and color approaches the status of painting's grammar, for, filling the trenches left by brush handle or fingernail, it takes shape as structuring, writing-like line. Color is not simply the ground for the discursive mark, for it assumes the latter's properties and shape. Qualities associated with color (musicality) attach themselves, by way of lyrical line, to design (thought), and vice versa. "Draw, draw, draw," Inness admonished. "Learn your art thoroughly, have it at the tips of your fingers, be able to do it with your eyes shut, so that if you have anything to express you will be able to do it without the slightest hesitancy. *Know forms, know nature, as a musician knows his notes before he attempts to render a harmony.*"[164] Construction and form become color, color becomes construction and form. All three become music, which doubles as design and, thus, thought—what words, composed of letters made out of lines, usually express: "Colors are words to him," the *Independent* wrote in 1881.[165]

By way of such confusion, Inness's scratches and scrapings push for the expansion, transformation, and collapse of categories, or systems of denotation, usually understood as distinct; language is asked to become painting, and painting a form of language. And beholding (looking at one of these pictures)—in that it evokes divergent modes of perceptual engagement—is posited as an act in which reading and seeing are not just coincident but may potentially be one. Beholding is also asked to become, or to take on the properties of breath or, at least, to invoke the apparatus responsible for producing the inhalation and expiration of air. As physical traces of Inness's hand, his scrapings and scratches serve as indexes of the artist's bodily presence and, thus, his capacity to breathe or, in the case of a dimension beyond time and space, breathe/see/read/know. In that they fold into paint, penetrating and flowing inside the body of his works, even as they entail the extraction of material (paint), these marks imitate the activity of respiration: taking air in, pushing air out. Their sinuous, sweeping course, especially in those canvases where their shape follows that of trees and tree limbs moved by the wind, might even be said to evoke the movement of air through space, another emblem for the rush of breath through mouth, throat, and lungs.

Inness preferred to exhibit his paintings in groups (in part, perhaps, because the 1884 monographic exhibition made him realize how necessary such a context was to the meaning and reception of his works). The *New York Herald* reported in 1889 that Inness had refused to contribute a painting to the American art section at the Paris Exposition; the American Art Association lent one, *Short Cut, Watchung Station, New Jersey* (1883), a gesture that angered Inness, who wrote an indignant letter to the *Herald*'s editor on March 8.[166] In a second letter, Inness explained that he was hesitant to exhibit a painting that he believed would fail to represent his project adequately and said he would have preferred to put a large number of his works on view: "I never promised to allow any pictures to be sent to Paris. I would have gladly exhibited could all the phases of my work been represented at the same time. I felt that would have encroached on space to which my brother artists were entitled. Finding I could not have the requisite space . . . I positively refused to be represented by a single picture."[167] Inness had expressed a related view several years earlier, in an 1879 interview published in the *New York Evening Post*. He voiced his thoughts on academies and exhibitions and suggested that artists congregate and exhibit according to affinities of style and purpose. "A mind of thorough artistic instincts," he declared, "can do its best only where its surroundings are sympathetic with itself. All outside issues, and all influences that do not cherish art tend to dissipate such instincts." In this way, the "confusion produced by viewing large unclassified exhibitions would be an other [*sic*] evil done away with" and "harmony and satisfaction might be made to rule."[168] His worry over exhibition conditions persisted into the final years of his life. "I do not care to exhibit at Chicago," he wrote to his patron Clarke about the 1893 Columbian Exposition. "I have no pictures which I care to put out of my own control for a

great length of time and I presume that those who own pictures painted by me feel the same. Besides, I consider these large exhibits . . . not conducive to the highest phases of art."[169]

It is impossible to say exactly why Inness felt that his landscapes should be exhibited in groups, with all aspects and phases of his career represented, but surely he did so with the beholder's experience in mind. It should be clear by now that Inness was doggedly bent on fashioning landscape into an instrumental language. It makes sense, then, that he was more than a little concerned with the conditions under which his paintings would be seen and read. It also makes sense that he preferred to show many of his landscapes at once. When faced with a number of his pictures, Inness's viewers would have been sure to notice the prominence and repetition of features such as foreground paths, back-turned figures, central and isolated trees, carefully coordinated parts, reconfigured allusions, dazzling color, sinking and soaked meadows, and scraped and scratched lines. In other words, they would have been faced with a set of landscapes that kept making the same demands. Inness painted with others of his pictures in mind (to be sure, all artists did, but Inness made the fact that he did so conspicuous); he repeated compositions, he painted on top of finished canvases, and he produced endless variations on a theme, so that his practice was as much about the process of painting as it was about the product. A monographic exhibit of Inness's landscapes would expose the beholder to the obsessive quality of his art, and it is likely that this is just what he had in mind, hoping to ensure that his viewers grasped his vocabulary and understood exactly what it was he was trying to convey.

By the same token, a monographic exhibition of Inness's landscapes would have ensured that if his viewers did not understand one aspect of his language they would be offered another, and another, and so forth (as if Inness the experimental scientist were saying to himself: "If one formula proves ineffective, I'll try a different one"). Inness's landscapes do indeed boast compulsive and sustained strategies and techniques, but as a collective they amount to a remarkably diverse array of features and forms (reckless experimentation, Jarves called it). As was Swedenborg (and his precursor Leibniz, and everyone else who wanted to make philosophy into a universal and truth-securing language and art), Inness was interested in devising a scientific formula that would reveal secrets and truths, and he wanted to do so using words that everybody could manipulate and understand. He hedged his bets, however, and allowed multiple languages to proliferate, so as to ensure that all of his viewers could (to use nineteenth-century parlance) read as they ran, that is, grasp his message even if they gave his pictures only a swift, passing glance.

What is more, if we take Inness's scrapings and scratches to be figurations of a new form of sight and speech, we can also see in his insistence on the monographic yet another attempt at building a model of spiritual vision, one that expands on the idea of scrapings and scratches as instantiations of an as-yet-unknown cognitive realm. If Inness understood seeing and knowing as a

form of communication between eyes and minds, then he may well have understood a room full of his own paintings as a replica of just such a mode: paintings entering into dialogue across a gallery space, the one inflecting or speaking to the other because of proximity and shared characteristics or compositions but also because each canvas a viewer took in would be seen through the memory of the canvas he had looked at a moment before. Intersubjectivity—that thing that Inness believed to be characteristic of penetrating vision— manifests at multiple levels in such a space: through paintings talking to one another but also by way of the fact that these conversing paintings represent internal dialogues of their own—between built-up and overlapping layers of pigment, between Inness's painting and the sketch of a friend, between the already-painted canvas of another artist and what Inness laid down on top of it, between Inness's memory of a scene and his vision of it, often years later, as he rendered it in paint (what, collectively, constituted a metaphorical mingling of breaths, a model for the actual communications between Swedenborg's men of the Most Ancient Church and God, as I explained in chap. 2). Such a space would buzz, filled with the chatter of ideas exchanged between eyes and minds, in some cases quite literally (as in Inness's borrowing of a colleague's sketch of nature so as to paint one of his own, what amounted to the use of someone else's eyes and thoughts). Inness said that the ideal exhibition space would be one of harmony rather than confusion, as if to suggest that a gathering of paintings could, indeed, correspond to or embody that "perfect harmony of vision" that occurred by way of immediate and uninterrupted intercourse among bodies, eyes, and minds and after which he so assiduously sought, as if, perhaps, to evoke the actual and sweet sound—the harmonics—of speaking/breathing in real time and space. Given that Inness believed that art was "the first great factor in social being," as he stated in his letter to Hitchcock in 1884, its "true use" consisting of its ability "to enter as a factor in general civilization," as he told *Harper's* in 1878—the artist, he insisted, "must refer back constantly to the principles of . . . his relation to life and to society," and he "may be of as salutary service in the make-up and development of humanity as the merchant, the tailor, the carpenter, and the editor"—it may not be claiming too much to say that this perfect harmony of vision and breath, this lovely, unified noise of enlightened exchange brought about by a room filled with his landscape art, was meant to intimate, through the model of cognition, the model of existence it offered up, access to knowledge and truth but also to a better, more harmonious, regenerated world.[170] If Inness believed impressionism and impressionist vision capable of endangering societal health, there is no reason why he would not have understood his own pictures, and the vision intimated therein, as capable of an opposite effect. Indeed, in speaking of his wish to refashion American exhibition and academy practice, he said that by making "order, harmony, and satisfaction" the rule, "the distinctive use of art as an element of social, and consequently national harmony [will] become a self-evident truth."[171]

What we have in these pictures, then, is an idea of what cognition might look like in a realm beyond conventional sense, as well as an idea of how it would behave and what it might achieve, which goes some way in explaining, among other things, the proliferation of scraping and scratching in Inness's late landscapes. But there is another, albeit not contradictory, way of understanding these marks. If color represented the loosening of Inness's grip on system and rule, and if disfigured time and space marked Inness's imaginative entrance into an unknown and lawless world, these scrapings and scratches, some denotative but most not, record the escape of the paintings from Inness's own grasp, what amounts to, at one and the same time, a conscious letting go and a pictorial "getaway" wherein volition falls willing victim to the unconscious and chance. As with the explosive zigs and zags of *Landscape with Trees* (plate 19), Inness's incised lines, if more delicate and understated, express a freedom and exuberance that remind one of an energetic and improvisatory dance. To be sure, Inness put brush handle, palette knife, or fingernail to canvas surface on purpose, and the grain cradle design, for one, is most certainly not the product of chance. Yet a majority of marks have the appearance of going their own way, as if Inness let consciousness lapse just a little bit and waited to see where his hand would have him go. Even the lines that map out the contours of spindly trees in *October Noon* and *Summer Montclair (New Jersey Landscape)*, in that they stay only partially on course, looping away here and there, abandoning the tree pattern for spiraling, exuberant flips, call to mind an artist willing to let things happen on their own, only periodically in control of the direction of his marks. These etched lines instantiate, we might say, Beecher's automatistic reverie, brought about by a dreamy lapse into memory and spontaneous association, and what Mariana Van Rensselaer, in her praise of a particular strain of art, characterized as "an automatic power . . . of the retina—as unconscious as is the pianist's memory of his notes, and as unerring," what amounted, in her estimation, to "simple vision exalted into a special gift."[172] These etched lines also instantiate what Swedenborg described as an intercourse with the divine so immediate and instantaneous (an influx of spirit and truth "in a minute's time") that it was as natural, unnoticed, and automatic as breath. In so doing, they trace a power of eye and mind so vast it escapes the grasp of consciousness and will.

We are faced, then, with more than a challenge to science, to principle, and to law, more than a tug-of-war between color's license and geometry's rule. What Inness gives us here is nothing less than an abandonment of design, the release of painting (at least parts of it) into the waters of accident and chance. Here, consultation and coordination—philosophical reasoning using the organization of forms in space, as if terms in a logical, Leibnizian calculation—makes way for jubilant happenstance. In Inness's own words (which we have encountered before): "You can only achieve something if you have an ambition so powerful *so as to forget yourself,* or if you are up on the science of your art. If a

man can be an eternal God when he is outside, then he is all right; if not, he must fall back on science."[173] With his scrapings, I want to suggest, Inness forgot himself, intimating with playful and half-conscious line a place where conventional science was not forced to compensate for inadequate sight, a realm where other, unfathomable circumstances enabled him to see like a god. "The greatness of Art," Inness said, lies in "the distinctness with which it conveys the impressions of a personal vital force, that act *spontaneously,* without fear or hesitation."[174] How else to fashion a world where our laws do not apply, where our eyes would not be able to see—how else to evoke the powerful and delightful force of an utterly new sense—but to abandon consciousness and vision in the very act of painting, to turn one's own hand and eye over to ungovernable but liberating play? What better way to insist on the present unknowableness of cosmic design than to eliminate the knower, letting pictures paint and think themselves?

EPILOGUE ❧

"We must work our way to Paradise"

I began this study by asking what it might mean for an artist in nineteenth-century America to consider himself a metaphysician and for that artist's colleagues, critics, and friends to call him such, repeatedly. Having spent six chapters leaning over Inness's shoulder as he conducted his "metaphysical research" (so called by his son), we now have a sense of how to answer these questions. We also have a sense of what Inness might have meant when he referred to his landscape practice as science.

For Inness, pursuing the work of a metaphysician meant nothing less than seeking to explain the nature of being, which for him entailed exploring and elucidating the processes by which we come to see and know. Drawing on a wide range of ideas and theories—from the musings of the mystic Swedenborg to the claims of psychophysiology, from the reveries of Beecher to the philosophy of Locke—and producing theoretical propositions of his own, Inness fashioned a pictorial practice wherein laying on paint was a matter of formulating and then testing a series of hypotheses, wherein putting brush to canvas was akin to generating and organizing thought. At one and the same time, then, Inness's landscapes were diagrams of perceptual and cognitive processes and instantiations of those processes at work: Inness showing us seeing and knowing, and Inness, himself, doing those things, all at once.

Being a metaphysician also meant, for Inness, hard and painstaking, even heartbreaking, work. Painting, he said shortly before his death, had for him consisted in mental struggles and torments of a magnitude inconceivable by anyone else.[1] "Eden was, it will not be again," he wrote to Ripley Hitchcock in

1884, lamenting the loss of a state of grace, or state of vision, wherein knowing truth and seeing God was as easy and automatic as taking a breath, and foreshadowing the labor of reconstruction to come: "We must *work* our way to Paradise."[2] Pages and piles of manuscript, his friends said he wrote; anxiety, excitability, fits of nervous exhilaration they said he endured ("his eyes burned like fire when in coal and red-hot," Daingerfield wrote, "through the days and hours of work"; "his peculiar energy and nervous excitement at his work," said Trumble, "had about it the suggestion of a battle").[3] Such labor and intensity of effort, in combination with what Inness called his curse, that is, his inability to "carry a thing nearer to perfection"—his obsessive consultation and coordination, his retooling and revising once again—were what he knew it would take to get his pictures where he wanted them, were what it would take to fulfill the mission of art: seeing reality in a new light, attaining the vision and insight of God.[4] People ask me, Inness said in 1894, "why I keep on, old as I am, for I am seventy, and I say simply because of a principle beyond me that goes on outside of me in developing higher and higher truths."[5] Without this keeping-on, Inness knew, his task would never be complete. "PreRaphaelitism," he said, "is like a measure worm trying to compass the infinite circumference, Impressionism is the sloath [*sic*] enrapt in its own eternal dullness."[6] More than a meager effort, Inness was well aware, was necessary to achieve what the measure worm and sloth could not; he had to be diligent, and his efforts had to be substantive, ambitious, and bold.

Above all, being a metaphysician meant, for Inness, knowing when his self-appointed task had him beat. He painted and repainted, piled on and scraped off his pigment, scratched and rubbed and dug at his canvases—destroying, he claimed, more than he ever sold—ever assiduous (some called it madness) in his search for that scientific formula of the subjective of nature that would make everything clear; he devised multiple strategies and tools to aid him in his quest, from middle tones to holes cut in paper, from disfigured allusions to disfigured time, from poetic captions to blazing color effects.[7] But these, he said in an interview conducted in the final decade of his life, "are merely scientific formula [*sic*]," as if to suggest that he knew they would fall short even before he put them to work (or, as I have said before, as if he wanted his strategies to falter so as to highlight the constitutive impossibility of what he was trying to do).[8] Inness's scratches and scrapings intimated a new form and space of consciousness; they might also be read as frustrated attacks on the medium—paint—that refused to let him do what he wished, violent slashings at canvases that could not take him where he wanted to go, excisings and incisions that shouted an angry surrender.

So why write a book that, in the end, tells a story about failure, however fascinating and riveting and purposeful and complex that failure may have been? Because it does not matter whether Inness got what he wanted; it is the fact that he attempted such a thing that counts for me. It counts because we now know a great deal more about the motivation and meaning of Inness's practice

than we did previously—we see it in a new light and with fresh eyes. And it counts because, in figuring out what it meant for Inness to call himself a metaphysician, and what it meant for him to formulate a science of landscape, the end of which was spiritual sight and the comprehension of cosmic design and truth, one realizes that the exercise of creating a landscape painting in nineteenth-century America was, at times, a far different thing than it has been made out to be. One of my aims here, in exploring what landscape was for Inness, was to restore the strangeness and idiosyncrasy of his art so as to reveal its complexity and particularity; I also meant to do the same for the landscape genre itself. By exploring how the work of making landscape was imagined or conceived in the United States at the time, I wanted to show that our understanding of the genre, albeit advanced, is as yet incomplete, in part because our approaches to it have become, if not predictable, somewhat restrictive, generating as they do the same (albeit productive) categories of interpretation, as well as similar conclusions about meaning. Much more than simply a record of nature, an illustration of an idea or event, or a reflection of ideology or sociohistorical circumstance, landscape, in nineteenth-century America, provided a space wherein disparate discussions of perceptual and cognitive capacity converged, a medium for use not only in creating representations of the world (images of nature, nation, or self) but in discovering and communicating how the world worked. Landscape, in nineteenth-century America, did not simply illustrate science or philosophy, it was these things, at least in the minds of those, Inness included, who understood the natural world as a medium of sight and thought, a space for testing out and thinking through conjectures about what and how, in this very world, we see. I do not mean to suggest that we should come to understand all American landscapes in these terms, or that my interpretation of Inness's landscape work can be generalized across multiple practices. What I am proposing is that we spend more time attending to the specificities and particularized motivations of the diversity of landscape practices at the time, thus replacing broad claims about the meaning of landscape in America with historically specific and focused accounts of particular artistic undertakings and endeavors, so as to underscore the richness and complexity of the tradition. What is exciting about landscape and landscape studies at present, in the American field and otherwise, is the fact that there is still so much to know; as did Inness, we have work yet to do. It is my hope that this study, in that it builds on even as it expands the scope of previous and provocative inquiries into the genre, goes some way in contributing to this effort. What I encountered when I began to look more closely at Inness surprised me, and it was that surprise, what De Kay called "some such shock"—he said what? he was reading who? he did that?—along with my delight in discovery, that motivated and drove my investigation of his work. It is my sense that analogous surprises and pleasures await those who turn to give landscape in America another, deeper look.

INTRODUCTION

1. George W. Sheldon, "George Inness," *Harper's Weekly* 26 (April 22, 1882): 246. Sheldon, art editor for the *New York Evening Post* and author of three books on art in the United States—*American Painters* (1879), *Hours with Art and Artists* (1882), and *Recent Ideals of American Art* (1890)—was a close friend of Inness's.

2. George W. Sheldon, "Characteristics of George Inness," *Century Magazine* 7 (February 1895): 530.

3. Charles De Kay, quoted in Nicolai Cikovsky, Jr., *George Inness* (New York: Harry N. Abrams, 1993), 103. Cikovsky does not cite the source of this remark but notes that it was made after Inness's death.

4. "American Artists," *Harper's Weekly* 11 (July 13, 1867): 433.

5. A. T. Van Laer, "George Inness," *Arts for America* 5 (February 1896): 17.

6. Arthur Hoeber, "A Remarkable Collection of Landscapes by the Late George Inness, N.A.," *International Studio* 43 (March 1911): 37.

7. Montgomery Schuyler, "George Inness: The Man and His Work," *Forum* 18 (November 1894): 312. This material appears to have been destroyed in a fire in 1942 (Nicolai Cikovsky, Jr., "The Life and Work of George Inness" [Ph.D. diss., Harvard University, 1965], 291–92, 352n. 27).

8. Elliot Daingerfield, introduction to *Life, Art, and Letters of George Inness,* by George Inness, Jr. (New York: Century Co., 1917), xxviii. Daingerfield, an artist himself, became a close friend of Inness's during the last decade of the latter's life; the two met in New York in 1884 at the Holbein studios where Inness and his son-in-law Jonathan Scott Hartley occupied studios.

9. G. Inness, Jr., *Life, Art, and Letters,* 61, 64.

10. Sheldon, "George Inness," 246.

11. I rely on Cikovsky's thorough account of Inness's art and career for much of the biographical information I relate herein ("Life and Work," esp. pt. 1, *George Inness* [New York: Praeger Publishers, 1971], and *George Inness* [1993]). Inness took four trips abroad: in 1851–52 he traveled to Florence and Rome, in 1853–54 to Paris and Amsterdam, in 1870–74 to Italy, Paris, and Etretat, and

in 1894 to Paris, Baden-Baden, Munich, and then to Bridge-of-Allen, Scotland, where he died on August 3.

12. Sheldon, "George Inness," 246. It was, of course, not so unusual to be reading Darwin at the time, and it is certain that Inness was not the only artist that did. See Barbara Novak, *Nature and Culture: American Landscape Painting, 1825–1875,* rev. ed. (New York: Oxford University Press, 1995), esp. chap. 4; Franklin Kelly, *Frederic Edwin Church and the National Landscape* (Washington, DC: Smithsonian Institution Press, 1988); and Stephen Jay Gould, "Church, Humboldt, and Darwin: The Tension and Harmony of Art and Science," in *Frederic Edwin Church* (Washington, DC: National Gallery of Art, 1989), 94–107. For further writing on Darwin and American art, see Alexander Nemerov, "Haunted Supermasculinity: Strength and Death in Carl Rungius's 'Wary Game,'" *American Art* 13 (Fall 1999): 2–31; and Michael Leja, "Progress and Evolution at the U.S. World's Fairs, 1893–1915" and Kathleen Pyne, "On Women and Ambivalence in the Evolutionary Topos," both in *Nineteenth-Century Art Worldwide* (special issue: "The Darwin Effect: Evolution and Nineteenth-Century Visual Culture," ed. Linda Nochlin and Martha Lucy), vol. 2 (Spring 2003) (www.19thc-art-worldwide.org). For recent writing on the intersection of nineteenth-century American landscape painting and scientific inquiry, see Amy R. W. Myers, ed., *Art and Science in America: Issues of Representation* (San Marino, CA: Huntington Library, 1998); and Rebecca Bedell, *The Anatomy of Nature: Geology and American Landscape Painting, 1825–1875* (Princeton, NJ: Princeton University Press, 2001).

13. Cikovsky's *George Inness* studies (1971 and 1993) restate the basic claims of his dissertation. For recent Inness scholarship, see Sally M. Promey, "The Ribband of Faith: George Inness, Color Theory, and the Swedenborgian Church," *American Art Journal* 26 (1994): 44–65; Leo G. Mazow, "George Inness: Problems in Antimodernism" (Ph.D. diss., University of North Carolina, Chapel Hill, 1996), and "George Inness, Henry George, the Single Tax, and the Future Poet," *American Art* 18 (Spring 2004): 58–77; Eugene Taylor, "The Interior Landscape: George Inness and William James on Art from a Swedenborgian Point of View," *Archives of American Art Journal* 37 (1997): 2–10; and Adrienne Baxter Bell, *George Inness and the Visionary Landscape* (New York: George Braziller, 2003).

14. In this regard, the work of Maurice Merleau-Ponty has been instrumental in shaping my understanding of and approach to Inness. See Maurice Merleau-Ponty, *The Merleau-Ponty Aesthetics Reader: Philosophy and Painting,* ed. Galen Johnson and Michael B. Smith (Evanston, IL: Northwestern University Press, 1993), and *Phenomenology of Perception,* trans. Colin Smith (London: Routledge & Kegan Paul; New York: Humanities Press, 1962).

15. See, e.g., Angela Miller, *The Empire of the Eye: Landscape Representation and American Cultural Politics, 1825–1875* (Ithaca, NY: Cornell University Press, 1993); David M. Lubin, *Picturing a Nation: Art and Social Change in Nineteenth-Century America* (New Haven, CT: Yale University Press, 1994); Alexander Nemerov, *Frederic Remington and Turn-of-the-Century America* (New Haven, CT: Yale University Press, 1995); and John Davis, *The Landscape of Belief: Encountering the Holy Land in Nineteenth-Century American Art and Culture* (Princeton, NJ: Princeton University Press, 1996).

16. See Bryan J. Wolf, *Romantic Re-Vision: Culture and Consciousness in Nineteenth-Century American Painting and Literature* (Chicago and London: University of Chicago Press, 1982), and *Vermeer and the Invention of Seeing* (Chicago and London: University of Chicago Press, 2001); Alexander Nemerov, *The Body of Raphaelle Peale: Still Life and Selfhood, 1814–1824* (Berkeley and Los Angeles: University of California Press, 2001), esp. chap. 3; Michael Fried, *Realism, Writing, Disfiguration: On Thomas Eakins and Stephen Crane* (Chicago and London: University of Chicago Press, 1987), and *Manet's Modernism, or, The Face of Painting in the 1860s* (Chicago and London: University of Chicago Press, 1996); T. J. Clark, *The Painting of Modern Life: Paris in the Art of Manet and His Followers* (Princeton, NJ: Princeton University Press, 1984), and *Farewell to an Idea: Episodes from a History of Modernism* (New Haven, CT: Yale University Press, 1999); Carol Armstrong, *Odd Man Out: Readings of the Work and Reputation of Edgar Degas* (Chicago and London: University of Chicago Press, 1991); and Martha Ward, *Pissarro, Neo-Impressionism, and the Spaces of the Avant-Garde* (Chicago and London: University of Chicago Press, 1996).

17. Recent considerations of the international contexts of American art include Theodore E. Stebbins, William H. Gerdts, et al., *The Lure of Italy: American Artists and the Italian Experience, 1760–1914* (New York: Harry N. Abrams, 1992); H. Barbara Weinberg, *The Lure of Paris: Nineteenth-Century American Painters and Their French Teachers* (New York: Abbeville Press, 1991); Wanda Corn, *The Great American Thing: Modern Art and National Identity, 1915–1935* (Berkeley and Los Angeles: University of California Press, 1999); and Susan Sidlauskas, *Body, Place, and Self in Nineteenth-Century Painting* (Cambridge: Cambridge University Press, 2000).

18. I must emphasize here that Cikovsky's 1965 dissertation ("Life and Work") has in many respects provided a model for the present study. Cikovsky was one of the first historians of American art to conduct a systematic examination of an aspect of nineteenth-century art criticism and to attend to the question of how works of art were perceived by viewers at the time they were produced. Cikovsky does not always take Inness's critics at their word, and I have followed his example. For instance, in the case of a nineteenth-century writer who described one of Inness's landscapes as "impossible," I do not attempt to explain why said landscape is impossible but, rather, I explore why, exactly, the writer would have thought or said that it was. That is to say, I set out to determine what assumptions lay behind any given critic's articulations and to identify trends within Inness criticism and within writing about art in general that reveal something about the manner in which Inness's landscapes were understood at the time they were produced. Two recent books make important contributions to the study of nineteenth-century American art criticism: David B. Dearinger, ed., *Rave Reviews: American Art and Its Critics, 1826–1925* (New York: National Academy of Design, 2000); and Margaret C. Conrads, *Winslow Homer and the Critics: Forging a National Art in the 1870s* (Princeton, NJ: Princeton University Press, in association with the Nelson-Atkins Museum of Art, 2001).

19. See Wolf, *Romantic Re-Vision*, 81–106, 177–236.

20. Again, see Dearinger, ed., *Rave Reviews;* and Conrads, *Winslow Homer and the Critics;* see also Sarah Burns, "The 'Earnest, Untiring Worker' and the Magician of the Brush: Gender Politics in the Criticism of Cecilia Beaux and John Singer Sargent," *Oxford Art Journal* 15 (1992): 36–53, and *Inventing the Modern Artist: Art and Culture in Gilded Age America* (New Haven, CT: Yale University Press, 1996); Kathleen Pyne, *Art and the Higher Life: Painting and Evolutionary Thought in Late-Nineteenth-Century America* (Austin: University of Texas Press, 1996), esp. chap. 5; and Kirsten Swinth, *Painting Professionals: Women Artists and the Development of Modern American Art, 1870–1930* (Chapel Hill: University of North Carolina Press, 2001), esp. chap. 5.

CHAPTER 1

1. "The Academy Exhibition: Critics on the Fence . . . George Inness, the Eccentric," *New York Times,* April 10, 1878, 2.

2. *New York Sun,* April 15, 1877, reprinted in Nicolai Cikovsky, Jr., and Michael Quick, *George Inness* (Los Angeles: Los Angeles County Museum of Art, 1985), 140.

3. "The Arts," *Appletons' Journal* 14 (September 18, 1875): 376. The phrase is from Ralph Waldo Emerson's essay "Nature," in *Essays and Lectures,* ed. Joel Porte (New York: Library of America, 1983), 18–19. Emerson's text reads "man" rather than "humanity."

4. "The Arts," *Appletons' Journal* 15 (April 8, 1876): 475; "The Arts," *Appletons' Journal* 13 (May 22, 1875): 663.

5. Asher Brown Durand, "Letters on Landscape Painting," pts. 1–9, *Crayon* 1 (January 3, 1855): 1–2, (January 17, 1855): 34–35, (January 31, 1855): 66–67, (February 14, 1855): 97–98, (March 7, 1855): 145–46, (April 4, 1855): 209–11, (May 2, 1855): 273–75, (June 6, 1855): 354–55, and (July 4, 1855): 16–17, respectively; Thomas Cole, "Essay on American Scenery," in *American Art, 1700–1960: Sources and Documents,* ed. John W. McCoubrey (Englewood Cliffs, NJ: Prentice Hall, 1965).

6. W. Mackay Laffan, "The Material of American Landscape," *American Art Review* 1 (November 1879): 30. Laffan's essay was part of a postbellum and nationalistic discourse concerning foreign influence and the idea of a "native art" or "national school." For a discussion of these issues, see Linda Docherty, "A Search for Identity: American Art Criticism and the Concept of the 'Native

School,' 1876–1893" (Ph.D. diss., University of North Carolina, Chapel Hill, 1985); Saul E. Zalesch, "Competition and Conflict in the New York Art World, 1874–1879," *Winterthur Portfolio* 29 (Summer/Autumn 1994): 103–20; and Carol Troyen, "Innocents Abroad: American Painters at the 1867 Exposition Universelle, Paris," *American Art Journal* 16 (Autumn 1984): 3–29. For discussion of the experience of artists who studied abroad, see Irma B. Jaffe, ed., *The Italian Presence in American Art, 1860–1920* (New York: Fordham University Press, 1989); Theodore E. Stebbins, William H. Gerdts, et al., *The Lure of Italy: American Artists and the Italian Experience, 1760–1914* (New York: Harry N. Abrams, 1992); H. Barbara Weinberg, *The Lure of Paris: Nineteenth-Century American Painters and Their French Teachers* (New York: Abbeville Press, 1991), and "Cosmopolitan Attitudes: The Coming of Age of American Art," in *Paris 1889: American Artists at the Universal Exhibition* (Philadelphia: Pennsylvania Academy of the Fine Arts, 1989), 33–51.

7. "The Arts," *Appletons' Journal* 13 (May 1, 1875): 567–68.

8. "Editor's Table: American Painters," *Appletons' Journal*, n.s., 6 (January 1879): 87.

9. "Imitation in Art," *Appletons' Journal*, n.s., 6 (June 1879): 564.

10. Margaret C. Conrads, *Winslow Homer and the Critics: Forging a National Art in the 1870s* (Princeton, NJ: Princeton University Press, in association with the Nelson-Atkins Museum of Art, 2001), 6 and passim.

11. George Inness, "A Painter on Painting," *Harper's New Monthly Magazine* 56 (February 1878): 460.

12. In a letter to his son, written in 1884, Inness declared that he was "doing better from nature than ever before" (Inness to George Inness, Jr., March 25, 1884, in CeCe Bullard, "Why Not Goochland? George Inness and Goochland County," *Goochland County Historical Society Magazine* 20 [1988]: 25). See also George Inness, Jr., *Life, Art, and Letters of George Inness* (New York: Century Co., 1917), 164–67; Charles Dudley Warner, *My Summer in a Garden* (Boston: Fields, Osgood, & Co., 1871), iv–v; and *New York Evening Post,* August 19, 1862.

13. "The Two New York Exhibitions," *Atlantic Monthly* 43 (June 1879): 778.

14. S. G. W. Benjamin, "Present Tendencies of American Art," *Harper's New Monthly Magazine* 58 (March 1879): 486. The "American school" to which he referred included "Durand, Kensett, Whittredge, Church, Bellows, Hart, Bristol, McEntee, Richards, Sanford R. Gifford, G. L. Brown" (482). Benjamin began his career as a painter of seascapes and harbor views in Boston; in 1876 *Harper's* sent him to Europe to write a series of articles on contemporary European art, which were collected and published in book form in 1877. A second series of articles for *Harper's,* on the history of American art, became *Art in America: A Critical and Historical Sketch* (1880). Benjamin also wrote art criticism for the *Atlantic Monthly,* the *American Art Review,* the *Art Journal,* and the *Magazine of Art* (Docherty, "A Search for Identity," 204–5).

15. "The Art Exhibition—Landscapes: George Inness," *Cincinnati Commercial,* September 18, 1875.

16. Edgar Fawcett, "An American Painter: George Inness," *Californian* 4 (December 1881): 453.

17. For discussion of certain of these artists, see Wanda M. Corn, *The Color of Mood: American Tonalism, 1880–1910* (San Francisco: M. H. de Young Memorial Museum/California Palace of the Legion of Honor, 1972).

18. See, e.g., "Art," *Atlantic Monthly* 36 (September 1875): 375–76; "The Academy Exhibition," *Art Journal,* n.s., 4 (1878): 158; and "The Two New York Exhibitions," *Atlantic Monthly* 43 (June 1879): 783.

19. "The Two New York Exhibitions," *Atlantic Monthly* 43 (June 1879): 783.

20. "The Association Exhibition: A Glance at Some of the Pictures," *Brooklyn Daily Eagle,* December 7, 1875. *Appletons'* echoed this sentiment: "That he is an independent thinker and a student all who know him are aware; that he is audacious, original, creative, his paintings bear witness to all; but to the unlearned in the mysteries of art theories they are in some things incomprehensible" ("Editor's Table: The Academy Exhibition," *Appletons' Journal* 6 [May 1879]: 469).

21. "Editor's Table: The Academy Exhibition," 469.

22. "George Inness," *Chicago Tribune,* September 17, 1875.

23. Fawcett, "An American Painter," 456.

24. "The Academy Exhibition: Critics on the Fence," 2.

25. Ibid.

26. "Academy of Design IV: Landscapes," *New York Daily Tribune*, April 21, 1877, 7.

27. "American Art at the Leavitt Gallery," *New York Daily Tribune*, January 26, 1877, 5.

28. Clarence Cook, "National Academy of Design," *New York Daily Tribune*, April 1879, 5. Despite their frequently derogatory tone, Cook's descriptions of Inness's paintings were insightful. A graduate of Harvard University, Cook, with Russell Sturgis, Thomas Farrer, and others, founded the Society for the Advancement of Truth in Art, which celebrated Pre-Raphaelitism and was greatly influenced by the work of John Ruskin. Cook edited *The New Path*, the society's journal, from 1863 to 1864; his biting but astute commentary in this and other publications was notorious. A critic for the *New York Tribune, Art Amateur, Putnam's,* and *Scribner's* as well, he published a three-volume study, *Art and Artists of Our Time*, in 1888. (Docherty, "A Search for Identity," 199–201). For a discussion of the American Pre-Raphaelite movement, see Linda S. Ferber and William H. Gerdts, *The New Path: Ruskin and the American Pre-Raphaelites* (Brooklyn: Brooklyn Museum of Art, 1985).

29. "Academy of Design IV: Landscapes," 7.

30. Ibid.

31. "Art at the Academy," *New York Daily Tribune*, April 12, 1878, 5.

32. "The Academy Exhibition," *Art Journal*, n.s., 3 (1877): 158.

33. See Cikovsky and Quick, *George Inness*, 128. Inness insisted that his paintings not be understood in topographical terms; for instance, rather than say, when asked, whether a work depicted a site in Medfield where he had lived from 1860 to 1864, he claimed he had never been there: "Medfield, Medfield—never saw the spot in my life!" (Arthur Turnbull Hill, "Early Recollections of George Inness and George Waldo Hill," in *New Salmagundi Papers* [New York: Library Committee of the Salmagundi Club, 1922], 109–15). Reginald Cleveland Coxe reported the following about his friend Inness, whose studio adjoined his own in the 1890s: "Once, after completing a sale in his studio, his purchaser asked: 'Now, Mr. Inness, where is that taken from; what part of the country?' 'Nowhere in particular; do you suppose I illustrate guide-books? That's a picture. . . . Whoever cares what scene a Corot represents?'" ("The Field of Art: George Inness," *Scribner's Magazine* 44 [October 1908]: 541).

34. For a discussion of landscape and anthropomorphism, see J. Gray Sweeney, "The Nude of Landscape Painting: Emblematic Personification in the Art of the Hudson River School," *Smithsonian Studies in American Art* 3 (Fall 1989): 42–65; and James Collins Moore, "The Storm and the Harvest: The Image of Nature in Mid-Nineteenth-Century American Landscape Painting" (Ph.D. diss., Indiana University, 1974), chap. 5.

35. For examples of properly functioning staffage figures, see Asher B. Durand, *Kindred Spirits* (1849; New York Public Library); Jasper Francis Cropsey, *Starrucca Viaduct, Pennsylvania* (1865; Toledo Museum of Art, OH); Albert Bierstadt, *Looking up the Yosemite Valley* (ca. 1865–69; Haggin Collection, Haggin Museum, Stockton, CA); and Thomas Moran, *The Grand Canyon of the Yellowstone* (1872; Smithsonian American Art Museum).

36. "National Academy of Design," *New York Evening Post*, April 25, 1874, 1. At least two other commentators reported that it was necessary to put distance between themselves and a landscape by Inness in order to view the picture. See "City Intelligence: American Paintings," *New York Evening Post*, May 2, 1877; and "George Inness," *Chicago Tribune*, September 17, 1875.

37. "The Academy Exhibition," *Art Journal*, n.s., 5 (1879): 159.

38. "Impressionism in Art," *Appletons' Journal*, n.s., 6 (April 1879): 377. The vehemence of this critic's response to Inness's painting was related to his apparent and intense dislike and distrust of the newly familiar impressionist aesthetic, as expressed throughout his essay.

39. Clarence Cook, "The National Academy Exhibition," *Art Amateur* 6 (May 1882): 118.

40. Durand, "Letter on Landscape Painting," pt. 3 (January 31, 1855): 66.

41. "The Fine Arts: National Academy Exhibition (Continued)," *Literary World* 3 (May 27, 1848), 328.

42. Inness, of course was not the only American landscape artist at this time to draw attention to technique and to make explicit the fact that his pictures were painted, nor was he the first. However, he did make emphatically clear his interest in paint's autonomous effects, and he did so early in his career. From the 1850s on, he consistently used paint to produce effects not necessarily related to what appeared to be his pictures' subjects, and this concern sustained itself until his death.

43. "National Academy of Design: Fortieth Annual Exhibition—George Inness," *New York Evening Post,* May 12, 1865, 1. In writing about art at the time, discussion of the proper relation of technique to expression formed part of a larger discussion concerning finish, similar to ongoing conversations about the topic in France. In fact, questions of finish preoccupied critics and artists, especially when American artists, following their European and, in particular, their French counterparts, began to produce pictures that were not highly finished, polished, or "licked." These pictures, which were often described as interested in technique first and foremost, were alternately praised for their freshness and originality and derided for their slovenliness and perceived lack of force. A number of American critics distinguished between finish and completion, as had Charles Baudelaire in his review of French painting at the Salon of 1845. ("Salon de 1845," in *Oeuvres complètes* [Paris: Robert Laffont, 1980], 624–25). They insisted that a picture could be technically unfinished yet still complete, possessive of vitality and lastingness. See, e.g., "Editor's Table," *Appletons' Journal,* n.s., 5 (August 1878): 185–86; Eugene Benson, "'Dropping Off'—a Sketch by Eastman Johnson," *Appletons' Journal* 5 (March 4, 1871): 255; "An Unfinished Discussion of Finish," *Art Journal,* n.s., 5 (1879): 316–19; "The Two New York Exhibitions," *Atlantic Monthly* 43 (June 1879): 777–87; "Society of American Artists . . . When Is a Painting Finished?" *New York Times,* March 7, 1878, 4; and "Exhibition of the Society of American Artists," *Art Journal,* n.s., 5 (1879): 156–58. Inness's pictures of the second half of the 1870s and the first half of the 1880s were at times described as lacking finish; some critics, however, did not perceive this to be a fault. See, e.g., "The Academy Exhibition: Critics on the Fence," 2; Susan N. Carter, "First Exhibition of the American Art Association," *Art Journal,* n.s., 4 (April 1878): 125, where Inness's entry was called "fine" yet "rather a sketch than a finished production"; and "Art as Decoration: Review of the Fourth Annual Exhibition of the Society of American Artists," *New York Evening Post,* April 12, 1881, 1, in which the following remark was made: "Mr. Inness's green 'Spring' landscape on the line at the left of the entrance to the gallery is a specimen of rapid workmanship, done in three or four hours, and completed, too. But only a master can accomplish such results." See also Docherty, "A Search for Identity," chaps. 3 and 4.

44. For discussion of this aspect of Homer's career, see Conrads, *Winslow Homer and the Critics.*

45. At least one critic described what he called Inness's "strange and unaccountable" landscapes as models of normal perceptual function: "Why Inness could not give us more detail and more accuracy in what he does give us, without sacrificing general force, it is hard to explain, and yet it is a common phenomenon of the human mind to see one thing so plainly as not to see another, and in this case, at any rate, we are compelled to accept satisfaction in one direction, and forego it in another" ("George Inness," *Chicago Tribune,* September 17, 1875).

46. George W. Sheldon, *American Painters* (New York: D. Appleton & Co., 1879), 33–34; emphasis added. For a compelling discussion of Inness and the idea of equilibrium, see Leo G. Mazow, "George Inness: Problems in Antimodernism" (Ph.D. diss., University of North Carolina, Chapel Hill, 1996), chap. 5.

47. Sheldon, *American Painters,* 34.

48. Henry Eckford [Charles De Kay], "George Inness," *Century Magazine* 24 (May 1882): 58. The son of naval hero George Coleman De Kay and a graduate of Yale University, Charles De Kay began his career as an art and literary critic in 1876 writing for the *New York Times,* a stint that lasted twenty years. His pseudonym, Henry Eckford, was the name of his maternal great-grandfather, a wealthy shipbuilder (Docherty, "A Search for Identity," 214–15). Docherty writes that De Kay's art criticism was "full of information and incident, but largely empty of ideas." To the contrary, the critic's essay on Inness demonstrates that he had a deep understanding of the art-theoretical issues of the day. Cikovsky argues persuasively that De Kay's essay was the single most important critical discussion of Inness written during the artist's lifetime, and I am inclined to agree (*George Inness*

[1993], 107). The critic for the *Chicago Tribune* described Inness's landscapes much as De Kay did: "There is little risk in saying that nine-tenths of the people who look as these pictures will smile and pass them by as amusing, inexplicable, and uninteresting; and there is perhaps as little danger in saying that the few people who take the pains to study them attentively will find a sense of their naturalness in certain directions gradually stealing over them, together with a disposition to defend the artist from the popular careless criticism" ("George Inness," Chicago Tribune, September 17, 1875).

49. "The Fine Arts," *Boston Daily Advertiser,* September 14, 1875.

50. Inness to Editor Ledger (1884), reprinted in G. Inness, Jr., *Life, Art, and Letters,* 169–70. It is unclear to whom "Editor Ledger" refers and in what publication Inness's letter may have appeared.

51. George W. Sheldon, "George Inness," *Harper's Weekly* 26 (April 22, 1882): 246.

52. In 1873, the *New York Daily Tribune* printed two notices about Rood's lecture series. ("Hints on Art and Science: The Relation of Optics to Painting," *New York Daily Tribune,* March 5, 1873, 8; and "Lectures and Meetings," *New York Daily Tribune,* March 11, 1873, 8). Rood's lecture was published a year later in two installments in *Popular Science Monthly,* from which the excerpts in text were taken: "Modern Optics and Painting," pts. 1 and 2, *Popular Science Monthly* 4 (February 1874): 415–21, and (March 1874): 572–81, respectively. Essays on color by Rood appeared in 1876 and 1878 ("The Constants of Color," *Popular Science Monthly* 9 [October 1876]: 641–48, and "The Contrast of Colors," *Popular Science Monthly* 14 [November 1878]: 1–16).

53. Sheldon, "George Inness," 244.

54. "His Art His Religion," *New York Herald,* August 12, 1894, 9.

55. Sheldon, "George Inness," 244. In speaking of a vision beyond that of the physical eye, Inness was neither simply referring to the imagination nor was he simply invoking the oft-cited nineteenth-century debate concerning the relation between the real and the ideal that considered the appropriateness of artistic arrangement and embellishment, describing artists and pictures as idealizing or realistic or both. For a discussion of these issues, see Docherty, "A Search for Identity," 204–5; Barbara Novak O'Doherty, "Some American Words: Basic Aesthetic Guidelines, 1825–1870," *American Art Journal* 1 (1969): 78–91; Barbara Novak, *American Painting of the Nineteenth Century: Realism, Idealism, and the American Experience* (New York: Praeger, 1969), and *Nature and Culture;* and William Gerdts, "The American 'Discourses': A Survey of Lectures and Writings on American Art, 1770–1858," *American Art Journal* 15 (Summer 1983): 61–78.

56. E., "Mr. Inness on Art-Matters," *Art Journal* 5 (1879): 376.

57. Ibid., 376.

58. Sheldon, "George Inness," 244.

59. E., "Mr. Inness on Art-Matters," 377. Inness's own paintings were frequently characterized as doing just this. Inness, noted Fawcett, "is a profound believer in the spiritual uses of art . . . and he considers landscape a noble medium for the communication of human sentiment" ("An American Painter," 454). "To [his] subtle sympathy with Nature, which is instinctive and a matter of temperament," *Appletons'* wrote, "Mr. Inness unites a perception of spiritual meanings underlying her external forms; and, to interpret these higher meanings aright, he devotes all the strength of his thought and the subtlety of his pigments" ("Art Notes," *Appletons' Journal* 9 [January 25, 1873]: 157).

60. E., "Mr. Inness on Art-Matters," 376.

61. Ibid., 377.

62. Inness, "Strong Talk on Art," *New York Evening Post,* June 3, 1879. Inness's concern over the sheer imitative nature of much landscape art echoed the sentiments of a group of critics who were troubled by what they characterized as painting's materialist turn. William Crary Brownell, e.g., compared the art of the academy to that of younger painters, recently returned from study in the ateliers of Europe (Paris and Munich, in particular), whose work shared certain characteristics with Inness's and who favored feeling over fidelity, saying that the former substituted imitation for "ideality" and accuracy for "real truth—the essential, spiritual, vital force of nature." Painting, he said, should be more than a matter of "accurately imitating natural forms" ("The Younger Painters of America: First Paper," *Scribner's Monthly* 20 [May 1880]: 1–2, 6–7). Brownell began his literary

career as a reporter for the *New York World* and from 1879 to 1881 wrote for the *Nation.* He contributed a number of essays to the *Magazine of Art* and published a book, *French Art,* in 1892. While living in New York, he befriended the painters John La Farge and Homer Dodge Martin and championed their art as well as Inness's (Docherty, "A Search for Identity," 216–18). "Poetic" and "poetry" were for critics such as Brownell epithets of success, and painters were praised if they conveyed more than facts. The landscapist R. Swain Gifford, e.g., received high marks in 1878 not for his exacting attention to detail but for the poetic sentiment of his *Old Orchard Near the Sea, Massachusetts* (1877; Smith College Museum of Art): "This picture is a poem in paint, full of the meat of thought, and palpable to the senses . . . and the objects in the picture cluster about themselves a vast crowd of unseen associations of the near farm, the open moaning sea. . . . In this fresh story-picture it is not till after we have appreciated the thoughts it awakens that we notice how rich and how fine are the browns, the purples, the blues, and the gray tones, so completely is the manner lost in the matter of this fine work" (Susan N. Carter, "First Exhibition of the American Art Association," *Art Journal,* n.s., 4 [April 1878]: 125). The Gifford is discussed in John Davis and Jaroslaw Leshko, *The Smith College Museum of Art: European and American Painting and Sculpture, 1760–1960* (New York: Hudson Hills Press, 2000), 166–67. Pictures, a critic for the *Atlantic Monthly* insisted, must retain something that "over and above the material form, fascinates the soul" ("Book Review: James Jackson Jarves, *Art Thoughts* [New York: Hurd & Houghton, 1869]," *Atlantic Monthly* 25 [February 1870]: 255–56).

63. Sheldon, "George Inness," 244.

64. Ibid.

65. Inness to Ripley Hitchcock, March 23, 1884, in *George Inness of Montclair* (Montclair, NJ: Montclair Art Museum, 1964), n.p.; emphasis added. Hitchcock's essay was to accompany a major monographic exhibition of Inness's work at the American Art Galleries in New York.

66. E., "Mr. Inness on Art-Matters," 377.

67. Ibid.

68. Inness, "A Painter on Painting," 458.

69. Nicolai Cikovsky, Jr., has drawn attention to Inness's insistence that art be both expressive of the spiritual world and "concretely plausible and coherent in terms of objective sensory experience" ("George Inness: Sense or Sensibility," in *George Inness: Presence of the Unseen* [Montclair, NJ: Montclair Art Museum, 1994], 20). For further discussion of Meissonier, see Marc J. Gotlieb, *The Plight of Emulation: Ernest Meissonier and French Salon Painting* (Princeton, NJ: Princeton University Press, 1996); Constance Cain Hungerford et al., *Ernest Meissonier: Rétrospective* (Lyon: Musée des beaux-arts, 1993), and *Ernest Meissonier: Master in His Genre* (Cambridge: Cambridge University Press, 1999).

70. "His Art His Religion," 9.

71. E., "Mr. Inness on Art-Matters," 377. Inness had been described in 1865 as opposed in motivation to the Pre-Raphaelites, and his "poetical" landscapes as far superior to their "dry sticks and stones and botanical specimens" (X., "Artistic Growls," *New York Evening Post,* June 7, 1865, 1).

72. Jonathan Crary, *Techniques of the Observer: On Vision and Modernity in the Nineteenth Century* (Cambridge, MA: MIT Press, 1990), 9.

73. Inness, "A Painter on Painting," 459.

74. Theodore Child, "The Meissonier Exhibition at Paris," *Art Amateur* 11 (July 1884): 34 and passim; Henry James, Jr., "The Bethnal Green Museum," *Atlantic Monthly* 31 (January 1873): 73.

75. E., "Mr. Inness on Art-Matters," 377.

76. Ibid.

77. Ibid.

78. William B. Carpenter, "Man as the Interpreter of Nature," *Popular Science Monthly* 1 (October 1872): 684, 685. See also Carpenter's "The Force behind Nature," *Popular Science Monthly* 16 (March 1880): 614–35, in which the author examines sensation and its role in the perception of natural phenomena. Born in 1813, Carpenter was apprenticed to a physician in Bristol in 1828 and attended lectures at the Bristol Medical School; he continued his medical education in London and

Edinburgh and, on receiving his degree, devoted himself to the study of physiology. Author of numerous works on the subject and editor of the *Medico-Chirurgical Review,* published in London, Carpenter was made a fellow of the Royal Medical Society in 1844 and was awarded the Royal Medal in recognition of his contributions to his field. Carpenter published frequently in *Popular Science Monthly,* and his work was often mentioned and discussed by other authors writing in this periodical. In 1871, *Appletons' Journal* published a biographical sketch of the scientist: David Duncan, "Dr. W. B. Carpenter, F.R.S.," *Appletons' Journal* 5 (April 22, 1871): 464–66. Other essays published during the period under discussion that presuppose connections between seemingly unrelated disciplines include Wyke Bayliss, "The Higher Life in Art," *Magazine of Art* 1 (September 1878): 117–19; George Fielding Blandford, "The Physiology of Emotion," *Popular Science Monthly* 1 (July 1872): 274–86; Titus Munsen Coan, "Critic and Artist," *Lippincott's Magazine* 12 (March 1874): 355–63 (an attempt to rewrite art criticism in light of Darwinism); N. J. Gates, "The Relation of the Finite to the Infinite," *Popular Science Monthly* 13 (May 1878): 73–78; "The Imagination in Science," *Appletons' Journal* 2 (October 2, 1869): 215–17; "Observation and Imagination," *Appletons' Journal,* n.s., 3 (December 1877): 511–18; A. Mary F. Robinson, "The Art of Seeing," *Magazine of Art* 6 (1883): 462–64; and LS, "Darwinism and Divinity," *Popular Science Monthly* 1 (June 1872): 188–202.

79. Carpenter, "Man as the Interpreter of Nature," 685, 695 and passim.

80. In a series of essays entitled "The Study of Sociology" published in *Popular Science Monthly* between May 1872 and December 1873 and in his three-volume *The Principles of Sociology* (1876–96), Herbert Spencer proposed a social science formulated around the general principles of evolution and claimed that the methods of scientific inquiry could be applied to the study of societies. He argued that societies, like biological organisms, evolved, and he attempted to explain the history of behavior—social, religious, and national—in evolutionary terms. Just as biology discovered "certain general traits of development, structure, and function, holding throughout all organisms, others holding throughout certain great groups, others throughout certain sub-groups," Spencer stated, "so Sociology has to recognize truths of social development, structure, and function, that are some of them universal, some of them general, some of them special" (*The Study of Sociology* [Ann Arbor: University of Michigan Press, 1966], 53). Spencer believed all disciplines were interrelated. In his *First Principles,* originally published in London in 1862, he described philosophy as the synthesis of all the truths of existence: "So long as these truths are known only apart and regarded as independent . . . even the most general of them cannot without laxity of speech be called philosophical. But when, having been severally reduced to a simple mechanical axiom, a principle of molecular physics, and a law of social action, they are contemplated together as corollaries of some ultimate truth, then we rise to the kind of knowledge that constitutes Philosophy proper . . . so the generalizations of philosophy comprehend and consolidate the widest generalizations of Science.Philosophy is completely-unified knowledge" ([New York: D. Appleton & Co., 1898], 21, 135–36). D. Appleton & Co. published a version of Spencer's *First Principles* as early as 1865. For discussion of Spencer and American art, see Kathleen Pyne, *Art and the Higher Life: Painting and Evolutionary Thought in Late-Nineteenth-Century America* (Austin: University of Texas Press, 1996); Leo G. Mazow, "George Inness: Problems in Antimodernism," chap. 5, and "Rethinking the Civilized Landscape: George Inness and Evolution in the 1880s and 1890s," in *George Inness: The 1880s and 1890s* (Annville, PA: Suzanne H. Arnold Art Gallery, Lebanon Valley College, 1999), 6–17.

81. John Fiske, "The Idea of God," pts. 1 and 2, *Atlantic Monthly* 56 (November 1885): 642–61, and (December 1885): 791–805, respectively.

82. James Jackson Jarves, *The Art-Idea* (1864), ed. Benjamin Rowland, Jr. (Cambridge, MA: Belknap Press, 1960), and *Art Thoughts* (New York: Hurd & Houghton, 1871). For a discussion of Jarves's criticism and the manner in which his spiritualist beliefs underlay his theories of art and evolution, see Charles Colbert, "A Critical Medium: James Jackson Jarves's Vision of Art History," *American Art* 16 (Spring 2002): 18–29. Colbert offers a summary account of Jarves's interest in Inness as well.

83. Spiritualism reached a height of popularity in the United States in the 1850s and again in the 1870s, 1880s, and 1890s. As with Swedenborgianism, to which it was often linked, spiritualism was a movement of the middle class, and it attracted intellectuals, professionals, educators, and reformers. For a discussion of spiritualism in the United States, see Russell M. Goldfarb and Clare

R. Goldfarb, *Spiritualism and Nineteenth-Century Letters* (Rutherford, NJ: Fairleigh Dickinson University Press, 1978); Howard Kerr, *Mediums, and Spirit Rappers, and Roaring Radicals: Spiritualism in American Literature, 1850–1900* (Urbana: University of Illinois Press, 1972); and Colbert, "A Critical Medium."

84. Elliot Daingerfield, "George Inness," *Century* 95 (November 1917): 73; Montgomery Schuyler, "George Inness: The Man and His Work," *Forum* 18 (November 1894): 311.

85. Spiritualist mediums contacted the dead by way of a trance; their interactions with the spirit world manifested in a variety of ways: clairvoyant speaking or writing, rapping or knocking, "table-tipping" or "table-turning" (furniture that moved on its own), sensations of touch, and apparitions.

86. R. R. Bowker, "Science and the Spirits," *Appletons' Journal* 7 (January 20, 1872): 67–69. See also "Editor's Table," *Appletons' Journal* 13 (February 20, 1875): 243–44, in which the author argues for a physical, rather than a mental, cause behind spiritualist manifestations and states that "it being true that the manifestations described have actually occurred, it follows that we should investigate them thoroughly, and endeavor to trace their operation back to the cause" (243).

87. Bowker, "Science and the Spirits," 67, 69. Bowker drew attention to those men of science who had investigated and then "pooh-poohed" what they called the "humbug" of spiritualism; that these men, despite their doubt, took it on themselves to use science in investigating the spiritual realm is telling, as is Bowker's own invocation of and reliance on scientific method in the space of an essay on the occult.

88. William B. Carpenter, "Mesmerism, Odylism, Table-Turning, and Spiritualism," pts. 1 and 2, *Popular Science Monthly* 11 (May 1877): 12–25, and (June 1877): 161–73, respectively. Carpenter compared mesmeric trances to "what is known in medicine as 'hysteric coma,'" a state caused by a "sort of spasmodic contraction of the blood-vessels" (pt. 1, 18–19), and to somnambulism, ascribing the manifestations of the spiritualist trance to the psychophysiological state of "expectant attention" and the involuntary action of the muscles (pt. 2, 170). In his *Mesmerism, Spiritualism etc. Historically and Scientifically Considered* (London: Longmans, Green, 1877), Carpenter provided a physical and scientific rationale for the phenomena described by spiritualism's proponents.

89. Joseph Rodes Buchanan, "The Psycho-Physiological Sciences," *Popular Science Monthly* 11 (October 1877): 731.

90. Ibid., 729.

91. Ibid., 731.

92. See, e.g., the following articles in *Popular Science Monthly:* W. J. Youmans, "Images and Shadows," 4 (April 1874): 665–72; "The Crooked Courses of Light," 5 (May 1874): 32–39; Julius Bernstein, "Observing the Interior of the Eye," 9 (October 1876): 684–90; Eliza A. Youmans, "Some Experiments in Optics," 11 (October 1877): 658–68; and Silvanus P. Thompson, "Optical Illusions of Motion," 18 (February 1881): 519–26.

93. See Crary, *Techniques of the Observer.*

94. In *Techniques of the Observer,* Jonathan Crary argues that vision was made an object of study in the nineteenth-century in a manner uncharacteristic of previous centuries. He claims that a massive and culturally determined reorganization of vision in the 1820s and 1830s, one that incorporated the effects of developing techniques of observation, produced a newly dominant model of the observer. This reorganization, he says, was driven by theoretical, experimental, and popular scrutiny of traditional models of perception and produced anxiety and doubt with regard to vision's normal functioning. In drawing attention to nineteenth-century American expressions of doubt with respect to perception and by situating the practice of a single artist with regard to these articulations, I hope to counter what, in Crary's book, amounts to an implied insistence on the uniformity or hegemony of perception's nineteenth-century incarnation and thus offer a more contextually specific analysis of the relation of theories of vision to artistic projects, complicating a more generalized understanding of the manner in which culturally constructed models of perception—there were more than one—shaped other cultural formations. Crary's more recent discussion of modern subjectivity and the transformation of attention and perception in the late nineteenth century is relevant here (*Suspensions of Perception: Attention, Spectacle, and Modern Culture* [Cambridge, MA:

MIT Press, 1999]).

95. Henry W. Williams, M.D., "Our Eyes, and How to Take Care of Them," pts. 1–5, *Atlantic Monthly* 27 (January 1871): 62–67, (February 1871): 177–83, (March 1871): 332–37, (April 1871): 462–66, and (May 1871): 636–39, respectively. For a compelling discussion of the meaning of strabismus within the context of nineteenth-century expedition narratives and the inversion of the operations of such narratives within the work of Robert Smithson, see Jennifer L. Roberts, "Landscapes of Indifference: Robert Smithson and John Lloyd Stephens in Yucatán," *Art Bulletin* 82 (September 2000): 544–567.

96. "Curiosities of Vision," *Appletons' Journal* 7 (April 27, 1872): 472–73.

97. A. Von Graefe, "Sight and the Visual Organ," *Popular Science Monthly* 1 (August 1872): 457–73. "Indirect" or "eccentric" vision was in fact necessary to perception's normal functioning, Von Graefe argued, for it was its blur that forced the eye when reading to "constantly move onward to the end of the line," single letters only gradually imprinting themselves on the direct point of vision, the "hollow" of the eye, so as to piece together words (471).

98. Ibid.

99. Ibid., 473

100. R. Liebreich, "Effects of Faulty Vision in Painting," *Popular Science Monthly* 1 (June 1872): 174–87. Liebreich's findings were discussed in "Miscellany: A Revelation in Regard to Turner's Paintings," *Appletons' Journal* 7 (May 11, 1872): 528–29. See also Sidney Allan [Sadakichi Hartman], "The Influence of Visual Perception on Conception and Technique," *Camera Work*, no. 3 (July 1903), 23–25, wherein the appearance of Inness's late landscapes is attributed to his failing eyesight. This article, and the larger issues raised by such a confluence of art criticism and medical diagnosis, are the subjects of a study on which I am currently at work.

101. Liebreich, "Effects of Faulty Vision in Painting," 184–85 and passim.

102. Montgomery Schuyler "George Inness," *Harper's Weekly* 38 (August 18, 1894): 787.

103. "His Art His Religion," 9.

104. Eckford [De Kay], "George Inness," 63.

105. "The Academy Exhibition," *Art Journal* 5 (1879): 159; "Art Notes," *Appletons' Journal* 9 (January 1873): 157; and Fawcett, "An American Painter," 460.

106. "His Art His Religion," 9.

CHAPTER 2

1. Inness, of course, did occasionally paint *sur le motif,* as he reported in a letter to his son, written March 25, 1884 (in CeCe Bullard, "Why Not Goochland? George Inness and Goochland County," *Goochland County Historical Society Magazine* 20 [1988]: 25). In 1892, Inness wrote to Clarke, "I need a change and shall take it by painting out of doors" (letter written on the reverse of a letter to Inness from Clarke dated June 1892; transcription provided by Nicolai Cikovsky, Jr.). See also George Inness, Jr., *Life, Art, and Letters of George Inness* (New York: Century Co., 1917), 164–67; Charles Dudley Warner, *My Summer in a Garden* (Boston: Fields, Osgood, & Co., 1871), iv–v; and the *New York Evening Post*, August 19, 1862. In fact, it can be difficult to determine just what Innesss's sketching habits were. Inness's contemporaries and posthumous commentators offer conflicting accounts, and none describe his methods in great detail. We know that he went outdoors to study nature, for his son tells us as much, but it is not clear what kind of studies he made while outside; relatively few drawings or pencil sketches from his hand exist. It could be that his watercolors were executed outside, for they appear as if rendered quickly *sur le motif,* but it is impossible to say so with certainty. That said, I am less interested in recovering what "actually happened," a questionable endeavor at best, than I am curious about what Inness's pictures compelled viewers to understand as the circumstances of their making.

2. "How One Landscape Painter Paints," *Art Journal,* n.s., 3 (August 1877): 284.

3. "Art and Artists," *Boston Evening Transcript*, September 24, 1875, 6.

4. "The Arts," *Appletons' Journal* 14 (September 18, 1875): 376.

5. G. Inness, Jr., *Life, Art, and Letters*, 45–46; emphasis added.

6. Ibid., 232.

7. "Some Living American Painters: Critical Conversations by Howe and Torrey," *Art Interchange* 32 (April 1894): 101.

8. Frederick Stymetz Lamb, "Reminiscences of George Inness," *Art World* 1 (January 1917): 250.

9. Elliot Daingerfield, "George Inness," *Century* 95 (November 1917): 71–72. Both Inness's son and Daingerfield described Inness as a kind of madman-painter, often overcome by the passion, nervous force, and fury of creation. Descriptions of this sort were common both during Inness's lifetime and after his death and deserve further analysis. See, e.g., Alfred Trumble, *George Inness, N.A.: A Memorial of the Student, the Artist, and the Man* (New York: The Collector, 1895), 14; and Henry Eckford [Charles De Kay], "George Inness," *Century Magazine* 24 (May 1882): 59.

10. Daingerfield, "George Inness," 71. Not everyone thought painting from memory was such a good idea. S. G. W. Benjamin attributed what he termed Inness's inconsistency to his reliance on memory. "There is inequality in his works, and sometimes a conflict of styles," the critic wrote, "as when he dashes off a composition, in two or three sittings, that is full of fire and suggestion; and then, perhaps with a relic of his first method still lingering in his memory like a habit, goes over it again, and smoothes away some of those bold touches which, to an imaginative observer, gave it additional force" ("Present Tendencies of American Art," in *Art in America: A Critical and Historical Sketch* [New York: Harper & Brothers, 1880], 191).

11. Trumble, *George Inness, N.A.,* 18.

12. Elliot Daingerfield, *George Inness: The Man and His Art* (New York: Frederic Fairchild Sherman, 1911), 31.

13. Montgomery Schuyler, "George Inness: The Man and His Work," *Forum* 18 (November 1894): 309. See also Reginald Cleveland Coxe, "The Field of Art: George Inness," *Scribner's Magazine* 44 (October 1908): 541.

14. John Austin Sands Monks, "A Near View of Inness," *Art Interchange* 34 (June 1895): 148. Daingerfield, among others, noted Inness's use of old canvases (*George Inness*, 31). See also Peter Bermingham, *American Art in the Barbizon Mood* (Washington, DC: Smithsonian Institution Press, 1975), 29, who says that Inness painted from old sketches and from those of his friends because he wished to eliminate distracting details.

15. George Inness, "A Painter on Painting," *Harper's New Monthly Magazine* 56 (February 1878): 458. The sometime art critic Henry James wrote that Decamps "painted not the thing regarded, but the thing remembered, imagined, desired" ("The Bethnal Green Museum," *Atlantic Monthly* 31 [January 1873]: 72–73). For Decamps, see Dewey F. Mosby, "Alexandre-Gabriel Decamps, 1803–1860" (Ph.D. diss., Harvard University, 1973); and Marc J. Gotlieb, *The Plight of Emulation: Ernest Meissonier and French Salon Painting* (Princeton, NJ: Princeton University Press, 1996).

16. Monks, "A Near View of Inness," 148. Apparently, Inness did not hesitate to work on or paint over his colleagues' works in progress. The painter Arthur Turnbull Hill, e.g., described how Inness transformed a picture on which his father, George Waldo Hill, was at work. The Hills were acquaintances of Inness's (Joseph Inness, the artist's brother, lived next door to the elder Hill in Brooklyn), and Inness's "scrubbing, rubbing, and spreading of the paint" across Hill's canvas, said the son, "completely changed" the work ("Early Recollections of George Inness and George Waldo Hill," in *New Salmagundi Papers* [New York: Library Committee of the Salmagundi Club, 1922], 109–15). See also Coxe, "The Field of Art," 509–12; Elliott Daingerfield, "A Reminiscence of George Inness," *Monthly Illustrator* (March 1895), quoted in Alfred Trumble, *George Inness, N.A.: A Memorial of the Student, the Artist, and the Man* (New York: The Collector, 1895), 265; and G. Inness, Jr., *Life, Art, and Letters*, 136–37.

17. Daingerfield, *George Inness*, 30.

18. Both James McNeill Whistler and Albert Pinkham Ryder extensively reworked and revised their canvases. As the critic Sadakichi Hartmann wrote of Ryder: "He is really painting the same picture on the same canvas a hundred times" ("The Story of an American Painter" [ca. 1926], Sadakichi Hartmann Papers, University of California, Riverside, quoted in Elizabeth Broun, *Albert*

Pinkham Ryder [Washington, DC: Smithsonian Institution Press, 1989], 128). As is well known, in Ryder's case this habit contributed to the extreme instability and deterioration of many of his paintings (Broun, *Ryder,* 129–30). A good deal more might be said about Inness's habits in comparison with Ryder's, of course, and about their shared investment in a working process both lengthy and labored as well.

19. See, e.g., James Jackson Jarves, *The Art-Idea* (1864), ed. Benjamin Rowland, Jr. (Cambridge, MA: Belknap Press, 1960), 191.

20. Susan N. Carter, "The Academy Exhibition," *Art Journal,* n.s., 4 (May 1878): 158.

21. Jarves, *The Art-Idea,* 191. See also Mariana Griswold Van Rensselaer, "Some Aspects of Contemporary Art," *Lippincott's Magazine* 22 (December 22, 1878): 711; "The Spring Exhibition of the National Academy," *Appletons' Journal* 7 (May 25, 1872): 578; "Book Review. James Jackson Jarves, *Art Thoughts* [New York: Hurd &Houghton, 1869]," *Atlantic Monthly* 25 (February 1870): 255–56; "The Arts," *Appletons' Journal* 13 (May 1, 1875): 569; and "Art," *Atlantic Monthly* 36 (August 1875): 252.

22. "Culture and Progress. The Academy of Design," *Scribner's Monthly* 10 (June 1875): 251.

23. Ibid.

24. Horace Lecoq de Boisbaudran, *The Training of the Memory in Art,* trans. L. D. Luard (London: MacMillan & Co., 1911). From 1841 to 1866, Lecoq was a professor at the École royale et spéciale de dessin et de mathématique, or the Petite école (now the École des arts décoratifs and, in the nineteenth century, an unofficial preparatory school for the École des beaux-arts) and its director from 1866 to 1869. His students included Henri Fantin-Latour, Alphonse Legros, Léon Lhermitte, Jean-Charles Cazin, and Auguste Rodin. For further discussion of Lecoq, see Petra ten-Doesschate Chu, "Lecoq de Boisbaudran and Memory Drawing: A Teaching Course between Idealism and Naturalism," in *The European Realist Tradition,* ed. Gabriel P. Weisberg (Bloomington: Indiana University Press, 1982), 242–89; Gotlieb, *The Plight of Emulation,* chap. 1; Susan Sidlauskas, "A 'Perspective of Feeling': The Expressive Interior in Nineteenth-Century Realist Painting" (Ph.D. diss., University of Pennsylvania, 1989), chap. 1, and *Body, Place, and Self in Nineteenth-Century Painting* (Cambridge: Cambridge University Press, 2000).

The *Éducation de la mémoire pittoresque* (The training of the pictorial memory) was not translated into English until 1911, but Inness may have read it in its original French. It appears that he had at least a reading knowledge of the language, for he noted in 1879 that he had read and enjoyed Émile Zola's *L'Assommoir,* the seventh novel in the Rougon-Macquart series, published in serial but abbreviated form in *Le Bien public* in 1876, as a complete series in *La République des lettres* by early 1877, and in book form that same year. Inness called *L'Assommoir* "the most remarkable novel of the day" and stated that he intended to "try to please *Gervaise*—she deserves some pleasure" and "show her truths that she never saw before" ("Strong Talk on Art").

25. Marie-Elisabeth Cavé, *Drawing from Memory: The Cavé Method for Learning to Draw from Memory* (New York: G. P. Putnam's Sons, 1868). A review of Cavé's text by her friend Eugène Delacroix, published in the September 15, 1850, issue of the *Revue des deux mondes,* was reprinted in American editions of Cavé's text. Madame Edmond Cavé, neé Marie-Elisabeth Blavot, was an artist and an author; her book on drawing was widely influential. Her first husband was Clément Boulanger, France's director of fine arts from 1839 to 1848.

26. Ibid., 47.

27. George W. Sheldon, "George Inness," *Harper's Weekly* 26 (April 22, 1882): 244.

28. Mariana Griswold Van Rensselaer, "Some Aspects of Contemporary Art," *Lippincott's Magazine* 22 (December 1878): 706, 708.

29. Ibid., 709–10.

30. William Morris Hunt, *Talks on Art,* ed. Helen M. Knowlton (Boston: H. O. Houghton & Co., 1875), 61–62.

31. Hunt arrived in Paris in 1846 after studying sculpture in Rome in 1843 with the American Henry Kirke Brown and a brief course of instruction at the Düsseldorf Academy in Westphalia; in Paris, he intended to continue his training as a sculptor with Jean-Jacques Pradier but was im-

pressed by the work of Thomas Couture and decided to study with him instead. In 1852, he apprenticed himself to Millet (Bermingham, *American Art in the Barbizon Mood*, chap. 2). Hunt most likely knew of Lecoq's method, for he stressed the importance of artistic individuality and the benefits of drawing from memory. The *Talks* is in fact filled with advice and instruction about the place of memory in artistic endeavors, as is a second series published in 1883 (William Morris Hunt, *On Painting and Drawing* [New York: Dover Publications, Inc., 1976]). Helen M. Knowlton drew attention to Hunt's tendency to paint from memory in her biography of the artist (*The Art-Life of William Morris Hunt* [Boston: Little, Brown, & Co., 1899], 137).

32. Bermingham, *American Art in the Barbizon Mood*, chap. 2; and Nicolai Cikovsky, Jr., *George Inness* (New York: Harry N. Abrams, 1993), 29–30, 135. Hunt exhibited one painting at the Salon in 1853, titled *Étude* (Lois Marie Fink, *American Art at the Nineteenth-Century Paris Salons* [Cambridge: Cambridge University Press, 1990], 359). The precise date of Inness's stop in Paris on his way home from his first European trip, to Italy, is not known, but he implied in his letter to Hitchcock that he had visited the Salon (Bermingham calls it the Salon of 1852, Cikovsky the Salon of 1851) when in that French city. It is impossible to know whether Inness actually saw the Salon of 1851, but it seems likely that he did not. Cikovsky has determined that Inness departed for Europe in February of 1851 and, as the artist informed Hitchcock, he spent fifteen months in Italy before visiting France. Inness was in Rome by February of 1852 and, after an incident in April, departed for the United States. Inness and his wife, the *New York Times* reported on May 15, 1852, were among passengers recently arrived in New York on the steamship *Great Britain*. Because Inness began his journey home, which included his stop in Paris, in 1852, it was then that he most likely saw the Salon, which opened in the spring of that year (Nicolai Cikovsky, Jr., "The Life and Work of George Inness" [Ph.D. diss., Harvard University, 1965]," 17–21, and "Inness and Italy," in *The Italian Presence in American Art, 1860–1920*, ed. Irma B. Jaffe [New York: Fordham University Press, 1992], 43–61). In the Hitchcock letter, Inness reported that he encountered the work of Théodore Rousseau at the Salon; he could have done so at either the Salon of 1851 or that of 1852, for Rousseau exhibited at both and, in 1852, was awarded the cross of the Légion d'honneur. Perhaps it was to this award that Inness referred in his letter when he wrote that "Rousseau was just beginning to make a noise" (Inness to Hitchcock, March 23, 1884, in *George Inness of Montclair* [Montclair, NJ: Montclair Art Museum, 1964], n.p.).

33. See, e.g., "Talks on Art," *Scribner's Monthly* 10 (October 1875): 787.

34. "As landscape painters," Inness stated, "I consider Rousseau, Daubigny, and Corot among the very best" ("A Painter on Painting," 459). For a discussion of Hunt's interest in and relationship to the painters of Barbizon, see Bermingham, *American Art in the Barbizon Mood;* and Sally Webster, *William Morris Hunt, 1824–1879* (Cambridge: Cambridge University Press, 1991).

35. Bermingham (*American Art in the Barbizon Mood*) provides a detailed account of the influence of the art of Barbizon in the United States and of the galleries, especially those in Boston, that encouraged an American market for Barbizon paintings. See also "The Arts," *Appletons' Journal* 13 (May 1, 1875): 569; "The Arts," *Appletons' Journal* 14 (September 18, 1875): 375; Edgar Fawcett, "An American Painter: George Inness," *Californian* 4 (December 1881): 455, 457; "The Fine Arts: The Exhibition at the Academy of Design. Second Notice—Our Landscape School of Artists," *New York Times*, April 17, 1875), 3, in which Inness is compared to the "French School" and to Corot, Rousseau, Daubigny, and Diaz; "William Morris Hunt," *Art Journal*, n.s., 5 (1879): 346–49, in which Hunt's tenure with Millet is discussed; George W. Sheldon, *American Painters* (New York: D. Appleton & Co., 1879), 88–93, in which Hunt's role in introducing the painters of Barbizon to American collectors is mentioned; and "Fine Arts: Boston Art," *Appletons' Journal* 11 (June 13, 1874): 764, in which it is noted that "Hunt seems to regard Nature much from Corot's point of view."

36. "Art," *Atlantic Monthly* 36 (September 1875): 375–76.

37. "Artists on Art," *New York Evening Post*, March 21, 1878. During his stay at the Eagleswood community, Inness met the artist Steele MacKaye, an art instructor there and a student of Hunt's (Kathleen Luhrs, ed., *American Painting in the Metropolitan Museum of Art* [New York: Metropolitan Museum of Art, 1980], 2:252).

38. Théophile Silvestre, *Histoire des artistes vivants, français et étrangers: Études d'après nature*

(Paris, 1853), 82–83, quoted in Vincent Pomarède, "The Making of an Artist," in Gary Tinterow, Michael Pantazzi, and Vincent Pomarède, *Corot* (New York: Metropolitan Museum of Art, 1996), 25–26. (Cette mémoire m'a, dit-il, mieux servi par moments que ne l'eût fait la nature elle-même.)

39. "Culture and Progress at Home: William Hunt's Pictures," *Scribner's Monthly* (February 1872), 501.

40. For further discussion of Corot and memory, see Vincent Pomarède, "Realism and Recollection," in Philip Conisbee et al., *In the Light of Italy: Corot and Early Open-Air Painting* (Washington, DC: National Gallery of Art, 1996), 89–105. As Jeremy Strick notes in his essay in the same volume, "Nature Studied and Nature Remembered: The Oil Sketch in the Theory of Pierre-Henri de Valenciennes," students competing for the French Academy's Prix de Rome for *paysage historique* (historical landscape) were required to produce a sketch of a tree, a painted study, and a finished landscape composition of a given subject, all from memory (83). Significantly, a number of Inness's paintings bear the title "Souvenir." See, e.g., Leroy Ireland, *The Works of George Inness: An Illustrated Catalogue Raisonné* (Austin and London: University of Texas Press, 1965), 145, 165, nos. 598, 675, respectively.

Millet, it was reported at the time, also painted from memory. Hunt referred to this practice in the passage cited earlier: "I never saw Millet out with an umbrella." The American critic Theodore Child, in a review of a Millet exhibition in Paris, also reported this tendency ("Jean-François Millet: The Millet Exhibition in Paris," *Atlantic Monthly* 60 [October 1887]: 511). In an essay on Millet, translated and reprinted in *Scribner's Monthly* in 1880 with an introductory essay by a "RWG," the French critic Alfred Sensier recounted an experience from the artist's student days:

> When Delaroche was painting the "Hemicycle," he often talked of it to the students in his atelier. Millet was once much abused by his comrades about a drawing from *chic* (out of his head), and "inventing his muscles." Delaroche, coming in at the moment, said: "Gentlemen, the study of nature is indispensable, but you must also know how to work from memory. He is right" (pointing to Millet) "to use his memory. When I began my 'Hemicycle,' I thought that letting the model stand, I could get the attitude of my personages, but I soon found I would have fine models, with no cohesion among them. I saw that one must invent, create, order and produce figures appropriate to each individuality. I had to use my memory. Do as he does, if you can." ("Jean-François Millet—Peasant Painter," pt. 2, *Scribner's Monthly* 20 [October 1880]: 828)

The essay was translated by "H. de K.," most likely Helena De Kay, Charles De Kay's sister, an artist who hosted salons that attracted the likes of Walt Whitman and Albert Pinkham Ryder and who helped organize a protest exhibition in 1875 after several of her works were rejected by the National Academy of Design. See Saul E. Zalesch, "Competition and Conflict in the New York Art World, 1874–1879," *Winterthur Portfolio* 29 (Summer/Autumn 1994): 107–10. For discussion of memory in the context of painting in nineteenth-century France, see Michael Fried, "Painting Memories: On the Containment of the Past in Baudelaire and Manet," *Critical Inquiry* 10 (March 1984): 510–42, and, on Millet and memory, *Absorption and Theatricality: Painting and Beholder in the Age of Diderot* (Berkeley and Los Angeles: University of California Press, 1980; reprint, Chicago: University of Chicago Press, 1988), 221–22n. 144 and *Courbet's Realism* (Chicago: University of Chicago Press, 1990), 43–45.

Perhaps it was the role of memory in their art that attracted Inness to the painters of Barbizon, or perhaps it was their art that encouraged him to explore the faculty's operations in the space of his paintings; either way, it seems fairly certain that Inness's interest in these painters corresponded with his interest in memory. It is worth noting that Inness's teacher, Régis-François Gignoux (1816–82), was a pupil of Paul Delaroche, the man who admonished his students to learn to draw and paint from memory, after Millet's example (Cikovsky, *George Inness* [1993], 11).

41. "The Academy Exhibition," *Appletons' Journal*, n.s., 6 (May 1879): 469. See also "The Arts," *Appletons' Journal* 14 (September 18, 1875): 376; "The Art Exhibition—Landscapes: George Inness," *Cincinnati Commercial*, September 18, 1875; and "Art Notes," *Boston Evening Transcript*, March 4, 1880, 4.

42. Edward Strahan [Earl Shinn], "The Fine Art of the International Exhibition," in *The Master-*

pieces of the Centennial International Exhibition (ca. 1876–78), 3 vols. (New York: Garland Publishing, 1977), 1:47–48.

43. William Hoppin, "A Glimpse of Contemporary Art in Europe: Second Paper," *Atlantic Monthly* 32 (September 1873): 261.

44. Jarves, *Art Thoughts* (New York: Hurd & Houghton, 1871), 273. See also S. G. W. Benjamin, "Practice and Patronage of French Art," *Atlantic Monthly* 36 (September 1875): 267; Henry C. Angell, "Records of William Morris Hunt: I," *Atlantic Monthly* 45 (April 1880): 559; and ES, "Private Art-Collections of Philadelphia," *Lippincott's Magazine* 10 (August 1872): 225.

45. "American Painters—Homer Dodge Martin," *Art Journal* 6 (November 1880): 323. See also "Obituary," *Art Journal* 1 (April 1875): 127; and "Jean-Baptiste-Camille Corot," *Art Amateur* 5 (August 1881): 48–49, which print versions of this passage.

46. Frances Power Cobbe, "The Fallacies of Memory," *Galaxy* 1 (May 15, 1866): 149, 156. William Carpenter addressed the inexactitude of memory in his *Mental Physiology* (and also referred to the work of Cobbe). "Though we are accustomed to speak of Memory as if it consisted in an *exact* reproduction of past states of Consciousness," he wrote, "yet experience is continually showing us that this reproduction is very often *inexact,* through the modification which the 'trace' has undergone in the interval. Sometimes the trace has been partially obliterated; and what remains may serve to give a very erroneous (because imperfect) view of the occurrence" (*Principles of Mental Physiology: With Their Applications to the Training and Discipline of the Mind, and the Study of Its Morbid Conditions* [London: C. Kegan Paul & Co., 1879], 456). See also "Memory," *Littell's Living Age* 84 (March 18, 1865): 513–16; "Letter to a Student Who Lamented His Defective Memory," *Appletons' Journal* 9 (June 7, 1873): 759; A. J. Faust, "Memory," *Appletons' Journal,* n.s., 11 (December 1880): 524–31; "Memory and Mind," *Appletons' Journal* 12 (December 19, 1874): 790–91; "Memory," *Appletons' Journal* 10 (July 12, 1873): 56; "Some Facts concerning Memory," *Appletons' Journal* 4 (August 13, 1870): 195; H. C. Wood, "Automatism: Concluding Paper," *Lippincott's Magazine* 26 (December 1880): 755–62; and Charles Morris, "Psychic Research," *Lippincott's Magazine* 35 (April 1885): 364–72.

47. Cobbe, "The Fallacies of Memory," 157–58. Cobbe called for a "philosophy of memory as might serve for the basis of scientific analysis of the faculty, and a method of distinguishing its false from its true exercise" (157). However, in keeping with the tone of popular philosophical and scientific discourse of her day, she closed her essay with a meditation on the degradation of the capacities of fancy and imagination at the hands of science, invoking as she did the power of the divine (161–62).

48. JS, "Illusions of Memory," *Littell's Living Age* 145 (May 1880): 433–35.

49. Ibid., 434.

50. Ibid., 438.

51. Inness to Hitchcock, March 23, 1884.

52. Inness, "A Painter on Painting," 458–59.

53. Interestingly, Theodore Child characterized Meissonier's practice as involving not direct observation but what might be termed historical recollection:

> [He] had seen nothing, heard nothing, and felt nothing that his contemporaries were seeing, hearing, and feeling. For fifty years Meissonier has had the force of will to isolate himself and to keep his eyes fixed on other centuries and on those picturesque costumes of the past which have furnished him an inexhaustible series of "pretexts" for pictures. . . . The resuscitation of this picturesque past seems marvelous. . . . Imagine, for a moment, the difficulty of painting in such conditions—the long studies and researches that must precede each picture begun, the second sight that must carry the artist back into the past and make him penetrate into the very heart and soul of his characters, the observation, the patience, the fixity of purpose, the persistency. ("The Meissonier Exhibition at Paris," *Art Amateur* 11 [July 1884]: 34)

It is possible that Meissonier's "second sight," a vision constituted by scientist-like observation and the effort of recovery or recollection, was closer to Corot's conception of vision than one might

at first imagine. Perhaps it was this aspect of Meissonier's photographically precise canvases that made them, in Inness's opinion, acceptable and useful, a suitable foil for Corot's half-uttered views of remembered scenes. See also Lucy H. Hooper's description of Meissonier in "The Foreshadowings of the Salon," *Art Journal* 4 (1878): 60–61; and "Exhibitions of British and French Art in New York," *Knickerbocker Magazine* 52 (January 1858): 52–61, where Meissonier's *The Chess Players,* a work admired by Inness, is discussed, and a joke is made about supplying "magnifying lenses, for the examination of paintings of the Meissonier school" (59).

54. See Cikovsky, "Life and Work," 316–62.

55. Sally M. Promey, "The Ribband of Faith: George Inness, Color Theory, and the Swedenborgian Church," *American Art Journal* 26 (1994): 44–65. I say more about the nature and significance of Promey's argument in chap. 5. See also Robert Jolly, "George Inness's Swedenborgian Dimension," *Southeastern College Art Conference Review* 11 (1986): 14–22; and Michael Quick, "George Inness: The Spiritual Dimension," in *George Inness: Presence of the Unseen* (Montclair, NJ: Montclair Art Museum, 1994), 29–32.

56. For a detailed history of Eagleswood before and during Inness's tenure there, see Mazow, "George Inness: Problems in Antimodernism" (Ph.D. diss., University of North Carolina, Chapel Hill, 1996), chap. 2. See also Cikovsky, *George Inness* (1993), 56–59; and Promey, "The Ribband of Faith," 47.

57. Mazow, "George Inness: Problems in Antimodernism," 59.

58. Introduced in the United States in 1784 by James Glen, who presented several lectures on Swedenborg's doctrine in Boston and Philadelphia, Swedenborg's teachings were disseminated at first by way of small informal reading groups and then by way of a more formal New Church organization whose members were predominantly upper-middle-class city dwellers (Richard Silver, "The Spiritual in America: The Influence of Emanuel Swedenborg on American Society and Culture, 1815–1860" [Ph.D. diss., Stanford University, 1983], 44–46).

59. G. Inness, Jr., *Life, Art, and Letters,* 61. The son of a Methodist mother, Inness joined the Baptist Church and was baptized in 1849. His stepmother, Inness's son reported, was a "devout Baptist" and his uncle was a "stanch [*sic*] Universalist . . . hence religious discussion became the principle [*sic*] topic of conversation, or, I should say, argument in the home-circle" (20).

60. George W. Sheldon, "Characteristics of George Inness," *Century Magazine* 7 (February 1895): 530.

61. Eckford [De Kay], "George Inness," 63; emphasis added.

62. In his dissertation, Silver notes that Swedenborg's ideas lay behind the belief held by a number of artists and critics, Inness included, that painting was concerned with the education of vision. He argues, e.g., that the dark haze in Inness's *Moonlight* (1893) was intended to represent natural man's inability to see clearly ("The Spiritual in America," chap. 8).

63. The first English translation of the *Arcana* by John Clowes was published in London between 1774 and 1806; the first American edition, a revision of the Clowes translation, was published in Boston between 1837 and 1847 ("Prefatory Notes," *Arcana Coelestia,* ed. John F. Potts [New York: American Swedenborg Printing and Publishing Society, 1909], 1:iii–vi). The Potts edition, used in this study, is the fourth American edition of the *Arcana;* it was published in twelve volumes between the years 1909 and 1910 and was based on previous translations. Henceforth cited in the text as *AC.*

64. Swedenborg organized the *Arcana* numerically. The "4" refers to the volume and the "2992" refers to the number assigned by Swedenborg to a particular section. Citations herein are as follows: (*AC* [volume number]:[section number]).

65. Among other things, Swedenborg demonstrated that each day in the Creation narrative corresponded to the spiritual regeneration of man. He said that the phrase "and God said, Let there be light, and there was light," to give one example, stood for the "first state [of regeneration] . . . when the man begins to know that the good and the true are something higher" (*AC* 1:20). Similarly, the phrase "and God created great whales" in his view signified the general principles of what he called "memory-knowledge," the memory, based on physical or external perceptions, of the natural man (*AC* 1:42).

66. Emanuel Swedenborg, *The True Christian Religion* (New York: General Convention of the New Jerusalem in the United States of America, 1865), 517. Along with the *Arcana, The True Christian Religion* was readily available in English translation in the United States during the period under discussion (Silver, "The Spiritual in America," 21). First published in 1771, the text provided a summary of Swedenborg's theology and was its most cohesive expression.

67. Emanuel Swedenborg, *Heaven and Hell,* trans. George F. Dole (New York: Swedenborg Foundation, 1979), 238. This work was one of the most widely distributed of Swedenborg's texts in the United States.

68. Emanuel Swedenborg, *Angelic Wisdom concerning the Divine Love and Wisdom* (New York: Swedenborg Foundation, 1928), 87–88.

69. For an informative discussion of Swedenborg's notion of the second coming, see William F. Wunsch, *The World within the Bible: A Handbook to Swedenborg's "Arcana"* (New York: New Church Press, 1929), esp. chap. 9. In the *Arcana,* Swedenborg demonstrated that the verses in Matthew that refer to the Last Judgment did not describe actual destruction but, rather, the consummation of the church and the return, or recollection, of the internal sense of the word (*AC* 5:4056–60).

70. "His Art His Religion," *New York Herald,* August 12, 1894, 9.

71. Sheldon, "George Inness," 244.

72. E., "Mr. Inness on Art-Matters," *Art Journal* 5 (1879): 376.

73. William Molyneux to John Locke, March 2, 1693, in *The Correspondence of John Locke,* ed. E. S. De Beer (Oxford: Clarendon Press, 1979), 4:651. The letter was written in response to a communication from Locke thanking Molyneux for his advice concerning the second edition of his *An Essay concerning Human Understanding,* on which he was at work. An earlier letter (1688) to Locke posed the same question (Morjolein Degenaar, *Molyneux's Problem: Three Centuries of Discussion of the Perception of Forms,* trans. Michael J. Collins [Dordrecht: Kluwer Academic Publishers, 1996], 17). See also Michael J. Morgan, *Molyneux's Question: Vision, Touch, and the Philosophy of Perception* (Cambridge: Cambridge University Press, 1977); and Martin Jay, *Downcast Eyes: The Denigration of Vision in Twentieth-Century French Thought* (Berkeley and Los Angeles: University of California Press, 1993), 98–102 and passim. Born in Dublin in 1656, Molyneux studied law as a young man but never practiced, although he did become a member of the Irish Parliament. His main interests were philosophy and science and, in particular, the study of optics and astronomy, and he helped found the Philosophical Society of Dublin in 1683. His publications included an English translation of Descartes's *Meditations* (1680) and a treatise on optics, the *Dioptrica nova* (1692), the preface to which included praise of Locke's *Essay* (1690) and prompted the latter to strike up a correspondence with the author. Molyneux's son, Samuel, tutored by Bishop George Berkeley at Trinity College, Dublin, was a well-known astronomer (Maurice Cranston, *John Locke: A Biography* [London: Longmans, Green & Co., Ltd., 1957], 359n 1; *La Grande encyclopédie* [Paris: Société anonyme de la grand encyclopédie, n.d.], 24:42).

74. *Correspondence of John Locke,* ed. De Beer, 651.

75. Inness to Ripley Hitchcock, March 23, 1884, in *George Inness of Montclair* (Montclair, NJ: Montclair Art Museum, 1964), n.p..

76. E., "Mr. Inness on Art-Matters," 377; emphasis added.

77. Inness to Editor Ledger (1884), reprinted in G. Inness, Jr., *Life, Art, and Letters,* 170.

78. Jonathan Crary discusses the Molyneux problem in *Techniques of the Observer: On Vision and Modernity in the Nineteenth Century* ([Cambridge, MA: MIT Press, 1990], 58–59) and the question of the relation of touch to vision in perception (passim).

79. See John Locke, *An Essay concerning Human Understanding* (1690), ed. P. H. Nidditch (Oxford: Oxford University Press, 1975), 145–46; Bishop George Berkeley, *An Essay towards a New Theory of Vision* (1709), in *The Works of George Berkeley,* ed. Alexander Cambell Fraser (Oxford: Clarendon Press, 1871), 1:72, 94; Voltaire, *Elémens de la philosophie de Neuton* (1838), in *The Complete Works of Voltaire,* ed. Robert L. Walters and W. H. Barber (Oxford: The Voltaire Foundation, Taylor Institution, 1992), 15:318–19; Étienne Bonnot, abbé de Condillac, *Essai sur l'origine des connaissances humaines* (1746) (Auvers-sur-Oise: Editions Galilée, 1973), 187; Denis Diderot, *Lettre sur les*

aveugles, à l'usage de ceux qui voient (1849), in *Oeuvres,* ed. Laurent Versini (Paris: Robert Laffont, 1994), 1:180, 182; Edmund Burke, *A Philosophical Inquiry into the Origin of Our Ideas of the Sublime and Beautiful,* ed. James T. Boulton (Notre Dame, IN: University of Notre Dame Press, 1958), 144–45; John Ruskin, *The Works of John Ruskin,* ed. E. T. Cook and Alexander Wedderburn (London: George Allen, 1903–12), 15:27–28; and William James, *The Principles of Psychology* (1890), ed. F. H. Burkhardt, F. Bowers, and I. K. Skrupskelis (Cambridge, MA: Harvard University Press, 1981), 2:844–45.

80. Degenaar, *Molyneux's Problem,* 53; Morgan, *Molyneux's Question,* 17.

81. William Cheselden, "An Account of some Observations Made by a Young Gentleman, who was Born Blind, or Lost his Sight so Early, that he had no Remembrance of Ever Having Seen, and was Couch'd between 13 and 14 years of Age," *Philosophical Transactions* 35 (London: Royal Society, 1728), 447–50, quoted in Degenaar, *Molyneux's Problem,* 54–55.

82. Carpenter, *Principles of Mental Physiology,* 188. Carpenter cited similar cases, including that of "Jemmy Morgan," a young woman blind from birth to whom sight was imparted by an operation.

83. Ibid., 187–88.

84. William Carpenter, "The Unconscious Action of the Brain," *Popular Science Monthly* 1 (September 1872): 544–64.

85. Carpenter, *Principles of Mental Physiology,* 189–90.

86. Ibid., 189. In a well-known passage from *The Elements of Drawing* (1857), John Ruskin invoked Molyneux's question, emphasizing the role of experience in acquiring vision:

> The Perception of solid Form is entirely a matter of experience. We *see* nothing but flat colours; and it is only by a series of experiments that we find out that a stain of black or grey indicates the dark side of a solid subject, or that a faint hue indicates that the object in which it appears is far away. The whole technical power of painting depends on our recovery of what may be called the *innocence of the eye;* that is to say, of a sort of childish perception of these flat stains of colour, merely as such, without consciousness of what they signify,—as a blind man would see them if suddenly gifted with sight. . . . Now, a highly accomplished artist has always reduced himself as nearly as possible to this condition of infantine sight. (*The Works of John Ruskin,* 15:27–28)

Inness's call for the exhumation of a mode of vision once lost, for the perceptual capacity of the Most Ancient Church, was not a call for a transcendent, disembodied mode of vision or for Ruskin's innocence of the eye, wherein art proceeded from a return to infantine perception, purely optical, of all things as flat. As I make clear in chap. 4, despite his appeal to a vision beyond that of the physical eye, the mode of sight Inness struggled to attain, or at least represent, had a bodily aspect. In his conception, more than just optical sensation was required in any effort to truly see, and a properly rendered impression, he insisted, depended in part on solidity—a quality associated with sensations of touch—lest painting, and vision, wind up "a linear impression only" or, in his words, broken and confused ("A Painter on Painting," 460; Inness to Editor Ledger [1884], reprinted in G. Inness Jr., *Life, Art, and Letters,* 169). Recall that Swedenborg described spiritual seeing as respiratory, as a corporeal process that required even as it seemed to circumvent bodily effects; in addition, he characterized interior memory and inner sight as "in like manner organic," as processes that affected the muscle fibers of the face. What is more, he insisted on the substantial nature of spiritual existence and the spiritual realm, and the dependence of spiritual perception on something similar to the physical human form (*AC* 12:10758). Crary discusses what he calls Monet's and Cézanne's wish for a purified subjective vision, as well as Ruskin's notion of the innocent eye in *Techniques of the Observer* (94–95). For further discussion of these issues, see Joel Isaacson, "Constable, Duranty, Mallarmé, Impressionism, Plein Air, and Forgetting," *Art Bulletin* 76 (September 1994): 427–50; and R. DeLue, "Pissarro, Landscape, Vision, and Tradition," *Art Bulletin* 80 (December 1998): 718–36.

87. Herbert Spencer, *The Principles of Psychology* (New York: D. Appleton & Co., 1873), 2:167–69; emphasis added. Spencer's studies of evolution, sociology, and psychology were published in serial and excerpted form in the 1870s and 1880s in American periodicals such as *Popular Science Monthly.* Spencer outlined his conception of the evolution of the senses in a section of the

Principles entitled "General Synthesis" (291–392). Evolution, he argued, consisted of the serial adjustment of inner relations to outer relations; changes in environment produced changes in an organism (304). The sensory faculties, he said, arise by way of connections and correspondences between the environment and the organism (385). Primordial and undifferentiated organisms, or monads, evolved into seeing, feeling, and thinking beings by virtue of stimulus and response; eyes, e.g., evolved in response to irritation of the monadic tissue (at the area of the soon-to-be organ of sight) caused by light waves or color (304, 399). It is tempting to conceive of Inness's characterization of perception and the acquisition of spiritual sight as a reconciliation of Spencer's notion of correspondential development, the idea that vision was the slowly developing effect of or response to a cause, and Swedenborg's doctrine of correspondence, the idea that things in the natural world were the effects of things in the spiritual world. See also William James, "Remarks on Spencer's Definition of Mind as Correspondence" (1878), in *Writings, 1878–1899* (New York: Library of America, 1992), 893–909. For Spencer and American art, again, see Kathleen Pyne, *Art and the Higher Life: Painting and Evolutionary Thought in Late-Nineteenth-Century America* (Austin: University of Texas Press, 1996); Mazow, "George Inness: Problems in Antimodernism," chap. 5; and Mazow, "Rethinking the Civilized Landscape: George Inness and Evolution in the 1880s and 1890s," in *George Inness: The 1880s and 1890s* (Annville, PA: Suzanne H. Arnold Art Gallery, Lebanon Valley College, 1999).

88. Cikovsky makes an eloquent point in his description of this picture in noting the contrast between the delicate rhythms of the vertical trees in the upper half of the canvas and the powerfully sculptural and horizontal form of the log in its foreground (in Cikovsky and Quick, *George Inness,* 156).

89. Clarence Cook, "The National Academy Exhibition," *Art Amateur* 6 (May 1882): 118.

90. "Art Notes," *Art Journal* 8 (1882): 158.

91. "The Academy Exhibition," *Boston Advertiser,* March 31, 1882, 5. See also "National Academy of Design," *New York World,* April 10, 1882.

92. Inness, "A Painter on Painting," 461.

CHAPTER 3

1. René Descartes, *Discourse on Method, Optics, Geometry, and Meteorology,* rev. ed. (Indianapolis: Hackett Publishing, 2001), 91–93. For recent writing on Descartes relevant to the present study, see Judith Butler, "'How Can I Deny That These Hands and This Body Are Mine?'" *Qui Parle* 11 (Fall/Winter 1997): 1–20; Philip Fisher, *Wonder, the Rainbow, and the Aesthetics of Rare Experiences* (Cambridge, MA: Harvard University Press, 1998); Dalia Judovitz, "Vision, Representation, and Technology in Descartes," in *Modernity and the Hegemony of Vision,* ed. David Michael Levin (Berkeley and Los Angeles: University of California Press, 1993), 63–86; George Levine, "The Narrative of Scientific Epistemology," *Narrative* 5 (October 1997): 227–51; Lyle Massey, "Anamorphosis through Descartes or Perspective Gone Awry," *Renaissance Quarterly* 50 (Winter 1997): 1148–89; and Joel Snyder, "Picturing Vision," *Critical Inquiry* 1 (Spring 1980): 499–526.

2. G. Inness, Jr., *Life, Art, and Letters of George Inness* (New York: Century Co., 1917), 284.

3. Ibid., 170.

4. Inness, "A Painter on Painting," *Harper's New Monthly Magazine* 56 (February 1878): 461.

5. Inness to Editor Ledger (1884), reprinted in G. Inness, Jr., *Life, Art, and Letters,* 170; emphasis added. Thus far, I have quoted numerous of Inness remarks, some more intelligible than others. During Inness's lifetime, colleagues and friends characterized his writing and conversation as difficult, erratic, and even impenetrable. "In reading a manuscript of Inness's," George W. Sheldon noted, "it was not always easy to understand his meaning. His sentences were long and involved, and lucidity of expression suffered from haste and inexperience" ("Characteristics of George Inness," *Century Magazine,* n.s., 7 [February 1895]: 530). His prose, agreed Montgomery Schuyler, "is incoherent and unreadable" ("George Inness: The Man and His Work," *Forum* 18 [November 1894], 312). The passage cited here, excerpted from a letter Inness wrote to the editor of a periodical (exactly which one is not known) is, while not unreadable, characteristic. Complicated and somewhat

convoluted, its layers of allusion to contemporary theology, art theory, and pictorial practice deserve further explication. I shall say more about the place of words and writing in Inness's practice in chaps. 5 and 6, but let me emphasize here that Inness's writing must be understood as an integral part of his pictorial project and that Inness conceived of painting and writing as corresponding activities. One might even say that the difficulty of his verbal articulations was meant to embody and reinforce the difficulty of his landscapes.

6. E., "Mr. Inness on Art-Matters," *Art Journal* 5 (1879): 376.

7. Inness to Ripley Hitchcock, March 23, 1884, in *George Inness of Montclair* (Montclair, NJ: Montclair Art Museum, 1964), n.p.

8. Elliot Daingerfield, "A Reminiscence of George Inness," *Monthly Illustrator* (March 1895), quoted in Alfred Trumble, *George Inness, N.A.: A Memorial of the Student, the Artist, and the Man* (New York: The Collector, 1895), 34.

9. "His Art His Religion," *New York Herald,* August 12, 1894, 9; emphasis added.

10. Inness, "A Painter on Painting," 459.

11. Ibid.

12. Ibid.

13. Inness to Hitchcock, March 23, 1884. As a statement such as this indicates, Inness was interested in the visual capacity of society, which he understood as intimately linked to collective well-being and advancement. Leo G. Mazow examines Inness's social and political activities and beliefs in detail, including his reaction to the "iron tramp" of civilization, his concerns about industrial capitalism, his engagement with Fourier's utopianism, and his interest in Henry George's single tax theory ("George Inness: Problems in Antimodernism," [Ph.D. diss., University of North Carolina, Chapel Hill, 1996], chaps. 2–4, and "George Inness, Henry George, the Single Tax, and the Future Poet," *American Art* 18 [Spring 2004]: 58–77). In the latter, Mazow discusses the contents and import of an article he discovered: "The George Dinner: The Great Banquet at the Metropolitan Hotel," *Standard* 7 (January 22, 1890): 8–11.

14. Daingerfield, *George Inness,* 25–26.

15. "His Art His Religion," 9.

16. *New York Evening Post,* January 5, 1895, quoted in G. Inness, Jr., *Life, Art, and Letters,* 272.

17. Henry Eckford [Charles De Kay], "George Inness," *Century Magazine* 24 (May 1882): 63.

18. *The Rainbow* is in the collection of the Canajoharie Library and Art Gallery, New York. The present locations of *The Afterglow* and *The Morning Sun* are unknown. See Leroy Ireland, *The Works of George Inness: An Illustrated Catalogue Raisonné* (Austin and London: University of Texas Press, 1965), 220, nos. 884 and 885.

19. For additional discussion of this episode, see Nicolai Cikovsky, Jr., "The Life and Work of George Inness" (Ph.D. diss., Harvard University, 1965), 68–73. Examples of Inness's poetry can be found in George W. Sheldon, "George Inness," *Harper's Weekly,* vol. 26 (April 22, 1882); and G. Inness, Jr., *Life, Art, and Letters,* 105–6. Inness included the text of one of the appended poems in a letter to the editor of the *New York Tribune* (April 11, 1878).

20. Susan N. Carter, "The Academy Exhibition," *Art Journal,* n.s., 4 (May 1878): 159.

21. Inness, "A Painter on Painting," 460.

22. Ibid., 459–60. As were many of Turner's landscapes, *Slavers Throwing Overboard the Dead and Dying, Typhoon Coming On* (*The Slave Ship*) was accompanied by a poetic caption, which the artist had written himself. This caption constituted one fragment of Turner's poem, "The Fallacies of Hope," which, as John Gage has pointed out, did not consist of a single composition but of sections written to accompany specific paintings (*J. M. W. Turner: "A Wonderful Range of Mind"* [New Haven, CT: Yale University Press, 1987], 192–94). *The Slave Ship* was in the United States by 1872, and in Boston by 1876.

23. Sheldon, "George Inness," 244; and "The Death of Inness," *New York Commercial Advertiser* (August 1894).

24. "Art," *Atlantic Monthly* 31 (January 1873): 115. Inness authored a circular that was distributed at the exhibition of *The Triumph of the Cross* in 1867. ("Inness's Allegorical Pictures," *New York*

Evening Post, May 11, 1867, 4). He also provided a pamphlet to accompany the exhibition of *The Sign of Promise* at Snedecor's in 1863 (*"The Sign of Promise." By George Inness. Now on Exhibition at Snedecor's [sic] Gallery, 768 Broadway, New York* [1863]). Inness's narrativizing gestures may be compared to those of other landscape painters, namely, Church, who provided visitors to the exhibitions of *The Heart of the Andes* (1859; Metropolitan Museum of Art) and *Jerusalem from the Mount of Olives* (1870; Nelson-Atkins Museum of Art) with textual explanations or visual keys to aid them in their examination of his panoramic scenes. See Kevin J. Avery, "'The Heart of the Andes' Exhibited: Frederic E. Church's Window on the Equatorial World," *American Art Journal* 18 (1986): 52–72; John Davis, "Frederic Church's 'Sacred Geography,'" *Smithsonian Studies in American Art* 1 (Spring 1987): 79–96, and *The Landscape of Belief: Encountering the Holy Land in Nineteenth-Century American Art and Culture* (Princeton, NJ: Princeton University Press, 1996).

25. Carter, "The Academy Exhibition," 158.

26. Clarence Cook's review of the academy exhibition from the *New York Tribune,* April 9, 1878, is quoted in Cikovsky, "Life and Work," 68–69. As Cikovsky notes, Martin Farquhar Tupper was the author of *Proverbial Philosophy* (1838–42), a collection of philosophical musings rendered in poetic form.

27. Cook (*New York Tribune,* April 12, 1878) was responding to a letter sent by Inness to the *Tribune's* editor on April 11 wherein the latter accused the former of "unintelligent wickedness," the very thing, Inness wrote, that he had meant to describe in the poem he appended to Hartley's statue (Inness included the poem's lines in his letter so as to illustrate his point). In response to Cook's second attack, which followed Inness's April 11 letter, Inness wrote once more to the *Tribune,* protesting against "the indiscriminate and generally unreasonable animadversions of the newspaper press upon the efforts of my profession" and "the illogical and absurd abuse so often indulged in, seemingly for the mere purpose of exhibiting 'critical acumen' or eking out a reportorial occupation." The editor responded by saying that Inness "ought to be ashamed of himself" for insinuating that Cook was both ignorant and mercenary ("Artists and Critics," *New York Tribune,* April 15, 1878, 5).

28. "Fine Arts: The National Academy Exhibition. Final Notice," *Nation* 26 (May 30, 1878): 363–64.

29. "The Academy Exhibition: Critics on the Fence . . . George Inness, the Eccentric," *New York Times,* April 10, 1878, 2. Part of this passage, the reader will recall, introduced the first chapter of this book. See also "Fine Arts: National Academy of Design," *New York Herald,* March 31, 1878, 7.

30. G. Inness, Jr., *Life, Art, and Letters,* 148. As early as 1879, the *New York Evening Post* reported Inness's increasing interest in figure painting ("Fine Arts," *New York Evening Post,* October 14, 1879, 1).

31. Inness to Elizabeth Hart Inness, July 1881, reprinted in G. Inness, Jr., *Life, Art, and Letters,* 148–49.

32. H. Barbara Weinberg, "Late-Nineteenth-Century American Painting: Cosmopolitan Concerns and Critical Controversies," *Archives of American Art Journal* 23 (1983): 19, 21, 24. As Weinberg says, the turn toward figure painting on the part of artists and collectors was precipitated by assimilation of foreign and, in particular, French artistic ideals. American artists who trained in Paris at the École des beaux-arts encountered a curriculum with the study of the human form at its center and learned to consider figural compositions as superior to landscape views. Demand for figure paintings and genre scenes overtook demand for landscape paintings as more and more artists and collectors studied and traveled abroad. "It cannot be said that landscape painting is declining," one critic wrote, "but it evidently engages the attention of fewer artists" ("Art Notes," *Art Journal* 8 [1882]: 157).

33. Inness to Elizabeth Hart Inness, July 6, 1881, reprinted in G. Inness, Jr., *Life, Art, and Letters,* 151.

34. There are exceptions, of course. *The Rigor of the Game, Conway, New Hampshire* (ca. 1875; Brooklyn Museum, New York) might be called a figure study.

35. Inness to Hitchcock, March 23, 1884.

36. Ibid.; emphasis added.

37. E., "Mr. Inness on Art-Matters," 374.

38. "His Art His Religion," 9.

39. Ibid.

40. Daingerfield, *George Inness,* 25–26.

41. Richard W. West, "The Apprehension of Pictures," *Art Journal* 10 (1884): 177.

42. Ibid.

43. Ibid.

44. Ibid.

45. Ibid., 179

46. Ibid., 180.

47. See, e.g., "The Academy of Design," *Scribner's Monthly* 18 (June 1879): 313; Susan N. Carter, "Fine Arts: Notes from American Studios in Italy," *Appletons' Journal* 12 (August 8, 1874): 188; "The Arts," *Appletons' Journal* 14 (September 18, 1875): 375; review of an exhibition at Snedecor's Gallery, *Appletons' Journal* 15 (April 8, 1876): 475; Edgar Fawcett, "An American Painter: George Inness," *Californian* 4 (December 1881): 459; and "Art: Some Landscapes at the Academy," *Appletons' Journal* 11 (May 9, 1874): 604.

48. "Art Notes," *Art Journal* 7 (1881): 189.

49. "The Two New York Exhibitions," *Atlantic Monthly* 43 (June 1879): 783.

50. "The Academy Exhibition: III," *Independent* 30 (April 25, 1878), 7.

51. For further discussion of Inness and equilibrium, see Mazow, "George Inness: Problems in Antimodernism," chap. 5.

52. G. Inness, Jr., *Life, Art, and Letters,* 67–68. Cikovsky writes that the notion of the middle tone most likely derived from the Swedenborgian concept of equilibrium and argues that it was vitally important to Inness's practice ("Life and Work," 204–5).

53. Daingerfield, *George Inness,* 42. It is not difficult to imagine that Inness's landscapes, described as noisy by at least one of his critics and as hinged on a vortex of sound by Daingerfield, were understood to bear some relation to the auditory. I do not include in this study a discussion of the role of sound or metaphors of sound in writing about art in the nineteenth century, but the topic is a fascinating one and deserves more attention than I give it here. In 1834, Thomas Cole described what he called a "color piano" in his journal, an instrument that "might be constructed by which colour could be played, and which would give to those, who had cultivated their taste in art, a pleasure like that given by music. . . . The instrument might be played by means of keys, like those of a piano, except, that instead of their moving hammers to strike strings, they might lift, when struck, dark or black screens from before coloured compartments" (David B. Lawall, "Asher Brown Durand: His Art and Theory in Relation to His Times" [Ph.D. diss., Princeton University, 1966], 404). Cole's proposal for this piano, wherein sensations of touch, sound, and sight combined in what he imagined was an experience of art, resembled Denis Diderot's 1751 description of a "machine singulière" that produced what the critic called "ocular music" (*Lettre sur les sourds et muets,* in *Oeuvres,* ed. Laurent Versini [Paris: Robert Laffont, 1996], 4:19).

54. Elliot Daingerfield, "Inness: Genius of American Art," *Cosmopolitan* 55 (September 1913): 523. See also "Art: Some Landscapes at the Academy," *Appletons' Journal* 11 (May 9, 1874): 604, in which the debate among artists, Inness included, over the middle tone was noted and described.

55. In discussing the concept of equilibrium in an essay published in the *Independent* in 1861, William Page indicated that unification and the middle-tone strategy used to achieve and express it were related to visual function:

> In the landscape from your window you observe how objects diminish as they recede; how only a branch from a near tree comes in, while further off a whole forest holds its place, and so on, till the distant tree covered hilltops show not even a mossy inequality, but only their medium colored surfaces. . . . Observe next the chiaro-scuro, or light and dark of the same scene. The snow near you in the sunlight is of dazzling brightness; that in the next field, if you turn your eye rapidly from one patch to the other, is sensibly dimmer, and so

on less white, till that on the distant hills, though still to your mind's eye "as white as snow," is, if actually contrasted with that on your door-step, as gray as the stone even;—that is, hold a piece of white paper against each, and you will find it to tell as brightly on one as on the other. Now compare this somber distant hilltop snow with the soft white cloud above it, and you find the two almost exactly the same middle-tint tone; and so from the nearest brilliant snow to that most remote, you will find all the intermediate gradations of more and less light, until you come to the horizon, where the actual snow still represents only middle tint in chiaro oscuro, being just half-way between nature's light and dark, and must be painted in a tone just half-way between white and black. ("Equilibrium of Nature and the Palette—and 'How to Do It,'" *Independent* 13 [July 25, 1861]: 1)

56. "Art Notes," *Appletons' Journal* 9 (January 25, 1873): 158.

57. Inness experimented with this technique for the rest of his career, testing it out in works such as *A Breezy Autumn* (1887); *Early Autumn, Montclair* (1888; fig. 79); *Niagara* (1889; plate 12); and *The Clouded Sun* (1891; fig. 73).

58. Recall that, in describing Inness's working methods, his pupil J. A. S. Monks reported that his teacher once requested him to "frotté [*sic*]" his canvas for him (see chap. 2). It is, of course, impossible to determine whether Inness actually used the word "frotée" (which means, literally, "with a smattering") when he asked Monks to begin a painting for him. The fact that Monks used the word is interesting, however, for the "en frotée" method involved the combination of light and dark patterns, beginning with thin sepia washes to which were added slightly thicker glazes, denoting half-tones and darks, and heavier glazes or impastos, denoting lighter passages (Peter Bermingham, *American Art in the Barbizon Mood* [Washington, DC: Smithsonian Institution Press, 1975], chap. 2). If Inness did indeed request that his pupil "frotée" in a sketch for him, he would have been asking him to determine its basic light and dark values as well as the relation of one value to another. In asking Monks to coordinate the values of his picture, Inness, essentially, would have been requesting that he find the middle tone for him, consulting all parts of the composition as he did. That the artist would hold another person responsible for producing the point where he imagined that his painting and his vision began is as startling as it is fascinating; such a gesture, however, makes sense if we understand Inness's paintings as purposefully generative of such effects of distancing, obscurity, and transference (from one eye or memory to another).

59. "Art and Artists," *Boston Evening Transcript,* September 5, 1876, 6.

60. For a discussion of these instruments, see Jonathan Crary, *Techniques of the Observer: On Vision and Modernity in the Nineteenth Century* (Cambridge, MA: MIT Press, 1990), chap. 4; and Barbara M. Stafford and Frances Terpak, *Devices of Wonder: From the World in a Box to Images on a Screen* (Los Angeles: Getty Research Institute, 2001).

61. The physicist Charles Wheatstone, inventor of the stereoscope, provided the answer to a longstanding question provoked by Kepler's discovery that images of the world were projected on the retina both upside down and flat: How was depth perceived when perception originated in flatness? Wheatstone, with the aid of his stereoscope, demonstrated that perception of depth occurred by virtue of the combination of two different retinal images or perspectives; he published his findings in 1838 (Morjolein Degenaar, *Molyneux's Problem: Three Centuries of Discussion of the Perception of Forms,* trans. Michael J. Collins [Dordrecht: Kluwer Academic Publishers, 1996], 105; Charles Wheatstone, "Contributions to the Physiology of Vision—Part the First: On Some Remarkable, and Hitherto Unobserved, Phenomena of Binocular Vision," *Philosophical Transactions of the Royal Society of London* 128 [1838]: 371–94). See also Crary's analysis of the place of binocular vision in changing conceptions and techniques of vision (*Techniques of the Observer,* chap. 4).

62. William Carpenter, *Principles of Mental Physiology: With Their Applications to the Training and Discipline of the Mind, and the Study of Its Morbid Conditions* (London: C. Kegan Paul & Co., 1879), 192.

63. What Carpenter described as the transformation of flatness into relief may remind us of Cook's description of the assault of Inness's picture at the academy exhibition in 1877, as cited in chap. 1 ("it seems to detach itself from the wall and advance to meet those who enter the North Room").

64. George W. Sheldon, "George Inness," *Harper's Weekly* 26 (April 22, 1882): 244.

65. Inness to Editor Ledger (1884), in G. Inness, Jr., *Life, Art, and Letters,* 170.

66. G. Inness, Jr., *Life, Art, and Letters,* 140–47, 190–97; Daingerfield, *George Inness,* 23–24, 38; Schuyler, "George Inness: The Man and His Work," 309; Eckford [De Kay], "George Inness," 59; Trumble, *George Inness, N.A.,* 14; Arthur Hoeber "A Remarkable Collection of Landscapes by the Late George Inness, N.A.," *International Studio* 43 (March 1911): xxxvii; and Henry Atkins, "William Keith, Landscape Painter, of California," *International Studio* 33 (November 1907): 40. As his son reported, Inness "had the idea firmly established in his mind that a work of art from his brush always remained his property, and that he had the right to paint it over or change it at will, no matter where he found it or who had bought it," as if to suggest that he doubted completion could ever be, finally and definitively, achieved (*Life, Art, and Letters,* 140). Again, Ryder's practice of repainting his canvases is relevant here.

67. Inness, "A Painter on Painting," 461.

68. S. C. G. Watkins, "Reminiscences of George Inness, the Great Painter, as I Knew Him," *Montclair Times,* April 14, 1928, reprinted in Watkins, *Reminscences of Montclair* (New York: A. S. Barnes & Co., 1929), 106–18, quoted in William Gerdts, "Some Reminiscences of George Inness," in *George Inness: Presence of the Unseen* (Montclair, NJ: Montclair Art Museum, 1994), 13–17; John Austin Sands Monks "A Near View of Inness," *Art Interchange* 34 (June 1895): 149. After describing Inness's many-layered Mount Washington, Monks made the following observation: "When away from the scene he painted from that experience several fine pictures that were no jumble, but typical and beautiful, giving one the feeling of the individual day and scene," as if to suggest that distance and memory enabled pictorial success.

69. Frank Fowler, "A Master Landscape Painter: The Late George Inness," *Harper's Weekly* 38 (December 29, 1894): 1239–42.

70. Schuyler, "George Inness: The Man and His Work," 309.

71. Atkins, "William Keith," 40. See also Ripley Hitchcock, "George Inness, N.A.," in *Catalogue. Special Exhibition of Oil Paintings, Works of Mr. George Inness, N.A.* (New York: American Art Galleries, 1884), 32; and DeWitt Lockman's interview with Will H. Low, June 25, 1927, 3–5, typescript, New York Historical Society Library, in Gerdts, "Some Reminiscences," 15.

72. Inness to Hitchcock, March 23, 1884.

73. G. Inness, Jr., *Life, Art, and Letters,* 194–95.

74. Ibid., 195.

75. Eckford [De Kay], "George Inness," 59.

76. I thank Alison Kemmerer of the Addison Gallery of American Art for drawing my attention to this extraordinary fact. The painting underneath the Addison's *The Coming Storm* was discovered when it was x-rayed during conservation at the Williamstown Regional Art Conservation Laboratory; one of George Inness, Jr.'s, it depicted a landscape with a team of oxen pulling a cart. Another version of Inness's middle-ground building appeared on the x-ray film as well (Artist Files, Addison Art Gallery; Wendy M. Watson et al., *Altered States: Conservation, Analysis, and the Interpretation of Works of Art* [South Hadley, MA: Mount Holyoke College Art Museum, 1994], 68–71). In his 1917 biography, Inness's son recounted the mysterious disappearance "about forty years ago" (around 1877) of one of his, the son's, paintings after it was exhibited at the gallery of Williams and Everett in Boston. "I wondered many times what had happened to it," he wrote, "I was sure myself that I had never sold it, and I had almost deluded myself into the belief and hope that some art lover had yielded to a great temptation and stolen it. But 'what a check to proud ambition!' One day recently, while visiting my sister, Mrs. Hartley, I was looking at a very wonderful canvas of my father's that is hanging in her house, a powerful storm effect, and catching it in a cross light, I saw under the clouds and landscape the outline of my team of oxen. The mystery was solved. My oxen had come to light, or, rather, I should say, they had been revealed in darkness. All these years they had been plodding through this glorious storm. Dear old Pop, in dire need of a canvas, had painted over my picture and immortalized it thus" (*Life, Art, and Letters,* 137).

77. As his contemporaries reported, approaching or passing storms were favorite subjects of Inness's ("The Lounger," *Critic* 4 [April 26, 1884]: 200).

78. James Sully, "The Pleasure of Visual Form," *Popular Science Monthly* 16 (April 1880): 780–88.

79. Ibid., 786.

80. Ibid., 788.

81. E., "Mr. Inness on Art-Matters," 377.

82. Sheldon, "George Inness," 246.

83. For Rood, see chap. 1.

84. Sheldon, "George Inness," 246.

CHAPTER 4

1. "National Academy of Design," *Knickerbocker Magazine* 33 (May 1849): 468; emphasis added. Inness also exhibited this painting at the American Art Union in 1849 ("Catalogue of Works of Art," *Bulletin of the American Art Union* 2 [December 1849]: 37).

2. Nicolai Cikovsky, Jr., discusses this body of criticism in his dissertation ("The Life and Work of George Inness" [Ph.D. diss., Harvard University, 1965), in his article about Inness's *The Lackawanna Valley* ("George Inness and the Hudson River School: *The Lackawanna Valley*," *American Art Journal* 2 [Fall 1970]: 36–57), and in his monograph on the artist (*George Inness* [New York: Harry N. Abrams, 1993]). Gaspard Dughet (1615–75) was a French landscape painter active in Rome in the seventeenth century. He was called Gaspar Poussin because he was the brother-in-law of Nicolas and painted landscapes in a classical idiom. His pictures, disseminated by way of engravings, exercised a great deal of influence on American painters and picture theory in the first half of the nineteenth century. For a discussion of Gaspar's career, see *Gaspard Dughet Called Gaspar Poussin, 1617–75: A French Landscape Painter in Seventeenth-Century Rome and His Influence on British Art* (London: Greater London Council, 1980).

3. "The Fine Arts: National Academy Exhibition," *Literary World* 3 (May 27, 1848): 328.

4. "Fine Arts: The Brooklyn Artists' Reception," *New York Evening Post*, March 5, 1863.

5. "The Fine Arts: Exhibition of the National Academy of Design," pt. 3, *Literary World* 10 (May 8, 1852): 332.

6. "Exhibition of the National Academy of Design," *Knickerbocker Magazine* 42 (July 1853): 95–96.

7. "Fine Arts: Exhibition of the National Academy," pt. 3, *New York Daily Tribune*, May 1, 1852, 5.

8. Ibid.

9. H., "When Is an Artist True to Himself?" *Boston Evening Transcript*, February 19, 1862, and "When Is an Artist True to Himself?" *Boston Evening Transcript*, March 7, 1862.

10. B., "When Is an Artist True to Himself?" *Boston Evening Transcript*, February 26, 1862.

11. See, e.g., C. P. Cranch, "Art: Recipes in Art," *Independent* 24 (June 6, 1872): 4; William Page, "The Italian Schools of Painting—No. 1," *Independent* 12 (October 11, 1860): 1; "The Thirty-Fourth Exhibition of the Academy of Design," *New York Evening Post*, April 25, 1859; "The Fine Arts: Exhibition of the National Academy of Design," pt. 3, *Literary World* 10 (May 8, 1852): 332; "The Fine Arts: Exhibition at the National Academy," *Literary World* 1 (May 8, 1847): 323; "The Fine Arts: Exhibition at the National Academy," *Literary World* 1 (May 15, 1847): 348; and "The Fine Arts: Exhibition at the National Academy," *Literary World* 1 (October 23, 1847): 277.

12. "Art Items," *New York Daily Tribune*, September 29, 1860, 4.

13. "Art and Artists," *Boston Evening Transcript*, September 24, 1875, 6. See also "Art News," *Boston Evening Transcript*, May 19, 1875, where Inness is said to have created a style "eminently and distinctively American" and is praised for his methods of studying foreign art "without absorbing it or being absorbed by it." "The influence of the French school of landscape Art," another critic reported, "is probably more strongly apparent in the works of GEORGE INNESS than in those of any other

American painter, and yet he is no imitator, although the more subtile [*sic*] features of his ideal may be detected in all of his pictures" ("American Painters—George Inness," *Art Journal* 2 [March 1876]: 84).

14. GWP, "Some Remarks on the Landscape Art, as Illustrated by the Collection of the American Art Union," *Bulletin of the American Art Union* 2 (November 1849): 22; H., "When Is an Artist True to Himself?" *Boston Evening Transcript*, February 19, 1862. See also "The Fine Arts: The Exhibition of the Academy," *Literary World* 12 (April 30, 1853), 358; "Fine Arts: Thirty-Eighth Annual Exhibition of the National Academy of Design," pt. 2, "Concluding Notice," *Independent* 15 (June 25, 1863): 6; and "National Academy of Design, North Room," *New York Times*, May 29, 1865, 4–5.

15. "Exhibition of the National Academy of Design," *Knickerbocker Magazine* 45 (May 1855): 533.

16. James Jackson Jarves, *The Art-Idea* (1864), ed. Benjamin Rowland, Jr. (Cambridge, MA: Belknap Press, 1960), 195; Sordello [Eugene Benson], "National Academy of Design: Fortieth Annual Exhibition," *New York Evening Post*, May 12, 1865.

17. Montgomery Schuyler, "George Inness," *Harper's Weekly* 38 (August 18, 1894), 787.

18. See, e.g., George W. Neubert, "George Inness: His Signature Years and the Modernist Tradition," in Marjorie Dakin Arkelian and George W. Neubert, *George Inness Landscapes: His Signature Years, 1884–1894* (Oakland, CA: Oakland Art Museum, 1978), 7–8; Cikovsky, "Life and Work," 363–70, and *George Inness* (1993), 105–6.

19. George W. Sheldon, *American Painters* (New York: D. Appleton & Co., 1879), 30. It has been said that when Inness was in Rome in the 1870s, he took a studio on the Via Sistina once occupied by Claude, a suggestive gesture, if it was a deliberate one (George Inness Jr., *Life, Art, and Letters of George Inness* [New York: Century Co., 1917], 75).

20. Cikovsky, *George Inness* (1993), 13, and "George Inness and the Hudson River School: The Lackwanna Valley, *American Art Journal* 2 (Fall 1970): 36–57.

21. NN, "The Exhibition of the National Academy of Design," *Bulletin of the American Art Union* 3 (May 1850): 20.

22. "The Fine Arts: The Inness Collection," *Boston Daily Advertiser*, May 15, 1875.

23. Ibid.

24. Clarence Cook, "The Fine Arts: The National Academy of Design," *Independent* 7 (April 5, 1855): 105. See also "The Fine Arts: The Cole Exhibition; Second Notice," *Literary World* 3 (April 15, 1848): 207.

25. GWP, "Some Remarks on the Landscape Art, as Illustrated by the Collection of the American Art-Union," *Bulletin of the American Art Union* 2 (November 1849): 23.

26. For a discussion of the relation between looking and owning with regard to landscape and landscape representation, see Albert Boime, *The Magisterial Gaze: Manifest Destiny and American Landscape Painting, ca. 1830–1865* (Washington DC: Smithsonian Institution Press, 1991).

27. GWP, "Some Remarks on the Landscape Art, as Illustrated by the Collection of the American Art-Union," pt. 2, *Bulletin of the American Art Union* 2 (December 1849): 15–16.

28. See James Collins Moore, "The Storm and the Harvest: The Image of Nature in Mid-Nineteenth-Century American Landscape Painting" (Ph.D. diss., Indiana University, 1974), esp. chap. 2; and Barbara Novak, *Nature and Culture: American Landscape Painting, 1825–1875*, rev. ed. (New York: Oxford University Press, 1995), chap. 6.

29. "The Fine Arts: The Art Union Pictures," *Literary World* 2 (October 30, 1847), 303.

30. BB, "Letters on Art. No. XIX. Generalization," *Independent* 9 (July 30, 1857): 1.

31. "The National Academy of Design, North Room," *New York Times*, May 29, 1865, 4–5.

32. "The Fine Arts: The Art Union Pictures," *Literary World* 2 (October 30, 1847), 302. See also BB, "National Academy of Design," *Independent* 10 (April 29, 1858); "Editor's Easy Chair," *Harper's New Monthly Magazine* 10 (May 1855): 841; "The Fine Arts: Exhibition of the National Academy of Design," *Literary World* 10 (May 8, 1852), 332; Russell Sturgis, "American Painters: The National Academy Exhibition," *Galaxy* 4 (June 1867): 234–35; G. M. James, "The Landscape Element in American Poetry: Street," *Crayon* 1 (January 17, 1855): 40; "Our Artists in Italy," *Atlantic Monthly* 9

(February 1862): 168; and Proteus, "Art Intelligence," *New York Commercial Advertiser,* June 12, 1862.

33. GWP, "Some Remarks on the Landscape Art," pt. 2, 16–17.

34. Ibid., 18.

35. Ibid., 17–18.

36. Ibid., 19.

37. Ibid., 18–19. In speaking of the eye's need to expatiate with freedom, GWP may have been referring to more than pictorial or spatial liberty. Earlier in pt. 2 of his essay he addressed the necessity of creating "great harmonious wholes, where each part is in perfect *keeping* with all the rest, and the result is a single irresistible impression, formed out of many—*e pluribus unum*—if such an application of words is admissible" (16). GWP's use of the phrase *e pluribus unum* ("one from many" or "one from many parts"), the motto on the great seal of the United States, dating from 1782, suggests that he saw his landscape criteria and American landscape art in general as not unrelated to the question of national identity. In GWP's text, of course, the phrase *e pluribus unum* also alluded to Gilpin's characterization of picturesque beauty as a condition of variety within unity; GWP's account is all the more interesting for these multiple associations and for the fact that he proclaimed artistic and political sovereignty by way of the vocabulary of European aesthetic convention. The relationship between American art and national identity has been discussed at length in numerous scholarly studies, and for this and other reasons (as stated in the introduction), the issue will not be considered in any detail here. See, e.g., Boime, *The Magisterial Gaze;* Franklin Kelly, *Frederic Edwin Church and the National Landscape* (Washington, DC: Smithsonian Institution Press, 1988); Angela Miller, *The Empire of the Eye: Landscape Representation and American Cultural Politics, 1825–1875* (Ithaca, NY: Cornell University Press, 1993); Novak, *Nature and Culture;* David C. Huntington, *The Landscapes of Frederic Edwin Church: Vision of an American Era* (New York: Braziller, 1966); David C. Miller, *Dark Eden: The Swamp in Nineteenth-Century American Culture* (Cambridge: Cambridge University Press, 1989); William H. Truettner, ed., *The West as America: Reinterpreting Images of the Frontier, 1820–1920* (Washington, DC: National Museum of American Art, 1991); William H. Truettner and Alan Wallach, eds., *Thomas Cole: Landscape into History* (New Haven, CT: Yale University Press, 1994); and Alan Wallach, "Making a Picture of the View from Mount Holyoke," in *American Iconology: New Approaches to Nineteenth-Century Art and Literature,* ed. David Miller (New Haven, CT: Yale University Press, 1993), 80–91.

38. "Art Gossip: Coming Departure of George Inness for Europe—His Latest Work," *New York Evening Post,* March 31, 1870, 1. The *Post* continued: "It was so easy to be a Claude, George thought, and he hugged the old volume to his heart, and he read it once again, and again he dreamed over it." Cikovsky discusses the *Post*'s report in "Inness and Italy," in *The Italian Presence in American Art, 1860–1920,* ed. Irma B. Jaffe (New York: Fordham University Press, 1992), 43.

39. John Barrell, *The Idea of Landscape and the Sense of Place, 1730–1840* (Cambridge: Cambridge University Press, 1972), 8–9.

40. "The Artist's Fund Society," *New Path* 2 (December 1865): 194. Thomas Charles Farrer's painting *Mount Holyoke* (1865) is in the collection of the Mount Holyoke College Art Museum. See also "The Fine Arts: Exhibition at the National Academy of Design: Second Saloon," *Literary World* 1 (June 5, 1847): 419; "The Fine Arts: The Art-Union Pictures (Concluding Notice)," *Literary World* 2 (November 13, 1847): 356; "National Academy of Design: Thirty-Fourth Exhibition," *New York Evening Post,* May 14, 1859, 1; and "Art and Artists: Landscapes in the National Academy," *Independent* 23 (May 25, 1871), 2.

41. *Lucas' Progressive Drawing Book,* published in Baltimore in 1827, provided an illustration of West Point that demonstrated "the method of managing the distance, middle ground, and foreground of a landscape," and in 1847 *Scientific American* published a series of articles on art, including several on landscape painting that instructed the reader to organize compositions according to what were called "the five distances" (*Lucas' Progressive Drawing Book* [Baltimore: Lucas Fielding, Jr., 1827], pt. I, plate 9; "The Art of Painting: Landscape Painting," *Scientific American* 2 [July 3, 1847]: 328). The *Scientific American* series began with the April 24, 1847, issue; discussion of landscape painting commenced May 29, 1847. See also John Henry Hopkins, *The Vermont Drawing Book*

of Landscapes (Burlington, VT, 1838); Fessenden Nott Otis, *Easy Lessons in Landscape, with Instructions for the Lead Pencil and Crayon* (New York: D. Appleton & Co., 1851); Benjamin H. Coe, *Easy Lessons in Landscape Drawing, with Sketches of Animals and Rustic Figures, and Directions for Using the Lead Pencil* (Hartford, CT: Robins & Folger, 1840); Asher Brown Durand, "Letters on Landscape Painting," pts. 1–9, *Crayon,* vol. 1 (1855); and "The Art of Sketching from Nature," pts. 1–3, *Bulletin of the American Art Union* 4 (July 1851): 54–55; (August 1851): 69–71; and (September 1851): 85–87, respectively.

42. N. Parker Willis, "The Highland Terrace above West Point," in *The Home Book of the Picturesque; or, American Scenery, Art, and Literature, Comprising a Series of Essays by Washington Irving, W. C. Bryant, Fenimore Cooper, and Others* (Gainesville, FL: Scholars' Facsimiles & Reprints, 1967), 108. See also "The Sketcher—No. V," *Crayon* 2 (July 4, 1855): 9; "The Sketcher—No. III," *Crayon* 1 (June 13, 1855): 379; and "Landscape-Gardening. Practical—Not Technical," *Crayon* 5 (February 1858): 51. Some commentators, in contrast, derogated the Gaspar- and Claude-derived landscape formula and called paintings that adopted it monotonous and tiresome. Their criticism gives some indication of the prevalence of this compositional type at the time and also attests to the centrality of the configuration in discussions about the nature and aims of landscape representation. See, e.g., Henry T. Tuckerman, "Frederic Edwin Church," *Galaxy* 1 (July 1866): 424; Proteus, "Our Artists," pt. 5, *New York Commercial Advertiser,* February 1862; "Fine Arts: The National Academy of Design," *Galaxy* 7 (June 1869): 911; "The Fine Arts: The National Academy of Design," *Independent* 7 (April 12, 1855): 113; "The Fine Arts: The Art-Union Pictures," *Literary World* 2 (October 30, 1847), 303; and "Character in Scenery: Its Relation to the National Mind," *Cosmopolitan Art Journal* 3 (December 1858): 11.

43. Elliott Daingerfield, *George Inness: The Man and His Art* (New York: Frederic Fairchild Sherman, 1911), 25–26.

44. Henry Ward Beecher, "Art among the People," in *Eyes and Ears* (Boston: Ticknor & Fields, 1862), 265–66.

45. Ralph Waldo Emerson, "Art," in *Essays and Lectures,* ed. Joel Porte (New York: Library of America, 1983), 432. It is interesting to note that, when writing about Inness's now-lost painting *The Sign of Promise,* which was exhibited in 1863, one critic directed the reader to an essay by Emerson, "Culture," published in the *Atlantic Monthly* in 1860 and in the collection *The Conduct of Life* that same year ("Art in Boston," *Independent* 15 [January 22, 1863], 5). Inness's art, as we know, was also characterized by way of Emerson's phrase "nature passed through the alembic of man" (see chap. 1). Emerson's name comes up frequently in scholarly discussions of American landscape painting. See, e.g., Barbara Novak, *American Painting of the Nineteenth Century: Realism, Idealism, and the American Experience* (New York: Praeger, 1969); and John Conron, "'Bright American Rivers': The Luminist Landscapes of Thoreau's 'A Week on the Concord and Merrimack Rivers,'" *American Quarterly* 32 (Summer 1980): 144–66. Much more, however, might be said about the relation of transcendentalist thought to landscape representation, beginning with the complexities of Emerson and Thoreau's texts themselves.

46. Emerson, "The Poet," in *Essays and Lectures,* 456.

47. John Durand and William Stillman, "The Position of the Artist," *Crayon* 1 (March 28, 1855): 193. Stillman was a Swedenborgian. See also "Perception," *Crayon* 2 (August 1, 1855): 63; Jarves, "Art: A New Phase in American Painting," *Independent* 25 (September 18, 1873): 1158; and E. L. Magoon, "Scenery and Mind," in *Home Book of the Picturesque,* 8.

48. Rev. W. S. Kennedy, "Conditions of the Development of National Art," *Cosmopolitan Art Journal* 3 (September 1859): 150, 152. See also Jarves, *The Art-Idea,* 35–36.

49. Russell Sturgis, "American Painters: The National Academy Exhibition," *Galaxy* 4 (June 1867): 234. See also J. Eliot Cabot, "On the Relation of Art to Nature," pt. 1, *Atlantic Monthly* 13 (February 1864): 183, 185, 186.

50. See, e.g., BB, "Letters on Art—No. XXVII: The Pre-Raphaelites," *Independent* 9 (November 19, 1857): 2; Ion Perdicaris [pseud.], "English and French Painting," *Galaxy* 2 (October 15, 1866): 380; "Art," *Atlantic Monthly* 29 (March 1872): 375–76; and "Exhibition of the National Academy of Design," *Knickerbocker Magazine* 45 (May 1855): 533.

51. "Exhibition of the National Academy of Design," *Knickerbocker Magazine* 45 (May 1855): 533.

52. Henry Ward Beecher, "Nature a Minister of Happiness," in *Star Papers; or, Experiences of Art and Nature* (New York: J. C. Derby, 1855), 305–6, and "Art among the People," 265–66.

53. Henry Ward Beecher, "Object Lessons," in *Eyes and Ears,* 244–45; Rembrandt Peale, *Graphics, the Art of Accurate Delineation: A System of School Exercise, for the Education of the Eye and the Training of the Hand, as Auxiliary to Writing, Geography, and Drawing* (Philadelphia: Edward C. Biddle, 1845), 3, iii. See also Coe, *Easy Lessons in Landscape Drawing,* n.p.; and John Rubens Smith, *A Key to the Art of Drawing the Human Figure* (Philadelphia: Samuel M. Steward, 1831), quoted in Peter C. Marzio, *The Art Crusade: An Analysis of American Drawing Manuals, 1820–1860* (Washington, DC: Smithsonian Institution Press, 1976), 31. Among other things, Marzio discusses the perceived link between drawing and learning to see (esp. 24–30).

54. J. G. Chapman, "Drawing in Public Schools," *Crayon* 6 (January 1859): 1. Chapman's *The American Drawing Book* was published in chapters beginning in 1847 and in complete form by 1858.

55. See, e.g., Coe, *Easy Lessons in Landscape Drawing;* Hopkins, *The Vermont Drawing Book of Landscapes;* William B. Fowle, trans., *An Introduction to Linear Drawing Translated from the French of M. Francoeur: With Alterations and Additions to Adapt It to the Use of Schools in the United States* (Boston: Hilliard, Gray, Little, & Wilkins, 1828); John Rubens Smith, *The Juvenile Drawing Book; Being the Rudiments of the Art, in a Series of Progressive Lessons* (Philadelphia: John W. Moore, 1843); Edward Seager, *No. 1 of Progressive Studies of Landscape Drawing. . . . Adapted to the Practice of Sketching from American Scenery* (Boston: J. H. Bufford, 1849); and John Ruskin, *The Elements of Drawing,* in *The Works of John Ruskin,* ed. E. T. Cook and A. Wedderburn (London: George Allen, 1904), 15:1–228.

56. Otis, *Easy Lessons in Landscape,* 21. See also *Lucas' Progressive Drawing Book,* pt. 1, pls. 5 and 6; and Hopkins, *The Vermont Drawing Book of Landscapes,* plate 2.

57. G. M. James, "The Landscape Element in American Poetry: Bryant," *Crayon* 1 (January 3, 1855): 3.

58. Durand, "Letters on Landscape Painting," pt. 3 of 9, *Crayon* 1 (January 31, 1855): 66.

59. Otis, *Easy Lessons in Landscape,* plate 10. Otis pointed out that the rendition of foliage was one of "the most difficult of the works of art. . . . Any effort to copy its minute formation . . . would prove not only laborious, but a never-ending and unsatisfactory task." For this reason, he continued, "some stenographic method must be used, by which [nature's] forms and peculiar characteristics may be easily and truthfully represented" (6).

60. I should add that many of these elements may have been suggested by the paintings of the Barbizon school. Inness, who visited the Rijksmuseum in the spring of 1854, was also interested in seventeenth-century Dutch landscape painting and the work of Jacob van Ruisdael (ca. 1628–82) and Meindert Hobbema (1638–1709), especially. Inviting foreground paths populate the work of both these artists, as they do the landscapes of Théodore Rousseau, and in a number of the Dutchmens' landscapes, a tree or stand of trees occupies the center or near-center of the pictorial field. "I remember that picture," Inness said of one of his works. "I was thinking of Hobbema when I painted it" (quoted in Cikovsky, *George Inness* [1993], 39). In 1860, a painting by the artist, most likely *A Passing Shower* (1868), was compared to Ruisdael's "dewy scenes"; another critic called it a "picture of extraordinary power; a Ruysdael like effect in the composition, and comparable to Rousseau only in subtlety of color" ("Art Items," *New York Daily Tribune,* September 29, 1860, 4; "Fine Arts," *World* [September 26, 1860], 5). In his study of the artist, Cikovsky describes Dutch art as only one in a series of influences (first Claude Lorrain and Gaspard Dughet, then Dutch landscape, and then the Barbizon school; Cikovsky, *George Inness* [1993], 29).

61. Artists such as Thomas Cole and Asher B. Durand, of course, often included back-turned figures in their landscape compositions, and their use of such a motif deserves more attention than I give it here.

62. George Inness, "A Painter on Painting," *Harper's New Monthly Magazine* 56 (February 1878): 461.

63. Ibid. See also G. W. Sheldon, "Characteristics of George Inness," *Century Magazine*, n.s., 27 (February 1895): 532.

64. For visual memory, see, e.g., Durand, "Letters on Landscape Painting," pt. 8 of 9, *Crayon* 1 (June 6, 1855): 354; Jarves, *The Art-Idea*, 191; Tuckerman, "Frederic Edwin Church," 428; "Art: The Heart of the Andes," *Atlantic Monthly* 4 (July 1859): 128; "The Heart of the Andes," *Crayon* 6 (June 1859): 193; Henry T. Tuckerman, *Book of the Artists: American Artist Life* (New York: G. P. Putnam & Son, 1867), 376; and "Pre-Raphaelitism," *Bulletin of the American Art Union* 4 (October 1, 1851): 103. For memory and instruction, see, e.g., "Art," *Atlantic Monthly* 32 (August 1873): 244; "The Academy Exhibition—No. I," *Crayon* 1 (March 28, 1855): 203; "Exhibition of the Academy of Design," pt. 2, *Crayon* 1 (April 4, 1855): 218; "Studying from Nature," *Crayon* 1 (June 6, 1855): 353; Chapman, "Drawing in Public Schools," 1; Ruskin, "On Education in Art," *Crayon* 6 (January 1859): 28–31; "Studying from Nature," *Crayon* 1 (June 6, 1855): 353; and C. D. Gardette, "Pestalozzi in America," *Galaxy* 4 (August 1867): 432–39. Marzio discusses Pestalozzi's ideas in *The Art Crusade* (esp. chap. 3). For the "memory criterion," see, e.g., GWP, "Some Remarks on the Landscape Art," pt. 2, 17, 18, and "Critical and Descriptive Articles: Painting and Music," *Bulletin of the American Art Union* 3 (July 1850): 52; "The Fine Arts: Exhibition of the National Academy," pt. 2, *New York Daily Tribune*, April 24, 1852, 5; "Our Artists," pt. 5, *New York Commercial Advertiser*, February 22, 1862; "Nebulae," *Galaxy* 1 (June 1, 1866): 273; "Fine Arts: Thirty-Eighth Annual Exhibition of the National Academy of Design," *Independent* 15 (June 25, 1863): 6; BB, "The Exhibition of the Academy," *Independent* 9 (May 28, 1857): 2, and "The National Academy," *Independent* 11 (April 21, 1859): 1. Inness's early landscapes were often described as memorable. In 1860, the *Independent* stated that "it is some two years since we first saw any of Innis's [*sic*] works—a lovely little study of North River scenery— which has ever since been treasured in our memory as a gem." In 1866, a critic for the *New York Evening Post* wrote that he was "pleased with the sentiment and tone of Inness's pictures—they re- main with us, and they make us serious." Two of Inness's landscapes on view at the gallery of Doll and Richards in 1875, the *Boston Evening Transcript* reported, "would live and forever tell their story of distinguishing climatic and national peculiarity" (Mrs. Conant, "George Innis [*sic*]," *Independent* 12 [December 20, 1860]; Sordello [Eugene Benson], "American Landscape Painters—I: George Inness and S. R. Gifford," *New York Evening Post*, March 30, 1866, 1; and "Art News," *Boston Evening Tran- script*, May 19, 1875.

65. Tuckerman, *Book of the Artists*, 25. This passage appeared in an earlier publication, Tucker- man's "New-York Artists," *Knickerbocker Magazine* 48 (July 1856): 26–42, in which the critic also noted the associative function of paintings by the artist J. F. Cropsey. "During this half-hour in Cropsey's studio," he wrote, "I have been lured to Rome, to the Catskills and the Passaic, to the Ramapo Valley and to Newport; and each locality, beside refreshing my eye with natural beauty, has wakened fond reminiscence" (35).

66. Rev. J. Leonard Corning, "Art: A Private Picture Gallery, and How to Make It," *Independent* 26 (July 23, 1874): 7.

67. Ibid.

68. Samuel Osgood, "Our Artists," *Harper's New Monthly Magazine* 28 (January 1864): 242–43. See also "Character in Scenery: Its Relation to the National Mind," *Cosmopolitan Art Journal* 3 (December 1858): 10; and "Exhibition of the National Academy of Design," pt. 2, *Crayon* 1 (April 4, 1855): 219.

69. See, e.g., Cikovsky, "George Inness and the Hudson River School," and "The Civilized Land- scape," *American Heritage* 36 (April/May 1985): 32–35; Robert Jolly, "George Inness's Swedenbor- gian Dimension," *Southeastern College Art Conference Review* 11 (1986): 18; and Leo G. Mazow, "George Inness: Problems in Antimodernism" (Ph.D. diss., University of North Carolina, Chapel Hill, 1996), chap. 5. Leo Marx has discussed the manner in which *The Lackawanna Valley* adapted pas- toralism to technological advance and industrialization ("Does Pastoralism Have a Future?" *Studies in the History of Art*, vol. 36 [Washington, DC: Center for Advanced Study in the Visual Arts, 1992], 209–25). See also Marx, "The Railroad-in-the-Landscape: An Iconological Reading of a Theme in American Art," in *The Railroad in American Art: Representations of Technological Change*, ed. Susan Danly and Leo Marx (Cambridge, MA: MIT Press, 1988), 183–209, and *The Machine in the Garden:*

Technology and the Pastoral Ideal in America (New York: Oxford University Press, 1964).

70. Nathaniel Hawthorne, *The Marble Faun; or, The Romance of Monte Beni,* in *The Complete Novels and Selected Tales of Nathaniel Hawthorne,* ed. Norman Holmes Pearson (New York: Modern Library, 1937), 590.

71. William M'Leod, "The Summer Tourist—Scenery of the Franconia Mountains, N.H.," *Harper's New Monthly Magazine* 5 (June 1852): 11. Not everyone saw such deficiency as a shortcoming. Thomas Cole, in his "Essay on American Scenery" (1836), addressed "what has been considered a grand defect in American scenery—the want of associations, such as arise amid the scenes of the old world." American scenes are not destitute of historical and legendary associations, he famously claimed, for "the great struggle for freedom has sanctified many a spot, and many a mountain, stream, and rock has its legend, worthy of poet's pen or the painter's pencil. But American associations are not so much of the past as of the present and the future" (*American Monthly Magazine,* n.s., 1 [January 1836]: 1–12, reprinted in *American Art, 1700–1960: Sources and Documents,* ed. John W. McCoubrey [Englewood Cliffs, NJ: Prentice Hall, 1965], 108). Durand also celebrated the American landscape's lack of historical memory ("yet spared from the pollutions of civilization," as he wrote) and insisted that the artist who attended to its newness would produce truly original work ("Letters on Landscape Painting," pt. 2 of 9, *Crayon* 1 [January 17, 1855], 35). See also "The Fine Arts: Exhibition of the National Academy of Design," pt. 3, *Literary World* 10 (May 8, 1852): 331. Earl A. Powell III has discussed Cole's attempts at creating a unique form of history painting, that is, a landscape mode that made claims about theology, philosophy, and aesthetics; evoked religious, historical, and legendary associations; and celebrated the divinity of the American wilderness. See his "Thomas Cole and the American Landscape Tradition: The Naturalist Controversy" and "Thomas Cole and the American Landscape Tradition: Associationism," *Arts Magazine* 52 (February 1978): 114–23, and (April 1978): 113–17, respectively. Durand's and Cole's view, shared by the writers just cited, reflected a larger argument concerning the merits of American scenery as compared to that of Europe as well as the virtues of painting American landscapes instead of European ones. See, e.g., "The Fine Arts: Exhibition at the National Academy," *Literary World* 1 (May 15, 1847): 347; "The Fine Arts: National Academy Exhibition," *Literary World* 3 (May 27, 1848): 328; "Character in Scenery: Its Relation to the National Mind," *Cosmopolitan Art Journal* 3 (December 1858): 9–11; and "Art and Artists," *Independent* 20 (December 3, 1868): 2.

72. N.N., "Twenty-Sixth Exhibition of the National Academy of Design," *Bulletin of the American Art Union* 4 (May 1, 1851): 21.

73. Malcolm Andrews discusses this device in *The Search for the Picturesque: Landscape Aesthetics and Tourism in Britain, 1760–1800* (Aldershot: Scolar Press, 1989), chap. 2, as does Barrell, *The Idea of Landscape,* chap. 1.

74. Barrell, *The Idea of Landscape,* 8–9.

75. "Painting and Poetry," *Crayon* 3 (December 1856): 362.

76. Henry Ward Beecher, "Hours of Exaltation," in *Eyes and Ears,* 37. Son of the Presbyterian minister Lyman Beecher and brother of Harriet Beecher Stowe, Henry Ward Beecher (1813–87) held two Presbyterian pastorates in Indiana, one in Lawerenceburg, the other in Indianapolis, before he began his tenure at the Plymouth Congregationalist Church in Brooklyn, New York, in 1847. There, he preached to crowds of two to three thousand people and became a popular as well as influential figure in nineteenth-century American cultural and religious life. In 1861, Beecher was made editor of the *Independent,* having been a contributor for several years. See W. C. Griswold, *Griswold's Life of Henry Ward Beecher* (Centerbrook, CT: W. C. Griswold & Co., 1887); Halford R. Ryan, *Henry Ward Beecher: Peripatetic Preacher* (New York: Greenwood Press, 1990); and Paxton Hibben, *Henry Ward Beecher: An American Portrait* (New York: Beekman Publishers, 1974). As Cikovsky has noted, Beecher and Inness probably became acquainted by 1860; Beecher owned one of the artist's works by this time and there were five in his collection when he died in 1887 ("Life and Work," 32, 184–85). Montgomery Schuyler stated that Beecher, "to the credit of his perceptions, was an early and habitual buyer of Innesses." When "somebody asked him whom he considered the first of American painters," the critic reported, Beecher unhesitatingly answered "Inness. 'And who is the worst?' 'Inness' came again, with as little hesitation" ("George Inness," 787). Inness's student J. A. S.

Monks described Beecher as a "friend and backer" of the artist (*Boston Evening Transcript*, August 27, 1894, quoted in Cikovsky, "Life and Work," 32). As both Sheldon and Inness's son reported, Beecher gave the title to Inness's 1862 allegorical painting *The Light Triumphant* (Sheldon, *American Painters*, 30; G. Inness, Jr., *Life, Art, and Letters*, 245).

77. For a historical and historiographical discussion of religion and American visual culture, see Sally M. Promey, "The 'Return' of Religion in the Scholarship of American Art," *Art Bulletin* 85 (September 2003): 581–603.

78. Henry Ward Beecher, "Niagara Falls, but Not Described," in *Eyes and Ears*, 174–76.

79. Henry Ward Beecher, "A Ride to Fort Hamilton," in *Star Papers*, 201–2. See also Beecher, "Towns and Trees," in *Star Papers*, 133, wherein trees are described as mingling "the olden time with the present." Beecher called the oak "venerable by association" but said that the elm was the "*ideal* of trees; the true Absolute Tree!" because it suggested ideas of strength, uprightness, majesty, grace, and beauty (135–36). See also "A Discourse of Flowers," in *Star Papers*, 101–2, and "Hours of Exaltation," in *Eyes and Ears*, 36–37.

80. Archibald Alison, *Essays on the Nature and Principles of Taste* (Edinburgh: Bell & Bradfute, 1811), 1:xi. In his article on Thomas Cole and associationism, Powell discusses the dissemination and influence of Alison's essays in the United States and describes the relation of associationist thought to Cole's practice ("Thomas Cole and the American Landscape Tradition: Associationism"). The artist, he argues, combined the "formal imperatives of the picturesque" with images that had "clear associative value," drawn from American history and legend, in order to produce a visual and symbolic system that established the historical and divine significance of the American landscape (117). Powell's argument differs from mine in that it limits itself to questions of subject matter; Alison, through Beecher and others, offered Inness not a repertoire of things to paint (i.e., picturesque and significant moments from history and legend that provoked feelings of pleasure and sublimity) but, rather, a way of understanding and configuring the experience of perception itself. Alison's *Essays* are not just about what we see, but how, and his theory of association concerns itself with the structures of thought and vision involved in looking at nature and art. As does Powell, Angela Miller considers the relation of Alison's theories to American landscape painting in terms of subject matter, or what she calls a "nationalist aesthetics." The "associational power of images," she writes, "reinforced a developing nationalist ideology. While preserving nature's totemic function, it simultaneously placed it in the service of the powerful colonizing energies of American settlement and industry by linking landscape to a specific cultural narrative." According to Miller, associational psychology "answered the need to contain the fluid and unauthorized possibilities opened up once the search for meaning began to respond to the prompting of the private self" (*The Empire of the Eye*, 79, 82, 102). See also Novak, *Nature and Culture*, chap. 7.

81. Alison, *Essays*, 6. Edmund Burke, of course, had argued otherwise in his *Enquiry*. Alison did concede that "although the qualities of matter are in themselves incapable of producing emotion, or the exercise of any affection . . . they may produce this effect, from their association with other qualities," rather than with an individual's memories, "and as being either the signs or expressions of such qualities as are fitted by the constitution of our nature to produce Emotion" (178). The emotions that derive from the picturesque, Alison claimed, do so in just such a manner (43).

82. Ibid., 58.

83. James Henry, "The Transition from the Un-Beautiful to the Beautiful," *Crayon* 1 (May 23, 1855): 322.

84. James Henry, "Pennsylvania Forest Scenery," *Crayon* 1 (February 28, 1855): 130–31. See also Wilson Flagg, "Beauty of Trees," *Atlantic Monthly* 21 (June 1868): 643, 641.

85. X, "Artistic Growls," *New York Evening Post*, June 7, 1865, 1.

86. Henry Ward Beecher, "Warwick Castle," in *Star Papers*, 18.

87. Ibid., 19–20.

88. Henry Ward Beecher, "The Louvre—Luxembourg Gallery," in *Star Papers*, 59–60.

89. Michael Fried identifies and accounts for what he calls Diderot's "pastoral conception" of painting in his *Absorption and Theatricality: Painting and Beholder in the Age of Diderot* (Berkeley

and Los Angeles: University of California Press, 1980; reprint, Chicago: University of Chicago Press, 1988). See also Ian J. Lochhead's study *The Spectator and the Landscape in the Art Criticism of Diderot and His Contemporaries* (Ann Arbor, MI: UMI Research Press, 1982).

90. See William Gilpin, *Three Essays: On Picturesque Beauty; On Picturesque Travel; and On Sketching Landscape, to which is added a poem, On Landscape Painting* (London: R. Blamire, 1792); and Uvedale Price, *An Essay on the Picturesque: As Compared with the Sublime and the Beautiful, and, On the Use of Studying Pictures, for the Purpose of Improving Real Landscape* (London: J. Robson, 1796). For a discussion of the influence of picturesque theory on American art and art-critical writing, see Earl A. Powell III, "Thomas Cole and the American Landscape Tradition: The Picturesque," *Arts Magazine* 52 (March 1978): 110–17; Robyn Asleson and Barbara Moore, *Dialogue with Nature: Landscape and Literature in Nineteenth-Century America* (Washington, DC: Corcoran Gallery of Art, 1985); Edward J. Nygren et al., *Views and Visions: American Landscapes before 1830* (Washington, DC: Corcoran Gallery of Art, 1986), esp. essays by Nygren, "From View to Vision," 3–81, and Bruce Robertson, "The Picturesque Traveler in America," 187–211; Sue Rainey and Roger B. Stein, *John Douglas Woodward: Shaping the Landscape Image, 1865–1910* (Charlottesville: Bayly Art Museum, University of Virginia, 1997); and Elizabeth Johns et al., *New Worlds from Old: Nineteenth-Century Australian and American Landscapes* (Canberra: National Gallery of Australia; Hartford, CT: Wadsworth Atheneum, 1998).

91. Durand, "Letters on Landscape Painting," pt. 3 of 9, *Crayon* 1 (January 31, 1855): 66.

92. Durand, "Letters on Landscape Painting," pt. 4 of 9, *Crayon* 1 (February 14, 1855): 98.

93. "National Academy of Design," *Knickerbocker Magazine* 33 (May 1849): 470; emphasis added. Another critic, writing four years later, called Church's landscapes "truly wonderful productions" and said they "enable one to lay out an imaginary journey over hills, across streams, to take sail on the slightly-ruffled lake, or make a friendly call in one of those away-off farmhouses" ("Exhibition of the National Academy of Design," *Knickerbocker Magazine* 42 [July 1853]: 94).

94. NN, "The Exhibition of the National Academy," *Bulletin of the American Art Union* 3 (May 1850): 21. See also Proteus [pseud.], "National Academy of Design: Second Article," *New York Commercial Advertiser,* May 22, 1862.

95. Outsider [pseud.], "The National Academy of Design: A Visit to the Exhibition," *Independent* 19 (April 25, 1867): 1. See also "A Last Visit to the National Academy," *Independent* 10 (June 17, 1858): 1; "The Fine Arts: Exhibition at the National Academy: Second Saloon," *Literary World* 1 (May 29, 1847): 397; "The Fine Arts: Exhibition of the National Academy of Design," pt. 3, *Literary World* 10 (May 8, 1852): 331; Tuckerman, "Frederic Edwin Church," 423; "Editor's Easy Chair," *Harper's New Monthly Magazine* 29 (July 1864): 265; "Art," *Atlantic Monthly* 29 (January 1872): 116; "Art," *Atlantic Monthly* 34 (September 1874): 375–76; "Editor's Easy Chair," *Harper's New Monthly Magazine* 19 (July 1859): 271; "The Fine Arts: The Art-Union Pictures," *Literary World* 2 (October 30, 1847): 302; NN, "The Exhibition of the National Academy," *Bulletin of the American Art Union* 3 (May 1850): 21; "Church's 'Heart of the Andes,'" *Cosmopolitan Art Journal* 3 (June 1859): 133; and Tuckerman, *Book of the Artists,* 189.

96. "Fine Arts," *New York Evening Post,* September 11, 1865, 2. Paintings were often praised in writing about art at this time for their ability to offer respite from the urban workaday world of commerce and toil.

97. "A Last Visit to the National Academy," *Independent* 10 (June 17, 1858): 1.

98. Tuckerman, *Book of the Artists,* 527.

99. Henry T. Tuckerman, "Inness's New Picture: Boston, February 26, 1863," *New York Evening Post,* March 3, 1863, reprinted in ibid., 528.

100. Tuckerman, *Book of the Artists,* 529. Edgar Fawcett's response to *Peace and Plenty* was similar: "The eye roams here and there about this really enormous picture, with a veritable out-of-door sensation. One imagines himself lying at ease in some meadow, only a slight distance away from some harvester who stands among the golden stacks of sheaves. If there is too much 'breadth' here, too manifest a shunning of anything that resembles finicality, the whole canvas has nevertheless a gentle, wholesome glory" ("An American Painter: George Inness," *Californian* 4 [December 1881]: 460).

101. "The Fine Arts: The Inness Collection," *Boston Daily Advertiser,* May 15, 1875; emphasis added.

102. Jarves, *The Art-Idea,* 195.

103. Ibid., 205.

104. Ibid., 205–6.

105. Henry Ward Beecher, "Warwick Castle," in *Star Papers,* 19–20.

106. Henry Ward Beecher, "A Sabbath at Stratford-on-Avon," in *Star Papers,* 28.

107. Henry Ward Beecher, "Snow Power," in *Eyes and Ears,* 45–46.

108. "National Academy of Design," *Knickerbocker Magazine* 33 (May 1849): 470.

109. Alison, *Essays,* 1:6.

110. Ibid., 11.

111. Ibid.

112. Ibid., 21–22.

113. Henry Ward Beecher, "Second Summer Letter," in *Eyes and Ears,* 43. See also Beecher, "Autumn Colors," in *Eyes and Ears,* 356–57.

114. Beecher, "The Louvre—Luxembourg Gallery," 59–60.

115. Henry Ward Beecher, "Oxford," in *Star Papers,* 52.

116. "Art: Some Landscapes at the Academy," *Appletons' Journal* 11 (May 9, 1874): 603.

117. H., "When Is an Artist True to Himself?" *Boston Evening Transcript,* February 19, 1862. H. attributed Inness's mode of facture, as did many critics, to the influence of the painters of "the French School," including those of the Barbizon group, and Rousseau especially. Debates over technique in writing about art at this time often pitted champions of finish against commentators sympathetic to works that appeared sketchy or painty and/or bore the mark of European influence.

118. "Science and Art," *Knickerbocker Magazine* 63 (January 1864): 94.

119. Sordello [Eugene Benson], "National Academy of Design: Fortieth Annual Exhibition," 1.

120. Sordello [Eugene Benson], "George Inness and S. R. Gifford," 1. See also Proteus [pseud.], "Sixth Reception of the Brooklyn Art Association," *New York Commercial Advertiser,* March 4, 1863; and "The Lounger: The National Academy," pt. 2, *Harper's Weekly* 6 (May 10, 1862): 290.

121. I borrow the idea of assuming and accommodating a look from Joseph Leo Koerner, *Caspar David Friedrich and the Subject of Landscape* (New Haven, CT: Yale University Press, 1990), 181.

122. I thank Esperança Camara for her observations regarding this phenomenon.

123. Inness expressed his preference for exhibiting his paintings in groups in a conversation with a writer for the *New York Herald* who reported on the controversy surrounding the artist's submission to the Paris Exposition ("That Picture for Paris Row," *New York Herald,* March 9, 1889, 4).

124. This is also the case in *Leeds in the Catskills, with the Artist Sketching* (ca. 1868), where an isolated tree is paired with a figure seated nearby. Because many of Inness's trees occupy the middle ground where, according to GWP, action was supposed to take place and enchain the eye, one might say that these trees assume the status of the figural; in this way, their centrality and their human-seeming presence invite viewers to see each of these tree-bodies in relation to their own.

125. Tuckerman reported that "Ruskin, when he first saw Church's Niagara, pointed out an effect of light upon water which he declared he had often seen in nature, especially among the Swiss waterfalls, but never before on canvas; and so perfect is the optical illusion of the iris in the same marvellous picture that the circumspect author of the Modern Painters went to the window and examined the glass, evidently attributing the prismatic bow to the refraction of the sun" ("Frederic Edwin Church," 423).

126. "A Chapter on Rainbows in Landscapes," *Crayon* 7 (February 1860): 40–41.

127. The figure in *Clearing Up* (1860; George Walter Vincent Smith Art Museum, Springfield, MA), while not back-turned, also wears a bright red garment. The red-vested figure appears in Inness's later works as well. See, e.g., *Near Perugia in Spring* (1879; private collection) and *Early Morning, Tarpon Springs* (1892; fig. 61).

128. Inness, "Colors and Their Correspondences," *New Jerusalem Messenger* 13 (November 13, 1867): 78–79, reprinted in Sally M. Promey, "The Ribband of Faith: George Inness, Color Theory, and the Swedenborgian Church," *American Art Journal* 26 (1994): 59.

129. Inness to A. D. Williams, August 13, 1872, reprinted in Leroy Ireland, *The Works of George Inness: An Illustrated Catalogue Raisonné* (Austin and London: University of Texas Press, 1965), 135.

130. Susi F. Williams to Mr. and Mrs. Hersey (n.d.), photocopy in artist files, Museum of Fine Arts, Boston.

131. Durand, "Letters on Landscape Painting," pt. 5 of 9, *Crayon* 1 (March 7, 1855): 146; emphasis added.

132. Ibid.

133. My discussion of these motifs owes much to the insight of Peter Low.

134. In his *Lectures on Art,* published in 1850, Washington Allston described what might be called a participatory response to the landscapes of Claude, the very artist whose example Inness wished to transform:

> The *spell* then opens ere it seems to have begun, acting upon us with a vague sense of limitless expanse, yet so continuous, so gentle, so imperceptible in its remotest gradations, as scarcely to be felt, till, combining with unity, we find the feeling embodied in the complete image of intellectual repose,—fulness and rest. The mind thus disposed, the charmed eye glides into the scene: a soft, undulating light leads it on, from bank to bank, from shrub to shrub; now leaping and sparkling over pebbly brooks and sunny sands; now fainter and fainter, dying away down shady slopes, then seemingly quenched in some secluded dell; yet only for a moment,—for a dimmer ray again carries it onward, gently winding among the boles of trees and rambling vines, that, skirting the ascent, seem to hem in the twilight; . . . and now, as in a flickering arch, the fascinated eye seems to sail upward like a bird, wheeling its flight through a mottled labyrinth of clouds, on to the zenith; whence, gently inflected by some shadowy mass, it slants again downward to a mass still deeper, and still to another, and another, until it falls into the darkness of some massive tree,—focused like midnight in the brightest noon: there stops the eye, instinctively closing, and giving place to the Soul, there to repose and to dream her dreams of romance and love. (*Lectures on Art* [Gainesville, FL.: Scholars' Facsimiles and Reprints, 1967], 149–50)

The eye is charmed; the mind falls into reverie, forgetting that it contemplates a picture and, thus, imaginatively, enters it. The eye's journey is unobstructed; it has free range over meadow, lake, mountain, and stream. It does not stop until it has progressed, in a picturesque but orderly fashion, to the far distance; on its way there, the gaze passes through alternating areas of light and shade— "a soft, undulating light leads it on," "gently inflected by some shadowy mass"—that structure and guide its course. Perhaps it was this sort of experience, wherein the eye easily traversed a scene, leaving the body behind, its surroundings "scarcely to be felt," for which Inness hoped to provide an antidote, replacing imperceptible gradations with thickly applied and attention-grabbing paint, unmarked horizons with obstructing screens of trees.

135. E., "Mr. Inness on Art-Matters," *Art Journal* 5 (1879): 376; emphasis added.

136. "National Academy of Design, North Room," *New York Times,* May 29, 1865, 4–5; emphasis added. Ireland, *The Works of George Inness,* no. 322.

137. "Art Notes," *Appletons' Journal* 9 (January 25, 1873): 157.

CHAPTER 5

1. Inness's son reported that "one of the canvases [*The Vision of Faith*] was destroyed in the Chicago fire, and another, the 'Delectable City' [*The New Jerusalem*], was destroyed or damaged in an accident at the Madison Square Garden" (G. Inness, Jr., *Life, Art, and Letters* [New York: Century Co., 1917], 69). Michael Quick, who generously shared his theories with me, suggests that *The New Jerusalem* was damaged, but not destroyed, when the roof of the exhibition building collapsed in 1880; Inness then salvaged portions of the canvas, repainting the Walters fragment but not the

other two. In his *catalogue raisonné*, Leroy Ireland called the fragment sold at Sotheby's in 1992 *Valley Road* (*The Works of George Inness: An Illustrated Catalogue Raisonné* [Austin and London: University of Texas Press, 1965], no. 706); it was titled *Visionary Landscape* in the auction catalog (*American Paintings, Drawings, and Sculpture* [New York: Sotheby's, December 3, 1992], lot no. 47). The Walters fragment is currently titled *Valley of the Olives* (Ireland, *Catalogue Raisonné*, no. 417); the Krannert's is titled *Evening Landscape* (Ireland, *Catalogue Raisonné*, no. 396).

2. G. Inness, Jr., *Life, Art, and Letters*, 68. Years later, Fletcher Harper, the owner of *The Valley of the Shadow of Death*, asked Walt Whitman to write a poem to accompany the painting; the poem appeared in *Harper's New Monthly Magazine* in 1892 (Walt Whitman, "Death's Valley," *Harper's New Monthly Magazine* 84 [April 1892]: 707–9).

3. James William Pattison, "George Inness, N.A.," in *Catalogue of the Loan Exhibition of Important Works by George Inness, Alexander Wyant, Ralph Blakelock* (Chicago: Galleries of Moulton and Ricketts, 1913), n.p. For information on Pattison, see Sally M. Promey, "The Ribband of Faith: George Inness, Color Theory, and the Swedenborgian Church," *American Art Journal* 26 (1994): 52.

4. See, e.g., *Diana Surprised by Actaeon* (ca. 1848) (Ireland, *Catalogue Raisonné*, no. 46) and *The Triumph of Calvary* (ca. 1874 [Ireland, *Catalogue Raisonné*, no. 672]).

5. For the engraving, see "American Painters—George Inness," *Art Journal* 2 (March 1876): 84; and George W. Sheldon, *American Painters* (New York: D. Appleton & Co., 1879), plate 81.

6. "Fine Arts: Academy of Design," *New York World*, April 26, 1862. See also Proteus, "Art in New York: National Academy of Design," *New York Commercial Advertiser*, April 4, 1862.

7. G. Inness, Jr., *Life, Art, and Letters*, 245 and Sheldon, *American Painters*, 30. Of course, as Nicolai Cikovsky, Jr., notes, Beecher's title may have had "little or nothing to do with Inness's purpose in painting the picture" ("Life and Work of George Inness" [Ph.D. diss., Harvard University, 1965], 191).

8. *"The Sign of Promise." By George Inness. Now on Exhibition at Snedicor's* [sic] *Gallery, 768 Broadway, New York*, n.p.

9. James Jackson Jarves, "Inness's 'Sign of Promise,'" *Boston Evening Transcript*, January 7, 1863, 2. See also *New York Evening Post*, November 20, 1863, 2; "Art Items," *New York Evening Post*, June 2, 1863; and "Inness's New Picture: Boston, February 26, 1863," *New York Evening Post*, March 3, 1863. Jarves's remarks were extensively excerpted in the pamphlet that accompanied the exhibition of the painting at Snedecor's and also in the review "Pictures on Exhibition," *New Path* 1 (December 1863): 99–100. Not surprisingly, the author of the *New Path* article called Inness's attempt at allegorical landscape "evil," "unbearable," and the "worst he can do" (101). He took issue with what Jarves and Inness's pamphlet implied was the artist's attempt to provide an antidote to the unmeaning naturalism, or "dexterous manipulation," of artists such as Church and, by extension, the American Pre-Raphaelites, whom the *New Path* championed.

10. For a recent discussion of *Peace and Plenty*, see Leo G. Mazow, "George Inness: Problems in Antimodernism" (Ph.D. diss., University of North Carolina, Chapel Hill, 1996), chap. 2. It has been suggested that Inness's *Peace and Plenty* (1865) was painted over a still-wet *The Sign of Promise*, a proposal that has been challenged in recent scholarship. See G. Inness, Jr., *Life, Art, and Letters*, 46–47; Cikovsky, "Life and Work," 42, 192; Promey, "The Ribband of Faith," 63n. 33; Kathleen Luhrs, ed., *American Paintings in the Metropolitan Museum of Art* (New York: Metropolitan Museum of Art, 1980), 2:253; Angela Miller, *The Empire of the Eye: Landscape Representation and American Cultural Politics, 1825–1875* (Ithaca, NY: Cornell University Press, 1993), 113–14; and Mazow, "George Inness: Problems in Antimodernism," 51.

11. Promey, "The Ribband of Faith," 51, 52, 59. Promey's essay, which makes the important point that for Inness, the process of painting itself was a means to spirituality (55), is the most thorough account of Inness's allegorical project to date.

12. Cikovsky, "Life and Work," 199–202. See also Eugene Taylor's discussion of *The Triumph of the Cross* in "The Interior Landscape: George Inness and William James from a Swedenborgian Point of View," *Archives of American Art Journal* 37 (1997): 2–10.

13. Promey, "The Ribband of Faith," 55.

14. Cikovsky, "Life and Work," 200–201. Pattison discounted Inness's involvement in the New Church altogether. We do not regret, he wrote, "that the artist's Swedenborgianism, however much he loved it, was, for the major part of his life, but little manifest" (Pattison, "George Inness, N.A.," n.p.).

15. For a discussion of this sort of textual motivation, see Stanley E. Fish, *Self-Consuming Artifacts: The Experience of Seventeenth-Century Literature* (Berkeley and Los Angeles: University of California Press, 1972), chap. 4.

16. A second version of *The Voyage of Life,* completed in 1842, is in the collection of the National Gallery of Art, Washington, DC. For further discussion of allegorical painting in the United States, see Franklin Kelly, "American Landscape Pairs of the 1850s," *Antiques* 146 (November 1994): 650–57

17. Henry T. Tuckerman, *Book of the Artists: American Artist Life* (New York: G. P. Putnam & Son, 1867), 529.

18. "Two Painters," *Round Table* 5 (June 1, 1867): 343.

19. "Inness's Allegorical Pictures," *New York Evening Post,* May 11, 1867, 4.

20. "Twenty-Sixth Exhibition of the National Academy of Design," *Bulletin of the American Art Union* 4 (May 1, 1851): 22–23.

21. "Allegory in Art," *Crayon* 3 (April 1856): 114.

22. Ibid.

23. Ibid. The critic GWP discussed the limits of painting and poetry and the relation of the one art to the other in "Critical and Descriptive Articles: Painting and Music," *Bulletin of the American Art Union* 3 (July 1850): 51–53, "Lessing's Laocoön," *Bulletin of the American Art Union* 3 (August 1850): 73–75, and "On the Choice of Subjects for Pictures," *Bulletin of the American Art Union* 3 (September 1850): 94–96.

24. "Art and Artists," *Independent* 21 (June 10, 1869): 2.

25. "Editor's Easy Chair," *Harper's New Monthly Magazine* 14 (December 1856): 130; emphasis added.

26. Thomas Cole's allegorical landscapes were accompanied by texts when they were exhibited. This may have made them more intelligible to some viewers, but others may have deemed them inadequate precisely because they required textual accompaniment. The written descriptions that accompanied *The Course of Empire* when it was exhibited in 1836 were published in the *Knickerbocker Magazine* 8 (November 1836): 629–30, and the *American Monthly Magazine,* n.s., 2 (November 1836): 513–14; those that accompanied *The Voyage of Life* were published in the *Bulletin of the American Art Union* 1 (June 10, 1848): 8–9. Ellwood C. Parry includes these texts, and those that accompanied *The Cross and the World,* probably written by Cole's biographer and friend, Louis Legrand Noble, in *The Art of Thomas Cole: Ambition and Imagination* (Newark: University of Delaware Press, 1988).

27. "The National Academy: A First View—Durand and the Landscapes," *Literary World* 6 (April 27, 1850): 424.

28. "The Fine Arts: Exhibition of the National Academy," pt. 2, *New York Tribune,* April 24, 1852, 5. Of course, theorizations of allegory's status and proper function were, to some extent, diverse and varied at the time. According to this critic, Cropsey's landscape pair, *The Spirit of War* and *The Spirit of Peace,* was not self-explanatory. The point of the latter picture, he said, "is to show that the tranquil life of the landscape is the result of Peace. To do this, evidently, something more is necessary than to paint a scene without an army. . . . No spectator would feel upon regarding the picture that it was intended to charm him with Peace as the cause of the tranquillity [sic] represented," that is, without the aid of title or text. Cropsey's pictures, it seems, were not properly allegorical; they were unintelligible to the point of being unrecognizable as allegorical in intent: "The truth," the reviewer wrote, "is that the subject [of peace and war] demands a kind of allegorical treatment."

29. George W. Sheldon, "George Inness," *Harper's Weekly* 26 (April 22, 1882): 244–46; Daingerfield, introduction to *Life, Art, and Letters,* by G. Inness, Jr., xxviii; "The Fine Arts," *Boston Daily Advertiser,* September 14, 1875; E., "Mr. Inness on Art-Matters," *Art Journal* 5 (1879): 376; and Inness

to Editor Ledger (1884), in G. Inness, Jr., *Life, Art, and Letters*, 169, 170/173.

30. George Inness, "A Painter on Painting," *Harper's New Monthly Magazine* 56 (February 1878): 458–61.

31. Alfred Trumble, *George Inness, N.A.: A Memorial of the Student, the Artist, and the Man* (New York: The Collector, 1895), 11.

32. Ibid.

33. *"The Sign of Promise." By George Inness*, n.p. For a discussion of this higher style, and Cole's attempts to fashion a historical landscape mode, see Powell, "Thomas Cole and the American Landscape Tradition," pts. 1–3 *Arts Magazine* 52 (February 1978): 114–23, (March 1978): 110–17, and (April 1978): 113–17, respectively; William H. Truettner and Alan Wallach, eds., *Thomas Cole: Landscape into History* (New Haven, CT: Yale University Press, 1994); A. Miller, *The Empire of the Eye*, chap. 1; and E. C. Parry, *The Art of Thomas Cole*, chap. 2.

34. Inness, "A Painter on Painting," 460. Inness was referring to Delacroix's ceiling painting *Apollo Vanquishing Python* (1850–51), one of a cycle of images by different artists depicting mythological scenes in the Galerie d'Apollon at the Musée du Louvre. The painting illustrates an episode from bk. 1 of Ovid's *Metamorphoses*. After a punishing flood sent to earth by Jupiter, the serpent Python appears, and Apollo slays him with arrows. For a discussion of this work, see Barthélémy Jobert, *Delacroix* (Princeton, NJ: Princeton University Press, 1998), 213–18.

35. Inness, "A Painter on Painting," 460.

36. *"The Sign of Promise." By George Inness*, n.p.

37. Promey, "The Ribband of Faith," 52. See also David E. Smith, "Illustrations of American Editions of 'The Pilgrim's Progress' to 1870," *Princeton University Library Chronicle* 26 (Autumn 1964): 16–25.

38. Kevin J. Avery and Tom Hardiman, *The Grand Moving Panorama of "Pilgrim's Progress"* (Montclair, NJ: Montclair Art Museum, 1999).

39. "Panorama of Pilgrim's Progress," *Independent* (December 5, 1850), 198.

40. Promey, "The Ribband of Faith," 52.

41. Rev. Theo. L. Cuyler, "An Evening with Bunyan," *Independent* 19 (November 14, 1867).

42. Nathaniel Hawthorne, "The Celestial Railroad," in *Mosses from an Old Manse*, in *The Complete Novels*, ed. Norman Holmes Pearson (New York: Modern Library, 1937), 1070–82.

43. John Bunyan, *The Pilgrim's Progress: Written under the Similitude of a Dream* (New York: J. M. Fairchild & Co., 1855), xxiv.

44. Ibid., 164. As I have already suggested, Inness, although he was looking to outdo mere physical perception, did not understand spiritual seeing to be a form of disembodied vision; perception's corporeal aspect was integral to his conception of penetrating sight. His landscapes did not provide for what Bunyan called a vision of the bodily eyes only; rather, they incorporated the body's effects in their attempt to describe how to see beyond the surface of things. As I have noted, Swedenborg described spiritual seeing in terms of a bodily capacity—breathing—and characterized Heaven and the world of spirits as material and substantial realms.

45. Ibid.; emphasis added.

46. Ibid., 31–43.

47. Ibid., 40.

48. Ibid., xxi.

49. Ibid., 178–79.

50. Ibid., 179.

51. Ibid., 72.

52. Ibid., 73.

53. G. Inness, Jr., *Life, Art, and Letters*, 69.

54. Bunyan, *Pilgrim's Progress*, 73.

55. Ibid.

56. "Inness's Allegorical Pictures," *New York Evening Post*, May 11, 1867, 4. See also "Fine Arts: The Roys Gallery—New Pictures," *New York Evening Post*, July 2, 1867, 1.

57. See Fish, *Self-Consuming Artifacts*, 240–50, for a discussion of the idea of the blindness of faith, which the author characterizes as a familiar formula for spiritual seeing. The idea, discussed here and in previous chapters, that spiritual sight begins with a condition of blind faith, or just blindness itself, of course predated both Inness and Bunyan. For a discussion of the medieval roots of this notion, see Herbert L. Kessler, "'Facies Bibliothecae Revelata': Carolingian Art as Spiritual Seeing," in *Testo e Immagine Nell'Alto Medioevo*. Settimane di Studio del Centro Italiano di Studi Sull'Alto Medioevo, 41 (Spoleto: Presso la Sede del Centro, 1994) and *Spiritual Seeing: Picturing God's Invisibility in Medieval Art* (Philadelphia: University of Pennsylvania Press, 2000).

58. Bunyan, *Pilgrim's Progress*, 77–78.

59. In his April 1882 article on the artist ("George Inness"), Sheldon included a poem by Inness entitled "The Pilgrim" that expresses a similar theme (245–46). It describes the narrator's encounter with a pilgrim "passing through the gates of Rome" who speaks eloquently of his quest for enlightenment. "The eagle eye," he says, is "denied to mortal man," whose sight is blocked by mists and vapors that "obscure the light." The pilgrim looks to the sun (God), blocked by hazy forms, his "vision drowned," but is eventually rewarded with an image of the "Unknown" and realizes that "what is seen [in the material world] is not reality." Sheldon also compared Inness's verse to Michelangelo's and said it was infinitely better than Turner's "frivolous . . . jingling."

60. "Inness's Allegorical Pictures," *New York Evening Post*, May 11, 1867, 4.

61. Bunyan, *Pilgrim's Progress*, 137, 139.

62. Ibid., 139.

63. Ibid., 139–40. This passage could also describe a stroll through what Ronald Paulson has called an emblematic landscape garden wherein predetermined, rather than individualized, meaning is derived from precisely configured nature, statuary, and text. (*Emblem and Expression: Meaning in English Art of the Eighteenth Century* [London: Thames & Hudson, 1975], chap. 2).

64. Bunyan, *Pilgrim's Progress*, 141.

65. Ibid., 141–42.

66. "Inness's Allegorical Pictures," *New York Evening Post*, May 11, 1867, 4.

67. "Art Gossip," *Frank Leslie's Illustrated Newspaper*, vol. 24 (June 1, 1867). *Round Table*, likewise, called this scene "pastoral and pleasant" ("Two Painters," *Round Table* 5 [June 1, 1867]: 343).

68. "Fine Arts: The Roys Gallery—New Pictures," *New York Evening Post*, July 2, 1867, 1.

69. "Church's Pictures of the Orient," *Chicago Tribune*, December 12, 1869.

70. *The New Jerusalem* appears to have shared several features with the second painting of Cole's *The Voyage of Life*, entitled *Youth*, where a river that originates in the foreground at right traverses a lush flower- and tree-filled plain and a hopeful young man is carried downstream toward a cloud palace in the distant sky. The message of Inness's *The New Jerusalem* was, of course, entirely different than that of the admonitory *Youth*, but it seems likely that he looked to Cole's canvas as a model for his own.

71. I should emphasize here that my analysis of Inness's series as an allegory of perception shares certain key claims with and owes much to Promey's reading of *The Triumph of the Cross* as an expression of the Swedenborgian concept of spiritual regeneration, wherein spiritual enlightenment, which involved learning to see truth, occurred by way of a developmental or evolutionary process (and, again, wherein painting itself, as Promey compellingly argues, was a means to regeneration, part of the process itself ["The Ribband of Faith," 54–56]).

72. James Turner, "Bunyan's Sense of Space," in *The Pilgrim's Progress: Critical and Historical Views*, ed. Vince Newey (Totowa, NJ: Barnes & Noble Books, 1980), 91–110.

73. The schematic drawing of the panorama's machinery appeared in the "New Inventions" section of *Scientific American* 4 (December 16, 1848): 100, along with descriptions of a "combined wrench and screw driver," "Munger's Yankee turbine wheel," and what the editor describes as a questionable report of the invention of a spectacle-making machine.

74. *Home Journal*, quoted in R. J. Greenwood, *Descriptive Catalogue of the Bunyan Tableaux*

(Albany, NY: Joel Munsell, 1856), quoted in Avery and Hardiman, *Grand Moving Panorama,* 19.

75. Fish, *Self-Consuming Artifacts,* chap. 4, esp. 251, 258.

76. Bunyan, *Pilgrim's Progress,* 39, 43.

77. Ibid., 125.

78. Ibid., 136.

79. Ibid., 134.

80. Ibid., 142, 153–55.

81. Ibid., 157.

82. Ibid., 12.

83. Gilpin, "Essay II: On Picturesque Travel" (1792), in *Three Essays: On Picturesque Beauty; On Picturesque Travel; and On Sketching Landscape, to which is added a poem, On Landscape Painting* (London: R. Blamire, 1792), 49; Edmund Burke, *A Philosophical Enquiry into the Origin of Our Ideas of the Sublime and Beautiful* (1757), ed. James T. Boulton (London: Routledge & Kegan Paul; New York Columbia University Press, 1958), 138.

84. Again, see the following articles by GWP: "Lessing's *Laocoön*," *Bulletin of the American Art Union* 3 (August 1850): 73–75, and "On the Choice of Subjects for Pictures," *Bulletin of the American Art Union* 3 (September 1850): 94–96. See also "*Laocoön,* or the Limits of Painting and Poetry. Translated from the German of Lessing," *Cosmopolitan Art Journal* 3 (March 1859): 56–58. For a brief discussion of the origins of the problem Lessing examined in *Laocoön,* see Edward Allen McCormick's introduction to his translation of the work (Indianapolis and New York: Bobbs-Merrill Co., Inc., 1962), ix–xxi.

85. *Boston Evening Transcript,* February 16, 1863, 2. This practice was not uncommon; as Kevin Avery has reported, visitors to the exhibition of Church's *The Heart of the Andes* (1859) were given the same advice ("'The Heart of the Andes' Exhibited: Frederic E. Church's Window on the Equatorial World," *American Art Journal* 18 [1986]: 70n. 45).

86. "Fine Arts: The Roys Gallery—New Pictures," *New York Evening Post,* July 2, 1867, 1.

87. Ibid.; emphasis added.

88. Tuckerman, *Book of the Artists,* 529–30; G. Inness, Jr., *Life, Art, and Letters,* 69

89. "Art Gossip," *Frank Leslie's Illustrated Newspaper,* vol. 24 (June 1, 1867).

90. "Art," *Atlantic Monthly* 31 (January 1873): 115.

91. "Art Gossip," *Frank Leslie's Illustrated Newspaper,* vol. 24 (June 1, 1867).

92. Pattison, "George Inness, N.A.," n.p.

93. Tuckerman, *Book of the Artists,* 529–30. See also "Fine Arts: The Roys Gallery—New Pictures," *New York Evening Post,* July 2, 1867, 1.

94. In Tuckerman, *Book of the Artists,* 531. When *The New Jerusalem* was exhibited at Somerville Gallery, New York, in 1873, the *New York Tribune* implied that its allegorical motive was not perspicuous: "One of the largest pictures there is by George Inness . . . ; it is better than its name, 'The New Jerusalem.' It is a broad and sunny landscape, spacious and broken by pleasant hills and streams, with suggestive walls and towers in the distance. But it might as well have been called Arcadia or the Land of Cockayne as what the artist has named it" (*New York Tribune,* March 19, 1873).

95. Daingerfield, *George Inness,* 17.

CHAPTER 6

1. Ripley Hitchcock, "George Inness, N.A.," in *Catalogue. Special Exhibition of Oil Paintings, Works of Mr. George Inness, N.A.* (New York: American Art Galleries, 1884), 3. In a review of Inness's *Niagara Falls,* the *Mail and Express* critic encouraged the idea of an exhibition of the artist's works that included examples from all stages of his career (*Mail and Express,* January 11, 1884, quoted in Hitchcock, "George Inness, N.A.," 29).

2. Inness's *Niagara Falls* was discussed widely in critical circles; the painting was repeatedly described as a new departure for Inness and was treated as if it were a kind of artistic debut, in this

case a belated one. For reviews of the painting, see "Mr. Inness's Niagara," *New York Daily Tribune,* January 9, 1884, 5; "Art News and Comments," *New York Daily Tribune,* January 13, 1884, 4; "'Niagara,' by George Inness," *Independent* 36 (January 24, 1884): 105; "The Studio: Notes and News," *Art Interchange* 12 (January 17, 1884): 17; and selected reviews in Hitchcock, "George Inness, N.A.," 27–32.

3. It is difficult to determine what role Inness played in selecting works for the exhibition. According to the catalog checklist, many of the paintings came from private collections, including that of one of the artist's most important patrons, Thomas B. Clarke; Henry Ward Beecher lent a picture from his collection, as did Inness's son. The remaining works appear to have been the property of the artist himself. As we know, Inness provided Hitchcock with a synopsis of his life and art in the form of a letter, written in 1884, to which the critic referred in his catalog essay. However, other than a brief statement included in the catalog in which Inness instructed visitors to consult with the gallery about purchasing his paintings and a note acknowledging various collectors, there is little that indicates at what level he may have been involved in the organization and planning of the first major public exhibition of his work (the largest during his lifetime). Whoever it was that organized the exhibition thought that it was important enough to warrant a fifty-page catalog that included Hitchcock's essay and extensive excerpts from press reviews as well as both "A Painter on Painting," the Inness interview published in *Harper's New Monthly Magazine* in 1878 (vol. 56 [February 1878]: 458–61), and De Kay's article on the artist from 1882 (Henry Eckford [Charles De Kay], "George Inness," *Century Magazine* 24 [May 1882]: 57–64). Clearly, the exhibition was meant to be a serious and significant examination of Inness's career up to 1884. Inness's landscapes had, of course, been exhibited in groups previously; in 1875, e.g., approximately twenty-five of his paintings went on view at the gallery of Doll and Richards in Boston. Yet it seems that the 1884 exhibition was conceived and received on a wholly different register.

4. Nicolai Cikovsky, Jr., *George Inness* (New York: Harry N. Abrams, 1993), 96.

5. See Nicolai Cikovsky, Jr., "The Home of the Heron," in Nicolai Cikovsky, Jr., and Michael Quick, *George Inness* (Los Angeles: Los Angeles County Museum of Art, 1985), 59. See also Cikovsky, *George Inness* (1993), 78.

6. "His Art His Religion," *New York Herald,* August 12, 1894, 9; emphasis added. The juxtaposition of dogma and science should remind the reader of Inness's Corot/Meissonner opposition. The terms are, of course, not identical, but the binaries have the theme of religion or spirit versus science or reason in common.

7. "A Painter on Painting," 458; George W. Sheldon, "George Inness," *Harper's Weekly* 26 (April 22, 1882): 244.

8. Sheldon, "George Inness," 246. I am grateful for the assistance of Kirstin Noreen in translating this Latin phrase.

9. The manuscript was probably lost in a 1942 fire, as reported by Nicolai Cikovsky, Jr. ("The Life and Work of George Inness" [Ph.D. diss., Harvard University, 1965]," 291–92, 352n. 27).

10. Sheldon, "George Inness," 246.

11. Ibid.

12. Ibid. Whately (1787–1863) was archbishop of Dublin from 1830 until his death and wrote several texts on logic and rhetoric. His *Elements of Logic* (1826) and *Elements of Rhetoric* (1828) were used widely in the nineteenth century in American high schools and colleges. His work would have been especially appealing to Inness because, as the *Independent* reported on the occasion of the archbishop's death in 1863, he was "a Rationalist . . . in the interests of faith" and applied his "skeptical mode of reasoning" to scriptural narrative ("The Late Archbishop Whately," *Independent* 15 [October 29, 1863]: 4). Whately wrote in *Elements of Logic* (Delmar, NY: Scholars' Facsimiles and Reprints, 1975) that logic, "in the most extensive sense which the name can with propriety be made to bear, may be considered as the Science, and also as the Art, of Reasoning. It investigates the principles on which argumentation is conducted, and furnishes rules to secure the mind from error in its deductions" (1).

13. "Art and Artists," *Boston Evening Transcript,* April 9, 1875, 6.

14. Eckford [De Kay], "George Inness," 63.

15. Ibid.

16. J. Walter McSpadden, *Famous Painters of America* (New York: Thomas Y. Crowell & Co., 1907), 134.

17. Sophia Antoinette Walker, "Fine Arts: George Inness," *Independent* 46 (August 30, 1894): 1115.

18. Cikovsky has suggested that *The Home of the Heron* may be unfinished, one of a number of canvases left unfinished in the artist's studio at the time of his death (*George Inness* [1993], 123, 129). This may be the case, although I am not convinced that this is a pressing or resolvable concern, especially in regard to an artist like Inness, who often could not tell if his own pictures were complete.

19. Celen Sabbrin [Helen Cecilia de Silver Abbott], *Science and Philosophy in Art* (Philadelphia: Wm. F. Fell & Co., 1886). For a detailed and compelling discussion of Abbott's piece, see Michael Leja, "Monet's Modernity in New York in 1886," *American Art* 14 (Spring 2000): 50–79. Kathleen Pyne briefly discusses Abbott's essay in *Art and the Higher Life: Painting and Evolutionary Thought in Late-Nineteenth-Century America* (Austin: University of Texas Press, 1996), 237–39, but calls her Helen Abbott Michael, using the name she took after marrying Arthur Michael, a professor at Tufts University, in 1888 (Leja, "Monet's Modernity," 54).

20. See, e.g., "Fine Arts: The Sixth Annual Exhibition of the Society of American Artists," *Nation* 36 (April 12, 1883): 327; Robert Jarvis, "Pictures by La Farge and Inness," *Art Amateur* 11 (June 1884): 13; "The Inness Exhibition: A Notable Collection of Paintings," *New York Daily Tribune*, April 12, 1884, 5; Mariana Griswold Van Rensselaer, "Fine Arts: The National Academy of Design," *Independent* 38 (April 15, 1886): 460; "The Academy Exhibition," *Harper's Weekly* 32 (April 7, 1888): 250; and "Fine Arts: The Academy Exhibition," *Nation* 48 (April 11, 1889): 313.

21. "The Fine Arts," *Boston Daily Advertiser*, May 10, 1875.

22. Cikovsky, *George Inness* (1993), 78.

23. *Moonrise, Alexandria Bay* (in a private collection) is reproduced in ibid., 108.

24. Ralph Waldo Emerson, "Circles," in *Essays and Lectures*, ed. Joel Porte (New York: Library of America, 1983), 403.

25. Guillaume Oegger, *The True Messiah; or, The Old and New Testaments Examined according to the Principles of the Language of Nature* (Paris, 1829), trans. Elizabeth Peabody (Boston: E. P. Peabody, 1842), reprinted in Kenneth Walter Cameron, *Young Emerson's Transcendental Vision* (Hartford, CT: Transcendental Books, 1971), 334, 339. As Cameron reports, Oegger was probably born in the 1790s in northeastern France. He began his career as a priest for the Church of Rome but after 1826 renounced the priesthood and embraced the doctrines of the Swedenborgian faith. *The True Messiah* was his first distinctly Swedenborgian work; Cameron includes only the introduction to *The True Messiah* in his study of Emerson as it appears that Peabody limited her translation to this portion of the text.

26. Emanuel Swedenborg, *The True Christian Religion* (New York: General Convention of the New Jerusalem in the United States of America, 1865), 169.

27. Emanuel Swedenborg, *The Soul, or Rational Psychology*, trans. and ed. Frank Sewall (New York: New-Church Press, Inc., 1887), 351; John Locke, *An Essay concerning Human Understanding* (1690), ed. P. H. Nidditch (Oxford: Oxford University Press, 1975), bk. 4, chap. 12, sec. 8.

28. Swedenborg, *The Soul, or Rational Psychology*, 353–54. Swedenborg's mention of "a calculus of infinites" most certainly refers to the almost simultaneous, and independent, discovery of the infinitesimal calculus—the mathematical operations, or universal laws, of differentiation and infinite summation, or integration—by Gottfried Wilhelm Leibniz and Isaac Newton, which engendered a controversy over its authorship that lasted for many years. See Morris Kline, *Mathematics in Western Culture* (New York: Oxford University Press, 1953), chap. 15.

29. Swedenborg, *The Soul, or Rational Psychology*, 352.

30. For a discussion of mathesis, see Michel Foucault, *The Order of Things: An Archaeology of the Human Sciences* (New York: Vintage Books, 1973), 71–77 and passim.

31. Donald Rutherford, "Philosophy and Language in Leibniz," in *The Cambridge Companion to Leibniz*, ed. Nicholas Jolley (Cambridge: Cambridge University Press, 1995), 224, 226, 233. As Rutherford notes, in discussing the characteristic, Leibniz provided only the most general of descriptions; in fact, he never fully theorized the concept and, not surprisingly, never found a way to put it into practice. Leibniz acknowledged the difficulty of his project in 1679, writing, "For although I discovered that one can assign a characteristic number to each term or notion (with whose help to calculate and to reason will, in the future, be the same) in fact, on account of the marvelous complexity of things, I cannot yet set forth the true characteristic numbers, not before I have put in order the most general categories under which most things fall" ("A Calculus of Consequences" (1679), in *Gottfried Wilhelm Leibniz: Philosophical Essays*, trans. and ed. Roger Ariew and Daniel Garber [Indianapolis: Hackett Publishing, 1989], 10–11). As Rutherford notes, Leibniz's interest in a universal philosophical language took part in a widespread universal language movement in the seventeenth century that sought to discover a form of expression that could be used by all humans as well as a system that would provide for a more rigorous form of reasoning. See, e.g., Thomas C. Singer, "Hieroglyphs, Real Characters, and the Idea of Natural Language in English Seventeenth-Century Thought," *Journal of the History of Ideas* 50 (January–March 1989): 49–70; Vivian Salmon, *The Study of Language in Seventeenth-Century England* (Amsterdam: John Benjamins B.V., 1979); Allison Coudert, "Some Theories of a Natural Language from the Renaissance to the Seventeenth Century," in *Magia Naturalis und die Entstehung der Modernen Naturewissenschaften*, Studia Leibnitiana 7 (Wiesbaden: Franz Steiner Verlag, 1978), 56–118; James Knowlson, *Universal Language Schemes in England and France, 1600–1800* (Toronto: University of Toronto Press, 1975); and Paolo Rossi, *Logic and the Art of Memory: The Quest for a Universal Language*, trans. and with an introduction by Stephen Clucas (Chicago and London: University of Chicago Press, 2000). See also Umberto Eco, *Serendipities: Language and Lunacy*, trans. William Weaver (New York: Harcourt Brace, 1998), esp. chaps. 3–5.

32. Gottfried Wilhelm Leibniz, "Preface to the General Science" (1677), in *Leibniz: Selections*, ed. Philip P. Wiener (New York: Charles Scribner's Sons, 1951), 16. See also Leibniz, "Two Studies in the Logical Calculus" (1679), in *Gottfried Wilhelm Leibniz: Philosophical Papers and Letters*, trans. and ed. Leroy E. Loemker (Dordrecht and Boston: D. Reidel Publishing, 1976), 235, and "A Calculus of Consequences," 10–14.

33. Leibniz, "The Art of Discovery" (1685), in *Leibniz: Selections*, ed. Wiener, 51.

34. Leibniz, "Letter to John Frederick, Duke of Brunswick-Hanover" (Fall 1679), in *Philosophical Papers*, ed. Loemker, 261, and "Letter to Countess Elizabeth, on God and Formal Logic" (1678?), in *Philosophical Essays*, ed. Ariew and Garber, 240. In his letter to the countess, Leibniz wrote of "another analysis in geometry which is completely different from the analysis of Viète and of Descartes, who did not advance sufficiently in this" and indicated that his geometrically based characteristic could account for the existence of God. See also Leibniz, "Studies in a Geometry of Situation with a Letter to Christian Huygens" (1679), in *Philosophical Papers*, ed. Ariew and Garber, 248–58. As Loemker points out, this letter may have been inspired by Leibniz's rereading in early 1679 of Euclid's *Elements of Geometry* (ca. 300 B.C.), which provided a model for the systematic presentation and analysis of a body of knowledge.

35. Leibniz to Tschirnhaus (May 1678), in *Philosophical Papers*, ed. Loemker, 193; Leibniz, "On the True Method in Philosophy and Theology" (ca. 1688), in *Leibniz: Selections*, ed. Wiener, 59.

36. Leibniz, "Preface to a Universal Characteristic" (1678–79), in *Philosophical Essays*, ed. Ariew and Garber, 6.

37. Swedenborg, *The Soul, or Rational Psychology*, 352.

38. Ibid., 353–54. The idea that the order of things could be represented in mathematical terms did not, of course, originate with Swedenborg, nor was it first articulated by Leibniz. Plato, e.g., understood geometric figures to be archetypes, or ideal forms—perfect, absolute, changeless, eternal, and universal expressions of knowledge over and against their inexact and temporal counterparts in the phenomenal world (*The Republic of Plato*, ed. Allen Bloom [New York: Basic Books, 1968]). In *Mystery of the Cosmos* (1596), Johann Kepler, building on the theories of Copernicus, attempted to account for the mathematical relations and geometrical harmonies that he believed connected all

varieties of natural phenomena, suggesting that the structure of the cosmos could be represented by mathematical laws (see Kline, *Mathematics in Western Culture,* 113–14). And, as Edwin Jones has noted, Galileo Galilei's geometrical demonstrations assumed an immutable correspondence between nature and mathematics (*Reading the Book of Nature: A Phenomenological Study of Creative Expression in Science and Painting* [Athens: Ohio University Press, 1989], 12–30). Philosophy, Galileo wrote, was written in the "grand book" of the universe in a "language of mathematics, and its characters are triangles, circles, and other geometrical figures" ("The Assayer," in *The Controversy of the Comets of 1618,* trans. Stillman Drake and C. D. O'Malley [Philadelphia: University of Pennsylvania Press, 1960], 183–84).

39. It is of course difficult to determine exactly what Inness meant by "psychology," for he was writing at a time of tremendous transformation regarding the theory and practice of psychology in the United States. For discussion of this matter, see various essays in Joel Pfister and Nancy Schnog, eds., *Inventing the Psychological: Toward a Cultural History of Emotional Life in America* (New Haven, CT: Yale University Press, 1997). Psychology was the subject of avid cultural interest and debate during the period under discussion; articles about the discipline appeared with regularity in the popular press, and the term "psychological" found its way into writing about art, especially where portraiture was concerned. For contemporaneous discussions of psychology, see, e.g., Borden P. Brown, "Evolution in Psychology," *Independent* 35 (December 27, 1883): 1641; Joseph Jastrow, "The Problems of 'Psychic Research,'" *Harper's New Monthly Magazine* 79 (June 1889): 76–82; O. B. Frothingham, "Some Aspects of Psychical Research," *Atlantic Monthly* 60 (August 1890): 203–7; "James's Psychology," *Atlantic Monthly* 67 (April 1891): 552–56; "Experimental Psychology," *Nation* 54 (May 17, 1892): 211; and "The American Psychological Association," *Nation* 56 (January 12, 1893): 25. The emergence of considerations of the "psychological" in art criticism coincided with widespread concern over what was perceived to be the purely surface quality of recent art (especially that art that bore the mark of French influence or experimented with the new "impressionist" style); many commentators worried that paintings no longer seemed concerned with interior life, imagination, or the soul. See, e.g., "The Fine Arts: The Fall Exhibition at the Academy," *Critic* 17 (November 29, 1890): 285; M. Van Rensselaer, "George Fuller," *Century Magazine* 27 (December 1883): 229, 230; "The Science of Color," *Art Amateur* 21 (July 1889): 31; "Elihu Vedder," *Magazine of Art* 8 (1885): 122, 123; Theodore Child, "American Artists at the Paris Exhibition," *Harper's New Monthly Magazine* 79 (September 1889): 498, 500, and "Some Modern French Painters," *Harper's New Monthly Magazine* 80 (May 1890): 817.

40. E., "Mr. Inness on Art-Matters," *Art Journal* 5 (1879): 377.

41. "His Art His Religion," 9.

42. Emerson, "Circles," 409.

43. E., "Mr. Inness on Art-Matters," 377.

44. Alfred Trumble, writing in *Collector* 4 (July 1, 1893): 246; emphasis added.

45. See, e.g., "Sketchings: National Academy of Design, First Notice," *Crayon* 7 (May 1860): 140; Sordello [Eugene Benson], "George Inness and S. R. Gifford," *New York Evening Post,* March 30, 1866, 1; "The National Academy of Design," *New York Daily Tribune,* May 9, 1867, 2; "Art," *Atlantic Monthly* 31 (January 1873): 115; "The Arts," *Appletons' Journal* 13 (May 22, 1875): 663; "The Academy Exhibition," *New York Times,* April 10, 1878, 2; and "The Academy Exhibition," pt. 3, *Independent* (April 25, 1878), 7.

46. George Inness, "A Plea for the Painters," *New York Evening Post,* March 21, 1878; emphasis added. This letter was one of several by different artists addressing the relative worth of painting and the graphic arts published in the *Post* in 1878 (March 16, 18, 20, 21, 22, and 25). Inness knew something about the graphic arts; as a young man, he was an apprentice at the New York engraving firm Sherman and Smith (Cikovsky, *George Inness* [1993], 10–11; Francine Tyler, *American Etchings of the Nineteenth Century* [New York: Dover Publications, 1984], xix and plate 57). As a series of letters from Inness to S. R. Koehler (now in the Museum of Fine Arts, Boston, and the New York Public Library) indicates, Inness was at work on an etching in 1879, under the auspices, it appears, of W. Wellstood and Co., Steel Plate Engravers and Printers, 46 Beekman Street, New York. The only known example of an etching by Inness, *Landscape on the Hudson* or *On the Hudson* (1879), which

may well be the work discussed in his correspondence, closely resembles two of his paintings: *On the Hudson* (Leroy Ireland, *The Works of George Inness: An Illustrated Catalogue Raisonné* [Austin and London: University of Texas Press, 1965], no. 762) and *Early Days on the Hudson* (Santa Barbara Museum of Art; undated, probably from around 1875). The Museum of Fine Arts in Boston has the first and second states of the etching in its collection; the Montclair Art Museum also has an example of the work.

47. Sally M. Promey, "The Ribband of Faith: George Inness, Color Theory, and the Swedenborgian Church," *American Art Journal* 26 (1994): 59–60.

48. Ibid., 59.

49. Ibid.

50. See my discussion of this painting in *George Inness: The 1880s and 1890s* (Annville, PA: Suzanne H. Arnold Art Gallery, Lebanon Valley College, 1999), 30.

51. E., "Mr. Inness on Art-Matters," 376.

52. Hitchcock, "George Inness, N.A.," 12, 11.

53. "Recent Death: George Inness, Landscape Painter," *Boston Evening Transcript,* August 4, 1894.

54. "The Fine Arts," *Boston Evening Transcript,* December 9, 1881, 3.

55. Henry Eckford [Charles De Kay], "A Modern Colorist: Albert Pinkham Ryder," *Century Magazine* 40 (June 1890): 251; Hitchcock, "George Inness, N.A.," 6, 8.

56. Hitchcock, "George Inness, N.A.," 11. See also George Parsons Lathrop, "The Progress of Art in New York," *Harper's New Monthly Magazine* 86 (April 1893): 741.

57. "Fine Arts: The Academy Exhibition," *Nation* 46 (April 19, 1888): 332.

58. Review of the National Academy of Design Exhibition, *Art Interchange,* vol. 20 (1888). See also "The Academy Exhibition," *Harper's Weekly* 32 (April 7, 1888): 250.

59. "Fine Arts: The Sixth Annual Exhibition of the Society of American Artists," *Nation* 36 (April 12, 1883): 327.

60. Ibid.

61. "Mr. Inness's Paintings," *New York Evening Post,* April 15, 1884. For a discussion of what has been called "American tonalism," see Wanda M. Corn, *The Color of Mood: American Tonalism, 1880–1910* (San Francisco: M. H. De Young Memorial Museum, 1972); William H. Gerdts et al., *Tonalism: An American Experience* (New York: Grand Central Art Galleries, Inc., 1982); and Mildred Thaler Cohen, *Tonalism: An American Interpretation of the Landscape* (New York: Marbella Gallery, 1993). See also "Fine Arts: The Academy Exhibition," *Nation* 48 (April 11, 1889): 313.

62. "Fine Arts: The National Academy Exhibition," *Nation* 40 (April 16, 1885): 328. See also "The Academy Exhibition," *Art Amateur* 14 (May 1886): 119.

63. "The National Academy of Design: The Sixtieth Annual Exhibition," *Studio,* no. 18 (April 11, 1885), 207–8; emphasis added.

64. For discussion of this debate, see Jacqueline Lichtenstein, *The Eloquence of Color: Rhetoric and Painting in the French Classical Age,* trans. Emily McVarish (Berkeley and Los Angeles: University of California Press, 1993); and Georges Roque, "Writing, Drawing, Color," in *Boundaries: Writing and Drawing,* ed. Martine Reid, Yale French Studies no. 84 (New Haven, CT: Yale University Press, 1994): 43–62.

65. See, e.g., Hélène Adhémar, ed., "L'exposition de 1874 chez Nadar (rétrospective documentaire): Critiques parues dans la presse en 1874," reprinted in *Centenaire de l'impressionnisme* (Paris: Grand Palais, 1974), 255–70; and Armand Silvestre, "L'école de peinture contemporaine," *Renaissance* (September 28, 1872), 178.

66. Charles Henry Hart, e.g., wrote: "That this is so can be seen in the works of many men exhibiting today; foremost and noblest of all the veteran landscapists, George Innes [sic], who was an ideal impressionist before there was any such word coined to dub the followers of Monet and his kind" ("Fine Arts: The Pennsylvania Academy Exhibition," *Independent* 44 [March 10, 1892], 335). A critic in the *Art Amateur* said that he considered Inness to be "the greatest American landscape

painter": "I believe much of his power, which is now of the impressionist order, comes from his early mastery of forms and careful study of nature. You remember there was a great deal of detail in his first pictures" ("Sketching from Nature," *Art Amateur* 25 [August 1891]: 55). Hitchcock, in contrast, insisted that Inness did not paint in an impressionist vein: "Why Inness should at this day be dubbed an impressionist it is hard to see, when we remember, on the one hand, works exhibited here by men like Mssrs. Currier and Muhram, and, on the other, those shown abroad by Manet and his disciples" (Hitchcock, "George Inness, N.A.," 11).

67. In referring to "impressionism," I do not mean to conjure up an idea of a monolithic movement or style. In fact, my discussion of impressionism and its fortunes in the United States is designed to demonstrate that our understanding of it is oversimplified and incomplete. For a thoughtful discussion of impressionism in America, see Pyne, *Art and the Higher Life,* chap. 5.

68. For discussion of this exhibition, see Leja, "Monet's Modernity," 50–79.

69. See, e.g., John Ferguson Weir, "The Artist as Painter," *New Princeton Review* 59 (September 1883): 165–66; Charles De Kay, "An American Gallery," *Magazine of Art* 9 (May 1886): 245–46; "Fine Arts: The Morgan Collection," *Nation* 42 (February 25 1886): 176; "The Fine Arts at the Paris Exposition," *Nation* 49 (September 5, 1889): 191; Eckford [De Kay], "A Modern Colorist," 250; Charles H. Moore, "The Modern Art of Painting in France," *Atlantic Monthly* 68 (December 1891): 807 and passim; and "Van Dyke on Painting," *Nation* 56 (April 20, 1893): 295–97.

70. Theodore Child, "The King of the Impressionists," *Art Amateur* 14 (April 1886): 101.

71. Charles De Kay, "George Fuller, Painter," *Magazine of Art* 12 (September 1889): 351.

72. RWH [probably Ripley Hitchcock], "Fundamental Truth in Art" (letter to the editor), *Collector* 5 (November 15, 1893): 30.

73. "The Fine Arts: The Exhibition at the National Academy of Design," *Critic* 24 (April 7, 1894): 244.

74. Hamlin Garland, "Impressionism" (1894), in *Crumbling Idols: Twelve Essays on Art Dealing Chiefly with Literature, Painting, and the Drama* (Cambridge, MA: Belknap Press, Harvard University Press, 1960), 97, 98, 99.

75. Cecilia Waern, "Some Notes on French Impressionism," *Atlantic Monthly* 69 (April 1892): 536. See also "Landscape Painting in Oils," *Art Amateur* 19 (August 1888): 52; and "Sketching from Nature," *Art Amateur* 25 (August 1891): 56.

76. M. Van Rensselaer, "The French Impressionists," pt. 1, *Independent* 38 (April 22, 1886): 491.

77. Ibid., 492. See also Theodore Child, "A Note on Impressionist Painting," *Harper's New Monthly Magazine* 74 (January 1887): 315.

78. Van Rensselaer, "Fine Arts: The National Academy of Design," pt. 1, *Independent* 38 (April 15, 1886): 460.

79. "The Inness Paintings," *Art Amateur* 32 (February 1895): 78.

80. "Fine Arts: The Autumn Academy," *Nation* 42 (December 17, 1885): 516.

81. "American Art-Association: Prize-Fund Exhibition," *Studio,* no. 19 (April 25, 1885), 223.

82. "Fine Arts: The Two Oil-Color Exhibitions," pt. 2, *Nation* (April 27, 1882), 366.

83. "The Mechanics' Fair Art Gallery: Second Notice—Landscapes," *Boston Evening Transcript,* October 7, 1881, 3.

84. Inness to Editor Ledger (1884), in G. Inness, Jr., *Life, Art, and Letters,* 168.

85. G. Inness, Jr., *Life, Art, and Letters,* 168.

86. Inness, "A Painter on Painting," 458.

87. G. Inness, Jr., *Life, Art, and Letters,* 169–70.

88. E., "Mr. Inness on Art-Matters," 377.

89. Lathrop, "The Progress of Art in New York," 746.

90. Theodore Child, "The Paris Salon: Some Pictures by American Artists," *Harper's Weekly* 31 (May 7, 1887): 337; "What Is Impressionism?" pts. 1 and 2, *Art Amateur* 28 (November 1892): 140, and (December 1892): 5, respectively. See also "Fine Arts: Society of American Artists," *Nation* 50 (May 8, 1890): 882; "The Fine Arts: An Impressionist Exhibition," *Critic* 22 (May 13, 1893): 318;

"The Science of Color," *Art Amateur* 21 (July 1889): 30; and "Art in Boston," *Art Amateur* 24 (May 1891): 141.

91. Charles Henry Hart, "Fine Arts: The Pennsylvania Academy Exhibition," *Independent* 42 (March 13, 1890): 343.

92. Ibid. See also Hart, "Fine Arts" (1892), 335.

93. Alfred Trumble, "Things of the Time," *Collector* 3 (December 15, 1891): 49. For a discussion of the meaning and usage of these and related terms in nineteenth-century America, see Karen Halttunen, *Confidence Men and Painted Women: A Study of Middle-Class Culture in America, 1830–1870* (New Haven, CT, and London: Yale University Press, 1982).

94. Trumble, "Things of the Time," 49. *Upas* refers to a tropical Asian tree (*Antiaris toxicaria*) that produces a milky juice sometimes used as a poison.

95. Ibid.

96. Ibid., 50, 51.

97. Ibid., 50.

98. Inness, "A Painter on Painting," 461.

99. E., "Mr. Inness on Art-Matters," 377.

100. I rely here Ian Dowbiggin's "Back to the Future: Valentin Magnan, French Psychiatry, and the Classification of Mental Diseases, 1885–1925," *Social History of Medicine* 9 (December 1996): 383–408.

101. Trumble, "Things of the Time," 50.

102. See, e.g., D. B. St. John Roosa, "The Human Eye as Affected by Civilization," *Cosmopolitan* 13 (October 1892): 759–68; and Theodore Child, "Some Modern French Painters," *Harper's New Monthly Magazine* 80 (May 1890): 817, 826. Trumble was not the only critic to link coloristic excess to disease. "If Santa Cruz, Cal., boasts the chromo-like qualities which Baron R. B. de Coursy gives in his picture of the spot," wrote the author of a review of the 1883 academy exhibition, "it is no wonder that so many people die there. It had been supposed that a too long neglected invalidism on the part of those who sought this renowned sanitarium accounted for the great mortality of the place, but now we can account for it on another ground" ("The Exhibition of the National Academy of Design," *Boston Evening Transcript,* April 11, 1883, 6). For further and illuminating discussion of painting's implication in physiological and social ill health, as well as its link to wellness, see Sarah Burns, *Inventing the Modern Artist: Art and Culture in Gilded Age America* (New Haven, CT: Yale University Press, 1996), chaps. 3 and 4.

103. Trumble, writing in *Collector* 4 (July 1, 1893): 246–47.

104. See Lichtenstein, *The Eloquence of Color,* chap. 6; and Roque, "Writing, Drawing, Color."

105. Lichtenstein, *The Eloquence of Color,* 3.

106. Ibid., 1–8.

107. Inness to Hitchcock, March 23, 1884, in *George Inness of Montclair* (Montclair, NJ: Montclair Art Museum, 1964), n.p.

108. Inness to Editor Ledger (1884), in G. Inness, Jr., *Life, Art, and Letters,* 173–74.

109. Ibid., 169; emphasis added.

110. Ibid.

111. See, e.g., "Fine Arts: The Sixth Annual Exhibition of the Society of American Artists," *Nation* 36 (April 12, 1883): 328; and "Fine Arts: The Academy Exhibition," pt. 2, *Nation* 38 (April 24, 1884): 370.

112. "Art Notes," *Appletons' Journal* 10 (December 20, 1873): 795.

113. De Kay, "George Fuller, Painter," 350.

114. Sordello [Eugene Benson], "George Inness and S. R. Gifford," 1; emphasis added.

115. "A Note on the St. Botolph," *Boston Evening Transcript,* December 24, 1883, 6.

116. "Fine Arts: The Morgan Collection," *Nation* 42 (February 25, 1886): 176.

117. "Van Dyke on Painting," *Nation* 56 (April 20, 1893): 296. See also Eckford [De Kay], "A

Modern Colorist," 252, 254; "Fine Arts: Mr. Walters's Art Gallery," *Nation* 38 (March 6, 1884): 220; and William J. Stillman, "Realism and Idealism," *Nation* 42 (February 11, 1886): 127. The distinctions drawn between color and design were, of course, not absolute. The *Appletons'* critic that made the connection between line, shape, and proportion, or design, and ideas—"truths in hieroglyphic"—noted that musical sounds possessed "profound relations" similar to those that abided in good design, which "penetrate our being because exact numerical relation pervades all things" ("Art Notes," *Appletons' Journal* 10 [December 20, 1873]: 795).

118. William Coffin, "The Columbian Exposition," pt. 3, *Nation* 57 (August 17, 1893): 115.

119. Montgomery Schuyler, "George Inness," *Harper's Weekly* 38 (August 18, 1894): 787.

120. "George Inness," *New York Evening Post,* August 7, 1894.

121. E., "Mr. Inness on Art-Matters," 377.

122. Ralph Waldo Emerson, "Swedenborg; or, The Mystic," in *Representative Men,* in *Essays and Lectures,* ed. Porte, 682.

123. Ibid., 688.

124. "His Art His Religion," 9.

125. Sheldon, "George Inness," 246.

126. We know, of course, that Inness understood color to possess at least some significatory value, for he said as much in his essay "Colors and Their Correspondences." As he explained, certain colors corresponded to specific ideas or concepts, such as love, and were supposed to bring specific words, or referents, to mind (reprinted in Promey, "The Ribband of Faith," 59–60).

127. E., "Mr. Inness on Art-Matters," 377.

128. See, e.g., "The Fine Arts at the Paris Exposition," *Nation* 49 (September 5, 1889): 191; and "Recent American Landscape," *Art Amateur* 19 (June 1888): 2.

129. L. Lejeune, "The Impressionist School of Painting," *Lippincott's Magazine* 24 (December 1879): 725.

130. Cecilia Waern, "Some Notes on French Impressionism," *Atlantic Monthly* 69 (April 1892): 537.

131. Mariana Van Rensselaer, "Fine Arts: The Second Prize Fund Exhibition," pt. 2, *Independent* 38 (June 17, 1886): 7. See also Charles H. Moore, "Materials for Landscape Art in America," *Atlantic Monthly* 64 (November 1889): 676–77; and "The Impressionist Pictures," *Studio,* no. 21 (April 1886), 249. For a discussion of instantaneity, invisibility, photography, and painting, see Michael Leja, "Eakins and Icons," *Art Bulletin* 83 (September 2001): 479–97.

132. Benjamin Constant, "Impressions of America," *Boston Evening Transcript,* April 6, 1889, 5.

133. "A Great American Painter," *Illustrated American* 16 (August 25, 1894): 251. Reginald Cleveland Coxe, who had a studio adjacent to Inness's in the early 1890s in New York, recalled Inness arriving from Montclair one day, having taken the train into the city, eager to paint "something he had seen from the car windows," thus ascribing to Inness, as had other writers, a desire to render transitory impressions, in this case, a fleeting view from the train ("Inness painted on impulse," Coxe also said ["The Field of Art: George Inness," *Scribner's Magazine* 44 (October 1908): 510–11]).

134. "The National Academy Exhibition," *Critic* 7 (November 28, 1885): 256.

135. Kenyon Cox, "William M. Chase, Painter," *Harper's New Monthly Magazine* 78 (March 1889): 549.

136. Elliott Daingerfield, "A Reminiscence of George Inness," *Monthly Illustrator* (March 1895), quoted in Alfred Trumble, *George Inness, N.A.: A Memorial of the Student, the Artist, and the Man* (New York: The Collector, 1895), 34–35.

137. "The Academy Exhibition," *Boston Evening Transcript,* April 6, 1885, 2.

138. "The Inness Paintings," *Art Amateur* 32 (February 1895): 77.

139. Inness rarely painted coastal scenes; this one was made during a trip to England in 1887 (Nicolai Cikovsky, Jr., "Off the Coast of Cornwall, England," in Cikovsky and Quick, *George Inness,* 170).

140. As I noted earlier, Cikovsky has discussed the question of finish in Inness (*George Inness*

[1993], 121, 123, 129, 130). Although Inness did leave a number of unfinished works in his studio at his death, I do not think this should lead to the assumption that all Inness paintings that to us look like they may not be finished are not.

141. Frank Fowler, "A Master Landscape Painter: The Late George Inness," *Harper's Weekly* 38 (December 29, 1894): 1239.

142. Sheldon, "George Inness," 246.

143. See chap. 1.

144. In insect vision, light enters the compound eye, the basic units of which are ommatidia, six-sided compartments composed of the corneal lens and crystalline cone (the optical elements) and the retinula and pigment cells (the sensory elements), before resolving into a bioelectric signal within the nervous system and creating an image on the brain. Insect eyes offer a less detailed view of the world than do human eyes but are far more sensitive to movement. See R. F. Chapman, *The Insects: Structure and Function,* 4th ed. (Cambridge: Cambridge University Press, 1999); and Marc J. Klowden, *Physiological Systems in Insects* (San Diego, CA, and London: Academic Press, 2002).

145. Elliott Daingerfield, "Inness: Genius of American Art," *Cosmopolitan* 55 (September 1913): 520, and "A Reminiscence of George Inness," 34.

146. Daingerfield, *George Inness,* 32–33.

147. Daingerfield, introduction to G. Inness, Jr., *Life, Art, and Letters,* xxviii.

148. "His Art His Religion," 9.

149. According to Trumble, "During the last dozen years of his life Inness, while even more industrious than in his youth, issued fewer evidences of his industry to the world, because he effaced and repainted so much, and left so many works in a state which he considered incomplete. The two hundred and forty canvases sold by his executors, and which represented the collection he left in his studio, were probably but a small part of the numbers which he discarded and destroyed" (*George Inness, N.A.,* 23). "He destroyed ruthlessly," said Daingerfield, "in the effort to reach better, greater results" (*George Inness: The Man and His Art* [New York: Frederic Fairchild Sherman, 1911], 22).

150. "The Fine Arts," *Boston Daily Advertiser,* September 14, 1875; "Art and Artists," *Boston Evening Transcript,* September 21, 1875, 6. In a letter to Genevieve M. Walton, Inness wrote, "I have not yet had the article I spoke of published and as I find it hardly the thing for the lighter magazines, I do not know when I shall make use of it. Should I do so before long, I will send it to you" (Inness to Walton, July 1879, in E. Maurice Bloch, *Kindred Spirits: The E. Maurice Bloch Collection,* pt. 1, *Books and Printed Matter,* Catalogue 87 [Boston: Ars Libri, Ltd., 1992]).

151. Sheldon, "George Inness," 244–46.

152. Ibid., 245.

153. McSpadden, *Famous Painters,* 135.

154. Trumble, *George Inness, N.A.,* 13. See also Daingerfield, *George Inness,* 41–42; and A. T. Van Laer, "George Inness," *Arts for America* 5 (February 1896): 19.

155. Daingerfield, "A Reminiscence of George Inness," 35.

156. E., "Mr. Inness on Art-Matters," 376.

157. See, e.g., De Kay, "George Fuller, Painter," 349–54; Titus Munson Coan, "Painters and Writers," *Art Review* 2 (October/November 1887): 23–36; and John C. Van Dyke, "Suggestiveness in Art," *New Englander and Yale Review* 50 (January 1889): 29–42.

158. De Kay, "A Turning Point in the Arts," *Cosmopolitan* 15 (July 1993): 272.

159. "Landscape Notes," *Art Amateur* 27 (August 1892): 56. See also L. E. M. Jones, *The Landscape Alphabet* (1825) (Northampton, MA: Friends of the Smith College Library, 1981).

160. "Fine Arts: The Sixth Annual Exhibition of the Society of American Artists," *Nation* 36 (April 12, 1883): 328; "Fine Arts: The Academy Exhibition," pt. 2, *Nation* 38 (April 24, 1884): 370. See also William Howe Downes, "Boston Painters and Painting," pt. 3, *Atlantic Monthly* 62 (September 1888): 393.

161. James Collins Moore, "The Storm and the Harvest: The Image of Nature in Mid-Nineteenth-Century American Landscape Painting" (Ph.D. diss., Indiana University, 1974), 9, 28. E. L. Magoon, e.g., referred to the "book of nature" in his essay "Scenery and Mind," calling nature "the art of God" (in *The Home Book of the Picturesque; or, American Scenery, Art, and Literature, Comprising a Series of Essays by Washington Irving, W. C. Bryant, Fenimore Cooper, and Others* [Gainesville, FL: Scholars' Facsimiles & Reprints, 1967], 5). In an article in the *Independent,* Talbot W. Chambers stated that "one and the same being is the author of Nature and the author of the Bible. The world and the Word are the two books of his self-revelation, and we are required to use both. . . . The book of Nature tells us much of the natural glories of the Godhead" ("Nature and Revelation," *Independent* 45 [February 2, 1893]: 139). See also Walter Crane, "The Language of Line: Of Outline," *Magazine of Art* 11 (1888): 145–50. Promey briefly discusses the idea of the book of nature in her article on Inness ("The Ribband of Faith," 50).

162. Hitchcock, "George Inness, N.A.," 12.

163. McSpadden, *Famous Painters,* 139.

164. G. Inness, Jr., *Life, Art, and Letters,* 246/249; emphasis added.

165. "Art and Artists in New York," *Independent,* vol. 33 (December 22, 1881).

166. "Our Artistic Show at Paris," *New York Herald,* March 8, 1889, 6. The *Herald* also printed a reply from American Art Commissioner Rush Hawkins, who Inness had criticized in his letter. The painting in question won a gold medal.

167. "That Picture for Paris Row," *New York Herald,* March 9, 1889, 4. The *Herald* reported that Elizabeth Hart Inness had asked other members of the artistic community, including Worthington Whittredge, Thomas Moran, Kenyon Cox, Walter Shirlaw, Arthur Parton, Edgar M. Ward, and J. G. Brown, to sign a petition in support of her husband's view. (Whittredge, Ward, and Parton did not sign.) A third article concerning the dispute appeared in the *Herald* on March 10. See also Sophia Antoinette Walker's description of Inness's preference for the monographic in "Fine Arts: George Inness," *Independent* 46 (August 30, 1894): 1115.

168. Inness, "Strong Talk on Art," *New York Evening Post,* June 3, 1879.

169. Inness to Thomas B. Clarke, December 30, 1892; transcription of letter provided by Nicolai Cikovsky, Jr. Initially, Inness used the phrase "the cause of art degradation" to characterize such exhibitions but crossed it out in the letter. Inness did exhibit at the exposition; this letter was followed by several others to Clarke regarding his participation, all of which expressed his reluctance to submit examples of his work.

170. Inness to Hitchcock, March 23, 1884; Inness, "A Painter on Painting," 461; and Sheldon, "George Inness," 49.

171. Inness, "Strong Talk on Art."

172. Mariana Van Rensselaer, "Some Aspects of Contemporary Art," *Lippincott's Magazine* 22 (December 1878): 709–10.

173. "His Art His Religion," 9; emphasis added.

174. E., "Mr. Inness on Art-Matters," 377; emphasis added.

EPILOGUE

1. "His Art His Religion," *New York Herald,* August 12, 1894, 9

2. Inness to Ripley Hitchcock, March 23, 1884, in *George Inness of Montclair* (Montclair, NJ: Montclair Art Museum, 1964), n.p.; emphasis added.

3. Elliot Daingerfield, "George Inness," *Century* 95 (November 1917): 71–72; Alfred Trumble, *George Inness, N.A.: A Memorial of the Student, the Artist, and the Man* (New York: The Collector, 1895), 14. See also Henry Eckford [Charles De Kay], "George Inness," *Century Magazine* 24 (May 1882): 59 ("for his nature is most excitable, and can only be made to apply itself by the strongest exercise of will").

4. G. Inness, Jr., *Life, Art, and Letters of George Inness* (New York: Century Co., 1917), 194–95.

5. "His Art His Religion," 9
6. Inness to Hitchcock, March 23, 1884.
7. "His Art His Religion," 9
8. Ibid.

SELECTED BIBLIOGRAPHY

This bibliography is divided into four sections: (1) "George Inness: Writings, Interviews, and Correspondence," which includes writings and interviews published in nineteenth-century periodicals as well as Inness's letters to newspapers, critics, and friends; (2) "George Inness: Art Criticism," which lists, in chronological order, books, articles, essays, and exhibition reviews from the nineteenth and early twentieth centuries concerned primarily with Inness's art and career; (3) "Primary Sources"; and (4) "Secondary Sources." Because of the amount of art-critical and primary source material that I consider in this study, sections 2 and 3 are necessarily abbreviated. For a more complete list of period art criticism (1847–) that mentions or discusses Inness or a more comprehensive survey of writing from the period relevant to this study (art critical and otherwise), and for information regarding sources not included herein, the reader should consult the notes to the text or the bibliography in Rachael Z. DeLue, "George Inness: Landscape, Representation, and the Struggle of Vision" (Ph.D. diss., Johns Hopkins University, 2000), 357–95.

GEORGE INNESS: WRITINGS, INTERVIEWS, AND CORRESPONDENCE (IN CHRONOLOGICAL ORDER)

"The Sign of Promise." By George Inness. Now on Exhibition at Snedicor's [sic] Gallery, 768 Broadway, New York. 1863.

"Inness's Allegorical Pictures." *New York Evening Post,* May 11, 1867, 4.

"Colors and Their Correspondences." *New Jerusalem Messenger* 13 (November 13, 1867): 78–79.

Inness, George. "A Painter on Painting." *Harper's New Monthly Magazine* 56 (February 1878): 458–61.

"Artists and Critics." *New York Daily Tribune,* April 15, 1878, 5.

"A Plea for the Painters." *New York Evening Post,* March 21, 1878.

E., "Mr. Inness on Art-Matters." *Art Journal* 5 (1879): 374–77.

Inness, George, letter to the editor, Clarence Cook. *New York Daily Tribune,* April 11, 1879.

"Strong Talk on Art." *New York Evening Post,* June 3, 1879.

Inness, George, to Ripley Hitchcock, March 23, 1884, in *George Inness of Montclair.* Montclair, NJ: Montclair Art Museum, 1964.

"Art Hints and Notes." *Art Amateur* 15 (October 1886): 96.

"Our Artistic Show at Paris . . . George Inness Protests Violently. . . ." *New York Herald,* March 8, 1889, 6.

"That Picture for Paris Row." *New York Herald,* March 9, 1889, 4.

"The George Dinner: The Great Banquet at the Metropolitan Hotel." *Standard* 7 (January 22, 1890): 8–11.

Inness, George. "Unite and Succeed." *American Federationist* 1 (August 1894): 119.

"His Art His Religion: An Interesting Talk with the Late Painter George Inness on His Theory of Painting." *New York Herald,* August 12, 1894, 9.

George Inness: Art Criticism (in chronological order)

Mrs. Conant. "George Innis [*sic*]." *Independent* 12 (December 27, 1860), 6.

H. "When Is an Artist True to Himself?" Pts. 1 and 2. *Boston Evening Transcript,* February 19, 1862, 1; March 7, 1862, 1.

B. "When Is an Artist True to Himself?" *Boston Evening Transcript,* February 25, 1862, 1.

Proteus [pseud.]. "Our Artists. VI. George Inness." *New York Commercial Advertiser,* March 20, 1862.

Jarves, James Jackson. "Inness's 'Sign of Promise.'" *Boston Evening Transcript,* January 7, 1863, 2.

SWH. "Innes's [*sic*] New Picture." *New York Evening Post,* March 3, 1863, 1.

Sordello [Eugene Benson]. "National Academy of Design: Fortieth Annual Exhibition—George Inness." *New York Evening Post,* May 12, 1865, 1.

Sordello [Eugene Benson]. "American Landscape Painters. I. George Inness and S. R. Gifford." *New York Evening Post,* March 30, 1866, 1.

"A New Landscape by George Inness." *New York Evening Post,* April 17, 1866.

"Inness's Allegorical Pictures." *New York Evening Post,* May 11, 1867, 4.

"Inness." *Art Journal* (Chicago) 1 (November 15, 1867): 16.

"Art Gossip: Coming Departure of George Inness for Europe: His Latest Work." *New York Evening Post,* March 31, 1870, 1.

Cobb, Darius. "The Inness Collection." *Boston Evening Traveler,* May 13, 1875.

"The Fine Arts: The Inness Collection." *Boston Daily Advertiser,* May 15, 1875.

"The Fine Arts: Inness's Paintings." *Boston Daily Globe,* June 19, 1875, 2.

"George Inness." *Chicago Tribune,* September 17, 1875.

"The Art Exhibition—Landscape: George Inness." *Cincinnati Commercial,* September 18, 1875.

"American Painters—George Inness." *Art Journal,* n.s., 2 (March 1876): 84–85.

"The Academy Exhibition: Critics on the Fence. . . . George Inness, the Eccentric." *New York Times,* April 10, 1878, 2.

"Mr. George Inness's Pictures." *Boston Evening Transcript,* March 11, 1880, 1.

Fawcett, Edgar. "An American Painter: George Inness." *Californian* 4 (December 1881): 453–60.

De Kay, Charles [Henry Eckford, pseud.]. "George Inness." *Century Magazine* 24 (May 1882): 57–64.

Catalogue: Special Exhibition of Oil Paintings, Works of Mr. George Inness, N.A. New York: American Art Galleries, 1884.

"Mr. Inness's Niagara." *New York Daily Tribune,* January 9, 1884, 5.

"Fine Arts: 'Niagara,' by George Inness." *Independent* 36 (January 24, 1884): 105.

"The Inness Exhibition." *New York Daily Tribune,* April 12, 1884, 5.

"George Inness Paintings." *Boston Advertiser,* April 14, 1884.

"George Inness Paintings: A Special Exhibition in New York—a Glance at the Works." *Boston Evening Transcript,* April 14, 1884, 6.

Jarvis, Robert. "Pictures by La Farge and Inness." *Art Amateur* 11 (June 1884): 12–13.

"American Artist Honored: Purchase of Six of Mr. Inness's Paintings by a French Firm." *New York Times,* January 20, 1889, 5.

Exhibition of the Paintings Left by the Late George Inness. New York: American Fine Arts Society, 1894.

"Obituary." *Magazine of Art* 17 (1894): xlviii.

"Some Living American Painters: Critical Conversations by Howe and Torrey." *Art Interchange* 32 (April 1894): 100–102.

"The Death of Inness." *New York Commercial Advertiser,* August 1894.

"Recent Deaths." *Boston Evening Transcript,* August 4, 1894.

"George Inness." *New York Evening Post,* August 7, 1894.

"The Fine Arts: George Inness." *Critic* 25 (August 11, 1894): 97.

Schuyler, Montgomery. "George Inness." *Harper's Weekly* 38 (August 18, 1894): 787.

"Artist Inness' Funeral." *New York Commercial Advertiser,* August 20, 1894.

"Recent Deaths." *Boston Evening Transcript,* August 24, 1894.

"A Great American Painter." *Illustrated American* 16 (August 25, 1894): 251.

Walker, Sophia Antoinette. "Fine Arts: George Inness." *Independent* 46 (August 30, 1894): 1115.

"The Fine Arts: Art Notes." *Critic* 25 (September 1, 1894): 147.

Montague [?] [pseud.]. "My Notebook." *Art Amateur* 31 (September 1894): 66.

"George Inness." *Art Amateur* 31 (October 1894): 89.

Trumble, Alfred. "George Inness: The Artist, the Scholar, and the Man." *Collector* 5 (October 1894): 247–53.

Schuyler, Montgomery. "George Inness: The Man and His Work." *Forum* 18 (November 1894): 301–13.

Fowler, Frank. "A Master Landscape Painter: The Late George Inness." *Harper's Weekly* 38 (December 29, 1894): 1239–42.

"Gallery and Studio: The Exhibition of Recent Works by Inness and Vos." *Brooklyn Daily Eagle,* December 30, 1894.

Catalogue of Paintings by the Late George Inness, N.A. New York: Fifth Avenue Art Galleries, 1895.

Trumble, Alfred. *George Inness, N.A.: A Memorial of the Student, the Artist, and the Man.* New York: The Collector, 1895.

"The Fine Arts: Paintings by the Late George Inness." *Critic* 26 (January 5, 1895): 17–18.

"George Inness." *New York Evening Post,* January 5, 1895.

Constant, Benjamin, to the Editor; *New York Times,* January 6, 1895.

"Gallery and Studio: More Pictures by George Inness on Exhibition." *Brooklyn Daily Eagle,* January 6, 1895.

"The First Inness Sale." *Collector* 6 (January 15, 1895): 94–95.

"The Inness Paintings." *Art Amateur* 32 (February 1895): 77–78.

Monks, J[ohn] A[ustin] S[ands]. "A Near View of Inness." *Art Interchange* 34 (June 1895): 148–49.

Van Laer, A. T. "George Inness." *Arts for America* 5 (February 1896): 17–21.

Downes, William Howe, and Frank Torrey Robinson. "Later American Masters." *New England Magazine* 14 (April 1896): 150–51.

"The Fine Arts: Paintings by Inness and Homer." *Critic* 29 (March 19, 1898): 201.

"Exposition of George Inness Landscapes." *Brooklyn Daily Eagle,* January 26, 1901.

"Pictures at the Union League Club." *New York Sun,* March 18, 1901.

"Two Important Exhibitions." *New York Sun,* March 29, 1901.

Hartmann, Sadakichi [Sidney Allan, pseud.]. "The Influence of Visual Perception on Conception and Technique." *Camera Work,* no. 3 (July 1903), 23–26

Atkins, Henry. "William Keith, Landscape Painter, of California." *International Studio* 33 (November 1907): 36–42.

Coxe, Reginald Cleveland. "The Field of Art: George Inness." *Scribner's Magazine* 43 (October 1908): 509–12.

Daingerfield, Elliot. *George Inness: The Man and His Art.* New York: Frederic Fairchild Sherman, 1911.

Hoeber, Arthur. "A Remarkable Collection of Landscapes by the Late George Inness, N.A." *International Studio* 43 (March 1911): 37–43.

Harrison, Birge. "The Field of Art. Subjects for the Painter in American Landscape." *Scribner's Magazine* 52 (July 1912): 765–68.

Catalogue of the Loan Exhibition of Important Works by George Inness, Alexander Wyant, and Ralph Blakelock. Chicago: Galleries of Moulton and Ricketts, 1913.

Daingerfield, Elliot. "Inness: Genius of American Art." *Cosmopolitan* 55 (September 1913): 518–25.

A Collection of Paintings by George Inness, N.A. With an introduction by Elliot Daingerfield. New York: Privately Printed, 1917.

Inness, George, Jr. *Life, Art, and Letters of George Inness.* New York: Century Co., 1917.

Lamb, Frederick Stymetz. "Reminiscences of George Inness." *Art World* 1 (January 1917): 250–52.

Daingerfield, Elliot. "George Inness." *Century* 95 (November 1917): 69–77.

Hill, Arthur Turnbull. "Early Recollections of George Inness and George Waldo Hill." in *New Salmagundi Papers* (New York: Library Committee of the Salmagundi Club, 1922), 109–15.

Watkins, S. C. G. *Reminiscences of Montclair.* New York: A. S. Barnes & Co., 1929.

Cobb, Stanwood. "Reminiscences of George Inness by Darius Cobb." *Art Quarterly* 26 (Summer 1963): 234–42.

PRIMARY SOURCES

Alison, Archibald. *Essays on the Nature and Principles of Taste.* 2 vols. Edinburgh: Bell & Bradfute, 1811.

"Allegory in Art." *Crayon* 3 (April 1856): 114–15.

Beecher, Henry Ward. *Star Papers; or, Experiences of Art and Nature.* New York: J. C. Derby, 1855.

———. "Overbeck and Cole." *Independent* 8 (January 3, 1856): 1.

———. *Eyes and Ears.* Boston: Ticknor & Fields, 1862.

Benjamin, Samuel Greene Wheeler. "Practice and Patronage of French Art." *Atlantic Monthly* 36 (September 1875): 259–69.

———. "Art-Criticism." *Art Journal* 5 (1879): 29–31.

———. "Present Tendencies in American Art." *Harper's New Monthly Magazine* 58 (March 1879): 481–96.

———. "Fifty Years of American Art: 1828–1878." Pts. 1–3. *Harper's New Monthly Magazine* 59 (July 1879): 241–57; (September 1879): 481–96; (October 1879): 673–88.

———. *Art in America: A Critical and Historical Sketch.* New York: Harper & Brothers, 1880.

———. "Tendencies of Art in America." *American Art Review* 1 (1880): 105–10; 196–202.

———. "American Art since the Centennial." *New Princeton Review,* n.s., 4 (July 1887): 14–30.

Benson, Eugene. "The Old Masters in the Louvre, and Modern Art." *Atlantic Monthly* 21 (January 1868): 111–18.

———. "Modern French Painting." *Atlantic Monthly* 22 (July 1868): 88–95.

Berkeley, George. *The Works of George Berkeley.* 3 vols. Edited by Alexander Cambell Fraser. Oxford: Clarendon Press, 1871.

Boisbaudran, Horace Lecoq de. *The Training of the Memory in Art.* Translated by L. D. Luard. London: MacMillan & Co., Ltd., 1911.

Bowker, R. R. "Science and the Spirits." *Appletons' Journal* 7 (January 20, 1872): 67–69.

Brown, Brownlee. "Letters on Art." (series) *Independent* 8 (October 2, 1856): 313; 8 (October 9, 1856): 321; 8 (October 30, 1856): 345; 8 (November 6, 1856): 353; 8 (November 13, 1856): 361; 8 (November 27, 1856): 377; 9 (January 1, 1857): 1; 9 (November 19, 1857): 2; 10 (May 13, 1858): 2.

Brownell, William Crary. "The Younger Painters of America." Pts. 1–3. *Scribner's Monthly* 20 (May 1880): 1–15; 20 (July 1880): 321–35; 22 (July 1881): 321–34.

———. "French Art." Pts. 1–3. *Scribner's Magazine* 12 (September 1892): 329–46; (October 1892): 432–449; (November 1892): 604–27.

Buchanan, Joseph Rodes, M.D. "The Psycho-Physiological Sciences." *Popular Science Monthly* 11 (October 1877): 721–34.

Bunyan, John. *The Pilgrim's Progress: Written under the Similitude of a Dream.* New York: J. M. Fairchild & Co., 1855.

Burke, Edmund. *A Philosophical Enquiry into the Origin of Our Ideas of the Sublime and Beautiful.* Edited and with an introduction by James T. Boulton. London: Routledge & Kegan Paul; New York: Columbia University Press, 1958.

Carpenter, William. "The Unconscious Action of the Brain." *Popular Science Monthly* 1 (September 1872): 544–64.

———. "Man as the Interpreter of Nature." *Popular Science Monthly* 1 (October 1872): 684–701.

———. *Principles of Mental Physiology: With Their Applications to the Training and Discipline of the Mind, and the Study of Its Morbid Conditions.* London: C. Kegan Paul & Co., 1879.

———. "Mesmerism, Odylism, Table-Turning, and Spiritualism." Pts. 1 and 2. *Popular Science Monthly* 11 (May 1877): 12–25; (June 1887): 161–73.

Cavé, Marie-Elisabeth. *Drawing from Memory: The Cavé Method for Learning to Draw from Memory.* New York: G. P. Putnam & Sons, 1868.

Child, Theodore. "A Note on Impressionist Painting." *Harper's New Monthly Magazine* 73 (January 1887): 313–15.

———. "The Paris Salon: Some Pictures by American Artists." Pts. 1 and 2. *Harper's Weekly* 31 (April 21, 1887): 287–96; (May 7, 1887): 337.

———. "American Artists at the Paris Exhibition." *Harper's New Monthly Magazine* 79 (September 1889): 489–521.

———. "Some Modern French Painters." *Harper's New Monthly Magazine* 80 (May 1890): 817–42.

Cobbe, Frances Power. "The Fallacies of Memory." *Galaxy* 1 (May 15, 1866): 149–62.

Coe, Benjamin H. Easy *Lessons in Landscape Drawing, with Sketches of Animals and Rustic Figures, and Directions for Using the Lead Pencil.* Hartford, CT: Robins & Folger, 1840.

Coultas, Harland. *What May Be Learned from a Tree.* Philadelphia: C. Sherman & Son, 1859.

Cowling, Richard O., M.D. "The Influence of Shock on Memory." *American Practitioner* 21 (January 1880): 1–5.

"Curiosities of Vision." *Appletons' Journal* 7 (April 27, 1872): 472.

Descartes, René. *Discourse on Method and Related Writings.* Translated by Desmond M. Clarke. London: Penguin Books, 1999.

———. *Discourse on Method, Optics, Geometry, and Meteorology.* Translated by Paul J. Olscamp. Rev. ed. Indianapolis and Cambridge: Hackett Publishing Co., 2001.

"The Development of Psychology." Pts. 1 and 2. *Popular Science Monthly* 5 (July 1874): 288–303; (August 1874): 412–23.

Durand, Asher Brown. "Letters on Landscape Painting." Pts. 1–9. *Crayon* 1 (January 3, 1855): 1–2; (January 17 1855): 34–35; (January 31, 1855): 66–67; (February 14, 1855): 97–98; (March 7, 1855): 145–46; (April 4, 1855): 209–11; (May 2, 1855): 273–75; (June 6, 1855): 354–55; (July 4, 1855): 16–17.

Emerson, Ralph Waldo. *Essays and Lectures.* Edited by Joel Porte. New York: Library of America, 1983.

Faust, A. J. "Memory." *Appletons' Journal* 11 (December 1880): 524–31.

Fiske, John. "The Idea of God." Pts. 1 and 2. *Atlantic Monthly* 56 (November 1885): 642–61; (December 1885): 791–805.

Fowle, William B., trans. *An Introduction to Linear Drawing; translated from the French of M. Francoeur, with alterations and additions to adapt it to the Use of Schools in the United States.* Boston: Hilliard, Gray, Little, & Wilkins, 1828.

Garland, Hamlin. *Crumbling Idols: Twelve Essays on Art Dealing Chiefly with Literature, Painting, and the Drama.* Edited by Jane Johnson. Cambridge, MA: Belknap Press, Harvard University Press, 1960.

Gilpin, William. *A Dialogue upon the Gardens of the Right Honourable the Lord Viscount at Stow in Buckinghamshire.* 1748; reprint, Los Angeles: University of California/Augustan Reprint Society, 1976.

———. *Three Essays: On Picturesque Beauty; On Picturesque Travel; and On Sketching Landscape, to which is added a poem, On Landscape Painting.* London: R. Blamire, 1792.

GWP. "Some Remarks on the Landscape Art, as Illustrated by the Collection of the American Art-Union." Pts. 1 and 2. *Bulletin of the American Art Union* 2 (November 1849): 21–23; (December 1849): 15–19.

———. "Critical and Descriptive Articles: Painting and Music." *Bulletin of the American Art Union* 3 (July 1850): 51–53.

———. "Lessing's 'Laocoön.'" *Bulletin of the American Art Union* 3 (August 1850): 73–75.

———. "On the Choice of Subjects for Pictures." *Bulletin of the American Art Union* 3 (September 1850): 94–96.

Hawthorne, Nathaniel. *The Complete Novels and Selected Tales of Nathaniel Hawthorne.* Edited by Norman Holmes Pearson. New York: Modern Library, 1937.

Henkle, W. D. "Remarkable Cases of Memory." *Journal of Speculative Philosophy* 5 (1871): 6–26.

The Home Book of the Picturesque; or, American Scenery, Art, and Literature, Comprising a Series of Essays by Washington Irving, W. C. Bryant, Fenimore Cooper, and Others. With an introduction by Motley F. Deakin. 1852; reprint, Gainesville, FL: Scholars' Facsimiles and Reprints, 1967.

Hopkins, John Henry. *The Vermont Drawing Book of Landscapes.* Burlington, VT, 1838.

Hoppin, William J. "A Glimpse of Contemporary Art in Europe." Pts. 1 and 2. *Atlantic Monthly* 32 (August 1873): 200–209; (September 1873): 257–67.

"How One Landscape-Painter Paints." *Art Journal*, n.s., 3 (August 1877): 284–85.

"How to Learn to Draw." Pts. 1 and 2. *Literary World* 3 (February 12, 1848): 29–30; (March 4, 1848): 87–88.

Humboldt, Alexander von. *Cosmos: A Sketch of a Physical Description of the Universe.* New York: Harper & Bros., 1858.

Hunt, William Morris. *Talks on Art.* Edited by Helen M. Knowlton. Boston: H. O. Houghton & Co., 1875.

———. *On Painting and Drawing.* 1883; reprint, New York: Dover Publications, Inc., 1976.

Hurd, H. W. "Some Facts Concerning Memory." *Appletons' Journal* 4 (August 13, 1870): 195.

James, Henry, Jr. "The Bethnal Green Museum." *Atlantic Monthly* 31 (January 1873): 69–75.

———. "The Picture Season in London." *Galaxy* 24 (August 1877): 149–61.

James, William. "The Association of Ideas." *Popular Science Monthly* 16 (March 1880): 576–93.

———. *Writings 1878–1899.* New York: Library of America, 1992.

Jarves, James Jackson. *The Art-Idea.* Edited and with an introduction by Benjamin Rowland, Jr. 1864; reprint, Cambridge, MA: Belknap Press, 1960.

———. *Art Thoughts.* New York: Hurd & Houghton, 1871.

———. "Color: Its Principles and Use." *Independent* 24 (February 8, 1872): 2.

Jones, L. E. M. *The Landscape Alphabet.* 1825; reprint, Northampton, MA: Friends of the Smith College Library, 1981.

JS, "Illusions of Memory." *Littell's Living Age* 145 (May 15, 1880): 432–44.

Laffan, W. Mackay. "The Material of American Landscape." *American Art Review* 1 (November 1879): 29–32.

Leibniz, Gottfried Wilhelm. *Leibniz: Selections.* Edited by Philip P. Wiener. New York: Charles Scribner's Sons, 1951.

———. *Leibniz: Logical Papers.* Translated and edited by G. H. R. Parkinson. Oxford: Clarendon Press, 1966.

———. *Gottfried Wilhelm Leibniz: Philosophical Papers and Letters.* Translated and edited by Leroy E. Loemker. Dordrecht and Boston: D. Reidel Publishing Co., 1976.

———. *Gottfried Wilhelm Leibniz: Philosophical Essays.* Translated and edited by Roger Ariew and Daniel Garber. Indianapolis: Hackett Publishing Co., 1989.

Lessing, Gotthold Ephraim. *Laocoön: An Essay on the Limits of Painting and Poetry.* Edited and with an introduction by Edward Allen McCormick. Indianapolis and New York: Bobbs-Merrill Co., 1962.

Liebreich, R. "Effects of Faulty Vision in Painting." *Popular Science Monthly* 1 (June 1872): 174–87.

Locke, John. *An Essay concerning Human Understanding.* Edited by P. H. Nidditch. Oxford: Oxford University Press, 1975.

———. *The Correspondence of John Locke.* Edited by E. S. De Beer. 8 vols. Oxford: Clarendon Press, 1976–89.

LS. "Darwinism and Divinity." *Popular Science Monthly* 1 (June 1872): 188–202.

Lucas' Progressive Drawing Book. Baltimore: Lucas Fielding, Jr., 1827.

Maudsley, Henry, M.D. "Hallucinations of the Senses." *Popular Science Monthly* 13 (October 1878): 698–714.

McSpadden, J. Walker. *Famous Painters of America.* New York: Thomas Y. Crowell and Co., 1907.

"Memory." *Littell's Living Age* 84 (March 18, 1865): 513–16.

"Memory." *Appletons' Journal* 10 (July 12, 1873): 56.

"Memory." *Blackwood's Magazine.* American ed., vol. 91 (October 1880): 421–35.

"Memory and Its Caprices." *Littell's Living Age* 34 (September 25, 1852): 606–609.

"Memory and Mind." *Appletons' Journal* 12 (December 19, 1874): 790.

Michael, Helen Abbott [Celen Sabbrin, pseud.]. *Science and Philosophy in Art.* Philadelphia: Wm. F. Fell & Co., 1886.

"Mnemotechnic System of Acquiring Languages." *Knickerbocker* 26 (November 1845): 476.

Morris, Charles. "Psychic Research." *Lippincott's Magazine* 35 (April 1885): 364–72.

Mortimer-Granville, J. *Common Mind-Troubles.* London: David Bogue, 1880.

———. *The Secret of a Good Memory; A Practical Treatise on Memory and Its Cultivation.* Boston: D. Lothrop & Co., 1885.

Noble, Louis L. *Church's Picture, "The Heart of the Andes."* New York, 1859.

Oegger, Guillaume. *The True Messiah; or the Old and New Testaments examined according to the Principles of the Language of Nature.* Translated by Elizabeth Peabody. Paris, 1829; reprint, Boston: E. P. Peabody, 1842.

Otis, Fessenden Nott. *Easy Lessons in Landscape, with Instructions for the Lead Pencil and Crayon.* New York: D. Appleton & Co., 1851.

Peale, Rembrandt. *Graphics, the Art of Accurate Delineation: A System of School Exercise, for the Education of the Eye and the Training of the Hand, as Auxiliary to Writing, Geography, and Drawing.* Philadelphia: Edward C. Biddle, 1845.

"Perception." *Crayon* 2 (August 1, 1855): 63.

Perdicaris, Ion [pseud.]. "English and French Painting." *Galaxy* 2 (October 15, 1866): 378–80.

"A Revelation in Regard to Turner's Paintings." *Appletons' Journal* 7 (May 11, 1872): 528–29.

Robinson, A. Mary F. "The Art of Seeing." *Magazine of Art* 6 (1883): 462–64.

Rood, Ogden N. "Modern Optics and Painting." Pts. 1 and 2. *Popular Science Monthly* 4 (February 1874): 415–21; (March 1874): 572–81.

———. "The Constants of Color." *Popular Science Monthly* 9 (October 1876): 641–48.

———. "The Contrast of Color." *Popular Science Monthly* 14 (November 1878): 1–16.

Roosa, D. B. St. John. "The Human Eye as Affected by Civilization." *Cosmopolitan* 13 (October 1892): 759–68.

"Science in Its Relations to Art." Pts. 1 and 2. *New Path* 2 (November 1865): 169–72; (December 1865): 185–188.

"The Science of Color." *Art Amateur* 21 (July 1889): 30–31.

Seager, Edward. *No. 1 of Progressive Studies of Landscape Drawing. . . . Adapted to the Practice of Sketching from American Scenery.* Boston: J. H. Bufford, 1849.

"Seeing: In Science, Arts, Religion." *Knickerbocker* 63 (April 1864): 368–74.

Sheldon, George W. *American Painters.* New York: D. Appleton & Co., 1879.

———. *Hours with Art and Artists.* New York: D. Appleton & Co., 1882; reprint, New York and London: Garland Publishing, 1978.

———. "George Inness." *Harper's Weekly* (April 22, 1882), 244–46.

———. "Characteristics of George Inness." *Century Magazine* 7 (February 1895): 530–33.

Smith, John Rubens. *A Key to the Art of Drawing the Human Figure.* Philadelphia: Samuel M. Steward, 1831.

———. *The Juvenile Drawing Book; Being the Rudiments of the Art, in a Series of Progressive Lessons.* Philadelphia: John W. Moore, 1843.

Spaulding, Douglas A. "The New Psychology." *Popular Science Monthly* 3 (May 1873): 32–38.

Spear, Samuel T. "Latent Memories." *Independent* 20 (October 1, 1868): 1.

Spencer, Herbert. *The Principles of Psychology.* 1855. 2 vols. New York: D. Appleton & Co., 1873.

———. *The Study of Sociology.* 1873; reprint, Ann Arbor: University of Michigan Press, 1966.

———. *First Principles.* 1862; reprint, New York: D. Appleton and Co., 1898.

Starr, M. Allen, M.D. "Where and How We Remember." *Popular Science Monthly* 25 (September 1884): 609–20.

Sully, James. "The Pleasure of Visual Form." Pts. 1 and 2. *Popular Science Monthly* 16 (April 1880): 780–88; (May 1880): 77–86.

Swedenborg, Emanuel. *A Hieroglyphic Key to Natural and Spiritual Mysteries by Way of Representations and Correspondences.* Translated by J. J. G. Wilkinson. 1744; reprint, London: William Newberry; Boston: Otis Clapp, 1847.

———. *Arcana Coelestia.* Translated by John Clowes. Revised and edited by John F. Potts. 12 vols. New York: American Swedenborg Printing & Publishing Society, 1909–10. Originally published in 8 vols., 1749–56.

———. *The Soul, or Rational Psychology.* Translated by Frank Sewall. 1742; reprint, New York: New-Church Press, 1887.

———. *Heaven and Hell.* Translated by George F. Dole. 1758; reprint, New York: Swedenborg Foundation, 1979.

———. *Angelic Wisdom concerning the Divine Love and Wisdom.* 1763; reprint, New York: Swedenborg Foundation, 1928.

———. *The True Christian Religion.* 1771; reprint, New York: General Convention of the New Jerusalem in the United States of America, 1865.

———. *A View from Within: A Compendium of Swedenborg's Theological Thought.* Translated and edited by G. F. Dole. New York: Swedenborg Foundation, 1985.

Thompson, Elizabeth. "Our Eyes." *Harper's New Monthly Magazine* 35 (July 1867): 253–55.

Thompson, Silvanus P. "Optical Illusions of Motion." *Popular Science Monthly* 18 (February 1881): 519–26.

Thomson, D. C. "Realism in Painting." *Art Journal*, n.s., 6 (September 1880): 282–84.

Thoreau, Henry David. *A Week on the Concord and Merrimack Rivers; Walden, or, Life in the Woods; the Maine Woods; Cape Cod.* New York: Library of America, 1985.

Trumble, Alfred. "Things of the Time." *Collector* 3 (December 15, 1891): 49–52.

———. "Notes for the New Year." *Collector* 3 (January 1, 1892): 65–72.

———. "Impressionism and Impressions." *Collector* 4 (May 15, 1893): 213–17.

Tuckerman, Henry T. "Art in America." *Cosmopolitan Art Journal* 3 (December 1858): 1–8.

———. *Book of the Artists: American Artist Life.* New York: G. Putnam & Son, 1867.

Van Dyke, John C. "Article III: Suggestiveness in Art." *New Englander and Yale Review* 50 (January 1889): 29–42.

Van Rensselaer, Mariana Griswold. "Some Aspects of Contemporary Art." *Lippincott's Magazine* 22 (December 22, 1878): 706–718.

Van Rensselaer, Mrs. Schuyler. "Fine Arts: The French Impressionists." Pts. 1 and 2. *Independent* 38 (April 22, 1886): 491–92; (April 29, 1886): 523–24.

———. "Fine Arts: The Society of American Artists." Pts. 1 and 2. *Independent* 38 (July 22, 1886): 913; (July 29, 1886): 946.

Von Graefe, A. "Sight and the Visual Organ." *Popular Science Monthly* 1 (August 1872): 457–73.

Waern, Cecilia. "Some Notes on French Impressionism." *Atlantic Monthly* 69 (April 1892): 535–41.

West, Richard. "The Apprehension of Pictures." *Art Journal* 10 (1884): 177–80.

"What We See By and What We See." *Knickerbocker* 63 (April 1864): 359–63.

Whately, Richard. *Elements of Logic.* With an introduction by Ray E. McKerrow. 1826; reprint, Delmar, NY: Scholars' Facsimiles and Reprints, 1975.

———. *Rhetoric.* Reprint, London: Charles Griffin & Co., 1872.

Whitman, Walt. "Death's Valley (to Accompany a Picture by George Inness; by Request)." *Harper's New Monthly Magazine* 84 (April 1892): 707–9.

Williams, Henry W., M.D. "Our Eyes, and How to Take Care of Them." Pts. 1–5. *Atlantic Monthly* 27 (January 1871): 62–67; (February 1871): 177–83; (March 1871): 332–37; (April 1871): 462–66; (May 1871): 636–39.

Winthrop, Theodore. *A Companion to "The Heart of the Andes."* New York: D. Appleton & Co., 1859.

Wood, H. C., M.D. "Automatism: Concluding Paper." *Lippincott's Magazine* 26 (December 1880): 755–62.

Youmans, Eliza. "Simple Experiments in Optics." *Popular Science Monthly* 11 (October 1877): 658–68.

Youmans, W. J., M.D. "Images and Shadows." *Popular Science Monthly* 4 (April 1874): 665–72.

Yule, George. *Instructions in the Use and Development of the Memory.* New York: William Knowles, Publisher, 1890.

Secondary Sources

Andrews, Malcolm. *The Search for the Picturesque: Landscape Aesthetics and Tourism in Britain, 1760–1800.* Aldershot: Scolar Press, 1989.

Arkelian, Marjorie Dakin, and George W. Neubert. *George Inness Landscapes: His Signature Years, 1884–1894.* Oakland, CA: Oakland Museum, 1979.

Avery, Kevin J. "'The Heart of the Andes' Exhibited: Frederic E. Church's Window on the Equatorial World." *American Art Journal* 18 (1986): 52–72.

Avery, Kevin J., and Tom Hardiman, *The Grand Moving Panorama of Pilgrim's Progress.* Montclair, NJ: Montclair Art Museum, 1999.

Barrell, John. *The Idea of Landscape and the Sense of Place, 1730–1840: An Approach to the Poetry of John Clare.* Cambridge: Cambridge University Press, 1972.

Bedell, Rebecca. *The Anatomy of Nature: Geology and American Landscape Painting, 1825–1875.* Princeton, NJ: Princeton University Press, 2001.

Bell, Adrienne Baxter. *George Inness and the Visionary Landscape.* New York: National Academy of Design, 2003.

Bermingham, Peter. *American Art in the Barbizon Mood.* Washington, DC: Smithsonian Institution Press, 1975.

Boime, Albert. *The Magisterial Gaze: Manifest Destiny and American Landscape Painting, c. 1830–1865.* Washington, DC: Smithsonian Institution Press, 1991.

Bryson, Norman. *Vision and Painting: The Logic of the Gaze.* New Haven, CT: Yale University Press, 1983.

Bullard, CeCe. "Why Not Goochland? George Inness and Goochland County." *Goochland County Historical Society Magazine* 20 (1988): 24–35.

Burns, Sarah. *Inventing the Modern Artist: Art and Culture in Gilded Age America.* New Haven, CT, and London: Yale University Press, 1996.

Calvert, George Chambers. "George Inness: Painter and Personality." *Bulletin of the Art Association of Indianapolis, Indiana, the John Heron Art Institute* 13 (November 1926): 35–57.

Carruthers, Mary J. *The Book of Memory: A Study of Memory in Medieval Culture.* Cambridge: Cambridge University Press, 1990.

Cikovsky, Nicolai, Jr. "The Life and Work of George Inness." Ph.D. diss., Harvard University, 1965.

———. "George Inness and the Hudson River School: The Lackawanna Valley." *American Art Journal* 2 (Fall 1970): 36–57.

———. *George Inness.* New York: Praeger Publishers, 1971.

———. "'The Ravages of the Ax': The Meaning of the Tree Stump in Nineteenth-Century American Art." *Art Bulletin* 61 (1979): 611–26.

———. "The Civilized Landscape." *American Heritage* 36 (April–May 1985): 32–34.

———. *George Inness.* New York: Harry N. Abrams, 1993.

Cikovsky, Nicolai, Jr., and Michael Quick. *George Inness.* Los Angeles: Los Angeles County Museum of Art, 1985.

Clark, T. J. *The Painting of Modern Life: Paris in the Art of Manet and His Followers.* Princeton, NJ: Princeton University Press, 1984.

———. *Farewell to an Idea: Episodes from a History of Modernism.* New Haven, CT: Yale University Press, 1999.

Colbert, Charles. "A Critical Medium: James Jackson Jarves's Vision of Art History." *American Art* 16 (Spring 2002): 18–35.

Comment, Bernard. *The Painted Panorama.* Translated by Anne-Marie Glasheen. New York: Harry N. Abrams, 2000.

Conisbee, Philip, et al. *In the Light of Italy: Corot and Early Open-Air Painting.* Washington, DC: National Gallery of Art, 1996.

Conrads, Margaret C. *Winslow Homer and the Critics: Forging a National Art in the 1870s.* Princeton, NJ: Princeton University Press, 2001.

Corn, Wanda. *The Color of Mood: American Tonalism, 1880–1890.* San Francisco: M. H. De Young Memorial Museum, 1972.

———. *The Great American Thing: Modern Art and National Identity, 1915–1935.* Berkeley and Los Angeles: University of California Press, 1999.

Cranston, Maurice. *John Locke: A Biography.* London: Longmans, Green, & Co., 1957.

Crary, Jonathan. *Techniques of the Observer: On Vision and Modernity in the Nineteenth Century.* Cambridge, MA: MIT Press, 1990.

———. *Suspensions of Perception: Attention, Spectacle, and Modern Culture.* Cambridge, MA: MIT Press, 1999.

Daniels, George H. *American Science in the Age of Jackson.* History of American Science and Technology Series. New York: Columbia University Press, 1968; reprint, Tuscaloosa: University of Alabama Press, 1994.

Danly, Susan, and Leo Marx, eds. *The Railroad in American Art: Representations of Technological Change.* Cambridge, MA: MIT Press, 1988.

Day, Gail. "Allegory: Between Deconstruction and Dialectics." *Oxford Art Journal* 22 (1999): 103–18.

Dearinger, David B. *Rave Reviews: American Art and Its Critics, 1826–1925.* New York: National Academy of Design, 2000.

Debus, Allen G., and Michael T. Walton, eds. *Reading the Book of Nature: The Other Side of the Scientific Revolution.* Sixteenth Century Essays and Studies, vol. 41. Kirksville, MS: Thomas Jefferson University Press at Truman State University, 1998.

Degenaar, Morjolein. *Molyneux's Problem: Three Centuries of Discussion of the Perception of Forms.* Translated by Michael J. Collins. Dordrecht: Kluwer Academic Publishers, 1996.

DeLue, Rachael Ziady. "Pissarro, Landscape, Vision, and Tradition." *Art Bulletin* 80 (December 1998): 718–36.

———. "George Inness: Landscape, Representation, and the Struggle of Vision," Ph.D. diss., Johns Hopkins University, 2000.

De Man, Paul. *Allegories of Reading: Figural Language in Rousseau, Nietzsche, Rilke, and Proust.* New Haven, CT: Yale University Press, 1979.

Derrida, Jacques. *The Truth in Painting.* Translated by Geoff Bennington and Ian McLeod. Chicago and London: University of Chicago Press, 1987.

Eco, Umberto. *Serendipities: Language and Lunacy.* Translated by William Weaver. San Diego, CA, and New York: Harcourt Brace & Co., 1999.

Edson, Laurie, ed. *Conjunctions: Verbal-Visual Relations: Essays in Honor of Renée Riese Hubert.* San Diego, CA: San Diego State University Press, 1996.

Ferber, Linda S., and William H. Gerdts. *The New Path: Ruskin and the American Pre-Raphaelites.* Brooklyn: Brooklyn Museum of Art, 1985.

Ferguson, Frances. *Solitude and the Sublime: Romanticism and the Aesthetics of Individuation.* New York: Routledge, 1992.

Fish, Stanley E. *Self-Consuming Artifacts: The Experience of Seventeenth-Century Literature.* Berkeley and Los Angeles: University of California Press, 1972.

Fisher, Philip. *Wonder, the Rainbow, and the Aesthetics of Rare Experiences.* Cambridge, MA: Harvard University Press, 1998.

Foucault, Michel. *The Order of Things: An Archaeology of the Human Sciences.* New York: Vintage Books, 1973.

Fried, Michael. *Absorption and Theatricality: Painting and Beholder in the Age of Diderot.* Berkeley and Los Angeles: University of California Press, 1980; reprint, Chicago and London: University of Chicago Press, 1988.

———. "Painting Memories: On the Containment of the Past in Baudelaire and Manet." *Critical Inquiry* 10 (March 1984): 510–42.

———. *Realism, Writing, Disfiguration: on Thomas Eakins and Stephen Crane.* Chicago and London: University of Chicago Press, 1987.

———. *Courbet's Realism.* Chicago and London: University of Chicago Press, 1990.

———. *Manet's Modernism; or, The Face of Painting in the 1860s.* Chicago and London: University of Chicago Press, 1996.

Gage, John. *J. M. W. Turner: "A Wonderful Range of Mind."* New Haven, CT: Yale University Press, 1987.

———. *Color and Meaning: Art, Science, and Symbolism.* Berkeley and Los Angeles: University of California Press, 1999.

Galison, Peter, and Caroline A. Jones, eds. *Picturing Science Producing Art.* New York: Routledge, 1998.

Gaspard Dughet Called Gaspar Poussin, 1617–75: A French Landscape Painter in Seventeenth Century Rome and His Influence on British Art. London: Greater London Council, 1980.

George Inness in Florida, 1890–1894, and the South, 1884–1894. Jacksonville, FL: Cummer Gallery of Art, 1980.

Gerdts, William. "The American 'Discourses': A Survey of Lectures and Writings on American Art, 1770–1858." *American Art Journal* 15 (Summer 1983): 61–78.

Gerdts, William, et al. *Tonalism: An American Experience.* New York: Grand Central Art Galleries, Inc., 1982.

Goldfarb, Clare R., and Russell M. *Spiritualism and Nineteenth-Century Letters.* Rutherford, NJ: Fairleigh Dickinson University Press, 1978.

Gombrich, E. H. *Art and Illusion: A Study in the Psychology of Pictorial Representation.* Princeton, NJ: Princeton University Press, 2000.

Gotlieb, Marc J. *The Plight of Emulation: Ernest Meissonier and French Salon Painting.* Princeton, NJ: Princeton University Press, 1996.

Gyllenhaal, Martha, et al. *New Light: Ten Artists Inspired by Emanuel Swedenborg.* Bryn Athyn, PA: Glencairn Museum, Academy of the New Church, 1988.

Harvey, Eleanor Jones. *The Painted Sketch: American Impressions from Nature, 1830–1880.* Dallas: Dallas Museum of Art, 1998.

Hungerford, Constance Cain. *Ernest Meissonier: Master in His Genre.* Cambridge: Cambridge University Press, 1999.

Ireland, Leroy. *The Works of George Inness: An Illustrated Catalogue Raisonné.* Austin: University of Texas Press, 1965.

Isaacson, Joel. "Constable, Duranty, Mallarmé, Impressionism, Plein Air, and Forgetting." *Art Bulletin* 76 (September 1994): 427–50.

Ishiguro, Hidé. *Leibniz's Philosophy of Logic and Language.* 2d ed. Cambridge: Cambridge University Press, 1990.

Jaffe, Irma B, ed. *The Italian Presence in American Art, 1860–1920.* New York: Fordham University Press, 1989.

Jay, Martin. *Downcast Eyes: The Denigration of Vision in Twentieth-Century French Thought.* Berkeley and Los Angeles: University of California Press, 1993.

Jolley, Nicholas, ed. *The Cambridge Companion to Leibniz.* Cambridge: Cambridge University Press, 1995.

Jolly, Robert. "George Inness's Swedenborgian Dimension." *Southeastern College Art Conference Review* 11 (1986): 14–22.

Jones, Edwin. *Reading the Book of Nature: A Phenomenological Study of Creative Expression in Science and Painting.* Athens: Ohio University Press, 1989.

Kammen, Michael. *Meadows of Memory: Images of Time and Tradition in American Art and Culture.* Austin: University of Texas Press, 1992.

Kelly, Franklin. "Myth, Allegory, and Science: Thomas Cole's Paintings of Mt. Etna," *Arts in Virginia* 23 (1982–83): 3–17.

———. *Frederic Edwin Church and the National Landscape.* Washington, DC: Smithsonian Institution Press, 1988.

———. "American Landscape Pairs of the 1850s," *Antiques* 146 (November 1994): 650–57.

Kemal, Salim, and Ivan Gaskell. *The Language of Art History.* Cambridge Studies in Philosophy and the Arts. Cambridge: Cambridge University Press, 1991.

Kemp, Martin. *The Science of Art: Optical Themes in Western Art from Brunelleschi to Seurat.* New Haven, CT: Yale University Press, 1990.

Kerr, Howard. *Mediums, and Spirit Rappers, and Roaring Radicals: Spiritualism in American Literature, 1850–1900.* Urbana: University of Illinois Press, 1972.

Kessler, Herbert L. "'Facies Bibliothecae Revelata': Carolingian Art as Spiritual Seeing." In *Testo e Immagine Nell'Alto Medioevo.* Settimane di Studio del Centro Italiano di Studi Sull'Alto Medioevo 41 (Spoleto: Presso la Sede del Centro, 1994).

———. "Real Absence: Early Medieval Art and the Metamorphosis of Vision." In *Morfologie Sociali e Culturali in Europa fra Tarda Antichità e Alto Medioevo*. Settimane di Studio del Centro Italiano di Studi Sull'Alto Medioevo 45 (Spoleto: Presso La Sede del Centro, 1998): 1157–1211.

———. *Spiritual Seeing: Picturing God's Invisibility in Medieval Art*. Philadelphia: University of Pennsylvania Press, 2000.

Klein, Morris. *Mathematics in Western Culture*. New York: Oxford University Press, 1953.

Knapp, Steven, and Walter Benn Michaels. "Against Theory." *Critical Inquiry* 8 (Summer 1982): 723–42.

———. "Against Theory 2: Hermeneutics and Deconstruction." *Critical Inquiry* 14 (Autumn 1987): 49–68.

Koerner, Joseph Leo. *Caspar David Friedrich and the Subject of Landscape*. New Haven, CT: Yale University Press, 1990.

Lawall, David B. "Asher Brown Durand: His Art and Theory in Relation to His Times." Ph.D. diss., Princeton University, 1966.

Leja, Michael. "Monet's Modernity in New York." *American Art* 14 (Spring 2000): 50–79.

———. "Eakins and Icons." *Art Bulletin* 83 (September 2001): 479–97.

Levine, Steven Z. "Seascapes of the Sublime: Vernet, Monet, and the Oceanic Feeling." *New Literary History* 16 (Winter 1985): 377–400.

Lichtenstein, Jacqueline. *The Eloquence of Color: Rhetoric and Painting in the French Classical Age*. Translated by Emily McVarish. Berkeley and Los Angeles: University of California Press, 1993.

Lubin, David M. *Picturing a Nation: Art and Social Change in Nineteenth-Century America*. New Haven, CT: Yale University Press, 1994.

Marx, Leo. *The Machine in the Garden: Technology and the Pastoral Ideal in America*. New York: Oxford University Press, 1980.

———. "Does Pastoralism Have a Future?" *Studies in the History of Art* 36 (1992): 209–25.

Marzio, Peter C. *The Art Crusade: An Analysis of American Drawing Manuals, 1820–1860*. Washington, DC: Smithsonian Institution Press, 1976.

Mazow, Leo. "George Inness: Problems in Antimodernism." Ph.D. diss., University of North Carolina, Chapel Hill, 1996.

———. "George Inness, Henry George, the Single Tax, and the Future Poet," *American Art* 18 (Spring 2004): 58–77.

Mazow, Leo, and Rachael Ziady DeLue. *George Inness: The 1880s and 1890s*. Annville, PA: Suzanne H. Arnold Art Gallery, Lebanon Valley College, 1999.

McCausland, Elizabeth. *George Inness: An American Landscape Painter, 1825–1894*. Springfield, MA: George Walter Vincent Smith Art Museum, 1946.

Melion, Walter, and Susanne Küchler, eds. *Images of Memory: On Remembering and Representation*. Washington, DC: Smithsonian Institution Press, 1991.

Merleau-Ponty, Maurice. *Phenomenology of Perception*. Translated by Colin Smith. London: Routledge & Kegan Paul; New York: Humanities Press, 1962.

———. *The Merleau-Ponty Aesthetics Reader: Philosophy and Painting*. Edited by Galen Johnson and Michael B. Smith. Evanston, IL: Northwestern University Press, 1993.

Miller, Angela. *The Empire of the Eye: Landscape Representation and American Cultural Politics, 1825–1875*. Ithaca, NY: Cornell University Press, 1993.

Miller, David C. *Dark Eden: The Swamp in Nineteenth-Century American Culture*. Cambridge: Cambridge University Press, 1989.

Moore, James Collins. "The Storm and the Harvest: The Image of Nature in Mid-Nineteenth-Century American Landscape Painting." Ph.D. diss., Indiana University, 1974.

Morgan, David, and Sally M. Promey, eds. *The Visual Culture of American Religions*. Berkeley and Los Angeles: University of California Press, 2001.

Morgan, Michael J. *Molyneux's Question: Vision, Touch, and the Philosophy of Perception*. Cambridge: Cambridge University Press, 1977.

Mosby, Dewey F. "Alexandre-Gabriel Decamps, 1803–1860." Ph.D. diss., Harvard University, 1973.

Myers, Amy R. W., ed. *Art and Science in America: Issues of Representation.* San Marino, CA: Huntington Library, 1998.

Nemerov, Alexander. *Frederic Remington and Turn-of-the-Century America.* New Haven, CT: Yale University Press, 1995.

———. *The Body of Raphaelle Peale: Still Life and Selfhood, 1812–1824.* Berkeley and Los Angeles: University of California Press, 2001.

Newey, Vince, ed. *The Pilgrim's Progress: Critical and Historical Views.* Totowa, NJ: Barnes & Noble Books, 1980.

Novak, Barbara. *American Painting of the Nineteenth-Century: Realism, Idealism, and the American Experience.* New York: Praeger Publishers, 1969.

———. "Some American Words: Basic Aesthetic Guidelines, 1825–1870." *American Art Journal* 1 (1969): 78–91.

———. *Nature and Culture: American Landscape and Painting, 1825–1875.* New York: Oxford University Press, 1980.

Nygren, Edward J., et al. *Views and Visions: American Landscapes before 1830.* Washington, DC: Corcoran Gallery of Art, 1986.

Oettermann, Stephan. *The Panorama: History of a Mass Medium.* Translated by Deborah Lucas Schneider. New York: Zone Books, 1997.

Packer, Barbara. *Emerson's Fall: A New Interpretation of the Major Essays.* New York: Continuum, 1982.

The Paintings of George Inness (1844–94). Austin: University Art Museum of the University of Texas, 1996.

Parry, Ellwood C. *The Art of Thomas Cole: Ambition and Imagination.* Newark: University of Delaware Press, 1988.

Parry, Lee. "Landscape Theater in America." *Art in America* 59 (November–December 1970): 52–61.

Paulson, Ronald. *Emblem and Expression: Meaning in English Art of the Eighteenth Century.* London: Thames & Hudson, 1975.

———. *Literary Landscape: Turner and Constable.* New Haven, CT: Yale University Press, 1982.

Pfister, Joel, and Nancy Schnog, eds. *Inventing the Psychological: Toward a Cultural History of Emotional Life in America.* New Haven, CT: Yale University Press, 1997.

Powell, Earl A., III. "Thomas Cole and the American Landscape Tradition." Pts. 1–3. *Arts Magazine* 52 (February 1878): 114–23; (March 1978): 110–17; (April 1878): 113–17.

Promey, Sally M. "The Ribband of Faith: George Inness, Color Theory, and the Swedenborgian Church." *American Art Journal* 26 (1994): 44–65.

———. *Painting Religion in Public: John Singer Sargent's Triumph of Religion at the Boston Public Library.* Princeton, NJ: Princeton University Press, 1999.

———. "The 'Return' of Religion in the Scholarship of American Art," *Art Bulletin* 85 (September 2003): 581–603.

Pyne, Kathleen. *Art and the Higher Life: Painting and Evolutionary Thought in Late Nineteenth-Century America.* Austin: University of Texas Press, 1996.

Rainey, Sue, and Roger B. Stein. *John Douglas Woodward: Shaping the Landscape Image, 1865–1910.* Charlottesville: Bayly Art Museum, University of Virginia, 1997.

Reid, Martine, ed. *Boundaries: Writing and Drawing.* Yale French Studies, no. 84. New Haven, CT: Yale University Press, 1994.

Roback, A. A. *History of American Psychology.* New York: Library Publishers, 1952.

Roberts, Jennifer L. "Landscapes of Indifference: Robert Smithson and John Lloyd Stephens in Yucatán." *Art Bulletin* 82 (September 2000): 544–567.

Rossi, Paolo. *Logic and the Art of Memory: The Quest for a Universal Language.* Translated by Stephen Clucas. Chicago and London: University of Chicago Press, 2000.

Rutherford, Donald. *Leibniz and the Rational Order of Nature.* Cambridge: Cambridge University Press, 1995.

Sears, John F. *Sacred Places: American Tourist Attractions in the Nineteenth Century.* New York: Oxford University Press, 1989.

Schama, Simon. *Landscape and Memory.* New York: Vintage Books, 1995.

Sidlauskas, Susan. *Body, Place, and Self in Nineteenth-Century Painting.* Cambridge: Cambridge University Press, 2000.

Silver, Richard. "The Spiritual in America: The Influence of Emanuel Swedenborg on American Society and Culture, 1815–1860." Ph.D. diss., Stanford University, 1983.

Simoni, John P. "Art Critics and Criticism in Nineteenth-Century America." Ph.D. diss., Ohio State University, 1952.

Stafford, Barbara M., and Frances Terpak. *Devices of Wonder: From the World in a Box to Images on a Screen.* Los Angeles: Getty Research Institute, 2001.

Stavitsky, Gail, et al. *George Inness: Presence of the Unseen.* Montclair, NJ: Montclair Art Museum, 1994.

Stebbins, Theodore E., et al. *The Lure of Italy: American Artists and the Italian Experience, 1760–1914.* Boston: Museum of Fine Arts, 1992.

Sutton, Peter C., et al. *Masters of Seventeenth-Century Dutch Landscape Painting.* Boston: Museum of Fine Arts, 1987.

Sweeney, J. Gray. "The Nude of Landscape Painting: Emblematic Personification in the Art of the Hudson River School." *Smithsonian Studies in American Art* 3 (Fall 1989): 42–65.

Taylor, Eugene. "The Interior Landscape: George Inness and William James on Art from a Swedenborgian Point of View." *Archives of American Art Journal* 37 (1997): 2–10.

Taylor, Jenny Bourne, and Sally Shuttleworth. *Embodied Selves: An Anthology of Psychological Texts, 1830–1890.* Oxford: Clarendon Press, 1998.

Taylor, Joshua C. *William Page: The American Titian.* Chicago and London: University of Chicago Press, 1957.

Tinterow, Gary, Michael Pantazzi, and Vincent Pomarède. *Corot.* New York: Metropolitan Museum of Art, 1996.

Truettner, William H., and Alan Wallach. *Thomas Cole: Landscape into History.* New Haven, CT: Yale University Press, 1994.

Wallach, Alan. "Thomas Cole's 'River in the Catskills' as Antipastoral." *Art Bulletin* 84 (June 2002): 334–50.

Ward, Martha. "Impressionist Installations and Private Exhibitions." *Art Bulletin* 73 (December 1991): 599–622.

———. *Pissarro, Neo-Impressionism, and the Spaces of the Avant-Garde.* Chicago and London: University of Chicago Press, 1996.

Watson, Wendy M., et al. *Altered States: Conservation, Analysis, and the Interpretation of Works of Art.* South Hadley, MA: Mount Holyoke College Art Museum, 1994.

Webster, Sally. *William Morris Hunt, 1824–1879.* Cambridge: Cambridge University Press, 1991.

Wehle, Harry B. "An Early Landscape by George Inness." *Bulletin of the Metropolitan Museum of Art* 28 (April 1933): 70–71.

Weinberg, H. Barbara. "Late-Nineteenth-Century American Painting: Cosmopolitan Concerns and Critical Controversies." *Archives of American Art Journal* 23 (1983): 19–26.

———. *The Lure of Paris: Nineteenth-Century American Painters and Their French Teachers.* New York: Abbeville Press, 1991.

Weisberg, Gabriel P., ed. *The European Realist Tradition.* Bloomington: Indiana University Press, 1982.

———. "Art for Art's Sake: 'In Pursuit of Beauty: Americans and the Aesthetic Movement.'" *Arts Magazine* 61 (December 1986): 41–45.

Wolf, Bryan J. *Romantic Re-Vision: Culture and Consciousness in Nineteenth-Century American Painting and Literature.* Chicago and London: University of Chicago Press, 1982.

———. *Vermeer and the Invention of Seeing.* Chicago and London: University of Chicago Press, 1991.

Wood, Christopher S. *Albrecht Altdorfer and the Origins of Landscape.* Chicago and London: University of Chicago Press, 1993.

Woofenden, William Ross. *Swedenborg Researcher's Manual.* Bryn Athyn, PA: Swedenborg Scientific Association, 1988.

Wunsch, William F. *The World within the Bible: A Handbook to Swedenborg's "Arcana."* New York: New Church Press, 1929.

Yates, Frances A. *The Art of Memory.* Chicago and London: University of Chicago Press, 1966.

Young, Morris N. *Bibliography of Memory.* Philadelphia and New York: Chilton Co., 1961.

Italicized numbers indicate illustrations

Abbott, Helen Cecilia de Silver, 176
aesthetics, 85, 123–24, 135–36
After a Summer Shower (Inness), 222, *224*
Alban Hills, The (Inness), 109, *111*, 140
Alison, Archibald, 123–24, 134–35, 271nn80–81
allegory, period discussion of, 149–51, 169–70,
 276n28. *See also under* Inness, George
Allston, Washington, *9*, 9–10; on Claude Lorraine,
 274n134; Inness on, 9, 18, 151; participation
 and, 274n134; *Vision of the Bloody Hand*, 9, 81
alphabet, the, 227–28
anthropomorphism, 131, 139, 243n34
Apollo Vanquishing Python (Delacroix), *152*, 152
Apple Blossom Time (Inness), *194*; drawing in,
 219; foreground in, 193; temporality and, 219
Apple Orchard (Inness), 183, *184*
Armstrong, Carol, 4
art, as an aid to perception, 20–22, 103–6, 235–36
associationism: Alison and, 123–24, 134–36;
 Beecher and, 123; Cole and, 270n71, 271n80;
 landscape and, 118–19
Atkins, Henry, 82
Autumn Gold (Inness), *183*, 183, 193
Autumn, Montclair, New Jersey (Inness), *192*,
 193, 223
Autumn Oaks (Inness), *plate 3*, 32; composition
 of, 64, 65; figures in, 13; horizon in, 63;
 memory and, 55; middle tone and, 76; vision
 and, 54–55

Autumn—on the Hudson River (Cropsey), *101*,
 101–2

Banvard, John, *Panorama of the Mississippi, Mis-
 souri, and Ohio Rivers*, *162*, *163*, 164
Barbizon school, 10, 37, 38, 252nn34–35,
 268n60
beautiful, the, 123
Beecher, Henry Ward, 270n76; on art and per-
 ception, 103; automatism and, 233; extra-
 physical vision and, 123; memory and,
 122–23, 125–26, 134–36; participation and,
 133–36, 168; on perception, 104, 121–26;
 spiritual sight and, 121–22, 135. *See also
 under* Inness, George
Beeches, The (Durand), *101*, 101–2
Bell, Clarke, 147
Belshazzar's Feast (Allston), *9*, 9–10, 18
Benjamin, S. W. G., 10, 242n14, 250n10
Benson, Eugene, 209
Berkeley, George, 51, 256n73
Bierstadt, Albert, 10, 15, *16*, 243n35; participa-
 tion and, 131–33
blind spot, 27, 28
blindness: as constitutive of vision, 80; cure of,
 50–51; in period discussion of visual func-
 tion, 80. *See also under* Inness, George
body, the, 5, 257n86. *See also under* Inness,
 George

book of nature, 228, 288n161

Boston Art Club, 37

Boughton, George H., 128–29

Boutelle, D. W. C., 99

Bowker, R. R., 26

Brown, Brownlee, 99

Brownell, William Crary, 245n62

Brush Burners, The (Inness), 178, *180*

Buchanan, Joseph, 27

Bunyan, John, 145–70 passim; "The Grand Mov-
 ing Panorama of Bunyan's *Pilgrim's Progress*,"
 153, *158*, 158, 159, *160*, 162, 162–64, *163*;
 "The Grand Moving Panorama of Bunyan's
 Pilgrim's Progress" as a model for Inness,
 162–69; landscape and, 161; memory and,
 149, 157–58, 165–66; *The Pilgrim's Progress*
 as a model for Inness, 148–49, 154–55; pop-
 ularity of work in United States, 153–54;
 reading and, 168; spiritual sight and, 149,
 161, 165–66; vision and, 149, 154–55, 156,
 157–58, 161, 277n44. *See also under* Inness,
 George

Bunyan's *Pilgrim's Progress* (broadside), *162*, 163

Burke, Edmund, 51, 85, 166, 271n81

camera obscura, 59

Carpenter, William, 246n78; on art and science
 26; blindness and, 80; on memory, 254n46;
 on science and philosophy, 26; on spiritual-
 ism, 27; on visual function, 51–52, 80–81.
 See also under Inness, George

Carter, Susan N., 34, 67, 68

Cartesianism, 62, 81

Cave, Marie-Elisabeth, 35, 251n25

Chapman, John Gadsby, 105

Chase, William Merritt, 215

Cheselden, William, 51, 86

Chess Players, The (Meissonier), 23, *24*, 61

Childe, Theodore, 203, 205, 254n53

*Christian on the Border of the Valley of the
 Shadow of Death* (Church), 153, *154*

Church, Frederic Edwin, *154*, *163*; foreground
 and, 98; memory and, 34; participation and,
 128, 131–33; *The Pilgrim's Progress* and, 153;
 rainbow in *Niagara* (1857), 139; style of, 10;
 text and, 259n24

Cikovsky, Nicolai, Jr., 3, 241n18; art criticism
 and, 4; on Inness and Swedenborg, 43; on
 Inness and unfinished paintings, 281n18; on
 Inness's allusions to past art, 96; on Inness's
 compositions, 172; on *Pine Grove of the Bar-
 berini Villa* (Inness), 176Civil War, 104, 147

Clark, T. J., 4

Clarke, Thomas B., 83, 84, 191

Clouded Sun, The (Inness), 193, *196*, 215, 262n57

Cobbe, Frances Power, 40

Coffin, William, 210

Cole, Thomas, 6; allegory and, 149, 150, 169,
 276n26; color piano and, 261n53; "Essay on
 American Scenery," 8; figures and, 268n61;
 GWP (critic) on, 100; Inness on, 151–52;
 Voyage of Life, 278n70

color, 140, 202–7, 208–10, 286n102. *See also
 under* Inness, George

Coming Storm, The (1878) (Inness), 64–65, *66*

Coming Storm, The (ca. 1879) (Inness), *plate 5*;
 afterimages in, 84; blindness and, 86; compo-
 sition of, 64–65, 83–84; dislocation in, 84;
 figures in, 13, 86; harmony in, 83–84; hori-
 zon in, 84; instability, flux, and motion in,
 84; memory and, 84; middle tone and, 76; as
 a model of spiritual sight, 84–85; painted
 over another image, 85, 263n76; science and,
 85; seeing as breathing in, 84; seriality in,
 84; storm as a metaphor for death, 84; unity
 and, 83–85; the unknowable and, 213–14;
 visual function and, 84

Condillac, Étienne Bonnot de, 51

Conrads, Margaret C., 9

Constable, John, 151

Constant, Benjamin, 215

Cook, Clarence, 243n28; dispute with Inness,
 260n27; on Inness's pictures, 11, 15, 55,
 262n63; on Inness's poetic captions, 68–69

Copernicus, 282n38

Corning, Rev. J Leonard, 118

Corot, Jean-Baptiste-Camille, 23, *24*; blindness
 and, 80; descriptions of in United States, 38;
 influence of, 37; Inness on, 23–24, 25, 151;
 Inness's art and, 29; Meissonier and, 23, 29;
 painting from memory and, 37–41, 254n53.
 See also under Inness, George

Couture, Thomas, 151, 252n31

Coxe, Reginald Cleveland, 287n133

Crary, Jonathan, 25, 248n94, 257n86

criticism (art), nineteenth-century American: al-
 legory and, 149–51; in art-historical interpre-
 tation, 6, 241n18; artistic practice and, 6; on
 Corot, 38–40; the eye and, 96–103; the fore-
 ground and, 98–100; instability of terminol-
 ogy in, 9; memory and, 34, 117–19; old mas-
 ters and, 100–103, 267n42; participation
 criterion and, 127–29, 272n93; perception
 and 103–6; temporality and, 214–15; themes
 in, 8, 9, 96–103; word and image and,
 149–51, 227–28

Cropsey, Jasper Francis, 10, *101*, 101–2, 243n35,
 269n65; allegory and, 276n28; *The Pilgrim's
 Progress* and, 153, *160*

Daingerfield, Elliot, 102, 239n8; on Inness and
 allegory, 170; on Inness and spiritualism, 26;

on Inness and the alphabet, 227; on Inness scraping and scratching canvas surfaces, 221; on Inness's intensity when painting, 236; on Inness's metaphysical research and writing, 1; on Inness's scientific principles, 33, 86; on Inness's working methods, 32, 33, 50, 62–63, 72, 218, 221, 250n9; on the middle tone, 75

Darwin, Charles, 1, 3, 240n12

Daubigny, Charles-François, 25, 37, 151, 174

"Dawn of Day over the Valley of the Shadow of Death," Panorama of Bunyan's "Pilgrim's Progress" (attr. Church), 163, 164

De Kay, Charles (pseud. Henry Eckford), 244n48; on color in art, 209; on Impressionism, 203; on Inness and metaphysics, 1; on Inness and Swedenborg, 29, 43; on Inness, logic, and mathematics, 29, 63, 175; on Inness's color, 200; on music, 209; on shock and Inness's paintings, 19, 57, 237; on word and image, 227

Decamps, Alexandre-Gabriel, 41, 42, 151, 250n15. See also under Inness, George

degeneracy, 207–8, 286n102

Delacroix, Euge?ne, 151, 152, 152, 251n25. See also under Inness, George

Delaroche, Paul, 253n40

Depew, Chauncey, 147

Descartes, Rene, 59, 81, 282n34

design (or disegno), 202–7, 208–10. See also under impressionism; Inness, George

Diderot, Denis, 51, 261n53, 127

distance: art-critical prescriptions for, 99–103; landscape painting and, 99–102; vision and viewing and, 103–6. See also under Inness, George Doll and Richards, gallery of, 37

drawing: GWP and, 104–6; learning to, 104–6; learning to see and, 104–6; manuals, 102–3, 105, 266n41. See also design; Inness, George, drawing and

Dughet, Gaspard, 91, 93, 94, 95, 100, 264n2

Durand, Asher B., 101; atmosphere and, 141–42; figures in landscapes, 243n35, 268n61; GWP and, 99, 106; Inness and, 151, 152; on learning to draw, 106; on learning to see, 106; "Letters on Landscape Painting," 8, 15; participation and, 15, 101–2, 128, 134; on study of nature, 8

Durand, John, 103

Eagleswood, 42, 148, 252n37

Early Autumn, Montclair (1888) (Inness), 223, 224, 262n57

Early Autumn, Montclair (1891) (Inness), 178, 223; color and, 199; geometry and, 178, 183–85, 193; scraped surface of, 222

Early Morning, Tarpon Springs (Inness), 182; color red in, 273n127; drawing in, 218; figure in, 182, 217–18; foreground in, 193; scraped surface of, 225; temporality and, 217–218

Early Recollections: A Landscape (Inness), 90; centered trees in, 113; Claude Lorrain and, 92; color red in, 140; critical response to, 91; the eye and, 96, 113; foreground in, 98; tradition and, 92

Eckford, Henry. See De Kay, Charles

emblem, 155, 157, 228, 278n63

Emerson, Ralph Waldo: and American art, 267n45; on art and vision, 103, 136; as cited in period art criticism on Inness, 8, 241n3, 267n45; on language, 212; on nature and geometry, 187, 191, 193; on Swedenborg, 211–12

empiricism, 25, 29, 51

equilibrium, 244n36, 261n55; Inness and, 18, 55, 61, 63, 74

Essays on the Nature and Principles of Taste (Alison), 123–24

Europe: American art and, 241n17; art of, in United States, 37; figure painting and, 260n32; influence of art of, 10, 37, 244n43; landscape tradition of, 92; study in, 8, 245n62

Evening at Medfield, Massachusetts (Inness), 97, 97

Evening Landscape (1862) (Inness), 113, 114

Evening Landscape (1867) (Inness), 146, 159–61, 274n1. See also New Jerusalem, The

eye, the: GWP on, 97–103; Inness and, 91, 96–117 passim, 136–37, 204; in period art criticism, 96–103

Eyes and Ears (Beecher), 122

Farrer, Thomas Charles, 102, 266n40

Fawcett, Edgar, 10, 11, 272n100

figure painting, 70; narrativity and, 73; period discussion of, 72–74; popularity of, 260n32; viewing and, 72–73; vision and, 73. See also under Inness, George

finish, 132, 244n43. See also under Inness, George

Fish, Stanley, 165, 276n15, 278n57

Fiske, John, 26

Fried, Michael, 4, 253n40, 271n89

Friedrich, Caspar David, 138

foreground, the: art-critical prescriptions for, 98–100; in landscape art, 98–100; period discussions of, 98–99; vision and viewing and, 98–100, 103–6. See also under Inness, George

forgetting: Inness and, 134–36, 143, 233–34;

participation and, 127; in viewing, 73
Fowler, Frank, 82
Fuller, George, 10

Galileo, 282n38
Garland, Hamlin, 203
geology, 15
geometry, 188. *See also under* Inness, George;
 mathematics
Georgia Pines (Inness), 182–83, *183*, 215
Gibson, W. H., *148*
Gifford, R. Swain, 10
Gifford, Sanford Robinson, 10, 11, 31, 209
Gignoux, Regis-FranÁois, 2, 253n40
Gilpin, William, 85, 127–28, 166
Going out of the Woods (Inness), *129*, 129–30
grammar. *See* Inness, George, grammar of paint-
 ing and; word and image
"Grand Moving Panorama of Bunyan's *Pilgrim's
 Progress*, The." *See under* Bunyan, John;
 Inness, George
Gray, Lowery, Day, A (Inness), *plate 7*, 78–79
guidebooks, travel, 102–3
GWP (critic), 97; art criticism of, 97–103; art
 education and, 104–6; the eye, treatment of,
 97–103 passim; foreground and, 97–100,
 109; Inness and, 102–3, 106–17, 126, 137;
 laws of vision and, 104; national identity
 and, 266n37; participation criterion and,
 126–27; zonal landscape formula of, 98–102

Hackensack Meadows, Sunset (Inness), *108*; the
 body and, 138, 139; centered tree in, 108,
 113; Claude Lorrain and, 119; participation
 and, 108; rejection of convention in, 107;
 transformation of tradition in, 119; visual
 traversal of, 139
Harper, Fletcher, 147, 275n2
Hart, Charles Henry, 205
Hartley, Jonathan Scott, 66, 68
Harvest Moon (Inness), 185, *186*, 193
Hawthorne, Nathaniel, 118, 154
Helmholtz, Hermann von, 51
Henry, James, 124
Hillside at Etretat (Inness), 109, *111*, 140
Hitchcock, Ripley, 22, 40–41, 50, 235; 1884 essay
 on Inness, 171–72; on Inness and the book
 of nature, 228; on Inness's color, 200; on
 Inness's working methods, 198. *See also
 under* Inness, George
Hobbema, Meindert, 268n60
Hoeber, Arthur, 1
Home at Montclair (Inness), *plate 21*, 218–19
Home Book of the Picturesque, The, 102
Home of the Heron, The (Inness), *plate 11*, 171;
 color in, 172; geometry and, 175–76; organi-
zation of, 175–76, 183
Homer, Winslow, 17
Homeward (Inness), 70, *70*
Hoppin, William, 38
horizon, the. *See under Autumn Oaks; The Com-
 ing Storm* (ca. 1879); Inness, George; *Sunset
 at Etretat; Winter Morning, Montclair*
hucksterism, 205, 206
Hudson River School: art and style of, 9, 10, 12,
 18; as described by Inness, 21, 25; Inness
 compared to, 2, 12, 79, 218
Hunt, William Morris, 36–37, 251n31, 252n32

imitation in art: Daingerfield on, 32; Inness on,
 21–22; versus interpretation, 103; period
 debates about, 245n62impressionism,
 285n67; color and, 202–3; degeneracy and,
 207–9; design (or *disegno*) and, 202–7;
 exhibitions, 202; hucksterism and, 205, 206;
 Inness described in terms of, 202, 203, 204,
 205, 215, 243n35, 284n66; instantaneity and,
 214–15; period discussion of, 202–8,
 243n35; photography and, 214–15; social
 body and, 207–9; temporality and, 214–15;
 in the United States, 202; vision and, 202,
 203–10; visual dysfunction and, 205–8,
 286n102. *See also under* Inness, George
Indian Summer (Inness), 178, *181*
Inness, Elizabeth Hart (wife of GI), 69, 70,
 289n167
Inness, George: allegory and, 67, 68, 145–70
 passim, 226 (see also under *Triumph of the
 Cross, The*); allusion and, 96, 117–21,
 121–26, 136, 143, 228, 236; anthropomor-
 phism and, 131, 139, 167, 273n124; on art
 and science, 23–25; associationism and,
 123–24, 143; atmosphere and, 73, 141–43,
 215; autobiographical letter, 22, 40–41,
 50–51, 71, 235, 252n32, 280n3; automatism
 and, 233–34; Beecher and, 103, 121–26, 147,
 168, 233, 235, 270n76; biography, 2, 19,
 255n59; blindness and, 13, 18–19, 20–21, 22,
 30, 34, 41, 60, 78; the body and, 5, 13,
 136–43, 230, 257n86; book of nature and,
 228; brushwork (visible) and, 137–38, 215,
 274n134; Bunyan's *Pilgrim's Progress* and,
 145–70 passim; Carpenter and, 51–52, 60,
 80, 81, 86; centered trees in, 107, 113,
 116–17, 119, 273n124; chance and, 173–74,
 214, 233; chiaroscuro and, 141–42; "civilized
 landscape" and, 117–19, 124, 126, 143;
 Claude Lorrain and, 68, 91–92, 93, 94, 95,
 101; Cole and, 151–52, 278n70; color and, 1,
 172, 197–213, 236, 273n127; on color, 42,
 140, 197–98, 229, 287n126; color/design
 debate and, 202–13 passim, 229, 286n117;

compositional strategies of, 60, 62–65, 71–72; convention and, 12, 13, 19, 106–17, 117–21; Corot and, 23–24, 25, 37–41, 174, 254n53, 60, 61; critics on, 7, 8, 10, 17, 131–33, 241n18; critics on his allegorical paintings, 68, 147, 149–50; critics on his color, 197, 200–202, 210–11; critics on his geometry, order, and organization, 174–76; critics on his paintings as bewildering and strange, 7, 13–14, 17, 23, 39, 68–69, 204; critics on his paintings as difficult to see and comprehend, 13–14, 201–2, 243n36; critics on his paintings as impossible, 10, 11, 13, 14, 201; critics on his paintings as violent, harmful, or disturbed, 11, 69, 201, 202, 204; death of, 240n11; on Decamps, 33, 41; degeneracy and, 207–8; on Delacroix, 67, 72; Descartes and, 59–60, 81, 84; design (or *disegno*) and, 151, 202–13 passim, 229; difference of, 10; difficulty of his paintings, 19, 30, 37, 54, 55, 57, 79, 191; distance, his theorization of, 71–72; distance in his art, 13, 14, 73–74, 216, 243n36; drawing and, 218–20, 229; drawing manuals and, 106; Durand and, 151, 152; Dutch art and, 268n60; Eagleswood and, 42, 148, 252n37; embodiment of vision and, 5, 136–43, 257n86, 277n44; Emerson and, 8, 187, 191–97 passim, 241n3, 267n45; empiricism and, 25, 29; on equilibrium, 18, 55, 61, 63, 74; on evolution, 174–74; exhibition, monographic (1884) and, 171–72, 230, 246n65, 280n3; exhibitions and exhibiting his work, 139, 230–32, 289n167, 289n169; experimentation, 28, 95; extraphysical vision and, 20–21, 32, 87–88, 220; the eye and, 91, 96–117 passim, 136–37, 204; failure as a strategy, 87–88, 191, 236; figure painting and, 69–74; figures, back-turned and, 113–16, 119–20, 138–39, 215; figures and, 13, 119–20, 182–83, 215–16; figures as surrogates, 120, 131, 138–41, 167–68, 215–16; finish and, 15, 56, 137–38, 219, 244nn42–43, 281n18, 287n140; finishing pictures, Inness's uncertainty regarding, 82–83, 236, 263n66, 288n149; flatness, 81–82; foreground and, 109, 116–17, 193, 215; forgetting and, 134–36, 143, 233–34; formula, rejection of, 173–74, 191–97 passim, 212–13, 214, 220; formula and, 28–29, 33, 61, 62, 71–72, 102–3; passimFrench art and, 4, 10, 38, 252n32, 268n60; geometry and, 3, 29, 61, 62–65, 72, 151, 172, 174–97, 213; grammar of painting and, 209, 212; "The Grand Moving Panorama of Bunyan's *Pilgrim's Progress*" and, 162–69; graphic arts and, 283n46; GWP and, 102–3, 106–17, 126,

137; hieroglyphics and, 151, 153, 168; Hitchcock and, 22, 40–41, 50–51, 71, 235, 252n32, 280n3; the horizon and, 14, 18–19, 54, 55, 63–64, 74–79; influence and, 94–95; imitation and, 21–22, 91–96, 143; impossibility of declared aims, 191, 214, 236; on the impression, 61, 71, 204, 205, 207, 212; impressionism and, 202–13 passim, 215, 232, 236, 243n35; on insect vision, 20, 220; instantaneity and, 69, 73, 214–18, 219; instrumentality of landscape and, 23, 125, 173, 189, 231–32, 235–36; intersubjectivity and, 49–50, 232; on invisibility, 21–22; irrationality and, 211, 213, 214; knowledge, his understanding of, 29–30, 173–74, 190; landscape tourism and, 164–65, 166; language, painting as, 173, 189, 226, 230, 231; late works, features of, 171–74; Leibniz and, 189–90, 231; on literary or narrative art, 67–68, 72, 74; Locke and, 3, 50–57, 235; logic and, 29, 175, 189–90; madness (perceived) of, 7, 11, 236, 250n9; Magnan and, 3, 207–8; mannerism and, 91–96, 106; mathematics and, 28, 29, 60, 174–97 passim; "The Mathematics of Psychology," 2, 3, 29, 174–75, 189–90, 198, 226; mathesis and, 189–90, 197, 212; Meissionier and, 23–24, 25, 28, 29, 41, 61, 62, 254n53; memorable, paintings described as, 34; passimmemory, painting from, 3, 32–41, 48–50, 56, 232; memory and, 22, 48–50, 55–56, 117–21 passim, 269n64; memory as a strategy of vision, 119–21, 136; metaphysics and, 1–2, 235–36, 237; on Michelangelo, 82, 151, 278n59; middle tone, theory of, 74–79, 236, 262nn57–58; mission of art, 30, 33, 61, 197, 207, 232, 235–36; Molyneux and, 3, 50–57, 86; music or sound and, 75, 209, 212, 213, 261n53; nature, painting from, 9–10, 31–32, 218, 243n33, 249n1; number theory and, 28, 174–75, 186, 189–90, 198; obscurity and, 18, 37, 54–56, 76, 191; old masters and, 91–96; optics and, 18, 61, 80, 81; originality and, 94–95; on other artists, 151; painting as research and demonstration, 28–29, 83–85, 190, 235–37; painting from other artists' work, 33–34, 49–50, 232; painting several layers and/or images on a single canvas, 32–33, 34, 48–50, 56, 80, 84, 85, 232, 236; participation criterion and, 108–17, 126–36, 136–43 passim, 161–62, 164–69; perception, his art discussed in terms of by critics, 17, 204; perception, his interest in, 3–4, 19–21, 220, 235–36, 277n44; philosophy, painting as, 173–75, 235–36; philosophy and, 50–57, 174–75; photography and, 219; pictorial strategies of, 3, 28, 34, 57, 59–60, 74–79, 80,

214–34, 236; picture theory of, 2–3, 3–4, 18–19, 26–29, 29–30, 57; play and, 174, 191, 212, 214, 220, 223, 234; poetic captions of, 3, 66–69, 72, 226, 236; poetry and, 29, 68, 197, 226–27, 278n59; precision of compositions, 62–63, 64–65; on Pre-Raphaelitism, 21, 22, 205, 209, 218, 236; principles and, 28, 61; psychology and, 29, 189–90, 197, 212; psychophysiology and, 51–57, 235; rainbows and, 13, 139, 140; realism and, 71–72, 86; repetition and, 231, 236; rhetoric and, 175; scholarship on, 2, 4–5, 171, 172–73, 220; on science, 23–25; science, limits of and, 87–88, 173–74, 191–97 passim, 211, 212, 234, 236; science, role of in his art, 3, 28–30, 37, 50–57, 57, 63, 86, 212, 231, 235, 236, 237; science of landscape, 6, 22, 28–30, 56, 86, 235, 237; scraped and scratched canvas surfaces, 141, 216, 220–34, 236; seeing as breathing and, 47, 49–50, 60, 86, 216, 229, 230, 232, 236, 257n86; shock as a strategy, 19, 213; sketches, use of in his art, 32–34; sketching and, 31, 249n1; social concern and, 207–8, 232, 259n13; Spencer and, 53, 60, 63–64, 257n87; spiritual sight and, 3, 21–22, 23–25, 29, 30, 34, 41, 42–50, 56, 71, 124–25, 190, 231, 234, 236, 237; spiritualism and, 26; struggle, his art as, 3, 22, 30, 83, 191, 235–36; the subjective and, 23, 30, 61, 71, 84, 197; Swedenborg and, 42–50, 56, 60, 148–49, 189–90, 231, 233, 235, 276n14; temporality as explored in his paintings, 214–20, 236; on theology and science, 25; touch in perception and, 136–43 passim; tradition, transformation of, 117–21 passim, 125–26, 136, 143, 236; tradition and, 92–96; training, 2, 253n40; travel overseas, 19, 37, 93, 94, 117, 239n11, 252n32, 265n19; truth, his understanding of, 9–10, 18–19, 21–22, 61; Turner and, 61–62, 67–68, 72, 93, 151; the unconscious and, 233–34; unity and, 59–88, 191; universal philosophy and, 189–90, 197, 231; the unknowable and, 87–88, 173–74, 213–14, 220, 228, 231–34; view from the train and, 287n133; viewers and viewing experience, 83, 96, 106–17 passim, 215–17, 220; vision, his pictures as models of, 17, 29, 48–50, 54–56, 60, 63–64, 82, 119–21, 141–43, 152–53, 154–70 passim, 229–34, 235–36; vision, rethinking of, 81, 220, 229–34; vision and painting, 62; working methods, 31–34, 48–50, 62–63, 82, 218, 221, 236, 262n58; writing and, 151, 166, 168, 170, 225–30, 230–34 passim; writing of, 1, 19, 25, 147, 151, 174–75, 236, 239n7, 258n5, 288n150; zonal landscape formula and, 102–3, 106–17

Inness, George, works of: *After a Summer Shower*, 223, *224*; *The Afterglow*, 66; *The Alban Hills*, 109, *111*, 140; *Apple Blossom Time*, 193, *194*, 219; *Apple Orchard*, 183, *184*; *Approaching Storm*, 225; *Autumn*, 11, 69; *Autumn Gold*, 183, *183*, 193; *Autumn, Montclair, New Jersey*, *192*, 193, 223; *Autumn Oaks*, plate 3, 54–55, 63, 64, 65, 76; *A Breezy Autumn*, 262n57; *The Brush Burners*, 178, *180*; *Clearing Up*, 273n127; *The Clouded Sun*, 193, *196*, 215, 262n57; *A Cloudy Day*, 13; *The Coming Storm* (1878), 64–65, *66*; *The Coming Storm* (ca. 1879), plate 5, 13, 64–65, 76, 83–86, 213–14; *A Day in June*, 201; *Early Autumn, Montclair* (1888), 223, *224*, 262n57; *Early Autumn, Montclair* (1891), 178, *178*, 183–85, 193, 199, 218, 222, 223; *Early Morning, Tarpon Springs*, 182, *182*, 193, 217–18, 225, 273n127; *Early Recollections: A Landscape*, 90, *91*, 92, 96, 98, 113, 140; *Etretat*, 140; *Evening*, 137; *Evening at Medfield, Massachusetts*, 97, *97*; *Evening Landscape* (1862), 113, *114*; *Evening Landscape* (1867), *146*, 159–61, 274n1; *Georgia Pines*, 182–83, *183*, 215; *Going out of the Woods*, 129, 129–30; *A Gray, Lowery, Day*, plate 7, 78–79; *Hackensack Meadows, Sunset*, 108, *108*, 113, 119, 138, 139; *Harvest Moon*, 185, *186*, 193; *Hillside at Etretat*, 109, *111*, 140; *Home at Montclair*, plate 21, 218–19; *The Home of the Heron*, plate 11, 171, 172, 175–76, 183; *Homeward*, 70, *70*; *In the Valley*, 225; *Indian Summer*, 178, *181*; *The Juniata River*, 116; *Kearsarge Village*, plate 1, 7, 10, 15–17, 38, 40, 54, 64, 65, 78; *The Lackawanna Valley*, 109, *110*, 114, 139, 269n69; *Lake Albano*, *120*, 139; *Lake Nemi*, plate 9, 109, 114, 140–43, 220, *221*; *Landscape*, 92, *92*, 101; *Landscape, Hudson Valley*, 114, *115*, 120, 138; *Landscape near Perugia*, 138, *138*; *Landscape, Sunset*, 113, 225; *Landscape with Cattle*, 109, *111*, 138; *Landscape with Cattle and Herdsman*, *109*, 109, 112–13, 119, 121; *Landscape with Farmhouse*, 131, *132*; *Landscape with Fishermen*, *112*, 113, 116, 140; *Landscape with Trees*, plate 19, 33, 199–200, 210; *Leeds in the Catskills, with the Artist Sketching*, 273n124; *The Light Triumphant*, 147, *148*, 270n76; *Medfield*, 64–65, *66*, 76; *Midsummer Greens*, 116; *The Mill Pond*, plate 20, 211; *Moonlight*, 255n62; *Moonlight, Tarpon Springs, Florida*, 178, *181*, 193, 215; *Moonrise, Alexandria Bay*, 185; *Morning, Catskill Valley*, plate 16, 193, 198, 225; *The Morning Sun*, 66; *Mountain Stream*, 11; *Nantucket Moor*, 215; *Near Perugia in Spring*,

273n127; *Near the Village, October,* 178, *179,*
182, 184–85, 193, 225; *The New Jerusalem,*
145, 147, 145–70 passim, 279n94; *Niagara,*
plate 12, 175–76, 199, 262n57; *Niagara Falls,*
171, 172, 279n2; *October,* 183, *185; October
Noon,* plate 14, 185–86, 193, 222, 222, 233;
Off the Coast of Cornwall, England, 216, *217,*
225; *The Old Farm, Montclair,* 183, *184,* 215;
Old Homestead, plate 2, 11–13, 64, 69, 78;
Old Time Sketching Ground, 13; *Passing
Clouds,* 76, *77; A Passing Shower,* 109, *110,*
114, 120, 139; *The Passing Storm,* plate 17,
198; *Peace and Plenty,* 130, 130–31, 147, 169,
272n100; *Pine Grove of the Barberini Villa,*
176–77, *177; The Rainbow,* 66, 77, *76; Road
through the Woods,* 129, 129–30; *The Road to
the Farm,* 113, *114; Saco Ford, Conway
Meadows,* plate 4, 13, 64–65, 79; *September
Afternoon,* 193, *195,* 198, 201, 222, 223; *Short
Cut, Watchung Station, New Jersey,* 200, 201,
230; *The Sign of Promise,* 147, 152–53, 166,
169; *Spirit of Autumn,* 193; *Spring Blossoms,
Montclair, New Jersey,* 193, *196,* 198, 199,
219; *Storm Clouds, Berkshires,* 106, *107;
Summer Evening, Montclair, New Jersey,* plate
13, 183, 185, 193; *Summer, Montclair,* 225;
Summer, Montclair (New Jersey Landscape),
plate 15, 186, 193, 221–22, 222, 233; *Summer
Storm near Leeds,* 11; *The Sun Shower,* plate
8, 107, 116, 119, 120, 121; *Sundown,* 178,
180, 215; *Sunny Autumn Day,* plate 18, 199,
210; *Sunrise,* 225; *Sunset,* 64, 65; *Sunset at
Etretat,* plate 6, 14–15, 38, 40, 54, 114, 140;
Sunset at Montclair, 225; *Sunset Glow,* 192,
193; *Sunshine and Clouds,* 63, 64, 76; *The
Triumph of the Cross,* plate 10, *144,* 145–70,
146, 226, 227; *Two Sisters in the Garden,* 70,
70; Valley of the Olives, 146, 159–61, 274n1;
The Valley of the Shadow of Death, plate 10,
145, 145–70 passim, 275n2; *A View near
Medfield,* 113; *The Vision of Faith,* 145,
145–70 passim; *Visionary Landscape,* 144,
159–61, 274n1; *Winter Moonlight (Christmas
Eve),* 113–14, *115,* 116; *Winter Morning
Montclair,* 14, 15, 55–56, 64–65, 76, 82; *The
Wood Chopper,* 112, 113, 114; *Woodland
Scene,* 178, *179,* 185, 225, 225
Inness, George, Jr. (son of GI): on Inness and
Beecher, 270n76; on Inness and Sweden-
borg, 42–43; on Inness painting over his
son's finished canvases, 263n76
insects, 20, 220, 288n144
intention, 5
invisibility, 21–22

James, Williams, 51

Jarves, James Jackson: on allegory, 147, 275n9;
Art-Idea, 26; *Art Thoughts,* 26; on Corot, 38;
influence of Spencer, 26; on Inness's experi-
mentation, 95; memory criterion and, 34;
on participation, 131–33, 164

Kearsarge Village (Inness), plate 1, 7, 10, 38;
compared to paintings by Inness's contem-
poraries, 15; composition of, 64, 65; figures
in, 13, 78; light in, 17; memory and, 40; ob-
structing effects in, 15; spatial and perspecti-
val distortions in, 16, 17; unintelligibility
and difficulty of, 15–17; viewing of, 15–17,
43; visible brushwork in, 15; vision and,
16–17, 54
Kennedy, Rev. W. S., 103–4
Kensett, John Frederick, 10
Kepler, Johann, 282n38
Kessler, Herbert L., 278n57
knowledge: empiricism and, 29; Inness's theo-
rization of 29, 30; period discussion of,
50–53
Knowlton, Helen M., 36
Kyle, Joseph, *158*

Lackawanna Valley, The (Inness), 109, *110,* 114;
anthropomorphism in, 139; figure in, 139;
industrialization and, 269n69
LaFarge, John, 34
Laffan, William Mackay, 8
Lake Albano (Inness), 120, 139
Lake Nemi (Inness), plate 9, 140–43; atmosphere
in, 141–43; back-turned figure in, 114,
140–41; foreground in, 109, 140, 141; Inness
on, 140–41; panoramic in, 140; participation
and, 109, 140–43; scraped surface of, 141,
220, 221
Lamb, Frederick S., 32
*"Land of Beulah," Panorama of Bunyan's "Pil-
grim's Progress"* (attr. Cropsey), 159, *160*
landscape: alphabet and, 227–28; association
and, 117–19; as a book, 228, 288n161; Cole
on, 8; conventions, 10, 96–103; drawing
manuals and, 102–3; Durand on, 8, 15; fan-
tasy of possession and, 98, 99, 132–33; figure
painting and, 69–74, 260n34; figures in,
69–74; French art and, 10; guidebooks and,
102; history and, 6, 117–19; as ideology, 4;
instrumentality of, 23, 235–36 (*see also
under* Inness, George); learning to see and,
103–6; memory and, 117–21 passim; nation-
alism and, 4; observation and, 8; participa-
tion criterion and, 100, 108, 127–29; as
philosophy, 235–37; scholarship on, 4, 237;
spiritual sight and, 103; tourism and, 164–65,
166; transformation of in nineteenth-century

United States, 97, 108; truth and accuracy
and, 8–9; vision and, 96–106, 237; zonal
landscape formula and, 97–103
Landscape (Inness), *92*, 92, 101
Landscape, Hudson Valley (Inness), 114, *115*,
120, 138
Landscape near Perugia (Inness), *138*, 138
Landscape with Cattle (Inness), 109, *111*, 138
Landscape with Cattle and Herdsman (Inness),
109; centered tree in, 119; foreground in,
109; participation and, 109; rejection of
convention in, 109, 112–13; transformation
of tradition in, 121
Landscape with Farmhouse (Inness), 131, *132*
Landscape with Fishermen (Inness), *112*, 113,
116, 140
Landscape with Trees (Inness), *plate 19*, 33,
199–200, 210
Lathrop, George P., 205
Lecoq de Boisbaudran, Horace, 34, 251n24
Leibniz, Gottfried Wilhelm: geometry and, 189,
282n34; infinitesimal calculus and, 281n28;
language and, 188–89; logic and, 188–89;
mathematics and, 189; mathesis and,
188–89; Newton and, 281n28; spiritual sight
and, 282n34; Swedenborg and, 188, 189;
universal language and, 282n31; universal
philosophy and, 188–89, 282n31
Lichtenstein, Jacqueline, 208
Light Triumphant, The (Inness), 147, *148*,
270n76
Locke, John, 3, 50, 188; Inness and, 3, 50–57, 235
logic, 29, 175; Inness and, 29, 175, 189–90
Lorrain, Claude, 100. *See also under* Inness,
George

Magnan, Valentin, 3, 207–8
Martin, Homer Dodge, 10, 38
mathematics: geometry, 176; infinitesimal cal-
culus and, 281n28; Inness's interest in, 28;
Inness's pictures described as mathematical,
29; universal philosophy and, 188–89,
282n38. *See also under* Inness, George;
Leibniz, Gottfried Wilhelm
mathesis, 187–90, 197, 212
May, Edward Harrison, *158*
McSpadden, J. Walter, 175, 227, 228
Medfield (Inness), 64–65, *66*, 76
Meissonier, Jean-Louis Ernest, *24*; Corot and, 23,
29; Inness on, 23–24, 25, 151; Inness's art
and, 28, 29, 41, 61; memory and, 254n53;
science and, 28
memory: art and, 34–35; Cave and, 35; as a
criterion for painting, 34, 117–18; cultiva-
tion of, 34–35; forgetting, 73, 127, 134–36;
French academy and, 253n40; Hunt and,

36–37; Inness painting from, 3, 32–34;
Inness's theorization of, 22; landscape and,
117–19; Lecoq and, 34–35; Millet and,
253n40; period discussion of, 39–40,
117–19; 254n46; role in painting process,
34; Van Rensselaer and, 35–36; vision and,
33–34, 85. *See also under* Inness, George
Merleau-Ponty, Maurice, 240n14
methodology, 4–6, 237, 241n18
Michelangelo, 82, 151
middle ground, the, 99; vision and viewing and,
103–6
Mill, John Stuart, 3, 175
Mill Pond, The (Inness), *plate 20*; color in, 211;
rejection of formula and logic in, 211
Millet, Jean-François, 36, 37, 253n40
Mind, 51
M'Leod, William, 118
Moat Mountain, Intervale, New Hampshire (Bier-
stadt), 15, *16*
Molyneux, William, 3, 50, 256n73. *See also
under* Inness, George
Monet, Claude, 176, 204, 205, 209
Monks, John A. S., 33, 82, 262n58
Moonlight, Tarpon Springs, Florida (Inness), *181*;
figure in, 215; foreground in, 193; geometry
and, 178
Moore, James Collins, 228
Moran, Thomas, 8, 243n35
Morning, Catskill Valley (Inness), *plate 16*; color
in, 198–99; foreground in, 193; scraped sur-
face of, 225
music, 209

National Academy of Design, 2, 21, 94
nationalism and national identity, 4, 241n6,
266n37
nature: book of, 228, 288n161; divine presence
in, 190; Durand on, 106, 141; Inness and,
9–10, 31–32, 218, 243n33, 249n1; study of,
8–9, 106
Near the Village, October (Inness), *179*; figure
in, 182; geometry and, 178, 184–85, 193;
scraped surface of, 225
Nemerov, Alexander, 4
New Jerusalem, The (Inness), *144*, 145, *146*, 146,
145–70 passim; as an allegory of perception,
161; critics on, 159, 167, 279n94; figures in,
160–61; Inness on, 158–59; participation
and, 167; rediscovered fragments of,
159–61; spiritual sight and, 161. See also
Triumph of the Cross, The
Newton, Isaac, 281n28
Niagara (Inness), *plate 12*; color in, 175, 199;
geometry and, 175–76; middle tone and,
262n57

numbers. *See under* Inness, George

October (Inness), 183, *185*, 193
October Noon (Inness), *plate 14*, 222; foreground in, 193; geometry and, 185–86; scraped surface of, 222, 233
Oegger, Guillaume, 187, 281n25
Off the Coast of Cornwall, England (Inness), 216, *217*, 225
Old Farm, Montclair, The (Inness), 183, *184*, 215
Old Homestead (Inness), *plate 2*; anthropomorphism and, 78; composition of, 64, 69; critic on, 11; difficulty of, 12–13; figure in, 13; as perplexing to viewer, 12; technique of, 12–13
Osgood, Samuel, 118
Otis, Fessenden Nott, 105–6

Page, William, 42, 75, 261n55
panorama: Banvard's, *162*, *163*, 164; "The Grand Moving Panorama of Bunyan's *Pilgrim's Progress*," 153, *158*, 158, 159, *160*, *162*, 162–64, *163*; and Inness, 153, 162–69; the panoramic in painting, 132
participation, in painting: as a criterion, 108, 127–29, 161–62; Durand on, 15, 141; spiritual sight and, 127. *See also under* Inness, George; *Triumph of the Cross, The*
Passing Clouds (Inness), 76, *77*
Passing Shower, A (Inness), *110*; the body and, 139–40; figure in, 114, 119, 139–40; foreground in, 109; participation and, 109, 139–40; rainbow in, 139
Passing Storm, The (Inness), *plate 17*, 198
Pattison, James William, 147, 169, 276n14
Paulson, Ronald, 278n63
Peabody, Elizabeth, 187
Peace and Plenty (Inness), *130*, 130–31, 147, 169, 272n100
Peale, Rembrandt, 105
perception: art as an aid to, 103–6; art education and, 105–6; drawing and, 105–6; extrasensory or extraphysical perception, 20–21, 123; Inness's interest in, 3–4, 19–20; Inness's paintings discussed in terms of, 17; Inness's theorization of, 18, 19–21; landscape and, 237; Ogden Rood on, 20; participation and, 133–35; period discussion of, 27–28, 29, 50–53. *See also* Inness, George, perception; vision
perspective: atmospheric perspective, 15; distorted in Inness, 14, 84
phenakistiscope, 80
photography: Chase and, 215; impressionism and, 214–15; Inness and, 219; landscape painting compared to, 8

picturesque, the, 127–28, 166, 272n90
Pilgrim's Progress, The. See Bunyan, John
Pine Grove of the Barberini Villa (Inness), 176–77, *177*
Plato, 282n38
Popular Science Monthly, 51
Poussin, Gaspar. *See* Dughet, Gaspard
Pre-Raphaelitism: Inness on, 21, 22, 25, 205, 236; Inness's art compared to, 92, 246n71, 275n9; in the United States, 102, 243n28, 275n9
Price, Uvedale, 127–28
Promey, Sally M., 42, 148–49, 278n71
psychology, 29, 283n39. *See also under* Inness, George
psychophysiology, 27, 29, 51–57, 235

Quick, Michael, 145, 274n1

Rainbow, The (Inness), 66, *77*, 76
rainbows, 13, 139, 140
Road through the Woods (Inness), 129, 129–30
Road to the Farm, The (Inness), 113, *114*
Rood, Ogden, 20, 87, 220
Rossiter, Thomas Prichard, 150
Rousseau, Theodore, 25, 37, 151, 252n32, 266n60
Ruisdael, Jacob van, 268n60
Ruskin, John, 51, 139, 209, 257n86, 273n125
Ryder, Albert Pinkham, 228, 250n18, 253n40

Saco Ford, Conway Meadows (Inness), *plate 4*; atmospheric perspective in, 79; composition of, 64–65; difficulty of, 79; figures in, 13; middle tone and, 79; vision and, 79
Schuyler, Montgomery: on Inness and Beecher, 270n76; on Inness and spiritualism, 26; on Inness's experimentation, 28; on Inness's working methods, 33, 82; on Inness's writing and manuscripts, 239n7
science: art and, 23–24, 25, 27–28, 240n12; interdisciplinarity of in nineteenth-century United States, 26–29; psychophysiology, 27, 29, 51–57, 235; religion and, 1, 26; spiritualism and, 26–27. *See also under* Inness, George
Scientific American, 163
September Afternoon (Inness), 193, *195*, 198, 200; scraped surface of, 222, 223
Sheldon, George, 239n1; on Inness and Beecher, 270n76; on Inness and metaphysics, 1; on Inness and "The Mathematics of Psychology," 1–2, 174–75; on Inness and the old masters, 95–96; on Inness's poetry, 226; interview with Inness, 18, 21
"*Shepherds Pointing out the Gates of the Celes-*

tial City from Hill Clear, The" Panorama of
 Bunyan's "Pilgrim's Progress" (attr. Kyle and
 May), 158, 158
Shinn, Earl, 38
Sign of Promise, The (Inness), 147; critics on,
 169; exhibition of, 166; Inness's pamphlet
 on, 147, 152–53; opera glasses and, 166
Slave Ship (Slavers Throwing Overboard the
 Dead and Dying, Typhoon Coming On)
 (Turner), 67, 67–68
sound, art and, 261n53
Spencer, Herbert: blindness and, 80; Inness and,
 53, 60, 63–64, 257n87; theory and research
 of, 26, 247n80, 257n87; on visual function,
 53
spiritual sight: allegory and, 153–70 passim;
 embodiment of, 5; in the middle ages,
 278n57; landscape painting and, 103–6;
 Swedenborg and, 21, 44–50, 84, 188, 233,
 257n86; zonal landscape formula and, 106.
 See also under Inness, George
spiritualism: Inness and, 26; nature and history
 of, 247n83, 248n85; psychophysiology and,
 27; science and, 26–27
Spring Blossoms, Montclair, New Jersey (Inness),
 193, 196; drawing in, 219; temporality and,
 219
staffage (figures): in American art, 243n35; Du-
 rand and, 243n35; Inness and, 13, 119–20
Star Papers (Beecher), 122
stereoscope, 52, 80, 167, 262n61
Stillman, William, 103
Storm Clouds, Berkshires (Inness), 106, 107
strabismus, 27, 206, 249n95
Sturgis, Russell, 103–4
sublime, the, 123
Suicide, The (Decamps) 41, 42
Sully, James, 85
Summer Evening, Montclair, New Jersey (Inness),
 plate 13; color and, 198, 199; geometry and,
 183, 185, 193
Summer Montclair (New Jersey Landscape) (In-
 ness), plate 15, 222; foreground in, 193;
 geometry and, 186; scraped surface of,
 221–22, 233
Sun Shower, The (Inness), plate 8; back-turned
 figure in, 120; centered tree in, 107, 119;
 foreground in, 116; rejection of convention
 in, 107; transformation of tradition in, 120,
 121
Sundown (Inness), 178, 180, 215
Sunny Autumn Day (Inness), plate 18, 199, 210
Sunset (Inness), 64, 65
Sunset at Etretat (Inness), plate 6, 14, 38; color
 red in, 14, 140; effect on eye, 14; figure in,
 14, 114; horizon in, 14; memory and, 40;

spatial and perspectival distortions in,
 14–15; strangeness of, 14; uneven finish in,
 14; viewing of, 54; vision and, 54
Sunset Glow (Inness), 192, 193
Sunshine and Clouds (Inness), 63, 64, 76
Swedenborg, Emmanuel, 42–50, 56; Arcana
 coelestia, 42–50; biography, 43–44; blind-
 ness and, 80; color and, 42; correspondence,
 theory of, 21, 188, 255n65; Emerson on,
 211–12; exegesis and, 44–45, 255n65; France
 and, 187; geometry and, 188; influence on
 Inness, 21, 42–50; Inness discussed in terms
 of, 29; Inness's study of, 21, 42–43; Leibniz
 and, 188, 189; Locke and, 188; mathematics
 and, 188; mathesis and, 188; psychology
 and, 187–88; psychophysiology and, 187–88;
 science and, 43–44; seeing as breathing, 47,
 49–50, 60, 86, 216, 229, 257n86, 277n44;
 The Soul or Rational Psychology, 187–88;
 spiritual sight and, 21, 44–50, 84, 188, 233,
 257n86; spiritualism and, 26; The True
 Christian Religion, 187; United States and,
 42, 255n58; universal philosophy and,
 187–88, 197. See also under Inness, George

theology, 25–26.
Tiffany, Louis Comfort, 34
toys, optical, 80. See also stereoscope
tradition, 91–96. See also under Inness, George
transcendentalism, 187
Triumph of the Cross, The (Inness), plate 10, 144,
 145–70 passim, 146, 227, 274n1; anthropo-
 morphism and, 167; commission, 147;
 critics on, 159, 167–68, 169–70, 279n94;
 Daingerfield on, 170; damage of, 274n1;
 figures as surrogates in, 167–68; Inness's
 pamphlet for, 151, 156, 157, 158–59, 164–65;
 memory and, 166; opera glasses and, 166;
 participation criterion and, 161–62, 164–69;
 reading and, 164–65, 166, 170; scholarship
 on, 148–49; spiritual sight and, 169; Swe-
 denborg and, 148–49; touristic seeing and,
 164–65, 166; viewing experience of, 166–69;
 word and image and, 168–69, 170; writing
 and, 226. See also Evening Landscape; New
 Jerusalem, The; Valley of the Olives; Valley of
 the Shadow of Death, The; Vision of Faith,
 The; Visionary Landscape.
Troyon, Constant, 37, 151
Trumble, Alfred: on eye-strain, 208; on impres-
 sionism, 206–7, 208, 210; on Inness as both
 poet and psychologist, 197; on Inness's
 intensity when painting, 236; on Inness's
 working methods, 32truth, 7, 8–9; Inness
 and, 9–10, 18–19, 21–22, 61
Tryon, Dwight W., 10

Tuckerman, Henry, 117, 130–31, 149, 169
Tupper, Martin Farquhar, 260n26
Turner, J. M. W., *67*; diagnosis of ocular dysfunction of, 26, 27, 28, 79; imagination and, 38; Inness and, 61–62, 67–68, 72, 93, 151; poetry and, 259n22
Two Sisters in the Garden (Inness), 70, *70*

unconscious, the, 35–36, 73–74, 233–34
universal language, 282n31

Valley of the Olives (Inness), *146*, 159–61, 274n1. See also *New Jerusalem, The*
Valley of the Shadow of Death, The (Inness), *plate 10*, 145–70 passim; as an allegory of perception, 155–57; anthropomorphism and, 167; blindness and, 156–57; critics on, 167, 169; expansion of allegory in, 168; faith and, 156–57; figure in, 167–68; foreground in, 167; Inness on, 156; participation and, 167–68; reading and viewing combined in, 168; stereoscope and, 167; Whitman and, 275n2. See also *Triumph of the Cross, The*
Van Dyke, John C., 209
Van Laer, A. T., 1
Van Rensselaer, Mariana Griswold, 35–36, 72, 203, 204, 214, 233
Ville d'Avray (Corot), 23, *24*, 38
vision: abnormal vision, 9, 17, 20, 27; in art criticism, 96–105, 202–10 passim; art explained in terms of (nineteenth century), 27–28, 203, 206; atmospheric perspective and, 15; binocular, 52, 80, 220, 262n61; blind spot, 27, 28; color red and, 140; hallucination, 28; impressionism and, 202–10; innocent eye, 209, 257n86; of insects, 20, 220, 288n144; modernity's effect on, 208; monocular, 80–81; perceived strangeness of, 27; period discussion of, 27–28, 5 photography and, 21